How This Book Will Make You a More Successful Writer

By applying rhetorical reading techniques to your writing, you will learn

- To shape your own texts to accomplish your specific purposes in relation to varying situations and audiences

- To use the composing processes of skilled academic writers

- To practice the three ways that writers typically use readings in academic settings: as models to adapt, as objects to analyze, and as voices to respond to in a conversation

- To communicate your understanding of a text through effective summaries and paraphrases

- To expand your repertoire of writing strategies so that you can adopt and use methods you encounter in a wide variety of texts

- To write successful analyses and critiques of a text's argument and rhetorical strategies

- To write successful college-level research papers that address significant questions and make important points within a larger conversation

- To follow appropriate conventions for incorporating excerpts from source materials into your own writing without letting them take over your paper

Reading Rhetorically

A READER FOR WRITERS

Second Edition

JOHN C. BEAN
Seattle University

VIRGINIA A. CHAPPELL
Marquette University

ALICE M. GILLAM
University of Wisconsin–Milwaukee

PEARSON
Longman

New York • San Francisco • Boston
London • Toronto • Sydney • Tokyo • Singapore • Madrid
Mexico City • Munich • Paris • Cape Town • Hong Kong • Montreal

Senior Vice President and Publisher: Joseph Opiela
Vice President and Publisher: Eben W. Ludlow
Development Manager: Janet Lanphier
Development Editor: Marion B. Castellucci
Marketing Manager: Deborah Murphy
Senior Supplements Editor: Donna Campion
Media Supplements Editor: Nancy Garcia
Production Manager: Charles Annis
Project Coordination, Text Design, and Electronic Page Makeup:
 Pre-Press Company, Inc.
Cover Designer/Manager: Wendy Fredericks
Manufacturing Buyer: Alfred C. Dorsey
Printer and Binder: RR Donnelley and Sons, Co.
Cover Printer: The Lehigh Press, Inc.

Library of Congress Cataloging-in-Publication Data
Bean, John C.
 Reading rhetorically: a reader for writers / John C. Bean, Virginia A. Chappell, Alice M. Gillam.—2nd ed.
 p. cm.
 Includes index.
 ISBN 0-321-23668-8
 1. College readers. 2. English language—Rhetoric—Problems, exercises, etc.
3. Report writing—Problems, exercises, etc. I. Bean, John C. II. Chappell, Virginia A. III. Gillam, Alice M. IV. Title.

 PE1417.B393 2005
 808'.0427—dc22

 2004000627

Visit us at http://www.ablongman.com/bean

ISBN 0-321-23668-8

10 9 8 7 6 5 4 3 —DOC— 07

Brief Contents

Detailed Contents

PART 2 *The Rhetorical Reader as Writer*

PART 3 *An Anthology of Readings*

8 Expressing and Reflecting 165

Thematic Contents

Social Class

Values and Beliefs

Preface

The second edition of *Reading Rhetorically* is, like the first, shaped by the belief that students need explicit instruction in analytical reading, not because they have problems with reading, but because college writing assignments demand sophisticated ways of reading. Gratified by the enthusiastic response to the first edition, we have created a second edition that preserves the strengths of the first while offering significant improvements based on the suggestions of those who have used the book. This aims-based reader (1) emphasizes reading as an inter-active process of composing meaning and (2) treats academic writing as a process in which writers engage with other texts.

Reading Rhetorically approaches reading as an advanced intellectual process that forms the basis for successful academic writing across the disciplines. Adoption of the regular or brief editions by faculty at a range of two- and four-year institutions for use in a variety of classrooms—including entry-level courses, upper-level writing courses, and even high school college prep courses—suggests that many writing instructors share our belief that academic reading, writing, and inquiry need to be taught as inextricably linked rhetorical acts. This edition adds visual texts—graphs, cartoons, and photographs—to the collection of materials that students are invited to analyze, and the text itself makes greater use of visual displays in tables and lists to help students understand rhetorical concepts.

Reading Rhetorically teaches students to read with an analytical eye and to write about what they have read with rhetorical insight. It defines "reading rhetorically" as attending to an author's purposes for writing and the methods the author uses to accomplish those purposes—the *how* and *what* of a text's message. That is, the book teaches students how to see texts as positioned in a conversation with other texts, how to recognize the bias or perspective of a given text, and how to analyze texts for both content and rhetorical method. The second edition maintains emphasis on academic writing as a process in which writers engage with other texts. By sharpening their analytical skills, students learn to write with more rhetorical sophistication. They learn how to analyze other texts by reading them with and against the grain, how to imitate other texts by learning their rhetorical strategies and genre conventions, and how to use other texts for their own purposes in conducting research. Many composition readers offer readings that provide either topics or models for student writing; in contrast, this collection organizes its selections by rhetorical aims. Our goal is to

offer readings—and visuals—for rhetorical analysis so that students can learn about, and then apply in their own writing, a variety of rhetorical strategies.

What's New in the Second Edition

Building on the book's strengths, we have revised the text substantially by adding the following features:

- Visual elements throughout the book as well as a two-color design that enhances the book's visual appeal
- A substantially revised first chapter that combines Chapters 1 and 2 from the first edition and concludes with a chart of the distinctive features of various rhetorical aims
- An expanded Chapter 3, which includes strategies for using a text's visual elements to predict content and for connecting the visual to the verbal while "listening" to a text
- A similarly expanded Chapter 4, which adds strategies for analyzing a text's use of visual elements
- Strategies for examining what a text's visual and verbal elements *do* and *say*
- An expanded treatment of the rhetorical analysis paper (Chapter 4), which is presented as the written counterpart of rhetorical reading
- Coverage of American Psychological Association citation conventions and formats as well as those of the Modern Language Association, in Chapter 7 and in the appendix
- Nineteen new professional texts in the anthology section, some with visual features and others that make a visual argument, including an editorial cartoon, comic strips, and a poster
- Four new student papers, modeling APA as well as MLA citation conventions

Distinctive Features

The second edition of *Reading Rhetorically* is distinguished by the following features:

- An anthology of high-interest readings and visual texts that vary widely by aim, genre, length, subject matter, and rhetorical situation, spanning a range of textual types that students will encounter in college
- Explanations of rhetorical concepts that provide an analytical framework for reading and writing
- Discussion of reading processes to show students how skilled academic readers construct a text's meaning
- Presentation of writing processes to emphasize strategies for writing about reading

- Three strands of writing assignments that invite students to engage with the readings in the anthology chapters by (1) writing to match the rhetorical aim of the chapter's readings, (2) writing to examine rhetorical strategies, and (3) writing to conduct inquiry and synthesize multiple readings
- Treatment of research as a process of rhetorical reading in which students learn to develop research questions and evaluate sources within a rhetorical context
- A discussion of how to evaluate sources that covers Web sources and licensed databases accessed through the Internet
- Presentation of citation methods as integral to rhetorical effectiveness
- An extended example that follows the evolution of one student's writing project from summary to rhetorical analysis to researched critique of a reading
- Extensive discussion of argument that introduces important concepts for rhetorical analysis such as ethical, logical, and audience-based appeals and categories of claims
- Examination of distinct forms of argument—position statements, evaluative arguments, proposals, Rogerian arguments, and visual arguments
- A sample of student writing in each anthology chapter, four with MLA internal citations and a works cited list, and two with APA internal citations and a references list
- Individual chapters on two important but often ignored aims: writing to explore and writing to seek common ground
- Short stories, belletristic essays, and a poem for literary analysis
- With each reading selection, prompts for (1) preview, (2) rhetorical analysis, and (3) applying techniques to one's own writing
- In the appendix, citation formats for print and electronic materials (including periodicals databases) with an extensive list of model MLA and APA style citations

Structure

The opening instructional portion of the text (Chapters 1 through 7) is organized into two parts that explain the demands of college reading and writing, and offer a conceptual framework and practical strategies for meeting these demands. Part One (Chapters 1 through 4) begins by asking students to reflect on *how* they read and *why*. Chapters 1 and 2 describe the special demands of academic reading and introduce students to the rhetorical reading strategies used by experts: building a context for reading and matching reading strategies to a text's genre and purpose. Chapters 3 and 4 teach *how* to read rhetorically, first by "listening" to what a text is doing and saying, and second by questioning what a text is doing and saying. Chapter 3 offers practice in listening through annotating, mapping idea structure, taking into account a text's visual features, summarizing, descriptive outlining, and writing a rhetorical précis, while Chapter 4 provides practice in questioning through analysis of a text's rhetorical appeals, language, visual elements, and ideology.

Part Two (Chapters 5 through 7) focuses on writing about reading. This section begins with an overview of typical reading-based writing assignments across the curriculum. It then advises students about how to maintain writerly authority and manage their writing process as they write about what they have read. Chapters 6 and 7 teach students how to meet the conceptual and practical demands of research writing. Chapter 6 focuses on how to use rhetorical reading as a research strategy as students formulate research questions and then choose and evaluate readings. Chapter 7 instructs students in the conventions of source-based writing—summary, paraphrase, direct quotation, citation practices—and places these practices in a rhetorical framework.

Part Three (Chapters 8 through 15) offers an anthology of readings organized by aim. Each chapter in the anthology begins by examining distinctive features of a rhetorical aim: reflecting, exploring, explaining, interpreting, taking a stand, evaluating, proposing solutions, and seeking common ground. Readings are accompanied by a contextualizing headnote, preview questions for reading logs, and questions that help students analyze rhetorical methods and recognize techniques they might adapt in their own writing. Each chapter ends with a set of three writing assignments based on ways in which academic writers use readings: as models, as objects for analysis, and as voices in a conversation.

Three Strands of Writing Assignments

The three assignment strands that appear at the end of the anthology chapters invite students to engage with the chapter's readings in ways that parallel common academic ways of writing about reading.

- *As models:* This assignment option asks students to try their hand at writing in a particular aims-based genre, using a topic and purpose of their choosing. Because this text emphasizes rhetorical reading, this assignment guides students through an examination of the conventions and rhetorical features of a particular type of text before inviting them to practice this type of writing. In addition, this assignment asks students to consider how rhetorical situations interact with genre conventions to shape individual texts and create variations within an aims-based genre.
- *As objects of analysis:* Because analysis is a common type of college writing assignment, this strand asks students to analyze rhetorically one or more of the texts in the chapter. Support for the analysis is offered through the questions that begin each chapter and that accompany each reading. These questions offer beginning points for analytical essays by helping students identify and evaluate the effects of various rhetorical strategies and choices.
- *As voices in a conversation:* This assignment option asks students to place texts in conversation with one another and to join that conversation by forwarding their own argument. In this strand, students use the readings in the chapter as a springboard for inquiry and discovery. Nearly all of these

assignments ask students to conduct research based on carefully formulated research questions and rhetorically based assessment and selection of sources. This strand of assignments prepares students to write the kind of multisource research papers frequently required in college courses across the curriculum.

Together, these strands offer instructors flexibility in the design and sequencing of assignments and give students guided practice in the three main ways that academic readers use texts in their writing.

Apparatus

The apparatus for the readings in the anthology section builds on the rhetorical reading concepts introduced in Parts One and Two. Specifically, Chapters 8 through 15 begin with a discussion of the ways in which a particular rhetorical aim shapes a text and influences reader response. Following this discussion is a series of questions designed to facilitate students' analytical reading of the chapter's texts. Because the questions are based on the rhetorical features common to texts with a particular aim, these questions encourage a more focused rhetorical reading.

To further enable students to read each text through a rhetorical lens, *Reading Rhetorically* provides contextualizing headnotes and pre- and post-reading questions. Headnotes not only provide biographical information about the author or authors but also information about the original context surrounding the text's publication. Each text is preceded by For Your Reading Log questions that ask students to preview and make predictions about a text as well as consider their own background knowledge and attitudes toward the text's topic. The Thinking Critically questions that follow each reading are of two types: Responding as a Reader and Responding as a Writer. Generally, the first set of questions focuses on understanding the way a text works rhetorically, both internally and in relationship to various external contexts. The second set of questions asks students to consider how they might apply the techniques used in a particular reading in their own writing.

Strategies for Using *Reading Rhetorically*

The text's organizational structure facilitates easy syllabus design. The book begins with seven short chapters (Parts One and Two) that provide a conceptual framework and practical strategies for reading and writing about the texts that appear in Part Three, An Anthology of Readings. Because the first seven chapters provide numerous opportunities for practicing the strategies being presented, students can work their way through these chapters before proceeding to the anthology chapters, or they can move back and forth between the chapters in Parts One and Two and the chapters in Part Three, trying out the reading and writing strategies on the readings in the anthology chapters.

Organized by aim, the anthology section offers high-interest reading selections that vary widely by aim, genre, length, and subject matter. There are many ways to use the chapters in the anthology section, and most instructors will select the aims-based chapters that best fit with their course goals. For those instructors who wish to select readings by theme, we provide a thematic table of contents.

Resources for Students and Instructors

Reading Rhetorically, second edition, is accompanied by an *Instructor's Resource Manual* and *Companion Website*, <http://www.ablongman.com/bean>, both of which enable considerable flexibility for syllabus design and for development of students' individual topics for writing.

The *Instructor's Resource Manual* offers suggestions that will help both experienced and new instructors make curricular decisions and plan daily classroom activities. The manual demonstrates *Reading Rhetorically*'s flexibility by (1) discussing several approaches to integrating instruction in rhetorical analysis with reading and writing assignments and (2) presenting syllabus templates for one- or two-term courses. These models are all adaptable according to curricular goals, whether the focus is on, for example, academic writing, introduction of a variety of aims, or persuasion and writing for the public sphere.

The first part of the manual is organized around the key concepts found in Chapters 1 through 7, offering suggestions for additional activities and applications. Next, the manual's discussion of the anthology chapters includes (1) suggestions for helping students understand the aim, (2) synopses of reading selections, (3) discussion of distinctive rhetorical features to show how each reading embodies the chapter's aim, (4) guidance for helping students understand the chapter's writing projects, and (5) thematic connections among the readings and ideas for extending those themes. The last section of the manual demonstrates the connections between *Reading Rhetorically* and the Council of Writing Program Administrators' *Outcomes Statement*. Throughout, the manual's format enables quick access to facilitate efficient planning.

The *Companion Website*, designed for both students and teachers, extends the textbook's concepts and activities in ways that are both inherently fun and intellectually engaging. The resources for students include discussion of each chapter's objectives, links for building an individualized Internet Rhetorical Tool Kit, links for additional information about authors, prompts for applying rhetorical reading strategies to Websites selected for their thematic connection to anthology selections, and writing exercises that can be submitted electronically. For instructors, the chapter-by-chapter organization of the *Companion Website* provides Quick Start Tips for introducing material, links to professional resources, and suggestions for helping students use the materials linked for the rhetorical tool kit. Of particular interest for classes that meet in computer classrooms is the site's Message Board, which provides students with the opportunity to engage in structured on-line brainstorming sessions with their classmates.

Acknowledgments

We begin by thanking the teachers who have used the first edition of *Reading Rhetorically* and offered excellent advice for the second edition: Kamala Balasubramanian, Grossmont College; Jami Carlacio, Ithaca College; Jacqueline E. Cason, University of Alaska–Anchorage; Avon Crismore, Indiana University–Purdue University Fort Wayne (and her students); Joan R. Griffin, Metropolitan State College of Denver; Patricia Jenkins, University of Alaska–Anchorage; Martha Marinara, University of Central Florida; Kerri Morris, University of Alaska–Anchorage; Carol Roberts, Indiana University–Purdue University Fort Wayne; and Martha Van Cise, Berry College.

We would also like to thank the instructors who reviewed the manuscript of the second edition and offered valuable suggestions for improvement: Dominic Delli Carpini, York College of Pennsylvania; Kathleen Baca, Dona Ana Branch Community College; and Kelley Hayden, University of Nevada-Reno.

In Milwaukee, colleagues and students (past and present) whose thinking was invaluable to this revision include Amy Branam, Lynn Bryant, Sarah Caryl, Michelle Dougherty, Derek Hanaman, Jennifer Heinert, Catherine Kalish, Virginia Kuhn, Lesley Kuras, Barrett McCormick, Olivia Taylor, Douglas VanBenthuysen, and Ann Wizenburg. For painstaking assistance with the index, we thank Jessica Demovsky, and for generosity and sharp focus as proofreaders, we thank Patricia Chappell, Cord Klein, and Jane Chappell Singleton.

Deep appreciation goes to our editor, Eben Ludlow, vice president of Allyn & Bacon/Longman, and Marion Castellucci, our development editor, an expert at finding elegant solutions to thorny editorial problems. Their enthusiastic support and wise counsel provided central inspiration for our work. In addition, our sincere thanks go to Marcy Lunetta of Page to Page and the able staff at Longman who assisted us at various stages of this book's production.

Finally, we would like to thank our students. Truly, the insights that inform this book largely come from what we have learned from them. For these learning opportunities we are profoundly grateful.

Reading Rhetorically

Reading for Academic Writing

*The process of reading is not just the interpretation
of a text but the interpretation of another person's
worldview as presented by a text.*

—Doug Brent

Imagine the following scenario: It's early evening, almost the end of the first week of classes. You've conquered the lines at the bookstore, lugged home shopping bags full of books, and lined up your newly purchased textbooks neatly on the shelf next to your desk. You're ready. With the weekend approaching, it's time to figure out just how many of those pages you will need to read by next Monday or Tuesday. Consider this hypothetical list of a weekend's worth of reading assignments early in a college term:

- For Chemistry, the textbook's introductory chapter
- For Political Science, a newspaper editorial of your choice, to be analyzed according to concepts laid out in a textbook chapter on "Interest Groups and the Media," which you are also assigned to read
- For Humanities 101, the Platonic dialog *The Crito*
- For Composition class, this chapter and a reflective essay from Chapter 8

In addition, an initial problem statement for your first major composition assignment is due in a week. Deciding on your problem statement will necessitate some reading based on library research—it's up to you to decide where to start, and when.

This scenario and list probably don't fit the specifics of your current situation, but it's likely that their general shape is similar to what you are facing. Probably none of these assignments by itself is overly long. However, taken together and combined with the reading and research assigned for the end of the *next*

week, the list may be fairly daunting. Furthermore, because professors seek to introduce students to particular academic methods and subject matters, each assignment necessitates reading with a different purpose and type of awareness. Each asks you to do something different with what you read, such as memorize definitions, understand and apply concepts, track the logic of an argument, or interpret ambiguities and patterns of expression.

Many college students are surprised, even overwhelmed, by the heavy reading they are assigned, and bewildered by their teachers' expectations, not only in English and other humanities classes but in natural science, social science, and preprofessional classes such as introductions to accounting or nursing. Beyond textbook chapters and other readings assigned for specific class sessions, your college reading will include specialized Websites, books, and articles that you will select and research as you prepare papers and reports in a wide variety of classes.

For the most part, students adapt to these new demands, gradually learn what academic reading entails, and—by the time they are juniors and seniors within their major fields—learn how to do the reading and writing demanded in their disciplines and future professions. But the process is often slow and frustrating, marked by trial and error and the panicky feeling that reading this way is like hacking through a jungle when there might be a path nearby that could make the journey easier.

This book is designed to help you find that path and thus accelerate your growth as a strong academic reader and writer. It aims to describe the special demands and pleasures of academic reading, teach you the reading strategies used by experts, and show you the interconnections between reading and writing in almost all college courses. As you can see from the table of contents, the last and largest section of this book (Part Three, comprising Chapters 8–15) is an anthology of readings, arranged along a spectrum of writers' purposes, chosen to illustrate the wide range of styles, subject matter, and formats (or "genres") that you are likely to encounter in college or the world of work.

Preceding the anthology are two parts (Chapters 1–7) that explain strategies for handling the demands of college reading assignments and of writing assignments based on readings. Part One, "Reading Rhetorically," invites you to explore your changing purposes for reading and teaches you how to *read rhetorically*—that is, to pay attention to an author's purposes for writing and the methods that author uses to accomplish those purposes. All authors have designs upon their readers; they want those readers to see things their way, to adopt their point of view. But rhetorical readers know how to maintain a critical distance and determine carefully the extent to which they will go along with the writer.

Part Two, "The Rhetorical Reader as Writer," focuses on the connections between reading and writing processes. Because most of your college writing assignments will probably involve readings that you are asked to imitate, analyze, or use as source material in pursuing your own inquiry, these chapters show you how to apply rhetorical reading strategies to your own writing. Throughout these instructional chapters and the anthology itself, we stress the importance of doing more with a text than just understanding what it says. Reporting about

what you have read will be only a beginning point. You will often be expected to write about your reading in a way that shows that you are "doing" a discipline, for example chemistry or political science. You will be asked to find meaning, not merely information, in books and articles. You will be asked to respond to that meaning—to explain it, to analyze it, to critique it, to compare it to alternative meanings that you or others create. To fulfill such assignments, you will need to analyze not just *what* texts say but *how* they say it. This double awareness is what we mean by "reading rhetorically." By analyzing both the content and technique of a given text, a rhetorical reader critically considers the extent to which he or she will accept or question that text.

The Challenges of Academic Reading

Once you get immersed in the academic life—caught up in the challenge of doing your own questioning, critical thinking, analysis, and research—you'll discover that academic reading has unique pleasures and demands. If you ask an experienced academic reader engaged in a research project why she reads, her answer may be something like this: "I'm investigating a problem, and much of my research requires extensive reading. As part of my investigation, I am doing a close analysis of several primary sources. Also I read to see what other researchers are saying about my problem and to position myself in that conversation."

This may seem a curious answer—one that you won't fully understand until you have had more experience writing papers requiring analysis or research. To help you appreciate this answer—and to see how it applies to you—consider that most college courses have two underlying goals:

1. **Conveying conceptual knowledge.** This first goal is for you to learn the body of information presented in the course—to master the course's key concepts and ideas, to understand its theories, to understand how the theories try to explain certain data and observations, to learn key definitions or formulas, and to memorize important facts. Cognitive psychologists sometimes call this kind of learning *conceptual knowledge*—that is, knowledge of the course's subject matter. Transmitting conceptual knowledge is the primary aim of most college textbooks. Certainly that would be the aim of the reading assignment for Chemistry on our hypothetical list at the beginning of this chapter. The assigned pages are undoubtedly packed with specialized terminology that chemistry students need to know if they are to follow lectures, pass exams, and, more generally, understand how chemists think about, label, and measure the physical world.
2. **Conveying procedural knowledge.** A second goal of most college courses is for you to learn the discipline's characteristic ways of thinking about the world by applying your conceptual knowledge to new problems. What

questions does the discipline ask? What are its methods of analysis or re-search? What counts as evidence? What are the discipline's shared or dis-puted assumptions? How do you write arguments in this discipline, and what makes them convincing (say in literature, sociology, engineering, or accounting)? Thus in addition to learning the basic concepts of a course, you need to learn how experts in the discipline pose problems and con-duct inquiry. Cognitive psychologists call this kind of learning *procedural knowledge*—the ability to apply conceptual knowledge to new problems by using the discipline's characteristic methods of thinking.

Teachers focus on procedural knowledge when they assign readings be-yond the typical textbook—newspaper or magazine articles, scholarly articles, or primary sources such as historical documents or literary texts—and ask you to analyze these readings or use them in other discipline-specific ways. Consider the next three assignments in our opening scenario. The political science pro-fessor who assigned analysis of the editorial undoubtedly wants students to learn what the textbook says about interest group politics (conceptual knowl-edge), and then to apply those concepts to analyze current events (procedural knowledge). As you read a variety of editorials looking for one to analyze, you would need to read them through the lens of your political science textbook. A different kind of challenge is presented by the Platonic dialog. Not only does it contain complex ideas, but it also demonstrates a form of discourse and a philo-sophical way of thinking that has had a lasting impact on European traditions. Still a different kind of challenge is presented by the library research project lead-ing to a problem statement for your first composition. It requires understand-ing what is meant by "reading rhetorically" and what the instructor means by a "problem statement." Then you would need to read the library sources with the goal of finding a problem to write about. As you read the various kinds of texts assigned in your courses and write different kinds of papers, you will dis-cover that academic disciplines are not inert bodies of knowledge but contested fields full of uncertainties, disagreements, and debate. You will see why college professors want you to *do* their discipline rather than simply study it. They want you not just to study chemistry or political science or history, but to *think like a chemist or a political scientist or an historian.*

The challenges of college reading will vary in different classes and for dif-ferent people because we all have different backgrounds, learning styles, and in-terests. It is important to realize that even students with sufficient background knowledge and high interest in a subject will sometimes find course textbooks daunting because each paragraph is dense with new concepts, vocabulary, and information. With so much unfamiliar material, each new sentence can seem just as important as the one before. When it is difficult to separate key concepts from supporting details, you may feel overwhelmed, thinking "I've got to know all of this—how will I ever write anything about it?" This book is designed to help you meet that challenge.

As you learn to read rhetorically you will learn to recognize different au-thors' purposes and methods, the ways that claims are typically asserted and

supported in different disciplines, and the types of evidence that are valued by those disciplines. For example, historians value primary sources such as letters and diaries, government records, and legal documents. Psychologists gather quite different kinds of research data, such as empirical observations of an animal's learning behaviors under different diet conditions, statistical data about the reduction of anxiety symptoms following different kinds of therapy, or "think aloud" transcripts of a person's problem-solving processes after varying amounts of sleep. Your accumulating knowledge about disciplinary discourses will teach you new ways of thinking, and you will learn to use those methods in your own writing.

Reading and Writing as Conversation

Consider again how our experienced researcher at the beginning of the last section answered the question "Why do you read?" It is obvious that she is immersed in *doing* her discipline and that she sees reading as central to her work. But she also says that she is reading "to position herself in a conversation." What does she mean by that? How is reading part of a "conversation"?

To understand reading as joining a conversation, think of writers as talking to readers—and of readers as talking back. For example, suppose our researcher's investigation leads her to new insights that she would like to share with others. If she is a professional scholar, she will write an academic article. If she is an undergraduate, she will write a research paper. In both cases, her audience would be academic readers interested in the same research problem. Her aim is to explain the results of her research, trying to persuade readers to accept her argument and claims. Her motivation for writing is her belief that she has produced something new or challenging or otherwise useful to add to the conversation—something that is different from, or that extends or improves upon, the work of others who have investigated the same problem.

Whenever you write, it is helpful to think of yourself as asserting your voice in a conversation. To prepare yourself for joining this conversation, you must read. As you read, you need to understand not only the text you are reading but also the conversation that it joins. One of the reasons that a particular reading might seem difficult to you—say a journal article on school violence that you find as part of your research for preparing a problem statement—is that you are not yet familiar with the conversation it is part of. That conversation is a multivoiced conversation. The first voice is that of the article's author; a second voice (actually a set of voices) is the network of texts the writer refers to—previous participants in the conversation. The third voice is yours as you respond to the article while you read, then later if you write something in response to it.

This broad view extends the metaphor of "conversation" to say that texts themselves are in a conversation with previously published texts. Each text acts in relationship to other texts. It asserts a claim on a reader's attention by invoking certain interests and understandings, reminding readers of what has been

written about the subject before. For example, articles in scientific journals typically include a summary of important research already conducted on the problem, called a *literature review*. Similarly, political commentators will summarize the views of others so that they can affirm, extend, or take issue with those views. Music, film, and book reviewers are likely to refer not just to the item under review but to the given artist's reputation, which, of course, was established not just by word of mouth but by other texts, texts with which the current reader may or may not be familiar.

The reasons any of us engage in conversation, oral or written, will vary widely according to the occasion and our individual needs. In general, we read because we want—perhaps need—to find out what others are saying about a given matter. Sometimes we may have purely personal reasons for reading, with no intention of extending the conversation further through writing of our own. Ultimately though, in school and workplace writing, we read so that we can make informed contributions to a conversation that is already in progress. Indeed, we are expected to join in.

Entering an oral conversation can sometimes be a simple process of responding to a question. ("Have you seen the new film at the Ridgemont?") But if a conversation is already well underway, finding an opening can sometimes be a complex process of getting people's attention and staking claim to authority on a subject. ("Um, you know, I've seen all of John Woo's films, and I think. . . .") The challenge is even greater if the goal is to redirect the conversation or contradict the prevailing opinion. ("Yes, but, listen! The reading I've done for my cinematography class tells me that his action films are not as innovative as the ads claim.") When we take up writing as a way of entering the conversation, we don't have to worry about interrupting, but we do have to review the conversation for the reader by laying out introductory background.

To explore the similarities between your motives for joining a conversation and your motives for reading, consider how the influential rhetorician and philosopher Kenneth Burke uses conversation as a metaphor for reading and writing.

> Imagine you enter a parlor. You come late. When you arrive, others have long preceded you, and they are engaged in a heated discussion, a discussion too heated for them to pause and tell you exactly what it is about. In fact, the discussion had already begun long before any of them got there, so that no one present is qualified to retrace for you all the steps that had gone before. You listen for a while, until you decide that you have caught the tenor of the argument; then you put in your oar. Someone answers; you answer him; another comes to your defense; another aligns himself against you, to either the embarrassment or gratification of your opponent, depending upon the quality of your ally's assistance. However, the discussion is interminable. The hour grows late, you must depart. And you do depart, with the discussion still vigorously in progress.*

*Kenneth Burke, *The Philosophy of Literary Form: Studies in Symbolic Action*, 3rd ed. (Berkeley: U of California P, 1973), 110–11.

● FOR WRITING AND DISCUSSION

The following exercise will help you explore the implications of Burke's parlor metaphor for your own reading processes. Write your answers to the questions in a notebook, or as your teacher directs, so that you can compare your responses with those of your classmates.

ON YOUR OWN

1. In what ways does Burke's parlor metaphor fit your experience? Freewrite for a few minutes about an oral conversation in which you managed to assert your voice—or "put in your oar," as Burke says—after listening for a while.

2. Then consider how the metaphor applies to your experience as a reader. Freewrite for another few minutes about a time when reading helped you gather a sense of the general flow of ideas so that you could have something to say about a topic.

3. Not all the "parlors" we enter are filled with unfamiliar conversations. Sometimes we engage in heated discussions on subjects that are very familiar to us. Make a list of one or more communities that you belong to where you feel that you can quickly catch the drift of an in-progress oral conversation. What are some "hot topics" of conversation in these communities? For example, when we were writing this chapter, a hot cultural topic was the legal battle between the entertainment industry and software developers over file-swapping on the Internet to obtain free music. Most of our students were familiar with the software and had strong opinions about file-swapping, particularly the advantages and disadvantages of it for musicians. They could join this conversation immediately. However, many faculty members, especially the older generation, were confused by the lawsuits because they weren't familiar with how the younger generation listens to music and didn't know anything about the software. If you wanted to address a general audience about this issue, how much background information about the music industry, the electronic transfer of digital information, and the varying fortunes of entertainers in post-rock culture would you have to provide to bring these oldsters up to speed?

4. Now let's reverse the situation. Have you ever listened to a conversation in which you were a baffled outsider rather than an insider? (Think of the plight of those oldsters suffering through a conversation about the downloading of MP3 files and the ways that pending lawsuits threaten the survival of indie musicians.) Describe an experience where you had to work hard to get inside an ongoing conversation. Then consider how that experience might be an appropriate analogy for a time when you were frustrated by trying to read a book or article addressed to an insider audience rather than to someone with your background.

WITH YOUR CLASSMATES

Share your responses with other members of your class. See if others have had experiences similar to yours. What have been the topics of conversations where they were in "insider" and "outsider" roles? Help each other appreciate the concepts of insider and outsider audiences and of reading as joining a conversation. ●

Reading Rhetorically as an Academic Strategy

The metaphor of conversation brings out the essential rhetorical nature of reading and writing. The term *rhetorical* always draws attention to a writer's relationship to and intentions toward an audience. However, Aristotle's definition of rhetoric as the art of discovering the available means of persuasion in a given situation highlights *discovery* along with *persuasion*. Writers must thoroughly understand their subject in order to discover the best—the most ethically responsible as well as the most persuasive—methods for presenting their material to others. Rhetoric's partnership of discovery and persuasion makes it clear why reading rhetorically is a powerful academic strategy in all disciplines.

WRITERS' PURPOSES

When we introduced the term *reading rhetorically* early in this chapter, we described authors as having designs on their readers. That phrasing underscores the fact that writers want to change readers' perceptions and thinking, and use both direct and indirect means to do so. Typically, a writer's goal is to change a reader's understanding of subject matter in some way. Sometimes the change might simply confirm what the reader thought beforehand (readers enjoy music and film reviews that affirm their own opinions and political columns that echo their views). At other times the change might involve an increase in knowledge or in clarity of understanding (an article explains how bluenose dolphins use whistling sounds to converse with each other, increasing your awe of sea mammals). Sometimes the change might radically reconstruct a reader's whole view of a subject (an article convinces you to reverse your position on legalization of hard drugs). How much change occurs? The reader decides.

A set of categories for conceptualizing the ways that writers aim to change readers' minds is summarized in Table 1.1 (see pp. 12–13). Based on a scheme developed by rhetoricians to categorize types of writing in terms of a writer's aim or purpose, the table identifies eight rhetorical aims or purposes that writers typically set for themselves—the same eight aims that we used to organize the anthology section of this book. For rhetorical readers, this scheme is particularly powerful because it helps them understand the writer's relation to subject matter and audience. In the table, we describe how texts in each category work, what they offer readers, and the response they typically aim to bring about. We illustrate the differences among the aims with examples of essays and articles that a hypothetical nature writer might compose in response to a proposal to designate

one of her favorite hiking and camping areas as a wilderness. (Wilderness designations, intended to preserve threatened land formations as well as animal and plant species, prohibit vehicles and limit human access.)

By labeling the table's fourth column "Desired Response," we emphasize that readers decide not only the extent to which they will accept the ideas and information put forth in a text, but how they will act in response. Readers determine—sometimes unconsciously, sometimes deliberately—whether the information they are reading is reliable, the ideas significant, the presentation convincing. Because writers try to persuade their intended audiences to adopt their perspective, they select and arrange evidence, choose examples, include or omit material, and select words and images to best support their perspective. Your awareness of how a text is constructed to persuade its intended audience (which may not include you) will enable you to decide how well the text meets your purposes for reading.

● FOR WRITING AND DISCUSSION

To explore the spectrum of aims presented in Table 1.1, choose an issue or situation that interests you and create sample writing scenarios and purposes for each of the eight categories on the table. You could base your examples on a single imagined writer as we do (perhaps an entertainment columnist or a sports writer), or you could expand the possibilities by imagining how different people would write with different aims about the same topic (perhaps a family matter such as pets or divorce, or a public matter such as Internet file-swapping or human rights). Choose whatever intrigues you. ●

WRITERS' PURPOSES VERSUS READERS' PURPOSES

As you read various selections in this textbook, you will often be asked to consider the fit between your purposes and the writer's purposes. This is an important question, one that is particularly pertinent when you are assigned research projects that require you to select sources from among what may be hundreds of possibilities. These potential sources will pose reading challenges different from those of your course textbooks because they will be written for many different audiences and purposes. On any given topic—let's take global warming as a broad example—it's likely your research will turn up books, scholarly articles, popular magazine articles, news reports, and a range of politically charged editorials and op-ed columns, all published in different contexts for readers with a range of different concerns: for experts and nonexperts, theorists and practitioners, politicians, policymakers, and ordinary citizens. As a reader who is planning to write, you will need to determine what among all this material suits *your* needs and purposes.

What do we mean when we refer to *your purposes* as a reader? To understand the answer to this question, consider our earlier statement that you, the reader, decide whether to assent to a writer's views or resist them. As you prepare to

TABLE 1.1 ● A SPECTRUM OF PURPOSES

Rhetorical Aim	Focus and Features	Offers Readers	Desired Response	Examples
Express and Reflect	**Focus:** Writer's own life and experience **Features:** Literary techniques such as plot, character, setting, evocative language	Shared emotional, intellectual experience	**Readers** can imagine and identify with writer's experience. **Success** depends on writer's ability to create scenes, dialog, and commentary that engage readers.	Nature writer's essay narrates her discoveries and reactions when backpacking in area that may be designated "wilderness."
Inquire and Explore	**Focus:** Puzzling problem seen through narration of writer's thinking processes **Features:** Delayed thesis or no thesis; examination of subject from multiple angles; writer's thinking is foregrounded	Shared intellectual experience, new information, new perspectives	**Readers** will agree question or problem is significant, identify with writer's thinking, and find new insights. **Success** depends on writer's ability to engage readers with question or problem and the exploration process.	Nature writer's essay puzzles over the impact of human use on natural areas, loss of recreation opportunities if area is declared wilderness, and the value of wilderness to humans, animals, and landscape.
Inform and Explain (also called *expository writing*)	**Focus:** Subject matter **Features:** Confident, authoritative stance; typically states point and purpose early; strives for clarity; provides definitions and examples; uses convincing evidence without argument	Significant, perhaps surprising, new information; presentation tailored to readers' interest and presumed knowledge level	**Readers** will grant writer credibility as expert, be satisfied with the information's scope and accuracy. **Success** depends on writer's ability to anticipate reader's information needs and ability to understand.	Nature writer's article provides details about rules and process of wilderness designation; reports history of the wilderness process in distant part of the state ten years earlier.
Analyze and Interpret	**Focus:** Phenomena that are difficult to understand or explain **Features:** Relatively tentative stance; thesis supported by evidence and reasoning; new or unsettling analyses and interpretations must be convincing; doesn't assume that evidence speaks for itself	New way of looking at the subject matter	**Readers** will grant writer credibility as analyst and accept insights offered, or at least acknowledge value of approach. **Success** depends on writer's ability to explain reasoning and connect it with phenomena analyzed.	Nature writer pursues ideas about wilderness further in an article analyzing the work of several well-known environmental thinkers, comparing those ideas to provisions of the law.

TABLE 1.1 ● (CONTINUED)

Rhetorical Aim	Focus and Features	Offers Readers	Desired Response	Examples
Persuasion: **Take a Stand**	**Focus:** Question that divides a community **Features:** States firm position, provides clear reasons and evidence, connects with readers' values and beliefs; engages with opposing views	Reasons to make up or change their minds about the question at issue	**Readers** will agree with writer's position and reasoning. **Success** depends on writer's ability to provide convincing support and to counter opposition without alienating readers.	Nature writer prepares opinion piece arguing in favor of the proposed wilderness designation.
Persuasion: **Evaluate and Judge**	**Focus:** Question about worth or value of a phenomenon **Features:** Organized around criteria for judgment and how phenomenon matches them	Reasons to make up or change their minds about the focal question regarding worth or value	**Readers** will accept writer's view of the worth or value of the phenomenon. **Success** depends on writer's ability to connect subject to criteria that readers accept.	Nature writer evaluates the consequences of designating wilderness areas in other states and argues that benefits of preservation outweigh negatives of limited access.
Persuasion: **Propose a Solution**	**Focus:** Question about what action should be taken **Features:** Describes problem and solution, then justifies solution in terms of values and consequences; level of detail depends on assumptions about readers' knowledge	A recommended course of action	**Readers** will assent to proposed action and do as writer suggests. **Success** depends on readers' agreement that a problem exists and/or that recommended action will have good results.	Nature writer urges state residents to support wilderness project, visit area to see where boundaries will be drawn, attend hearing, and write to legislators.
Persuasion: **Seek Common Ground**	**Focus:** Multiple perspectives on a vexing problem **Features:** Lays out the values and goals of the various stakeholders so that others can find commonalities to build on; does not advocate	New perspectives and reduced intensity regarding difficult issues	**Readers** will discover mutuality with opponents; conflict perhaps not resolved; could lead to cooperative action. **Success** depends on readers' discovery of mutual interests.	Nature writer undertakes a common-ground project, interviewing advocates and stakeholders about where wilderness boundaries should be drawn; her goal is to find and highlight points of agreement.

write an academic paper, you need to acquaint yourself with a number of viewpoints on your subject matter, understand the reasoning and evidence presented by different writers, and determine how to use these ideas in a new context—your own work. Suppose, for example, that in the process of your research on current thinking about global warming you read an article calling for several more years of extensive study before the United States endorses international agreements to reduce emissions from carbon-based fuels. (We'll call this hypothetical article "Not Yet.") You must weigh the views in "Not Yet" against the scientific evidence and political reasoning in other articles you read. If this reading makes you skeptical of global warming or concerned that the United States will suffer economic loss from stricter regulation of emissions, you might use material from "Not Yet" for evidence that supports your points. In contrast, if your reading provides compelling evidence that global warming is real and is already causing extensive damage, you might summarize "Not Yet" as an opposing view you wish to rebut. Finally, if your reading leaves you undecided, or if you question the evidence presented by "Not Yet," you would do well to continue your research. Ultimately, your paper might analyze the science and politics of arguments made from a variety of viewpoints on the matter.

To fulfill your own purposes as a reader and writer, you often have to overcome the difficulty of not being part of a text's intended audience. For example, in the situation just described, if you were to explore the current status of research on global warming you might encounter highly technical articles that sail over your head because they are written primarily for scientific audiences. Articles written for policy wonks who know all the details of international treaties might omit background information that you need. When you encounter such materials, you may wish to skim quickly to decide whether to move on to something easier or to keep reading to see what you can learn. Eventually you will read enough materials on the subject to be able to fill in the background and begin to read with an expert's understanding.

Until you are thoroughly familiar with the conversation a text is joining, you will also have the challenge of determining how complete a picture of its subject matter a text provides. It is inevitable that no text tells the whole story. To forward an argument, some will deliberately distort opposing perspectives. The genre and purpose of others will make certain perspectives invisible.

As an illustration, suppose you are researching the problem of the melting Arctic ice cap. You become interested in this problem when you read an online article explaining that scientists are divided on how to interpret recent data about the melting of polar ice, whether it is part of a natural cycle that will reverse itself or part of long-term, irreversible, global warming caused by humans. As you research this issue, you will need to realize how different writers, in trying to persuade their intended audiences toward their position on the issue, use rhetorical strategies that best support their own cases. You need to be wary. Some research may be biased by economic or political entanglements—for example, many people charge that global warming research funded by petroleum companies should be discounted. Some research may provide what seems like frightening data and yet draw only a few cautious conclusions.

FIGURE 1.1 This 2000 photo of Jökulsárlón, a lagoon in southern Iceland, accompanied the *Chronicle of Higher Education* article about ice melt described here. Formed by glacial runoff, the iceberg-filled lake did not exist 100 years ago and doubled in size during the 1990s.

For example, an article in the July 2000 issue of the highly specialized journal *Science* reported that eleven cubic miles of ice are disappearing from the Greenland ice sheet annually, but left it up to the article's intended audience of experts to ponder what kinds of conclusions to draw. However, when the findings of the *Science* article were reported in the popular press, many articles downplayed the scientists' caution and highlighted imagined details of a world fifty years from now with no ice caps—an approach swaying readers to accept uncritically the assumption that the melting ice is an irreversible trend, presumably resulting from human-caused global warming. Once political commentators got hold of the *Science* article, they put a spin on it that reflected their own values and beliefs. Environmentalists used the melting ice cap data to support their case for international regulations to slow or eventually to reverse global warming. Pro-business writers in turn emphasized the original study's cautious call for more research. A more balanced and neutral approach was demonstrated by a *Chronicle of Higher Education* article, also in July 2000, that was headlined, "The Great Melt: Is It Normal, or the Result of Global Warming? Scientists Are Having Difficulty Pinpointing the Causes of Glacial and Sea-Ice Decline." This article provided a background overview for curious academic readers who accept the tentativeness of scientific findings and want to learn about the conflicting interpretations in this controversy. For student writer-researchers, such articles can be gold mines because they provide balanced explanations without attempting to draw the reader to a specific set of conclusions.

Our point here is that the ability to recognize the persuasive strategies built into a text is a powerful academic skill. How can you tell whether a text is trying to give you the whole picture in a fair and reliable way or is simply making another one-sided argument in a hotly contested debate? By learning to read rhetorically.

Questions That Rhetorical Readers Ask

In the language of the epigraph to this chapter, rhetorical readers have learned to recognize and interpret the worldview that a text sets forth. We will discuss *worldview* in more detail later, but for now consider "worldview" to mean a writer's underlying beliefs, values, and assumptions. You probably already recognize these without much effort when you are reading material on familiar subjects. What you already know about a close friend's values makes it relatively easy to recognize whether that friend's e-mail is serious or teasing. Similarly, you can quickly tell whether a review of your favorite musician's latest CD reflects your own musical values and assumptions. In academic settings, though, unfamiliar subject matter and contexts can make analyzing a writer's underlying values and assumptions more problematic. With difficult new material, readers' natural tendency is to concentrate on getting what information and meaning they can from a text without paying attention to its rhetorical strategies. Rhetorical readers, however, analyze rhetorical strategies as a way of understanding a writer's purpose and worldview. This analysis involves eight important questions about how the text works and how you respond to it. Chapter 4 will show in detail how using these questions for critical analysis can reveal a writer's basic values and assumptions and thus help you understand a text more fully.

QUESTIONS FOR READING RHETORICALLY

1. What questions does the text address? (Why are these significant questions? What community cares about them?)
2. Who is the intended audience? (Am I part of this audience or an outsider?)
3. How does the author support his or her thesis with reasons and evidence? (Do I find this argument convincing? What views and counterarguments are omitted from the text? What counterevidence is ignored?)
4. How does the author hook the intended reader's interest and keep the reader reading? (Do these appeals work for me?)
5. How does the author make himself or herself seem credible to the intended audience? (Is the author credible for me? Are the author's sources reliable?)
6. Are this writer's basic values, beliefs, and assumptions similar to or different from my own? (How does this writer's worldview accord with mine?)
7. How do I respond to this text? (Will I go along with or challenge what this text is presenting? How has it changed my thinking?)
8. How do this author's evident purposes for writing fit with my purposes for reading? (How will I be able to use what I have learned from the text?)

TAKING STOCK OF WHY YOU READ

Given this chapter's discussion of writers' and readers' varying purposes, we invite you to pause before moving on to the chapters about specific strategies and reflect upon your own purposes for reading in different situations. In Chapter 2 we will invite you to extend this exploration of *why* you read into an exploration of *how* you read.

● **FOR WRITING AND DISCUSSION**

This exercise asks you to list your recent reading experiences and then to reflect on your motives and strategies, which probably varied with the occasion. The first part asks you to jot down answers on paper; the second part asks you to use these notes in class to compare your responses with those of your classmates.

ON YOUR OWN

1. What have you read so far today? Divide a sheet of paper into two columns.
 a. In the left column, jot down as many items as you can remember reading in the past 24 hours. Try to make this list as long as you can by including texts that you just happened across in the course of the day.
 b. In the right column, note what prompted you to read each item—was it an assignment for school or work? A discussion with a friend? A need to find out something specific, such as tomorrow's weather or the score in yesterday's game, or the latest news from home? Relaxation—thumbing through a magazine or surfing the Web? Or was it chance—the item was "just there," such as a cafeteria menu or a hallway poster?
2. Were the last 24 hours of reading typical for you? If not, draw a line across the bottom of the two columns and list any other items that you would typically read on a given day when school is in session but that you didn't happen to read in the last 24 hours. Perhaps you ordinarily would have read the textbook for a particular course. Perhaps you usually turn on the TV to check the news crawl for sports scores, but you didn't in the past 24 hours. Since this exercise is meant to help you explore your own reading activities, add whatever you think gives a full picture of them.
3. Draw another horizontal line across the page. Extending your view to the past month, note something that you have read in each of the following categories:
 a. Something you found particularly enjoyable
 b. Something you thought particularly important
 c. Something you struggled to understand
 d. Something you were eager to talk about with your family or friends

4. Now, as you look back over your notes, consider what they say about you as a reader, as a college student, and as a person. Freewrite for several minutes about the proportion of time you spend reading "on assignment" as opposed to just following your own inclinations. (By "freewrite" we mean writing rapidly nonstop in order to brainstorm on paper—without worrying about spelling, punctuation, or structure. Your goal is to discover new insights by using nonstop writing to stimulate thinking.)

5. To sum up this taking stock exercise, draw one last horizontal line across the page and address this question: *Why* do you read? Freewrite for several minutes, trying to sum up all that you have discovered through this exercise.

WITH YOUR CLASSMATES

In small groups or as a whole class, compare responses to the reading inventory. As the discussion unfolds, listen carefully so that you can jot down notes about these questions:

1. What patterns of common experience emerged during the discussion?
2. In what ways are your typical reasons for reading different from those of your classmates?

ONCE MORE ON YOUR OWN

Take a few minutes after the discussion to reflect in writing about what you've become aware of through your writing and class discussion. Consider these questions:

1. How was your description of your reading habits similar to and different from what your classmates described?
2. If others seem to enjoy reading more or less than you, how do you explain that difference?
3. What would you like to change about your typical approach to reading? How can you gain greater strength as a reader? •

Summary

In this chapter we have provided a brief overview of the book and explained how it will help you build a repertoire of reading strategies to meet the challenges of academic reading and writing assignments. In the preceding pages, we

• Defined rhetorical reading as paying attention to both the content of a text ("what") and the author's method of presenting that content ("how")

- Described the special challenges of academic reading, which often requires recognizing how different academic disciplines value evidence and report research
- Used the metaphor of conversation to describe how academic reading and writing involve responding to other texts and adding your own ideas
- Showed the value of rhetorical reading as an academic strategy through which a reader analyzes a text's content and strategies in order to decide how to respond—whether to assent to the writer's ideas, modify them, or resist them
- Provided a table showing how writers' purposes can be arranged on a "spectrum of purposes" that identifies eight different aims
- Pointed out that writers' purposes and readers' purposes for the same text may be quite different
- Provided a list of eight questions rhetorical readers use to judge how a text works and how to respond to it

Finally, as a foundation for your work in this book, we invited you to take stock of your typical reasons for reading.

Strategies for Reading Rhetorically

*It is like the rubbing of two sticks together to make a fire,
the act of reading, an improbable pedestrian task that leads
to heat and light.*

—Anna Quindlen

In the preceding chapter we saw that academic readers read because they are captivated by questions and are challenged to find new or better answers. They also read to pursue their research projects, to see what other researchers are saying, and to position themselves in a scholarly conversation. To read effectively, they have to read rhetorically by attending to both the content and the persuasive strategies in a text. In this chapter, we focus specifically on introducing the rhetorical reading strategies used by experts. We begin by explaining two pieces of background knowledge you will need to read rhetorically: (1) that reading is an active rather than passive process (we say that both reading and writing are acts of composing) and (2) that the choices skilled writers make about content, structure, and style depend on their rhetorical context. Understanding these concepts will help you employ the rhetorical strategies we describe in the last half of the chapter.

Reading and Writing as Acts of Composing

As part of their background knowledge, rhetorical readers know that reading, like writing, is an active process of composing. The idea that writing is an act of composing is probably familiar to you. Indeed, the terms *writing* and *composing* are often used interchangeably. Originally associated with fine arts such as painting, music, or literary writing, the term *composing* still carries with it the idea of originality or creativity even though it has come to mean the production of any

kind of written text, from a memo to a Pulitzer-prize-winning novel. Unlike the term *writing, composing* suggests more than just the transcription of a preexisting meaning or idea; it suggests a creative putting together of words and ideas to make a new whole. Except for literally recopying what someone else has written, all writing, even memo writing, is a matter of selecting and arranging language to accomplish a purpose that is unique to a particular situation and audience.

The idea that reading is an act of composing, however, may be less familiar. The ancients thought of reading as a passive activity in which the author via the text deposited meaning in a reader; the text was metaphorically (or even literally) "consumed." The Old Testament prophet Ezekiel, for example, has a vision in which he is instructed by the Lord to open his mouth and literally consume a book that gives him the knowledge he needs to speak to the rebellious Israelites. Commenting on the consumption metaphors associated with reading, Alberto Manguel in *A History of Reading* notes the parallels between the cooking metaphors associated with writing—the author "cooks up" a plot or "spices" up her introduction—and the eating metaphors associated with reading—the reader "devours" a book, finds "nourishment" in it, then "regurgitates" what he has read.*

While the image of Ezekiel's eating a text seems fantastic, the mistaken idea persists that reading is a one-way transaction: author → text → reader. To illustrate the flaws in this model of the reading process, let's try a simple experiment described by reading researcher Kathleen McCormick. Read the following passage and jot down your interpretation of its meaning:

> Tony slowly got up from the mat, planning his escape. He hesitated a moment and thought. Things were not going well. What bothered him most was being held, especially since the charge against him had been weak. He considered his present situation. The lock that held him was strong but he thought he could break it. . . . He was being ridden unmercifully. . . . He felt that he was ready to make his move.†

There are two common interpretations: readers assume that Tony is either in jail or in a wrestling match. Unless you are familiar with wrestling, you probably thought Tony was a prisoner planning a jailbreak. However, if this paragraph appeared in a short story about a wrestler, you would immediately assume that "mat," "escape," "charge," "being held," and "lock" referred to wrestling even if you knew very little about the sport. This experiment demonstrates two important aspects of the reading process: (1) readers use their previous experiences and knowledge to create meaning from what they read; and (2) context influences meaning.

Research such as McCormick's shows that readers make sense of a text not by passively receiving meaning from it but by actively composing a reading of

*Alberto Manguel, *A History of Reading* (New York: Penguin, 1997), 170–71.
†Kathleen McCormick, *The Culture of Reading and the Teaching of English* (Manchester, England: Manchester UP, 1994), 20–21.

it. This composing process links the reader's existing knowledge and ideas with the new information encountered in the text. What the reader brings to the text is as important as the text itself. In other words, reading is not a process in which an author simply transfers information to the reader. Rather it is a dynamic process in which the reader's worldview interacts with the writer's worldview; the reader constructs meaning from the text, in effect creating a new "text" in the reader's mind—that reader's active reading or interpretation of the text.

This view of reading as a transaction between text and reader is captured evocatively in the poem "The Voice You Hear When You Read Silently" by Thomas Lux. Take a moment at this time to read Lux's poem and then to do the exercises that follow it.

The Voice You Hear When You Read Silently

is not silent, it is a speaking-out-loud voice in your head: it is *spoken*,
a voice is saying it as you read.
It's the writer's words, of course, in a literary sense his or her "voice"
but the sound of that voice is the sound of *your* voice.
Not the sound your friends know or the sound of a tape played back
but your voice
caught in the dark cathedral of your skull, your voice heard by an internal
ear informed by internal abstracts
and what you know by feeling, having felt.
It is your voice saying, for example, the word "barn" that the writer wrote
but the "barn" you say is a barn you know or knew.
The voice in your head, speaking as you read, never says anything
neutrally — some people hated the barn they knew,
some people love the barn they know
so you hear the word loaded and a sensory constellation is lit:
horse-gnawed stalls, hayloft, black heat tape wrapping a water pipe,
a slippery spilled *chirrr* of oats from a split sack,
the bony, filthy haunches of cows . . .
And "barn" is only a noun — no verb or subject has entered into the
sentence yet! The voice you hear when you read to yourself
is the clearest voice: you speak it
speaking to you.

—Thomas Lux

• FOR WRITING AND DISCUSSION
ON YOUR OWN

1. When you hear the word *barn*, what barn or barns from your own life do you first see? What feelings and associations do you have with this

word? How do you think the barn in your head is different from the barns in your classmates' heads?

2. When you hear the word *cathedral,* what images and associations from your own life come into your head? Once again, how might your class-mates' internal images and associations with the word *cathedral* differ from yours?

3. Now reread the poem and consider the lines "Not the sound your friends know or the sound of a tape played back/but your voice/caught in the dark cathedral of your skull." What do you think Lux means by the metaphor "dark cathedral of your skull"? What seems important about his choice of the word *cathedral* (rather than, say, *house* or *cave* or *gymnasium* or *mansion*)? How does *skull* work (rather than *mind* or *brain* or *head*)? Freewriting for several minutes, create your interpretation of "dark cathedral of the skull."

4. Finally, reflect for a moment about your thinking processes in trying to interpret "cathedral of the skull." Did you go back and reread the poem, looking for how this line fits other lines of the poem? Did you explore further your own ideas about cathedrals and skull? Our goal is to see if you can catch yourself in the act of interacting with the text—of actively constructing meaning.

WITH YOUR CLASSMATES

5. Compare your responses to questions 1 and 2 with those of your class-mates. How do images of and associations with barns and cathedrals vary?

6. Compare your interpretations of "dark cathedral of the skull." Are there any interpretations that become purely private—that is, that range so far from the text that they can't be supported by evidence in the rest of the poem? (For example, it would be difficult to argue that this metaphor means that the poem is secretly about religion because it uses the term *cathedral.*) Which interpretations make the most sense of the text? ●

What we have tried to show in the preceding exercise is that a reader's reading or interpretation of the text results from a dynamic *two-way interaction.* On the one hand, the text shapes and limits the range of possible meanings: "The Voice You Hear When You Read Silently" cannot be plausibly interpreted as being about racing in the Indianapolis 500, or about the schizophrenic experience of hearing strange voices in your head. On the other hand, each reader will have a slightly different interpretation or private set of associations with the text based on her or his experiences, knowledge, and attitudes.

When college writing assignments ask you to explain and support your reading of a text, it is important to distinguish between *private* associations that are only loosely related to a text and interpretations that are *publicly* defensible in terms of textual evidence. Private associations are one-way responses in which a certain word, image, or idea in a text sends you off into your own world, causing you to lose track of the network of cues in the text as a whole.

While such private responses are natural, and indeed one of the pleasures of reading, if you are to offer a public interpretation, you must engage in a two-way interaction with a text, attending both to the text's network of cues and to your personal responses and associations with the text. Thus a good interpretation of "dark cathedral of the skull" must connect to the whole of the poem and illuminate its meaning in a way that makes sense to other readers. In short, "good" or sound interpretations are those that are supported by textual evidence and thus are understandable and persuasive to other readers, whose experiences and beliefs may differ from yours.

Texts and Their Rhetorical Contexts

A second piece of background knowledge used by rhetorical readers is their awareness that authors base their choices about content, structure, and style on their *rhetorical context*—what we define as the combined factors of audience, genre, and purpose. Recognizing the influence of context helps rhetorical readers understand a writer's intentions regarding the subject matter and the intended audience, and thus to reconstruct the strategy behind the author's choices.

For example, suppose a writer wants to persuade legislators to raise gasoline taxes in order to reduce fossil fuel consumption. His strategy is to persuade different groups of voters to pressure their congressional representatives. If he writes for a scientific audience, his article can include technical data and detailed statistical analyses. If he addresses the general public, however, the style will have to be less technical and more lively, with storylike anecdotes rather than tabular data. If he writes for an environmental publication, he can assume an audience already supportive of his pro-environment values. However, if he writes for a business publication such as the *Wall Street Journal,* he will have to be sensitive to his audience's pro-business values—perhaps by arguing that what's good for the environment is in the long run good for business.

Besides adapting content and style to different audiences, writers also adapt their work to the genre in which they publish. The term *genre* refers to the conventions of structure, style, format, approach to subject matter, and document design that distinguish different categories of writing from each other. Literature, for example, includes such genres as plays, novels, and poems, and within each of these broad literary genres are subgenres such as the sonnet, epic poem, and haiku. Similarly, nonfiction includes a range of genres from technical reports to newspaper feature articles. Thus, a *Popular Science* article on genetic research will differ in structure, style, and presentation from an article on the same subject in a scholarly journal. The wording and layout of a magazine article about trends in athletic shoe design will be quite different from the wording and layout of a Web presentation of the same trends, where hyperlinks and animation can be used. What's important about these different genres is that readers' expectations vary for different genres.

When you recognize how a text is shaped according to the writer's purpose, audience, and genre, you can decide how to use the text for your own purposes. Say, for instance, that you are reading a newspaper op-ed piece about drilling for oil in the Alaskan Natural Wildlife Reserve (ANWR) to learn more about what is at issue in this controversy. Because it is an op-ed piece for a general audience, you know that it is written in terms that should be understandable to you, but you also know that since it is an op-ed piece, it is the writer's opinion and not an informational article that attempts to be neutral. Thus, your challenge is to read somewhat skeptically, not taking the author's representation of the issue as necessarily the only way the issue might be considered. Let's now turn to a more detailed example.

AN EXTENDED EXAMPLE: ARTICLES ABOUT TEENAGERS' SLEEP HABITS

In this section we provide specific examples of how purpose, audience, and genre affect the way texts are presented. Consider how differently scientific findings are presented in specialized journals versus the popular press. An original scientific study usually appears first as a technical report in a scientific journal. Such articles are written for highly specialized experts and are accepted for publication only after being extensively scrutinized for methodology and integrity by expert peer reviewers (also called referees). When a published scientific article contains newsworthy findings, science writers for general circulation newspapers and magazines or for specialized professional organizations "translate" the original technical material into a form and style appropriate for their targeted audiences. The actual content varies also since the "translators" focus on some parts of the original article and omit other parts. In the original scientific article, the authors carefully review previous literature, describe their methodology in great detail, and usually express their findings cautiously. In the popular press articles, in contrast, the writer usually lavishes attention upon the findings, speculates on their potential usefulness to the public, downplays the original scientists' caution, and says little about methods. Writers for specialized professional publications focus only on aspects of the article relevant to a particular professional field. For example, a scientific study about the effectiveness of a new chicken pox vaccine might be discussed in the *Journal of Community Health Nursing* in terms of patient care and in the *Journal of Health Politics, Policy and Law* in terms of government regulations.

To illustrate the different forms that the information from a scientific study can take, we traced the work of sleep researchers Amy Wolfson and Mary Carskadon through several types of publications whose readers differ in their interests and purposes for reading.* Because these articles represent the variety

*Our approach builds on Arthur Walzer's study, "Articles from the 'California Divorce Project': A Case Study of the Concept of Audience," *College Composition and Communication* 36 (1985): 150–159.

of texts you are likely to encounter when you do research for college papers, the following exercise will be good preparation for your work as a rhetorical reader.

● **FOR WRITING AND DISCUSSION**

In this exercise we provide the opening paragraph(s) of five articles concerning a "Sleep Habits Survey" that Wolfson and Carskadon administered to high school students in 1994. They reported their findings at a scholarly meeting in June 1996, and the study itself was published in 1998. The excerpts are from articles printed in five different periodicals that target five different audiences. Each introduction signals the kinds of interests the writers expect their readers will bring to the articles. Read the excerpts *rhetorically* to see what you can discern about the intended readers for each (their interests, their values, their purposes for reading) and then try to match each introduction to its place of original publication on the list that follows the excerpts. To guide your analysis, consider the following questions:

1. What implicit question or problem does each introduction address?
2. Who, in particular, does each article seem to be targeting as readers?
3. What does each introduction suggest about its author's credibility on the subject?
4. How does the introduction draw the reader in? What shared understanding or values does the writer use as a starting point?
5. What beneficial knowledge does each introduction seem to be offering to readers?
6. What clues can you discern in each introduction about the article's genre—for example, scholarly article, newspaper story, magazine feature?

Article 1
An epidemic of sleeplessness is taking a heavy toll on the nation's children and their ability to learn. A majority of kids say they are sleepy during the day and 15 percent admit to falling asleep in school, a survey reveals.

The problem, which hits teenagers especially hard, is of such looming concern that parents and school districts across the country are considering starting high school hours later, so students will not only rise but shine.

"School is starting at a time when their brains are still on their pillows," said Mary Carskadon, an expert on adolescent sleep and a professor at Brown University. "They're just not there."

Article 2
Our understanding of the development of sleep patterns in adolescents has advanced considerably in the last 20 years. Along the way, theoretical models of the processes underlying the biological regulation of sleep have

improved, and certain assumptions and dogmas have been examined and found wanting. Although the full characterization of teen sleep regulation remains to be accomplished, our current understanding poses a number of challenges for the education system.

Article 3

Adolescence is a time of important physical, cognitive, emotional, and social change when the behaviors in one developmental stage are constantly challenged by new abilities, insights, and expectations of the next stage. Sleep is a primary aspect of adolescent development. The way adolescents sleep critically influences their ability to think, behave, and feel during daytime hours. Likewise, daytime activities, changes in the environment, and individual factors can have significant effects on adolescents' sleeping patterns. Over the last two decades, researchers, teachers, parents, and adolescents themselves, have consistently reported that they are not getting enough sleep (Carskadon, 1990a; Carskadon, Harvey, Duke, Anders, & Dement, 1980; Price, Coates, Thoresen, & Grinstead, 1978; Strauch & Meier, 1988).

Article 4

High school will open at 8:30 AM this fall, 65 minutes later than last year, in Edina, Minn, a Minneapolis suburb. School officials hope the 1300 students in grades 9 through 12 will get more sleep and, as a result, be sharper in class.

Area physicians lobbied for the new hours. The Minnesota Medical Association (MMA) wrote the state's 450 school district superintendents in 1994, noting that puberty resets the internal biological clock, prompting teenagers to go to bed later and to need to sleep later than younger children. The MMA cited studies linking inadequate sleep with lower grades and more frequent car crashes. It urged high schools to open at 8 AM or later.

"When the medical community speaks out on an issue of health," said Kenneth Dragseth, Edina superintendent of schools, "it carries a lot of clout."

Article 5

Tired all the time? It's not your fault! Three reasons why:

1. Teens naturally fall asleep later than adults or young children. "People assumed this was because teens wanted independence or had more going on socially," says Mary Carskadon, Ph.D., professor of psychiatry and human behavior at Brown University School of Medicine. Recent studies show that teens secrete melatonin, the hormone that induces sleep, about an hour later than children and adults.

The five introductions you have just read appeared in the publications listed below. Which article introduction goes with which periodical? Briefly

freewrite your reasons for linking each piece to its appropriate source. What evidence supports your choice?

- *JAMA: The Journal of the American Medical Association*
- *YM: Young and Modern*
- *Child Development* (published by the Society for Research in Child Development)
- *The Arizona Republic* (daily newspaper in Phoenix)
- *Phi Delta Kappan* (published by the educators' honor society, Phi Delta Kappa)

Additional hint: The *JAMA* article was published under the "Medical News and Perspectives" section.

For the correct answers, see the full article citations at the end of this chapter (but don't look until after you have made your own arguments!). ●

Learning from the Practices of Experienced Readers

When we ask students to describe the behaviors of good readers, many initially say "speed" or "the ability to understand a text in a single reading." Surprisingly, most experienced readers don't aim for speed reading, nor do they report that reading is an easy, one-step process. On the contrary, experienced readers put considerable effort into reading and rereading a text, adapting their strategies and speed to the demands of the text at hand and to their purpose for reading. Studies of experienced readers show that they consistently do the following:

- Build a context for reading by attending to cues in the text as well to their own purpose and knowledge
- Match their reading strategies with the text's genre
- Vary their reading strategies according to their purpose for reading

Let's look at each in turn.

BUILDING A CONTEXT FOR READING

Experienced readers understand that a text is more than just content or information; it is the work of a real person writing on a specific occasion in order to have real effects on real readers. They understand that the text is part of a larger conversation about a particular topic, and they use textual cues—such as style, format, and terminology—as well as their own background knowledge to speculate about the original context, to make predictions about the text, and to formulate questions.

These strategies for actively building a context for reading are illustrated in Ann Feldman's report of interviews with expert readers reading texts in their own fields.* For example, Professor Lynn Weiner, a social historian, had this to say about a chapter from Philippe Aries' *Centuries of Childhood: A Social History of Family Life* entitled "From the Medieval Family to the Modern Family," written in 1962:

> This work isn't precisely in my field and it is a difficult text. I also know it by its reputation. But, like any student, I need to create a context in which to understand this work. When the book was written, the idea of studying the family was relatively new. Before this time historians often studied kings, presidents, and military leaders. That's why this new type of social history encouraged us to ask, "How did ordinary people live?" Not the kings, but the families in the middle ages. Then we have to ask: "Which families is [Aries] talking about? What causes the change that he sees? . . . For whom is the change significant?" . . . I'll want to be careful not . . . to assume the old family is bad and the new family is good. The title suggests a transition so I'll be looking for signs of it.

As Professor Weiner reads, she continues to elaborate this context, confirming and revising predictions, asking new questions, evaluating what Aries has to say in light of the evidence he can provide, and assessing the value of his ideas to her work as a social historian. She concludes by saying, "A path-breaking book, it was credited with advancing the idea that childhood as a stage of life is historically constructed and not the same in every culture and every time. In my own work I might refer to Aries as I think and write about families as they exist today."

Professor Weiner's description of creating a context for understanding Aries suggests that the ability to recognize what you do not know and to raise questions about a text is as important as identifying what you do know and understand. Even experts encounter texts that they find "difficult." As a college student, you will often be asked to read texts in disciplines that are new to you. Although it may seem challenging to build a context for reading in these situations, it is on these very occasions that it is particularly important to do so. By using textual cues to speculate about the situation that produced the text, you will be in a much better position (1) to identify *what you do understand* about the text and (2) to identify *what you do not yet understand* about the text (terms, concepts, references to other texts). Equipped with this kind of information, you can make better predictions about the text's meaning and decide what you need to know and ask in order to accomplish your purposes for reading.

● FOR WRITING AND DISCUSSION

Even when a text is about an unfamiliar or difficult subject, you can use textual cues to uncover a surprising amount of information that will help you

*Ann Feldman, *Writing and Learning in the Disciplines* (New York: Harper, 1996), 16–17, 25–29.

build a context for reading. Imagine that you are enrolled in an introductory philosophy course and have been asked to read philosopher Anthony Weston's *Toward Better Problems: New Perspectives on Abortion, Animal Rights, the Environment, and Justice.* The passage below excerpts key sentences from the opening of Chapter 1, "Practical Ethics in a New Key." In it, find textual cues that might help you build a context for reading. After you have read the passage, answer the questions below.

Many other "practical ethics" books take up the same topics as this one: abortion, other animals, the environment, justice. Peter Singer covers much the same ground in a book called simply *Practical Ethics.*

The actual practicality of the usual brand of practical ethics, however, is somewhat partial. What we are usually offered is the systematic application of some ethical theory to practice. Singer's book represents an admirably lucid application of utilitarianism. Others apply theories of rights to the same set of issues. . . .

In these well-known kinds of practical ethics, moreover, there is a natural tendency toward a certain kind of closure. The project is to sort out the practical questions at stake in a way that finally allows one or a few facts—one or a few kinds of issues, one or a few aspects of value—to determine the answer. . . .

It is possible, however, to take up practical problems in a radically different spirit, a spirit associated in particular with the work of the American pragmatist John Dewey. This book is an attempt to do so.*

ON YOUR OWN

Jot down brief answers to the following questions:

1. What, if any, background knowledge do you bring to this text?
2. Given your level of background knowledge, how would you go about reading the chapter?
3. What questions can you pose for getting as much as possible from your first reading?
4. What terms or references are unfamiliar to you? Where might you find out more about these terms and references?
5. What do you understand so far about the text's meaning? What don't you understand? What do you predict that Weston will say next?
6. What seems to be Weston's purpose for writing? How will his text be different from other texts?

*Excerpted and reprinted from Anthony Weston, *Toward Better Problems: New Perspectives on Abortion, Animal Rights, the Environment, and Justice,* by permission of Temple University Press. © 1992 by Temple University. All rights reserved.

WITH YOUR CLASSMATES

Compare your answers with those of your classmates.

1. What strategies for reading did people offer? Can you agree on a recommended strategy?
2. List the various questions that people formulated for getting as much as possible from the reading. How are they similar and different?
3. List the various predictions your group has made about what will follow in this text. What are various points of agreement and disagreement based upon? Can you clarify any confusion by sharing perspectives? ●

MATCHING STRATEGIES WITH A TEXT'S GENRE

Besides creating a context for reading, experienced readers use their knowledge of a text's genre conventions to guide their reading process. They know that different genres invite different ways of reading. As we explained earlier, genres are distinguished by recurring patterns in form, style, and use of evidence. Familiarity with a particular genre, such as news stories, can guide your reading of that genre, sometimes unconsciously. Knowing from experience that news reports begin with the key facts of the story and then broaden out to offer background information and additional details (what journalists call the *inverted pyramid structure*), you may just read the first paragraph of the report and skip the details if you're in a hurry or not particularly interested in them.

The same predictability permits expert readers to use genre conventions quite consciously to make their reading more strategic and efficient. Illustration comes from the work of researchers who studied the way that physicists read articles in physics journals.* They found that the physicists seldom read the article from beginning to end but instead used their knowledge of the typical structure of scientific articles to find the information most relevant to their interests. Scientific articles typically begin with an abstract or summary of their contents. The main body of the article includes a five-part structure: (1) an introduction that describes the research problem, (2) a review of other studies related to this problem, (3) a description of the methodology used in the research, (4) a report of the results, and (5) the conclusions drawn from the results. The physicists in the study began by reading the abstracts first to see if an article was relevant to their own research. If it was, the experimental physicists went to the methodology section to see if the article reported any new methods while the theoretical physicists went to the results section to see if the article reported any significant new results. These experts, in other words, were guided both by their purpose for reading (based on their own research interests) and by their familiarity with the genre conventions of the scientific

*Research reported by Cheryl Geisler, *Academic Literacy and the Nature of Expertise* (Hillsdale, NJ: Earlbaum, 1994) 20–21.

research report (which they used to select the portions of the text most relevant to their purpose).

In your college education, you will encounter a wide range of genres, many of which will be initially unfamiliar. Learning the conventions of new genres is one of the ways you gain expertise in the subjects you are studying. When you major in a subject, you need to learn to read and write in the genres valued by that discipline—for example, business majors learn to read and write business proposals and reports; philosophy majors learn to read and write philosophical arguments; anthropology majors learn to read and write ethnographic narratives, and so forth.

MATCHING STRATEGIES WITH PURPOSE FOR READING

Although all readers change their approach to reading according to their purpose, the situation, and the text at hand, most do so unconsciously, relying on a limited set of strategies. By contrast, experienced readers vary their reading process self-consciously and strategically. Here's how one accomplished undergraduate, Sheri, contrasts her "school" reading process with her "reading-for-fun" process:

When I am reading for class, for starters I make sure that I have all of my reading supplies. These include my glasses, a highlighter, pencil, blue pen, notebook paper, dictionary, and a quiet place to read, which has a desk or table. (It also has to be cold!) Before I read for class or for research purposes I always look over chapter headings or bold print words and then formulate questions based on these. When I do this it helps me to become more interested in the text I am reading because I am now looking for answers.

Also, if there are study guide questions, I will look them over so that I have a basic idea of what to look for. I will then read the text all the way through, find the answers to my questions, and underline all of the study guide answers in pencil.

When I read for fun, it's a whole other story! I always take off my shoes and sit on the floor/ground or in a very comfortable chair. I always prefer to read in natural light and preferably fresh air. I just read and relax and totally immerse myself in the story or article or whatever!*

You'll notice, no doubt, that Sheri's reading strategies combine idiosyncratic habits (the blue pen and cold room) with sound, widely used academic

*Sheri's description of her reading process is quoted in Paula Gillespie and Neal Lerner, *The Allyn and Bacon Guide to Peer Tutoring* (Boston: Allyn & Bacon, 2000), 105.

reading habits (looking over chapter headings, checking for study guide questions, and so on). Your own reading process is probably a similar combination of personal habits or rituals and more general types of reading behaviors.

As we noted in Chapter 1 when we introduced rhetorical reading as an academic strategy, your purposes for reading academic assignments will vary considerably. So must your academic reading strategies. You will read much differently, for example, if your task is to interpret or analyze a text than if you are simply skimming it for its potential usefulness in a research project.

One way in which your reading process will vary according to purpose is the rate at which you read. Contrary to popular myth, expert readers are not necessarily "speed" readers. Experienced readers pace themselves according to their purpose, taking advantage of four basic reading speeds.

- *Very fast:* Readers scan a text very quickly if they are looking only for a specific piece of information.
- *Fast:* Readers skim a text rapidly if they are trying to get just the general gist without worrying about details.
- *Slow to moderate:* Readers read carefully in order to get complete understanding of an article. The more difficult the text, the more slowly they read. Often difficult texts require rereading.
- *Very slow:* Experienced readers read very slowly if their purpose is to analyze a text. They take elaborate marginal notes and often pause to ponder over the construction of a paragraph or the meaning of an image or metaphor. Sometimes they reread the text dozens of times.

As you grow in expertise within the fields you study, you will undoubtedly learn to vary your reading speed and strategies according to your purposes, even to the point of considering "efficient" reading of certain texts to involve rereading.

TAKING STOCK OF HOW YOU READ

The first step in self-consciously managing your reading process is to become aware of what you already do when you read. Inevitably, we adjust our reading strategies to fit our purposes. Consider the intricacies of bus and train schedules, the baffling help screens for new Web design software, or the densely packed explanations in your college textbooks. How you read these texts will be governed by your purpose. If you need to know when the next train to Richmond leaves or how to import a pie chart into your marketing proposal, you can skip over lots of irrelevant material. On the other hand, if you are preparing to give a workshop on the essential features of a new computer program or trying to grasp the basic concepts of macroeconomics, you must look beyond specific details to discern overall patterns and meanings.

The beginning of a college writing course is a good time to examine your individual reading processes. In the following exercise, we invite you to think about how you read and how you read differently according to situation and purpose.

• FOR WRITING AND DISCUSSION

ON YOUR OWN

Choose two different reading situations that will occur in the next day or two. When you actually do the reading, record all the details you can about these two activities. Use the following questions to guide your two accounts:

1. List your reasons or purposes for undertaking each reading.
2. Describe the setting as fully as possible—the place where you are reading, the surroundings, the level of noise or other distractions, the presence or absence of other materials besides the text (pens, laptop, coffee, etc.).
3. Notice what you do to get started—what do you say to yourself, what do you actually do first, what "rituals," if any, do you have for this kind of reading?
4. What are your initial expectations regarding each reading? Do you expect the reading to be easy or difficult, enjoyable or a chore? Do you expect to learn something new, to be entertained, to be surprised, or perhaps to be inspired?
5. List all of the strategies you use as you read—glancing ahead; pausing to reread; reading word-for-word, scanning, or skimming; taking notes. How do you "manage" this particular reading experience? That is, what do you do to keep yourself moving along?
6. Note how often you stop, and think about why you stop. What do you do when you stop? How do you get restarted?
7. How long does it take you to complete this reading?
8. What are the results of this reading? Did the text meet your expectations? What criteria are you using to judge whether the reading experience was successful or satisfying in this case?

After you have completed your two accounts, compare the various aspects of the way you read the two texts and note differences and similarities, then answer these two additional questions:

9. To what extent did your purposes for reading and the reading situations account for these differences or similarities?
10. What most surprised you about your reading processes?

WITH YOUR CLASSMATES

In small groups or as a whole class, share passages from your two accounts and the results of your comparison. What range of reading situations emerges? How did these differences in situation affect reading processes? What common reading practices emerge? What idiosyncratic reading practices are reported? •

Summary

This chapter began by explaining two essential pieces of knowledge that you need in order to read rhetorically.

- Reading and writing are acts of composing. Reading is an active process in which readers construe a text's meaning by bringing their own values and experiences to the text.
- Authors vary their texts according to their rhetorical context—audience, genre, and purpose.

This background knowledge prepared you for the second half of the chapter, which focused on three expert strategies you can use to

- Build a context for reading
- Match your reading strategy with a text's genre
- Match your reading strategy with your purpose for reading

SOURCES OF THE ARTICLE EXCERPTS ABOUT TEENAGERS' SLEEP PATTERNS

This list of sources is presented in the same order as the excerpts used in the For Writing and Discussion exercise on page 26. The citations follow Modern Language Association (MLA) format. (Sample MLA formats for other types of sources are presented in the appendix at the end of this book.)

Article 1

McFarling, Usha Lee. "Kids Clobbered by Sleeplessness; Schools Try Later Starting Times." Arizona Republic 27 Mar. 1999, final chaser ed.: A9.

Article 2

Carskadon, Mary A. "When Worlds Collide: Adolescent Need for Sleep Versus Societal Demands." Phi Delta Kappan Jan. 1999: 348-53.

Article 3

*Wolfson, Amy R., and Mary A. Carskadon. "Sleep Schedules and Daytime Functioning in Adolescents." Child Development 69 (1998): 875-87.

Article 4

Lamberg, Lynne. "Some Schools Agree to Let Sleeping Teens Lie." JAMA 276 (1996): 859.

Article 5

Rapoport, Jennifer. "The ZZZ-Files." YM: Young and Modern Sept. 1998: 48-49.

*This article is reprinted in full in Chapter 10.

Listening to a Text

Read as though it made sense and perhaps it will.

—I. A. Richards

I n Chapters 1 and 2 we explained what it means to read rhetorically, high-lighted the value of rhetorical reading as an academic skill, and provided an overview of the strategies experienced readers use when they encounter academic texts. In Chapters 3 and 4 we focus specifically on the nuts and bolts of reading the kinds of texts you will be assigned in college. You will learn to make the strategies used by experienced readers part of your own reading repertoire. These strategies will make you both a better reader and a shrewder writer. Indeed, rhetorical reading strategies overlap with the process of writing by providing you lots of grist for your writing mill.

Our discussion in these chapters extends the metaphor of reading as conversation by using the terms "listening" and "questioning" to describe specific reading techniques. In this chapter we show how listening to a text involves preparation strategies as well as careful reading. As you apply these various techniques for rhetorical reading, your goal is to understand what an author is trying to say. *Listening strategies* help you attend closely to a text and thus give it the fairest hearing possible. When you listen attentively to a text, you are reading with the grain, trying to understand it in the way the author intended. In Chapter 4, we explain *questioning strategies*, which will take you back to the text with a different purpose and approach: to read against the grain in order to compose a deeper, critical reading of the text. Your goal then is to apply your own critical thinking so that you can "speak back" to texts with authority and insight.

Let's turn now to listening strategies. We begin by explaining how rhetorical readers read with pen in hand in order to interact with the text and record

their ideas-in-progress. We then offer specific listening strategies that you can use at different stages of your reading process, including strategies that take into account a text's visual features. These are:

1. *Preparing strategies,* which include identifying your purpose, recalling background knowledge, using visuals to plan and predict, reconstructing the text's rhetorical context, and spot reading
2. *Strategies for initial reading,* which include noting organizational signals, marking unfamiliar terms, identifying difficult parts, connecting the visual to the verbal, and making marginal notes
3. *Strategies for rereading,* which include mapping the idea structure, descriptive outlining, composing a summary, and writing a rhetorical *précis*

Writing As You Read

Skilled rhetorical readers write as they read. Often they write in the margins of the text (unless it is a library book) or they keep a reading log or journal in which they record notes. Sometimes they stop reading in the middle of a passage and freewrite their ideas-in-progress. The text stimulates them to think; writing down their ideas captures their thinking for future reference and stimulates further thought. To put it another way, rhetorical reading strategies focus on both *comprehension* (a reader's understanding of a text) and *invention* (the ideas generated in response to a text). Thus, writing while you read helps you generate ideas as well as interact more deeply with the text.

For these reasons, most of the rhetorical reading strategies that we present require you to write. To foster the reading-writing connection, we recommend that you keep a reading log (a notebook or journal) in which you practice the strategies described in this chapter. Keeping a reading log will help you develop advanced reading skills as well as generate a wealth of ideas for essay topics. (Reading log questions accompany all the readings in Part Three, the anthology.)

Depending on your goals for reading a given text, some of the strategies described in this chapter will probably seem more appropriate than others. Some are used consciously by experienced readers on a regular basis; others are designed to help you acquire the mental habits that have become second nature to experienced readers. Experienced readers, for example, almost always take notes as they read, and they frequently write summaries of what they have read. However, experienced readers would be less likely to write a descriptive outline with *says* and *does* statements (see p. 54–55)—not because the exercise isn't valuable but because they have already internalized the mental habit of attending to both the content and function of paragraphs as they read. By practicing descriptive outlines on a couple of readings, you too will internalize this dual focus of rhetorical reading. Furthermore, descriptive outlining is a valuable tool to use in your own writing as you analyze a draft in order to make decisions about revision.

To illustrate the strategies in the rest of this chapter and in Chapter 4, we will use excerpts from philosopher Anthony Weston's *Toward Better Problems* (a portion of which was examined in Chapter 2), and the full text of Larissa MacFarquhar's "Who Cares If Johnny Can't Read?", which you will find at the end of this chapter. We use Weston's text to illustrate the kind of reading you are likely to be assigned in courses across the curriculum. We use MacFarquhar's text as an example of the lively popular pieces you are likely to encounter when doing research on contemporary culture.

Preparing to Read

In completing the "Taking Stock of How You Read" exercise in Chapter 2, you probably discovered that you already have various rituals for reading—a place where you typically read, a favorite snack or beverage that you like to have on hand, and various tricks to keep yourself reading. But did the exercise reveal any time spent preparing to read, such as previewing the text for its gist, scope, and level of difficulty? Taking some time to plan your reading enables you to work efficiently and get the most out of your reading experience from the start. Furthermore, thinking about your purpose will help you maintain a sense of your own authority as you read. The strategies we present in this section encourage you to prepare to read as though you were about to join the text in a multivoiced conversation. As we explained in Chapter 1, the text you are reading is one voice among a network of other voices. Your response to the text constitutes yet another voice in the ongoing conversation about the topic. Practicing the following strategies will prepare you to read in this powerful way:

1. *Identifying your purpose* helps you articulate what you wish to get out of a reading.
2. *Recalling background information* reminds you of what you bring to a text.
3. *Taking a text's visual elements into account* helps you plan your reading and offers you information about genre and purpose.
4. *Reconstructing a text's rhetorical context* alerts you to the writer's purpose, audience, and occasion for writing, and thus enables you to make predictions about the text's content, methods, scope, and level of difficulty.
5. *Spot reading* allows you to flesh out the context for reading by assessing the fit between your aims for reading and the writer's aims for writing.

IDENTIFYING YOUR PURPOSE

Identifying your purpose at the outset helps you set goals and plan your reading accordingly. Your purpose for reading may seem like a self-evident matter—"I'm reading this sociology chapter because it was assigned by my professor." That may be, but what we have in mind is a more strategic consideration of your purpose. How does the reading assignment tie in with themes established in class? How does it fit with concepts laid out on the course syllabus? Is this

your first course in sociology? If so, then your purpose might be "to note the types of topics, questions, and special vocabulary used by sociologists." This basic but strategically stated goal might lead you to allow extra time for the slowed down reading that is usually necessary at the beginning of introductory courses.

Let's assume you are skimming articles to select some to read more closely for possible use in a researched argument on gun control. As we discuss in detail in Chapter 6, if you've identified a clear and compelling research question, you will know what you're looking for, and your reading will be more purposeful and productive. At times, your purpose may be at odds with a particular author's purpose in writing the text. Suppose, for example, that you oppose gun control and are reading pro–gun control articles in order to summarize and rebut their arguments. In such a case, you are intentionally reading against the purposes of those authors. Setting goals ahead of time helps you know what to look for. At the same time, you should leave open the possibility that your ideas and purposes for writing might change as you read. Reading pro–gun control articles might cause you to moderate or reconsider your anti–gun control stance. Sometimes you might even discover a new and unexpected purpose. For example, in doing gun control research, you might encounter discussions about conflicts between the right to privacy and background checks and decide that this subissue could become the focus of your paper. Our point, then, is that articulating your purpose for reading will make your reading more efficient and productive.

RECALLING BACKGROUND KNOWLEDGE

Another preparation strategy is to recall your prior knowledge, experience, and opinions regarding the text's subject. What experiences, for example, led to your opposition to gun control? What do you need to learn from your research to write a persuasive argument? A brief review of your background will give you benchmarks for recognizing gaps in your knowledge that you hope to fill through reading and for assessing a given text's effect on your current views or beliefs. Considering your background knowledge will help you determine whether a text has taught you something new, made you consider something you hadn't thought of before, changed your mind, or confirmed your prior knowledge and beliefs. A journal or reading log is the perfect place to brainstorm what you already know or feel about a subject. If you have little knowledge about the subject, jot down some questions about it that will enable you to engage more interactively with what you read.

USING VISUAL ELEMENTS TO PLAN AND PREDICT

One of the first things we notice about a text are its visual features. The color, design, and images on a book or magazine are typically what intrigue us to open it. On Websites, color, design, and images—and, increasingly, animation—are combined to grab our attention so that we'll pause to read instead of clicking on.

Textbooks also capitalize on color and page design to hold and guide readers' attention; it is common practice for students to leaf through a textbook chapter to spot any illustrations, charts, or graphs, and to note the headings on subsections. Yet while we often notice such features, we seldom actively use them as clues to guide our reading of a text. Careful attention to a text's visual features can help you plan your reading of it as well as enable you to make predictions about its purpose and genre.

To make the most out of the preliminary information provided by a text's visual elements, we suggest a simple approach. Begin by noting the kinds of visual elements present in a text; then use these observations to plan your reading and make predictions, two activities that go hand-in-hand. Generally, these elements fall into the following categories:

- *Print features:* Typeface, size, and style (bold, italics, underlining)
- *Document design:* Paper quality, page layout, bullets, numbers, use of color or shading, and other organizational features such as boxes, subheadings, and highlighted quotes
- *Images:* Drawings, photographs, cartoons, art reproductions
- *Information graphics:* Charts, tables, graphs, maps, and diagrams

(See Chapter 10 for further discussion of information graphics and their use in texts that inform and explain.)

Attending to both the obvious and less obvious visual features of a text will alert you to the ways in which these features affect your initial expectations, attitudes, and level of interest. This information, in turn, can help you plan your reading. What do you notice about the "look" of a text? Is the text long or short? Does its appearance draw you into it, or does it make the reading task look daunting? If the text is dense, with long paragraphs uninterrupted by subheadings, you probably expect reading it to be time-consuming and a bit tedious, and you may well decide that you will need to take frequent breaks or that you will save the reading for the time when you are most alert and able to concentrate. On the other hand, if an article or chapter includes pictures or illustrations that pique your interest, or if the text itself is divided into sections by white space or inviting quotations highlighted between the columns (known as *pull-quotes*), you probably expect reading it to be easier and more enjoyable.

Although it may seem as if the visual features of a text are distinct from the verbal, all written texts include print features that affect our attitudes and expectations about a reading. A text set in `Courier font`, for example, resembles typewritten copy and thus has the serious look of a school paper or business letter; a text set in *Lucida Calligraphy*, by contrast, looks ornate, as if it belonged on a fancy invitation or a program for a concert. Or consider the effect of a text or portion of a text written in all caps. IT SEEMS TO BE SHOUTING AT READERS! Additionally, the type of paper on which a text is printed has a particular look and feel. A magazine printed on heavy paper stock has an expensive, sophisticated feel that leads to expectations of high-class content—high fashion if it is a

fashion magazine, fine arts if it is an arts magazine, and so on. All of these features affect our expectations about a text.

Increasingly, texts include elements of document design that enhance readability and emphasize key points. These reader-friendly visual signals affect our first impressions of a text and provide directions about what's important. They say "pay attention," "remember," "slow down and make sure you understand this," or "follow these steps." Perhaps the best way to illustrate how design elements affect our response to a text and ability to make predictions about its content is to offer a comparison. If you were to skim "Why Do Those #&*?@! 'Experts' Keep Changing Their Minds?" (p. 258) and "Clinical Research—What Should the Public Believe?" (p. 458) and compare your initial impressions of these two texts, you would undoubtedly expect the former to be a quicker and easier read. While both articles offer a similar message, the first article's bulleted lists, subheadings, and highlighted boxes not only guide a reader efficiently through the text but also make its main points easily identifiable. The second text, by contrast, includes no visually enhancing design elements and thus, as you might expect, requires a closer reading to discern its main points.

Images, which technology has made easy to include, also affect our attitude toward a reading and help us make predictions about its tone, content, and purpose. To illustrate their influence, consider Figure 3.1, which was published in

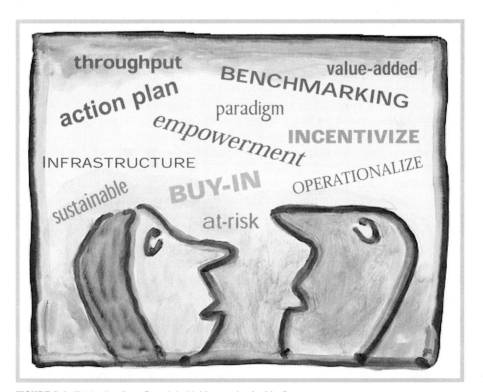

FIGURE 3.1 Illustration from Proscio's "Jabberwocky Junkies"

a magazine for grant writers alongside Tony Proscio's "Jabberwocky Junkies" (Chapter 14). Placed in the original just beneath the title, to the right of the subtitle, this illustration was immediately eye-catching. The puzzled cartoon faces and the disconnected jargon floating overhead function not only to draw attention but, in connection with the title, provide important signals about both the content and attitude of the article. You might readily predict that the article takes a humorous attitude toward the language represented in the thought bubbles—probably making fun of overblown terms such as "throughput" and "operationalize." This prediction is confirmed by the article's subtitle: "Why we're hooked on buzzwords—and why we need to kick the habit." If you peruse the article further, you will find another visual element, a box entitled "Avoiding Jargon," which offers specific, practical advice (p. 453). Taken together, these visual elements, along with the title and subtitle, enable you to predict that the article's purpose is to criticize, with a touch of humor, the use of jargon among grant writers and to offer recommendations for eliminating it.

A text's visual features also reveal its genre, from which you can begin to predict its purpose. In our everyday lives, we easily differentiate an envelope containing a credit card bill from an offer for a new credit card, and we can usually distinguish "serious" fiction from a romance novel by a glance at a book's cover. Similarly, when reading for academic purposes, we encounter many nonacademic and academic genres that are recognizable just by their look. Newspaper articles have short paragraphs to facilitate reading in narrow columns, a characteristic that often makes these articles look choppy when they are reproduced in wide formatting. Book reviews characteristically begin with a short notation, perhaps in boldface, that provides publication information about the book or books under review, and poems are readily recognizable by their layout on the page. As we explained in Chapter 2, rhetorical theorists have found that our knowledge of genres sets up particular expectations and affects how we go about reading a text. Plainly, we approach the reading of a poem quite differently than we do the reading of a scholarly article, résumé, or comic strip. Consider the visual features of this chapter: frequent subheadings, italicized terms, bulleted lists, annotated examples. What do these features suggest about its genre? About how to go about reading it? Even if you were reading a photocopy of this chapter without the context of the book, you would easily recognize that it came from a textbook because its instructional features emphasize important points and break up information for ease of reading and review. Since you are quite familiar with textbooks, you have undoubtedly developed strategies for reading texts like this one—skimming the headings before reading, noting words in bold, using the bulleted information for review.

Beyond textbooks, the broad genre of academic writing generally includes fewer visual elements than popular texts do because academic texts presume an interested and knowledgeable reader. Therefore, it is especially important to preview these texts for any visual signals that might help you plan and predict your reading of them. For example, in texts with long paragraphs and complex

reasoning such as *Toward Better Problems*, the Anthony West book we have been discussing, headings and sub-headings signal key ideas and thus help readers anticipate main ideas and read strategically.

In Part Three, you will find articles from various genres, some academic or scholarly, others more popular, intended for a general audience. If you use the visual elements to skim Wolfson and Carskadon's "Sleep Schedules and Daytime Functioning in Adolescents" in Chapter 10, for instance, you will notice the article is preceded by an *abstract* that summarizes its contents and is divided into four major sections—introduction, methods, results, and discussion—each subdivided by topic. You will also notice that this article includes two types of information graphics: tables of data and bar graphs. All of these features mark this text as a research report, and readers familiar with this genre will have developed particular strategies for reading this type of article or for reading only selected sections of it, depending on their interests and purpose for reading, like the physicists we described in Chapter 2, who often chose to read only those portions of a research article that pertained to their own research interests. Even if you are not yet familiar with the genre conventions of research reports, you probably recognize that Wolfson and Carskadon's opening abstract provides an overview of the study and that a preview of the charts and graphs will introduce you to key elements in the study. For example, Table 3 in the Wolfson and Carskadon study (p. 286), which compares data about daytime behaviors (listed in the first column) in regard to "adequate versus less than adequate sleepers," fleshes out a reader's understanding of the title "Sleep Schedules and Daytime Functioning in Adolescents."

● FOR WRITING AND DISCUSSION

ON YOUR OWN

This exercise invites you to examine the impact visuals can have on a reader's initial responses to a text and ability to predict its genre and purpose. Find two sample texts, one written for a popular audience, the other a scholarly text in your intended major. List the visual features of each type of text, from page design to actual images. Then freewrite in response to the following questions:

1. How do these features affect your attitude toward each reading?
2. How might they guide your reading of each text?
3. What information do they offer about genre and purpose?
4. What do they tell you about what you can expect to get out of the text?

WITH YOUR CLASSMATES

1. Take turns presenting your examples and freewrites.
2. As a group, make a list of the genres represented in the examples shared. Under each genre, list the visual features typical of that genre. Be prepared to present your group's findings about how visual features signal differences in genre and purpose. ●

RECONSTRUCTING RHETORICAL CONTEXT

In Chapter 2 we showed how a text's content, organization, and style are influenced by a writer's rhetorical context—that is, by the writer's intended audience, genre, and purpose. Reconstructing that context before or as you read is a powerful reading strategy. Sometimes readers can reconstruct context from external clues: a text's visual appearance (as we explained in the previous section), a text's title, background notes on the author, date and place of publication, table of contents, headings, introduction, and conclusion. But readers often have to rely on internal evidence to get a full picture. A text's context and purpose may become evident through some quick spot reading (described below), especially of the introduction. Sometimes, however, context can be reconstructed only through a great deal of puzzling as you read. It's not unusual that a whole first reading is needed. Once context becomes clear, the text is easier to comprehend upon rereading.

To establish a sense of the text's original rhetorical context, use the available sources of information to formulate at least tentative answers to the following questions:

1. What question(s) is the text addressing?
2. What is the writer's purpose?
3. Who is the intended audience(s)?
4. What situational factors (biographical, historical, political, or cultural) apparently caused the author to write this text?

To explore how external clues reveal context, suppose you are enrolled in a philosophy class and have been assigned to read the Anthony Weston book first mentioned in Chapter 2, *Toward Better Problems: New Perspectives on Abortion, Animal Rights, the Environment, and Justice.* The title and subtitle suggest that the book will address the following question: "How can we find better ways to define difficult social problems such as abortion, animal rights, the environment, and justice?" The words "better" and "new" in the title also imply that this book is a response to other books on the subject and that the author's purpose is to propose a change in outlook. The phrase "better problems" is intriguing—is there such a thing as a "good" or "better" problem? This strange notion, along with the promise of "new" perspectives on thorny social issues, seems designed to pique readers' curiosity.

To place the book in a larger context, however, and to identify the intended audience, we need further information. A quick perusal of the back cover tells us the publisher, Temple University Press, has categorized the text as "Philosophy/Applied Ethics," so we might predict that the book was written for an academic audience, or at least a well-educated one, and that Weston will deal with ethical issues from a philosophical perspective (as opposed to a theological, sociological, or political one). This conclusion is further confirmed by information on the cover that Weston teaches philosophy at the State University of New York–Stony Brook, a note that establishes his academic credentials for writing

about this subject. If you don't have a strong background in philosophy, this information may further lead you to conclude that this text may be difficult to read—all the more reason to devote time to investigating its context and purpose, which we explore further in the next section. After all, by virtue of enrolling in the philosophy course, you have become part of Weston's intended audience.

SPOT READING

Spot reading is a process that gives you a quick overview of a text's content and structure, thus accomplishing two purposes: (1) determining the fit between the text's purpose and your own purposes for reading; and (2) giving you an initial framework for predicting content and formulating questions. For example, when your purpose for reading is to acquaint yourself with the vocabulary and concepts of a new field, then spot reading will help you to determine whether a book or article is written at an introductory level. If it is, then you can expect textual cues to point to important new vocabulary and concepts. If it is not, then you may decide to find a more introductory text to read first, or you may decide to allot extra time to reread and look up unfamiliar terms.

If the text that interests you has an abstract or introduction, you might begin spot reading there. Other places for productive spot reading are the opening and concluding paragraphs or sections of a text. The opening usually introduces the subject and announces the purpose, and the conclusion often sums up the text's major ideas. If the text is short, you might try reading the opening sentences of each paragraph. If the text is longer, note chapter titles in the table of contents. Sometimes tables of contents, particularly in textbooks, provide chapter contents and subdivisions. If you are working with a text that provides summaries and study questions, read through these before beginning to read the section they describe. Spot reading a table of contents can help you determine what content will be covered and whether a text will help you address a research question. The organizational strategy revealed through a table of contents also provides important information about an author's method, perhaps guiding you to choose certain sections as essential reading.

As illustration, let's return to Weston's *Toward Better Problems* to consider what the chapter titles in his table of contents reveal about his purpose and method.

Chapter 1: Practical Ethics in a New Key

Chapter 2: Pragmatic Attitudes

Chapter 3: Rethinking the Abortion Debate

Chapter 4: Other Animals

Chapter 5: The Environment*

*An excerpt from this chapter appears in Chapter 14.

Chapter 6: Justice

Chapter 7: Conclusion

These titles suggest that the first two chapters spell out his theory for constructing "better problems" and "new perspectives" while each of the next four chapters is devoted to one of the topics listed in the book's subtitle. If you were reading this book independently for background on just one of these topics, perhaps environmental ethics, you might read only the first two chapters and then the one on the environment.

This particular table of contents lists major subtopics within all but the first chapter (which is only five pages long). The list of subtopics for Chapter 2 gives further indication not only of Weston's purpose and method but of the chapter's crucial value for understanding his approach in the problem-focused chapters that follow it:

CHAPTER 2: PRAGMATIC ATTITUDES

From Puzzles to Problematic Situations

Reconstructive Strategies

Integrative Strategies

Given the book title's forecast of "better problems" and "new perspectives," it seems reasonable to predict that in this chapter Weston contrasts two ways of viewing ethical problems—as "puzzles" and as "problematic situations"—and that he favors the latter. From these basic clues you can begin to articulate your own purpose for reading and to formulate questions that will help you understand the text: What's the main difference between thinking of ethical problems as puzzles and thinking of them as problematic situations? Why is the latter approach better than the former?

The framework that spot reading provides for making predictions and posing questions about content will help you make sense of ideas and information as you read. It can also help you anticipate and tolerate difficult-to-understand passages, confident that even though you don't understand every bit of the text on the first reading you nevertheless have some sense of its overall meaning. In short, spot reading helps you to stay in control of your reading process by helping you confirm and revise your predictions and look for answers to your questions. It takes little time and offers a worthwhile payoff in increased understanding.

● FOR WRITING AND DISCUSSION

To demonstrate the value of the various preparation strategies we have described, we invite you to try them out on Larissa MacFarquhar's "Who Cares If Johnny Can't Read?" Later in the chapter we will ask you to read this article carefully. For now, set yourself 10 minutes of preparation time (look at your watch) and try to accomplish the following.

•

ON YOUR OWN

1. Do some initial spot reading of the text and headnote to get a sense of what the article is about.
2. Based on what you discover about its content, write down a possible purpose you might have for reading it other than for an assignment, or what purpose an instructor might have for assigning it.
3. Freewrite briefly about your background on this topic and your feelings about it.
4. Reconstruct the text's rhetorical context: What question(s) does this text address? Who is the intended audience? What seems to be MacFarquhar's main purpose? What historical or cultural factors cause her to write?
5. Continue to spot read to help you answer the above questions.

WITH YOUR CLASSMATES

Share what you each accomplished in 10 minutes.

1. Compare various purposes proposed by group members.
2. What different backgrounds and feelings emerged?
3. What agreement was there about the text's rhetorical context?

ON YOUR OWN AGAIN

Our goal in presenting this exercise is to show you the value of taking a short time to prepare to read, as opposed to simply plunging into a text. What did you learn from the experience? How successful have we been in convincing you to use these strategies? •

Listening As You Read Initially

"Listening" to a text means trying to understand the author's ideas, intentions, and worldview—that is, reading *with the grain* of the text, trying to understand it on its own terms. Just as good listeners attend carefully to what their conversational partners say, trying to give them a fair hearing, so too do good readers attend carefully to what a text says, trying to consider the ideas fairly and accurately before rushing to judgment. In particular, college reading requires you to give an impartial hearing to ideas and positions that are new and sometimes radically different from your own. Moreover, in class discussions, examinations, and paper assignments, you will frequently be asked to demonstrate that you have listened well to your assigned texts. Professors want to know that you have comprehended these texts with reasonable accuracy before you proceed to analyze, apply, or critique the ideas in them. In the language of Kenneth Burke's metaphor of the conversational parlor introduced in Chapter 1, you might think of this listening phase of the reading process as the phase where you try to catch

the drift of the conversation and give it the fullest and fairest hearing before "putting in your oar."

Listening strategies help you to understand what to listen for, how to hear it, and how to track your evolving understanding of what the text is saying. We have divided this section into two sets of strategies because you need to listen differently the first time you are reading a text than when you are rereading. The first time through, you are trying to understand a text's overall gist and compose a "rough-draft interpretation" of its meaning. The second time through, after you have a sense of the gist, you are aiming to confirm, revise if necessary, and deepen your understanding.

We opened this chapter by urging you to read with a pen or pencil in hand, to adopt experienced readers' practice of marking passages, drawing arrows, and making notes. The following five strategies will guide you through your first reading of a text:

1. *Noting organizational signals* enables you to create a mental road map of the text's idea structure.
2. *Marking unfamiliar terms and references* identifies terms and ideas to look up later.
3. *Identifying points of difficulty* reminds you of passages to bring up in class or reread.
4. *Connecting the visual to the verbal* helps you understand the ways in which visual elements function in relation to the verbal content.
5. *Annotating* a text provides a record to use later for rereading, writing about the text, or reviewing for a test.

NOTING ORGANIZATIONAL SIGNALS

Organizational signals help you anticipate and then track the text's overall structure of ideas. Experienced readers use these signals to identify the text's central ideas, to distinguish major ideas from minor ones, to anticipate what is coming next, and to determine the relationship among the text's major ideas. Organizational signals and forecasting statements (which directly tell you what to expect) function like road signs, giving you information about direction, upcoming turns, and the distance yet to go. For example, experienced readers note words such as *however, in contrast,* or *on the other hand* that signal a change in the direction of thought. Likewise, they note words such as *first, second,* and *third* that signal a series of parallel points or ideas; words such as *therefore, consequently,* or *as a result* that signal cause/effect or logical relationships; and words such as *similarly, also,* or *likewise* that signal additional evidence or examples in support of the current point. Experienced readers often circle or otherwise mark these terms so that a quick glance back will remind them of the structure of ideas.

MARKING UNFAMILIAR TERMS AND REFERENCES

As you read, it is important to mark unfamiliar terms and references because they offer contextual clues about the intended audience and the conversation of which this text is a part. Their very unfamiliarity may tell you that the text is written for an insider audience whose members share a particular kind of knowledge and set of concerns. We suggest that you mark such terms with a question mark or write them in the margins and return to them after you finish your initial reading. Stopping to look them up as you read will break your concentration. By looking them up later, after you have a sense of the text's overall purpose, you will gain insight into how key terms function and how they represent major concerns of a particular field or area of study.

IDENTIFYING POINTS OF DIFFICULTY

Perhaps one of the most important traits of experienced readers is their *tolerance for ambiguity and initial confusion*. They have learned to read through points of difficulty, trusting in I. A. Richards's advice in the epigraph to this chapter, "Read as though it made sense and perhaps it will." When you are reading about new and difficult subject matter, you will inevitably encounter passages that you simply do not understand. As we suggested in our advice about building a context for your reading, explicitly identifying what you don't understand is an important reading strategy. We recommend that you bracket puzzling passages and keep reading. Later you can come back to them and try to translate them into your own words or to frame questions about them to ask your classmates and professor.

CONNECTING THE VISUAL TO THE VERBAL

Nowadays visual elements frequently accompany verbal texts as ways to enhance, support, and extend a text's meaning as well as to increase its rhetorical effectiveness (a topic we discuss in Chapter 4). A number of factors work together to make the use of visual elements particularly powerful. For one thing, we live in a highly visual culture where information is often transmitted through images. Consequently, our attention is more readily attracted and engaged by verbal texts that include visual elements. For another, there is a general belief not only that "a picture is worth a thousand words" but also that "pictures don't lie" and "seeing is believing," despite widespread knowledge that images can be doctored or manipulated. For all of these reasons, careful readers must be alert to the subtle and indirect messages conveyed through visuals.

The importance of visual elements, particularly images, in relation to a text can vary considerably. At one end of the continuum are visual elements that are clearly incidental to the verbal message—for example, generic clip art added to

a newsletter. At the other end are texts in which the visual message predominates and verbal elements play only a minor role—for example, the photograph of Christina Aguilera in Chapter 4 and the American Library Association's "Read" poster with Oprah Winfrey in Chapter 14. Somewhere in between is the special case of cartoons, where the visual and verbal are tightly intertwined, with the visual sometimes leading, sometimes carrying the verbal. In academic writing, visual elements are usually subordinate to the verbal content, with their importance depending on their function.

Here we discuss three common ways in which visual elements can function in relation to the verbal message: (1) by *enhancing* its appeal, (2) by *supporting* its claims, and (3) by *extending* its meaning. Often, visual elements serve more than one of these functions in relation to a text; however, we will explain these three functions separately to highlight their subtle but important differences in relation to the verbal text.

1. **Visuals That Enhance Verbal Content.** Photographs, drawings, and other images often function to attract readers' attention, set a tone, and frame responses to a text. In these ways, they *enhance* the text's verbal content by augmenting it with the vividness and immediacy of visual images. Consider the photograph of the Icelandic lagoon in Chapter 1, which appears along with our description of a series of articles that took different approaches to presenting scientific research about the melting of polar ice. The photograph was taken by the author of an overview article and published along with it. The photo's role in the original publication was similar to the role it plays in our text: It adds visual interest to a page that would otherwise include only text at the same time that it gives presence to the matter under discussion.

2. **Visuals That Support Verbal Content.** A second common way in which the visual relates to the verbal is to *support* the verbal message. Here authors directly refer to visual elements in order to provide evidence for their claims. In "Mickey Mouse Meets Konrad Lorenz" (Chapter 10), for example, Stephen Jay Gould's argument that Mickey Mouse's appearance became more youthful over the years depends on the evidence he provides through the pictures of Mickey's evolving facial features and head size (p. 268).

3. **Visuals That Extend Verbal Content.** A third function visual elements can serve is to *extend* the meaning of a verbal text by enlarging or highlighting a particular dimension of it. Visual elements that function in this way can suggest new interpretations, provoke particular responses, or create links to other ideas. In many of these cases, a reader might initially puzzle over the connection between an image and the verbal text it accompanies, not knowing quite how to interpret it until after reading the text. Consider, for example, the drawing of three embracing figures that accompanies Maureen Dowd's "Scarred for Life: Courage Begets Courage" (Chapter 14, p. 471), which was added by a newspaper editor when the column was reprinted. The drawing's connection to the text is not readily apparent, so even after reading Dowd's essay about organ donation, readers might interpret its meaning variously. However, most would

probably agree that the drawing is linked to the abstract idea of courage, suggesting, perhaps, that the support of others enables us to be courageous and to rise above selfish concerns.

ANNOTATING

When you annotate a text, you underline, highlight, draw arrows, and make marginal comments. Annotating is a way of making the text your own, of literally putting your mark on it—noting its key passages and ideas. Experienced readers rely on this common but powerful strategy to note reactions and questions, thereby recording their in-process understanding of a text. By using their pen or pencil to mark the page, they are able to monitor their evolving construction of a text's meaning.

Annotations also serve a useful purpose when you return to a text to reread or review it. They not only remind you of your first impressions of the text's meaning but also help you identify main points and come to new levels of understanding—clearer answers to earlier questions, new insights, and new questions. Indeed, we recommend that you annotate each time you read a text, perhaps using a different colored pen so that you have a record of the new layers of meaning you discover each time you read. Of course, annotating can become counterproductive if you underline or highlight too enthusiastically: a completely underlined paragraph tells you nothing about its key point. To be useful, underlining must be selective, based both on your own purposes for reading and on what you think the writer's main points are. In general, when it is time to review the text and recall its main ideas, notes in the margin about main ideas, questions or objections, and connections among ideas will be far more useful to you than underlining or highlighting.

To illustrate this listening strategy, we have annotated the opening passage of Weston's "The Need for Environmental Ethics," which is Chapter 5 of *Toward Better Problems*. (A longer excerpt from this chapter is found in Chapter 14.) The annotations were made from the perspective of a student enrolled in an introductory philosophy class that includes a unit on ethics. They demonstrate the student's efforts to uncover Weston's central argument and purpose. Read through the passage and annotations carefully. Think about the student's purpose—and whether the annotations helped him achieve his purpose—and consider the uses the student might make of these annotations.

Effective analogy Examples of "danger signs"	We are beginning to struggle with the intimation that something is seriously wrong with our relation to the natural world. It is a little like suspecting cancer but not wanting to know. But the danger signs are all around us. Garbage dumped a hundred miles off the Atlantic coast is now washing up annually on beaches. The federal government is continuing its increasingly desperate search for a way to dispose of the highly toxic radioactive

Check recent news about Yucca Mt. as a nuclear dumping site

Examples of our relation to the natural world—all distance us

Artificial environments = cocoons

"Winds laugh for no one"? What does he mean?

Short-term, practical versus fundamental—key issues for Weston

Key issue to track

wastes that American nuclear reactors have been generating since they began operating, so far without any permanent disposal plan at all. A state-sized chunk of South American rain forest is slashed, cut, or burned every year, in large part to clear land to graze beef cattle, though the resultant pasture is of marginal quality and will be reduced to desert within ten years. And our society, affluent beyond the wildest dreams of our ancestors and most of the rest of the human race, increasingly fortifies itself inside artificial environments—we see the countryside through the windshield or the airplane window, we "learn about nature" by watching TV specials about endangered African predators—while outside of our little cocoons the winds laugh for no one and increasingly, under pressure of condominiums and shopping malls, the solace of open space is no more.

Short-term solutions of course suggest themselves. If the seas can no longer be treated as infinite garbage pits, we say, let us incinerate the garbage instead. Rain forest cutting could be curtailed by consumer action if North Americans paid a little more for home-grown meat. Sooner or later, we suppose, "science" will figure out something to do with nuclear wastes. And so on. This kind of thinking too is familiar. The problems may seen purely practical, and practical solutions may be in sight. Environmental ethics, however, begins with suspicion that something far deeper is wrong, and that more fundamental change is called for.

● FOR WRITING AND DISCUSSION

Earlier in this chapter you tried out some "preparing to read" strategies on Larissa MacFarquhar's "Who Cares If Johnny Can't Read?" It is now time for you to read that essay carefully, listening to MacFarquhar's argument.

ON YOUR OWN

As you read the essay the first time, try your hand at marking and annotating.

1. Note organizational signals, unfamiliar terms, and difficult passages.
2. Annotate what you believe to be her key ideas and the most important passages.
3. Record your reactions and questions in the margins.

WITH YOUR CLASSMATES

Compare your markings and annotations of this essay.

1. What differences and similarities were there in different people's underlining, marking, and marginal notes? What do you conclude will be an efficient strategy for you?

2. As a group, make a brief list of MacFarquhar's key points and ideas. Compare your group's list with those of other groups and try to arrive at a consensus. ●

Listening As You Reread

Rhetorical reading, as we have been suggesting, is not a one-step process but may often require careful reading and rereading to confirm and deepen your understanding of a text. Of course not every text requires rereading; however, whenever detailed analysis is required or whenever a text is particularly difficult, a careful second and sometimes third reading is needed.

To help you acquire the mental habits of strong readers and to give you practice with the types of writing you will use frequently as part of college-level analysis and research, we offer the following four strategies:

1. *Mapping the idea structure* provides you with a visual representation of a text's major ideas and the relationships among those ideas.
2. *Descriptive outlining* enables you to distinguish what a text (or visual) *says* from what it *does* rhetorically.
3. *Composing a summary* requires you to focus on and articulate the gist of the text, which is good practice for incorporating source material into your own writing.
4. *Writing a rhetorical précis* provides a structured model for describing the rhetorical strategies of a text as well as capturing the gist of its content.

MAPPING THE IDEA STRUCTURE

One of the goals of rereading is to get a sense of how the text works as a whole— how its ideas connect and relate to one another. Idea maps provide a visual representation of the ways that a text's ideas relate to each other, enabling you to distinguish main ideas from subordinate ones and to understand relationships among the writer's points. You might think of idea maps as X-rays of the text's idea structure.

The time to map a text's idea structure is after you have finished reading it and are sitting back to review its main ideas. To create a map, draw a circle in the center of a page and write the text's main idea inside the circle. Then record the text's supporting ideas on branches and subbranches that extend from the center circle. In Figure 3.2 we offer a sample idea map of the entire text of Weston's "The Need for Environmental Ethics" found in Chapter 14. Creating a map is not an easy task because it forces you to think about the text's main ideas in a new way. You may even find that creating a map reveals inconsistencies in the text's organizational structure or puzzling relationships among ideas. This, too, is important information and may be an issue you should bring up in class discussion or in

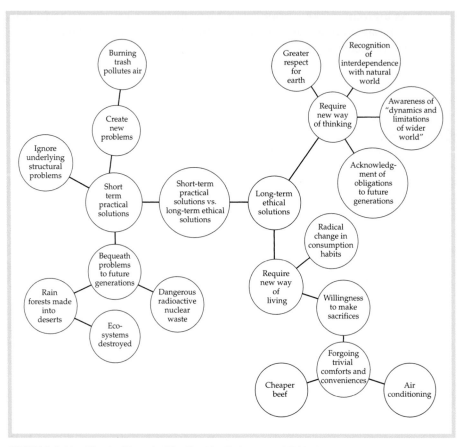

FIGURE 3.2 Idea Map for Weston's "The Need for Environmental Ethics"

your written responses to the text. In any case, creating idea maps is a way to understand a text at a deeper level and thus to evaluate its importance in relation to course content or in relation to a writing project of your own.

DESCRIPTIVE OUTLINING

Making a descriptive outline is a particularly powerful technique for examining how a text is constructed in terms of what discrete parts of it *do* and *say*.* The technique calls for brief statements about the function and content of each paragraph or cluster of related paragraphs in a text. The *does* statement identifies a paragraph's or section's function or purpose, while the *says* statement summarizes

*For our discussion of descriptive outlining, we are indebted to Kenneth Bruffee, *A Short Course in Writing,* 3rd ed. (Boston: Little Brown, 1985), 103.

the content of the same stretch of text. *Does* statements should not repeat the content but focus instead on the purpose or function of the content in relation to the overall argument. Sample *does* statements might be, "offers an anecdote to illustrate previous point," "introduces a new reason in support of main argument," "provides statistical evidence to support the claim," or "summarizes the previous section."

Does and *says* statements help you see how a text works at the micro level, paragraph by paragraph, section by section. This kind of analysis is particularly useful if you intend to write a summary of the passage, and it is a good way to begin an analysis or critique of an author's rhetorical methods. Because of the analytical distance this technique provides, it also serves as a useful aid to revision of your own writing, helping you to see whether the content of your text matches your intentions.

To illustrate, here are *does* and *says* statements for the Weston paragraphs annotated in the previous section:

PARAGRAPH 1

Does: States the problem and illustrates with dramatic examples.

Says: Severe environmental problems are forcing us to realize that there's something profoundly wrong with our relationship to the natural world.

PARAGRAPH 2

Does: Contrasts two approaches to dealing with the problem.

Says: We respond to environmental problems with short-term solutions such as burning trash that then pollutes the air rather than with fundamental changes in our thinking and behavior.

To assist you in writing *does* statements, usually the more difficult statement to write, we offer the following list of verbs that you can use to describe the rhetorical functions performed by a paragraph or section of a text:

VERBS THAT DESCRIBE WHAT TEXTS DO

Each of these verbs might be used to complete a phrase such as "This paragraph [or section] _____."

adds (e.g., adds detail)	continues	evaluates
	contradicts	explains
analyzes	contrasts	expresses
argues	demonstrates	extends
asks	describes	generalizes
cites	details	illustrates
compares	dramatizes	informs
connects	elaborates	interprets

introduces	proposes	states
lists	qualifies	speculates
narrates	questions	suggests
offers	quotes	summarizes
opposes	reasons	supports
predicts	rebuts	synthesizes
presents	reflects	traces
projects	repeats	uses

● **FOR WRITING AND DISCUSSION**

ON YOUR OWN

Make an idea map of Larissa MacFarquhar's essay. Now make a descriptive outline of the essay, paragraph by paragraph. At first you will find both tasks difficult, and you will probably be forced to reread the article slowly, part by part. (That's one of our points—the need to reread.) Soon, however, your puzzlement will evolve into a much clearer understanding of her argument. Trust us. You may find that it is easier to do the descriptive outline first and then the idea map. To help you get started, here is a descriptive outline of the first three paragraphs of MacFarquhar's essay. This outline was written by a student named Jenny, whose work we will follow closely in this and later chapters.

Par. 1:
Does: Introduces subject of article and presents three common beliefs about the subject.
Says: Many believe America is in a state of cultural decline because Americans read less than they used to, because they don't read the "classics," and because new media threaten to make the book obsolete.

Par. 2:
Does: Rebuts all three of these common beliefs with facts.
Says: The claims that Americans read less and know nothing about the classics are false, as is the idea that books are becoming obsolete.

Par. 3:
Does: Continues to rebut opposing claims with facts and figures.
Says: Americans are buying and reading more books than they did in the past.

WITH YOUR CLASSMATES

Working in small groups, compare your idea maps and descriptive outlines. Each group can then draw a revised idea map and put it on the board or an overhead for comparison with those of other groups. ●

The strategies of descriptive outlining can also help you analyze a text's visual features by enabling you to understand more deeply their role and significance in relation to the text's verbal content. To write the *says* statement, you must analyze the visual element on its own terms, describing the message it would convey if it stood alone, without the text. It is important to offer a literal description of what you think the visual image says. For example, the photograph accompanying Peter von Ziegesar's "Brothers" (Chapter 8, p. 186) depicts two brothers sitting side-by-side, riding a subway, both with their arms crossed, one looking into the camera, the other looking away. When you write the *does* statement, you take into consideration the visual element's connection to the verbal text, asking why it is there and how it works in relationship to the text's verbal message. You might start by considering the *enhancing*, *supporting*, and *extending* functions we discussed earlier and compose a *does* statement that specifies one of those functions (for example, "the visual *enhances* by . . .") If you think that the visual functions in more than one important way, you may wish to write more than one *does* statement.

To illustrate how descriptive outlining works with visual elements, we offer two examples, a straightforward information graphic referred to within the text and a more abstract image added by an editor.

First, let's consider the line graph in Stephen Jay Gould's essay "Mickey Mouse Meets Konrad Lorenz" (Chapter 10, p. 270). This visual element maps the evolution of various features of Mickey's face, such as head and eye size, over time. Sample s*ays* and *does* statements for this information graphic follow:

"MICKEY MOUSE MEETS KONRAD LORENZ"(LINE GRAPH)

Does: Adds scientific authority to author's claim by offering quantitative evidence.

Says: Mickey's facial features became more childlike or juvenile over time, more like the face of his young nephew Morty.

Second, let's consider an image we mentioned earlier, the drawing of three embracing figures that accompanies Dowd's "Scarred for Life: Courage Begets Courage" (p. 471). This abstract image is open to interpretation both in terms of its meaning and its relationship to the essay. To descriptively outline this visual element, you would need first to consider what the drawing says, then how it connects with Dowd's essay. Here's one interpretation, clearly not the only one possible:

"SCARRED FOR LIFE: COURAGE BEGETS COURAGE"

Does: Inspires readers by using an image to represent an abstract idea.

Says: Three figures embracing one another rise together.

In Chapter 4, we discuss ways to analyze more fully the rhetorical work performed by visuals.

COMPOSING A SUMMARY

Probably the best way to demonstrate your understanding of what a writer has said is to compose a *summary*—a condensed version of a text's main points written in your own words, conveying the author's main ideas but eliminating all the supporting details. In academic and professional work, summaries take many forms and fulfill a variety of functions. In research papers, you will often present brief summaries of sources to give readers an overview of another writer's perspective or argument, thus bringing another voice into the conversation. Such summaries are particularly useful to set the context for a quotation. If the source is particularly important, you might write a longer summary—perhaps even a full paragraph. For example, many academic writing assignments call for a *review of the literature,* a section in which you summarize how previous researchers have addressed your research problem. In a persuasive "take a stand" paper, you'll likely use summaries to provide evidence that supports your view as well as to present fully and accurately any arguments that oppose your view (after which you will try to counter these arguments). If you are writing a paper in the social or physical sciences, you will often be expected to write an *abstract* of your paper, since it is conventional in the sciences to begin a published work with a highly condensed overview in case busy readers don't have time to read the whole paper. In business and professional life, the equivalent of an abstract is the *executive summary,* a section that appears at the front of any major business report or proposal. Summary writing, in other words, is not simply a strategy for rhetorical reading; it is one of the most frequent types of writing you will do in your academic and professional life.

Depending on their purpose, summaries can vary in length. At times, you may summarize a text in a single sentence as a way of invoking the authority of another voice (probably an expert) to support your points. For example, suppose you wanted to use Weston's approach to ethical issues in a paper exploring whether the Makah people of the Pacific Northwest should be allowed to hunt whales. In part this is an ethical issue pitting the rights of whales against the rights of native peoples to follow their ancient traditions. You might begin a section by summarizing Weston as follows: "In the introduction to *Toward Better Problems,* Anthony Weston argues that complex ethical problems like environmental issues cannot be viewed as simple puzzles to be solved." After this brief summary, which helps you make your point that environmental issues are many-sided without right answers, you would proceed to explain how the puzzle concept has been wrongly applied in this controversy. Perhaps you would later use ideas Weston develops in his chapters "Other Animals" and "The Environment" as frames for presenting an alternative way of understanding the Makah whaling controversy.

At other times, summaries may be one of your main purposes for writing. A typical college assignment might ask you to summarize the arguments of two writers and then analyze the differences in their views. In the summary part of this assignment, your professor is asking you to demonstrate your understanding of what may be quite complex arguments.

COMPOSING A SUMMARY

- ☐ Step 1: Read the text first for its main points.
- ☐ Step 2: Reread carefully and make a descriptive outline.
- ☐ Step 3: Write out the text's thesis or main point. (Suppose you had to summarize the whole argument in one sentence.)
- ☐ Step 4: Identify the text's major divisions or chunks. Each division develops one of the stages needed to make the whole main point. Typically these stages or parts might function as background, review of the conversation, summary of opposing views, or subpoints in support of the thesis.
- ☐ Step 5: Try summarizing each part in one or two sentences.
- ☐ Step 6: Now combine your summaries of the parts into a coherent whole, creating a condensed version of the text's main ideas in your own words.

Writing a fair and accurate summary requires that you identify a text's main ideas, state them in your own words, and omit supporting details. The best first step for writing a summary is to create a descriptive outline of the text, where the *says* statements summarize the main point of each paragraph. (A first draft of your summary could be simply your sequencing of all your *says* statements.) Making a descriptive outline will help you see the text's different sections. Almost all texts—even very short ones—can be divided into a sequence of sections in which groups of paragraphs chunk together to form distinctive parts of the argument or discussion. Identifying these parts or chunks is particularly helpful because you can write a summary of each chunk and then combine the chunks.

To illustrate this process, let's look at the notes Jenny took while following these steps, and then examine her summary of MacFarquhar's essay. (The beginning of Jenny's descriptive outline appears on page 56; these notes begin at Step 3 of the summary procedure.)

JENNY'S PROCESS NOTES FOR WRITING A SUMMARY

Step 3—Text's main idea:

> MacFarquhar disagrees with the popular idea that reading is good and TV watching is bad and asks us to think more deeply about what kinds of reading and what kinds of TV watching might be good.

Steps 4 and 5—Text's major chunks and main points of each chunk:

> Par. 1-2: Introduces debate about literacy. <u>Main point</u>: Common claim that reading is declining is wrong.

> Par. 3-8: Compares old and new reading habits. <u>Main points</u>: Differences between present and past reading habits are exaggerated. Certain genres of reading are very popular today, although not the classics.

Par. 9-14: Discusses two related questions: Does it matter what one reads? Or is reading valuable in and of itself? <u>Main point</u>: It is too simple to say that reading is good and TV watching is bad.

Par. 15: Concludes with new question. <u>Main point</u>: We are asking the wrong question. We should be asking why certain kinds of reading and television matter in terms of cultural health.

CHECKLIST FOR EVALUATING SUMMARIES

Good summaries must be fair, balanced, accurate, and complete. This checklist of questions will help you evaluate drafts of a summary.

☐ Is the summary economical and precise?
☐ Is the summary neutral in its representation of the original author's ideas, omitting the writer's own opinions?
☐ Does the summary reflect the proportionate coverage given various points in the original text?
☐ Are the original author's ideas expressed in the summary writer's own words?
☐ Does the summary use attributive tags (such as "Weston argues") to remind readers whose ideas are being presented?
☐ Does the summary quote sparingly (usually only key ideas or phrases that cannot be said precisely except in the original author's own words)?
☐ Will the summary stand alone as a unified and coherent piece of writing?
☐ Is the original source cited so that readers can locate it?

JENNY'S SUMMARY

In "Who Cares If Johnny Can't Read?" published in the online journal <u>Slate</u> on April 16, 1997, Larissa MacFarquhar informs readers that those who think that Americans no longer read books are mistaken. According to MacFarquhar, Americans are reading more than ever, although they are reading genre fiction and self-help books instead of the classics. This preference for "popular" books leads MacFarquhar to raise two related questions: Does it matter what people read or only if they read? Many persons today, says MacFarquhar, believe that reading in and of itself matters because reading is considered more intellectually stimulating and culturally valuable than watching television. MacFarquhar opposes this view by suggesting that watching television can sometimes be more stimulating and culturally valuable than reading. What matters, she believes, is the quality of what is being watched or read. (par. 16).*

HOW TO STRUCTURE A RHETORICAL PRÉCIS

☐ **Sentence 1:** Name of author, genre, and title of work, date in parentheses; a rhetorically accurate verb (such as "claims," "argues," "asserts," "suggests"); and a THAT clause containing the major assertion or thesis statement in the work.

☐ **Sentence 2:** An explanation of how the author develops and supports the thesis, usually in chronological order.

☐ **Sentence 3:** A statement of the author's apparent purpose, followed by an "in order to" phrase.

☐ **Sentence 4:** A description of the intended audience and/or the relationship the author establishes with the audience.

WRITING A RHETORICAL PRÉCIS

A *rhetorical précis* differs from a summary in that it is a less neutral, more analytical condensation of both the content and method of the original text. ("Précis" means "concise summary.") If you think of a summary as primarily a brief representation of what a text says, then you might think of the rhetorical précis as a brief representation of what a text both says and does. Although less common than summary, a rhetorical précis is a particularly useful way to sum up your understanding of how a text works rhetorically.

Part summary and part analysis, the rhetorical précis is a powerful skill-building exercise often assigned as a highly structured four-sentence paragraph.[†] These sentences provide a condensed statement of a text's main point (the summary part), followed by brief statements about its essential rhetorical elements: the purpose, methods, and intended audience (the analysis part).

JENNY'S RHETORICAL PRÉCIS

In her online article "Who Cares If Johnny Can't Read" (1997), Larissa MacFarquhar asserts that Americans are reading more than ever despite claims to the contrary and that it is time to reconsider why we value reading so much, especially certain kinds of "high culture" reading. MacFarquhar supports her claims about American reading habits with facts and statistics that compare past and present reading practices, and she

*Because MacFarquhar's essay was published online, page references for quotes cannot be provided. Jenny is following her teacher's request for in-text references to the paragraph numbers in the reprint at the end of this chapter.

†For the rhetorical précis assignment, we are indebted to Margaret K. Woodworth, "The Rhetorical Précis," *Rhetoric Review* 7 (1988): 156–65.

challenges common assumptions by raising questions about reading's intrinsic value. Her purpose is to dispel certain myths about reading in order to raise new and more important questions about the value of reading and other media in our culture. She seems to have a young, hip, somewhat irreverent audience in mind because her tone is sarcastic, and she suggests that the ideas she opposes are old-fashioned positions.

Summary

This chapter focused on the nuts and bolts of preparing to read and listening to a text.

- To read effectively, you need to read with pen in hand, interacting with texts by making annotations as you read.
- Before reading, practice preparatory strategies such as identifying your purpose for reading, recalling background knowledge, reconstructing the text's rhetorical context, using visual features to plan and predict, and spot reading.
- While reading, note organizational signals, mark unfamiliar terms and references, make connections between the visual and the verbal, and annotate the text with marginal comments and queries.
- To deepen your understanding of a text, reread and employ such strategies as the following: idea mapping, writing descriptive outlines, summarizing, and writing a rhetorical précis.

In the next chapter we show how rhetorical readers "speak back" to a text through questioning.

● A BRIEF WRITING PROJECT

Your instructor will identify a text for you to read carefully and annotate using the rhetorical reading strategies suggested in this chapter. Then submit to your instructor the following three pieces of writing:
1. A descriptive outline of the text
2. A 150- to 200-word summary of the text
3. A four-sentence rhetorical précis of the text ●

Larissa MacFarquhar

Who Cares If Johnny Can't Read?
The Value of Books Is Overstated.

This essay was published on April 16, 1997, in *Slate,* Microsoft's online magazine about politics and culture. Larissa MacFarquhar, a widely published book reviewer and magazine writer, was then a frequent contributor to that magazine as well as a contributing editor of *Lingua Franca,* a magazine about higher education, and an advisory editor at the *Paris Review,* a prestigious literary journal. The title of the following selection alludes to Rudolf Flesch's 1955 *Why Johnny Can't Read,* one of the first books to declare a national literacy crisis. To find out more about *Slate* and read other articles by MacFarquhar, go to its Website at http://slate.msn.com.

———— ● ————

Among the truisms that make up the eschatology of American cultural decline, 1 one of the most banal is the assumption that Americans don't read. Once, the story goes—in the 1950s, say—we read much more than we do now, and read the good stuff, the classics. Now, we don't care about reading anymore, we're barely literate, and television and computers are rendering books obsolete.

None of this is true. We read much more now than we did in the '50s. In 1957, 2 17 percent of people surveyed in a Gallup poll said they were currently reading a book; in 1990, over twice as many did. In 1953, 40 percent of people polled by Gallup could name the author of *Huckleberry Finn*; in 1990, 51 percent could. In 1950, 8,600 new titles were published; in 1981, almost five times as many.

In fact, Americans are buying more books now than ever before—over 2 bil- 3 lion in 1992. Between the early '70s and the early '80s, the number of bookstores in this country nearly doubled—and that was before the Barnes & Noble superstore and Amazon.com. People aren't just buying books as status objects, either. A 1992 survey found that the average adult American reads 11.2 books per year, which means that the country as a whole reads about 2 billion—the number bought. There are more than 250,000 reading groups in the country at the moment, which means that something like 2 million people regularly read books and meet to discuss them.

In his book about Jewish immigrants in America at the turn of the century, 4 *World of Our Fathers,* Irving Howe describes a time that sounds impossibly antiquated, when minimally educated laborers extended their workdays to attend lectures and language classes. Howe quotes an immigrant worker remembering his adolescence in Russia: "How can I describe to you . . . the excitement we shared when we would discuss Dostoyevsky? . . . Here in America young people can choose from movies and music and art and dancing and God alone knows what. But we—all we had was books, and not so many of them, either."

5 Hearing so much about the philistinism of Americans, we think such sentiments fossils of a bygone age. But they're not. People still write like that about books. Of course, most aren't reading Dostoyevsky. The authors who attract thousands and thousands of readers who read everything they write and send letters to them begging for more seem to be the authors of genre fiction—romances, science fiction, and mysteries.

6 Romance readers are especially devoted. The average romance reader spends $1,200 a year on books, and often comes to think of her favorite authors as close friends. Romance writer Debbie Macomber, for instance, gets thousands of letters a year, and when her daughter had a baby, readers sent her a baby blanket and a homemade Christmas stocking with the baby's name embroidered on it. It's writers like Macomber who account for the book boom. In 1994, a full 50 percent of books purchased fell into the category of "popular fiction." (Business and self-help books were the next biggest group at 12 percent, followed by "cooking/crafts" at 11 percent, "religion" at 7 percent, and "art/literature/poetry" at 5 percent.)

7 These reading habits are not new. Genre fiction and self-help books have constituted the bulk of the American book market for at least 200 years. A survey conducted in 1930 found that the No. 1 topic people wanted to read about was personal hygiene. And you just have to glance through a list of best sellers through the ages to realize how little we've changed: *Daily Strength for Daily Needs* (1895); *Think and Grow Rich* (1937); *Games People Play: The Psychology of Human Relationships* (1964); *Harlow: An Intimate Biography* (1964).

8 Romance writers tend to be clear-eyed about what it is they're doing. They don't think they're creating subversive feminine versions of Proust. They're producing mass-market entertainment that appeals to its consumers for much the same reason as McDonald's and Burger King appeal to theirs: It's easy, it makes you feel good, and it's the same every time. The point of a romance novel is not to dazzle its reader with originality, but to stimulate predictable emotions by means of familiar cultural symbols. As romance writer Kathleen Gilles Seidel puts it: "My reader comes to my book when she is tired. . . . Reading may be the only way she knows how to relax. If I am able to give her a few delicious, relaxing hours, that is a noble enough purpose for me."

9 But then, if romance novels are just another way to relax, what, if anything, makes them different from movies or beer? Why should the activity "reading romances" be grouped together with "reading philosophy" rather than with "going for a massage"? The Center for the Book in the Library of Congress spends lots of time and money coming up with slogans like "Books Make a Difference." But is the mere fact of reading something—*anything*—a cultural achievement worth celebrating?

10 We haven't always thought so. When the novel first became popular in America in the latter half of the 18th century, it was denounced as a sapper of brain cells and a threat to high culture in much the same way that television is denounced today. In the 1940s, Edmund Wilson declared that "detective stories [are] simply a kind of vice that, for silliness and minor harmfulness, ranks somewhere between smoking and crossword puzzles." You almost never hear this kind of talk anymore in discussions of American reading habits: *Not all reading is worth doing. Some books are just a waste of time.*

As fears of cultural apocalypse have been transferred away from novels 11
onto a series of high-tech successors (radio, movies, television, and now com-
puters), books have acquired a reputation for educational and even moral wor-
thiness. Books are special: You can send them through the mail for lower rates,
and there are no customs duties imposed on books imported into this country.
There have, of course, been endless culture wars fought over what kind of books
should be read in school, but in discussions of adult reading habits these dis-
tinctions tend to evaporate.

The sentimentalization of books gets especially ripe when reading is com- 12
pared with its supposed rivals: television and cyberspace. Valorization of read-
ing over television, for instance, is often based on the vague and groundless no-
tion that reading is somehow "active" and television "passive." Why it is that the
imaginative work done by a reader is more strenuous or worthwhile than that
done by a viewer—or why watching television is more passive than, say, watch-
ing a play—is never explained. Sven Birkerts' maudlin 1994 paean to books, *The
Gutenberg Elegies: The Fate of Reading in an Electronic Age,* is a classic example of
this genre. *Time* art critic Robert Hughes made a similarly sentimental and mys-
terious argument recently in the *New York Review of Books:*

> Reading is a collaborative act, in which your imagination goes halfway to meet
> the author's; you visualize the book as you read it, you participate in making
> up the characters and rounding them out. The effort of bringing something
> vivid out of the neutral array of black print is quite different, and in my experi-
> ence far better for the imagination, than passive submission to the bright icons
> of television, which come complete and overwhelming, and tend to burn out
> the tender wiring of a child's imagination because they allow no re-working.

I cannot remember ever visualizing a book's characters, but everyone who 13
writes about reading seems to do this, so perhaps I'm in the minority. Still, you
could equally well say that you participate in making up TV characters because
you have to imagine what they're thinking, where in a novel, you're often pro-
vided with this information.

Another reason why books are supposed to be better than television is that 14
books are quirky and individualistic and real, whereas television is mass-pro-
duced corporate schlock. But of course popular books can be, and usually are,
every bit as formulaic and "corporatized" as television. The best books might be
better than the best television, but further down the pile the difference gets
murkier. Most of the time the choice between books and television is not be-
tween Virgil and Geraldo but between *The Celestine Prophecy* and *Roseanne.* Who
wouldn't pick *Roseanne?*

If the fertility of our culture is what we're concerned about, then 15
McLuhanesque musing on the intrinsic nature of reading (as if it had any such
thing) is beside the point. Reading *per se* is not the issue. The point is to figure
out why certain kinds of reading and certain kinds of television might matter in
the first place.

Questioning a Text

A good question is never answered. It is not a bolt to be tightened into place but a seed to be planted and to bear more seed toward the hope of greening the landscape of idea.

—John Ciardi

Whereas the previous chapter focused on listening to a text *with the grain* in order to understand it as fully as possible, in this chapter we focus on questioning a text, which involves reading it analytically and skeptically, *against the grain*. If you think of listening to a text as the author's turn in a conversation, then you might think of questioning the text as your opportunity to respond to the text by interrogating it, raising points of agreement and disagreement, thinking critically about its argument and methods, and then talking back.

What It Means to Question a Text

Learning to question a text is central to your academic success in college. Your professors will ask you to engage with texts in ways that you may not be used to. They expect you to do more than just "bank" the knowledge you glean from reading; they expect you to use this knowledge to do various kinds of intellectual work—to offer your own interpretations or evaluations, to launch a research project of your own, to synthesize the ideas among readings and draw independent conclusions.

However, questioning does not necessarily mean just fault-finding, and it certainly doesn't mean dismissing an author's ideas wholesale. Rather, it entails carefully interrogating a text's claims and evidence and its subtle forms of persuasion so that you can make sound judgments and offer thoughtful responses.

Your job in critiquing a text is to be "critical." However, the term *critical* means "characterized by careful and exact evaluation and judgment," not simply by "disagreement" or "harsh judgment." In questioning a text, you bring your critical faculties as well as your experience, knowledge, and opinion to bear on it, but you do so in a way that treats the author's ideas fairly and makes judgments that can be supported by textual evidence.

This chapter offers you a repertoire of useful strategies to help you question a text and explore your responses to it. At the end of the chapter, we show you an analytical paper that student writer Jenny (whose work you followed in Chapter 3) wrote in response to an assignment calling for a rhetorical analysis of Larissa MacFarquhar's article, "Who Cares If Johnny Can't Read?" In that paper, Jenny uses the questioning strategies described in this chapter to analyze MacFarquhar's argument and methods. Our purpose is to demonstrate how such strategies can enable you to write critical analyses valued by college professors.

Strategies for Questioning a Text

The six questioning strategies in this section offer powerful ways to question a text's argument, assumptions, and methods by examining a writer's credibility, appeals to reason, strategies for engaging readers, language, and any visual elements, as well as the worldview or ideology that informs the text. The first three strategies examine an author's use of the three classical rhetorical appeals identified by Aristotle:

- *Ethos:* the persuasive power of the author's credibility or character
- *Logos:* the persuasive power of the author's reasons, evidence, and logic
- *Pathos:* the persuasive power of the author's appeal to the interests, emotions, and imagination of the audience

Although these three appeals interconnect and sometimes overlap—for example, a writer may use a touching anecdote both to establish credibility as an empathic person (*ethos*) and to play on the reader's emotions (*pathos*)—we introduce them separately to emphasize their distinct functions as means of persuasion. The last three questioning strategies involve vehicles through which appeals are made, implicitly and explicitly:

- *Language:* the words authors use to create a persona, connect with the audience, and represent their ideas as reasonable and compelling
- *Visual elements:* the drawings, photographs, graphs, and other images that are used to enhance, support, and extend rhetorical appeals
- *Ideology:* the worldview or set of values and beliefs invoked by a text

EXAMINING A WRITER'S CREDIBILITY

To change readers' minds about something, writers must make themselves credible by creating an image of themselves that will gain their readers' confidence. In most cases, writers want to project themselves as knowledgeable, fair-minded, and trustworthy. To examine a writer's credibility, ask yourself, "Do I find this author believable and trustworthy? Why or why not?" Experienced readers always try to find out as much as possible about an author's background, interests, political leanings, and general worldview. Sometimes they have independent knowledge of the writer, either because the writer is well known or because the reading has a headnote or footnote describing the writer's credentials. Often, though, readers must discern the writer's personality and views from the text itself by examining content, tone, word choice, figurative language, organization, and other cues that help create an image of the writer in the reader's mind. Explicit questions to ask might include these: Does this writer seem knowledgeable? What does the writer like and dislike? What are this writer's biases and values? What seems to be the writer's mood? (Is he or she angry? Questioning? Meditative? Upset? Jovial?) What is the writer's approach to the topic? (Formal or informal? Logical or emotional? Scientific or personal?) What would it be like to spend time in this writer's company?

● **FOR WRITING AND DISCUSSION**

ON YOUR OWN

1. To help you consider an author's image and credibility, try these activities the next time you are assigned a reading. Describe in words your image of this author as a person (or draw a sketch of this person). Then try to figure out what cues in the text produced this image for you. Finally, consider how this image of the writer leads you to ask more questions about the text. You might ask, for example, Why is this writer angry? Why does this writer use emotionally laden anecdotes rather than statistics to support his or her case? What is this writer afraid of?

2. Try these activities with Larissa MacFarquhar's article at the end of Chapter 3. What kind of an image does she create for herself in this text? How would you describe her in words or portray her in a drawing? Take a few minutes to find and jot down the cues in the text that create this image for you.

WITH YOUR CLASSMATES

Compare your impressions of MacFarquhar with those of your classmates. Do any contradictory traits come up? That is, do some people in the group interpret the textual cues differently? Some people, for example, might see a comment as "forthright" and "frank" while others might see it as "rude." What aspects of her character (as represented in the text) do you as a group agree on? What aspects do you disagree about? ●

EXAMINING A WRITER'S APPEALS TO REASON

Perhaps the most direct way that writers try to persuade readers is through logic or reason. To convince readers that their perspective is reasonable, skilled writers work to anticipate what their intended readers already believe and then use those beliefs as a bridge to the writer's way of thinking. They support their claims through a combination of reasons and evidence.

For example, imagine a writer arguing for stricter gun control laws. This writer wants to root his argument in a belief or value that he and his readers already share, so he focuses on concerns for the safety of schoolchildren. The line of reasoning might go something like this: Because the ready availability of guns makes children no longer safe at school, we must pass strict gun control laws to limit access to guns. Of course, readers may or may not go along with this argument. Some readers, although they share the writer's concern for the safety of schoolchildren, might disagree at several points with the writer's logic: Is the availability of guns the main cause of gun violence at schools or are there other more compelling causes? Will stricter gun control laws really limit the availability of guns? If this same writer wished to use evidence to strengthen this argument, he might use statistics showing a correlation between the rise in the availability of guns and the rise in gun violence in schools. Here, the writer would be operating on the assumption that readers believe in facts and can be persuaded by these statistics that increased gun violence in schools is linked to the availability of firearms.

Experienced readers are alert to the logical strategies used by authors, and they have learned not to take what may appear as a "reasonable" argument at face value. In other words, they have learned to question or test this reasoning before assenting to the position the author wants them to take. To examine a writer's reasoning, you need to be able to identify and examine carefully the basic elements of an argument—claims, reasons, evidence, and assumptions. The following questions will help you examine a writer's reasoning:

- What perspective or position does the writer want me to take toward the topic?
- Do the writer's claims, reasons, and evidence convince me to take this perspective or position?
- Do I share the assumptions, stated or unstated, that authorize the writer's reasoning and connect the evidence to the claim?

In Chapter 12, Taking a Stand, we discuss logical strategies in relation to the specific case of texts whose main aim is persuasion. Here we briefly explain the basic elements of argument as they generally apply to writers' use of reasoning for a range of rhetorical purposes.

Claims

The key points that a writer wants readers to accept are referred to as *claims*. For example, Anthony Weston's initial claim in the passage on page 51 is this: "We

are beginning to struggle with the intimation that something is seriously wrong with our relation to the natural world." Or take another example. Early in her essay on page 63, MacFarquhar claims that "None of this [a series of beliefs about reading] is true." Once you have identified various claims in a text, then you can raise questions about them, especially about their wording and scope. Is the meaning of key words in the claim clear? Can particular words be interpreted in more than one way? Is the claim overstated? For example, one might ask of Weston's claim, "To whom do 'we' and 'our' refer?" "What evidence is there that 'we' are beginning to struggle with this awareness?" "What is wrong with our relation to the natural world? 'Wrong' in what sense or according to what ethical standards?" "How serious is this problem?" Similarly, one could ask of MacFarquhar, "Are none of these beliefs true in any sense?"

Reasons

Reasons are subclaims that writers use to support a main claim. A reason can usually be linked to a claim with the subordinate conjunction "because." Consider the gun control argument mentioned earlier, which we can now restate as a claim with reason: "We must pass gun control laws that limit access to guns [claim] because doing so will make children safer at school [reason]." This argument has initial appeal because it ties into the audience's belief that it is good to make children safe at school, but as we have discussed earlier, the causal links in the argument are open to question. To take another example, Weston offers readers the following reasons for accepting his approach to environmental problems:

> We are beginning to struggle with the intimation that something is seriously wrong with our relation to the natural world [claim]
>
> - because the danger signs of environmental damage are occurring all around us [reason]
> - because short-term solutions have caused other environmental problems that will have dire consequences for future generations [reason]

If readers are to accept the first reason, they must agree that there are danger signs all around us and that these signs are serious enough to call for action. However, some readers may believe that environmentalists exaggerate the dangers posed by environmental problems. If readers are to accept the second reason, they must believe not only Weston's claims that short-term solutions don't work but also his predictions about the serious consequences for future generations.

As these examples illustrate, once you've identified the reasons that the author offers for various claims, then you can proceed to examine the adequacy of these reasons. Do they really support the claim? Do they tie into values, assumptions, and beliefs that the audience shares?

Evidence

The facts, examples, statistics, personal experience, and expert testimony that an author offers to support his or her view of the topic are referred to as *evidence*. To examine the author's use of evidence, consider whether the evidence is reli-

able, timely, and adequate to make the case. Or ask whether there is more than one way the evidence can be interpreted. When MacFarquhar argues that none of the "truisms" many people believe about reading are true, she relies heavily on evidence. She offers facts, statistics, expert testimony, example, and so forth throughout the essay mainly to refute positions with which she disagrees. Readers skeptical of MacFarquhar's argument might question her interpretations of some facts and statistics: Couldn't people just be saying that they are reading a book because they're embarrassed to admit they're not? Couldn't people have learned the name of the author of *Huckleberry Finn* from television and not from reading? Similarly, in our gun control example, skeptics could question whether the statistical correlation between rising availability of guns and rising gun violence in schools is in fact a causal relationship. The fact that A and B happened at the same time does not mean that A caused B. Or readers might question Weston's use of the destruction of South American rain forests as an example of an environmental "danger sign" and ask for clear scientific evidence for his claim that this land will become desert within ten years.

Assumptions

In an argument, the often unstated values or beliefs that the writer expects readers to accept without question are referred to as *assumptions*. You can interrogate an argument by casting doubt on those assumptions. For example, when Weston argues that fundamental changes in our relationship to the environment are needed to address environmental problems, he assumes that such changes will make a difference and that the value of improving the environment outweighs potential negative effects on the economy. Some readers may question these assumptions by arguing that policies to improve the environment won't actually work or that the negative effects will outweigh the benefits. Similarly, part of the gun control argument is based on an assumption that gun control legislation will in fact limit the availability of guns. You can question this assumption by pointing to the existence of black markets.

● **FOR WRITING AND DISCUSSION**

ON YOUR OWN

Find a newspaper or magazine opinion piece (an editorial or an individual op-ed piece), and identify its claims, reasons, evidence, and assumptions. You may find that some of these elements are missing or only implied. Then analyze the writer's reasoning in the opinion piece by answering the three questions we listed on page 69 as fundamental to examining a writer's reasoning.

WITH YOUR CLASSMATES

1. Briefly summarize your opinion piece and your analysis of it with a small group of classmates.
2. After each group member has presented his or her editorial, try to decide which of the editorials involves the most persuasive reasoning and why.

Present the results of your discussion to the rest of the class. If there is disagreement about which piece involves the best reasoning, then present more than one to the class, explaining the differences of opinion. ●

EXAMINING A WRITER'S STRATEGIES FOR ENGAGING READERS

The third of the classical rhetorical appeals is to an audience's interests and emotions—the process of engaging readers. How does a writer hook and keep your interest? How does a writer make you care about the subject? How does a writer tweak your emotions or connect an argument with ideas or beliefs that you value?

Rhetoricians have identified four basic ways that writers engage readers at an emotional or imaginative level by influencing the reader to identify (1) with the writer, (2) with the topic or issue, (3) with a certain group of fellow readers, or (4) with certain interests, values, beliefs, and emotions. Let's look at each in turn.

In the first approach, writers wanting readers to identify with them might use an informal conversational tone to make a reader feel like the writer's buddy. Writers wanting to inspire respect and admiration might adopt a formal scholarly tone, choose intellectual words, or avoid "I" altogether by using the passive voice—"it was discovered that. . . ." In the second approach, writers wanting readers to identify with the topic or issue might explain the importance of the issue or try to engage readers' emotions. In urging community action against homelessness, for example, an author might present a wrenching anecdote about a homeless child. Other methods might be the use of vivid details, striking facts, emotion-laden terms and examples, or analogies that explain the unfamiliar in terms of the familiar. In the third approach, writers try to get readers to identify with a certain in-group of people—fellow environmentalists or feminists or Republicans or even fellow intellectuals. Some writers seek to engage readers by creating a role for the reader to play in the text. For example, Weston invites readers to think of themselves as serious and intelligent, interested in tough ethical issues. In the fourth approach, writers appeal to readers' interests by getting them to identify with certain values and beliefs. For example, a politician arguing for changes in the way Social Security is funded might appeal to voters' desires to invest in high-yield stocks. If workers could pay lower Social Security taxes, they could invest the difference in the stock market. If you are aware of how all of the above appeals work, you will be able to distance yourself from arguments in order to examine them critically.

● FOR WRITING AND DISCUSSION

Consider all of the ways in which Larissa MacFarquhar tries to engage readers of her text. What kind of a relationship does she try to establish with readers? How does she try to make you care about her topic? How does she try to engage and keep your interest? What interests and values does she assume

her audience shares? Do you consider yourself part of her intended audience? Why or why not? ●

EXAMINING A WRITER'S LANGUAGE

Besides looking at a text's classical appeals, you can examine a text rhetorically by paying careful attention to its language and style. Diction (which includes tone, word choice, and level of formality), figurative language, sentence structure and length, and even punctuation are all techniques through which a writer tries to influence the reader's view of a subject. Consider, for example, the connotation of words. It makes a difference whether a writer calls a person "decisive" rather than "bossy," or an act "bold" rather than "rash." Words like "decisive" and "rash" are not facts; rather they present the writer's interpretation of a phenomenon. You can question a text by recognizing how the writer makes interpretive words seem like facts.

At times, you might overlook features of the writer's language because they seem natural rather than chosen. You probably seldom stop to think about the significance of, say, the use of italics or a series of short sentences or a particular metaphor. Readers rarely ask what's gained or lost by a writer saying something one way rather than another—for example, calling clear-cut logging in the Northwest a "rape" rather than a "timber extraction process."

Take, for example, Weston's use of analogy in the first paragraph of the passage from *Toward Better Problems* (p. 51). He compares our "intimation that something is seriously wrong with our relation to the natural world" to the situation of "suspect[ing] cancer but not wanting to know." Since no single word probably evokes more fear than the word "cancer," Weston is able to connect a fear with which readers can readily identify with a less common one, the fear that our attitude toward nature is causing catastrophic environmental damage that we or our descendants will pay for. Further, this analogy implies a whole range of associations that Weston need not spell out. In both cases, we "do not want to know" because knowing will force us to face eventual suffering and loss; it will make us feel hopeless and helpless. Consequently, we repress the knowledge, hoping the problem will magically go away. Or consider the last two sentences in the first paragraph of MacFarquhar's essay: "Once, the story goes—in the 1950s, say—we read much more than we do now, and read the good stuff, the classics. Now, we don't care about reading anymore, we're barely literate, and television and computers are rendering books obsolete." Try reading those sentences aloud, paying particular attention to the punctuation. It's hard to say them out loud in anything but a mock serious, singsong, sarcastic tone of voice. Her tone tells us that these are not her own sentiments but rather sentiments she is ascribing to others. To signal her distance from and disdain for these views, she makes the claims sound vague and baseless ("once . . . in the 1950s, say"), exaggerated ("we're barely literate"), and trite (classics are "the good stuff"). By contrast, the voice in the next paragraph is very businesslike—the sentences are short and clipped; the information is presented in listlike fashion. We know it is

this voice we are supposed to listen to. Through language that creates particular tones of voice, MacFarquhar tries to get readers to think about the subject—commonplace beliefs about reading—in the same way she does.

Experienced readers have developed antennae for recognizing these subtle uses of language to manipulate responses. One way to develop this sensitivity is to ask why a writer made certain choices rather than others. For example, if you were examining paragraph 9 of MacFarquhar's essay, you might note her striking comparison of reading romance novels to drinking beer and getting a massage. What effect does she achieve through these specific comparisons? What would be different if she'd compared reading romances to going dancing or floating down a river?

● FOR WRITING AND DISCUSSION

BACKGROUND

What follows below is the introduction to an article by freelance writer Bruce Barcott entitled "Blow-Up," which appeared in the February 1999 issue of *Outside,* a magazine described by its editors as "driven by the search for innovative ways to connect people to the world outdoors." After you have read the introduction, consider the following questions: What do you think is the author's persuasive intention in the whole article? How does the use of language in this introduction help contribute to the author's persuasive intentions? Pay attention to word choice, tone, sentence patterns, punctuation, figurative language, levels of diction, and other language features.

ON YOUR OWN

Write out your own analysis of the use of language in this passage.

WITH YOUR CLASSMATES

Share your analyses. See if you can reach consensus on the ways that this writer uses language for persuasive intent.

Introduction to "Blow-Up"

1 By God we built some dams!

2 We backed up the Kennebec in Maine and the Neuse in North Carolina and a hundred creeks and streams that once ran free but don't anymore. We stopped the Colorado with the Hoover, high as 35 houses, and because it pleased us we kept damming and diverting the Colorado until the river no longer reached the sea. We dammed our way out of the Great Depression with the Columbia's Grand Coulee, a dam so immense you had to borrow another fellow's mind because yours alone wasn't big enough to wrap around it. The Coulee concrete was not even hardened by the time we finished building a bigger one still, cleaving the Missouri with Fort Peck Dam, a structure second only to the Great Wall of China,

a jaw-dropper so outsized they put it on the cover of the first issue of *Life*, and wasn't that a hell of a thing? We turned the Tennessee, the Colorado, the Columbia, and the Snake from continental arteries into still bathtubs. We dammed the Clearwater, the Boise, the Santiam, the Deschutes, the Skagit, the Willamette, and the McKenzie. We dammed the North Platte and the North Yuba, the South Platte and the South Yuba. We dammed the Blue, the Green, and the White as well. We dammed Basher Kill and Schuylkill; we dammed Salt River and we dammed Sugar Creek. We dammed Crystal River and Muddy Creek, the Little River and the Rio Grande. We dammed the Minnewawa and the Minnesota, and we dammed the Kalamazoo. We dammed the Swift and we dammed the Dead.

3 One day we looked up and saw 75,000 dams impounding more than half a million miles of river. We looked down and saw rivers scrubbed free of salmon and sturgeon and shad. Cold rivers ran warm, warm rivers ran cold, and fertile muddy banks turned barren.

4 And that's when we stopped talking about dams as instruments of holy progress and started talking about blowing them out of the water. ●

EXAMINING A TEXT'S USE OF VISUAL ELEMENTS

Besides language, another vehicle for rhetorical appeals is the use of visual elements, which merit close attention when you analyze any text. The common belief that pictures are more truthful and compelling than words can make visual images powerful persuasive devices. Moreover, images can shape perceptions, emotions, and values without the reader's conscious awareness, thus making their influence particularly seductive. Questioning the ways in which visual elements make a text more persuasive allows you to step back and avoid the automatic consent implied in the "seeing is believing" cliché.

In Chapter 3, we discussed how consideration of a text's visual elements helps you understand a text's message more fully. Here we discuss how analysis of a text's visual elements helps you recognize and question those elements' rhetorical effects. To analyze the ways in which visual elements work, you need to consider a visual's rhetorical appeals (how the visual works) and its persuasive function in relation to the verbal text (why it is there). We suggest that you begin your analysis of visual elements with the following questions:

- How does the visual element relate to the writer's overall point or argument? Is this relationship explicit or implied?
- How important is this visual element to the author's argument?
- What kinds of rhetorical appeals does the visual element employ? How does it work rhetorically to influence the intended audience?

Visual Elements as Ethical Appeals

Visual elements frequently enhance a writer's credibility and authority. Thus, an article by a yoga teacher includes a picture of him in an advanced yoga position; an article by a scientist reporting a new scientific breakthrough includes a picture of the scientist working in her lab. Similarly, newspapers and magazines include head shots of syndicated columnists whom they regularly publish. These usually flattering photographs may offer an image of the writer as smiling and approachable or, perhaps, as intellectual, sophisticated, or down to earth. Head shots also offer information about the author's age, ethnicity, and gender (if not evident from the writer's name), and this information is likely to affect our reading of the text, sometimes without our being aware of it. When the subject is affirmative action or racial profiling, for example, the race and perhaps gender of the author are likely to affect readers' perceptions of his or her credibility on the issue.

Of course, these photographs can be misleading. Many writers use the same picture for years, thus preserving the image and credibility of a younger person. The late Ann Landers' column still pictured her as a woman in her mid-forties when she was well into her seventies. Consider the difference it would have made if readers pictured the advice she offered as coming from an elderly, white-haired woman. In short, rhetorical readers need to question even these apparently straightforward visual appeals based on a writer's *ethos* as well as their implications. For example, the yoga teacher pictured in an advanced pose may be an expert practitioner of yoga, but does it follow logically, as the picture (and article) implies, that he is a good teacher of yoga?

The key questions to ask in analyzing how visual elements establish a writer's *ethos* are the following:

- How does the visual element contribute to the writer's image, credibility, and/or authority?
- How does the image of the author created by the visual element influence your reading of the text?
- To what extent does the visual image fit the image created by the text?

Visual Elements as Logical Appeals

Drawing on the idea that "seeing is believing," writers often support their claims with visual evidence. Thus, the most common use of visual elements as logical appeals is to supply evidence to verify or support a writer's argument. Whether the visual element is a pie chart, a table of data, or a picture, these elements appear to add concreteness and factuality to an author's claims.

In Stephen Jay Gould's argument that Mickey Mouse's image has become more childlike over the years, for example, the sample pictures of Mickey at various stages of his career (p. 268) provide evidence that is essential to Gould's claim. In other cases, visual elements supplement an author's claims.

Indeed, the genre conventions of scholarly journals dictate that authors provide information graphics to help readers understand and evaluate the strength of the research. For example, in "Sleep Schedules and Daytime Functioning" (Chapter 10), tables and charts clarify and reinforce the findings discussed in the text. (See the introduction to Chapter 10 for a fuller discussion of information graphics.)

Visual elements play an even more central role in academic and journalistic writing that analyzes and critiques them. For example, in "The Elián Pictures" (Chapter 11, pp. 348–353) William Saletan questions the apparent truth of two widely circulated news photos that were part of the media frenzy surrounding the Elián Gonzáles case in the spring of 2000. Elián, as you may recall, is a young Cuban boy whose rescue off the coast of Miami, Florida, created a custody battle between his father, who wished to claim him and take him back to Cuba, and his late mother's Miami family, who wished to keep him in the United States. The opposing sides used the two photographs—one of Elián being forcibly removed from the Miami relatives' home by federal agents, the other of Elián in the arms of his father—to rally support. According to Saletan, however, both pictures need to be examined closely for what they "disguise" and "omit" (p. 348). He contends that the meaning of pictures is seldom singular or transparent. Rather, he says, pictures "can project illusions and take events out of context" (p. 348). In this case, the success of Saletan's argument depends on convincing us not of the veracity of his visual evidence, the two photographs, but of their unreliability in representing the whole truth about what happened. In short, Saletan's analysis suggests, a healthy antidote for the cliché "seeing is believing" is the cliché "appearances can be deceiving." The following questions will help you analyze how visuals interact with logical appeals:

- Does the writer make explicit the relationship between the visual element and his or her argument?
- How would you define this relationship? Is it the focal point of the argument? Or does it provide additional support or evidence for the author's claims?
- Is the visual evidence reliable, timely, and adequate to make the case?
- Does the visual itself make a kind of argument, and if so, is it convincing?

● FOR WRITING AND DISCUSSION

Some arguments are made through a combination of visual and verbal elements, such as the argument implied by the introductory page of an *Us Weekly* cover story featuring Christina Aguilera (Figure 4.1). Try translating this page into a paragraph-long written argument. To do so, you will need to identify the central claims made by the page's combination of verbal and visual elements, the evidence used in support of those claims, and the assumptions that connect the claims and evidence. After you have composed a written version of this visual argument, apply the questioning strate-

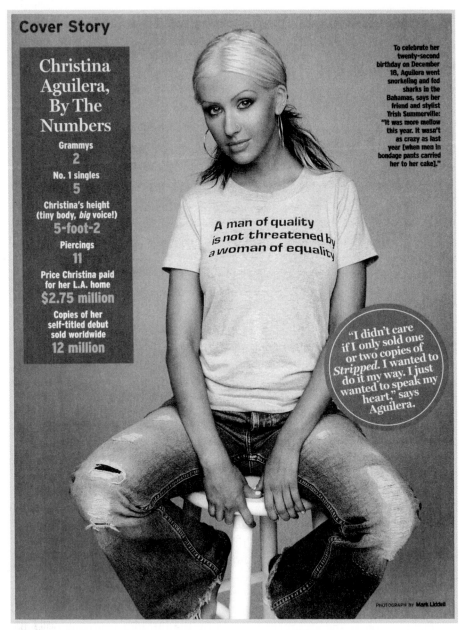

Cover Story

Christina Aguilera, By The Numbers

Grammys
2

No. 1 singles
5

Christina's height
(tiny body, *big* voice!)
5-foot-2

Piercings
11

Price Christina paid
for her L.A. home
$2.75 million

Copies of her
self-titled debut
sold worldwide
12 million

To celebrate her twenty-second birthday on December 18, Aguilera went snorkeling and fed sharks in the Bahamas, says her friend and stylist Trish Summerville: "It was more mellow this year. It wasn't as crazy as last year [when men in bondage pants carried her to her cake]."

A man of quality is not threatened by a woman of equality

"I didn't care if I only sold one or two copies of *Stripped*. I wanted to do it my way. I just wanted to speak my heart," says Aguilera.

PHOTOGRAPH BY Mark Liddell

FIGURE 4.1 First Page of an Article About Christina Aguilera in *Us Weekly*

gies suggested throughout this chapter to analyze and assess the argument's persuasiveness. You might want to compare your analysis to Anna Weiss's argument, "Sex and Equality: Christina Aguilera" (Chapter 12), which is based on Weiss's reading of Aguilera's T-shirt. •

Visual Elements as Audience Appeals

Probably the most powerful rhetorical use of visual elements is to appeal to an audience's emotions, values, and interests. Three common and often overlapping ways in which visual elements create audience appeals are by setting a tone, fostering identification, and evoking emotions and values.

To see how graphic elements can set a tone or context that frames a reader's response, consider the image accompanying Laurence Zuckerman's article "Words Go Right to the Brain, but Can They Stir the Heart?": a photograph of the Rev. Martin Luther King, Jr., delivering his famous "I Have a Dream" speech set against a PowerPoint slide with a bulleted list of phrases about dreams and freedom (p. 411). This eye-catching incongruity probably drew many busy readers to the article when it first appeared in the *New York Times*. Those readers would discover that even though Zuckerman's subject is PowerPoint, not King (whom he doesn't mention), the page editor's choice of visuals had prepared them well for the gist of Zuckerman's negative evaluation of PowerPoint. The illustration is only partially connected with the article's subject matter, but it does provide a visual version of the argument, one likely to draw a response from even a casual reader. Since photographs and drawings are frequently the first thing we notice about a text, it is important to pause and consider how they frame our attitude toward the subject both before and after reading.

Visual elements can also create identification with a person, situation, or topic. The photograph of Christina Aguilera in Figure 4.1, for example, invites young readers of *Us Weekly* to identify with Aguilera as well as with the message on her T-shirt. This identification, in turn, encourages those casually flipping through this magazine to read the cover story that follows. A more complex kind of identification is prompted by the photograph of author Peter von Ziegesar and his homeless brother that accompanies "Brothers" (p. 186). For some readers, this photograph may trigger identification with one or both of the brothers; for others, identification with the tension in their relationship. Whatever the connection created, the presence of the photograph colors our reading of "Brothers," causing us to interpret it differently than we might have if there had been no photo.

Closely tied to identification are the emotions and values often elicited by visual images. A story about widespread starvation in Africa, for example, is made more compelling if accompanied by pictures of skeletal children with distended bellies. We not only identify more readily with the human toll but also feel sadness and compassion, and these responses shape our reading of the story. Or consider the likely responses to the photograph discussed by Saletan of a federal agent pointing a machine gun at a terrified Elián Gonzáles (p. 349). Not surprisingly, this photograph outraged the public and led many to conclude that unnecessary force had been used in removing the child from his Miami relatives' home. However, as Saletan's critical reading of the photograph demonstrates, the situation may not have been as threatening as the photograph made it appear. While we cannot avoid "gut" responses to visual images, it is important to stop

and consider their intended effect and to question their veracity, recognizing that photographs and images, like words, are selected and constructed to create particular emotional responses.

The key questions to ask in relation to the use of visuals to appeal to your emotions, interests, and values are the following:

- What purpose does the visual element seem to serve in relation to the text?
- To which emotions, interests, and values does the visual element appeal? What assumptions are being made about readers' values, interests, and emotions?
- How do specific parts of the visual element work to elicit a response? How do the parts work together as a whole?
- Are there other ways of reading or interpreting these elements?

EXAMINING A TEXT'S IDEOLOGY

Another approach to questioning a text is to identify its *ideology,* a more technical term for the word *worldview,* which we introduced in the epigraph to Chapter 1. An ideology is a belief system—a coherent set of values and concepts through which we interpret the world. We sometimes think that ideology applies only to other people's worldviews, perhaps those of zealots blinded by a certain rigid set of beliefs. In fact, the term *ideology* applies to all of us. Each of us has our own beliefs, values, and particular ways of looking at the world. Our perspectives are inevitably shaped by family background, religion, personal experience, race, class, gender, sexual orientation, and so on. As you continue with your education, you may even discover that your perspective is influenced by the types of courses you are taking—science majors are sometimes skeptical about the ambiguities of literary texts, for example, and humanities students can similarly resist the details required in laboratory reports. Moreover, each of us is to some extent "blinded" by our worldviews, by our way of seeing. For instance, middle-class persons in the United States, by and large, share a variety of common beliefs: "Hard work leads to success." "Owning your own home is an important good." "Punctuality, cleanliness, and respect for the privacy of others are important values." "All persons are created equal." If we are among the privileged in this country, we literally may not be able to see existing inequities and barriers to success faced by less privileged Americans.

If we are to become astute readers, we must look for signals that reveal the ideology informing a text. One way to begin doing so is to look for patterns of opposites or contrasts in a text (sometimes called *binaries*) and see which of the opposing terms the writer values more. We generally understand things through contrast with their opposites. We would have no concept of the term *masculine,* for example, without the contrasting term *feminine.* To understand light, we have to understand dark (or heavy). Our concept of liberal depends on its con-

trast with conservative. We could list hundreds of these opposites or binaries: civilized is that which is not primitive; free is that which is not enslaved; abnormal is that which is not normal; people of color are those who are not Caucasian. When these binaries occur as patterns in a text, one term is generally valued above the other. When you examine the pattern of those values, you can begin to uncover the text's ideology. Sometimes the opposite or devalued terms are only implied, not even appearing in the text. Their absence helps mark the text's ideology.

For example, suppose you are reading an article that opposes a proposed five-day waiting period for the purchase of handguns. If you make a list of valued words, concepts, or ideas and then match them against their nonvalued opposites, you might produce the two-column pattern shown in Table 4.1. Lists such as these can help you clarify a text's ideology—in this case, conservative, individualistic, and supportive of the rights of individuals against the state.

Sometimes it is not immediately evident which terms are valued by a text and which ones are devalued. In such cases you can often identify a major contrast or binary in the text—for example, loggers versus tree huggers, school vouchers versus neighborhood schools, old ways versus new ways, scientific

TABLE 4.1 ● BINARY PATTERNS IN ANTI–WAITING PERIOD ARTICLE

Words, Concepts, and Ideas Valued by This Text	Words, Concepts, and Ideas Not Valued by This Text
2nd Amendment: the right to keep and bear arms	Bureaucratic bungling that will result in infringements on the right to keep and bear arms
Reliance on individual self to oppose an assailant	Reliance on police to oppose an assailant; administration of waiting periods would drain police resources
Conservatives	Liberals
Limited government	Active government
Examples of well-known shootings where waiting period would have been irrelevant—no statistical evidence of effectiveness of waiting period or other gun control laws	Examples of mentally ill persons with guns harming or killing people
Examples of criminals thwarted by individual citizens with guns	Examples of children killed by accidental shootings (excluded from text)
Hard time for hard crime, victim's rights	Plea bargaining, lax enforcement of existing gun control laws

TABLE 4.2 • BINARY PATTERNS IN THE WESTON EXCERPT	
Words, Concepts, and Ideas Valued by This Text	**Words, Concepts, and Ideas Not Valued by This Text**
Facing up to problems	Ignoring problems
Engagement with nature	Distance from nature
Natural environments—e.g., open spaces	Artificial environments—e.g., shopping malls
Fundamental change in our relation to nature and our consumption habits	Short-term solutions that don't change our relation to nature or our consumption habits

medicine versus alternative medicine. You can then determine which of the opposed terms is more valued. Once you can identify the main controlling binary, you can often line up other opposites or contrasts in the appropriate columns.

If you were to use these oppositions to draw conclusions about the ideology informing Weston's text (see Table 4.2), you might say something like the following: "Weston's text seems informed by liberal values generally and 'green' or environmentalist values, particularly. He is critical of many aspects of American life—our wealth, isolation from nature, and habits of consumption—and implicitly calls into question the value Americans place on 'progress' and 'a better life' over preservation of the natural world."

If the text includes visual elements, these often provide clues about ideology. Think about how the photograph of Aguilera appeals to various beliefs and values, such as the value of the liberated, powerful woman who doesn't care whether her albums sell as long as she can "do it [her] way." The ideology of this page is complex, however, because the words and images invoke competing beliefs and values—for instance, sex appeal versus independence, financial success versus the willingness to forgo it based on principle. Or consider the values and beliefs invoked by the second picture of Elián Gonzáles discussed by Saletan, the family photograph of a smiling Elián in the arms of his father, flanked by his stepmother and baby stepbrother (p. 352). This photograph draws on our belief in the sanctity of the child-parent relationship and in the value of raising children in traditional two-parent families.

• FOR WRITING AND DISCUSSION
ON YOUR OWN

Return to the introduction to "Blow-Up" (p. 74). Make a two-column chart of the binaries you find in that passage. Put the words, concepts, or ideas that the author values in the left column. Place the opposing words, concepts, or ideas that the author doesn't value in the right column. (Remember, the nonvalued terms may only be implied and not actually appear in the text.)

Then write a short analysis of the author's ideology, following the models we provided based on the anti-waiting period argument and Weston's text.

WITH YOUR CLASSMATES

Share your list of binaries and your analysis of Barcott's ideology. Try to reach consensus on both. ●

Exploring Your Responses to a Text

The previous section has explained six questioning strategies based on examining the details of a text. In this section we explain a different approach to interrogating a text, one that asks you simply to explore your own reactions to something you've read. This approach encourages you to record on paper your first gut reactions to a text and then, after reflection, your more sustained and considered responses. We describe in this section three informal, easy-to-use strategies for helping you explore and articulate your own reaction to a text: (1) before/after reflections, (2) the believing and doubting game, and (3) interviewing the author.

BEFORE/AFTER REFLECTIONS

To consider how much a text has influenced your thinking, try writing out some before and after reflections by freewriting your responses to the following statements.

1. What effect is this text trying to have on me? What kind of change does the writer hope to make in my view of the subject?

Here is how Jenny answered this question after she first read Larissa MacFarquhar's article.

MacFarquhar wants me to reject certain commonplaces about reading—that Americans don't read much any more, for example—and to question other common assumptions such as the assumption that reading is always a more worthwhile activity than watching TV or that reading the classics is better than reading romance fiction.

2. Before reading this text, I believed this about the topic: _____ _____. But after reading the text, my view has changed in these ways: _____ _____.

3. Although the text has persuaded me that _____, I still have the following doubts: _____.

4. The most significant questions this text raises for me are these: _____
_____.

5. The most important insights I have gotten from reading this text are
these: _____.

● **FOR WRITING AND DISCUSSION**

We gave you an example of Jenny's before/after reflection responding to the
question "What kind of change does the writer hope to make in my view of
the subject?" Based on your reading of the MacFarquhar article, write out
your own before/after reflections for statements 2 through 5. Share your re-
sponses with classmates. ●

THE BELIEVING AND DOUBTING GAME

Playing the believing and doubting game with a text is a powerful strategy both
for recording your reaction to a text and for stimulating further thinking. De-
veloped by writing theorist Peter Elbow, the believing and doubting game will
stretch your thinking in surprising ways. You begin the game by freewriting all
the reasons why you believe the writer's argument. Then you freewrite all the
reasons why you doubt the same argument. In the "believe" portion, you try to
look at the world through the text's perspective, adopting its ideology, actively
supporting its ideas and values. You search your mind for any life experiences
or memories of reading and research that help you sympathize with and support
the author's point of view or ideas. If you find the author's ideas upsetting, dan-
gerous, or threatening, the believing game may challenge—even disturb—you.
It takes courage to try to believe views that you feel are dead wrong or contrary
to your most deeply held beliefs. Nevertheless, to be a strong rhetorical reader,
you need to look at the world through perspectives different from your own.

According to Elbow, the believing game helps you grow intellectually by let-
ting you take in new and challenging ideas. In contrast, the doubting game
helps you solidify your present identity by protecting you from outside ideas.
Like an antiballistic missile, the doubting game lets you shoot down ideas that
you don't like. The "doubt" portion of this game thus reverses the believing
process. Here you try to think of all of the problems, limitations, or weaknesses
in the author's argument. You brainstorm for personal experiences or memories
from reading and research that refute or call into question the author's view. (Of
course, the doubting game can be threatening if you already agree with the au-
thor's views. In such a case, doubting causes you to take a stand against your
own beliefs.)

In the following example, student writer Jenny plays the believing and
doubting game with MacFarquhar's article. Note how this exercise promotes
critical thinking that goes beyond just expressing her subjective opinions.

The results of playing the believing and doubting game are nearly always a bit surprising.

JENNY'S BELIEVING-DOUBTING GAME FREEWRITE

Believe

It's easy for me to believe what MacFarquhar has to say about how Americans are not reading less than they used to but actually more, especially books like romance fiction. I used to read every Sweet Valley High book I could get my hands on. As a kid, I also loved the Judy Blume books. It irritates me when people think that the only reading that counts is Shakespeare or something. I've learned a lot about life from reading Judy Blume's books. For example, <u>Hey, God, It's Me Margaret</u> is about a girl whose parents get divorced just like mine did. It really meant a lot to me to read about a character who had some of the same experiences and feelings I had. If reading is not about helping you get through life, then what is it about? Like MacFarquhar says, book clubs are a big thing nowadays and that proves that reading is as popular as ever. I heard that a professor here offered a literature course called "Oprah's Books," and so many students enrolled that they had to open up another section of the course. My next door neighbor and her middle-school-aged daughter even belong to a mother/daughter book club. MacFarquhar also presents a lot of facts about reading that are hard to argue with. Also, it has always irked me that people think you are an idiot if you like to watch a lot of TV. I think many shows today are as good as many books. Even though some people call it just "fluff," I love <u>Will and Grace</u> and try not to miss it. Plus, I know that many educated adults (including some of my profs!) watch HBO shows like the <u>Six Feet Under</u> and <u>The Sopranos</u> even though some people call them nighttime soap operas. I agree with MacFarquhar that TV and video games are not destroying people's love of reading and that Americans are reading more than ever!

Doubt

It's harder for me to doubt what MacFarquhar is saying because I generally agree with everything she has to say. I suppose some people might call into question her statistics. How reliable are the responses people give to Gallup polls? MacFarquhar seems to think facts and

statistics absolutely prove that people read a lot—but can't facts and statistics be manipulated? I know a lot of my teachers feel that students' reading abilities and knowledge of the classics are not what they were in the past. I must admit that I did get a lot out of the "classics" that I have had to read in high school and college even though I wouldn't have read them on my own. I particularly remember reading Heart of Darkness in high school, and just recently reading The Great Gatsby. Recently, I was watching a television report on the famine in Africa, and the news report quoted a line from The Heart of Darkness—"The horror of it all"—and it really made me feel good that I knew what the reporter was referring to. I also guess I can see why people are concerned that television and video games are replacing reading. My younger brother is just addicted to video games, and he never reads. I know, even for myself, sometimes I sit down to watch just one favorite program and end up watching the next show even though I'm not that interested in it and it isn't even that good. So I realize that TV can be addictive and a lot of it does feel more passive than reading. The only other thing that makes me doubt or question what she has to say is her attitude. I don't like the way she sometimes seems to insult people who have a different point of view.

INTERVIEWING THE AUTHOR

Another strategy for exploring your reactions to a text is to imagine interviewing the author and brainstorm the questions you might ask. This strategy urges you to identify the text's hot spots for you. These might be places where you want the author to clarify something, expand on something, or respond to your own objections or counterviews. Here are some questions Jenny developed to ask MacFarquhar.

JENNY'S INTERVIEW QUESTIONS

Are Gallup polls really conclusive evidence that more Americans are reading? Couldn't people just be saying that they are reading a book out of embarrassment? You offer convincing evidence that the books that are the most popular in contemporary America are genre fiction and self-help books, but what do you think of this? Do you think it's a loss or problem that not many Americans read the classics? You seem to think that watching TV can be as valuable as reading. Why do you think that? What

would you say to the accusation that you spend most of your time attacking others' positions without really offering your own opinions?

Writing a Rhetorical Analysis Paper: Guidelines and an Example

A rhetorical analysis paper is the written counterpart of rhetorical reading. Writing this kind of paper gives you the opportunity to draw together and apply all the listening and questioning strategies discussed in this and the previous chapter for a two-fold purpose: articulating your own insights about how a text works to influence its readers and communicating those critical insights to other readers. Here we offer general guidelines for writing a rhetorical analysis paper, followed by a student example.

GUIDELINES FOR WRITING A RHETORICAL ANALYSIS

Getting Started

We suggest you begin your rhetorical analysis with the following preliminary activities:

1. Write a summary of the text you are going to analyze to make sure that you understand it well enough to represent its meaning accurately and fairly.
2. Make a descriptive outline in order to determine the distinction as well as the relationship between what a text says and what a text does.
3. Write a rhetorical précis of the text. (See pp. 61–62 for instruction on writing a rhetorical précis).
4. Try one of the three exploratory activities to identify a strong response or significant effect the text had on you as a reader.

Selecting a Focus for Your Analysis

To write an effective rhetorical analysis, you will need to focus on some aspect of the text's rhetorical methods, an aspect that merits close examination or critique. We suggest one of two approaches. You can start deductively with the effect the text had on you as a reader—a strong positive or negative response, a tension or contradiction you found in the text, or some aspect of the text that confused or surprised you. If you begin with your response, you will need to analyze the text to discover the rhetorical features that account for this response. How do they work? Why are these features effective or ineffective? Alternatively, you can start inductively by identifying and then analyzing particularly striking rhetorical features. If you begin inductively, you will need to consider how these

features work and to what effect. What new understanding of the text does your analysis reveal?

Whether you begin deductively or inductively, you will need to select specific rhetorical features to write about. Choose features that you consider particularly effective or ineffective, or in which you detect inconsistencies or tensions between two different appeals. To frame your analysis, choose among the questions about texts' rhetorical methods suggested throughout the chapter.

Drafting Your Paper

Once you have determined a focus, reread the text carefully to find specific examples of these features, taking notes on how they contribute to the effect you have identified. Use these notes to draft a working thesis that states the gist of the insights your rhetorical analysis will offer about the text's meaning and methods. You can revise and refine this working thesis after you draft the whole paper. In your final draft, the thesis should clearly introduce the new understanding that results from your analysis and indicate what that analysis says about the text's effectiveness or ineffectiveness.

The full draft of your paper should have the following elements:

1. An introduction that includes (a) a brief summary of the text, (b) contextual information about the text, and (c) your thesis about the text's rhetorical effect
2. A series of body paragraphs that develop the thesis by (a) discussing specific rhetorical features that produce the rhetorical effect and (b) providing specific textual evidence to back up your points
3. A conclusion that makes clear (a) why the new understanding your paper presents is important and (b) why the insights of your analysis are significant to other readers

AN EXAMPLE OF A RHETORICAL ANALYSIS PAPER

In Chapter 3, we looked at the summary and rhetorical précis of Larissa MacFarquhar's "Who Cares If Johnny Can't Reader" written by Jenny, the first-year writing student whose work we have been following. We now present the paper Jenny wrote about MacFarquhar's essay in response to the assignment below. We have annotated Jenny's paper to highlight the questioning strategies that she uses to analyze the article as well as the rhetorical writing strategies she uses to support her analysis.

JENNY'S ASSIGNMENT TO WRITE A RHETORICAL ANALYSIS PAPER

Write an essay of approximately 750 words in which you examine a key rhetorical strategy (or several related ones) used by Larissa MacFarquhar to engage readers with her point of view regarding reading and its value. Your purpose is to offer your readers a new perspective on how the text works rhetorically, a perspective gleaned from your analysis of the text.

Caring If and What Johnny Reads

As a future elementary school teacher, interested 1
particularly in language arts, I am always drawn to stories
about reading and its supposed decline due to television
and the Internet. Therefore, I was curious to see what
Larissa MacFarquhar had to say about the subject in her
essay, "Who Cares If Johnny Can't Read," published in the
online magazine Slate in 1997. As the attention-getting
title of her essay suggests, MacFarquhar questions some
common assumptions regarding reading, specifically that
Americans read less than they used to and that reading
books is better and more intellectually stimulating than
watching television or surfing the Internet. To challenge
each of these common beliefs, MacFarquhar relies mainly
on logical argument. A close examination of her essay,
however, reveals that her argument is not entirely
convincing. She is successful in showing that reading has
not declined in America. However, she is less successful in
challenging the belief that reading has unique value
because she focuses more on disproving (and belittling) the
ideas of others than she does on presenting a convincing
argument of her own.

 MacFarquhar begins by challenging the view that 2
Americans "don't care about reading anymore." Her
mocking description of this belief suggests that it is the
opinion of old fogies who glorify the past and blame new
technology for this "cultural decline": "Once, the story
goes—in the 1950s, say—we read much more than we do
now, and read the good stuff, the classics. Now . . . we're
barely literate, and television and computers are rendering
books obsolete" (par. 1).* To show just how mistaken these
ideas are, she goes on to offer evidence that Americans are
actually reading more than ever: "In 1957, 17 percent of

States topic's relevance to her

Gives publication information

Offers one-sentence summary of LM'sarticle

Identifies the key rhetorical strategy, logos, which her paper will examine

States thesis

Elaborates thesis

Offers support for her claim that LM belittles those with opposing views

Points out LM's use of evidence to support her claim that Americans do care about reading

*As in her summary in the previous chapter, Jenny's in-text citations refer to the paragraph numbers on the reprint of "Who Cares If Johnny Can't Read?" at the end of Chapter 3.



Cites examples
of this evidence

Evaluates logical
persuasiveness
of LM's evidence

Provides a
transition to her
next point of
analysis—LM's
second main
claim that
reading is
"overvalued"

Offers further
examples of
LM's tendency to
belittle those
with opposing
views

Analyzes LM's
first reason for
challenging the
value placed on
reading

Develops
analytical point
by citing textual
evidence

Points out
inconsistency in
LM's reasoning



people . . . said they were currently reading a book; in 1990 over twice as many did" (par. 2). In 1992, she reports, Americans bought over 2 billion books, and a survey conducted that year "found that the average adult American reads 11.2 books a year" (par. 3). Although some readers may doubt the reliability of this statistical data, most are likely to be convinced that reading is alive and well in America.

3 MacFarquhar has more difficulty challenging the assumption that reading is intrinsically more valuable than watching television or surfing the Internet. Again, she attempts to influence her readers by representing the assumptions she wishes to challenge as old-fashioned. For example, she describes Sven Birkerts's book The Gutenberg Elegies: The Fate of Reading in an Electronic Age as a "maudlin 1994 paean to books." She also says that Time art critic Robert Hughes's argument that books stimulate the imagination in a way that television cannot is "sentimental" and "mysterious" (par. 12).

4 She uses logical argument to question the idea that books have a unique intellectual value. She disputes the idea that reading in and of itself is a valuable activity no matter what the content by asking rather sarcastically, "Why should the activity 'reading romances' be grouped together with 'reading philosophy' rather than with 'going for a massage'?" (par 9). Even the writers of romance fiction, she argues, admit that their novels are not great literature and are written mainly as "mass market entertainment" (par. 8). MacFarquhar supports her implicit claim that the value of reading depends on its content by quoting 1940s critic Edmund Wilson, who wrote that detective fiction was "a kind of vice, that, for silliness and minor harmfulness, ranks somewhere between smoking and crossword puzzles" (par. 10). Initially, MacFarquhar's argument seems surprising and even convincing. However, it is inconsistent with her earlier dismissal of concerns about the failure of

contemporary readers to read the classics, which she refers to sarcastically as "the good stuff."

Although we may acknowledge that the value of reading increases if the content is better, many of us believe that reading is a uniquely valuable intellectual activity in and of itself. MacFarquhar, however, disagrees. She disputes the idea that reading is active and television watching passive, calling this notion "vague" and "groundless" (par. 12). In particular, she cites her own experience to challenge Hughes's contention that books stimulate the imagination: "I cannot remember ever visualizing a book's characters, but . . . perhaps I'm in the minority" (par. 13). Since this is the only evidence she offers, she also could be accused of making a claim that is weak and groundless. Moreover, because she is concentrating so much on discrediting the views of book advocates, she gets trapped into offering a negative argument against book reading based on her own experience rather than a positive argument that book reading and television may both be intellectually valuable but in different ways. This different-but-equal view seems to be the point of her last sentence: "The point is to figure out why certain kinds of reading and certain kinds of television might matter in the first place" (par. 15).

In conclusion, MacFarquhar's argument is only partially convincing. While I am persuaded that Americans are still reading books and that the value of reading is somewhat dependent on the quality of what is read, I am not persuaded that the activity of reading lacks intrinsic value. Not only does MacFarquhar put off some readers by her dismissive attitude toward those who advocate reading, she also fails to offer convincing evidence that reading is not a uniquely valuable activity. As a future teacher, I continue to care deeply about if and what Johnny reads.

5 Moves to LM's second reason for challenging the value placed on reading

Critiques evidence LM uses to refute the argument that reading is more active than TV watching

Points out a serious weakness in LM's argumentative approach

6 Concludes essay by offering a mixed evaluation of the effectiveness of MacFarquhar's argument

Works Cited

MacFarquhar, Larissa. "Who Cares If Johnny Can't Read?" Slate 16 Apr. 1997. Rpt. in Reading Rhetorically. 2nd ed. John C. Bean, Virginia A. Chappell, and Alice M. Gillam. New York: Longman, 2005. 63–65.

● **FOR WRITING AND DISCUSSION**

ON YOUR OWN

In your reading log, write a response to Jenny's paper. How does her reading of MacFarquhar compare with yours? What issues or ideas does she leave out? Is hers a fair criticism of the essay? Does she back up her analysis with adequate and convincing evidence? If you had been given the same assignment, what rhetorical aspects of the text would you have written about?

WITH YOUR CLASSMATES

Share your responses with classmates. Working as a whole class or in small groups, list some additional ideas or insights that Jenny might have incorporated into her paper. ●

Summary

This chapter has explained strategies for questioning a text, which involves carefully interrogating a text's argument and methods in order to critique it and join its conversation. We presented questioning strategies for examining

- The writer's credibility
- The argument's reasoning and logic
- The writer's appeals to the audience's interests and emotions
- The text's language
- The text's use of visual elements
- The text's ideology

We then explained three easy-to-use methods for exploring your own reactions to a text: writing out before/after responses, playing the believing and doubting game, and imagining an interview with the author. Finally, we offered guidelines for writing a rhetorical analysis paper and an example, Jenny's rhetorical analysis of MacFarquhar's article. This example shows how the questioning strategies described in this chapter can help you write a college-level analysis of a text.

PART **2**

The Rhetorical Reader as Writer

Writing About Reading: The Special Demands of Academic Writing

Academic writing, reading, and inquiry are inseparably linked; and all three are learned by not doing any one alone, but by doing them all at the same time.

—James Reither

As our epigraph suggests, academic tasks often require you to read, write, and inquire simultaneously. Reading, as we have been suggesting all along, is an act of inquiry—a process in which you both listen to and question a text. Similarly, writing is an inquiry process that usually involves reading. The next three chapters focus on helping you do the kind of writing most frequently required by college professors: writing that grows out of reading. However, it is not just college or the academic life that requires writing based on reading. To dramatize the practical value of rhetorical reading as an integral part of effective writing well beyond academic study, we invite you to consider the following scenarios:

- A public relations intern at a regional theater company is asked to report on how comparable theaters around the country are presenting themselves on the World Wide Web. Her supervisor expects detailed information about the visual and verbal content of the other Web pages along with an overview of their various advertising strategies. The intern also wants to communicate her own marketing and design expertise because she hopes to do such a good job that she'll be hired to revamp this theater's Web page.
- A management trainee at an electric utility is assigned to research the cost and competitive features of microform readers and printers that the company might purchase as part of its overhaul of document-handling procedures. As he works, he discovers that he not only has to boil down

extensive technical data in the stacks of sales material he's collected but must also decipher marketing lingo that makes it difficult to compare the equipment directly. He knows that his own boss wants a report that will enable a speedy purchasing decision by a management committee. He also knows that a good report will speed up his own promotion out of "trainee" status.

- A law clerk assisting a judge with an important legal opinion must summarize reams of government documents and position papers about a controversial new environmental policy. He knows that the judge expects his report to provide legal, not political, criteria for analyzing and evaluating the opposing arguments in the case.
- The judge, who chairs the board of a nonprofit women and children's shelter, sits down to write an annual report for volunteers and donors. She must distill a year's worth of dry monthly reports into a short, readable text that will thank the shelter's supporters for past effort and inspire them to further generosity.

All these writers must read and synthesize multiple texts so that they can create a new document with an audience and purpose quite different from those of the original materials. The workplace and community contexts we have described may be unfamiliar to you, but the rhetorical problems facing these reader/writers are parallel to those that you will need to solve when you are asked to incorporate material from outside sources into your own academic writing. These writers may have never heard the term "rhetorical reading," but the effectiveness of the texts they write will depend on how well they analyze both content and technique in their sources and then, on the basis of this analysis, select material that will serve their purposes for influencing the thinking of the next set of readers.

Overview of Part Two

In Part One of this book, we introduced you to the whys and hows of rhetorical reading, arguing for its value in deepening your understanding of what you read and in generating ideas for writing. Now, in Part Two, we turn our attention to the special demands of using the ideas gleaned from reading to create new texts. In Chapter 5, we begin by describing typical reading-based writing assignments that you are apt to receive in classes across the curriculum. Then we turn to the problem of how to assert your authority when you use readings—that is, how you make an argument in your own voice rather than patch together quotes and paraphrases from your sources. Finally, we offer tips on how to manage your writing process—how to produce effective texts that assert your authority as a writer and meet the expectations of college professors.

Chapter 6 guides you through the task of searching for and selecting readings to use in your research-based writing. It explains how to formulate and then

use strategic questions to find and evaluate readings that fit your purposes for writing. Chapter 7 covers the nuts and bolts of incorporating the ideas and words of others into your own text. It discusses the rhetorical choices involved when you decide to summarize, paraphrase, or quote a source, and it explains the conventions for doing so ethically and effectively.

Typical Reading-Based Writing Assignments Across the Curriculum

In college, a reading assignment is often only the first step in a complex series of activities that lead toward writing something that will be graded. What you write will naturally vary from situation to situation and can range from a quick answer on an essay exam to an extensive source-based paper. In this section, we discuss five common college writing assignments in which reading plays a major role:

1. Writing to understand course content more fully
2. Writing to report your understanding of what a text says
3. Writing to practice the conventions of a particular type of text
4. Writing to make claims about a text
5. Writing to extend the conversation

These roles can be placed along a continuum, starting with writing tasks in which the ideas in the readings predominate and moving to assignments in which the readings are subordinated to your own ideas and aims. The first two assignment types focus primarily on using writing to learn course subject matter and to practice careful listening to texts. The last three focus primarily on writing your own analyses and arguments for academic audiences. Writing teachers sometimes distinguish these two categories of assignment goals by the terms "writing to learn" versus "learning to write."

WRITING TO UNDERSTAND COURSE CONTENT MORE FULLY

"Writing-to-learn" assignments aim to deepen your understanding of the reading material by asking you to put the author's ideas into your own words or to identify points of confusion for yourself. The primary audience for these types of writing is often yourself even though teachers sometimes ask you to turn these writings in so that they can check on your understanding and progress. The style is informal and conversational. Organization and grammatical correctness are less important than the quality of your engagement with the content of the reading. These assignments typically take one of the following forms.

In-Class Freewriting

The point of freewriting is to think rapidly without censoring your thoughts. Freewriting is often done in class as a way to stimulate thinking about the day's subject. A typical in-class freewrite assignment might be this:

> Choose what for you personally is the single most important word in the text we read for today. You need not speculate about which word the author or your instructor or any other classmate would choose. Just choose the word that seems most important to you. This word may occur only once, a few times, or perhaps it appears frequently. Then explore in writing why you chose the word as the most important word in the essay.*

Reading or Learning Logs

Reading or learning logs are informal assignments that ask you to record your understanding, questions, and responses to a reading. Some teachers give specific prompts to guide your entries while others just ask that you write entries with a certain regularity and/or of a certain length. A typical question about the Larissa MacFarquhar essay might be "How would you describe the author's voice in this essay?" If a teacher asks you simply to write your own reflections in a log, you might use some of the questions rhetorical readers ask presented in Chapter 1 about the text's method and your response to it.

Double-Entry Notebooks

Double-entry notebooks are a special kind of reading log in which you conduct an ongoing dialogue with your interpretations and reactions to the text. Here's how they work: Divide a notebook page with a line down the middle. On the right side of the page record reading notes—direct quotations, observations, comments, questions, objections. On the left side, record your later reflections about those notes—second thoughts, responses to quotations, reactions to earlier comments, answers to questions or new questions. Rhetorician Ann Berthoff, who popularized this approach, says that the double-entry notebook provides readers with a means of conducting a "continuing audit of meaning."† In keeping a double-entry journal, you carry on a conversation with yourself about a text.

One-Page Response Papers or Thought Pieces

Written for an instructor, one-page response papers or "thought" pieces are somewhat more formal than the previous writing-to-learn assignments but still a great deal more informal than essay assignments. They call for a fuller response than the previous types of writing-to-learn assignments, but the purpose

*We thank Joan Ruffino, an instructor at the University of Wisconsin–Milwaukee, for this freewriting assignment.

†Ann Berthoff, *The Making of Meaning* (Montclair, NJ: Boynton Cook, 1981), 45.

will be similar—to articulate an understanding of a text and to respond to it, often within the context of major themes or concepts being addressed in a particular course. Usually, a teacher will give students a specific question as a prompt for these papers. Here is a sample thought piece written in response to a prompt from a freshman seminar in psychology. The teacher asked the students to write about the insights they gleaned about obsessive-compulsive disorder (OCD) from reading Lauren Slater's "Black Swans," in which the author narrates the onset of her ongoing battle with OCD.

Reading Lauren Slater's "Black Swans" taught me some basic information about OCD, but more importantly, it taught me how terrifying this disease can be. It begins with a single obsessive thought that leads to a cycle of anxiety, repetitive behaviors such as repeatedly washing one's hands, and avoidance of situations that produce the obsessive thoughts. In severe cases, like Slater's, the person completely avoids life because the obsessive thought invades every aspect of one's life. The essay also makes it clear that experts understand very little about the causes for this disease or about how to treat it.

What impressed me most about this essay, however, was Slater's ability to put me in her shoes and make me feel some of the terror she felt. She vividly describes her experience at being stricken with this condition without warning. A single thought—"I can't concentrate"—suddenly blocked out all other thoughts. Ordinary surroundings like the blue floor of her room appeared strange and frightening. Even her own body seemed foreign to her and grotesque: "the phrase 'I can't concentrate on my hand' blocked out my hand, so all I saw was a blur of flesh giving way to the bones beneath, and inside the bones the grimy marrow, and in the grimy marrow the individual cells, all disconnected. Shattered skin." To me, this was the most frightening description in the essay. I can't imagine being disconnected from my own body. I think the most terrifying aspect of this disease is the sense of being completely out of control of your mind. Slater describes it as, "My mind was devouring my mind." While one can <u>never</u> really know what the disease feels like without actually experiencing it, this essay gives us a disturbing glimpse of what it might be like.

Effective response papers or thought pieces, like the one above, identify significant points in the reading and offer a personal response or interpretation of those significant points. In this book, there are numerous places where we give short writing-to-learn tasks designed to help you learn and apply key concepts of rhetorical reading.

WRITING TO REPORT YOUR UNDERSTANDING OF WHAT A TEXT SAYS

Another common reading-based assignment asks you to report your understanding of what a text says. For example, you will frequently need to summarize readings in a paper and to explain an author's ideas as part of an essay exam. You may also be asked to write an annotated bibliography that provides brief summaries of sources related to a particular topic or question. In Chapter 3, we discussed how to write summaries and the various purposes they serve in college reading and writing assignments. In your own writing, a summary of an article might be short; for example, you might write a one-sentence summary in order to put into context a quotation you are going to use in your research paper. Or it might be fairly detailed; for example, you might want to summarize the complete argument of an important article on a controversial issue. Sometimes an entire paper can be a sequence of summaries, as when you write a review of literature about a particular topic—for example, about new treatments for obsessive-compulsive disorder in a psychology course or about scientific studies of the relationship between pesticides and cancer in a biochemistry course. Although summaries or reports of your understanding of a text will vary in length and purpose, they are all expected to be accurate, fair, and balanced. In short, they require you to listen carefully to the text.

WRITING TO PRACTICE THE CONVENTIONS OF A PARTICULAR TYPE OF TEXT

Assignments that ask you to analyze and practice the conventions of a particular type of writing—its organizational format, style, ways of presenting evidence, and so on—use readings as models. Such assignments are common in college courses. In a journalism class, for example, you would learn to write a news report using the inverted pyramid structure; in a science course you might be asked to write up results of experiments in the form of a laboratory report. Similarly, in courses using this textbook, you might be asked to write aims-based essays modeled after some of the readings in the anthology—that is, to write your own reflective essay, informative essay, exploratory essay, or proposal argument.

For each chapter in the anthology section of this book, one of the formal assignment options asks you to use the chapter's readings as models. This assignment asks you to write your own aims-based essay, on a subject matter of your choosing, using the chapter's essays as examples or guides for creative imitation or adaptation. Generally, using readings as models involves the following activities:

- Identifying the features that characterize a particular type of text
- Noting the ways in which rhetorical situation affects the features identified in model texts
- Coming up with your own topic and reason for writing this particular type of text

- Using the features of the model text (or texts) and your own rhetorical situation to guide your writing

Let's say, for example, that you've been asked to write a proposal argument. Chapter 14 identifies three features of proposal writing: description of the problem, proposal of a solution, and justification of that solution. As you read through this chapter, you will find that various authors deal with these features differently depending on their audience and purpose. In some cases, for example, there is a great deal of description of the problem because the intended audience is unfamiliar with it; in other cases, there is very little description because it is presumed that the intended reading audience already knows a lot about the problem. The key is to adapt the model's characteristic structure and style to your own rhetorical purpose, not to follow the model slavishly.

In courses across the curriculum, your ability to analyze and adopt the conventions particular to a given discipline's ways of writing will help you write successful papers. For example, when you are asked in a philosophy class to write an argument in response to Immanuel Kant's *Critique of Pure Reason,* you are primarily being asked to engage with the ideas in the text. But secondarily you are also being asked to practice the conventions of writing a philosophical argument in which counterexamples and counterarguments are expected. It pays, then, to be alert to the structure and style of material you are assigned to read in any field of study as well as to the ideas.

WRITING TO MAKE CLAIMS ABOUT A TEXT

Assignments in this category ask you to analyze or critique readings. Many academic writers take as their field of study the texts produced by others. Literary critics study novels, poems, and plays; cultural critics analyze song lyrics, advertisements, cereal boxes, and television scripts; historians analyze primary source documents from the past; theologians scrutinize the sacred texts of different religions; lawyers analyze the documents entered into court proceedings, the exact wording of laws and statutes produced by legislators, or the decisions of appellate court judges.

Because this kind of assignment is so common in college courses, another of the assignment options in each of the anthology chapters in this book asks you to analyze a specific text. These assignments ask you to analyze one or more readings by identifying specific rhetorical methods and strategies used by the author, showing how these rhetorical choices contribute to the text's impact, and evaluating the choices in light of the author's evident purpose. Your claims must go beyond what a text says to make judgments and draw conclusions. In these types of assignments, the text and your ideas about the text are of equal importance. Assignments asking for analysis or critique are not invitations for you to refer briefly to the text and then take off on your own opinions about the topic, nor are they invitations merely to summarize or rehearse what the text has said. Rather, these assignments expect you to engage critically with a specific text. On the one hand, you will be expected to represent what the text said accurately and fairly. On the other hand, you will be expected to offer your own

analysis, interpretation, or critique, one that enables readers to see the text differently. A specialized form of this type of assignment is the rhetorical analysis or critique. Chapter 4 includes guidelines for writing a rhetorical analysis as well as a sample assignment and a student paper, Jenny's rhetorical analysis of MacFarquhar's article.

WRITING TO EXTEND THE CONVERSATION

These assignments treat texts as voices in a conversation about ideas. They typically call for you to read and synthesize material from several sources. Here, your own ideas and aims take center stage; your source texts play important but less prominent backup roles. The most familiar form this assignment takes is the research or seminar paper. What distinguishes such college work from high school research paper assignments is the expectation that the paper will present your own argument, not the arguments provided by the sources. In other words, you are expected to articulate a significant question or problem, investigate relevant data, research what published authors have said about it, and then formulate your own argument. To write these multisource papers successfully, you should use other texts primarily to position yourself in the conversation and to supply supporting data, information, or testimony. The argument—your main points—must come from you.

To help you understand the importance of research writing in college, each of the anthology chapters in this book offers an assignment that asks you to treat texts you have read as springboards for further research and discovery. These assignments treat the chapter's readings as voices in a conversation. They ask you to write an essay that joins the conversation introduced by one or more of the readings in the chapter or by other texts you have read on your own. Frequently they ask you to seek out other voices—often through library, Web, or field research—and then to enter the conversation with your own position and argument. By giving you the opportunity to define your own purposes for writing in dialogue with other texts, this category of assignments will prepare you for the research assignments typical of many college courses, where your goal is to synthesize material from a number of sources and then produce your own paper, inserting another voice—your own—into the ongoing conversation. To illustrate this kind of research writing, we include at the end of Chapter 7 Jenny's researched argument on romance novels, a paper that grew out of her work with Larissa MacFarquhar's essay.

Asserting Your Authority
as a Reader and Writer

"I have nothing to say! It's all been said!" This complaint is a familiar one. In the midst of a complicated reading and writing project, it's not unusual for any of us—students, teachers, or professional writers—to lose sight of our original goals and thus lose our confidence that we have ideas worth writing about.

Throughout this book, we have argued that reading is an active, constructive process. We don't need to convince you that writing, too, is an active process; after all, to write, one must actually make words appear on a page or screen. Nevertheless, as we turn to the subject of connecting reading and writing, we do want to warn you against *passive writing,* writing that just translates what's on someone else's page onto your page. Passive writing is packed full of summaries, paraphrases, and quotes (sometimes very lengthy quotes) but contains very little content from the writer. Some teachers refer to such writing as "patchwriting"—patches from source materials stitched together by a few sentences of the student's own. Such papers don't make their own arguments. They just cut and paste their sources' writing in order to fill the page. Passive writing of this sort doesn't assert its author's reason for writing and so it doesn't give its audience a reason for reading.

Passive writing occurs because many people (not just students!), when confronted with already published materials, find it difficult to maintain their own sense of purpose as authors: they lose track of their *author-ity.* Perhaps uncertain about the source text's content or purposes, they begin to insert quotations or paraphrases into their own texts without clear purpose. Perhaps awed by the rush of facts and abstractions in materials they are reading, they yield their authority as readers/writers to previously published texts. They begin to copy rather than compose, to cut and paste rather than argue. In effect, they let themselves be silenced by the experts. When they simply must put words on a page (because the assignment is due), the resulting product resembles a pasted-together collage of quotes and paraphrases. By letting their source materials take over the paper, writers not only fail to gain their readers' confidence but lose the opportunity to make their own contribution to the discussion.

As you work with the advice in this chapter, you will begin to discover a powerful truth: rhetorical reading leads to rhetorically powerful writing. Just as rhetorical reading involves analyzing and critiquing an author's method as well as content, rhetorically effective writing asserts its purpose and method along with its content. Strong writers use the knowledge and understanding gained from their reading to build their own authority so that they can, in turn, *author* their own texts. These strong texts will engage readers because they not only "say" clearly what they mean but "do" what they intend: extend the conversation by providing new information and asserting new ideas that will alter their readers' view of the subject.

Managing Your Writing Process

To assert your authority as a writer, you need to think of writing as an active process of making new meaning, of adding your voice to an ongoing conversation about a subject. It is not a matter of just retrieving something that is fully formed in your head or of finding other voices to cobble together; rather, it is a matter of finding a compelling reason to write and then actively constructing a

text that accomplishes that purpose. Perhaps Kenneth Burke, whom we mentioned in Chapter 1, puts it best when he describes the unique contribution each speaker or writer makes to a conversation as "putting in your oar."

Recognizing that the process of creating a text will vary from writer to writer and from situation to situation, we offer in this section a variety of strategies that will help you claim your own authority as a writer. You should think of the strategies and processes we describe as *recursive*; in other words, you don't go lockstep through the strategies in a strictly linear fashion but frequently circle back to repeat earlier strategies because you have discovered a new angle or refined your main idea or purpose for writing.

STRATEGIES FOR GETTING STARTED

As a college writer, you are more likely to succeed when you can make an assignment your own. Rather than writing just to fulfill an assignment, you need to construct your own "take" on the subject by imagining yourself writing to a real audience for a real purpose. You assert your own authority by creating your own *exigence*—a useful term from rhetorical theory that means a circumstance that is other than it should be, a situation in need of attention. To resolve the situation, you write to bring about some kind of change in your audience—to correct a misunderstanding, to talk back to something someone else has said, to propose a solution to a problem, to explore and shed new light on an issue, to change your audience's thinking or attitudes, to make your audience appreciate something or value it differently, to call for action.

In writing projects that involve reading, the exigence or reason for writing grows either out of your analysis and response to a single text (you have something new to say about the text that is surprising or challenging to your audience) or out of your own research question, which then leads to a search for texts that will expand and complicate your understanding of your subject. Your increased understanding, in turn, provides you with insights and information you need to develop an argument that brings about a desired change in your audience's view of a subject. When your writing project involves reading, here are some strategies for getting started.

- For assignments that ask you to analyze and respond to a text, the questioning strategies explained in Chapter 4 should generate responses that can serve as points of departure. As you consider various starting points for writing about a text, consider what kind of change you want to make in *your* readers' thinking about this text and why this change is important. For example, do you want readers to see an inconsistency or contradiction they might otherwise miss? Do you want them not to be taken in by a particular persuasive ploy or faulty reasoning? Do you want to impress upon them the broad significance of what the text has to say?
- For assignments that ask you to begin with your own question, issue, or stance and to conduct research, you might begin by brainstorming a list of questions or problems that intrigue you. What are the points of dis-

agreement? Why does this question or problem matter? To whom is this question or issue important and why? These questions can help you refine your starting point or stance and thus help guide your research. In Chapter 6 we discuss question analysis, a technique for formulating strategic questions to guide you through the process of finding, evaluating, and selecting sources.

Whatever kind of writing assignment you are given, the starting point of the writing process should be a problematic question or a risky claim. Although it might be tempting to start with ideas that are familiar or safe, that you are already firmly committed to or that are already settled in your mind, this approach usually leads to flat, perfunctory writing that fails to engage readers. The better approach is instead to start with a question that is genuinely puzzling to you or with a tentative claim that provokes multiple perspectives and invites audience resistance or skepticism.

STRATEGIES FOR GENERATING IDEAS

Once you have identified a starting point, you'll need to develop your ideas by analyzing more fully the single text you are writing about or by finding additional texts that can expand, deepen, and challenge your understanding of your research question. In either case, the rhetorical reading strategies in Chapters 3 and 4 should help you generate ideas for your writing project. Here are a few additional suggestions.

- A useful place to begin is to consider your rhetorical situation: Whose minds are you trying to change about what, and why? What kind of information do you need to establish your credibility? How can you make your readers concerned about your topic? What kind of supporting evidence will be persuasive to them? What values or interests do you share with your readers? What differences in opinions or values might you need to try to overcome?
- If you are writing to make a claim about a particular text, reread the text with your starting point in mind and note all the textual details you might use to support your claim. Likewise, look for counterevidence that you will have to account for in some way. Perhaps this counterevidence will cause you to modify your claim.
- If you are assigned to do library or Internet research, consider how a given source will advance your purpose for writing. (Chapter 6 offers extensive advice on both finding and evaluating sources.) As you take notes from the texts you plan to use as sources, consider how you might use each source in your paper. Does this source provide background information? Support for your claims? An alternative perspective? A compelling example or illustration of a point? With answers to these questions in mind, try out various organizational plans by making an informal outline or drawing an idea map of how the materials you've read connect

with each other. This kind of preliminary planning can help you see the "big picture" of your evolving ideas.
- Conferencing with your teacher, peer group, or a writing center tutor is another good way to generate ideas for writing. When you try to explain your rough or tentative ideas to someone else, it's likely you will discover new ideas and connections that you didn't see before. Moreover, your conferencing partners will also ask you questions that will trigger new lines of thinking or enable you to see gaps in your current thinking that may require further analysis or research.

STRATEGIES FOR WRITING A FIRST DRAFT

Good first drafts are usually messy, confusing, and imperfect. Fear of this messiness, or fear of the blank screen or page, often prevents writers from producing idea-generating early drafts and thus reduces the time available for multiple revisions. To get past such fears, it can be helpful to think of first drafts as *discovery drafts*. Their purpose, in other words, is to extend the process of figuring out what you have to say and how to say it. A writer's most original ideas often appear in the final paragraph of these drafts, at the point where the writer discovered them. This is not a problem at the rough draft stage because your goal is simply to start working out ideas. During revision you can reshape these ideas to meet your readers' needs. What follows are some strategies for getting your ideas onto screen or paper so that you can work with them, learn from them, and use them to guide your next steps in writing:

- Try to produce a complete first draft without worrying about perfection or even clarity for readers. When you get stuck, make notes to yourself in caps about ideas that might go in a particular section—a transition, an example, another point in support of your claim, or even just your doubts. If you have a vague idea but can't figure out how to say it, freewrite, again in caps, "WHAT I REALLY WANT TO SAY IS. . . ."
- Another strategy for overcoming the fear of getting started is to "blind write": Turn off the monitor on your computer so that you can't see what you're writing, and write for a while. The idea of blind writing is to silence your internal critic that finds fault with every sentence. What you want to do is get the words flowing so that you can determine how the ideas you have generated so far work, where the gaps are, what is still not clear to you.
- If you have trouble with introductions, try starting in the middle or with a particularly strong or well-formulated point. When you have most of the paper drafted and know what it will say, you can come back and write a focused opening.
- If your paper assignment calls for a particular organizational format—such as a classical argument, a technical report, an evaluative review of literature—use that format as an idea-generating template for producing

various parts of your text. For example, a classical argument includes an introduction that explains the significance of the issue, provides background information, and gives the writer's thesis or claim; a section that supports the claim through a sequence of reasons and evidence; a section that summarizes and responds to opposing views; and a concluding section that calls for action or relates the argument to larger issues. Structures like this can help you build your first draft section by section. The specific requirements for each section will provide you with implicit questions to address in it. When you write out the answers, you'll have a discovery draft.

- Try talking out your draft by having a conversational partner (classmate, writing center tutor, teacher, or friend) listen to your ideas and take notes, or try talking directly into a tape recorder and then transcribing what you said. Since we're more accustomed to talking than we are to writing, we can often discover what we have to say orally better than we can in writing.

STRATEGIES FOR EVALUATING YOUR DRAFT FOR REVISION

Producing an initial draft is only the first step in producing a final polished product. For most college assignments, success requires substantial revision through multiple drafts. Effective revision is not just minor repair or sentence correction but literally reseeing a draft's ideas. As you gain experience as a writer, you will find that the urge to revise begins when, in reading a draft, you discover confusing passages, points that need support and development, contradictions or flaws in thinking, gaps in your argument, places where the text fails to anticipate audience questions or objections, and so forth. Sometimes you will even decide to change your thesis and reorganize. To see these sorts of things requires a critical distance that is not easy to achieve. Therefore, you will benefit from specific techniques that enable you to adopt a reader's perspective toward your own text. Here are some suggestions.

- Try to "listen" to your own text in some of the ways outlined in Chapter 3. Write a descriptive outline of your draft, draw an idea map, or write a rhetorical précis. Because these strategies ask you to take your draft apart in various ways, they will inevitably provide you with a new, more "objective" view of your text and in the process reveal various problems—missing connections among ideas, digressions, gaps, vagueness, and so on.
- Most of us compose on screen these days, but reviewing your draft screen by screen can make you lose sight of the big picture. Instead, we recommend that you print your draft periodically and read from hard copy, annotating it for problems and ideas for revision.

STRATEGIES FOR PEER RESPONSE AND REVISION

One of the best ways to see your text differently is through another reader's eyes. Because you know what you meant to write, it is often difficult to see any gaps or confusing points in what you actually wrote. Other readers, not privy to your inner thoughts, can spot these problems much more readily. A common technique for getting this kind of perspective on your draft is through peer response. Peer response groups allow you to receive feedback from a "live" audience, whether this feedback comes in the form of written comments by a peer or face-to-face response to your draft. The benefits of working in a peer response group go beyond the insights you gain about your own draft; you also benefit from the experience of offering feedback to others. For one thing, you learn to recognize and understand various kinds of writing problems better by seeing them in someone else's writing. This understanding, with practice, helps you detect them in your own writing. In addition, offering constructive feedback helps you develop a language for talking about what's working and what's not working in writing. This language, in turn, helps you analyze your own writing. Put simply, receiving and giving peer response enables you to achieve the kind of critical distance on your own writing that is so crucial to revision.

Tips for Offering Feedback to Others

- Get a sense of the whole before formulating your responses. If the peer is reading a draft aloud, listen to the whole draft before jotting down a few notes. Ideally, you should make your notes while listening to the paper being read aloud a second time so that you can confirm or rethink your first impressions. For convenience, you might record your responses in three columns: positive comments, negative comments, and questions. If you are reading the draft and will write out your response, read the paper through completely, using wavy lines or marginal notes to mark passages that you want to look at again or comment on. A second reading will then help you fill out a peer response form or decide on the most constructive feedback you might offer the writer. If you are not given explicit guidelines for responding, be sure to be selective in your comments. Although you may mark various passages with a question mark or underline a number of confusing sentences, select only two or three major concerns to comment on in detail. When there are too many comments, writers are not sure where to start with their revision. They feel overwhelmed and discouraged rather than motivated to revise.
- Respond honestly and productively. Perhaps the most frequent complaint we hear from student writers about peer response groups is that the responders didn't offer any real feedback but instead offered vague, polite comments.
- Offer your comments from a reader's perspective, not an evaluator's. Instead of saying—"This is illogical"—say "I don't follow your reasoning here. After you offered example X, I was expecting you to come to con-

clusion Y." Or if the paper seems disorganized, explain where as a reader you get lost.

- Make sure that your comments are text-specific, not general. Rather than praising a paper by saying, "I liked your introduction," say "The personal anecdote you started with really captured my attention and made me want to read on." Or rather than saying that "Some points are unclear," identify specific points that were unclear to you as a reader and try to explain what was unclear about them, the questions they raised.

- Ask questions to help the writer generate ideas for clarification and support and to help the writer extend and complicate his or her thinking about the topic. Depending on the paper's aim, you may want to play the devil's advocate and introduce objections or other points of view to help the writer make a more convincing argument.

Tips for Using Feedback to Revise

- When possible, ask for feedback in terms of your rhetorical aim and your own assessment of your draft's rhetorical effectiveness. That is, think about the change you hope to make in your reader's attitude, understanding, or opinion about your subject matter and ask your peer responders whether your text accomplished this purpose. Ask specific questions about passages that you have already identified as potentially problematic. For example, you might ask readers if you need further evidence to support a particular point or if you need to explain an unfamiliar term more fully. Or you might ask if you come on too strong in a given passage or if your tone is appropriate in light of your purpose.

- Try to keep an open mind as you listen to or read through peer responses. That is, try to resee your paper from the reader's perspective. Let go of the urge to defend what you've written. Remember that the feedback from response groups is meant to help you improve your writing and should not be viewed as a personal attack. Experienced writers regularly seek feedback on their writing and understand that it enables them to see their writing in a way they can't on their own.

- Expect to get some mixed or contradictory feedback from peers. Try on these varied and conflicting perspectives to determine what in the text is causing these mixed responses or confusion. If several readers identify the same problem, you should probably try to fix it even if you don't fully agree with the feedback. Ultimately, however, it is up to you to weigh the feedback you receive and decide which responses you will attend to in your revising process.

- Use peer feedback to develop a revision plan. Two considerations should guide your revision plan: (1) what the feedback tells you about this draft's successes and failures, and (2) your sense of which responses are the most important to address first. Generally, you should attend to higher-order concerns (focus, organization, development of ideas, logic) before

lower-order concerns (sentence-level and grammatical and mechanical problems). You might find that problem sentences disappear once you focus on higher-order concerns. By revising for clearer ideas, you may create clearer sentences without grammatical tangles.

STRATEGIES FOR EDITING AND POLISHING YOUR FINAL DRAFT

College professors expect final drafts that are carefully edited and proofread. Editing can be difficult, however, because most of us have trouble seeing the surface errors in our own writing—omitted words, spelling and punctuation errors, wrong or repeated words. We literally fail to see what's on the page, instead substituting what we intended to write for what's there. Consequently, you must train yourself to detect and correct errors in sentence structure, word choice, spelling, punctuation, citation conventions, and grammar or usage. We suggest the following strategies for producing a polished final draft:

- As simple as it may sound, reading your text aloud to yourself or someone else (classmate, friend, tutor) is one of the most effective ways to catch missing words, wrong words, and other kinds of errors. Conversely, sometimes it's helpful to have someone else read your paper back to you. Although there are many errors that you cannot detect through just hearing your paper, you can often recognize snarled or unclear sentences and awkward wording when you hear someone else's voice reading it.
- Another effective strategy is to read through your paper line by line, using another sheet of paper to cover the part of the text you have not yet read. Such a practice slows down your reading and forces you to look at each word and sentence, making it more likely you'll see what's really on the page, not what you hope is there.
- Computer programs now provide a number of editing aids—spelling and grammar checkers. You may want to turn these checkers off while you are drafting because they can intrude on your composing process. Once you are ready to proofread, however, take advantage of them, particularly the spelling checker. But do not rely on them solely to detect the errors in your paper. Spelling checkers, for example, do not detect homonym errors—*its* when you need *it's*—and they don't flag misspellings that turn out to be correctly spelled words that are not what you meant—*cant* for *want*. Similarly, grammar checkers mechanically mark things like passive voice or repeated words that may actually be appropriate in a particular writing context. For example, the computer highlighted the second *that* in the following sentence: "I believe that that is wrong." But this sentence might be perfectly appropriate in a context where what the second *that* refers to is perfectly clear. As a rule of thumb, use such computerized aids as only *one* of several steps in your editing process. Many experienced writers have

an intense dislike for grammar checkers, which can only perform countable calculations and do not actually understand language.

- You may find that having a friend or classmate read over your final paper is a necessary step in your editing process because no matter how careful you are, there are errors that you miss.
- To improve your editing skills, try to keep track of the kinds of errors you habitually make, and try to be on the lookout for these errors as you proofread.
- To check on word choices, punctuation, grammar, and usage rules as well as citation conventions, keep nearby a recently published handbook and dictionary or a CD-ROM reference guide.

Summary

We began this chapter with an overview of five typical types of reading-based writing assignments: writing (1) to understand course content more fully, (2) to report your understanding of what a text says, (3) to practice the conventions of a particular type of text, (4) to make claims about a text, and (5) to extend the conversation. We then discussed the importance of the following:

- Asserting your own authority when you use readings; that is, making your points in your own voice rather than patching together quotes and paraphrases from sources
- Claiming and maintaining your authority as you generate ideas and draft your paper
- Reading and analyzing your own drafts rhetorically so that you attend both to your content ("what") and your methods ("how") as you revise through multiple drafts

CHAPTER 6

Using Rhetorical
Reading to Conduct
Research

*The only way in which a human being can make some approach
to knowing the whole of a subject is by hearing what can be
said about it by persons of every variety of opinion and studying
all modes in which it can be looked at by every character of
mind. No wise [person] ever acquired wisdom in any mode but
this; nor is it in the nature of human intellect to become wise
in any other manner.*

—John Stuart Mill

A
s the opening epigraph suggests, wisdom emerges only through careful examination of many differing perspectives. John Stuart Mill's admonition to hear "every variety of opinion" on a subject, although probably not literally possible to follow, serves as an important reminder that new knowledge is made only through our interaction with the thinking and writing of others, including—perhaps, especially—those with whom we do not expect to agree. In this chapter we address the difficult challenge of finding and selecting materials that will provide you with reliable and diverse perspectives on the questions and issues you investigate for college writing assignments. As our chapter title suggests, our intent is to demonstrate the value of rhetorical reading as a research strategy.

This chapter will show you how to use rhetorical reading strategies to handle the challenges you face when you need to write a paper that synthesizes material from outside readings, challenges such as (1) finding sources that speak directly to the questions your paper seeks to address, and (2) evaluating the reliability of potential sources. The next chapter will then demonstrate practical techniques for incorporating material from your sources into your own writing

so that your papers make new knowledge out of your diverse sources. Together, the two chapters will show you how to find sources for and write rhetorically effective papers that contribute your voice and ideas to extend the conversation about a topic.

First, we show how to formulate initial research questions and predict where you will find the best materials—before you even begin looking for sources—through a systematic process called *question analysis*. The middle section of the chapter provides background information contrasting search tools (library databases and Web search engines) and publication contexts for various types of print sources. Finally, we show how you can evaluate potential sources by asking questions about relevance, currency and scope, authors and experts, and publishers (of print sources) and sponsors (of Web sources). We will illustrate our discussion by following the work of Jenny, the composition student working on Larissa MacFarquhar's "Who Cares If Johnny Can't Read?", as she responds to the writing assignment below. Her final essay—a researched argument entitled "Romance Fiction: Brain Candy or Culturally Nutritious?"—appears at the end of Chapter 7.

JENNY'S ASSIGNMENT TO EXTEND THE CONVERSATION

Here is the writing assignment Jenny received to evaluate a particular genre of reading or television. The assignment invites students to "extend the conversation" by contributing their own ideas to an ongoing conversation initiated by other writers. (For additional discussion of evaluative writing, see the introduction to Chapter 13.)

> In the last paragraph of "Who Cares If Johnny Can't Read?" Larissa MacFarquhar poses the following challenge to readers: "Reading *per se* is not the issue. The point is to figure out why certain kinds of reading and certain kinds of television might matter in the first place." Write a paper in which you extend the conversation introduced by MacFarquhar's challenge. Choose a particular kind of reading with which you are familiar—romance fiction, science fiction, detective fiction, inspirational books—or a kind of television program—the Nature channel, police dramas, reality TV—and ask these questions: Is this kind of reading or television culturally valuable? If so, how? If not, why not?
>
> Your paper should include the following: a working definition of "cultural value" and criteria for judging it; your own experience with this kind of print or media text; and the published opinion of others regarding its cultural value. It should be four to six pages long and include MLA in-text citations and a works cited list.

Formulating Questions

Knowing what you are looking for is essential to successful research-based writing. Whether you are fulfilling an assignment for a first-year writing class or for a capstone seminar in your major, the first step in your research process—the step

before you begin searching for sources—is articulating your purpose: What is it that you want to investigate and write about?

CLARIFYING YOUR PURPOSE

When you are doing research for a writing assignment, your goal is to find source readings that will support your writing project in two basic ways: (1) by helping you uncover and understand the ongoing conversation about the subject, and (2) by providing information and concepts you can use to develop your paper. The question analysis process that we describe in the next section will help you determine in advance what you will be "listening" for once you begin looking at sources. In Chapter 2 we described how experienced readers approach their reading purposefully and predict content by recognizing genre conventions and reconstructing rhetorical context. Similarly, experienced researchers go to the library (perhaps via their Internet browser) with more than a generalized "topic" in mind. They begin with a carefully worked out question and a set of expectations about how they will recognize relevant answers. You need to do the same. As your research progresses, you will probably revise your original question, narrowing or broadening it as you catch the drift of the ongoing conversation about it. (Most researchers—not only students—find that they must narrow their initial questions significantly just to make their project feasible for the amount of time available and the number of pages allotted for the assignment.) Your question will undoubtedly change somewhat as your project unfolds until it eventually becomes part of your paper's introduction. Combined with the answers you find, it will lead into your thesis statement to signal your paper's purpose to your readers.

But first you need the question. How else will you recognize answers?

In the past, you may have encountered research assignments that asked you to do little more than report on a topic by gathering information and funneling it into paragraphs. The expectations and standards of your college teachers who assign papers with research components will be quite different. In the language of our service economy, these professors expect you to provide "value-added" content that demonstrates your own thinking about the subject of your paper. The information you need for your paper is "out there" in publications and on Websites; indeed, we are awash in information. But what it means is not always apparent. Your task, like that of the writers in the workplace scenarios in Chapter 5, is to survey the raw data of the information you collect, discover patterns of meaning within it, select relevant material from it, and then explain that material's significance to your readers. The value you add comes from the analysis and organization you provide to help your readers make sense out of the disconnected array of available information.

This multilayered researching/reading/writing process involves rhetorical reading at its most challenging. In our electronic information age, where thousands, even millions, of research sources are available within seconds of a mouse click, locating information is only a small step in the research process. Some new college students make the mistake of thinking that, with so much information

available, researching a paper is a quick, easy matter. It's true that computers make it easy to obtain potential source materials. With the full text of many magazine and journal articles available through library databases such as EBSCOhost, Lexis-Nexis, or ProQuest, it's possible to collect many sources without even looking up a call number and going to the stacks. But making sense of the information in all those potential sources presents a wholly different challenge.

Think of research-based writing assignments this way: Your job is to conduct an inquiry, not to shop around for sources. We offer a cautionary tale. Consider what went wrong when a student we'll call Stacey treated a research assignment as a hunt for bargains instead of an inquiry. Her assignment was an explanatory paper that would examine the potentially negative consequences of something that interested her. She had heard that Barbie dolls were being redesigned to have more natural proportions, so she thought Barbies would be an interesting "topic." She skipped the assigned step of writing out an initial question because, as she wrote in a later reflection, she thought that since Barbie was in the news, it would be faster just to do some computer searches and see "what there was to say." She felt overwhelmed at first by all the sources she found in just one periodicals database, so she just chose the first three articles for which full text was available online.

The result was a paper that amounted to the "patch-writing" we caution against in Chapter 5. It interspersed engaging descriptions of her own favorite Barbies between three long paragraphs that summarized a feminist's reflections about her childhood dolls, a psychological study about gender stereotypes and eating disorders, and a commentary about the negative impact of Teen Talk Barbie's dislike for math class. There was nothing about Barbie's new figure, her original topic. The descriptions of Stacey's dolls were fun to read and showed that she was a fluent writer with a good vocabulary. But other than that, the paper was three long, loosely connected summaries. It lacked purpose. Stacey had not defined a purpose for her reading and research, and so she did not have one for her paper.

QUESTION ANALYSIS

What could Stacey have done instead? The question analysis (QA) technique we recommend is a systematic examination of your initial research question in terms of what you already know about your subject matter and what you hope to find out by doing research.* The QA prompts that follow will enable you to make a preliminary map of the terrain you need to cover so that you can plan your research and consider in advance what kind of sources are going to be most useful for you to retrieve, read, and eventually integrate into your paper. Because QA is preliminary to your active search for sources, just as note-taking and

*The term *question analysis* comes from the work of academic librarian Cerise Oberman, who first broached it in "Question Analysis and the Learning Cycle," *Research Strategies* 1 (Winter 1983): 22–30.

freewriting during planning stages of the writing process are preliminary to ac-
tive drafting, it will help you begin your actual searching with a focused sense of
purpose. Then you can use your rhetorical reading skills to select the sources most
relevant to your purposes. Students who use QA for the first time are often sur-
prised to discover how much they already know about where they are likely to find
relevant sources and what issues those sources will raise. The QA process takes you
out of a passive role like Stacey's, waiting to see what you can find, and puts you
in charge of your research.

Prompts for Question Analysis

Jot down answers to these questions *before* you begin searching for sources.

1. What question do you plan to investigate in this paper?
2. What makes this question worth pursuing?
3. What kind of expert would be able to provide good answers or the cur-
 rent best thinking about finding answers? (Perhaps a physician? Wildlife
 biologist? Water resource engineer? CPA? Social worker?)
4. Where do you expect to find particularly good information about the
 matter? General interest publications? Specialized publications? Are you
 aware of a specific source with material relevant to your needs?
5. How recent must materials be to be relevant? What factors might make
 information outdated (such as a congressional election or the announce-
 ment of important medical findings)? Do you need information recorded
 before a particular event? For situations that change rapidly, such as AIDS
 research or foreign policy, even a few months could make a difference in
 the relevance of some material to your project. Defining a particular cal-
 endar period will help you search more efficiently.
6. What individuals or interest groups have a major stake in answering your
 question in a particular way? For example, players' unions and sports
 team owners look at salary caps from different perspectives; lumber com-
 panies and environmental activists evaluate the effectiveness of the En-
 dangered Species Act differently.
7. What kinds of bias do you need to be especially alert for on this particu-
 lar question? Neutral sources are valuable, but bias of some kind is un-
 avoidable, so it's important to recognize how it is operating in your
 sources.
8. Finally, jot down some words or phrases that you might use to begin
 searching.

The first two QA prompts ask you to jot down not only the question that you
will address in your paper, but also your reasons for pursuing that question.
Thinking carefully about the importance of your question will help you negoti-
ate complexities you may find in your sources. For academic writing projects, a
question with an obvious or simple answer is probably not worth investigating.
You'll want to choose a question without clear-cut answers. Perhaps experts
have been unable to discover an answer or are at odds with each other because

of different values, political perspectives, or research approaches. Ask yourself also why pursuing the question is important. What benefits will come from answering the question? What readers are interested in the question? Why are you yourself interested in the question? Whatever your purpose, if you clarify it for yourself in advance, you will greatly reduce the risk of losing sight of your purpose once you dive into the search process. To illustrate the QA process, we invite you to examine the following excerpts from Jenny's answers to the QA prompts.

EXCERPTS FROM JENNY'S RESEARCH LOG

Question Analysis

1. My question: How do people defend romance novels? (I'm assuming some people do!) What do they say is the value of them? What criteria do they use? Maybe I have to set up criteria, but I'd like some experts to base my ideas on and use for support!

2. Why it's worth pursuing: Because (1) MacFarquhar uses romance novels as an example, so they'll fit the "extending the conversation" idea, (2) lots of people read them—including me, sometimes, (3) I need to understand what my future students might be reading. . . .

3. Experts I need: teachers, librarians, maybe that Center for the Book that LM mentions

4. Sources I think will work: I hope there will be good material in regular newsstand magazines, possibly women's magazines, maybe magazines/journals for teachers & librarians.

5. Dates? They have to be pretty current, from 1997 (LM's article) to now.

6. People with a stake in this: teachers, except I don't know which way they'd lean. Some of my teachers thought they were OK!

7. Bias to watch for: Publishers and bookstores—they want to sell books, no matter what kind. I have to watch out for material that's just hyping romance writing. Would data about bestsellers prove cultural value? Probably not. Need to find serious discussion, not just somebody arguing back at MacFarquhar.

8. Words for searching: "romance novels" (obviously), "reading" ?? (possibly too broad) "readers" ?? Maybe look for reviews of books by specific authors—Nora Roberts, Amanda Quick—and see how reviewers talk about them for evidence of cultural value. Look for author names on bestseller list? Ask at bookstore?

• FOR WRITING AND DISCUSSION

Working individually or in small groups, use the question analysis method to develop a more productive approach than Stacey's for researching a paper about the potential negative effects of Barbie dolls.

1. Start by brainstorming a few possible research questions. Then choose one that you consider significant to use for practicing all eight steps of the QA method.
2. Compare notes with other classmates or groups to see how many different approaches to the subject your class can come up with. •

Planning Your Search: Background Information

The QA prompts asking about experts, publication type, controversy, and bias all draw attention to matters that are important for rhetorical reading: the credibility, intended audience, and evident purpose of the sources you might examine. Initial clues about these matters will often be evident in the basic bibliographic information for a source. In other words, the same information that helps you locate materials may also help you quickly assess the reliability and relevance of a potential source. That assessment will in turn help you make good decisions about how far you want to pursue retrieval of that source.

The background information we provide here about the kinds of sources you might retrieve will help you use the QA questions and the questions for evaluating sources in the next section. At the end of the chapter we include more excerpts from Jenny's research log to illustrate how one student applied these guidelines to her own work. As you look over Jenny's log entries, note that as she sifts through potential sources and refines her purpose she continues to ask questions.

PUBLICATION CONTEXTS

QA questions 3 and 4 ask you to consider—before you start searching—what types of materials to look for and where you might find them. In general, your preferred sources should be those that have undergone solid editorial and fact-checking processes. Whether you access your materials in the library stacks, through an electronic library database, or through a Web search engine, you must scrutinize their contexts and purposes for relevance and reliability. We recommend searching your library's catalogue and periodicals databases before jumping on the Web, which contains garbage as well as gold. It can be difficult to assess the credibility of Web authors or the motives of a site sponsor; furthermore, the Web's global reach and the vastness of its contents make finding relevant and reliable overviews difficult. For example, when Jenny did a Web search for "romance novels," she turned up 147,000 hits, which a quick sampling suggested were mostly book lists and fan mail.

The abundance and immediacy of information now available through the Internet make careful scrutiny crucial to your research work, especially during the early stages of your research, when your main goal is to catch the drift of the published conversation relevant to your research question. Once you have read some good overview materials from sources you know are reputable, you will be more adept at judging whether the opinions expressed on an impressive Web page or in a Web log (or "blog") are grounded in genuine expertise. As knowledgeable as some of those opinions might seem, as enjoyably irreverent as critiques of media icons on "watchdog" Websites such as Cursor.org or the Media Research Center (mrc.org) might be, these assertions usually come directly from just one person, with no intermediaries to check facts or calm him or her down. Whether you are reading in print or on line, the more you feel like someone is shouting, or the more ads that come along with the source, the more cautious you need to be. For academic papers, you need sources with a calm, evenhanded approach.

For currency and reliability (but not always evenhandedness), periodicals with large circulations and good reputations are your best bet. The editorial process at national newspapers, magazines, and journals is typically rigorous, more rigorous than for most materials that appear only on the Web. This editing work represents major investments of time and money. It involves multiple readers, fact-checking, quote-checking, and even background-checking of sources who are quoted. With so many people not only checking content but staking their professional reputations on quality and credibility, such materials clearly deserve preference. This is not to say that there are no reliable materials on Websites. Many Web materials have undergone rigorous editorial processes, and print periodicals often publish archives and major articles on the Web. But for the sake of efficiency in both searching and evaluating, we recommend print periodicals for their consistent reliability.

LIBRARY DATABASES AND WEB SEARCH ENGINES

Library databases (such as ProQuest or Lexis-Nexis) and Web search engines (such as Yahoo! or Google)—all at your command from a desktop computer—will lead you to significantly different types of material because they search entirely different parts of the Internet.* Libraries pay substantial subscription fees for the database services that give you access to electronic archives of material that has appeared in print periodicals—magazines, scholarly journals, and major newspapers. "We pay for quality," librarians at both public and university libraries commonly stress at student orientations. In contrast, Web search engines search the free access part of the Internet. You can use these engines without charge because their revenue comes from advertisers. When you enter keywords in the search box of one of these engines and click "search," the software scours

*We follow the practice of using "Internet" to refer to the entire network of linked computers around the world and "Web" to refer to material available through the graphical interface used by browsers such as Netscape and Internet Explorer.

computers around the globe—all the computers linked to the free access portion of the Web—to find postings that include your word or phrase. Every item or "hit" on your results list represents a place on one of those computers where the words are found. Within seconds you can accumulate an overwhelming number of potential sources, most of them unreliable and unrelated to your purposes. Indeed, even those links that do appear helpful might no longer be working, or might take you to a Website where a promising article or report is no longer available.

In contrast, clicking "search" in a database to which a library subscribes sets off a search of the indexes and archives of sources recommended by experienced researchers and experts in a wide variety of fields. The focus is primarily on print sources, but some databases have begun to index materials from radio and TV broadcasts, particularly public radio and television. Even if a transcript isn't available in the database, the abstract's information about a date and program may enable you to find the audio or video via the network's Website.

Some specialized databases are available only on CD-ROM in the library itself, but the extensive general interest databases are stored on computers that may be miles away from the library, computers that while conducting your search might also be conducting a search for your best friend from home, who is attending school in another state. When you use these databases from campus, they may seem as free of cost as a Web search engine; however, be assured that libraries do pay subscription fees to the database companies. That is why access is often limited or restricted off campus.

PRINT PERIODICALS AS A STARTING POINT

Librarians usually recommend that student researchers begin a research project by using a periodicals database to look for relevant magazine and journal articles. These materials are easy to access, efficient to use, and more current than books, which take a long time to write and manufacture.

Periodicals databases are indexed according to traditional bibliographic categories (author, article title, publication title, etc.) as well as specialized search terms connected to subject matter. When you enter search terms, the computer checks these indexed categories as well as article abstracts, a process that results in a list of bibliographic citations with the titles and brief abstracts of relevant articles. These lists are usually much smaller and more manageable than those produced by Web searches. As you will see in the next section, rhetorical readers can pick up important evaluative cues from this material.

A bonus of database searches is that most of the citations on a results list will include all the article's official subject terms, which often offer valuable clues about a more efficient way to conduct your research. For example, if you have been using the term "capital punishment" or "secondary school," you might discover that "death penalty" or "high school" would yield more extensive or focused results in that database. However, manipulating subject terms and doing advanced searches can be a complex and frustrating business. If you aren't getting the results you expect, ask a librarian for help.

General Interest and Specialized Periodicals

Your ability to understand your sources will be important to the success of your project, so you need to find material written at a suitable level of expertise. You can count on being able to read general interest publications comfortably, but if they seem oversimplified (perhaps even sensationalized) or don't provide the depth of information you are looking for, try a newsstand periodical that provides in-depth discussion for the general public on certain topics, such as *Sports Illustrated*, *American Health*, *Money*, or *Psychology Today*. These can be good places for a student researcher to find extended but readily understood material. Be forewarned, however: The more specialized the publication, the greater the likelihood that you will find it difficult to understand, either because the material is too technical or because the author assumes readers are more familiar with the subject than you are. If your question has been addressed only at these high levels of scholarship, you will probably need to revise it.

Scholarly Journals

In the academic world, the most highly regarded periodicals are peer-reviewed journals, also known as *refereed journals*. Articles published in them have been approved by several experts as meeting high scholarly standards and contributing to new knowledge. These high levels of credibility make these journals excellent sources for college papers. The drawback is that material written for experts and scholars may be difficult for readers outside the field to understand. However, the abstracts and literature reviews that are standard in this genre can often provide helpful background. Furthermore, even if you cannot understand all the details in material from scientific journals such as the *New England Journal of Medicine* or *JAMA,* reading the abstract, background, and conclusions sections of a study may provide you with better insights than you will find in a newspaper report of that same study.

Evaluating Potential Sources

In this section we offer specific questions to guide your evaluation of texts you are considering as sources for a research project. These questions show how to apply your rhetorical reading skills to infer the original context and purpose of potential sources. Your understanding of a source's context and purpose will give you a basis for answering the following questions:

- How will this source help me answer my research question?
- How can I use this source in my own writing?

QUESTIONS TO ASK ABOUT RELEVANCE

You can determine many basic relevance issues from the bibliographic information you will find in library catalogs and databases. (For Web sources, however, we recommend that you examine the actual source, not just the link supplied by the search engine.)

To evaluate a potential source's relevance to your project, you need to ask three basic questions about its purpose and method.

1. *What ideas and information does this text offer?* For answers about a print publication, examine the title, subtitle, and abstract in the bibliographic citation. Also note carefully the title of the magazine or journal the article appeared in, or, if the publication is a book, note the publisher. What you already know or can discern about the intended audience of the periodical or the book publisher will indicate the article's approach.
2. *Can I trust the source of information?* Consider what you know or can gather about the author's and the publisher's or Web sponsor's credentials and reputation. For Web sources, if there's no evidence of a reputable site sponsor, don't use the source.* (Material from an individual's home page isn't usually acceptable for academic papers, no matter how impressive it may appear.)
3. *Will I be able to understand what the source says—was it written for someone at my level of expertise?* Draw inferences about the intended readers from the title, publisher's reputation, and abstract, then spot read as needed. If the article is full of technical material, concentrate on making sense of the abstract, the literature review, and the conclusions sections.

QUESTIONS TO ASK ABOUT CURRENCY AND SCOPE

Take your evaluation further by using bibliographic information about date of publication and length to determine how usable the material is for your purposes. Abstracts, if supplied, will frequently help you catch a publication's tone and scope, but in many instances you may have to find paper copy that you can skim to see if you want to read the source in detail. Use the following questions as a guide:

1. *How current is the source?* You will usually want the most recent information available, but if you are researching a historical phenomenon, "current" doesn't necessarily mean "recent."
2. *How extensive is the source? How much detail is present? What kind of evidence is used?* A twenty-page article contrasting American and Japanese management styles might be just what you need, or it might be far too detailed for your purposes. A cheery three-paragraph piece in *Glamour* or *GQ* about the value of regular dental checkups might enable you to make a

*"Site sponsor" refers to the organization sponsoring the Web page, not to advertisers who may be listed on it.

point about dental education in popular magazines, but it probably won't tell you much about how well people take care of their teeth or the quality of available dental care.

QUESTIONS TO ASK ABOUT
AUTHORS AND EXPERTS

Your background knowledge about subject matter and sources will often help you answer questions about the trustworthiness of an author or expert. When you need more information, look for quick answers within the bibliographical data about the source, then try other available search tools as explained below. Once you have selected certain materials to read in depth, use those texts to consider again the following questions about credibility:

1. *What are the author's credentials and qualifications regarding the subject?* If you recognize the name, it will tell you a lot. But if you don't, see what you can tell about this person's professional expertise. An abstract or a note at the end of a full text article may supply biographical information. Is the writer an expert in the field? A journalist who writes about the subject frequently? A quick search by author (perhaps via a click on the name) will show you what else this person has written recently. You might discover, for example, that the author of a piece on rap music regularly writes about the business side of the entertainment industry. This discovery may signal that the article is not likely to help you if you plan to write about rap's roots in the African American folk tradition, but if you are interested in how rap has been marketed or how it fits into the larger entertainment market, looking for additional articles by this author may lead to just what you need.

2. *What are the credentials and qualifications of experts who are cited?* In journalistic pieces, the writer's expertise is probably less important than that of the sources interviewed. Gathering information about the people quoted usually requires skimming to see what background information is supplied. Looking for material written by those experts can lead to more in-depth sources.

3. *What can you tell about the writer's or expert's political views or affiliations that might affect their credibility?* You are more likely to uncover this information in the text than in the citation. (Much of the time you have to use your rhetorical reading skills to infer the writer's ideology—see Chapter 4.) If the purpose of your paper dictates that you find out more about a writer's ideological biases, a quick search in *Books in Print* or in a biography database, or on the Web will probably tell you what you need to know. You might learn, for example, that a particular writer recently received an award from the American Civil Liberties Union or that a medical expert interviewed about the dangers of plastic surgery is a well-known celebrity doctor. It will be up to you to determine the extent to which this

information adds or detracts from the person's credibility in relation to your research project's purposes.

QUESTIONS TO ASK ABOUT PUBLISHERS AND SPONSORS

Crucial information for evaluating a source can become apparent when you examine the purposes and motives of its publisher. Whether you are considering a paper or online source, it is important to consider how and why the material has become available in the first place. These questions about audience, review process, and reputation will help you round out the process of evaluating your sources.

1. *What is the periodical's target audience? Is this a well-known general interest magazine or is it a little-known journal for a specialized audience? Is it known for providing good information about the subject that interests you?* If you are researching antidepressants, for example, you will find that articles in popular magazines are often upbeat about their value. You'll probably find more reliable information about the potential side effects of drugs in medically oriented journals.

2. *How extensive a review process did the article have to undergo before the text was published? Is it from a scholarly journal?* Most Internet materials have not undergone any editorial screening. But not everything on the Web is posted by individuals. As increasing numbers of print periodicals, particularly newspapers, post material on the Web, you will be able to rely on their editorial processes. Nevertheless, it's important to remember that most general circulation publications are driven by marketplace concerns. Their editors choose articles that will help sell copies (or draw eyeballs) because circulation increases advertising revenue. Be alert for overstatement.

3. *Is the publisher or site sponsor known to have a viewpoint that might influence its coverage of material relevant to your question?* Pay attention to liberal and conservative political biases, for example, not because you can avoid bias but because you may want to be sure to consult sources with different leanings. A wide variety of nonprofit, public service, and governmental entities have extensive and useful Websites. You must determine how the organization's mission may influence its Web presentations. If you use material from an organization known for supporting certain causes or positions, scrutinize it carefully and be sure to let your own readers know any relevant but nonobvious information about the source's reputation.

MORE EXCERPTS FROM JENNY'S RESEARCH LOG

To illustrate how a student might apply these evaluation strategies to her own research project, we conclude this chapter with more excerpts from Jenny's research log.

Evaluating Sources
My Searches

"Romance novels" and "Romance + reading" led me to lots of articles in Publishers Weekly about publishing trends (more emphasis on romance novels from a multicultural point of view, for example) and specific authors. But I don't want to write about the commercial side of this.

Most Relevant Article So Far

TIME, 3/20/2000, "Passion on the Pages" – Paul Gray and Andrea Sachs. (EBSCOhost). Abstract suggests it's much more factual and analytical than the catchy title, but that's TIME. Definitely trustworthy and written for the general reader. It includes reports from a survey. I e-mailed full text to myself.

Currency and Scope? Yes, well-known magazine, fairly recent (more recent than LM, so it's an update!).

Author and experts quoted? Yes. Stats from the Romance Writers Association (self-interested?) and interview of a famous author, Nora Roberts (!). Paul Gray, author of article, writes book reviews for almost every issue of TIME. This is solid.

* * *

Still to Do

- I want to check out the Web page I saw mentioned in an Entertainment Weekly article: theromancereader.com.
- Find book reviews. Where? Do newspapers review romance novels? Seems like a good place to get an everyday view. Check.
- I saw a Library Journal article that reviewed TWO reference books about romance novels. Didn't print it out because I'm not sure how relevant it is. Depends. How could these reference books add to my points about cultural value?
- Most of all, I need to find something related to teaching and education!! Nothing's working on the databases. These books are so popular with

teenagers, people MUST have written about whether to use them in schools. <u>Ask a librarian where I should look</u>.

Summary

This chapter has described how rhetorical reading skills will help you succeed in two of your key tasks as a researcher: formulating questions and evaluating resources. Because college teachers expect students to demonstrate their own thinking about a given research question, successful academic papers are those in which the student's claims and commentary are more prominent than their research sources.

To assist your preresearch and research processes, we discussed the following:

- Question analysis (QA) prompts to use before you begin your active search for sources
- The differences between searching for sources through library databases and using Web search engines
- The differences in publication and editing processes for different kinds of print sources

We then recommended that you evaluate potential sources by applying questions about the following:

- The relevance of a text's purpose and method
- A text's currency and scope
- The background and reputation of authors and experts
- The credibility and likely biases of publishers and Web page sponsors

To illustrate these processes, we provided excerpts from Jenny's research log.

Making Knowledge: Incorporating Reading into Writing

The mind in action selects and orders, matches and balances, sorting and generating as it shapes meanings and controls their interdependencies.

—Ann E. Berthoff

I n this chapter we address one of the biggest challenges in college writing: incorporating other texts into your own without letting them take over. The techniques we present here will help you foreground your sense of purpose and thus to author strong, rhetorically effective texts. As we have stressed in the preceding chapters, composing a text is an opportunity to add your voice to the ongoing conversation about a particular topic. Your readers, whether your peers or your professors, want to read what *you* have to say, not a rehash of what others have said. Our warning against "passive writing" in Chapter 5 urged you to take an active role in analyzing how the goals and methods of your source materials fit with your purpose for writing. In Chapter 6, we provided guidelines and evaluation questions for selecting source materials directly relevant to the questions that shape your research inquiries. We now turn to specific techniques for using these materials to extend and develop *your* points and for making the distinctions between your ideas (and words) and your sources' ideas (and words) absolutely clear to your readers.

First, we offer guidelines for three methods of incorporating source material into your own writing: summary, paraphrase, and quotation. Your careful use of these techniques will help you avoid the "patch-writing" we described in Chapter 5 and steer clear of any hint of academic dishonesty or plagiarism. Next we explain how to use attributive tags and in-text citations to connect your sources to your own argument. We also show you the rhetorical value of attributive tags for enhancing your own credibility and guiding your reader's response to your sources. In the second half of the chapter, we provide guidelines for in-text

parenthetical references in the formats of both the Modern Language Association (MLA) and the American Psychological Association (APA). (Explanations and guidelines for creating bibliographic lists of sources in both formats are provided in the appendix, Building a Citation with MLA and APA Formats, along with numerous model citations.) At the end of the chapter, Jenny's "extending the conversation" paper, "Romance Fiction: Brain Candy or Culturally Nutritious?", which uses MLA format, illustrates many of the principles we discuss.

Summary, Paraphrase, and Direct Quotation

The effective use of sources in your papers will enable you to position your ideas in relation to those of others and will establish your credibility as an informed writer. Success in this aspect of your writing will be measured by your ability to incorporate the words and ideas of others judiciously (keeping readers' attention on *your* points), smoothly (using clear, grammatically correct sentences), and correctly (representing the points and language of your sources without distortion). In the next few pages, we will discuss in detail three techniques for accomplishing these goals: summary, paraphrase, and direct quotation. We summarize our advice in Table 7.1 (p. 135). Because each technique serves a useful and distinct purpose, you should become adept at all three so that you can choose the one that best suits your purpose. The way that you use sources in your texts should be a careful rhetorical choice.

USING SUMMARY

Summary is probably the most common way of incorporating a source in your own writing. As we described in Chapter 3, when you summarize all or part of another writer's text, you present in your own words a condensed version of that writer's points. It is best to introduce a summary of others' work with an attributive tag alerting the reader to the fact that what follows comes from an outside source, and you must provide an accurate reference that pinpoints where others can find that source.

Summarizing is an especially effective rhetorical strategy in the following situations:

- When the source directly supports your thesis, or alternatively, when the source offers a position you wish to argue against or analyze
- When the source offers important background information for your ideas
- When you need to provide readers with an overview of a source's whole argument before analyzing particular ideas from it
- When you want to condense and clarify information from a source

The length of your summary will depend on its location and function in your paper. Your goals for your paper will dictate how much of a source you need to summarize. Usually it's better to summarize only material that is directly relevant to *your* purpose. (See pp. 58–60 for more details about summaries.)

Let's examine two different uses of summaries in Jenny's two papers about Larissa MacFarquhar's article, "Who Cares If Johnny Can't Read?" The first comes from the opening paragraph of Jenny's rhetorical analysis paper at the end of Chapter 4, "Caring If and What Johnny Reads." Notice how the summary gives readers a context for the analysis that will follow. Jenny's one-sentence summary nutshells MacFarquhar's whole argument.

SUMMARY EXAMPLE 1

As the attention-getting title of her essay suggests, MacFarquhar questions some common assumptions regarding reading, specifically that Americans read less than they used to and that reading books is better and more intellectually stimulating than watching television or surfing the Internet.

Our second example is a longer summary from paragraph 6 of Jenny's paper at the end of this chapter, "Romance Fiction: Brain Candy or Culturally Nutritious?" Jenny uses this summary to set up a series of paragraphs that will discuss in detail an article by Carol Ricker-Wilson, a high school teacher who uses romance novels in her classes. Ricker-Wilson is one of several experts Jenny uses to support her claim that romance fiction has cultural value.

SUMMARY EXAMPLE 2

Although not a romance fiction reader herself, Carol Ricker-Wilson, a high school English teacher, offers an interesting perspective on the potential educational value of romance novels in "Busting Textual Bodices: Gender, Reading, and the Popular Romance." Writing in the English Journal for teachers who think of romances as "escapist trash" (58), Ricker-Wilson argues that this widespread belief blinds teachers from seeing romance fiction's personal value to their students and its possibilities for classroom use.

The summary's opening sentence introduces Ricker-Wilson's credentials, which are of key interest here because she is an English teacher, someone whom readers would probably expect to condemn romance fiction. Ricker-Wilson's authority adds authority to Jenny's paper. The summary's second sentence articulates Ricker-Wilson's core point, which Jenny goes on to develop through additional summary as well as paraphrase and a few brief quotations.

We offer two cautions about writing summaries. First, you should summarize only the points that are essential to your purpose. Even though summaries may vary in length, summaries that are too long or that cover too many points will distract readers from your purpose. Second, make sure that your summary fairly and accurately represents the original text's meaning. Be on guard against

distorting the original to make it fit your argument. Ask yourself whether the original author would consider your summary to be fair and accurate.

USING PARAPHRASE

Paraphrase involves a more detailed presentation of the ideas from a source. Because paraphrases follow the original wording closely, you must include the page number, if one is available, when you cite the source. Unlike summaries, in which you condense the original text's ideas, paraphrases restate in your words all of the original passage's points. Often, they are as long as or even longer than the original, so it is best to paraphrase only short passages.

Paraphrasing is a particularly valuable rhetorical strategy in the following situations:

- When you want to emphasize especially significant ideas by retaining all of the points or details from the original
- When you want to clarify ideas that are complex or language that is dense, technical, or hard to understand

Because paraphrase involves closely re-presenting the original text, you must take care not to give the impression that these are your ideas. Putting someone else's ideas into your own words does not make these ideas your own. To paraphrase effectively and ethically, you must translate the writer's wording entirely into your own words and acknowledge the source with an attributive tag and a citation.

To illustrate the process and rhetorical effects of paraphrasing, we invite you to consider the parallels and variations between a passage from the Ricker-Wilson article on romance fiction and a paraphrase of it from Jenny's paper about romance fiction.

GUIDELINES FOR EFFECTIVE PARAPHRASE

☐ Avoid mirroring the sentence structure or organization of the original.

☐ Simplify complex ideas by pulling them apart and explaining each smaller component of the larger idea.

☐ Use synonyms for key words in the original and replace unfamiliar or technical vocabulary with more familiar terms.

☐ As a check, try paraphrasing the passage twice, the second time paraphrasing your own paraphrase; then compare your second paraphrase with the original to make sure that you have sufficiently recast it into your own language.

RICKER-WILSON'S ORIGINAL PASSAGE

But while a number of researchers such as Radway and Christian-Smith have maintained that romance reading operates primarily as an unfortunate but justifiable effort to escape from the adversities of real heterosexual relations, it may also offer an escape from what its readers construe to be even less favorable depictions of women in other genres. Fundamentally, I would argue, romance readers *really like to read,* they like to read about women, and they don't want to read about their unmitigated despoliation and dispatch. But once readers venture out of the formulaic romance genre, fiction is a wild card and identification with female protagonists an emotional risk.

JENNY'S PARAPHRASE

Ricker-Wilson acknowledges that some researchers claim that romance fiction provides women readers with escape from their difficult relationships with the men in their lives. She counters this negative view by proposing that romance fiction permits readers to escape something even worse: the negative images of women in other literature. She argues that readers who enjoy romance novels do so because they enjoy reading about women but do not like to read about women who are victimized or killed off, as they often are in other forms of fiction (58).

Jenny's paragraph accomplishes the two important goals of paraphrase. It elaborates and thereby emphasizes two significant and surprising ideas from Ricker-Wilson: that reading romance fiction to escape might actually be a positive thing and that reading other types of fiction might actually be a bad thing for young women. Furthermore, her paraphrase recasts the scholarly language of the *English Journal* article into more everyday terms.

Paraphrasing difficult ideas or dense passages is a good way to help your readers understand the material as well as to demonstrate your own understanding of it. However, recasting scholarly or technical language can be difficult, so we offer some cautionary advice. First, take care to avoid the problem of inadequate paraphrase. If your paraphrase is too close to the original wording, you may open yourself to a charge of plagiarism. Second, to avoid the potential problem of inaccurate presentation, be sure you fully understand any passage you are paraphrasing. One valuable technique is to imagine how you would convey the gist of the source's point conversationally. If you can't move beyond the words of the original, it's likely that you need to obtain a better understanding of the ideas before you use them in your paper. Although students sometimes try to get around this difficulty by quoting entire passages, this tactic can actually make matters worse. Long quotations can suggest that you find the original points so daunting that you can't put them into your own words. As with summary, be concise: Paraphrase from the original only what you need to develop your points. A long paraphrase can draw so much attention to itself

that it distracts the reader. Keep readers' focus on your ideas about how the source material fits your points.

USING DIRECT QUOTATION

Direct quotation inserts the words of someone else into your own text. Whenever you use another writer's exact wording, you must mark the beginning and end of the passage with quotation marks and provide as precise a reference to the original source as possible. Used selectively and sparingly, quotations strengthen your credibility by showing that you have consulted appropriate authorities on a particular subject. However, quoting too frequently or using unnecessarily long quotations in your text can actually undermine your credibility. Overreliance on direct quotations weakens your authority and suggests that you have no ideas of your own to contribute to the conversation.

Direct quotations are most effective in enhancing your credibility in the following situations:

- When the language of the source is vivid, distinctive, or memorable
- When the quotation directly supports a key point in your paper
- When the person quoted is such a well-known authority on the matter that even a few well-chosen words carry considerable weight

To demonstrate the importance of these guidelines, we present two versions of a passage from Jenny's paper on romance fiction. When she first composed the paper, Jenny included in the fourth paragraph the following long quotation from MacFarquhar to illustrate derogatory views of romance fiction.

INEFFECTIVE LONG QUOTATION FROM JENNY'S FIRST DRAFT

She says that romance writers are "producing mass-market entertainment that appeals to its consumers for much the same reason as McDonald's and Burger King appeal to theirs: It's easy, it makes you feel good, and it's the same every time. The point of a romance novel is not to dazzle its reader with originality, but to stimulate predictable emotions by means of familiar cultural symbols."

MacFarquhar's vivid comparison to McDonald's and Burger King led Jenny to include this quote in her first draft. But later, when she read over the whole paper to consider revisions, she realized that the quotation was too long for what she wanted to accomplish at that point in her text (the end of paragraph 4). She had already introduced her own claim about the positive aspects of romance fiction and was using the MacFarquhar quote to indicate typical criticisms of romance fiction that the paper would counter. But the long quotation unduly shifted the reader's focus to negative opinions about romance novels. Furthermore, the colorful language from MacFarquhar detracted from Jenny's own important phrase at the end of the paragraph: "brain candy." She decided to pare

down her use of MacFarquhar by using paraphrase with a few direct quotations, a decision that shifts the focus to her own argument.

JENNY'S REVISED USE OF QUOTATION

She describes romance fiction as "mass-market entertainment" that appeals to people because "it's easy, it makes you feel good, and it's the same every time." Its purpose, she says, is not to stimulate thinking and the imagination, "but to stimulate predictable emotions by means of familiar cultural symbols."

The quotations that Jenny has woven into her own prose are now serving her purposes instead of competing with them. By using more of her own language, Jenny is able to keep the focus on her own argument. In addition, Jenny's revised version achieves greater coherence because her words "stimulate thinking and imagination" echo concepts she develops earlier in the essay as criteria for judging something's cultural worth. By replacing MacFarquhar's vivid phrase "not to dazzle its readers with originality" with her own less vivid phrase "not to stimulate thinking and imagination," Jenny links this paragraph back to the criteria.

The guidelines on page 134 will help you quote accurately and effectively. We must again add notes of caution. First, not only is absolute accuracy in quotations important ethically, but any inaccuracies will undermine your credibility. Furthermore, be sure that you are not quoting someone out of context. Doing so is a surprisingly common mistake because complex texts or unfamiliar subject matter can make it difficult to recognize changes in tone or references to opposing views. For example, although Larissa MacFarquhar's text isn't technical, its shifts in tone can be tricky. It would misrepresent her to quote her sarcastic statement— "Now, we don't care about reading anymore"—as if it were her opinion when it is actually one of the attitudes she seeks to discredit. Be sure that the way you use a quotation does not misconstrue or misinterpret its original meaning.

Our advice on using summary, paraphrase, and quotation is summarized in Table 7.1.

● **For Writing and Discussion**

One way to develop skill at incorporating the ideas of others into your own papers is to see how other writers do it. To try this out, track the use of direct quotations in Jenny's paper at the end of this chapter.

ON YOUR OWN

Note all the places where she uses direct quotations, and describe how each quotation is used. Find places, for example, where she uses sources to support or illustrate one of her points, to represent an opinion she opposes, to increase her credibility, or to capture vivid or distinctive language from a source. Some of her direct quotations may serve more than one function.

GUIDELINES FOR USING DIRECT QUOTATIONS EFFECTIVELY

☐ Prefer short quotations. Use long quotations only rarely because they will distract from the focus of your own discussion.

☐ Whenever possible, instead of quoting whole sentences, work quotations of key phrases into your own sentences.

☐ Make sure you are absolutely accurate in the wording of direct quotations.

☐ Punctuate your quotations exactly as in the original.

☐ If you must use a longer quotation, instead of using quotation marks set the material off from the text using block indentation. In MLA format, quotations longer than four typed lines start on a new line, are indented a full inch, and are double-spaced. In APA format, quotations longer than forty words start on a new line, are indented a half inch, and are double-spaced.

☐ Make sure your use of quotations fairly and accurately represents the original source.

☐ Make sure you fully understand the ideas that you quote directly. While the words in a quotation may sound impressive, if you cannot explain them and relate them to your own ideas, incorporating the quotation will detract from your credibility instead of enhancing it.

☐ As part of your proofreading routine, compare all quoted material to the original passage and make any needed adjustments, no matter how small.

WITH YOUR CLASSMATES

Compare your lists and descriptions. Are there differences or disagreements about how a particular direct quotation is being used? How effectively does she use quotations? Are there any quotations that might have been eliminated or shortened? Are there any places where you think her paper might have been strengthened by the use of a direct quotation where there isn't one? •

Avoiding Plagiarism

Whether you are summarizing, paraphrasing, or quoting, you must give credit to others' words and ideas by using a recognized system for referring readers to your sources, such as the MLA and APA systems explained later in this chapter and in the appendix. These citation systems, widely used in undergraduate classes, use short in-text citations that refer to a full list of sources at the end of the paper.

TABLE 7.1 ● DO'S AND DON'TS WITH SUMMARY, PARAPHRASE, AND QUOTATIONS

	Do	Don't
When You Summarize	• Make your summary as concise as possible • Represent your source's meaning accurately and fairly	• Distract readers by including points not directly relevant to your purpose
When You Paraphrase	• Paraphrase only what you need to develop your points • Be sure you understand the language you are paraphrasing • Recast sentences to create a genuine paraphrase	• Merely change a few words • Distort the original's meaning or intention
When You Quote	• Keep the actual quotation as short as possible • Fit the quotation naturally into your own sentence structure • Verify the absolute accuracy of the quotation	• Use quotes as a shortcut around difficult ideas • Distract readers with long quotes

With All Three Techniques

• Link your text to your sources with clear attributive tags and appropriate citations.
• Represent the source fairly and accurately.

You must acknowledge borrowed ideas and information, and all directly quoted language must be marked as such with quotation marks or appropriately indented formatting. Even if your quote is only a short phrase from the original source, quotation marks are essential. Omission of either the quotation marks or the reference information has the effect of creating a text that presents someone else's words or ideas as if they were your own. In that case, you are committing *plagiarism*, a serious form of academic misconduct in which a writer takes material from someone else's work and fraudulently presents it as if it were the writer's own ideas and wording.

The three most common forms of plagiarism are the following:

• Failure to use quotation marks to indicate borrowed language
• Failure to acknowledge borrowed ideas and information

- Failure to change the language of the source text sufficiently in a paraphrase

Student writers sometimes have problems managing the details of quotations because they neglect to take careful notes that clearly mark all directly quoted material. During their revision processes, inexperienced writers sometimes lose track of which sentences and phrases are directly quoted. To avoid such problems and symptoms of potential plagiarism, make sure you take scrupulous care to mark all directly quoted language and its source in your notes. *Write down all relevant bibliographic information even before you begin reading and taking notes.* In drafting papers, some writers use color highlighting or put directly quoted language in a different font so that, as they move passages around during revision, they can keep track of which words are directly quoted. Other writers keep full original quotations at the end of their paper file or in a separate electronic file so that they can check for accuracy and proper citation as part of their final preparations before submission.

You must also acknowledge borrowed ideas and information. That is, all ideas and information that are not your own require citation through attributive tags, internal citation, and the list of sources at the end of the paper. The only exception is common knowledge. Common knowledge, as the phrase suggests, refers to information and knowledge that is widely known. (For example: George Washington was the first president or thunderstorms are more likely in hot weather.) You can verify that certain information is common knowledge by consulting general information sources such as encyclopedias. If you are in doubt about whether something is common knowledge, or if you are concerned that your readers might credit an idea to you that is not yours, cite your source.

Perhaps the most difficult aspect of incorporating sources in a way that avoids plagiarism is sufficiently rewording the language of a source when you paraphrase. (This is why we recommend paraphrasing source material twice.) As we noted in the section on paraphrase, using the same sentence pattern as the original source and changing only a few words does not create an acceptable paraphrase, even if the writer includes a reference to the source. In the following examples, compare the acceptable and unacceptable paraphrases with the original passage from Paul Gray and Andrea Sachs's "Passion on the Pages," one of the sources on romance fiction that Jenny used for her paper:

ORIGINAL

Other genres—mystery, thriller, horror, sci-fi—attract no cultural stigma, but those categories also appeal heavily to male readers. Romances do not, and therein, some of the genre's champions argue, lies the problem.

PLAGIARISM

According to Gray and Sachs, other types of books—horror, mystery, sci-fi— experience no cultural stigma, but these types of books are those that appeal mainly to male readers. Romances, by contrast, do not, and that, some of its champions argue, is the problem (76).

ACCEPTABLE PARAPHRASE

> According to Gray and Sachs, popular books that attract mostly male readers, such as science fiction and thriller novels, do not suffer the same public condemnation as romance novels. Some fans of romance fiction believe that this is no coincidence and that condemnation of it is due to the fact most of its readers are female (76).

By following the guidelines we present for quoting and paraphrasing, you can incorporate the ideas of others while avoiding plagiarism. We close this section by passing along a final bit of advice: when incorporating materials from outside sources, write with your eyes on your own text, not on your source.* Your unfolding text should come from your mind, not someone else's text.

Using Attributive Tags

All three of the techniques we have described for incorporating source material—summary, paraphrase, and quotation—work best with *attributive tags* such as "Ariel Jones says" or "According to Ariel Jones."† These short tag phrases connect or attribute material to its source. In the process of acknowledging the source, the tags can also enhance the rhetorical effect of your text by giving readers valuable information about the credibility of that source, shaping your readers' response to it, and demonstrating that you, not your sources, are in charge. Here's how they do all this.

1. Attributive tags help readers distinguish your sentences and ideas from those in your sources (whether summarized, paraphrased, or quoted). In fact, a lack of attributive tags is often symptomatic of the passive patch-writing we have been warning against. As illustration, consider the difference between two versions of a sentence from Jenny's paper.

CONFUSION CAUSED BY LACK OF ATTRIBUTIVE TAG

> Romance readers insist on formulaic plots of "childlike restrictions and simplicity," and as a result, these books lack "moral ambiguity" (Gray and Sachs 76).

SENTENCE REVISED WITH ATTRIBUTIVE TAG

> The *Time* article mentioned earlier claims that romance readers insist on formulaic plots of "childlike restrictions and simplicity," and says that as a result, these books lack "moral ambiguity" (Gray and Sachs 76).

*This advice comes from *The Craft of Research* by Wayne Booth, Gregory Colomb, and Joseph Williams, who say "If your eyes are on your source at the same moment your fingers are flying across the keyboard, you risk doing something that weeks, months, even years later could result in your public humiliation" (Chicago: U Chicago P, 1995), 170.

†We are grateful to freelance writer Robert McGuire, formerly a writing instructor at Marquette University, for his valuable insights and advice about attributive tags.

As the first sentence begins, a reader has every reason to think that it states Jenny's ideas. Matters become confusing when the quotation marks signal that another voice has entered the text, but we don't know its source and the authors' names in the citation are not particularly informative. Readers would have to go to the works cited list to get the contextualizing information that the second sentence provides. In contrast, the attributive tag in the revised sentence not only makes clear the source of the idea, but specifically refers back to earlier discussion of material from the same source.

2. Attributive tags enhance your credibility by showing readers that you are careful with source materials and remain in charge of the paper. You are the one lining up and tying together source materials to fit your purposes for writing. Notice that the tags in these two sentences excerpted from the second paragraph of Jenny's "Brain Candy" paper allow her to link together two sources in a way that helps her build toward her own defense of romance fiction.

> MacFarquhar's essay offers extensive evidence that Americans are reading more than ever, especially "popular fiction" like romance novels. A July 2000 Time magazine article verifies this claim and reports that over 50% of all paperbacks sold in the United States each year are romance novels (Gray and Sachs 76).

3. Attributive tags enhance your text's credibility by indicating the credentials or reputation of an expert you are using as a source. For example, you might say "high school teacher Sam Delaney," "Molly Smith, an avid fan of romance literature," or "Josephine DeLoria, a controversial defense lawyer." Sometimes, credentials will convey more information than a name will: "the Justice Department's main espionage prosecutor for over twenty years."

4. Attributive tags provide a quick method of showing readers the published context of your source material. This context will help you show how the text you are writing fits within a published conversation. Here are some examples: "In her review of Victoria M. Johnson's book, Martha Smith argues . . . ," "Kim Ochimuru, in an article detailing the results of the Harvard study, contends . . . ," or "A letter to the editor objecting to the paper's editorial stance outlines the following complaint."

5. Attributive tags give you the opportunity to shape reader's responses to the material you are presenting. Your choice of verb to describe the source's influence is important because it will imply your attitude toward the source. Some verbs suggest that you agree with the source and others suggest doubt about what the source says. For example, the first two of the following examples convey the writer's positive attitude toward the source material being introduced; the second two convey a skeptical attitude, leading the reader to expect that the writer will counter the source's point:

A July 2000 *Time* magazine article verifies this claim.

Research by Carskadon and her colleagues documents the scope of the problem.

Predictable plots, so the argument goes, offer escape.

Some literary critics claim that the books depend too much on magic.

Attributive tags work best near the beginning of a sentence, but can be placed after other introductory phrases at any natural break. Here are some examples of tags placed at different points in sentences:

Published in 1997 in the on-line journal *Slate* MacFarquhar's essay offers . . .

At the end of her essay, MacFarquhar challenges readers . . .

Its purpose, she says, is not to stimulate thinking and the imagination, but . . .

Your first attributive tag about a source is likely to be longer than subsequent ones, as illustrated by these contrasting examples from Jenny's paper:

Although not a romance fiction reader herself, Carol Ricker-Wilson, a high school English teacher, offers . . .

According to Ricker-Wilson . . .

Ricker-Wilson argues . . .

In some instances, an author's name may not be as interesting or important to your readers as the place where an article appeared. For example, Jenny's reference to *Time* at the start of the following sentence tells readers much more than the authors' names would have; the parenthetical citation with the authors' names provides the necessary reference information.

PERIODICAL TITLE USED AS ATTRIBUTIVE TAG

A July 2000 <u>Time</u> magazine article verifies this claim and reports that over 50% of all paperbacks sold in the United States each year are romance novels (Gray and Sachs 76).

As the various preceding examples illustrate, attributive tags can offer a variety of information in accordance with a writer's purpose and sense of the intended audience's background knowledge. The possibilities range from facts that appear in citations (e.g., author's name, work's title, publisher, or date) to supplementary details about the author (e.g., credentials or purpose) or about the work (e.g., its context or reputation since publication). Of course, if you used all this information in one tag, the sentence would have hardly any room left for your own ideas. You don't want to overwhelm your readers with details that don't immediately convey significance. Readers can always find complete titles and publication information on your works cited or references list. If you decide readers need a lot of background, you may want to provide it in a separate sentence, as Jenny does at the beginning of her extended discussion of the Ricker-Wilson article: "Although not a romance fiction reader herself, Carol - Ricker-Wilson, a high school English teacher, offers an interesting perspective on

GUIDELINES FOR USING ATTRIBUTIVE TAGS EFFECTIVELY

☐ Make the tag part of your own sentence.

☐ The first time you bring in a particular source, put the tag before the quotation or summary so that readers will have the background they need when they reach the borrowed source material.

☐ Vary the format and vocabulary of your tags. You want to avoid a long string of phrases that repeat "according to" or "he says."

☐ Provide just enough background to help readers understand the significance of the material you are bringing in, not everything there is to say about the source.

☐ Base your decisions about attributive tags on what you are confident readers will recognize and what will help them recognize the relevance of the source you are using. For example, *Time* is a well-known magazine and the *Journal of Urban History* has a self-explanatory title, so using those titles in a tag would probably provide more context than an author's name would. However, stating that an article appeared in a journal with an ambiguous title—for example, we are aware of at least three periodicals named *Dialogue*—would probably be pointless without further explanation. Rather than use space explaining the audience and purpose of the journal, it would be preferable to supply a brief context-setting phrase about the author's background or about how the material you are using fits the larger published conversation.

the potential educational value of romance novels in 'Busting Textual Bodices: Gender, Reading and the Popular Romance.'"

Using Parenthetical Citations

Clear, accurate *citations* of outside sources are an essential element of academic writing. Designed to help readers locate source materials, citations present a formalized statement of a work's author, title, publication date, publisher, and exact location—that is, page numbers for anything shorter than a book and/or an Internet address. As we explained in the section on avoiding plagiarism, citations are required for statistics, quotations, paraphrases, and summaries of other writers' work and ideas—any information that is not common knowledge. Citations give credit where credit is due, and help you show your readers how and where you are positioning your ideas within a published conversation. Furthermore, like attributive tags, citations add to your authority and reveal the quality of the sources you used. When handled well, they also enhance a text's readability.

In the remainder of this chapter, we explain how to create and use paren-thetical citations in both MLA and APA formats—what to include and where to place the in-text citations in your sentence. In the Building a Citation appendix you will find guidelines for creating MLA and APA bibliographic lists as well as models for complete bibliographic citations for a variety of sources.

UNDERSTANDING ACADEMIC CITATION CONVENTIONS

All academic disciplines require that you cite sources, but different disciplines use different formats, known as *citation conventions*. Each set of conventions specifies a particular format for presenting information that refers readers to a source. The variety of citation conventions across disciplines is evident among the reading selections included in Part Three from refereed journals. Compare, for example, the in-text author-date citations used by psychology professors Amy Wolfson and Mary Carskadon in "Sleep Schedules and Daytime Func-tioning in Adolescents" (pp. 273–294) with the endnotes used by historian Kirk Savage in "The Past in the Present: The Life of Memorials" (pp. 323–330) and the sequentially numbered citations used in the articles from medical journals in Chapter 14.

You will also find variations in the punctuation conventions used by some readings in the anthology. This results from our intention of presenting the read-ings in a format as close to the original as possible (other than changes in the page layout). You will find, for example, that selections originally published in newspapers typically use quotation marks rather than italics or underlining on book titles, and some articles normalize capitalization on trademark words, for example, instead of "PowerPoint," one uses "Powerpoint." Another commonly noticed difference is that writers who use Associated Press (AP) style do not use a final series comma before *and* in phrases such as "magazines, newspapers and Web pages." In contrast, the style we use in this book does insert that "final se-ries comma," so we would punctuate that phrase this way: "magazines, news-papers, and Web pages." While punctuation and citation conventions may vary from text to text, from genre to genre, you will find consistency *within* a given text, which you should strive for as well.

In this book, we discuss the two citation systems most commonly required in undergraduate courses: the Modern Language Association (MLA) format, used widely in the humanities, and the American Psychological Association (APA) format, used widely in the social sciences.* Both systems rely on brief *in-text* or *parenthetical citations* in the body of the paper that are keyed to a list of complete citations—alphabetized by authors' last names—at the paper's end. The short in-text references, placed within parentheses inside any sentence that contains material derived from outside sources, provide readers with enough in-formation to locate the full citation on the list. Full citations help readers see what

* Our discussion here and in the appendix is based on Joseph Gibaldi, *MLA Handbook for Writers of Research Papers*, 6th ed. (New York: MLA, 2003) and the *Publication Manual of the Amer-ican Psychological Association*, 5th ed. (Washington, DC: APA, 2001).

kinds of materials the writer used as a basis for the current text, what information was used from a particular source, and exactly where the original material can be found.

In-text citations are placed in parentheses to minimize the intrusion of bibliographic information on the reading experience. When a writer has handled the citations well, readers hardly notice them as they read but can return to them and use them to find additional information efficiently. Here's an example from Jenny's paper.

MLA IN-TEXT CITATION

. . . 50% of all paperbacks sold in the United States each year are romance novels (Gray and Sachs 76).

The authors' names inside the parentheses tell readers where to find the full citation of the work on the alphabetized works cited list at the end of the paper.

CORRESPONDING FULL CITATION ON MLA WORKS CITED LIST

Gray, Paul, and Andrea Sachs. "Passion on the Pages." Time 20 Mar. 2000: 76-78. Academic Search Elite. EBSCO. Memorial Lib., Marquette Univ. 31 July 2000 <http://www.epnet.com/>.

The page number in the parenthetical in-text citation will help the reader pinpoint the cited material.

The MLA and APA systems use slightly different formats and punctuation for both in-text citations and the full lists of works those citations refer to. These lists are referred to as "Works Cited" in MLA format and as "References" in APA format. Both systems require that every source on a Works Cited or References list be referred to within the paper (by either a parenthetical citation or an attributive tag) and that full information about every source referred to is available in the list at the end of the paper. Before we go any farther, we want to assure you that the details of citation conventions are not something to memorize. Scholars regularly consult models and guidelines such as those in this chapter and the appendix. You should do the same.

Because accurate use of a discipline's citation format necessitates attention to many formatting details, students sometimes overlook the rhetorical value of carefully prepared citations. First of all, clear, accurate, consistently formatted citations not only acknowledge sources appropriately but present you as knowledgeable and responsible. Furthermore, the content of citations communicates important information about the context and purpose of sources and, thus, about the reliability and authority of the source materials. When you read scholarly articles in specialized courses for your major, you will discover that citations are also an invaluable source of information about where you can find additional resources for research projects.

In some courses, particularly history, instead of in-text citations you may be asked instead to use footnotes that follow the format laid out in the *Chicago Manual of Style* (also called Turabian format, after the author whose handbooks pop-

ularized it). Furthermore, professors in political science or sociology might ask you to follow specialized conventions for their discipline. Professors in natural science and technical classes, where it is common to refer repeatedly to many sources, may ask you to use a citation-sequence method for in-text references such as that laid out in the Council of Science (formerly Biology) Editors' *CBE Manual* or a numbering system based on the overall alphabetical order of the sources in a list at the end of the paper. These and other formats are described in many composition handbooks; specialized guides are readily available on line or at library reference desks.* Whenever you aren't sure what is expected regarding citations, check with your instructor.

MLA IN-TEXT CITATIONS

Basic MLA In-Text Citation Format

The basic skeleton of an MLA in-text citation is simple: author's surname plus, if you are quoting or paraphrasing, the page number:

(Name 00)

If your discussion refers to an entire work, not part of it, the *MLA Handbook* suggests that instead of inserting a parenthetical citation, it is better simply to mention the author's name in the sentence, as you would in an attributive tag.

In the examples that follow, note the details of format and punctuation for MLA style in-text citations, which are typically placed at the end of a sentence. The first example indicates that the quotation comes from page 76 of material by authors whose surnames are Gray and Sachs.

If no author is listed on a source, a shortened form of the work's title is used. The next example indicates that the writer is paraphrasing something on page 15 of a work without a listed author, the title of which begins with "Romance."

*On-line writing centers usually have helpful information that is easy to access. Try the Websites for the centers at Purdue <http://owl.english.purdue.edu/handouts/research/index.html/> or the University of Wisconsin <http://www.wisc.edu/writetest/Handbook/Documentation.html>.

Variations on the Basic MLA In-text Citation

The content of in-text citations depends partly on your rhetorical purpose and partly on the information you have about the source. Because these factors will vary, not every MLA in-text citation includes an author's name and a page number. We turn now to MLA guidelines regarding these variations. All of the guidelines stem from this paramount rule: Provide readers with the name or title word(s) that they will find at the left margin of the alphabetized Works Cited list.

When Citation Information Appears in an Attributive Tag. Earlier in the chapter, we pointed out that the inclusion of some bibliographic information in an attributive tag can have valuable rhetorical impact. When an attributive tag does provide bibliographic information, that information does not need to be repeated in a parenthetical citation. As long as there is no chance of confusion, only the page number for a quotation or paraphrase needs to appear in the parenthetical cite. Let's compare the rhetorical effect of two different decisions about combining a tag and a citation. In the first example, the spotlight is on the authors as the source of an idea or phrase.

> According to Gray and Sachs, these books lack "moral ambiguity" (76).

In contrast, when the authors' names appear only in the parenthetical citation, the ideas in the sentence receive greater focus.

> Some critics find that romance novels lack "moral ambiguity" (Gray and Sachs 76).

The disadvantage of this approach is its lack of clarity. Are Gray and Sachs the critics who complain about moral ambiguity, or do they simply report that some critics feel this way? Furthermore, the citation seems to imply that the work by Gray and Sachs was mentioned earlier. If it wasn't, a reader may feel confused.

When You Must Quote Indirectly. If you want to use something that one source attributes to another source, your best course of action is to find the original version and cite it directly. Only then can you be assured that the quotation is accurate and that you understand its context. If you can't get to the original, combine an attributive tag referring to the original source with a citation for your indirect source that includes the abbreviation "qtd. in"—for "quoted in." For example:

> Robert Hughes says that reading is a collaboration "in which your imagination goes halfway to meet the author's" (qtd. in MacFarquhar 65).*

Use "qtd. in" only when your source quotes from published material. When an author is simply quoting someone else's spoken words, from an interview, for

*To show how to use a page number in these citations, we've used the page number for the reprint in Chapter 3 of MacFarquhar's 1997 *Slate* article, "Who Cares If Johnny Can't Read?" You can find models for full citations of reprinted articles in the appendix.

example, no special note is needed—simply follow the guidelines for citing authors or titles.

When an Article Has Only One Page or Page Numbers Are Unavailable. MLA format permits omission of page numbers from an in-text citation, even for a quotation, for three types of materials: (1) a print article complete on one page, (2) a print article retrieved from a periodicals database in a format where it is not possible to pinpoint page numbers, and (3) an article published on a Website without page or paragraph numbers. In these cases, the in-text citation needs to include only the author's name, even for a quotation. (The full citation on the Works Cited list should include page numbers, however.) The following example sentences quote from the first Kathleen Parker column reprinted in Chapter 12, which was originally published on one newspaper page.

MLA IN-TEXT CITATIONS FOR AN ARTICLE COMPLETE ON ONE PAGE

The shooting death of six-year-old Kayla Rolland outraged many people, including a columnist who said it pushed "the limits of rational thought" (Parker).

Kathleen Parker responded that the shooting death of six-year-old Kayla Rolland pushed "the limits of rational thought."

When Paragraph Numbers Are Available. Some on-line publications provide paragraph numbers that both you and your readers can use to pinpoint a reference when page numbers are not available. For MLA format, you should provide a paragraph number only if it appears in the original; don't count paragraphs yourself because different browsers may present the material differently. When you do cite paragraphs by number, use the abbreviation "par." after the author's name and use a comma to separate the two words:

(Stephens, par. 17)

When a Work Has More Than One Author. For two or three authors, include all their names; for four or more authors, you may use the first author's name plus "et al.," which abbreviates the Latin for "and others." The term should not be underlined; "al" is followed by a period. Some examples:

(Fisher and Rinehart 438)

(Fisher, Rinehart, and Manber 12)

(Manber et al. 84)

When a Paper Has More Than One Source by One Author. To avoid potential confusion on a works cited list that has two or more items by the same author, add a *short title* to the citation after the author's name, placing a comma between name and title and using the appropriate title punctuation—quotation marks or underlining. To create a short title, use the first word or the first few words of

the full title, enough words for readers to find the right citation readily in the alphabetized works cited list.

MLA IN-TEXT CITATIONS WITH SHORT TITLES

> (Friedman, "Eastern")
>
> (Friedman, "Self-Destruction")

CORRESPONDING FULL MLA CITATIONS ON WORKS CITED LIST

> Friedman, Thomas L. "Eastern Middle School." New York Times 2 Oct. 2001, late ed.: A25.
> ---. "Self-Destruction Flourishing." Milwaukee Journal Sentinel 17 June 2003: 15A.

When Two Authors Have the Same Surname. Use first and last name in any attributive tag, or add the author's first initial to the parenthetical citation:

> Kathryn Schabel writes . . . (17).
>
> (K. Schabel 17)
>
> Mattias Schabel reports . . . (267).
>
> (M. Schabel 267)

When a Source Doesn't List an Author or Editor. Many Web pages and short articles do not list authors. In these cases, the works cited entry will begin with the title of the article or Web page, so for the in-text citation, use a short title that matches it. For example, for an article without a listed author entitled "Can Antioxidants Save Your Life?" you would use the first two words for a short title:

> ("Can Antioxidants" 5)

(Merely using "can" would seem cryptic.) For some documents, such as a Website or an annual report, an organization or agency—a *corporate author*—should be listed:

> (Greater Milwaukee Foundation)
>
> (Centers for Disease Control)

If you are citing an entire document rather than a specific part of it, it will often be better to name the organization in the text itself:

> In its annual report, the Greater Milwaukee Foundation lists . . .

Although some databases label such articles "anonymous," you should not use that word in your citations unless it actually appears in the original publication. In the event that you are working with two works with no listed author and the same title—for example, an encyclopedia article and Website

about jellyfish—MLA recommends that you include a distinguishing element from the full citations that will help readers locate the right source on the works cited list:

("Jellyfish," Britannica)

("Jellyfish," Ask Jeeves)

Placement of MLA In-Text Citations

For smooth reading, in-text citations work best at the end of the sentence in which you use material from the source. However, a citation can be placed at any natural pause in the sentence and should be placed as close as possible to the material it refers to. All quoted material should be cited immediately at the end of the phrase or sentence in which the quotation appears. Here is a hypothetical example of two citations in one sentence:

> . . . such romances are said to lack "moral ambiguity" (Gray and Sachs 76) or to feed unrealistic fantasies (Hopewell 15).

In disciplines that use MLA style, multiple references in one parenthetical citation are not common, but when they are needed, separate them with semicolons. While the previous example highlighted a direct quotation and a paraphrase, the following example with combined citations foregrounds a generalization based on ideas in those works:

> In the 1990s, several commentators noted that the plots of romance novels turn on unrealistically simple moral questions (Gray and Sachs; Hopewell).

MLA does not specify a particular order for sequencing references inside the same parentheses, but using alphabetical order as on the Works Cited list would be a convenience to your readers.

When a summary of a source covers several sentences in a row, your citation may come at the end of the summary, but an attributive tag at its beginning should make it clear that you are about to draw someone else's work into your text and thus alert readers to expect the citation. In the following example of a multisentence summary, notice Jenny's placement of page number citations for the quotations. The attributive tags referring to Ricker-Wilson make it unnecessary to repeat her name in parenthesis.

Writing in the English Journal for teachers who think of romance fiction as "escapist trash" (58), Ricker-Wilson argues that this widespread belief blinds teachers from seeing romance fiction's personal value to their students and its possibilities for classroom use. By allowing a group of young women in her lower-track English class to read the novels of

Danielle Steele for extra credit, she learned about the many benefits romance fiction offered her students. Among these benefits were camaraderie and escape in a positive sense. According to Ricker-Wilson, these five women students became an "authentic community" of readers, regularly exchanging books and eagerly sharing their ideas about them (62).

APA IN-TEXT CITATIONS

Basic APA In-Text Citation Format

Developed for disciplines where scholars publish frequently and the currency of research is very important, APA format emphasizes dates of publication by requiring dates in parenthetical citations. Specific page or paragraph numbers are used only for direct quotations.

The basic APA internal citation provides the author's surname (or the work's title if no author is given) and the publication date, separated by a comma:

(Name, year)

If a quotation is used, its page number is added after the abbreviation "p." or "pp." In APA style, this page information must be included even for articles that are complete on one page:

(Parker, 2000, p. 10A)

To familiarize you with APA style, we draw attention to punctuation details in the following examples. The first, which is from the article about adolescents' need for sleep by Wolfson and Carskadon in Chapter 10, tells readers where they can find major research that supports the sentence's assertion.*

Persistent sleep problems have also been associated with learning difficulties throughout the school years (Quine, 1992).

 ↑ ↑ ↑

 space comma period follows parenthesis

The second example is from a hypothetical student paper that quotes from the Wolfson and Carskadon article; it cites the pagination of the original publication. Notice that this format saves space inside the parentheses by using an ampersand between authors' names. However, in regular text, use "and" between authors' names as you normally would.

*Many of our examples of sentences with APA citations are taken from or refer to the 1998 article "Sleep Schedules and Daytime Functioning in Adolescents" by Amy R. Wolfson and Mary A. Carskadon, reprinted in Chapter 10. Their references list begins on p. 291.

Researchers suggest that "adolescent moodiness" is partly "a repercussion of insufficient sleep" (Wolfson & Carskadon, 1998, p. 885).

 ↑↑ ↑ ↑ ↑↑ ↑

 closing space ampersand commas | period after parenthesis

 quotation mark abbreviation

When you read articles that use APA style, you will see that authors often use long strings of citations as a shorthand way of establishing a foundation for the research they are reporting. Consider, for example, how much information is packed into the following sentence, which appears at the end of the first paragraph of the Wolfson and Carskadon article in Chapter 10. Note that the four citations in the list are separated by semicolons.

> Over the past 2 decades, researchers, teachers, parents, and adolescents themselves, have consistently reported that they are not getting enough sleep (Carskadon, 1990a; Carskadon, Harvey, Duke, Anders, & Dement, 1980; Price, Coates, Thoresen, & Grinstead, 1978; Strauch & Meier, 1988).

The combination of the authors' names and the dates of publication provides the key to finding each work's full citation on the alphabetized list at the end of a paper or article, called "References" in APA style.

In the sections that follow, we explain some important variations in APA format for parenthetical citations. The following four guidelines will give you a solid foundation for creating APA parenthetical citations:

- Provide readers with the information they need to find a full citation on the references list. The word(s) in parentheses should match the word(s) at the left margin of the list.
- Always provide a date or the notation "n.d." for "no date."
- Use a comma between author and date.
- Page numbers, required for direct quotations, are marked with the abbreviation "p." or "pp."

Variations on the Basic APA In-Text Citation

APA format, like MLA format, provides for the content of in-text citations to vary according to the information available and the writer's rhetorical intent. The guidelines in this section show how to avoid repeating information already in attributive tags and how to distinguish among similar references when confusion is possible.

When Citation Information Appears in an Attributive Tag. If the author's name is already present in the sentence, the parenthetical cite includes only the date of publication. For example:

> A 6-year longitudinal summer sleep laboratory study by Carskadon and colleagues (1980) . . .

Conversely, if your sentence highlights the date, only the name would be needed in the parentheses.

> In 1980, the results of an important longitudinal study were published (Carskadon et al.).

Sentences highlighting a date are likely to include an author's name as well, making a parenthetical citation unnecessary unless a page number is needed for a quotation, as in these examples.

> In 1980, Carksadon and her colleagues published their important longitudinal study.

> In their 1998 study, Wolfson and Carskadon suggest that "adolescent moodiness" is partly "a repercussion of insufficient sleep" (p. 885).

When You Must Quote Indirectly. Finding the original source is always preferable because you may make incorrect assumptions about the context of a quotation. When you must indirectly cite a quotation from a published work, use an attributive tag to refer to the original publication and in the parenthetical citation insert APA's phrase "as cited in."

> Robert Hughes says that reading is a collaboration "in which your imagination goes halfway to meet the author's" (as cited in MacFarquhar, 2005, p. 65).

This citation of MacFarquhar's article refers to the reprint in Chapter 3 of this book. Note that APA format calls for using the date of the reprinted work.

When Page Numbers Are Unavailable. APA requires page numbers for articles complete on one page, but it does recognize that complete page numbers are sometimes not available in on-line databases or Web pages. In some instances, you may be able to use paragraph numbers to document quotations (see below). When a page number is unavailable, use just the author's name and the date in the citation, unless they are already provided in an attributive tag. If the source originally appeared in print, take careful notes so that you can provide beginning and ending page numbers—known as *inclusive pagination*—on the references list citation, which should follow APA format for material retrieved from a database or Website.

When Paragraph Numbers Are Available. Because of the variations in Internet browsers and professors' expectations, we advise you to ask your instructor if citations by paragraph number are expected when page numbers are unavailable. APA suggests that if the original doesn't have page or paragraph numbers you can use headings to pinpoint the relevant section, and then count paragraphs from the heading to the location of the quoted material. To cite a para-

graph instead of a page, put a comma after the date, insert either the ¶ symbol or the abbreviation "para.", and add the number. In the following reference to the on-line version of the MacFarquhar article, a paragraph number pinpoints the paraphrase:

> According to survey data, books on personal hygiene were popular at least as long ago as the 1930s (MacFarquhar, 1997, para. 7).

The next example illustrates how to provide headings plus a paragraph number. Note the punctuation and that APA format capitalizes only the first word of headings.

> Wolfson and Carskadon suggest that "adolescent moodiness" is partly "a repercussion of insufficient sleep" (1998, Discussion: Additional consequences section, ¶ 3).

When a Work Has More Than One Author. Multiple authorship is more common in the social sciences than in the humanities. To avoid confusing your reader you must designate the authorship of coauthored works carefully. Here are the APA guidelines for using "et al." (for "and others") in in-text references with multiple authors. For reference list entries, the guidelines are slightly different; see the appendix.

FOR WORK BY TWO AUTHORS
Use both names in all in-text references.

FOR WORK WITH THREE TO FIVE AUTHORS
On the first reference use each name; on subsequent references, use the first author's name, then "et al." You can use "et al." in attributive tags as well as in parenthetical citations.

FOR WORK WITH SIX OR MORE AUTHORS
Use the first author plus "et al." for all references.

In any instance where the "et al." form could refer to two or more articles on your list with the same publication date, give as many names as needed to identify each before inserting "et al." For example, the following citations refer to two articles published in 1997 by Carskadon (lead author) and Acebo (second author). In the subsequent references, note that "al" is followed by a period, then a comma before the date.

FIRST IN-TEXT REFERENCES
(Carskadon, Acebo, Richardson, Tate, & Seifer, 1997)
(Carskadon, Acebo, Wolfson, Tzischinsky, & Darley, 1997)

SUBSEQUENT IN-TEXT REFERENCES

(Carskadon, Acebo, Richardson, et al., 1997)

(Carskadon, Acebo, Wolfson, et al., 1997)

When a Paper Has More Than One Source by an Author. On most APA references lists, the year of publication serves to distinguish among several works by the same author or group of authors. However, if a list includes more than one work published in a given year with the same authorship, lowercase letters inserted immediately after the date serve to prevent confusion. These letters should be inserted according to the alphabetical order of the works' titles in the references list.

APA IN-TEXT CITATIONS WITH DATE AND LETTER

(Kramer, 2000a)

(Kramer, 2000b)

CORRESPONDING FULL APA CITATIONS ON REFERENCES LIST

Kramer, M. (2000a). Dreaming has content and meaning not just form. *Behavioral and Brain Sciences, 23,* 959.

Kramer, M. (2000b). The variety of dream experience: Expanding our ways of working with dreams. *Journal of the American Academy of Psychoanalysis, 28,* 727–729.

When Two Authors Have the Same Surname. For the sake of clarity, use the author's first initial in either the text or a parenthetical citation, even if the years of publication are different:

E. Sutton's study (2001)…

(E. Sutton, 2001)

According to M. Sutton (1990) . . .

(M. Sutton, 1990)

When a Source Doesn't List an Author or Editor. For short articles and Web pages that do not list an author, use the first few words of the title to create a short title for the parenthetical reference. APA style capitalizes only the first word of titles and subtitles and does not use title punctuation (quotation marks) for articles:

(Can antioxidants, 1998)

Some works, particularly Websites and print publications such as program brochures, annual reports, or publications of a government agency should be cited as having a group or corporate author:

(Greater Milwaukee Foundation, 2002)

(Centers for Disease Control, 2003)

If readers will understand an abbreviation sufficiently to find full information on the references list, group authors can be abbreviated. Indicate the abbreviation parenthetically when you first refer to the entity in a reference or attributive tag.

FIRST REFERENCE

(Centers for Disease Control [CDC], 2003)

SUBSEQUENT REFERENCES

(CDC, 2003)

If abbreviations can be misleading or confusing, such as "NSF" for both the National Science Foundation and the National Sleep Foundation, continue to spell out the group name in all references. If you want to refer to an entire Website in general, not to cite a specific document within it, APA guidelines say that putting the URL in the text is sufficient reference, as in the following sentence:

> Much of this sleep research has been boiled down to advice for average consumers and is available at the Website of the National Sleep Foundation (http://www.sleepfoundation.org/).

When a Source Doesn't Provide a Date Because dates are so important in APA format, when a work has none available, the in-text citation should include "n.d." (for "no date") where the date would normally be placed:

(McCormick, n.d.)

Dates are frequently not available on Websites, where author names and page numbers are also frequently unavailable. In these cases, formulate the full reference, then for the parenthetical reference use the first few words as a title and insert "n.d." where the date would go. Consider the following example, which refers to a self-test for which no author or date is given on the National Sleep Foundation Website:

(How's your sleep? n.d.)

We might have used the Website sponsor, the National Sleep Foundation, as author but the reference communicates more both to a reader and to someone looking for the quiz if the title is used. We used the quiz's complete title because shortened versions, "How's" or "How's your," would be puzzling. The citation

on the references page would begin with the title and list the Sleep Foundation, along with the URL and a date of retrieval. (See the appendix for models.)

Placement of APA In-Text Citations

Papers and scholarly articles that follow the APA citation style typically use parenthetical references not only to acknowledge the source of summarized, paraphrased, or quoted material, but to refer to and build on entire studies. Because clarity is crucial, APA references to published work should not be deferred to the end of a sentence or a natural sentence break; instead, they must be provided as soon as the work is mentioned. Thus, parenthetical citations of dates usually follow immediately after an author or group of authors is named in a sentence. Cites may even be placed between a subject and verb, as in the following examples from the introduction to Wolfson and Carskadon (1998), the article in Chapter 10:

> Price et al. (1978), for example, found . . .
>
> Although sleeping less than when younger, over 54% of high school students in a Swiss study (Strauch & Meier, 1988) endorsed a *wish for more sleep* (emphasis in original).
>
> Another consistent report (Bearpark & Michie, 1987; Petta, Carskadon, & Dement, 1984; Straunch & Meier, 1988) is that . . .

Similarly, all quoted material should be cited immediately. As a result, page references are often separated from the author-date reference. To illustrate, we have rewritten in APA style two excerpts from the earlier example in which Jenny uses short quotations from the Ricker-Wilson *English Journal* article.

> Ricker-Wilson (1999), writing for teachers who think of romance fiction as "escapist trash" (p. 58), argues that . . .
>
> According to Ricker-Wilson (1999), these five women students became an "authentic community" (p. 62) of readers, regularly exchanging books and eagerly sharing ideas about them.

Finally, when you combine references within the same parentheses, use semicolons to separate items by different authors. APA specifies that the author-date items should appear in the same order as the works are listed on the references list; that is, arrange them first in alphabetical order; then put dates of works by the same author in chronological order, separated by commas. Arrange dates for works published by one author in the same year according to the alphabetical order of the lowercase letters appended to them. Here is a hypothetical example based on items in the Wolfson and Carskadon (1998) references list:

> (Carskadon, 1982, 1990a, 1990b; Carskadon et al., 1986; Carskadon, Orav, & Dement, 1983; Carskadon et al., 1989.)

Summary

In this chapter we described the differences among summary, paraphrase, and direct quotation, and explained that skillful incorporation of source materials into your own texts enhances your credibility and clarifies how your ideas fit into the larger published conversation about a topic. Throughout the discussion we emphasized the importance of subordinating source materials to your own purposes, ideas, and organization. We stressed the importance of careful note-taking as a means of avoiding even inadvertent plagiarism. The guidelines we provided show how to

- Incorporate brief summaries, paraphrases, and direct quotations into your work
- Avoid plagiarism by using genuine paraphrases, taking careful notes, and attending to the details of bibliographic information
- Use attributive tags to help shape the response you desire from readers
- Provide clear and correct in-text citations using both MLA and APA formatting

In the sample student paper that follows, you will find numerous examples of these techniques. The appendix to this book offers models of full MLA and APA citations for many types of materials you will be likely to use in your own papers.

Incorporating Reading into Writing: An Example in MLA Format

Here is Jenny's researched evaluation argument, written in response to the assignment at the beginning of Chapter 6 (p. 113). It uses MLA format for citing sources.

Romance Fiction: Brain Candy or Culturally Nutritious?

In junior high school, I was a big fan of Sweet Valley High novels. I read every one I could get my hands on, and my friends and I passed them around and talked about the characters as though they were a part of our group of friends. Even then, I could see that there was a formula: heroine pines for popular boy who doesn't know she's alive; things look hopeless for a long time; then something happens and he notices her; and in the end they walk off into the sunset. Actually, knowing that there would be a happy ending was part of the fun. The interesting thing was how it would work out. My parents, who are both

1 Opens with a personal anecdote

Introduces
tension

teachers, considered these books a waste of time, but I
loved them anyway.

Explicitly
connects to
assignment

2 I haven't read novels like this since junior high, but
reading Larissa MacFarquhar's "Who Cares Why Johnny
Can't Read?" reminded me of this early fondness for
romance fiction and the widespread idea that these books
lack cultural value. MacFarquhar's essay offers extensive
evidence that Americans are reading more than ever,

Detailed tag
provides context

especially "popular fiction" like romance novels. A July
2000 Time magazine article verifies this claim and reports

First MLA
citation gives
page number for
statistic

that over 50% of all paperbacks sold in the United States
each year are romance novels (Gray and Sachs 76). At the
end of her essay, MacFarquhar challenges readers to
consider whether it is reading in and of itself that has

No page or
paragraph
numbers on-line;
author named in
tag, so in MLA
style, no citation
for quotation

cultural value or whether it is what people read (or watch
on television) that contributes to "the fertility of our
culture." Since romance fiction is so popular, it seems to
me that we ought to ask this question of romance fiction.
Does it have cultural value and contribute to "the fertility

Clear statement
of evaluation
issue

of our culture"? Is it only brain candy or does it have
some cultural nutrition?

New paragraph
raises issue of
criteria

3 But how do we determine what contributes to cultural
growth or nutrition? Although it is unclear how
MacFarquhar herself might define and judge cultural
value, she refers disapprovingly to the "reputation for
educational and even moral worthiness" that books have
acquired. According to MacFarquhar, book advocates claim
that books activate the imagination and encourage original
thinking by being "quirky and individualistic and real."

Counters
MacFarquhar;
offers her own
criteria

Despite MacFarquhar's sarcasm about these claims for
books, it seems to me that educational and moral worth as
well as stimulation of the imagination and intellect are all
legitimate bases for judging cultural value. However,
research and the memory of my early reading experiences
have convinced me that these criteria, though valid, are
too limited. Other factors such as emotional sustenance

and community building also contribute to our cultural welfare. In this essay, I review briefly the arguments of those who believe romance fiction is without cultural value, then offer arguments for why romance fiction does have cultural value, even in terms of traditional criteria, and certainly in terms of other, equally important, criteria.

Maps how rest of essay will proceed; forecasts her delayed thesis

The key reason many people believe that romance fiction has no cultural value is its lack of originality. Predictable plots, so the argument goes, offer escape but not intellectual stimulation. The Time article mentioned earlier claims that romance readers insist on formulaic plots of "childlike restrictions and simplicity," and says that as a result, these books lack "moral ambiguity" (Gray and Sachs 76). Although MacFarquhar makes no direct judgment about the cultural value of romance fiction, her description of this genre echoes the criticism of Gray and Sachs. She describes romance fiction as "mass-market entertainment" that appeals to people because "it's easy, it makes you feel good, and it's the same every time." Its purpose, she says, is not to stimulate thinking and the imagination, but "to stimulate predictable emotions by means of familiar cultural symbols." As my friends would put it, MacFarquhar describes romance fiction as brain candy.

4

Clear statements acknowledge opposing views

Elaborates on views opposing hers

Compares MacFarquhar and Time critics

Weaves short quotations into her own prose

Ends paragraph with echo of "brain candy" from paragraph 2

However, many intelligent fans of romance fiction would disagree. They, in fact, describe romance fiction as having some of the characteristics that people traditionally associate with cultural value. Katherine Hennessey Wikoff, an English professor at Milwaukee School of Engineering and a self-described "life-long romance reader," for example, says that "Years of romance fiction amply reinforced my own character growth." In her review of Victoria M. Johnson's book, All I Need to Know in Life I Learned from Romance Novels, Wikoff says that she "cut her romance novel teeth" at age twelve on Gone with the Wind, from which she learned both positive and negative

5

Rebuttal begins

Attributive tag gives credentials of expert

Attributive tag sets context for quotations and paraphrases

lessons: to be resourceful like Scarlett but not to be so proud like Scarlett, who lost Rhett because she wouldn't risk telling him she loved him for fear of rejection. Wikoff goes on to list the life lessons she, like Johnson, claims to have learned from romance fiction. A few examples are these: "Communication is the key to a healthy

Review was complete on one page—in MLA format, no page references needed in an in-text citation

relationship"; "Attitude makes all the difference"; and "Love changes everything." In Wikoff's opinion, and apparently Victoria Johnson's, reading romance fiction can be morally uplifting and contribute to character growth, surely important cultural values.

6 Although not a romance fiction reader herself, Carol Ricker-Wilson, a high school English teacher, offers an

Moves to second expert supporting her view—entire sentence as attributive tag— title adds flavor

interesting perspective on the potential educational value of romance novels in "Busting Textual Bodices: Gender, Reading, and the Popular Romance." Writing in the English Journal for teachers who think of romances as "escapist

Summary sets up discussion in paragraphs 7–9

trash," Ricker-Wilson argues that this widespread belief blinds teachers from seeing romance fiction's personal value to their students and its possibilities for classroom use. By allowing a group of young women in her lower-track English class to read the novels of Danielle Steel for extra credit, she learned about the many benefits romance fiction offered her students. Among these benefits were camaraderie and escape in a positive sense. According to Ricker-Wilson, these five women students became an "authentic community" of readers, regularly exchanging books and eagerly sharing their ideas about them (62).

Cites page for quotation

7 Ricker-Wilson acknowledges that some researchers claim that romance fiction provides women readers with

Paraphrase recasts R-W's points into everyday language

escape from their difficult relationships with the men in their lives. She counters this negative view by proposing that romance fiction permits readers to escape something even worse: the negative images of women in other literature. She argues that readers who enjoy romance novels do so because they enjoy reading about women

but do not like to read about women who are victimized or killed off, as they often are in other forms of fiction (58).

Page citation for paraphrase

Finally, Ricker-Wilson argues that romance novels have educational benefits if they are treated seriously. Her one requirement for reading these books was that students write about them in response to her romance questionnaire, which asked about the depiction of women, romantic relationships, and other aspects of the novels (58). What Ricker-Wilson discovered was that her students were quite capable of criticizing these books and seeing the mixed messages they give to women. Despite Ricker-Wilson's reservations about some of the "troubling" messages sent by these books, she concludes that "popular romance offers one of the richest imaginable repositories for exploring conflicting understandings of gender and sexuality" (63).

8

Summary continues

Page citation pinpoints information

Closes Ricker-Wilson discussion with quotation and page reference

Ricker-Wilson's point about the potential of shared reading experiences for building community is something that the publishers of romance novels seem to understand. A November 1999 Publishers Weekly article describes the trend of targeting new romance books to "niche markets," particularly African Americans, Latinos, and readers looking for a spiritual dimension in their romance reading (Rosen). Another aspect of community is evident at The Romance Reader (TRR) Website, where many fans of romance novels post reviews and comments. In an article for the TRR Forum, Linda Mowery tells of the pleasure of rereading favorite books and the personal benefits offered by these novels. She calls the romance books that she rereads "comfort reads" and "emotional safety nets." She writes, "Rereading favorite books is being with old friends, friends who understand us and accept us." Tina Engler, one of the TRR reviewers who posted comments in response, adds, "To me, rereading a favorite book is like crawling under the covers with a cup of hot cocoa on a rainy day. . .

9

Jenny's response to Ricker-Wilson begins, supported by another source

No page number available for quotation from article accessed on-line

No parenthetical citations for Mowery or Engler because authors' names in tags and no page or paragraph numbers on Website

it's relaxing, invigorating, and acts as an emotional security blanket in that I already know everything that's going to happen."

10 Comments such as these remind me of all the good times my friends and I had talking about Sweet Valley High novels. These books gave us a way to talk indirectly about our own insecurities about being popular and liking boys who often didn't notice us. If romance novels can create bonds among people, honor their ethnic or spiritual identity, and help them cope with difficult times by escaping into a book from time to time, aren't these important cultural values? Like comfort food, romance novels may not provide the same nutrition that the literary equivalents of granola and tofu do, but apparently they provide a kind of nutrition that many people in our culture need.

Wraps up argument by returning to personal experience

Presents delayed thesis in full

Works cited list would start on new page in actual paper

Works Cited

Uses double spacing and hanging indents throughout

Engler, Tina. The Romance Reader Forum. 11 July 2000. 8 Aug. 2000 <http://www.theromancereader.com/forum21.html>.

Provides inclusive pagination for print publication from database

Gray, Paul, and Andrea Sachs. "Passion on the Pages." Time 20 Mar. 2000: 76-78. Academic Search Elite. EBSCO. Memorial Lib., Marquette Univ. 31 July 2000 <http://www.epnet.com/>.

No punctuation between date of access and URL

MacFarquhar, Larissa. "Who Cares If Johnny Can't Read?" Slate 16 Apr. 1997. 23 May 2000 <http//slate.msn.com/Concept/97-04-16/Concept.asp>.

URLs can break across lines at slash, only at slashes

Mowery, Linda. "The Second Time Around: The Magic of Rereading." The Romance Reader Forum. 11 July 2000. 8 Aug. 2000 <http://www.theromancereader.com/forum21.html>.

Ricker-Wilson, Carol. "Busting Textual Bodices: Gender, Reading, and the Popular Romance." English Journal 88.3 (1999): 57-64.

Rosen, Judith. "Love Is All Around You." Publishers Weekly 8 Nov. 1999: 37-43. ProQuest. Memorial Lib., Marquette U. 31 July 2000 <http://proquest.umi.com/>.

Wikoff, Katherine Hennessey. "Romance Novels More than Heaving Bosoms." Rev. of All I Need to Know in Life I Learned from Romance Novels by Victoria M. Johnson. Milwaukee Journal Sentinel 4 Feb. 1999: E2.

Inclusive pagination for print publication from database

Format for book review citation

PART 3

An Anthology
of Readings

CHAPTER 8

Expressing
and Reflecting

Readings that express and reflect grow out of writers' desires to tell their stories—to share experiences or ideas with others and in the process, to articulate for themselves what those experiences or ideas mean. To one degree or another, this double purpose characterizes all writing that expresses and reflects. In her essay "Why I Write," Joan Didion comments on both motivations. On the one hand, she says, "writing is the act of saying *I*, of imposing oneself upon other people, of saying *listen to me, see it my way, change your mind*"; on the other hand, she says, "I write to remember what it was like to be me."* Both in sharing their experiences with others and in reflecting upon these experiences for themselves, writers of expressive essays focus on the self. However, it is important to remember that the "self" or "I" created in the text is not identical with the writer composing the text nor is the experience a "factual" account of what happened. As you are probably well aware, no two people remember an event in quite the same way nor do people see themselves quite as others see them. Therefore, experiences put into words and representations of oneself in language are inevitably shaped by the speaker/writer's subjective perceptions, intentions, and communicative situation.

While expressive or reflective writing may address issues beyond the writer's experience—writers may, for example, reflect on public events or

*Joan Didion, "Why I Write," *New York Times Book Review* 5 Dec. 1976: 2.

include information about a subject—personal experience is nevertheless at the heart of the essay, forming the lens for reflecting on the topic at hand. To *reflect* is to turn or look back, to reconsider something thought or done in the past from the perspective of the present. The term comes from the Latin word meaning to bend *(flectere)* back *(re)*. Etymologically, then, the term means "to throw or bend back (light, for example) from a surface," the phenomenon by which a mirror throws back images. When we contemplate our image in a mirror, we have a double perspective, the self who is viewing and the self being viewed. Similarly, reflective writers consider their experiences from the double perspective of the past and present, from the self who was and the self who is. And just as the purpose of self-contemplation before a mirror is often to assess, study, or interpret one's appearance, so, too, the purpose of reflective writing is to evaluate, analyze, or interpret the meaning of one's experiences.

Barbara Kingsolver, for example, uses the occasion of a trip to her small Kentucky hometown to recount with wry amusement her awkward adolescence as seen from her current perspective as a successful author returning home for a book signing. On a much more somber note, Peter von Ziegesar reflects on his renewed relationship with his homeless brother and, specifically, on his ambivalence about becoming his brother's "keeper." Other writers in this section use personal observations and experience to illuminate and comment on larger social, cultural, and political issues. In each case, personal experience is viewed from multiple perspectives created by time, cultural difference, different aspects of the self, or the perspectives of others.

Not only does reflective writing include a dual or multiple authorial perspective but also it often includes a dual sense of audience and purpose as suggested in the comments of Joan Didion cited earlier. Some reflective writers seem to be writing for themselves as much as they are for the reader; therefore, readers of self-expressive prose sometimes feel as if they are eavesdropping on an inner dialogue, privy to the unfolding of meaning as it occurs to the writer. In such inner-directed reflections, the tone may be contemplative and intimate, even lyrical and poetic. At other times, reflective writing seems primarily directed to others. In these cases, the primary aim of self-expression and reflection may be coupled with other aims, such as explanation or even argument.

But whether the purpose is self- or other-directed, exploratory or didactic, expressive writing always has some sort of design upon its readers, although that design may be much less obvious than in writing to inform or persuade. Indeed, expressive writing that blatantly uses the writer's experience to teach or preach usually leaves readers cold. Often the intended effect is a subtle one. The writer is trying to enable readers to apprehend vicariously something they have never experienced before or to consider familiar experiences from a new perspective. Effective expressive writing is more interested in using the author's experience and perspective to defamiliarize the familiar, uncover contradictions, and challenge commonplace ideas than it is in using personal experience to arrive at moralistic lessons or conventional truths.

To accomplish this aim of offering readers a new perspective, effective expressive writing must re-create or render the writer's experience in a compelling manner—through carefully selected and telling details and through the use of various literary devices, such as plot, setting, character, and evocative or figurative language. The verb *to express* comes from Latin and literally means "to press out," to take inward ideas, feelings, and perceptions and give them external form. The famous dictum "show rather than tell" is thus particularly applicable to expressive and reflective writing. Expressive writing is most effective in communicating new insights and perspectives when readers feel as if they have come to this new realization on their own. Rather than telling readers, for example, that witnessing an execution is a horrifying experience that should cause them to pause and reconsider their views on capital punishment, the writer tries to render her experience of this event in a way that evokes horror in readers and prompts them to change their attitude toward capital punishment even if they don't change their position on the subject.

As a college student, you may read academic texts that include personal experience as well as scholarly analysis. For example, in anthropology classes you may read ethnographies in which the anthropologist includes personal anecdotes about living in another culture, or in other social science and education classes you may encounter research reports that describe the researcher's role as a participant observer. Additionally, you may be asked to write reflectively about your own experiences in order to make connections between the concepts you are learning in a course and your prior experience, knowledge, and beliefs. For example, you might be asked by a writing teacher to write a literacy narrative—that is, a story of a significant reading or writing experience. The aim of this assignment is to make you aware of the hidden assumptions you may have about reading and writing and to connect your past literacy learning with the new academic ways of reading and writing you are learning in college. Or perhaps a social psychology professor will ask you to write about a time when you were an outsider as a backdrop for studying various theories regarding the nature of social belonging.

Yet another kind of reflective writing that is increasingly required in college courses is self-evaluative reflections in which you are asked to describe or evaluate your process of writing a paper, solving a problem, conducting an experiment, or learning a new concept. According to learning theorists, self-reflective evaluations such as these enhance learning because the activity of identifying and assessing your own intellectual work enables you to control such activities more consciously in the future. You gain a certain "know-how" or process knowledge from retracing your steps in learning or performing a particular academic task. Moreover, such writing prepares you for the workplace—where you will quite likely be asked to write self-reflective performance reviews on a regular basis. Whether the context for reading and writing expressive/reflective prose is personal, academic, or professional, such activities nurture a certain habit of mind and create self-awareness.

QUESTIONS TO HELP YOU READ EXPRESSION AND REFLECTION RHETORICALLY

The reading selections in this chapter present a range of expressive and reflective purposes and strategies. Use your knowledge of rhetorical strategies to identify and connect these writers' aims with their strategies, particularly their use of literary devices to engage readers in relating to their experiences and the meaning they make of these experiences.

1. What seems to be the author's intention(s) in writing this reflection? What new perspective or insight is the author offering the reader?
2. How does the "story" of the author's experience—that is, the presentation of plot, setting, and characters—contribute to this purpose or purposes? How does the author's use of details contribute to this purpose or purposes?
3. How would you describe the speaker or the "I" in this text? Is there more than one version of the "self" presented? That is, does the speaker offer double or even multiple perspectives? Does the speaker's character change in the course of the essay? What in the text accounts for your impressions of the speaker's character?
4. What is the speaker's attitude(s) toward the event(s) or issues represented? How does the speaker's language reveal his or her feelings, attitudes, or stances toward the experience? (See Chapter 4, pp. 73–74, for tips on examining a writer's use of language.) Does the author's attitude toward the experience change? If so, what accounts for the change?
5. Are points of view or perspectives other than the author's introduced? If so, how do these perspectives affect the author's account of his or her experience and your interpretation of it as a reader?
6. Does the primary audience seem to be the writer himself or herself or other readers? What leads you to this conclusion? That is, what in the text seems directed to the writer? To readers?
7. How is the occasion or experience(s) about which the author writes related to other, more general issues?

BARBARA KINGSOLVER

In Case You Ever Want to Go Home Again

Barbara Kingsolver (b. 1955), an author of best-selling novels as well as short fiction, poetry, and essays, grew up in rural Kentucky. Trained as a biologist, she worked as a science writer and journalist before turning mainly to fiction. Her first novel, *The Bean Trees*

(1988), is about a young Kentucky woman who travels west to resettle and along the way finds herself the unofficial adoptive mother of a withdrawn two-year-old Cherokee girl. Now living in Tucson, Kingsolver says that she sees her writing "as a form of social action." Her most recent writing includes two novels—the critically acclaimed *Poisonwood Bible* (1998) and *The Prodigal Summer* (2000)—and *Small Wonder* (2002), a collection of essays written in response to the 9/11 tragedy. In 2000, she received the National Humanities Medal, the United States' highest honor for service through the arts. In this selection, taken from *High Tide in Tucson*, a collection of essays published in 1995, the author reflects on her trip back to her hometown in Kentucky, where she had been invited to appear for a book signing for *The Bean Trees*.

● FOR YOUR READING LOG

1. Recall a time when you revisited a house where you used to live, school you used to attend, or town you used to live in. What was this experience like? What surprised you? How did this experience make you feel? What were the differences between your memory of the place and your perceptions on your return visit? Take a few minutes to freewrite about this experience.
2. Since the author is recalling her experiences and feelings of being in high school, you will no doubt find passages that resonate with your own experiences and feelings, whether you felt like the misfit that she did in high school or not. As you read, note the passages that remind you of your feelings about high school. ●

———— ● ————

I have been gone from Kentucky a long time. Twenty years have done to my hill accent what the washing machine does to my jeans: taken out the color and starch, so gradually that I never marked the loss. Something like that has happened to my memories, too, particularly of the places and people I can't go back and visit because they are gone. The ancient brick building that was my grade school, for example, and both my grandfathers. They're snapshots of memory for me now, of equivocal focus, loaded with emotion, undisturbed by anyone else's idea of the truth. The schoolhouse's plaster ceilings are charted with craters like maps of the moon and likely to crash down without warning. The windows are watery, bubbly glass reinforced with chicken wire. The weary wooden staircases, worn shiny smooth in a path up their middles, wind up to an unknown place overhead where the heavy-footed eighth graders changing classes were called "the mules" by my first-grade teacher, and believing her, I pictured their sharp hooves on the linoleum.

My Grandfather Henry I remember in his sleeveless undershirt, home after a day's hard work on the farm at Fox Creek. His hide is tough and burnished wherever it has met the world—hands, face, forearms—but vulnerably white at the shoulders and throat. He is snapping his false teeth in and out of place, to provoke his grandchildren to hysterics.

3 As far as I know, no such snapshots exist in the authentic world. The citizens of my hometown ripped down the old school and quickly put to rest its picturesque decay. My grandfather always cemented his teeth in his head, and put on good clothes, before submitting himself to photography. Who wouldn't? When a camera takes aim at my daughter, I reach out and scrape the peanut butter off her chin. "I can't help it," I tell her, "it's one of those mother things." It's more than that. It's human, to want the world to see us as we think we ought to be seen.

4 You can fool history sometimes, but you can't fool the memory of your intimates. And thank heavens, because in the broad valley between real life and propriety whole herds of important truths can steal away into the underbrush. I hold that valley to be my home territory as a writer. Little girls wear food on their chins, school days are lit by ghostlight, and respectable men wear their undershirts at home. Sometimes there are fits of laughter and sometimes there is despair, and neither one looks a thing like its formal portrait.

5 For many, many years I wrote my stories furtively in spiral-bound notebooks, for no greater purpose than my own private salvation. But on April 1, 1987, two earthquakes hit my psyche on the same day. First, I brought home my own newborn baby girl from the hospital. Then, a few hours later, I got a call from New York announcing that a large chunk of my writing—which I'd tentatively pronounced a novel—was going to be published. This was a spectacular April Fool's Day. My life has not, since, returned to normal.

6 For days I nursed my baby and basked in hormonal euphoria, musing occasionally: all this—and I'm a novelist, too! *That*, though, seemed a slim accomplishment compared with laboring twenty-four hours to render up the most beautiful new human the earth had yet seen. The book business seemed a terrestrial affair of ink and trees and I didn't give it much thought.

7 In time my head cleared, and I settled into panic. What had I done? The baby was premeditated, but the book I'd conceived recklessly, in a closet late at night, when the restlessness of my insomniac pregnancy drove me to compulsive verbal intercourse with my own soul. The pages that grew in a stack were somewhat incidental to the process. They contained my highest hopes and keenest pains, and I didn't think anyone but me would ever see them. I'd bundled the thing up and sent it off to New York in a mad fit of housekeeping, to be done with it. Now it was going to be laid smack out for my mother, my postal clerk, my high school English teacher, anybody in the world who was willing to plunk down $16.95 and walk away with it. To find oneself suddenly published is thrilling—that is a given. But how appalling it also felt I find hard to describe. Imagine singing at the top of your lungs in the shower as you always do, then one day turning off the water and throwing back the curtain to see there in your bathroom a crowd of people, rapt, with videotape. I wanted to throw a towel over my head.

8 There was nothing in the novel to incriminate my mother or the postal clerk. I like my mother, plus her record is perfect. My postal clerk I couldn't vouch for; he has tattoos. But in any event I never put real people into my fiction—I can't see the slightest point of that, when I have the alternative of inventing utterly

subservient slave-people, whose every detail of appearance and behavior I can bend to serve my theme and plot.

Even so, I worried that someone I loved would find in what I'd written a rea- 9 son to despise me. In fact, I was sure of it. My fiction is not in any way about my life, regardless of what others might assume, but certainly it is set in the sort of places I know pretty well. The protagonist of my novel, titled *The Bean Trees,* launched her adventures from a place called "Pittman, Kentucky," which does resemble a town in Kentucky where I'm known to have grown up. I had written: "Pittman was twenty years behind the nation in practically every way you can think of except the rate of teenage pregnancies. . . . We were the last place in the country to get the dial system. Up until 1973 you just picked up the receiver and said, Marge, get me my Uncle Roscoe. The telephone office was on the third floor of the Courthouse, and the operator could see everything around Main Street square. She would tell you if his car was there or not."

I don't have an Uncle Roscoe. But if I *did* have one, the phone operator in my 10 hometown, prior to the mid-seventies, could have spotted him from her second-floor office on Main Street square.

I cherish the oddball charm of that town. Time and again I find myself writ- 11 ing love letters to my rural origins. Growing up in small-town Kentucky taught me respect for the astounding resources people can drum up from their backyards, when they want to, to pull each other through. I tend to be at home with modesty, and suspicious of anything slick or new. But naturally, when I was growing up there, I yearned for the slick and the new. A lot of us did, I think. We craved shopping malls and a swimming pool. We wanted the world to know we had once won the title "All Kentucky City," even though with sixteen-hundred souls we no more constituted a "city" than New Jersey is a Garden State, and we advertised this glorious prevarication for years and years on one of the town's few billboards.

Homely charm is a relative matter. Now that I live in a western city where 12 shopping malls and swimming pools congest the landscape like cedar blight, I think back fondly on my hometown. But the people who live there now might rather smile about the quaintness of a *smaller* town, like nearby Morning Glory or Barefoot. At any rate, they would not want to discover themselves in my novel. I can never go home again, as long as I live, I reasoned. Somehow this will be reckoned as betrayal. I've photographed my hometown in its undershirt.

During the year I awaited publication, I decided to calm down. There were 13 other ways to think about this problem:

1. If people really didn't want to see themselves in my book, they wouldn't. 14 They would think to themselves, "She is writing about Morning Glory, and those underdogs are from farther on down Scrubgrass Road."

2. There's no bookstore in my hometown. No one will know. 15

In November 1988, bookstoreless though it was, my hometown hosted a big 16 event. Paper banners announced it, and stores closed in honor of it. A crowd assembled in the town's largest public space—the railroad depot. The line went out

the door and away down the tracks. At the front of the line they were plunking down $16.95 for signed copies of a certain book.

17 My family was there. The county's elected officials were there. My first-grade teacher, Miss Louella, was there, exclaiming to one and all: "I taught her to write!"

18 My old schoolmates were there. The handsome boys who'd spurned me at every homecoming dance were there.

19 It's relevant and slightly vengeful to confess here that I was not a hit in school, socially speaking. I was a bookworm who never quite fit her clothes. I managed to look fine in my school pictures, but as usual the truth lay elsewhere. In sixth grade I hit my present height of five feet almost nine, struck it like a gong, in fact, leaving behind self-confidence and any genuine need of a training bra. Elderly relatives used the term "fill out" when they spoke of me, as though they held out some hope I might eventually have some market value, like an under-fed calf, if the hay crop was good. In my classroom I came to dread a game called Cooties, wherein one boy would brush against my shoulder and then chase the others around, threatening to pass on my apparently communicable lack of charisma. The other main victim of this game was a girl named Sandra, whose family subscribed to an unusual religion that mandated a Victorian dress code. In retrospect I can't say exactly what Sandra and I had in common that made us outcasts, except for extreme shyness, flat chests, and families who had their eyes on horizons pretty far beyond the hills of Nicholas County. Mine were not Latter-day Saints, but we read Thoreau and Robert Burns at home, and had lived for a while in Africa. My parents did not flinch from relocating us to a village beyond the reach of electricity, running water, or modern medicine (also, to my delight, conventional schooling) when they had a chance to do useful work there. They thought it was shameful to ignore a fellow human in need, or to waste money on trendy, frivolous things; they did not, on the other hand, think it was shame-ful to wear perfectly good hand-me-down dresses to school in Nicholas County. Ephemeral idols exalted by my peers, such as Batman, the Beatles, and the Hula Hoop, were not an issue at our house. And even if it took no more than a faint pulse to pass the fifth grade, my parents expected me to set my own academic goals, and then exceed them.

20 Possibly my parents were trying to make sure I didn't get pregnant in the eighth grade, as some of my classmates would shortly begin to do. If so, their ef-forts were a whale of a success. In my first three years of high school, the num-ber of times I got asked out on a date was zero. This is not an approximate num-ber. I'd caught up to other girls in social skills by that time, so I knew how to pretend I was dumber than I was, and make my own clothes. But these things helped only marginally. Popularity remained a frustrating mystery to me.

21 Nowadays, some of my city-bred friends muse about moving to a small town for the sake of their children. What's missing from their romantic picture of Grover's Corners is the frightening impact of insulation upon a child who's not dead center in the mainstream. In a place such as my hometown, you file in and sit down to day one of kindergarten with the exact pool of boys who will be your potential dates for the prom. If you wet your pants a lot, your social life ten years

later will be—as they say in government reports—impacted. I was sterling on bladder control, but somehow could never shake my sixth-grade stigma.

At age seventeen, I was free at last to hightail it for new social pastures, and you'd better believe I did. I attended summer classes at the University of Kentucky and landed a boyfriend before I knew what had hit me, or what on earth one did with the likes of such. When I went on to college in Indiana I was astonished to find a fresh set of peers who found me, by and large, likable and cootie-free.

I've never gotten over high school, to the extent that I'm still a little surprised that my friends want to hang out with me. But it made me what I am, for better and for worse. From living in a town that listened in on party lines, I learned both the price and value of community. And I gained things from my rocky school years: A fierce wish to look inside of people. An aptitude for listening. The habit of my own company. The companionship of keeping a diary, in which I gossiped, fantasized, and invented myself. From the vantage point of invisibility I explored the psychology of the underdog, the one who can't be what others desire but who might still learn to chart her own hopes. Her story was my private treasure; when I wrote *The Bean Trees* I called her Lou Ann. I knew for sure that my classmates, all of them cool as Camaros back then, would not relate to the dreadful insecurities of Lou Ann. But I liked her anyway.

And now, look. The boys who'd once fled howling from her cooties were lined up for my autograph. Football captains, cheerleaders, homecoming queens were all there. The athlete who'd inspired in me a near-fatal crush for three years, during which time he never looked in the vicinity of my person, was there. The great wits who gave me the names Kingfish and Queen Sliver were there.

I took liberties with history. I wrote long, florid inscriptions referring to our great friendship of days gone by. I wrote slowly. I made those guys wait in line *a long time.*

I can recall every sight, sound, minute of that day. Every open, generous face. The way the afternoon light fell through the windows onto the shoes of the people in line. In my inventory of mental snapshots these images hold the place most people reserve for the wedding album. I don't know whether other people get to have Great Life Moments like this, but I was lucky enough to realize I was having mine, right while it happened. My identity was turning backward on its own axis. Never before or since have I felt all at the same time so cherished, so aware of old anguish, and so ready to let go of the past. My past had let go of *me,* so I could be something new: Poet Laureate and Queen for a Day in hometown Kentucky. The people who'd watched me grow up were proud of me, and exuberant over an event that put our little dot on the map, particularly since it wasn't an airline disaster or a child falling down a well. They didn't appear to mind that my novel discussed small-town life frankly, without gloss.

In fact, most people showed unsurpassed creativity in finding themselves, literally, on the printed page. "That's my car isn't it?" they would ask. "My service station!" Nobody presented himself as my Uncle Roscoe, but if he had, I happily would have claimed him.

28 It's a curious risk, fiction. Some writers choose fantasy as an approach to truth, a way of burrowing under newsprint and formal portraits to find the despair that can stow away in a happy childhood, or the affluent grace of a grandfather in his undershirt. In the final accounting, a hundred different truths are likely to reside at any given address. The part of my soul that is driven to make stories is a fierce thing, like a ferret: long, sleek, incapable of sleep, it digs and bites through all I know of the world. Given that I cannot look away from the painful things, it seems better to invent allegory than to point a straight, bony finger like Scrooge's mute Ghost of Christmas Yet to Come, declaring, "Here you will end, if you don't clean up your act." By inventing character and circumstance, I like to think I can be a kinder sort of ghost, saying, "I don't mean *you*, exactly, but just give it some thought, anyway."

29 Nice try, but nobody's really fooled. Because fiction works, if it does, only when we the readers believe every word of it. Grover's Corners is Our Town, and so is Cannery Row, and Lilliput, and Gotham City, and Winesburg, Ohio, and the dreadful metropolis of *1984*. We have all been as canny as Huck Finn, as fractious as Scarlett O'Hara, as fatally flawed as Captain Ahab and Anna Karenina. I, personally, am Jo March, and if her author Louisa May Alcott had a whole new life to live for the sole pursuit of talking me out of it, she could not. A pen may or may not be mightier than the sword, but it is brassier than the telephone. When the writer converses privately with her soul in the long dark night, a thousand neighbors are listening in on the party line, taking it personally.

30 Nevertheless, I came to decide, on my one big afternoon as Homecoming Queen, that I would go on taking the risk of writing books. Miss Louella and all those football players gave me the rash courage to think I might be forgiven again and again the sin of revelation. I love my hometown as I love the elemental stuff of my own teeth and bones, and that seems to have come through to my hometown, even if I didn't write it up in its Sunday best.

31 I used to ask my grandfather how he could pull fish out of a lake all afternoon, one after another, while my line and bobber lay dazed and inert. This was not my Grandfather Henry, but my other grandfather, whose face I connected in childhood with the one that appears on the flip side of a buffalo nickel. Without cracking that face an iota, he was prone to uttering the funniest things I've about ever heard. In response to my question regarding the fishing, he would answer gravely, "You have to hold your mouth right."

32 I think that is also the secret of writing: attitude. Hope, unyielding faith in the enterprise. If only I hold my mouth right, keep a clear fix on what I believe is true while I make up my stories, surely I will end up saying what I mean. Then, if I offend someone, it won't be an accidental casualty. More likely, it will be because we actually disagree. I can live with that. The memory of my buffalo-nickel grandfather advises me still, in lonely moments: "If you never stepped on anybody's toes, you never been for a *walk*."

33 I learned something else, that November day, that shook down all I thought I knew about my personal, insufferable, nobody's-blues-can-touch-mine isolation of high school. Before the book signing was over, more than one of my old

schoolmates had sidled up and whispered: "That Lou Ann character, the insecure one? I know you based her on me."

• THINKING CRITICALLY ABOUT "IN CASE YOU EVER WANT TO GO HOME AGAIN"

RESPONDING AS A READER

1. The title of this essay seems to address the reader directly. In the last two sentences of paragraph 7, the speaker again addresses the reader directly. What effect does this use of direct address have on you as a reader? What other techniques does Kingsolver use to engage readers' interest and enable identification with the experiences she is describing? What is your response to these techniques? At what points in the essay were you most engaged?

2. Most readers find Kingsolver's essay humorous even though she is clearly writing about some very painful experiences. Find various passages in which she communicates a painful experience with humor. What effect does her use of humor have on your attitude toward the image(s) that Kingsolver constructs of herself in the essay?

3. Like many reflective texts, this essay relies on figurative language to recreate experience and communicate emotions and ideas. Several metaphors recur—for example, the snapshot, telephone party line, and pregnancy/birth. Choose one of these repeated metaphors or another one that appeals to you and track the references to it throughout the essay. How is this metaphor helpful in enabling you to understand the writer's experiences, emotions, or ideas?

RESPONDING AS A WRITER

1. Kingsolver's essay has three parts, which are signaled by breaks between paragraphs 15 and 16 and between 27 and 28. What's the thematic focus of each part? How do these themes connect with one another? How does she make these connections apparent to readers? Write a paragraph in which you explain your understanding of the connections among Kingsolver's themes, raising questions about any passages that don't seem to you to fit with other themes.

2. In the opening four paragraphs, Kingsolver reflects on different kinds of memories and the roles memory plays in our lives. She uses specific memories to illustrate the ideas she wants to suggest about memory. Choose two or three of these specific memories, and list them on a sheet of paper. Beside each example, write a few sentences, explaining your understanding of this example's meaning and your response in terms of your own memories.

3. Describe the image that Kingsolver creates of her adolescent "self." How did she feel about various high school experiences at the time? Now

describe her adult attitude toward this adolescent self and her adult at-
titude toward these same high school experiences. What are some dif-
ferences in the adolescent and adult point of view toward these high
school experiences? Think of a memorable grade school or high school
experience, and write for about ten minutes about how you perceived
and felt about the experience at the time, how you perceive and feel
about it now, and the differences between your two points of view. •

Kyoko Mori

Language

A Japanese-born naturalized American citizen, Kyoko Mori (b. 1957) writes about her ex-
periences growing up in one culture and living her adult life in another. Her books include
Shizuko's Daughter (1993), a young-adult novel, and *The Dream of Water* (1995), a memoir.
"Language" is taken from a collection of essays entitled *Polite Lies: On Being a Woman
Caught Between Two Cultures* (1997). Except for one chapter, "Women's Place," each of the
twelve essays in *Polite Lies* uses a single word as its title: "Family," "Secrets," "Rituals,"
"School," "Bodies," "Home," and so on. As the subtitle of the book suggests, each chap-
ter explores a particular aspect of being "a woman caught between two cultures." Mori,
who teaches creative writing at Harvard University, is working on a novel tentatively ti-
tled *The Glass Ark.*

• **FOR YOUR READING LOG**

1. What does the phrase "polite lies" mean to you? Think of a time when
 you felt you had to choose your words carefully to avoid causing some-
 one else pain or yourself embarrassment. Take a few minutes to describe
 the situation, the words you used, and the consequences of the polite lie.
2. Think of the contact you have had either with languages other than your
 native one or dialects other than the one you speak. How would you
 characterize some of the differences between your native language and
 this other language or dialect? What is your attitude toward these lan-
 guage differences? •

—— • ——

1 When my third grade teacher told us that the universe was infinite and endless,
 I wrote down her words in my notebook, but I did not believe her. An endless
 universe was too scary to be true—a pitch-black room in which we were lost for-
 ever, unable to find the way out. It worried me just as much, though, to think of
 the universe having an end. What was on the other side? I pictured a big cement

wall floating in outer space, light-years away. At night, I dreamed that I was alone on a spaceship that orbited the earth in gradually widening circles. I didn't know how to turn the ship around or steer it out of its orbit. Outside the window the black sky stretched all around me, and the Earth looked like an old tennis ball, faded and fuzzy. Unable to go back home or to land on another planet, I circled around endlessly.

Now, thirty years later, I think of that dream when I fly to Japan from the 2 American Midwest. On the twelve-hour flight between Detroit and Tokyo or Osaka, I imagine myself traveling in outer space for eternity, always getting farther and farther away from home.

Japan has not been my home for a long time. Though I was born in Kobe, I 3 have not lived there as an adult. I left at twenty to go to college in Illinois, knowing that I would never return. I now live in Green Bay, Wisconsin. I am an American citizen. My life can be divided right down the middle: the first twenty years in Japan, the last twenty years in the American Midwest. I'm not sure if I consider Green Bay to be my "home," exactly. Having grown up in a big city, I am more comfortable in Chicago or Milwaukee. But even the small towns in the Midwest are more like my home than Japan, a country I know only from a child's perspective. I don't understand Japan the way I have come to understand the Midwest—a place I learned gradually as an adult so that I can't remember when I didn't know the things I know now and take for granted. I recall Japan with the bold colors and truncated shapes of a child's perception. My memory seems vivid and yet unreliable.

Since I left, I have made only five short trips to Japan, all of them in the last seven 4 years, all for business, not pleasure. Japan is a country where I was unhappy: my mother killed herself when I was twelve, leaving me to spend my teenage years with my father and stepmother. I usually think of those years as a distant bad memory, but a trip to Japan is like a sudden trip back in time. The minute I board the plane, I become afraid: the past is a black hole waiting to suck me up. When I was in kindergarten, I worried at night that my room was full of invisible holes. If I got out of my bed and started walking, I might fall into one of the holes and be dragged through a big black space; eventually, I would come out into the wrong century or on another planet where no one would know me. I feel the same anxiety as I sit on the plane to Japan, my elbows and knees cramped against the narrow seat: one wrong move and I will be sucked back into the past.

As soon as everyone is seated on the plane, the Japanese announcement wel- 5 coming us to the flight reminds me of the polite language I was taught as a child: always speak as though everything in the world were your fault. The bilingual announcements on the plane take twice as long in Japanese as in English because every Japanese announcement begins with a lengthy apology: "We apologize about how long it's taken to seat everyone and thank you for being so patient," "We are so sorry that this has been such a long flight and we very much appreciate the fact that you have been so very cooperative with us," "We apologize for the inconvenience you will no doubt experience in having to fill out the forms we are about to hand out."

6 Every fourth or fifth sentence has the words *sumimasenga* (I am sorry but) or *osoremasuga* (I fear offending you but) or *yoroshikereba* (if it's all right with you). In the crowded cabin, the polite apologies float toward us like a pleasant mist or gentle spring rain. But actually this politeness is a steel net hauling us into the country where nothing means what it says. Already, before the plane has left American airspace, I have landed in a galaxy of the past, where I can never say what I feel or ask what I want to know.

7 In my family, proper language has always been an obstacle to understanding. When my brother called me from Japan in 1993, after our father's death, and asked me to come to Japan for a week, he never said or hinted at what he wanted me to do once I got there. I could not arrive in time for the funeral even if I were to leave within the hour. He didn't tell me whether he wanted me to come all the same to show moral support or to discuss financial arrangements. In a businesslike manner, he said, "I was wondering if you could spare a week to come here. I know you're busy with school, but maybe you could make the time if it's not too inconvenient." When I agreed, he added, "It'll be good to see you," as if I were coming to visit him for fun. And I replied, "I'll call my travel agent right away and then call you back," businesslike myself, asking no questions, because we were speaking in Japanese and I didn't know how to ask him what he really wanted.

8 Our conversation wasn't unusual at all. In Japanese, it's rude to tell people exactly what you need or to ask them what they want. The listener is supposed to guess what the speaker wants from almost nonexistent hints. Someone could talk about the cold weather when she actually wants you to help her pick up some groceries at the store. She won't make an obvious connection between the long talk about the cold weather and the one sentence she might say about going to the store later in the afternoon, the way an English speaker would. A Japanese speaker won't mention these two things in the same conversation. Her talk about the cold weather would not be full of complaints—she might even emphasize how the cold weather is wonderful for her brother, who likes to ski. She won't tell you how she hates the winter or how slippery and dangerous the sidewalks are. But if you don't offer her a ride, you have failed her. My Japanese friends often complain about people who didn't offer to help them at the right time. "But how could these people have known what to do?" I ask. "You didn't tell them." My friends insist, "They should have done it without being asked. It's no good if I have to spell things out to them. They should have been more sensitive."

9 Having a conversation in Japanese is like driving in the dark without a headlight: every moment, I am on the verge of hitting something and hurting myself or someone else, but I have no way of guessing where the dangers are. Listening to people speak to me in Japanese, over the phone or face to face, I try to figure out what they really mean. I know it's different from what they say, but I have no idea what it is. In my frustration, I turn to the familiar: I begin to analyze the conversation by the Midwestern standard of politeness. Sometimes the

comparison helps me because Midwesterners are almost as polite and indirect as Japanese people.

Just like Japanese people, Midwesterners don't like to say no. When they are 10 asked to do something they don't want to do, my Midwestern friends answer, "I'll think about it," or "I'll try." When people say these things in Japanese, everyone knows the real meaning is no. When people in Wisconsin say that they will "think about" attending a party or "try to" be there, there is a good chance that they will actually show up. "I'll think about it" or "I'll try" means that they have not absolutely committed themselves, so if they don't come, people should not be offended. In Japan or in the Midwest, when people don't say yes, I know I should back off and offer, "Don't worry if you can't. It isn't important."

In both cultures, the taboo against saying no applies to anything negative. 11 Once, in Japan, I was speaking with my aunt, Akiko, and my brother. My aunt was about to criticize my stepmother, whom she disliked. Because she was with my brother, who feels differently, Akiko began her conversation by saying, "Now, I know, of course, that your stepmother is a very good person in her own way. She means well and she is so generous."

I could tell that my aunt didn't mean a word of what she said because my 12 Midwestern friends do the exact same thing. They, too, say, "I like So-and-so. We get along just fine, but" before mentioning anything negative about almost anyone. They might then tell a long story about how that person is arrogant, manipulative, or even dishonest, only to conclude the way they started out: "Of course, he is basically a nice person, and we get along fine." They'll nod slightly, as if to say, "We all understand each other." And we do. "I like So-and-so" is simply a disclaimer meant to soften the tone. I expect to hear some version of the disclaimer; I notice when it is omitted. If a friend does not say "So-and-So is a nice person" before and after her long, angry story, I know that she truly dislikes the person she is talking about—so much that the only disclaimer she can make is "I don't like to be so negative, but," making a reference to herself but not to the other person. The omission implies that, as far as she is concerned, the other person no longer deserves her courtesy.

When I go to Japan and encounter the code of Never Say No and Always Use 13 a Disclaimer, I understand what is really meant, because I have come to understand the same things in the Midwest. But sometimes, the similarities between the two forms of politeness are deceptive.

Shortly after my father's death, my uncle, Kenichi—my mother's brother— 14 wanted to pay respects to my father's spirit at the Buddhist altar. I accompanied him and his wife, Mariko, to my stepmother's house, where the altar was kept. Michiko served us lunch and tried to give Kenichi my father's old clothing. She embarrassed me by bragging about the food she was serving and the clothes she was trying to give away, laughing and chattering in her thin, false voice.

As we were getting ready to leave, Michiko invited Kenichi and Mariko to 15 visit her again. She asked them to write down their address and phone number. Squinting at the address Mariko was writing down, my stepmother said, "Hirohatacho. Is that near the Itami train station?"

16 "Yes," Mariko replied. "About ten minutes north, on foot." Then, smiling and bowing slightly, she said, "Please come and visit us. I am home every afternoon, except on Wednesdays. If you would call me from the station, I would be very happy to come and meet you there."

17 "You are welcome to visit here any time, too," Michiko returned, beaming. "You already know where I live, but here is my address anyway." She wrote it down and handed it to Mariko.

18 Putting the piece of paper in her purse, Mariko bowed and said, "I will look forward to seeing you."

19 As I walked away from the house with Mariko and Kenichi, I couldn't get over how my stepmother had wangled an invitation out of them. The thought of her coming to their house made me sick, so I asked point-blank, "Are you really going to have Michiko over to your house?"

20 They looked surprised. Kenichi said, "We didn't mean to be insincere, but we don't really expect her to come to our house."

21 "So you were just being polite?" I asked.

22 "Of course," Kenichi replied.

23 I would never have guessed the mere formality of their invitation even though polite-but-not-really-meant invitations are nothing new to me. People in Wisconsin often say, "We should get together sometime," or "You should come and have dinner with us soon." When I hear these remarks, I always know which are meant and which are not. When people really mean their invitations, they give a lot of details—where their house is, what is a good time for a visit, how we can get in touch with each other—precisely the kind of details Mariko was giving Michiko. When the invitations are merely polite gestures, they remain timeless and vague. The empty invitations annoy me, especially when they are repeated. They are meant to express good will, but it's silly to keep talking about dinners we will never have. Still, the symbolic invitations in the Midwest don't confuse me; I can always tell them apart from the real thing.

24 In Japan, there are no clear-cut signs to tell me which invitations are real and which not. People can give all kinds of details and still not expect me to show up at their door or call them from the train station. I cannot tell when I am about to make a fool of myself or hurt someone's feelings by taking them at their word or by failing to do so.

25 I don't like to go to Japan because I find it exhausting to speak Japanese all day, every day. What I am afraid of is the language, not the place. Even in Green Bay, when someone insists on speaking to me in Japanese, I clam up after a few words of general greetings, unable to go on.

26 I can only fall silent because thirty seconds into the conversation, I have already failed at an important task: while I was bowing and saying hello, I was supposed to have been calculating the other person's age, rank, and position in order to determine how polite I should be for the rest of the conversation. In Japanese conversations, the two speakers are almost never on an equal footing: one is senior to the other in age, experience, or rank. Various levels of politeness and formality are required according to these differences: it is rude to be too fa-

miliar, but people are equally offended if you are too formal, sounding snobbish and untrusting. Gender is as important as rank. Men and women practically speak different languages; women's language is much more indirect and formal than men's. There are words and phrases that women are never supposed to say, even though they are not crude or obscene. Only a man can say *damare* (shut up). No matter how angry she is, a woman must say, *shizukani* (quiet).

Until you can find the correct level of politeness, you can't go on with the 27 conversation: you won't even be able to address the other person properly. There are so many Japanese words for the pronoun *you*. *Anata* is a polite but intimate *you* a woman would use to address her husband, lover, or a very close woman friend, while a man would say *kimi*, which is informal, or *omae*, which is so informal that a man would say this word only to a family member; *otaku* is informal but impersonal, so it should be used with friends rather than family. Though there are these various forms of *you*, most people address each other in the third person—it is offensive to call someone *you* directly. To a woman named Hanako Maeda, you don't say, "Would you like to go out for lunch?" You say, "Would Maeda-san (Miss Maeda) like to go out for lunch?" But if you had known Hanako for a while, maybe you should call her Hanako-san instead of Maeda-san, especially if you are also a woman and not too much younger than she. Otherwise, she might think that you are too formal and unfriendly. The word for *lunch* also varies: *hirumeshi* is another casual word only a man is allowed to say, *hirugohan* is informal but polite enough for friends, *ohirugohan* is a little more polite, *chushoku* is formal and businesslike, and *gochushoku* is the most formal and businesslike.

All these rules mean that before you can get on with any conversation be- 28 yond the initial greetings, you have to agree on your relationship—which one of you is superior, how close you expect to be, who makes the decisions and who defers. So why even talk, I always wonder. The conversation that follows the mutual sizing-up can only be an empty ritual, a careful enactment of our differences rather than a chance to get to know each other or to exchange ideas.

Talking seems especially futile when I have to address a man in Japanese. 29 Every word I say forces me to be elaborately polite, indirect, submissive, and unassertive. There is no way I can sound intelligent, clearheaded, or decisive. But if I did not speak a "proper" feminine language, I would sound stupid in another way—like someone who is uneducated, insensitive, and rude, and therefore cannot be taken seriously. I never speak Japanese with the Japanese man who teaches physics at the college where I teach English. We are colleagues, meant to be equals. The language I use should not automatically define me as second best.

Meeting Japanese-speaking people in the States makes me nervous for another 30 reason. I have nothing in common with these people except that we speak Japanese. Our meeting seems random and artificial, and I can't get over the oddness of addressing a total stranger in Japanese. In the twenty years I lived in Japan, I rarely had a conversation with someone I didn't already know. The only exception was the first day of school in seventh grade, when none of us knew one another, or when I was introduced to my friends' parents. Talking to clerks at

stores scarcely counts. I never chatted with people I was doing business with. This is not to say that I led a particularly sheltered life. My experience was typical of anyone—male or female—growing up in Japan.

31 In Japan, whether you are a child or an adult, ninety-five percent of the people you talk to are your family, relatives, old friends, neighbors, and people you work or go to school with every day. The only new people you meet are connected to these people you already know—friends of friends, new spouses of your relatives—and you are introduced to them formally. You don't all of a sudden meet someone new. My friends and I were taught that no "nice" girl would talk to strangers on trains or at public places. It was bad manners to gab with shopkeepers or with repair people, being too familiar and keeping them from work. While American children are cautioned not to speak with strangers for reasons of safety, we were taught not to do so because it wasn't "nice." Even the most rebellious of us obeyed. We had no language in which we could address a stranger even if we had wanted to.

32 Traveling in Japan or simply taking the commuter train in Kobe now, I notice the silence around me. It seems oppressive that you cannot talk to someone who is looking at your favorite painting at a museum or sitting next to you on the train, reading a book that you finished only last week. In Japan, you can't even stop strangers and ask for simple directions when you are lost. If you get lost, you look for a policeman, who will help you because that is part of his job.

33 A Japanese friend and I got lost in Yokohama one night after we came out of a restaurant. We were looking for the train station and had no idea where it was, but my friend said, "Well, we must be heading in the right direction, since most people seem to be walking that way. It's late now. They must be going back to the station, too." After about ten minutes—with no train station in sight yet— my friend said that if she had been lost in New York or Paris, she would have asked one of the people we were following. But in her own country, in her own language, it was unthinkable to approach a stranger.

34 For her, asking was not an option. That's different from when people in the Midwest choose not to stop at a gas station for directions or flag down a store clerk to locate some item on the shelves. Midwestern people don't like to ask because they don't want to call attention to themselves by appearing stupid and helpless. Refusing to ask is a matter of pride and self-reliance—a matter of choice. Even the people who pride themselves on never asking know that help is readily available. In Japan, approaching a stranger means breaking an unspoken rule of public conduct.

35 The Japanese code of silence in public places does offer a certain kind of protection. In Japan, everyone is shielded from unwanted intrusion or attention, and that isn't entirely bad. In public places in the States, we all wish, from time to time, that people would go about their business in silence and leave us alone. Just the other day in the weight room of the YMCA, a young man I had never met before told me that he had been working out for the last two months and gained fifteen pounds. "I've always been too thin," he explained. "I want to gain twenty more pounds, and I'm going to put it all up here." We were sitting side by side on different machines. He indicated his shoulders and chest by patting them with

his hand. "That's nice," I said, noncommittal but polite. "Of course," he continued, "I couldn't help putting some of the new weight around my waist, too." To my embarrassment, he lifted his shirt and pointed at his stomach. "Listen," I told him. "You don't have to show it to me or anything." I got up from my machine even though I wasn't finished. Still, I felt obligated to say, "Have a nice workout," as I walked away.

I don't appreciate discussing a complete stranger's weight gain and being shown his stomach, and it's true that bizarre conversations like that would never happen in a Japanese gym. Maybe there is comfort in knowing that you will never have to talk to strangers—that you can live your whole life surrounded by friends and family who will understand what you mean without your saying it. Silence can be a sign of harmony among close friends or family, but silent harmony doesn't help people who disagree or don't fit in. On crowded trains in Kobe or Tokyo, where people won't even make eye contact with strangers, much less talk to them, I feel as though each one of us were sealed inside an invisible capsule, unable to breathe or speak out. It is just like my old dream of being stuck inside a spaceship orbiting the earth. I am alarmed by how lonely I feel—and by how quietly content everyone else seems to be. 36

In Japanese, I don't have a voice for speaking my mind. When a Japanese flight attendant walks down the aisle in her traditional kimono, repeating the endlessly apologetic announcements in the high, squeaky voice a nice woman is expected to use in public, my heart sinks because hers is the voice I am supposed to mimic. All my childhood friends answer their telephones in this same voice, as do the young women store clerks welcoming people and thanking them for their business or TV anchor women reading the news. It doesn't matter who we are or what we are saying. A woman's voice is always the same: a childish squeak piped from the throat. 37

The first time I heard that voice coming out of my own mouth, about three years ago, I was lost at a subway station in Osaka. Though there were plenty of people gathered around the wall map I was trying to read, I did not stop any of them. I flagged down a station attendant, identifiable by his blue uniform. "*Ano, sumimasen,*" I started immediately with an apology ("Well, I'm so sorry to be bothering you"). Then I asked where I could catch the right train. Halfway through my inquiry, I realized that I was squeezing the air through my tightly constricted throat, making my voice thin and wavering. *I have to get out of here*, I thought. *It's a good thing I'm leaving in just a few days.* 38

I was afraid of being stuck in Japan, unable to speak except in that little-bird voice. I'm afraid of the same thing every time I go there. 39

People often tell me that I am lucky to be bilingual, but I am not so sure. Language is like a radio. I have to choose a specific station, English or Japanese, and tune in. I can't listen to both at the same time. In between, there is nothing but static. These days, though, I find myself listening to static because I am afraid to turn my dial to the Japanese station and hear that bird-woman voice. Trying to speak Japanese in Japan, I'm still thinking in English. I can't turn off what I really want to say and concentrate on what is appropriate. Flustered, I try to work 40

out a quick translation, but my feelings are untranslatable and my voice is the voice of a foreigner. The whole experience reminds me of studying French in college and being unable to say or write what I thought.

41 In my second-year French class, I had to keep a journal. I could only say stupid things: "I got up at six. I ate breakfast. It's cold. I'm tired." I was reduced to making these idiotic statements because I didn't have the language to explain, "It's cold for September and I feel sad that summer is over. But I try to cheer myself up by thinking of how beautiful the trees will be in a month." In my French, it was either cold or not cold. Nothing in between, no discussion of what the weather meant. After finishing my entry every day, I felt depressed: my life sounded bleak when it was reduced to bad weather and meal schedules, but I wasn't fluent enough in French to talk about anything else. Now, my Japanese feels thin in the same way.

42 In any language, it is hard to talk about feelings, and there are things that are almost unsayable because they sound too harsh, painful, or intimate. When we are fluent, though, we can weave and dodge our way through the obstacles and get to the difficult thing we want to say; each of us weaves and dodges in slightly different ways, using our individual style or voice. In the way we say the almost unsayable, we can hear the subtle modulations and shifts that make each of our voices unique.

43 When I studied the poetry of Maxine Kumin, Anne Sexton, and Sylvia Plath in college, I was immediately drawn to their voices. I still love the eloquence with which these poets talk about daily life and declare their feelings, balancing gracefully between matter-of-fact observations and powerful emotions. After a particularly emotional statement, the poets often step back and resume describing the garden, the yew trees and blackberries, before returning to the feelings again. They say the almost unsayable by balancing on the edge of saying too much and then pulling back, only to push their way toward that edge again. Reading them in college, I wanted to learn to speak with a voice like theirs.

44 My whole schooling has been a process of acquiring a voice. In college and graduate school, I learned to speak, write, and think like my favorite writers— through imitation and emulation, the way anyone learns any language. I have not had the same experience in Japanese. The only voice I was taught was the one that squeezed my throat shut every time I wanted to say, *Help me. This is what I want. Let me tell you how I feel.*

45 On my trips to Japan, I am nervous and awake the whole way. Sitting stiffly upright in the cone of orange light, I read my favorite novelists in English: Margaret Atwood, Amy Tan, Anne Tyler. I cannot shed my fear of the Japanese language. When the plane begins its descent toward Tokyo or Osaka and the final sets of announcements are made in the two languages, I don't try to switch from the English station of my mind to the Japanese. I turn the dial a little closer to the Japanese station without turning off the English, even though my mind will fill with static and the Japanese I speak will be awkward and inarticulate. I am willing to compromise my proficiency in Japanese so that I can continue to think the thoughts I have come to value in English.

his hand. "That's nice," I said, noncommittal but polite. "Of course," he continued, "I couldn't help putting some of the new weight around my waist, too." To my embarrassment, he lifted his shirt and pointed at his stomach. "Listen," I told him. "You don't have to show it to me or anything." I got up from my machine even though I wasn't finished. Still, I felt obligated to say, "Have a nice workout," as I walked away.

I don't appreciate discussing a complete stranger's weight gain and being 36 shown his stomach, and it's true that bizarre conversations like that would never happen in a Japanese gym. Maybe there is comfort in knowing that you will never have to talk to strangers—that you can live your whole life surrounded by friends and family who will understand what you mean without your saying it. Silence can be a sign of harmony among close friends or family, but silent harmony doesn't help people who disagree or don't fit in. On crowded trains in Kobe or Tokyo, where people won't even make eye contact with strangers, much less talk to them, I feel as though each one of us were sealed inside an invisible capsule, unable to breathe or speak out. It is just like my old dream of being stuck inside a spaceship orbiting the earth. I am alarmed by how lonely I feel—and by how quietly content everyone else seems to be.

In Japanese, I don't have a voice for speaking my mind. When a Japanese flight 37 attendant walks down the aisle in her traditional kimono, repeating the endlessly apologetic announcements in the high, squeaky voice a nice woman is expected to use in public, my heart sinks because hers is the voice I am supposed to mimic. All my childhood friends answer their telephones in this same voice, as do the young women store clerks welcoming people and thanking them for their business or TV anchor women reading the news. It doesn't matter who we are or what we are saying. A woman's voice is always the same: a childish squeak piped from the throat.

The first time I heard that voice coming out of my own mouth, about three 38 years ago, I was lost at a subway station in Osaka. Though there were plenty of people gathered around the wall map I was trying to read, I did not stop any of them. I flagged down a station attendant, identifiable by his blue uniform. "*Ano, sumimasen,*" I started immediately with an apology ("Well, I'm so sorry to be bothering you"). Then I asked where I could catch the right train. Halfway through my inquiry, I realized that I was squeezing the air through my tightly constricted throat, making my voice thin and wavering. *I have to get out of here,* I thought. *It's a good thing I'm leaving in just a few days.*

I was afraid of being stuck in Japan, unable to speak except in that little-bird 39 voice. I'm afraid of the same thing every time I go there.

People often tell me that I am lucky to be bilingual, but I am not so sure. Lan- 40 guage is like a radio. I have to choose a specific station, English or Japanese, and tune in. I can't listen to both at the same time. In between, there is nothing but static. These days, though, I find myself listening to static because I am afraid to turn my dial to the Japanese station and hear that bird-woman voice. Trying to speak Japanese in Japan, I'm still thinking in English. I can't turn off what I really want to say and concentrate on what is appropriate. Flustered, I try to work

out a quick translation, but my feelings are untranslatable and my voice is the voice of a foreigner. The whole experience reminds me of studying French in college and being unable to say or write what I thought.

41 In my second-year French class, I had to keep a journal. I could only say stupid things: "I got up at six. I ate breakfast. It's cold. I'm tired." I was reduced to making these idiotic statements because I didn't have the language to explain, "It's cold for September and I feel sad that summer is over. But I try to cheer myself up by thinking of how beautiful the trees will be in a month." In my French, it was either cold or not cold. Nothing in between, no discussion of what the weather meant. After finishing my entry every day, I felt depressed: my life sounded bleak when it was reduced to bad weather and meal schedules, but I wasn't fluent enough in French to talk about anything else. Now, my Japanese feels thin in the same way.

42 In any language, it is hard to talk about feelings, and there are things that are almost unsayable because they sound too harsh, painful, or intimate. When we are fluent, though, we can weave and dodge our way through the obstacles and get to the difficult thing we want to say; each of us weaves and dodges in slightly different ways, using our individual style or voice. In the way we say the almost unsayable, we can hear the subtle modulations and shifts that make each of our voices unique.

43 When I studied the poetry of Maxine Kumin, Anne Sexton, and Sylvia Plath in college, I was immediately drawn to their voices. I still love the eloquence with which these poets talk about daily life and declare their feelings, balancing gracefully between matter-of-fact observations and powerful emotions. After a particularly emotional statement, the poets often step back and resume describing the garden, the yew trees and blackberries, before returning to the feelings again. They say the almost unsayable by balancing on the edge of saying too much and then pulling back, only to push their way toward that edge again. Reading them in college, I wanted to learn to speak with a voice like theirs.

44 My whole schooling has been a process of acquiring a voice. In college and graduate school, I learned to speak, write, and think like my favorite writers— through imitation and emulation, the way anyone learns any language. I have not had the same experience in Japanese. The only voice I was taught was the one that squeezed my throat shut every time I wanted to say, *Help me. This is what I want. Let me tell you how I feel.*

45 On my trips to Japan, I am nervous and awake the whole way. Sitting stiffly upright in the cone of orange light, I read my favorite novelists in English: Margaret Atwood, Amy Tan, Anne Tyler. I cannot shed my fear of the Japanese language. When the plane begins its descent toward Tokyo or Osaka and the final sets of announcements are made in the two languages, I don't try to switch from the English station of my mind to the Japanese. I turn the dial a little closer to the Japanese station without turning off the English, even though my mind will fill with static and the Japanese I speak will be awkward and inarticulate. I am willing to compromise my proficiency in Japanese so that I can continue to think the thoughts I have come to value in English.

Yet as the plane tips to the right and then to the left, I feel the pull of the 46
ground. Gravity and nostalgia seem one and the same. Poised over the land of
my childhood, I recognize the coastline. The sea shines and glitters just like the
one in the old songs we sang in grade school. The mountains are a dark green
and densely textured. It comes to me, like a surprise, that I love this scenery. *How
could I have spent my adult life away from here?* I wonder. *This is where I should have
been all along.* I remember the low, gray hills of the Midwest and wonder how I
could have found them beautiful, when I grew up surrounded by real mountains.
But even as part of me feels nostalgic, another part of me remains guarded, and
my adult voice talks in the back of my mind like a twenty-four-hour broadcast.
Remember who you were, it warns, *but don't forget who you are now.*

• THINKING CRITICALLY ABOUT "LANGUAGE"
RESPONDING AS A READER

1. In the first paragraph of the essay, Mori tells the story of a childhood
 fear. What kind of tone is set by this opening anecdote? Do you think
 this story is an effective opening to her essay? How is this opening story
 related to other themes in the essay?
2. Throughout the essay, Mori offers a number of anecdotes to illustrate
 particular Japanese or American language practices. What do you see
 as the function of these examples? Select two or three that you found
 particularly engaging, and be prepared to discuss your response to
 these examples.
3. How is language tied to self-image or identity in this essay? How
 many different images of Mori's self can you identify (for example, her
 Japanese-speaking self, her Midwestern-American-speaking self, her
 childhood self)? What characterizes these various selves and how does
 she connect language use to each?

RESPONDING AS A WRITER

1. "Language" is divided into seven short sections, with each one indi-
 cated by extra spacing between paragraphs. Using the instructions in
 Chapter 3 for descriptive outlining, write *does* and *says* statements for
 each of these sections. What new insights does this exercise give you
 about the essay's meaning?
2. In Chapter 4, we explain how a text's value system or ideology is often
 revealed through the use of opposing terms in which one set of terms
 is clearly valued by the author and another set of terms is not. Make a
 list of valued terms and concepts in this essay and match them with
 terms and concepts not valued. (Remember that valued and not-valued
 terms or concepts may be implied rather than directly stated.) For ex-
 ample, the concept "voice for speaking my mind" is clearly a positive
 term in this text, and its opposite—the "high, squeaky voice a nice
 [Japanese] woman is expected to use in public"—is not (par. 37). After

you have compiled a list, write a paragraph in which you draw some conclusions about the beliefs or values that inform this text.

3. "My whole schooling," writes Mori, "has been a process of acquiring a voice. In college and graduate school, I learned to speak, write, and think like my favorite writers—through imitation and emulation, the way anyone learns any language" (par. 44). How would you describe this "voice" and "language" she has worked to acquire as they are evident here? What are their characteristics? Find passages in this essay that are examples of this voice and language. ●

PETER VON ZIEGESAR

Brothers

Peter von Ziegesar is a documentary filmmaker who lives in New York City. A graduate of the Kansas City Art Institute, von Ziegesar has produced films on a wide variety of subjects: *Alaska* (1980), *Who Shall Remain Homeless* (1978), and *Concern for the City* (1986). He also writes frequent reviews of art exhibits for the *New York Times*. For the past several years, von Ziegesar has been working on a documentary movie about his schizophrenic stepbrother, who shares his name. "Brothers" appeared in the winter 2000 issue of *DoubleTake*, a journal that features photography and photographic essays as well as fiction and literary nonfiction. Accompanying the essay is a photograph of "Little Peter" von Ziegesar and the author, "Big Peter" von Ziegesar, riding New York City's F Train. The photo was taken by James Syme, a classmate and long-time friend of the author. Syme

"Little Peter," left; "Big Peter," the author, right.

has also befriended the homeless younger brother and documented his life in still photographs. In 2002, an exhibit of Syme's photographs, "The Chronicle of a Schizophrenic and His Reluctant Helpers," was displayed at the Glass Curtain Gallery in Chicago.

• **FOR YOUR READING LOG**

1. Take a few minutes to study the photograph of the two brothers. In your reading log, describe the image of each brother created in the photograph as well as the relationship suggested by the photograph.
2. Think about the photographs of your family members in albums, on the refrigerator, or framed throughout your house. Choose a photograph that is particularly memorable, and describe the photo. Consider what this photograph suggests about the family members pictured and their relationship. •

— ● —

Not long ago, in the middle of a record-cold winter in New York City, I looked out of my apartment window at the slush and refuse on the street and realized that out there, somewhere in the darkness, a man who bore my first and last name was hopelessly foraging through garbage cans and sleeping on subways—and that it was up to me, somehow, to do something about it. 1

The man in question was my stepbrother, the son of my father's second wife. "Little Peter," as he is still known in my family, was diagnosed as having schizophrenia only recently. Before that he had been considered merely a difficult adolescent, a delinquent young adult, a slacker, an alcohol and drug abuser, a college dropout, a disappointment, and a failure. Given the world of privilege in which he'd been raised—the private schools, the music lessons, the European vacations—most who knew him considered his fall from grace to have been caused by a spectacular case of bad attitude. Even just a few years ago, in Idaho, after he'd assaulted his mother, pushing her down on the floor of her porch and banging her head against the boards, a psychiatrist assigned by the state to assess his chances for involuntary commitment in a state hospital concluded that my stepbrother was just a "spoiled kid" who needed a swift kick in the pants. 2

Schizophrenics live in a world of violence that matches their internal chaos; they assault and are assaulted (and also commit suicide) with greater frequency than the rest of the population. Peter's increasingly troubled career does not contradict this. In a bar fight in Leadville, Colorado, local drunks used Peter's head as a battering ram to break down the tavern's front door; he received three months in jail and had to pay for the damage. In Montana he was run over by a harvest combine while sleeping off a drunk. The blades sheared off both of his hands; in Salt Lake City, after the hands had been meticulously reattached, he pushed a nurse down a flight of stairs. One night, in Indianapolis, he was clocked going 110 miles an hour past the governor's mansion in his new car. Convinced 3

that pursuing cops were in league with a ring of automobile thieves, he crashed into a police roadblock. Last year he spent more than a month in a lockup in Blaine County, Idaho, after trying to break into the rock musician Steve Miller's Sun Valley guest house. And so on. One cannot account for, much less count, the number of times he has driven drunk or been arrested, beaten, kicked, robbed, and thrown off trains. If his life maintains its current trajectory, Peter could easily be dead by the time he's forty. He's thirty-three now.

4 On that winter day I decided to do what I could to help Peter. Fully aware of his history of violence, I went out to find him. I chose a corner on West Twenty-third Street that I knew he had frequented in the past, sat on a concrete hump at the entrance to a taxi garage, and waited for him to show up.

5 Sure enough, a few minutes later the doors of a coffee shop across the street swing open, and Peter emerges to stand, beetle-browed and uncomprehending, in the low rays of winter sunlight. Like a lizard, he seems to be gathering just enough warmth to make his limbs move.

6 He wears torn jeans and a stained corduroy jacket that is too small for his thick and doughy body. The sleeves of a flannel shirt stick out beyond his jacket's sleeves, and over the flannel shirt is a long and untucked T-shirt. He's growing a beard, and his hair, once blond, is now orange mixed with toffee brown, and is molded over his head like a bowl. Even from the other side of the street I can see that his eyes, always remarked upon as Paul Newman blue, remain brilliant and clear.

7 Scratching himself sleepily under the arms, my stepbrother begins to lumber down the street, and I get up to follow. His walk is one that stray cats and homeless men develop unconsciously, an ambulatory cringe that says to the world, "Don't beat me, I'm moving on. I'm just taking this broken sandwich, this container of moo shu pork, this spit-soaked cigarette butt. You didn't want it. Now I've got it. I'll stop defiling your view in a minute."

8 Peter has a bend at the waist and a thickness in the back that is almost a hump, and his beggarly flinch remains even when he thinks he's alone and unobserved. The demeanor, the shuffling walk, and the clothes are so familiar that he could quickly and easily disappear from sight, falling in with the other ragged, baggy beggars—a third to a half of whom are schizophrenic—who form the grotesquerie of the New York City landscape.

9 His foraging starts immediately. He picks a white paper bag from a trash can, pries it open, and rattles the interior. The sound and motion are familiar and mechanical; they remind me of the motions of a caged fox returning again and again to its pan to check if any specks of food remain.

10 It's wrenching for me to recall, as I watch him, that this is the boy whose music teacher at Dalton said he played violin like "the next Paganini"; the same angel-faced five-year-old whom I carried on my back on the green lawns of Connecticut; the boy who later took skiing vacations in Austria and who received so much largess each Christmas that his parents would hide it from us, the earlier set of my father's children, so that we would not know how favored he was among us.

Peter pries open a few more garbage cans and rummages through their con- 11
tents. He does not dig very deeply, I notice; anything too compressed will be rot-
ten, he will later tell me, understandably proud of his urban foraging skills.
Here is pay dirt: a folded carton with three slices of pizza inside, and napkins,
too, creased in a triangular wad. Peter goes to a corner deli, emerges with a take-
out cup of coffee, and sets up shop on a loading platform across the street, where
he can absorb wintry sun and congealed cheese at the same time. I go to the deli
too, get a coffee and a doughnut—and, on second thought, another doughnut,
a jelly one—and go out to join Peter on his chilly ledge.

He greets me without a single question, even though we have not talked in 12
seven years. Whatever tiny devils are working in his head, they are quiet this
afternoon.

We have a long, philosophical conversation regarding the tao of drinking 13
tea—Peter likes to sip green tea at the kiosks of Chinatown. He pulls out several
books on Eastern thought, each one curled and thumbed. The world is con-
trolled by a single clear note, he says, produced somewhere deep in the universe,
as from a Chinese gong. Exceptional musicians, among them Ozzy Osbourne,
have the power to tap into that note and open up a funnel into our brains. But
anyone can tune in by listening hard enough: it's what you hear on the last seat
of the last car on the A train when it rumbles across the Jamaica Bay causeway
at two in the morning.

Do you talk to your mother anymore? 14

She doesn't want to hear the truth, that I'm living like a rat on the street and 15
licking the crumbs off my frozen whiskers.

Has the winter been exceptionally cold? 16

Perhaps the sun is pulling her skirts away from the earth, shocked by what 17
she's seen.

Shambling off in search of shade and shadows, Peter puts in a touch for 18
twenty dollars. "It's so hard to budget your money in New York City," he con-
fides to me. I leave thinking that I've helped him out, but the truth is that the drug
dealers on Fourteenth Street will skim the money from him within minutes.

That afternoon I become a keeper of sorts. I check Peter into the Riverview, a run- 19
down but clean and safe hotel near my home in Greenwich Village. I gamely start
the process of procuring medications, which he refuses to take, and social ser-
vices, with which he refuses to cooperate. Within a few days I spend more than
a thousand dollars, to very little effect.

He stays in New York for an intense month or two, until the electronic 20
demons return to scribble messages with sharp ballpoint pens on his naked
scalp and he boards the Greyhound bus for nowhere, anywhere: he's a Neal Cas-
sidy without women, without Jack Kerouac for a biographer, a beat figure rid-
ing through the night without friends, fresh clothes, a shower, or money—and,
of course, without glory.

I am his only friend, the one he calls from a pier in San Francisco; from a psy- 21
chiatric hospital in Twin Falls, Idaho; from a phone booth in the crack zone in
Miami, when he is feeling suicidal. I'm the one he begs to wire him $100 at the

spur of the moment so that he can go to a Santana concert with a *companiero* he's just picked up in the Albuquerque bus station; the one who talks long-distance to his court-appointed lawyers, psychiatrists, and jailers; the one who tries to make sense of his multifarious and inchoate needs and assertions.

22 I keep a record of sorts, a noir journal to mark the dark passages of my step-brother's mind. The more I chronicle our strange and sometimes sad encounters, the more I am convinced that his story, the story of the American schizophrenic, has not been truly told, or at least not been told forcefully enough to sink into our uncaring, hidebound national consciousness.

23 The journal grows over the years, as I learn more about the disease and begin to explore the shadowy places, psychic and real, in which my stepbrother spends his time. At a certain point, I make the decision to involve Jim Syme, a photographer I've known and worked with since art school, in the project. Jim and Peter quickly develop a rapport that at times I find impenetrable. They share an interest in sailing and in the vast unknown desert spaces of the Southwest, in flying saucers, government plots, and grand technological conspiracies of all kinds. When Jim first takes out his camera, Peter's face freezes, but after a while, despite his fear of police and surveillance, Peter loosens up and lets out a wary grin.

24 Sometimes I fear Jim has become too involved. He drives alone to Leadville, Colorado, a furious three-day road trip, to spring Peter from jail, where he has unexpectedly landed because of a standing warrant. They drive for days in a wide, eccentric orbit around Denver, following Peter's instincts, until they spin off for Idaho to pay a visit to Peter's mother's river-rafting company. It's a demented odyssey that I am able to monitor, hour by hour, via my cellular phone, from New York. I quote passages from *On the Road* over the airwaves to keep up Peter's and Jim's spirits.

25 One night, Peter, Jim, and I are holed up in a dim motel room near the airport in Miami. The following morning Peter is to go into drug rehabilitation. It is a hard-core hospital lockup scene about which he is understandably leery. After dinner, to allay his nervousness, Jim and I allow him to drink beer after beer.

26 "Do you remember when you used to saw away at that old violin of yours?" I ask. "We all thought you were going to turn pro. You were always pounding away on the piano, too. What ever became of all that?"

27 Peter pulls his boating cap low over his deeply tanned face. "That was a long time ago," he replies. His huge, scarred right arm lies on the bedcovers like a beached whale. He's been scanning the channels for hours and is somewhat alarmed at the presence of Leonardo DiCaprio on the television screen everywhere he turns.

28 "Do you have the same love for music that you had before?" I ask. "Do you still listen?"

29 He thinks. The tapes in his bag run more toward heavy metal than baroque.

30 "I still hear Bach in my head," he says at last, slowly. "I hear it every night when I'm alone. Mostly Bach. Sometimes it's Mozart. Sometimes it's others."

"Other composers? Classical composers?" 31

"I hear the notes playing in my head, but they are notes no one has ever 32
heard before."

"Music you've composed yourself?" 33

"I guess." He seems wary. 34

"Could you write it down?" 35

"I would if I had the time," he says, turning back to the TV screen. "But all 36
that just seems like a lot of work to me."

Peter has chosen to inhabit the dark places that most people spend their lives 37
avoiding. Take him to a nice, well-lit restaurant and he feels that people's eyes
are lasers etching cruel patterns into his heart. Out on the sidewalk, the sun pours
over his head like a nuclear fountain. He demands the darkest possible sun-
glasses; they must be from Chinatown, for spiritual value, and they must cost five
dollars—no more. I try to buy him a pair of Ray Bans, but he rejects them because
they are not dark enough, not cheap enough, and, more important, because they
might draw attention to his existence. He wants to walk the streets unknown, in-
visible and alone.

Sometimes I forget how hard it is to "help" Peter. His present way of life has 38
its own codes and values, and they are not to be lightly broken. For example: I
take him into an army-navy store to try on a new jacket and boots, to replace his
torn, filthy ones. He fidgets in the store, complains about feeling conspicuous,
and won't try on any of the shoes. Finally he loses his temper. "I'm a street per-
son," he says, almost in despair. "Don't you understand? I don't want to look any
different than this!"

When I first found my stepbrother on West Twenty-third Street, his head was 39
awash with strange, angry conspiracies concerning President Clinton and a mi-
crochip the government had supposedly planted in Peter's brain to monitor and
control his thoughts. I was afraid of Peter then—afraid of what he might do to
me, or my family, or even my credit rating or my police record, since we do share
the same name. But the years have mellowed Peter. I have seen movement. I have
seen progress. He has lost his interest in the evils that flow from Washington. His
pursuits have narrowed. He likes to travel by bus, to arrive in a strange city at
night. Doing what he calls his "alone thing," he goes for days without talking to
anyone, consumed with the repetitive movements of bare survival. He has be-
come, in certain essential ways, a man who knows himself and is content with
his lot.

"Which of us has known his brother?" Thomas Wolfe asked, in *Look Home-* 40
ward Angel, and in the same sentence wondered, "Which of us is not forever a
stranger and alone?" When I look into myself, I find that Peter and I are not com-
pletely unalike in our stance toward the world. We have both been slow starters,
school dropouts, idle dreamers, social moles, and knee-jerk antiauthoritarians.
The difference is that, painfully, I have learned to adjust, to hold back, to temper
my impulses to the occasion, and, eventually, have found a home. Peter cannot,

and he is therefore condemned to live his life in an endless circle. "As far as I've come," he once admitted to me, in a message left on my answering machine from a truck stop somewhere in Nevada, "I really haven't gotten anywhere." Wherever he is now, I hope Peter someday finds a home too, because everyone deserves a place they can stay a while.

• THINKING CRITICALLY ABOUT "BROTHERS"
RESPONDING AS A READER

1. In paragraphs 5–9, von Ziegesar uses vivid detail and figurative language to create a verbal picture of his brother's appearance and movements when he first sees him after many years. He compares his brother's movements to a lizard, cat, and caged fox. What attitudes toward the brother do these details and metaphors inspire in you as a reader?

2. How much does the author directly or indirectly reveal about himself in this essay? As a reader, what is your attitude toward the narrator, particularly in his role as elder brother, and what in the text accounts for your attitude?

3. In Chapter 3, we discuss various possible relationships between the verbal text and the accompanying visual elements. How would you describe the relationship between the essay "Brothers" and the accompanying photograph of the brothers? How does the photograph affect your response to the text?

RESPONDING AS A WRITER

1. Imagine that the story of these brothers' relationship is told from either the younger brother's perspective or from Jim Syme's perspective. Freewrite about how the story of the relationship might differ.

2. The layout of the essay in *DoubleTake* uses spacing to divide the essay into the following six sections: paragraphs 1–4; paragraphs 5–18; paragraphs 19–24; paragraphs 25–36; paragraphs 37–38; and paragraphs 39–40. Write a descriptive outline or *does/says* statements for each of these six sections. After you have completed your descriptive outline, write a brief commentary on the rhetorical effect of this essay's structure.

3. Although this essay is written from the older brother's perspective, we do get some insight into the younger Peter's point of view in paragraph 38 when the author writes that his younger brother's "present way of life has its own codes and values, and they are not to be lightly broken." Imagine that you have the opportunity to interview the younger Peter for a paper you are writing on homelessness. What questions might you ask him about these codes and values? •

bell hooks

keeping close to home: class and education

Writer Gloria Watkins (b. 1952) writes under the name of her "sharp-tongued" grandmother, bell hooks, whom she "discovered, claimed, and invented" as her "ally." Feminist, scholar, essayist, poet, and public intellectual, bell hooks is known for her incisive critiques of white feminism, classism, and patriarchy. hooks has taught at Oberlin College, City College of New York, and Yale University. The first book to bring hooks national recognition was *Ain't I a Woman: black women and feminism* (1981); since then, she has written fourteen books of nonfiction, several books of poetry, and numerous essays. Among her most recent publications are *All About Love: new visions* (2000); *Homemade Love* (2001), a book for children; and *Communion: female search for love* (2002). "keeping close to home: class and education" is taken from *Talking Back: thinking feminist, thinking black* (1989), which was published by South End Press, a nonprofit collectively run book publisher "committed to radical social change." *Talking Back* includes twenty-five essays by hooks; other essay titles include "on being black at yale: education as the practice of freedom" and "'when i was a young soldier for the revolution': coming to voice."

● **FOR YOUR READING LOG**

1. Given the above background information about hooks and the title of the collection, *Talking Back*, make some predications about what she will have to say about "home," "education," and "class."
2. When hooks left her small town home of Hopkinsville, Kentucky, and her working-class black family to attend Stanford University, she experienced something of a culture shock. Many students experience some kind of culture shock when they first enter college, though often it is not as dramatic as that experienced by hooks. Think about whether you have experienced any culture shock upon entering college. If so, describe this experience and your feelings about it in your reading log. If not, speculate about why not. What accounts for your ease or difficulty in adjusting to college? ●

———— ● ————

We are both awake in the almost dark of 5 a.m. Everyone else is sound asleep. 1
Mama asks the usual questions. Telling me to look around, make sure I have everything, scolding me because I am uncertain about the actual time the bus arrives. By 5:30 we are waiting outside the closed station. Alone together, we have

a chance to really talk. Mama begins. Angry with her children, especially the ones who whisper behind her back, she says bitterly, "Your childhood could not have been that bad. You were fed and clothed. You did not have to do without—that's more than a lot of folks have and I just can't stand the way y'all go on." The hurt in her voice saddens me. I have always wanted to protect mama from hurt, to ease her burdens. Now I am part of what troubles. Confronting me, she says accusingly, "It's not just the other children. You talk too much about the past. You don't just listen." And I do talk. Worse, I write about it.

2 Mama has always come to each of her children seeking different responses. With me she expresses the disappointment, hurt, and anger of betrayal: anger that her children are so critical, that we can't even have the sense to like the presents she sends. She says, "From now on there will be no presents. I'll just stick some money in a little envelope the way the rest of you do. Nobody wants criticism. Everybody can criticize me but I am supposed to say nothing." When I try to talk, my voice sounds like a twelve year old. When I try to talk, she speaks louder, interrupting me, even though she has said repeatedly, "Explain it to me, this talk about the past." I struggle to return to my thirty-five year old self so that she will know by the sound of my voice that we are two women talking together. It is only when I state firmly in my very adult voice, "Mama, you are not listening," that she becomes quiet. She waits. Now that I have her attention, I fear that my explanations will be lame, inadequate. "Mama," I begin, "people usually go to therapy because they feel hurt inside, because they have pain that will not stop, like a wound that continually breaks open, that does not heal. And often these hurts, that pain has to do with things that have happened in the past, sometimes in childhood, often in childhood, or things that we believe happened." She wants to know, "What hurts, what hurts are you talking about?" "Mom, I can't answer that. I can't speak for all of us, the hurts are different for everybody. But the point is you try to make the hurt better, to heal it, by understanding how it came to be. And I know you feel mad when we say something happened or hurt that you don't remember being that way, but the past isn't like that, we don't have the same memory of it. We remember things differently. You know that. And sometimes folk feel hurt about stuff and you just don't know or didn't realize it, and they need to talk about it. Surely you understand the need to talk about it."

3 Our conversation is interrupted by the sight of my uncle walking across the park toward us. We stop to watch him. He is on his way to work dressed in a familiar blue suit. They look alike, these two who rarely discuss the past. This interruption makes me think about life in a small town. You always see someone you know. Interruptions, intrusions are part of daily life. Privacy is difficult to maintain. We leave our private space in the car to greet him. After the hug and kiss he has given me every year since I was born, they talk about the day's funerals. In the distance the bus approaches. He walks away knowing that they will see each other later. Just before I board the bus I turn, staring into my mother's face. I am momentarily back in time, seeing myself eighteen years ago, at this same bus stop, staring into my mother's face, continually turning back, waving

farewell as I returned to college—that experience which first took me away from our town, from family. Departing was as painful then as it is now. Each movement away makes return harder. Each separation intensifies distance, both physical and emotional.

To a southern black girl from a working-class background who had never 4 been on a city bus, who had never stepped on an escalator, who had never travelled by plane, leaving the comfortable confines of a small town Kentucky life to attend Stanford University was not just frightening; it was utterly painful. My parents had not been delighted that I had been accepted and adamantly opposed my going so far from home. At the time, I did not see their opposition as an expression of their fear that they would lose me forever. Like many working-class folks, they feared what college education might do to their children's minds even as they unenthusiastically acknowledged its importance. They did not understand why I could not attend a college nearby, an all-black college. To them, any college would do. I would graduate, become a school teacher, make a decent living and a good marriage. And even though they reluctantly and skeptically supported my educational endeavors, they also subjected them to constant harsh and bitter critique. It is difficult for me to talk about my parents and their impact on me because they have always felt wary, ambivalent, mistrusting of my intellectual aspirations even as they have been caring and supportive. I want to speak about these contradictions because sorting through them, seeking resolution and reconciliation has been important to me both as it affects my development as a writer, my effort to be fully self-realized, and my longing to remain close to the family and community that provided the groundwork for much of my thinking, writing, and being.

Studying at Stanford, I began to think seriously about class differences. To 5 be materially underprivileged at a university where most folks (with the exception of workers) are materially privileged provokes such thought. Class differences were boundaries no one wanted to face or talk about. It was easier to downplay them, to act as though we were all from privileged backgrounds, to work around them, to confront them privately in the solitude of one's room, or to pretend that just being chosen to study at such an institution meant that those of us who did not come from privilege were already in transition toward privilege. To not long for such transition marked one as rebellious, as unlikely to succeed. It was a kind of treason not to believe that it was better to be identified with the world of material privilege than with the world of the working class, the poor. No wonder our working-class parents from poor backgrounds feared our entry into such a world, intuiting perhaps that we might learn to be ashamed of where we had come from, that we might never return home, or come back only to lord it over them.

Though I hung with students who were supposedly radical and chic, we did 6 not discuss class. I talked to no one about the sources of my shame, how it hurt me to witness the contempt shown the brown-skinned Filipina maids who cleaned our rooms, or later my concern about the $100 a month I paid for a room off-campus which was more than half of what my parents paid for rent. I talked

to no one about my efforts to save money, to send a little something home. Yet these class realities separated me from fellow students. We were moving in different directions. I did not intend to forget my class background or alter my class allegiance. And even though I received an education designed to provide me with a bourgeois sensibility, passive acquiescence was not my only option. I knew that I could resist. I could rebel. I could shape the direction and focus of the various forms of knowledge available to me. Even though I sometimes envied and longed for greater material advantages (particularly at vacation times when I would be one of few if any students remaining in the dormitory because there was no money for travel), I did not share the sensibility and values of my peers. That was important—class was not just about money; it was about values which showed and determined behavior. While I often needed more money, I never needed a new set of beliefs and values. For example, I was profoundly shocked and disturbed when peers would talk about their parents without respect, or would even say that they hated their parents. This was especially troubling to me when it seemed that these parents were caring and concerned. It was often explained to me that such hatred was "healthy and normal." To my white, middle-class California roommate, I explained the way we were taught to value our parents and their care, to understand that they were not obligated to give us care. She would always shake her head, laughing all the while, and say, "Missy, you will learn that it's different here, that we think differently." She was right. Soon, I lived alone, like the one Mormon student who kept to himself as he made a concentrated effort to remain true to his religious beliefs and values. Later in graduate school I found that classmates believed "lower class" people had no beliefs and values. I was silent in such discussions, disgusted by their ignorance.

7 Carol Stack's anthropological study, *All Our Kin,* was one of the first books I read which confirmed my experiential understanding that within black culture (especially among the working class and poor, particularly in southern states), a value system emerged that was counter-hegemonic, that challenged notions of individualism and private property so important to the maintenance of white-supremacist, capitalist patriarchy. Black folk created in marginal spaces a world of community and collectivity where resources were shared. In the preface to *Feminist Theory: from margin to center,* I talked about how the point of difference, this marginality can be the space for the formation of an oppositional world view. That world view must be articulated, named if it is to provide a sustained blueprint for change. Unfortunately, there has existed no consistent framework for such naming. Consequently both the experience of this difference and documentation of it (when it occurs) gradually loses presence and meaning.

8 Much of what Stack documented about the "culture of poverty," for example, would not describe interactions among most black poor today irrespective of geographical setting. Since the black people she described did not acknowledge (if they recognized it in theoretical terms) the oppositional value of their world view, apparently seeing it more as a survival strategy determined less by conscious efforts to oppose oppressive race and class biases than by circumstance, they did not attempt to establish a framework to transmit their beliefs and values from generation to generation. When circumstances changed, values al-

tered. Efforts to assimilate the values and beliefs of privileged white people, presented through media like television, undermine and destroy potential structures of opposition.

Increasingly, young black people are encouraged by the dominant culture 9 (and by those black people who internalize the values of this hegemony) to believe that assimilation is the only possible way to survive, to succeed. Without the framework of an organized civil rights or black resistance struggle, individual and collective efforts at black liberation that focus on the primacy of self-definition and self-determination often go unrecognized. It is crucial that those among us who resist and rebel, who survive and succeed, speak openly and honestly about our lives and the nature of our personal struggles, the means by which we resolve and reconcile contradictions. This is no easy task. Within the educational institutions where we learn to develop and strengthen our writing and analytical skills, we also learn to think, write, and talk in a manner that shifts attention away from personal experience. Yet if we are to reach our people and all people, if we are to remain connected (especially those of us whose familial backgrounds are poor and working-class), we must understand that the telling of one's personal story provides a meaningful example, a way for folks to identify and connect.

Combining personal with critical analysis and theoretical perspectives can 10 engage listeners who might otherwise feel estranged, alienated. To speak simply with language that is accessible to as many folks as possible is also important. Speaking about one's personal experience or speaking with simple language is often considered by academics and/or intellectuals (irrespective of their political inclinations) to be a sign of intellectual weakness or even anti-intellectualism. Lately, when I speak, I do not stand in place—reading my paper, making little or no eye contact with audiences—but instead make eye contact, talk extemporaneously, digress, and address the audience directly. I have been told that people assume I am not prepared, that I am anti-intellectual, unprofessional (a concept that has everything to do with class as it determines actions and behavior), or that I am reinforcing the stereotype of black people as non-theoretical and gutsy.

Such criticism was raised recently by fellow feminist scholars after a talk I 11 gave at Northwestern University at a conference on "Gender, Culture, Politics" to an audience that was mainly students and academics. I deliberately chose to speak in a very basic way, thinking especially about the few community folks who had come to hear me. Weeks later, Kum-Kum Sangari, a fellow participant who shared with me what was said when I was no longer present, and I engaged in quite rigorous critical dialogue about the way my presentation had been perceived primarily by privileged white female academics. She was concerned that I not mask my knowledge of theory, that I not appear anti-intellectual. Her critique compelled me to articulate concerns that I am often silent about with colleagues. I spoke about class allegiance and revolutionary commitments, explaining that it was disturbing to me that intellectual radicals who speak about transforming society, ending the domination of race, sex, class, cannot break with behavior patterns that reinforce and perpetuate domination, or continue to

use as their sole reference point how we might be or are perceived by those who dominate, whether or not we gain their acceptance and approval.

12 This is a primary contradiction which raises the issue of whether or not the academic setting is a place where one can be truly radical or subversive. Concurrently, the use of a language and style of presentation that alienates most folks who are not also academically trained reinforces the notion that the academic world is separate from real life, that everyday world where we constantly adjust our language and behavior to meet diverse needs. The academic setting is separate only when we work to make it so. It is a false dichotomy which suggests that academics and/or intellectuals can only speak to one another, that we cannot hope to speak with the masses. What is true is that we make choices, that we choose our audiences, that we choose voices to hear and voices to silence. If I do not speak in a language that can be understood, then there is little chance for dialogue. This issue of language and behavior is a central contradiction all radical intellectuals, particularly those who are members of oppressed groups, must continually confront and work to resolve. One of the clear and present dangers that exists when we move outside our class of origin, our collective ethnic experience, and enter hierarchical institutions which daily reinforce domination by race, sex, and class, is that we gradually assume a mindset similar to those who dominate and oppress, that we lose critical consciousness because it is not reinforced or affirmed by the environment. We must be ever vigilant. It is important that we know who we are speaking to, who we most want to hear us, who we most long to move, motivate, and touch with our words.

13 When I first came to New Haven to teach at Yale, I was truly surprised by the marked class divisions between black folks—students and professors—who identify with Yale and those black folks who work at Yale or in surrounding communities. Style of dress and self-presentation are most often the central markers of one's position. I soon learned that the black folks who spoke on the street were likely to be part of the black community and those who carefully shifted their glance were likely to be associated with Yale. Walking with a black female colleague one day, I spoke to practically every black person in sight (a gesture which reflects my upbringing), an action which disturbed my companion. Since I addressed black folk who were clearly not associated with Yale, she wanted to know whether or not I knew them. That was funny to me. "Of course not," I answered. Yet when I thought about it seriously, I realized that in a deep way, I knew them for they, and not my companion or most of my colleagues at Yale, resemble my family. Later that year, in a black women's support group I started for undergraduates, students from poor backgrounds spoke about the shame they sometimes feel when faced with the reality of their connection to working-class and poor black people. One student confessed that her father is a street person, addicted to drugs, someone who begs from passersby. She, like other Yale students, turns away from street people often, sometimes showing anger or contempt; she hasn't wanted anyone to know that she was related to this kind of person. She struggles with this, wanting to find a way to acknowledge and affirm

this reality, to claim this connection. The group asked me and one another what we do to remain connected, to honor the bonds we have with working-class and poor people even as our class experience alters.

Maintaining connections with family and community across class bound- 14 aries demands more than just summary recall of where one's roots are, where one comes from. It requires knowing, naming, and being ever-mindful of those aspects of one's past that have enabled and do enable one's self-development in the present, that sustain and support, that enrich. One must also honestly confront barriers that do exist, aspects of that past that do diminish. My parents' ambivalence about my love for reading led to intense conflict. They (especially my mother) would work to ensure that I had access to books, but would threaten to burn the books or throw them away if I did not conform to other expectations. Or they would insist that reading too much would drive me insane. Their ambivalence nurtured in me a like uncertainty about the value and significance of intellectual endeavor which took years for me to unlearn. While this aspect of our class reality was one that wounded and diminished, their vigilant insistence that being smart did not make me a "better" or "superior" person (which often got on my nerves because I think I wanted to have that sense that it did indeed set me apart, make me better) made a profound impression. From them I learned to value and respect various skills and talents folk might have, not just to value people who read books and talk about ideas. They and my grandparents might say about somebody, "Now he don't read nor write a lick, but he can tell a story," or as my grandmother would say, "call out the hell in words."

Empty romanticization of poor or working-class backgrounds undermines 15 the possibility of true connection. Such connection is based on understanding difference in experience and perspective and working to mediate and negotiate these terrains. Language is a crucial issue for folk whose movement outside the boundaries of poor and working-class backgrounds changes the nature and direction of their speech. Coming to Stanford with my own version of a Kentucky accent, which I think of always as a strong sound quite different from Tennessee or Georgia speech, I learned to speak differently while maintaining the speech of my region, the sound of my family and community. This was of course much easier to keep up when I returned home to stay often. In recent years, I have endeavored to use various speaking styles in the classroom as a teacher and find it disconcerts those who feel that the use of a particular patois excludes them as listeners, even if there is translation into the usual, acceptable mode of speech. Learning to listen to different voices, hearing different speech challenges the notion that we must all assimilate—share a single, similar talk—in educational institutions. Language reflects the culture from which we emerge. To deny ourselves daily use of speech patterns that are common and familiar, that embody the unique and distinctive aspect of our self is one of the ways we become estranged and alienated from our past. It is important for us to have as many languages on hand as we can know or learn. It is important for those of us who are black, who speak in particular patois as well as standard English, to express ourselves in both ways.

16 Often I tell students from poor and working-class backgrounds that if you believe what you have learned and are learning in schools and universities separates you from your past, this is precisely what will happen. It is important to stand firm in the conviction that nothing can truly separate us from our pasts when we nurture and cherish that connection. An important strategy for maintaining contact is ongoing acknowledgement of the primacy of one's past, of one's background, affirming the reality that such bonds are not severed automatically solely because one enters a new environment or moves toward a different class experience.

17 Again, I do not wish to romanticize this effort, to dismiss the reality of conflict and contradiction. During my time at Stanford, I did go through a period of more than a year when I did not return home. That period was one where I felt that it was simply too difficult to mesh my profoundly disparate realities. Critical reflection about the choice I was making, particularly about why I felt a choice had to be made, pulled me through this difficult time. Luckily I recognized that the insistence on choosing between the world of family and community and the new world of privileged white people and privileged ways of knowing was imposed upon me by the outside. It is as though a mythical contract had been signed somewhere which demanded of us black folks that once we entered these spheres we would immediately give up all vestiges of our underprivileged past. It was my responsibility to formulate a way of being that would allow me to participate fully in my new environment while integrating and maintaining aspects of the old.

18 One of the most tragic manifestations of the pressure black people feel to assimilate is expressed in the internalization of racist perspectives. I was shocked and saddened when I first heard black professors at Stanford downgrade and express contempt for black students, expecting us to do poorly, refusing to establish nurturing bonds. At every university I have attended as a student or worked at as a teacher, I have heard similar attitudes expressed with little or no understanding of factors that might prevent brilliant black students from performing to their full capability. Within universities, there are few educational and social spaces where students who wish to affirm positive ties to ethnicity—to blackness, to working-class backgrounds—can receive affirmation and support. Ideologically, the message is clear—assimilation is the way to gain acceptance and approval from those in power.

19 Many white people enthusiastically supported Richard Rodriguez's vehement contention in his autobiography, *Hunger of Memory*, that attempts to maintain ties with his Chicano background impeded his progress, that he had to sever ties with community and kin to succeed at Stanford and in the larger world, that family language, in his case Spanish, had to be made secondary or discarded. If the terms of success as defined by the standards of ruling groups within white-supremacist, capitalist patriarchy are the only standards that exist, then assimilation is indeed necessary. But they are not. Even in the face of powerful structures of domination, it remains possible for each of us, especially those of us who are members of oppressed and/or exploited groups as well as those radical visionaries who may have race, class, and sex privilege, to define and de-

termine alternative standards, to decide on the nature and extent of compromise. Standards by which one's success is measured, whether student or professor, are quite different for those of us who wish to resist reinforcing the domination of race, sex, and class, who work to maintain and strengthen our ties with the oppressed, with those who lack material privilege, with our families who are poor and working-class.

When I wrote my first book, *Ain't I A Woman: black women and feminism*, the issue of class and its relationship to who one's reading audience might be came 20 up for me around my decision not to use footnotes, for which I have been sharply criticized. I told people that my concern was that footnotes set class boundaries for readers, determining who a book is for. I was shocked that many academic folks scoffed at this idea. I shared that I went into working-class black communities as well as talked with family and friends to survey whether or not they ever read books with footnotes and found that they did not. A few did not know what they were, but most folks saw them as indicating that a book was for college-educated people. These responses influenced my decision. When some of my more radical, college-educated friends freaked out about the absence of footnotes, I seriously questioned how we could ever imagine revolutionary transformation of society if such a small shift in direction could be viewed as threatening. Of course, many folks warned that the absence of footnotes would make the work less credible in academic circles. This information also highlighted the way in which class informs our choices. Certainly I did feel that choosing to use simple language, absence of footnotes, etc. would mean I was jeopardizing the possibility of being taken seriously in academic circles but then this was a political matter and a political decision. It utterly delights me that this has proven not to be the case and that the book is read by many academics as well as by people who are not college-educated.

Always our first response when we are motivated to conform or compromise within structures that reinforce domination must be to engage in critical reflec- 21 tion. Only by challenging ourselves to push against oppressive boundaries do we make the radical alternative possible, expanding the realm and scope of critical inquiry. Unless we share radical strategies, ways of rethinking and revisioning with students, with kin and community, with a larger audience, we risk perpetuating the stereotype that we succeed because we are the exception, different from the rest of our people. Since I left home and entered college, I am often asked, usually by white people, if my sisters and brothers are also high achievers. At the root of this question is the longing for reinforcement of the belief in "the exception" which enables race, sex, and class biases to remain intact. I am careful to separate what it means to be exceptional from a notion of "the exception."

Frequently I hear smart black folks, from poor and working-class backgrounds, stressing their frustration that at times family and community do not 22 recognize that they are exceptional. Absence of positive affirmation clearly diminishes the longing to excel in academic endeavors. Yet it is important to distinguish between the absence of basic positive affirmation and the longing for continued reinforcement that we are special. Usually liberal white folks will

willingly offer continual reinforcement of us as exceptions—as special. This can be both patronizing and very seductive. Since we often work in situations where we are isolated from other black folks, we can easily begin to feel that encouragement from white people is the primary or only source of support and recognition. Given the internalization of racism, it is easy to view this support as more validating and legitimizing than similar support from black people. Still, nothing takes the place of being valued and appreciated by one's own, by one's family and community. We share a mutual and reciprocal responsibility for affirming one another's successes. Sometimes we have to talk to our folks about the fact that we need their ongoing support and affirmation, that it is unique and special to us. In some cases we may never receive desired recognition and acknowledgement of specific achievements from kin. Rather than seeing this as a basis for estrangement, for severing connection, it is useful to explore other sources of nourishment and support.

23 I do not know that my mother's mother ever acknowledged my college education except to ask me once, "How can you live so far away from your people?" Yet she gave me sources of affirmation and nourishment, sharing the legacy of her quilt-making, of family history, of her incredible way with words. Recently, when our father retired after more than thirty years of work as a janitor, I wanted to pay tribute to this experience, to identify links between his work and my own as writer and teacher. Reflecting on our family past, I recalled ways he had been an impressive example of diligence and hard work, approaching tasks with a seriousness of concentration I work to mirror and develop, with a discipline I struggle to maintain. Sharing these thoughts with him keeps us connected, nurtures our respect for each other, maintaining a space, however large or small, where we can talk.

24 Open, honest communication is the most important way we maintain relationships with kin and community as our class experience and backgrounds change. It is as vital as the sharing of resources. Often financial assistance is given in circumstances where there is no meaningful contact. However helpful, this can also be an expression of estrangement and alienation. Communication between black folks from various experiences of material privilege was much easier when we were all in segregated communities sharing common experiences in relation to social institutions. Without this grounding, we must work to maintain ties, connection. We must assume greater responsibility for making and maintaining contact, connections that can shape our intellectual visions and inform our radical commitments.

25 The most powerful resource any of us can have as we study and teach in university settings is full understanding and appreciation of the richness, beauty, and primacy of our familial and community backgrounds. Maintaining awareness of class differences, nurturing ties with the poor and working-class people who are our most intimate kin, our comrades in struggle, transforms and enriches our intellectual experience. Education as the practice of freedom becomes not a force which fragments or separates, but one that brings us closer, expanding our definitions of home and community.

• THINKING CRITICALLY ABOUT "KEEPING CLOSE TO HOME: CLASS AND EDUCATION"

RESPONDING AS A READER

1. What differing images does hooks create of herself in this essay? Are some more likable or approachable than others? At what points did you respond positively or sympathetically to the self being described? At what points, if any, did you respond negatively or with resistance? How does she anticipate and attempt to forestall the resistance of readers positioned differently from herself in terms of race and class?

2. Who is her intended audience or audiences? What evidence can you point to in the text to support your answer? Do you feel part of that audience? Why or why not?

3. What do you think was the author's purpose(s) in writing this essay? What new perspective does she want readers to come away with? Did you come away with the new perspective you think she intended? Why or why not?

RESPONDING AS A WRITER

1. Reread the first three paragraphs of this essay, where hooks describes her attempt to communicate with her mother across the generation gap. What similar experiences have you had in trying to communicate with parents or other older relatives across the generation gap? Briefly describe one of these experiences.

2. In paragraph 12, hooks writes, "If I do not speak in a language that can be understood, then there is little chance for dialogue." To what extent do you think she is successful in speaking in a language that you, as a college student, can understand? To what extent does she persuade you that she is interested in establishing a dialogue with you about intersections of race, class, and education? Write out your answer to these questions, citing particular passages to support your answer.

3. To identify the ideology revealed in this essay, make a two-column list of the binaries you find. Put the words, concepts, or ideas that hooks values in the left column; place the words, concepts, or ideas that she doesn't value in the right column. Remember that some of the nonvalued or even the valued terms may only be implied and not stated directly. After you have created this list, write a paragraph discussing hooks's ideology as revealed in this text. (See Chapter 4 for examples of ideological mapping.) •

Just Off Main Street

Poet, essayist, performance artist, and activist Elmaz Abinader (b. 1954) writes frequently about her Lebanese family's history as well as about her experiences growing up as an Arab American. The title of an early article in the *New York Times* (1991) captures her sense of being an outsider in both cultures: "Here, I'm an Arab; There, an American." This sense of being an outsider has led to her interest in mentoring young writers of color through such programs as the Hurston/Wright Writers' Week West and The Voice of Our Nations Arts Foundation. Abinader's publications include a collection of poems, *In the Country of My Dreams* (1999), which won the 2000 Josephine Miles Oakland PEN Award for multicultural poetry, and *The Children of the Roojme: A Family's Journey from Lebanon* (1991), a family memoir. Her work has been published and performed widely in both the United States and the Middle East. *Country of Origin*, a one-woman storytelling performance, has won two Drammies, Portland's critics' circle awards for theater. A teacher of creative writing at Mills College, Abinader published "Just Off Main Street" as part of a recent on-line series of articles entitled "Writers on America," sponsored by the U.S. Department of State.

● **FOR YOUR READING LOG**

1. If you were asked to write an essay about your national identity (i.e., American, Mexican, Canadian, etc.), what do you think you might say? Take a few minutes to freewrite about the first ideas that occur to you.
2. As you read, note the concrete details (for example, the list of the "standard downtown features" in paragraph 1) that you find particularly effective in recreating Abinader's experiences. ●

━━━━ ● ━━━━

I. Crossing the Threshold

1 When I was young, my house had a magic door. Outside that door was the small Pennsylvania town where I grew up. Main Street ran in front of our house bearing the standard downtown features: a bank, a newsstand, the hardware store, the auto parts supply, and other retail businesses. Families strolled the streets, particularly on weekends, looking at the displays of furniture in Kaufman's giant window, the posters for movies hanging behind the glass at the Rex Theatre, and the mannequins, missing hands or fingers, sporting the latest fashions in the windows of my aunt's clothing store. In those days, the early 1960s, the small businesses in a town like Masontown fed the community's needs for food, clothing, and shelter.

My family's shops took their positions on Main Street as well: Nader's Shoe 2
Store, Nader's Department Store, and the Modernnaire Restaurant. From the face
of it, our businesses looked like any others and we gratefully satisfied the local
mother trying to buy church-worthy shoes for the children, the father in for a
good cigar and the newspaper, and the after-school crowd, who jittered near the
juke box on the restaurant tiles. My father and my uncle stood in the doorways
of their establishments, perfectly dressed in gray suits and white shirts, ties, and
glossy polished shoes.

At that moment, frozen in second grade, at the threshold of the store, I saw no 3
difference between my father, uncle, and the people who passed by. Many of them
too sent their children to Mrs. Duffy for piano lessons, shopped at the A & P, and
bar-b-qued in the backyard on the Fourth of July. Many of my dad's customers had
their children in All Saints School with me. Their daughters had shiny bikes with
streamers flowing from the handlebars. The popular girls, Jeannie and Renee,
wore freshly polished Mary Jane shoes every day, and discussed quite vocally their
ever-growing collection of Barbie doll paraphernalia. I listened with fascination to
the descriptions of a house for Barbie, her car, and her wardrobe. Jeannie wrapped
her finger around her blond pony tail as she described Barbie's ball gown. Renee
pulled her spit curl into a C as she showed us pictures of her trip to Virginia Beach.

In these moments of social exchange, the illusion of similarity between me 4
and the girls in my class floated away, bubble light. Despite sharing the same
school uniform, being in the Brownies, singing soprano in the choir, and being
a good speller, my life and theirs were separated by the magic door. And al-
though my classmates didn't know what was behind that portal, they circled me
in the playground and shouted "darkie" at my braids trying to explode into a
kinky mop, or "ape" at my arms bearing mahogany hair against my olive pale
skin. It was dizzying and my stomach squirrel-squealed in loneliness.

I dragged myself home to our gray-shingled house on Main Street feeling 5
the weight of my book bag and the heaviness of the differences between me and
the girls jumping rope just across the street. As I pulled on the silver aluminum
handle of the screen door that led to the hallway of our house, the rust crumbled
against my thumb. Nothing was particularly enchanting about this door, but
when I entered, the context of the world changed.

Drawing me from the entrance, down the hall, to the dining room, was one 6
of my favorite smells. It was Wednesday, the day of the week when my mother
covered the table for eight with newspaper, dragged two large blue cans from
the pantry, and lined up the cookie sheets. By the time I arrived home from school
in the afternoon, the house smelled of Arabic bread and loaves and loaves of the
round puffy disks leaned against each other in rows on the table. She made tri-
angles of spinach pies, cinnamon rolls, and fruit pies filled with pears from the
trees growing on our land. Before greeting me, she looked up, her face flour-
smudged, and said, "There are 68 loaves. You can have one."

By now, my sisters have joined me at one end of the table, where we pass the 7
apple butter to each other to slather on the warm bread. When Arabic bread
comes out of the oven, it is filled with air and looks like a little pillow; as it cools,
the bread flattens to what Americans recognize as "pita" bread. Other bread was

rarely eaten in our house; even when we put hot dogs on the grill, they were dropped into a half of *cohbs*, then covered with ketchup.

8 The smell was hypnotic and mitigated the melancholy I carried home with my lessons to do that night. The revelry ended soon after we finished our treat. Each child of the six of us had after-school duties. My three brothers reported to the store to clean and manage the inventory, and we three girls shared the demands of house and garden. In the summer, we weeded, watered, and picked the vegetables; in the fall, we reported to the basement where we canned fruits, beans, jams, and pickles. Between these seasons were endless piles of laundry, ironing, and cleaning to maintain the nine people who filled our little house. Barbies, coloring books, after-school sports were other children's worlds, not ours.

9 Behind the magic door, the language shifted as well. Mother-to-daughter orders were delivered in Arabic—homework, conversations, and the rosary, in the most precise English possible. Three things dominated our lives: devotion to God, obedience to our parents, and good grades in school. A sliver of an error in any of these areas was punished with swiftness and severity. The reputation of our family relied on our perfection and my parents had no idea that their struggling-to-be-perfect daughters digested unsavory ridicule from their peers.

10 Our social interactions on the other side of the door had little weight inside the house. We had a different community who gathered on weekends and during the summer. Relatives from towns around Pennsylvania and Ohio filled our living room and dining room, circling the table crowded with my mother's fabulous array of Arabic dishes: *hummus*, chick bean dip, *baba ghanouj*, eggplant with sesame, stuffed grape leaves, shish kebob, *kibbee*, raw or fried lamb and bulgur wheat patties, a leg of lamb, a turkey stuffed with rice and raisins, and platter after platter of side dishes. The famous Arabic bread sat skyscraper-high on plates at either end.

11 My uncle, the priest, blessed the table, and the chatter of Arabic began as cousins dipped their bread, scooped up the tabouleh salad, and daintily bit the sweet baklava pastry. As the end of the meal approached, we pushed slightly away from the table, as my father told a story of the old days, or someone read a letter from Lebanon; or a political argument snarled across the empty dishes.

12 We girls cleared the table and Arabic music wound its way out of the record player. Before we knew it, someone started a line dance and others linked arms, and stomping and kicking and clapping shook the house. As children and as worker bees, we were busy, both cleaning dishes and bringing the adults anything they wanted, as well as standing up to having our cheeks pinched and our bodies lifted into the air.

13 My family scenes filled me with joy and belonging, but I knew none of it could be shared on the other side of that door. The chant of schoolyard slurs would intensify. Looking different was enough; having a father with a heavy accent already marked me, dancing in circles would bury me as a social outcast.

II. Making a Writer

14 In college, a school one hundred times larger in population than my home town, I walked the campus with a fascination. Past the line of the ginkgo trees, I en-

tered the Cathedral of Learning, the skyscraper at the University of Pittsburgh where the English Department was housed. On the first floor of this beautiful building are the Nationality Classrooms. These rooms are designed to represent different cultural notions of classroom design. The English Room featured benches from the House of Commons, the Hungarian Room presented the paprika-colored panels of flower design set into the wall, and the Chinese Room, dedicated to Confucius, put the students in round tables without a sense of hierarchy. We had some classes in these quarters, often unhappy with the stiffness of the furniture or the care we had to take with our equipment. One room was locked and could only be seen by permission or during a tour. I studied the plaque outside the door. *The Syria-Lebanese Room.* Here again, a door dividing the outside "American" world from my world. Naturally, I made it a point to see the room, inviting my friends along.

At the moment we entered, our breath froze. The room was covered in Persian rug designs, glass multi-colored lights, brass tables, and cushions against the wall around the perimeter. It was lush and exotic and suddenly the pride of being associated with this palace worked its way inside of me. In charge of my own identity in college, I announced my heritage, wrote about my grandmother, cooked Arabic food for my friends, and played the music of Oum Khalthoum at gatherings at my house. 15

It wasn't long before I understood that my display of my Arab-ness served to exoticize me. In the curriculum, nothing of Arab writing was represented; on television, the only person associated with Lebanon was Danny Thomas; and *Lawrence of Arabia* became the footnote to my culture. Concurrently, the events in the Middle East clarified the sympathies in the United States as not pro-Arab; and as I grew, feelings toward Arabs became more negative and sometimes bordered on distrust, even from my own colleagues. 16

I persisted in my writing. A poem about my mother leaving Lebanon and making a home in the United States, a story about my grandfather living like a refugee during World War I, my father's adventures as a rubber trader in Brazil when he was a young man became my themes, and I intuitively released these stories and poems as if the whole history was bottled up inside of me. 17

Still, my writing was happening *inside* the door. Outside, in my classroom, in my bachelor's and master's program, some years later, the literature we read was as foreign to my natural sensibility as Barbie was to my childhood milieu. The models for writers included a substantial number of European-identified male authors who wrote eloquently about mainstream American culture. In my writing corner of the world, I penned stories of children dying during the Ottoman siege of our village in Lebanon. I felt music in my poetry that was strange to American ears; my images gathered in a shiny brocade of detail, more lush than other writing of the 1970s. 18

I did not feel welcome outside the door. 19

But I persisted. Somewhere in my journey, I put my hand on a book that made the difference. The title first attracted me: *The Woman Warrior,* and the author had a name that was uncommon: *Maxine Hong Kingston.* Inside this book, I discovered a grandmother who talked stories, daughters who were too 20

American for their family; a culture completely strange to the people around them. In essence, this writer knew, she knew, what was inside the door and she wrote about it. This book not only led me to the body of literature available in the Chinese American canon, but I found African American, Latino, Native American writers, whose voices resounded about some of the same issues: belonging, identity, cultural loneliness, community, and exoticization.

21 The strains of my music seeped through cracks and under the threshold, the stomp of the dance pushed the door out of the way. I listened to Toni Morrison in an interview answer the question, "Do you write because of racism?" She said, "I write *in spite* of racism." Writers were claiming their place not only in literature, but also in the perception of history.

22 Participating in activism had always been an important part of being a citizen of the United States for me. My years were marked with political causes for which I marched, protested, signed petitions, and organized committees. Now I began to understand: As a writer, I was also an activist. Telling a good story, writing a beautiful poem pierced the reader more deeply than any rhetoric could manage.

23 In addition, I found a community: American writers and artists of color often travel the same terrain as I do, living with dual sensitivities, negotiating where one culture I inhabit conflicts with my other culture, looking for a place that is home.

24 Times have been challenging for Arab Americans because our countries of origin are often embroiled in conflict and political controversy. The more difficult it becomes, the bigger role *my good story* and *my beautiful poem* play in contributing to a perspective of the events and the people. Readers will often trust literature more than speeches or articles, and I find that my love of writing is interwoven with my responsibility to write.

25 I have a new small town. It's not anywhere in particular, or maybe it's everywhere. In this village, people live with their doors open, moving back and forth over the threshold of what has been exclusive to what will some day be inclusive. As a writer, I make my life known and woven into the fabric of literature. As an activist, I look toward other young writers of color and let them know, they might have to lean with their shoulder, put their whole body into it, but if they push on that door it will eventually open.

● THINKING CRITICALLY ABOUT "JUST OFF MAIN STREET"

RESPONDING AS A READER

1. Choose three or four details that you marked as particularly effective, and consider why each is effective. What associations does each detail have for you as a reader? How does each connect with what you perceive to be the central themes in the essay?

2. Throughout the essay, the narrator refers to various kinds of thresholds and doors, beginning with what she calls the "magic door." What mean-

ings does the word "magic" evoke for you? What do these various thresholds/doors seem to represent for the narrator? Think of as many different meanings as possible.

3. Consider the occasion for which Abinader wrote this essay: a post-9/11 on-line series entitled "Writers on America" sponsored by the U.S. Department of State. What audiences and purposes do you think she had in mind? Support your answer with evidence from the text.

RESPONDING AS A WRITER

1. The essay is divided into two sections, "Crossing the Threshold" and "Making a Writer." If you were to choose a *pull-quote* (see p. 40) for each section, what sentences would you choose? Explain why you chose each sentence. What effect do you think the use of *pull-quotes* would have on readers?

2. Write a two- or three-sentence summary of what being an American means to the narrator.

3. How would you describe the narrator's voice or voices in this essay? Cite specific passages in the text to support your answer. •

HEIDI STEENBERG (STUDENT)

Reflection as Knowledge

Heidi Steenberg (b. 1974) is a recent graduate of Marquette University, where she was a Writing-Intensive English major. Currently, she works as an agent and account executive for a Milwaukee insurance company. In the future, she hopes to return to school to earn a master's degree and a Ph.D. in English. "Reflection as Knowledge," which was written for a writing workshop she took in her junior year, reflects both on the meaning of her volunteer experience at Casa Maria, a homeless shelter for women and children in Milwaukee, Wisconsin, and on the act of writing about this experience.

• FOR YOUR READING LOG

1. Have you ever been involved in either a volunteer or service learning project where you encountered people whose experience was quite different from your own due to age, illness, ableness, or economic circumstance? If so, take a few minutes and jot down how it felt to encounter people different from yourself. What did you learn about yourself from this encounter? If not, try to imagine your concerns and expectations upon entering a shelter for homeless people, a home for the elderly, or some other facility as a volunteer.

2. Think of a time when you found it difficult to communicate an important experience to others. Take ten minutes to freewrite about this experience. What caused this difficulty? What ultimately happened? Did the experience remain a private one, unarticulated to others, or did you eventually find the words or perhaps a particularly receptive person to whom you could explain the experience? What do you see as the advantages and disadvantages of trying to communicate important experiences to others? •

———— • ————

1 Last winter break I went to Casa Maria, which is a homeless shelter for women and children here in Milwaukee. I was on a volunteer program through Marquette University called the Marquette Action Program (MAP) with four other women. The purpose of the MAP trip is to immerse students in areas of the country that need service, such as building houses for Habitat for Humanity in Georgia, helping immigrants in Texas, or in my case, helping the homeless in the inner city. Therefore, I lived at Casa Maria, I ate there, and I worked there for an entire week. It was this strange, wonderful, fascinating, crazy, heart-wrenching week. When I returned back to school, I was in a complete daze. I was overcome with emotions and thoughts about my experience. I was exhausted both physically and mentally. I couldn't unpack my bag or prepare for my classes that started the next day. I listened to my friends tell me about their Christmas vacations, the brand new Trek bicycle, grandmother's famous homemade stuffing, and sitting on the couch in front of the television every day all day. They asked me how my week was at Casa Maria. I could not answer. I could not find the words or the energy to express what had happened to me there, how I had changed, and why it was so special. So I was silent.

2 As I began attending classes again, I was still thinking about my service trip. I kept remembering everything that I had seen and done that week. I could not stop thinking about what it was like to hand out bread at the welfare office or to know, really know, become friends with, a family who fled from an abusive father in Missouri with only a few of their most treasured possessions. The boy clings to his Sony Walkman.

3 Thoughts. Thoughts of the children without toothbrushes and coats. Thoughts of the mothers without homes, without food, without jobs, without money. Thoughts of the innocent faces of children dressed in clothes that were donated that day, trying to do math problems without notebooks or pencils. Thoughts of people so unlike me . . . and so like me. I could not stop thinking of Casa Maria. I could concentrate on little else. I needed to find a way to tell the story, to tell what happened to the homeless people, to tell what happened to me. I had already discovered that I could not communicate these thoughts to my friends in conversations. They were just too powerful, too emotional. So I wrote, recording my thoughts in my journal and writing about the experience for class assignments.

For Advanced Composition, I wrote an essay that I entitled "Breaking Down 4
the Walls." The assignment was very broad, calling for a reflective essay. I could
not even think of writing about anything but my service trip. It was as though I
had to write about my experiences at Casa Maria before I could write any other
words. Until I could understand this trip, I could not write another essay. In or-
der to make sense of the experience, I needed to articulate and make sense of it
in the framework of a formed essay. The journal entries I wrote while I was at
Casa Maria were full of disbelief and confusion. For example, "Wow, Bambie
found a winter coat today." This selection from my journal is descriptive, it tells
something. However, it does not frame the experience. It does not tell why it was
so special that Bambie received a coat, that his family's home was destroyed and
all their possessions stolen by Southside gang members.

I wrote and I reflected. I reflected and I wrote. I was not worried about mak- 5
ing any sense at first. I wrote about everything in one entire night. I closed my
eyes and allowed myself to concentrate only on the service trip. I thought about
everything that happened that week at Casa Maria. I began to resee things again
and again, and I wrote about the suffering, wondering, yet still cheerful children
staying at the shelter. Here is an excerpt from the final draft of my essay:

> A little boy tells me about his father's strong hands, under which the boy and
> his mother would suffer each day. A little girl explains to me, as if it were a nat-
> ural occurrence in everyone's life, that she hears gunfire outside of her apart-
> ment each night as she plays with her brothers and sisters. A boy of nearly
> fourteen tells me he has no friends at school because, in order to have friends,
> he would have to join a gang. Another child begs me to read her a story every
> time I walk into the room. Her mother never reads to her because, I learn from
> the child, her mother cannot read.

The confusion about my service at Casa Maria finally began to disappear. 6
The trip suddenly became real again. Writing became my means of speaking. It
opened up a new understanding, knowledge of what I had discovered through
my service. The random reflections began to take shape and form, and sud-
denly my word processor had a five-page essay. I found a million different ideas
in my reflection and writing about Casa Maria, yet I kept coming back to how it
related to my experiences at Marquette, why I was unable to tell my friends about
one of the most thought-provoking weeks of my life. I reflected on this central
question and suddenly it became a title, "Breaking Down the Wall." Suddenly I
had a self-discovery, a world-discovery, and a reflective essay that showed me
what I had been wanting to say, needing to say, since the day I came back from
my service trip to a homeless shelter:

> When I return to Marquette and walk to and from classes, I will see a commu-
> nity of people walking with me through the streets. I will see the Marquette
> students, and I will see the people beyond them, waiting at bus stops, doing
> laundry at the Laundromat, eating at Dairy Queen, and sipping coffee at Stone
> Creek Coffee Shop. . . . As I pull away from Casa Maria, I am not quite sure

where this trip has taken me. I see the children and the mothers cry and, at the same time, I feel the warm trickle of my own tears as I leave Casa Maria only a week after I arrive. The children run after the car as I head back the few blocks, around the shattered remains of the wall, to the Marquette community where I have another home. In not even a few minutes, I arrive at my destination. It feels strange now, as I stare out the window of my apartment. It seems I can see so much farther . . . now that the walls have been torn down.

My journals had given wonderful detail, showing the chaos of the trip, but only through writing a complete essay was I able to answer the essential questions. Who really were the people at Casa Maria, why had the experience changed me, how could I show others the value in the trip?

7 I took the first draft of my paper, which I had written entirely in one night, into the writing group of my Advanced Composition class. It was extremely difficult to make this move, to take criticism, and even praise, from a group of three complete strangers about a piece of writing that was so highly personal. The members of the writing group agreed on the places in my essay that were weak, which were the parts of the essay where I told and did not show. For example, I said that the homeless mothers in the shelter made me laugh. I knew inside how the women made me laugh, by giving me advice about my relationships and making fun of me for the awful food I cooked, but I did not articulate these things in the essay. So in the revision I showed more. I wrote, "Laughter permeates the house during these late night talks about the day's events. I do not think I will ever hear the end of the casserole I accidentally burned to a crisp for dinner that night, or how ridiculously funny the black hair extensions would look in my blonde hair."

8 Because the essay was so personal, I was somewhat hesitant to change any of it. All the words, sentences, and paragraphs meant so much to me. But I soon realized that this essay was not part of the journal I kept during my stay at Casa. I had already done that, and the journal would always be mine. However, this was an essay for class. I felt the need now to show the importance of my experience to others. I had to show the audience why they should care. I framed the essay according to the trip's chronology—leaving Marquette to begin the experience, describing what happened during the week, and ending with what happened to me as I left Casa Maria. In the first draft of the essay, I would sometimes tell things later that actually happened earlier than others, which is okay as long as the chronology doesn't confuse readers. I knew the experience at Casa so well, but my audience did not. I needed to be clearer for them. I really didn't want to do this at first. It was my essay after all. But I found that as I clarified the organization of the paper, I also clarified the experience at Casa Maria. Confusing sentences, I learned, show confusing ideas and feelings. So I fixed the sentences, and the essay became even more mine, and more importantly, it became an essay for other people as well.

9 By writing an essay about the service I had done at Casa Maria, I found a way to subdue the confusion of this exhausting, yet gratifying week, into some kind of coherence. I used the form of a reflective essay for self-discovery, for sharing

information about the neighborhoods beyond a given campus, and for perhaps even convincing others to become active in helping their own communities. I saw beyond the invisible barriers between my campus "home" and the shelter a few blocks away. I wanted to share that with others, so I wrote an essay that I shared with an Advanced Composition writing group, a class magazine, a writing contest, and later at a roundtable discussion attended by professors from other colleges. Now, in reflecting on both the experience itself and the experience of writing about my time at Casa Maria, I think I understand my experience even better, though I still get a little nervous sharing such personal reflections with others. Recording my private thoughts in a journal and writing a reflective essay for others to read helped me clarify my thoughts and feelings about my time at Casa Maria. In both cases, I used reflection as a means to knowledge, but every time I talk or write about the service trip again, I continue to learn new things. I say to you "Here, look what I did on my service trip to Casa Maria" . . . but sometimes I still am not sure what it is I have actually done.

● THINKING CRITICALLY ABOUT "REFLECTION AS KNOWLEDGE"

RESPONDING AS A READER

1. In the first few paragraphs of this essay, Steenberg tries to re-create her state of mind and feelings after she returned to campus after a week at Casa Maria. How successful is she in doing this? Which sentences or passages are most effective in helping you, as a reader, identify with her thoughts and feelings?

2. Does the audience for this essay seem to be primarily the writer herself, her readers, or both? What assumptions does she make about her audience's ability to comprehend her experience? Explain your answers by referring to particular passages.

3. How would you describe Steenberg's tone and style in this essay? What kind of an image of the writer is created through these stylistic choices? How do you respond to this image?

RESPONDING AS A WRITER

1. Revisit your reading log entries and choose one of the two experiences about which you wrote. How do Steenberg's experiences compare to the experiences you reflected upon in your reading log entry? Did Steenberg's essay make you see your own experience in any new way?

2. If you were a member of a peer group reading and responding to this essay, what would you point out as its greatest strengths and weaknesses? What questions, if any, do you have after reading the essay? What suggestions for revision would you make to this writer?

3. There have been various proposals that young people be required to engage in two years of public or volunteer service just as young people in

the past had to fulfill their civic obligation through military service. Would you support or be opposed to such a proposal? Why or why not? Write a letter to the editor in which you argue for or against this proposal. You may or may not wish to use evidence from Steenberg's essay to support your position. ●

Writing to Express and Reflect

The texts in this section communicate the writers' reflections on various kinds of experiences. In most cases, the writers reflect on a past experience in the present to explore its meaning for themselves and others. The assignment prompts below offer several kinds of invitations for you to engage further with expressive and reflective writing: (1) by writing an essay in which you reflect on your own experience; (2) by writing an essay that looks more closely at the strategies employed by a particular writer; or (3) by writing a reflective essay that extends the conversation introduced by one of the writers.

REFLECTING ON EXPERIENCE

Think of an experience that challenged your beliefs or attitudes or that perplexed, disturbed, or produced mixed feelings in you. Write an essay about this experience in which you look back, reconsider, question, and interpret this experience from your present perspective. How has your perspective on this experience changed over time? How has this experience affected your beliefs, attitudes, or values? What new perspective do you want your readers to come away with? Like Kyoko Mori and Heidi Steenberg, you may wish to use this assignment to understand an experience better or more deeply, or like bell hooks, you may wish to examine this experience for insights into larger social or cultural issues. It will be important to describe your experience with enough detail so that the reader can understand the experience's significance to you.

As you plan and revise your essay, consider carefully the ways in which you hope to change your readers' perspectives. Then make organizational and stylistic decisions to support that purpose.

EXAMINING RHETORICAL STRATEGIES

Choose one of the reflective essays in this section and offer a rhetorical analysis of it, considering this author's rhetorical choices in light of what you believe to be the author's purpose or purposes. What seems to be the author's main purpose (or purposes) in writing this reflection? What makes you say so? How is this purpose reflected in the author's choice of narrative detail, tone, and style? What do tone and style reveal about the writer's point of view? Note the oppositions or tensions that you find in the text. What do these reveal about the writer's ideology? What is the main thing you take away from this reflection? That is, to what extent is your image of the subject or issue altered or "reconstructed" by this essay?

EXTENDING THE CONVERSATION

Some of the essays in this section use personal experience as a springboard to reflect on larger social or cultural issues such as race and class, homelessness, or language difference. Undoubtedly, at least one of the essays in this chapter raises an issue about which you have some concern, experience, or knowledge. Choose a reading (or two thematically related readings), and write an essay that "talks back" to or responds directly to that reading (or readings). In a way, this assignment asks you to reflect upon your experience in reading the essay. What questions did the author's treatment of the subject raise for you? At what points were you reminded of similar experiences? At what points did you identify or think of contrary experiences? You may wish to raise issues related to the topic that were not raised by the author or other ways of looking at the topic. Do you have explanations other than what the author offered?

CHAPTER 9

Inquiring and Exploring

Texts that inquire and explore may at first seem strange to some readers. We are so used to reading for information and new knowledge that students and teachers alike can overlook exploratory writing's subtlety and power. Yet exploration is at the heart of the academic enterprise because it is only through asking good questions that we can build new knowledge.

When writers' purpose is to inquire and explore, they typically take the approach of explicitly posing questions and examining multiple ways of answering them. Some emphasize the process of exploration; others emphasize the multiplicity of answers. An exploratory piece may take the reader on a journey through varying perspectives in relation to a personally important or troubling topic, as the Bill McKibben essay in this chapter does. Or an exploratory piece may undertake a deliberate investigation of a more public matter, looking for explanations and solutions, and finding many, some that are partially satisfactory but none that fully satisfy. We see this approach in Robert McGuire's article on family violence, which presents a collage of personal anecdotes and journalistic interviews. Some exploratory pieces ultimately offer the reader a fairly clear picture of the author's conclusions about the topic under discussion; others do not. Sometimes an exploratory approach is dictated by the fact that a phenomenon is so new that answers are still unfolding, as in Barbara Crossette's article on the limits of cultural tolerance. Other times the writer's questioning stance in relation to the material is a means of making a point, explicitly or implicitly,

or of keeping alternative approaches in balance so that one need not choose among them.

The exploratory form has deep roots in the very idea of an "essay," a term from the French *essayer*, "to try." In an exploratory essay, a writer tries on perspectives, tries out ideas, and invites a reader to do the same. As the texts in this chapter show, writers' presentations of their explorations can vary considerably. Like the expressive and reflective texts in Chapter 8, exploration allows for considerable personal expression and reflection, but external subject matter rather than personal expression receives the primary emphasis. Whatever the subject matter, exploratory pieces are driven by the questions they raise. Some are answered, some are not.

If you have been trained to "underline the main idea" when reading school assignments, you may be uncomfortable with the inherent ambiguity of many exploratory texts. Many readers aren't sure how to work with the open-ended structure and explicit uncertainty of exploratory texts. Students who have been taught that "good writing" means highly structured, thesis-driven papers may distrust essays that invite them to explore a topic and end without drawing a conclusion. Yet the very purpose of such texts (and writing assignments) is to help readers discover complexity, to get beyond simple explanations and customary perspectives. Only by disrupting our usual way of viewing things can we discover new ideas. Only by considering problems and experiences from multiple angles can we appreciate the viewpoints of people who express opinions that seem outlandish to us.

The emphasis on questioning and complexity in exploratory texts has made them increasingly popular as assignments for both reading and writing in a variety of college courses, not just writing courses. Why? Because moving beyond a simple answer to wrestle with new ideas fosters intellectual development. You probably already have experience with some forms of informal, exploratory writing in journals and reading logs. You will probably encounter other forms of exploratory assignments in your college classes. Faculty across the curriculum have found that when students take courses in a discipline that is new to them they tend to stop too soon in their efforts to address subject matter questions. To help students get beyond these roadblocks, or mind blocks, instructors assign readings that refuse to articulate a conclusion, readings that come to a conclusion only by a circuitous route, or readings that demonstrate that a unitary conclusion isn't justified. Similarly, your professors may ask you to write an exploratory paper to help you articulate your current understanding of a complex subject, perhaps as an informal assignment in advance of formal study about the subject. Exploratory writings may also serve as preliminary work that leads to a major research project. Whether formal or informal, assignments that stipulate an exploratory form will give you an opportunity to develop your ability to articulate questions, assert their significance, and gather multiple perspectives.

QUESTIONS TO HELP YOU READ EXPLORATIONS RHETORICALLY

As you read and work with the selections in this chapter, consider carefully how the writers' exploratory stances affect your understanding of their subject. The following questions will help you with your analysis.

1. What are the central questions posed in the piece, and what prompts the author to pose them? Why are they difficult to answer? What conflicts of evidence, values, or beliefs are involved?
2. On what basis does the author assert the significance of the question(s) that the text will explore? Did you need to be persuaded of the significance of the issue?
3. Where does the author turn for answers? What kinds of authority and reasoning connect the answers with the author's question(s)? Do you find those connections credible?
4. How does the text engage you? What role does it construct for you as reader? What does the author assume about the audience's knowledge, beliefs, and values? Where do you find yourself doubting the author or having trouble following the train of thought?
5. How do questions change as the piece develops? Does the initial question, for example, develop into narrower, more specific subquestions? Or does it build into broader, more general overarching questions? What organizational patterns are apparent in the search for answers (such as chronology or division into parallel parts)?
6. As the piece closes, to what extent does the *author* seem to consider the answers he or she has found to be satisfactory? From *your* point of view, which answers are more and less satisfactory?
7. What ambiguities remain? Where/when might additional views and more satisfactory answers be found?
8. What is your sense of how the author wanted to change your view of the questions and/or phenomena explored? To what extent was the author successful? Perhaps the subject is something that you'd never thought about before. Where do you predict your thinking about it might go from here?

BILL MCKIBBEN

The Problem with Wildlife Photography

Writer Bill McKibben (b. 1960) is often described as an environmentalist. He began his career as a staff writer for *The New Yorker* in the 1980s, and since then has published numerous books and magazine articles centered around the theme of "living lightly on the

earth," a phrase from the subtitle of his 1995 book, *Hope, Human and Wild*. He is best known for his first book, *The End of Nature* (1989), which originally appeared in *The New Yorker*. The book sounded one of the first alarms to the general public about the dangers of greenhouse gases. In it, McKibben laments humankind's control of the earth and what were once its natural processes, from mountain meadows to havoc-wreaking storms. His most recent book is *Enough: Staying Human in an Engineered Age* (2003). The essay here was published in *How We Want to Live: Narratives on Progress* (1998), a collection of personal essays by writers invited to contemplate the notion of progress as the 1900s drew to a close. McKibben lives with his wife and daughter in Vermont.

• FOR YOUR READING LOG

1. Given its title, what do you expect this essay to be about? What is there about photographs of wildlife that could be a problem?
2. Reflect a bit on your own experience of looking at photographs and film of wild animals, on greeting cards, nature programs, natural history magazines, or wherever you may have encountered them. What do you remember best? What are your favorites? •

———— • ————

There's a bright blue sky in the woods this morning, sun lifting from behind the 1 mountain, snow mostly melted but ice still scabbed on the northward slopes. What living things do I see? Only a red-winged blackbird, and a startled blur of quail whirring off through the branches. And several piles of scat—deer, hare, coon, coyote.

This essay, ostensibly a brief study of certain controversies about wildlife 2 photography, raises an unlikely question: in the time now approaching—inarguably an age of limits—will we want to find limits for ideas and expressions as we will for things?

The art of wildlife photography employs quite a few people scattered around 3 the country. Filmmakers supply hour upon hour of video for PBS, the major networks, and cable channels. Still photographers take pictures for magazines, calendars, books, and advertisements, and they market countless trips for amateurs and aspiring professionals, teaching them the tricks of the trade. And their images do a lot of good—from Flipper and Jacques Cousteau to the mountain lion nuzzling her kit on your latest mailing from an environmental group, they've helped change how we see the wild. I've seen neighbors of mine, who had no use for wolves, begin to melt during a slide show about the creatures. It is no great exaggeration to say that dolphin-safe tuna flows directly from the barrel of a Canon, that without Kodak there'd be no Endangered Species Act.

At the same time, and in more easily observable ways than with other kinds 4 of art, wildlife photography raises ethical problems. They stem from the fact that most animals are extremely shy and extremely good at keeping their distance from people. I walk in the woods every day here, and mostly it's like this morning's trek—the occasional sign of wildlife, but very rarely the sight, especially of

those charismatic fauna most highly prized by magazine editors and calendar makers. I see raccoons pretty often, but I've come across bears twice in all my years in the Adirondacks, and that's twice more than most of my neighbors. I once spent several days in a bug-ridden North Carolina swamp helping researchers from the Fish and Wildlife Service try to trap a few red wolves. These wolves were wearing radio collars and we had the receiver, and we still managed not even a glimpse—just the occasional scatter of feathers or fur where they'd made a meal.

5 In a partial effort to overcome this handicap, wildlife photographers, who include among their number some of the most accomplished and intrepid outdoorspeople I know, have copied a number of strategies from hunters. Filmmakers, for whom the rewards are greatest and the costs of waiting around the highest, have been accused of staging scenes—the *Denver Post*, in a recent series, quoted employees of the PBS series *Wild America* as saying animals had been tied to posts with fishing line so that others could attack them, a charge the program's host denies. Still photographers may wait by a water hole for animals to come in and drink; they may spread a little bait (bears like jelly doughnuts); they may lure in animals with decoys or with calls. All of those strategies cause problems, of course. An animal may smell someone hiding in a blind by a water hole and steer clear, though he needs the water. A wolf might have been hunting fruitlessly for three days, near the end of her strength, when she chases off after a tape recording of a baby rabbit. I've talked to a photographer who scared a cougar off a mountain goat it killed; the result was that it had to kill another goat. And even these strategies don't always work, especially with the shiest creatures. "I don't know of any pros who have gotten pictures of cougars without going to the extreme of tracking them down with dogs and treeing them," says Art Wolfe, one of the country's premier wildlife photographers. Erwin Bauer, a veteran of the profession, owns a hundred acres in Montana. "From time to time a mountain lion comes through. I know he does, because I see his tracks, find deer he's killed. But we never see the animal."

6 To overcome such problems, wildlife photographers have increasingly turned in recent years to a series of private game farms, small zoos. Jay Diest runs the Triple D Game Farm in Kalispell, Montana. It is home to a long list of "primary species" (black bear, wolf, lynx, bobcat, cougar, mountain lion, arctic fox, fisher, wolverine, river otter) as well as a number of "secondary species" (badger, raccoon, porcupine, mink, snowshoe hare, and wild turkey). Still photographers pay three hundred dollars a day to stand outside the "professionally designed enclosures" and shoot one primary species; if you want to shoot three primary species, the fee drops to two hundred dollars apiece. But the grizzly bear cub—he's four hundred dollars. "They respond to certain commands," says Diest. "They will stand up, they will sit, they will pretend like they're growling. On command they will get up on things—if you want them up on a large rock, they will get up there. They will strike poses." The animals are by all accounts well fed and humanely treated, and they have an increasing number of peers in other places. Montana alone now boasts three such operations, and tropical countries as well are getting into the act. There is, for instance, a famously approachable

jaguar in a game farm in Belize that several picture editors told me about—if you've seen a photo of a jaguar recently, there's a good chance it's this one.

Pictures taken at game farms are not uncommon. One day a couple of years 7 ago, for instance, the staff at *Natural History* gathered to plan a piece on cougars. The photo editor projected slide after slide on the walls, remembers managing editor Ellen Goldensohn. "She told us to guess which ones were captive animals and which were wild. Most of the really good ones turned out to be from the game farms." If you see a close-up of a snake in a magazine, it almost certainly hasn't been taken in the wild, but instead in a cage designed by the herpetologist and outfitted with lights. "In the field, copperheads are quite rarely seen in a non-cluttered environment," says photographer Joe MacDonald. "They live in brush piles—you're never going to see them from a ground-level perspective. You're not belly to belly with them." It's not just still photos, either—a great many of the television nature sequences come straight from the game farms. Such images—I repeat—can be easily defended, both as more ethical than those shot in the wild and as necessary for a greater good. "Game farm animals are like animal soldiers," says MacDonald. "In a war you have people who die to save democracy. These animals, which are not suffering, are also playing a very important role. Without the pretty pictures, would there be the same affection for them?"

But there are problems here, too, severe ones. You get a small hint of them 8 when you talk to wildlife biologists like Don White at Montana State University. "I'll see a picture and say, 'How in the world did he get that? It's got to be staged. But it's passed on as part of the natural world.' And then you understand when you see an elderly lady bail out of her car and run up to a grizzly to take a picture. She got within fifteen feet. Fortunately he didn't think she was important enough to kill. But it's that kind of thing that makes you wonder if we're communicating any kind of common-sense understanding of animals." That elderly lady was not alone. Chuck Bartlebaugh, director of the Center for Wildlife Information, spends much of his time trying to reduce encounters between Yellowstone tourists and Yellowstone bears, who end up being shot when they become too habituated to tourists. After surveying four hundred people who were taking pictures along the roads, he and his colleagues concluded that the images provided by professional nature photographers were the biggest cause of problems. "We asked these people where they got their information that it was safe to approach bears or elk or whatever, and they immediately referred to TV programs and other pictures that showed biologists or photographers getting close to animals. A lot of the magnificent shots that the public tries to imitate in our national parks were taken of captive animals with handlers there." Chuck Jonkel, who runs the International Wildlife Film Festival, instructs his judges to scrutinize pictures carefully. "Some of those pictures tell a lie. They say you can get this close to an animal."

Wildlife photographers and editors, to their credit, have begun to think seri- 9 ously about the peril that game farm photos might pose both to hapless shutterbugs and to our general understanding of the natural world. And the solution slowly gaining ground is to label photos, either in the caption or the photo credit,

as coming from game farms. Videomaker Marty Stouffer, whose *Wild America* series for public television has come under particular attack, has offered to label "factual recreations" in his footage. Some photographers say such fine print is entirely unnecessary; others that they might favor it when sending pictures to a scientific publication like *Natural History* but not to an advertising agency; others simply label their slides and let editors decide. It's akin to the warning labels on cigarettes, even closer to the warnings that carmakers flash on the screen before a commercial showing the latest model careening down both lanes of some mountainous highway. That it probably won't matter very much can be assumed from the photographer's credo about the relative worth of a picture and a thousand words.

10 But even if it did reduce the number of Kodachrome maulings, little labels on a picture can't overcome the deepest problems, which have to do with how we perceive the world, in this case, the natural world. After a lifetime of nature shows and magazine photos, we arrive at the woods conditioned to expect splendor—surprised when the parking lot does not contain a snarl of animals attractively mating and killing each other. Because all we get is close-ups, we've lost much of our sense of how the world actually operates, of the calm and quotidian beauty of the natural world, of the fact that animals are usually preoccupied with hiding, or wandering around looking for food. There is something frankly pornographic about the animal horror videos ("Fangs!") marketed on late-night TV, and even about some of the shots you see in something as staid as *Natural History*. Here is an emerald boa eating a parrot—the odds, according to the photographers I talked to, were "jillions to one" that it was a wild shot. Indeed, the photographer who took it boasted to *People* magazine about how he'd spray-painted ferrets to convert them to the endangered blackfooted kind, and how he'd hoisted táme and declawed jaguars into tree branches for good shots, and starved piranhas so they'd attack with great ferocity. Another photographer took a game stab at defending the shot of the emerald boa munching down the parrot—"It very graphically illustrates the relationship between higher and lower vertebrates," he said. So it does—but that's a little like saying Miss September graphically illustrates the development of the mammary gland in *Homo sapiens*.

11 Even worse, perhaps, is the way the constant flow of images undercuts the sense that there's actually something wrong with the world. How can there really be a shortage of whooping cranes when you've seen a thousand images of them—seen ten times more images than there are actually whooping cranes left in the wild? In Ellen Goldensohn's words, "They imply an Edenic world. And yet the real world is shrinking cruelly." No one ever shows a photograph of the empty trees where there are no baboons anymore; whatever few baboons remain are dutifully pursued until they're captured on film, and even if all the captions are about their horrid plight, the essential message of the picture remains: baboons.

12 At this point we could—indeed we should—start talking about a new ethic. People have tried, from time to time, to promulgate ethics for most of the arts, and nature photography is no exception. As the photographer Daniel Dancer

points out in a recent issue of *Wild Earth* magazine, the British organization of nature photographers issues a single commandment: "The welfare of the subject is more important than the photograph." It's an apt rule, but as Dancer also points out it does nothing to address the larger questions I've alluded to, what he calls "the impact on society and our relationship to nature as a *whole*. If over-imaging the world furthers our separation from nature, then there is something inherently wrong in our covenant with the camera." He offers a number of practical ways that individual photographers might rewrite that covenant—by offering "sacrifices" to their "prey" by using the photos for advocacy purposes, for instance, and by shooting the clear-cut next to the forest, too.

Others offer suggestions from the point of view of an editor. Fred Ritchin, 13 for instance, former picture editor of the *New York Times* magazine and author of *In Our Own Image: The Coming Revolution of Photography* calls much of nature photography "nostalgia at this point—and a vicious kind of nostalgia, like big game hunters putting the horns of an elephant over their fireplace." Instead of worrying about game farms, he says editors could rethink their whole approach. "I might want to send a photographer out to spend a week with a snake and take notes and photograph the snake every hour for the entire time. Or to begin to take pictures of what the photographer understands would be the point of view of the snake. Or photograph snake fragments for a week, as if it were a disembodied thing. So you could really see it, as opposed to saying, 'There's only one part of a snake that's interesting—its head—and only one or two poses, and we're going to do them over and over again."

Reading and talking to such thinkers, though, it's easy to find a note of res- 14 ignation—the deep suspicion that such rhetoric is not going to affect very quickly or very profoundly the marketplace in which photographers operate. If one photographer or editor falters, chances are there will be another to take his place, offering the nostrils of the snake. Changing course even slightly makes an editor nervous, says Ritchin, because "you might not be pleasing your readership. It's like going out on your first date. Once you've told a great joke you don't want to tell a more matter-of-fact joke." Dancer offers the wise advice of Wendell Berry that "one must begin in one's own life the private solutions that can only in turn become public solutions." That is so. But my work on environmental issues has made me wary of completely private solutions—the momentum of our various tragedies makes the slow conversion of small parts of the society insufficient. Aren't we ethically impelled to also try to imagine ways that such private solutions might turn into public and widespread practice?

And it's precisely for that reason that wildlife photography interests me so 15 much. It's a small enough world that, at least for purposes of argument, you could postulate real changes. Suppose the eight or nine magazines that run most of the nature photos, and the three or four top TV nature shows, formed among them a cooperative or clearinghouse for wildlife pictures, and announced that anyone could mail them as many slides as they wished for their files by a certain date. *And that after that date they wouldn't take any new submissions.* Then, when the editors of *Natural History* decided they needed some elephant photos, the

staff of the cooperative agency could send them a wide array to choose from. For the fact is, there are already plenty of elephant photos in the world—when *Wildlife Conservation* was planning a piece on elephants a few years ago, according to art director Julie Maher, they reviewed ten thousand slides. If *Nova* needed a mountain lion, they could ask for the miles of film already shot and then make their selections.

16 If some member of the consortium had a good reason for needing a new picture—if there was a new species, or a new behavior that needed illustrating, or someone was needed to accompany a scientific expedition—then the cooperative could assign a photographer, along with strict instructions about conduct; about how far away to stay, for instance. These measures might solve some of the ethical problems involving treatment of animals. And it's possible such an agency could also eventually begin to deal with the larger questions, too—for instance, over time, it could cull from its stock extreme close-ups and other kinds of photos that miseducate viewers about the natural world. It's the kind of place where a new ethic might *adhere*, might grow into something powerful.

17 Since most of the competitors would belong to this cooperative, the commercial pressure that prevents such backing-off at the moment might diminish; no one else would have a two-inch-away close-up of the golden tamarind monkey either. "A big problem we see is an editor who says 'I want this kind of picture,' and then the word gets out," says Chuck Jonkel of the Wildlife Film Festival. "They'll say, 'Give us a picture of a caribou running full tilt and we'll give you $1,700.' Someone's going to hire a helicopter and run the shit out of them so they can get their $1,700. I don't blame the photographer for that—I blame the editors." Such pressure would ease; there'd be a place to bring complaints. At the same time, such an agency could become a real center for those who wanted to use cameras to document the ongoing destruction of animals and habitat that is the crucial chore for nature journalists in the late twentieth century.

18 It is not even completely quixotic to imagine such a clearinghouse forming, I think. Most of the magazines involved are the publications of various environmental groups or nonprofit societies like the National Geographic; a good deal of the film appears on public channels here and abroad. A fairly small number of members of these groups might become convinced that these issues are important and campaign for the formation of such an agency, which would have the added benefit of saving money for the participating enterprises; once it was well established, no serious publication could afford to operate without its seal of approval. (Check out your supermarket and see how much non-dolphin-safe tuna they're selling.) There would surely be all sorts of advertisers and calendar makers and rogue video artists—but at least there'd be something to measure them against.

19 Imagining institutions allows you to test the strength of the ethic on which they're based against very real and practical objections. In this case, the most obvious drawback is that it would put photographers out of work, or force them to find new subjects. If it worked as planned, this cooperative agency would need very few new wildlife photos annually—no one would be paying for zebras any-

more. And this, we intuitively feel, is not fair—who am I, or you, to tell some-one else how they can or can't make a living. We're reasonably comfortable with the process as long as the impersonal economy makes the decision. We don't grieve for blacksmiths, and the tears we shed over the "downsized" are, frankly, few. If public fashion changed suddenly and there was no *demand* for photos of animals, no one would suggest supporting photographers in their vocation. But it feels different to set out on a campaign that would as a direct byproduct put people out of work. Still, it's not much different from, say, enacting zoning laws in a town—you can be pretty certain that'll cut the work for carpenters. Or say you campaign for a recycling system in your community—it's only a matter of time before some mill-worker in Maine loses his job.

In this case, though, you couldn't even argue that new work will be created. 20 Newspaper recycling, after all, creates whole new categories of occupation—collecting the papers, working in sorting plants, running recycling mills. This po-tential clearinghouse for wildlife photos would announce, in effect: We've got enough images now; we can recycle them more or less forever; please don't bother taking any more. And since negatives don't really degrade with use, that would be that. *It is an almost unknown thing in our society to say, "That's enough."* To answer the question "How much is enough" with "We've got plenty."

And it sounds especially heretical in any creative endeavor. The word 21 *censorship* rises unbidden to one's lips. And even if you can convince yourself that it's not really censorship—it's not the government, after all; it's no more censor-ship than some magazine telling you they won't print your story for whatever damn reason; it's *editing*—even so, it seems repressive. It *is* repressive. It's the im-position of a new taboo, something we've rarely done in recent centuries. We've been about the business of demolishing taboos, and we've succeeded. Con-sumers aren't supposed to have taboos; they're supposed to consume, and con-sume we do: not just goods and services, but images, ideas, knowledge. Noth-ing is off limits. So there's something a little creepy about saying, "We'll be buying no new photos of wildebeests. We don't think it's a good idea to be tak-ing them." It is a new taboo—do we want any new taboos?

The case I've constructed about wildlife photography depends for its clarity on 22 several peculiarities: the obvious problems (as well as benefits) inherent to the practice; the fact that it might conceivably be voluntarily restrained because of the size and the environmentally minded sponsorship of the industry; most cru-cially, perhaps, the fact that animals evolve very slowly and so there is little rationale for constantly redocumenting them. By contrast, pornography can ob-viously be destructive, but since *Hustler* isn't published by the National Orga-nization for Women you'd need government involvement with all the dangers that portends. (Either that or you'd need a new taboo to spread among the con-sumers of pornography.) Documentary films or photos or writings about peo-ple can cause real problems for their subjects, which is one reason anthropolo-gists have evolved codes for their work; but human societies evolve so quickly and radically that it's unlikely we'd ever reach the point where we would want to

simply stop that kind of journalism. Still, a developing *sense* of taboo wouldn't hurt these endeavors—a sense that one was treading on somewhat sacred ground, and so needed to proceed with care.

23 I can remember writing a piece for *The New Yorker* on homelessness. I was twenty-one, had just moved to the city, and Mr. Shawn, the editor, asked me to spend some time living on the streets—this was before the idea had become cliché, before people had completely noticed homelessness as a crisis. And it was a good, absorbing piece. A few years later I reprised it—spent another fascinating stretch living without a roof. I spent time at the last remaining private flophouse in the city, and in the vast armory at 168th Street where thousands of men slept each night, and on the endless A train run to Rockaway, a mobile dormitory for dozens of men and women. And yet when the time came to run the piece, I pulled it at the last minute, out of some inchoate sense that this would hurt, not help; that it was part of what was by now a flood of media, the total impact of which was to normalize the crisis, to make it seem not a crisis at all but an inevitable fact of urban living, like pigeons.

24 As I've become more interested in environmental matters I've thought a lot about these questions of restraint, about when one's curiosity or creative impulse can be bane as well as boon. About whether there are places where taboos once more make sense. It's easier to see when it comes to things, not ideas. Clearly, for instance, we'd be better off environmentally if as a culture we frowned on automobiles; if we said that the freedom they afforded was not worth the cost in terms of global warming, suburban sprawl, and so forth. And a taboo against the next ever-larger version of the Ford Explorer, even if it somehow developed, wouldn't seem a real threat to the human spirit.

25 But there are other, tougher questions, ones that focus more clearly on ideas. Take genetic engineering as an example, the greatest creative endeavor now gripping the scientific community. There's probably more human imagination being spent on this task than on any other. And for good reason—it carries certain obvious hopes, like the eradication of childhood diseases. But it also carries certain great dangers, I think, and in the wake of Dolly the doppelgänger sheep, I am not alone in thinking so. It gives most people a slightly queasy feeling if they think about it, not so much because they fear the creation of some Frankenstein germ, but because they sense the implication for the human soul of seizing control of every force around us on the planet. Do we want to be redesigning the most basic biological instructions, inevitably for the benefit of our species? Perhaps we do—perhaps what we want most is a sort of shopping mall world, planned solely for our material ease and delight. Perhaps we don't. I'm not making the case for a new taboo here, one that might allow us to limit our tinkering to cystic fibrosis and muscular dystrophy. All I'm saying is that it's an open debate.

26 But it's a debate we're incapable of having because we operate under the assumption that debate is unnecessary, even repellent. We take as a given that we should find out everything we can, develop everything we can, photograph and write about everything we can, and then let the marketplace decide what to do with it. By definition, therefore, if it sells it is good. We've short-circuited the

process of thinking things through as a culture—which may be the basic task of a culture. We have no way to entertain the possibility of restraint as a society—even mentioning that we might not want to find out everything there is to know about the genetic code seems deeply repressive.

And yet self-restraint is the uniquely human gift, the one talent no other crea- 27
ture or community possesses even as a possibility.

The sky by afternoon has turned shiny gray, but it's warm, and the woods are 28
noisy—a crow caw-cawing nearby, angry about something I can't see. A blur of rabbit catches the corner of my eye. I nestle in the big root of a hemlock and watch a squirrel hop branches.

● THINKING CRITICALLY ABOUT "THE PROBLEM WITH WILDLIFE PHOTOGRAPHY"

RESPONDING AS A READER

1. In the second paragraph, McKibben explicitly announces that this essay is only *ostensibly* about wildlife photography and raises a much broader question about limits for "ideas and expressions." What was your response to this announcement? How did his stated double purpose change your expectations and influence your reading of the essay? By the end, to what extent has he convinced you to accept his perspective?

2. Which issues that McKibben raises did you find the most significant and compelling? Try to pinpoint specific aspects of his presentation that engaged you and/or that you found yourself resisting.

3. As a reader, how effective did you find the descriptive scenes that frame the essay in the opening and closing paragraphs? How do they connect with McKibben's points?

RESPONDING AS A WRITER

1. McKibben's organization of the essay includes some fairly major shifts in subject matter and perspective as he moves from the problem with wildlife photography to his larger points, which connect with the theme of the book *How We Want to Live*, in which this piece appears. Specifically, how does the extra white space between paragraphs 11 and 12, 21 and 22, and 27 and 28 contribute to the essay's overall effect? For comparison, examine how Robert McGuire uses white space in the next essay in this chapter.

2. Choose a paragraph of the essay that you find especially effective, and spend a few minutes picking out the specifics that made it work well for you. Then try writing a rhetorical précis *just on that paragraph and how it works in the essay*. What does this exercise reveal to you about McKibben's writing?

3. McKibben participates in Web chats from time to time. If you had an opportunity to engage him in this kind of written conversation, what

questions would you ask about this essay? Jot a few questions in two broad categories: (a) the issues he explores and (b) how he wrote the essay. Then compare your questions with those that your classmates have developed. As a class, chose ten to fifteen questions that you think would create the basis of an enjoyable Web chat with McKibben. ●

ROBERT MCGUIRE

Witness to Rage

Robert McGuire (b. 1970) spent several years as a reporter, freelance writer, and college writing instructor in Milwaukee, Wisconsin, and New Haven, Connecticut. He now works in marketing for a charitable organization in New Haven. This article, which combines emotionally intense personal narrative with journalistic interviews and fact-finding, was the cover story in *Milwaukee Magazine* in July 1999. Its first page had only the title, printed on a full-page close-up of a man's angry face. On the next page, the first sentence was set in type three quarters of an inch high. Large, boldface pull-quotes from the narrative were interspersed throughout the text. The story won local and state prizes for excellence in nonfiction as well as a National Council on Crime and Delinquency award established to recognize "responsible and factual coverage that explores the root causes of crime."

● FOR YOUR READING LOG

1. What has been (or might be) your response to learning that a friend of yours, someone your own age, experienced domestic abuse as a child?
2. As soon you as you finish reading, while the experience is still fresh, take a few minutes to jot down your emotional response to the essay as a whole. ●

— ● —

1 I boil inside.

2 There have been times when I have fled the house in fear of the tremor in my arms, the pictures in my head of what might come next.

3 I have panted, short of breath, furious, stuttering. I have let a look come over me, a tone come into my voice that has made my wife afraid of me.

4 I have punched holes in doors and walls. Once, I put my hands on my wife's arms and shook her as I shouted during an argument—my greatest regret in life.

5 There is a regular kind of anger that comes in the arguments all couples have. And then there is this irrational, out-of-the-blue rage that sometimes turns the air in our home to poison.

6 My father was a wife beater. I am not. I've beaten the odds that say children of violent homes will become violent. Still, during that out-of-the-blue anger, I

see the spittle flying from my lips and the fearful expression on my wife's face and realize how much I must look like my father—sweat high on my forehead, my Adam's apple bobbing.

There is a sense in which I am a violent man. When I feel put upon or mis- 7 understood, I feel that satisfaction would be mine if I would clench my fist and swing, if I would demolish whatever is near me.

I have a happy life, work I enjoy, a terrific marriage—a true companion. I 8 have interests that I throw myself into with enthusiasm.

And I have spent afternoons pondering warm baths and sharp kitchen 9 knives, high bridges, five-day waiting periods.

I am academically successful, cultured, a teacher, a person of authority and 10 responsibility.

And I drift from one job to another, squandering the opportunities that come 11 from sticking with one employer. At 28, I have yet to choose a career.

I've been wondering lately what happens when children witness domestic 12 violence, when they see someone they love beaten, humiliated and degraded by another person they love.

At the Milwaukee Women's Center's shelter for battered women, where I have 13 volunteered for three and a half years, children arrive in the playroom dazed and bashful. I play checkers with them and help them put together puzzles. They ask for their mothers, who are busy downstairs dealing with the crisis in their lives. Sometimes they squabble and hit each other and I tell them it's wrong to hit, that we don't allow hitting here.

Sometimes they're protective older brothers standing like sentinels behind 14 their sisters, glowering at anyone who comes near them. When they play, their anxieties are transparent: They call police on plastic telephones, and spank and scold dolls. Some become angels after a little attention is paid to them. Others remain belligerent or withdrawn. Some seem fine and then burst into tears over a missing puzzle piece. Others appear normal.

When kids arrive, I am glad to see them out of harm's way, but I know they 15 have a long road ahead. Witnessing violence has long-term effects. Young crim- inal offenders are four times more likely to have come from abusive homes, ac- cording to studies by the American Psychological Association. Boys from violent homes may end up batterers themselves and girls may later find themselves in relationships with men who beat them, reports the APA. Whether or not they re- peat the violence, many children will suffer and participate in a host of emotional and social problems—from bedwetting to drug addiction.

Where I grew up, there is a long strip of diners, truck stops and cheap motels— 16 squat cinder block buildings fronted by neon signs like "The Tropicana" or "The Thunderbird Inn." I passed these places every day of my childhood.

They were our domestic violence shelters. At the height of my father's 17 drunken rages, when my mother feared for our lives, these are the places she took us, though both of my parents had family in town.

Many nights, I would lie in bed listening to the storm at the other end of the 18 house, my mother begging my father to stop beating her. The walls rattled with

the commotion and the air pulsed with antagonism. Finally, it would stop. My father would bang out of the house or simply go to bed, leaving my mother sobbing.

19 A few of these nights each year, though, my mother would suddenly appear beside my bed, whispering fiercely, "Robert. Get up. Get your shoes on." The urgency in her voice alarmed me. And then we would go fleeing into the night to these motels.

20 In the morning, my mother would drive us kids to school. We would stop at a gas station and buy packaged cinnamon rolls for our breakfast. We would take the bus home from school as usual and my parents would be there, apparently having taken the day off from work. My father would be contrite and would keep his voice down for a few days.

21 Social workers now call this the cycle of violence—honeymoon, tension, battering, honeymoon. The abuser will be on his best behavior, courting his partner, reminding her of why she fell in love with him in the first place. As he becomes more comfortable, he returns to his domineering and antagonistic behavior, building tension until there is a blowup, followed by another round of apologies and courting.

22 Children under 12 live in more than half of the homes affected by domestic violence, according to a 1998 U.S. Department of Justice report. Seventy-five percent of the homes to which police are called on domestic violence cases have children, according to an APA study, which included Milwaukee in its sample. That adds up to an estimated 3.3 million children per year who are witnessing fathers or boyfriends beating their mothers.

23 Because it is rarely reported, there's no accurate estimate of domestic violence cases in the Milwaukee area, but in 1996, police in Milwaukee County, with its population of 963,900, reported 12,364 incidents. Waukesha County, with a population of 334,077, reported 1,313 incidents. Across Wisconsin, which has more than 5.1 million people, there were 30,479 cases of domestic violence that year.

24 It wasn't the night my father tried to kill us that made the biggest impression on me but the next day. Coming through the door that afternoon, I saw it—the brown plastic handle of a steak knife sticking out of the wall, its dull serrated blade planted deep in the paneling about as high as my father's shoulder. He had apparently plunged it there sometime during his raging the night before.

25 My mother and father were standing in the kitchen when I got home. They had spent the day in their routine of cleaning up and making up. But they missed the knife, the brown handle camouflaged against brown paneling.

26 That's when the significance of the previous 24 hours really hit me. The gun in the night had made me limp with terror, but it was that steak knife the next afternoon that wounded me. I had always wished things were different, but at that moment, I stopped wishing. I started thinking in terms of what my life was instead of what it should be.

27 As a society, we know little about what happens to children who witness domestic violence. In fact, we know more about the effects violent television shows

have on children. The few dozen studies on the subject have been mostly limited to families that go to shelters or call the police. Social stigma, the unpredictable behavior of police called to the scene, fear of the abuser and fear of government agencies all undermine accurate reporting. My mother, for example, was beaten several times a year for about 13 years, but I only saw a cop once in all that time. And I never saw a social worker. We weren't on the radar.

Most of the effort in domestic violence cases is placed upon impending 28 threats or treating wounds. According to Mary Lauby, executive director of the Wisconsin Coalition Against Domestic Violence, child protection agencies and shelters for battered women have their hands full with these crises. When child protection agencies do take the issue of children witnessing violence seriously, they tend to blame mothers for not protecting their children. That puts them at odds with the shelters, which worry that mothers have enough difficulty leaving violent homes without worrying that their children will be taken away.

Meanwhile, according to Nancy Worcester, founder of the Wisconsin 29 Domestic Violence Training Project, researchers suspect that when it comes to long-term consequences for children, there's not much difference between experiencing violence at home and witnessing it.

"In fact, they're very similar," she says. "They have the same warning signs." 30

When I was in fifth grade, my teacher called my mother and told her I had so 31 many nervous habits that she wanted me to see the school psychologist. My grandmother was dying then from lung cancer, which upset me. So that's the official reason for my nervous habits. I still have them. I twitch and fidget a lot. I don't spend more than 15 minutes on any single task.

I talked to the psychologist about my grandmother and then played a game 32 of checkers. She let me win, and I still resent her for it. I didn't know how to accept a favor or a compliment—and still don't. In my family, being nice to people and giving gifts aren't done out of genuine feeling but to discharge a social duty.

It's the cover-your-ass theory of relationships. I'm convinced my friends are 33 kind to me because they have an obligation to be. If you knew me and told me you liked this article, I'd figure you were only saying what politeness demands. If you neglected to mention it at all, I'd stay up late worrying about what you thought of me.

"Survivors tend to isolate themselves, drawing only on their own strengths, in- 34 telligence, information-gathering skills and intuition. Since the outside world has proved to be very dangerous and unpredictable, it is safer not to interact, trust, depend or count on anyone other than oneself. Such behavior denies the survivor the experience of caring and being cared for that is the foundation of all social interaction."—Christina Crawford in *No Safe Place: The Legacy of Family Violence.*

What I most remember about growing up is not specific violent events but the 35 atmosphere in our home the weeks before a major row. I can still feel the hostility and tension.

Watching television, we held our breath, hoping that tonight my father 36 wouldn't snap at my brother or me because we were watching in a way he

didn't like, laughing at the wrong time, fidgeting. My father would sigh heavily or curse under his breath at some private torment. At the commercial, he would stomp into the kitchen, slamming cabinets, looking for something not to be there so he could want it. He would come back to the living room and, staring fiercely at the television, say softly to my mother: "Why can't we ever have the goddamn chips I asked you for?"

37 Menacing is the word. Everything we said or did was objectionable. We moved, he shook his head in disgust. We spoke, he snorted. If we stopped speaking, he baited us: "What are you thinking? Why don't you say something?" The simple question, "What did you do today?" was deadly, especially when directed at my mother. There was something objectionable in every possible answer.

38 At our house, we learned early that if my mother hadn't bought the chips my father wanted, it was because she was too busy screwing every man she knew (my father's language). Imperfect shopping made my mother a whore. I heard her called that as often as I heard her name. I heard her accused of the vilest treacheries as often as I heard her thanked for cooking dinner.

39 Witnessing domestic violence causes a variety of cognitive, emotional and behavioral effects, according to the only definitive, book-length source on the effects of children witnessing violence, *Children of Battered Women* (by Peter Jaffe, David Wolfe and Susan Wilson). The text is a summary of the smattering of surveys that appeared in academic journals in the 1980s.

40 These studies conclude that children who live in homes where violence occurs have reduced intellectual competency and language delays, often misdiagnosed as attention deficit disorder. They also face emotional difficulties, including fear of abandonment and powerlessness, inability to set limits or follow directions, lethargy, loneliness, moodiness and anxiety.

41 This leads to social and behavioral problems such as delinquency, eating disorders, excessive attention-seeking, poor impulse control, running away from home, early and risky sexual activity, suicide—and more violence. According to the APA, boys from violent homes are four times more likely than other boys to be violent with their dates, 25 times more likely to rape and 1,000 times more likely to be violent with their adult partners or children.

42 One night, when I was 13 years old, we ran off as usual. This time, my mother was more fearful that my father would search for us so she settled on a motel that was just over the city limits. There was one bed that my brother and sister and I shared and no phone.

43 I woke up to the booming sound of the steel door rattling in its frame. Crouched on the floor, my mother was begging my father to go away. "Just go home," she whispered into the crack at the door. "Just leave us alone. We'll see you in the morning."

44 The noise was terrific. When he finally went away, my mother took up a post peeking out from behind the drapes, alert for his return. I fell asleep again.

45 A little later, I woke to the sound of more shouting. My mother was kneeling on the floor, gagging from fear. Snot and tears streaming from her face, her

voice hoarse, she was pleading with my father who demanded that my mother hand over my little sister—an infant at the time. "You're drunk. You can see her in the morning. Go home. We'll come home in the morning."

I heard the sound of the small engine on my father's import pickup wind up. 46 My mother was gasping for breath. Then the sound of the truck returned. My mother was peeking through the drapes at the parking lot. "I'm really scared, kids," she said. And then a moment later, she croaked, "Oh my God, kids, I think he has a gun."

This is what terror is. The sound of fear in my mother's voice had completely 47 incapacitated me. Next to me, my brother was whimpering like a puppy. I went cold. I felt like a puddle of ice water lying in bed. I'd never been so cold. My head was swimming and I couldn't get enough air, but I couldn't even gasp. It was as if the spark of life had been stolen from my body. I couldn't move or think or reflect. I couldn't even panic.

I don't remember anything else. I don't remember how it ended. 48

My mother tells me now that what I do remember isn't entirely accurate. He 49 didn't leave and come back a few times; it all happened in just a couple of minutes. I didn't fall asleep during part of it. I didn't lie frozen in panic, she says, but threw my body over my brother as if to protect him.

She didn't actually see a gun, but he told her through the motel room door 50 that he had one in the truck he would use. He had pointed his loaded deer rifle at her twice in the past, so she didn't doubt it.

She bargained that we were more likely to survive if she let him in than if 51 he broke down the door. She was too afraid of him to keep him locked out. She let him in. He took my baby sister and drove away with her.

I've always suspected this, but I didn't know until now. I knew my sister was 52 in that motel room and I couldn't remember her being there in any of the aftermath. But I couldn't make it add up in my head. I blocked it out. I suspect now that my memory of me falling asleep as he came and went was really me blacking out in fear.

The next thing I remember, my mother was ordering me to action: to cross 53 the parking lot to the motel office and ask them to call the police. And to hurry.

I don't know how I walked across that asphalt in the middle of the night 54 wearing my pajamas. I burned with shame to ask the motel clerk to call the police. He was one of the sons of a family of immigrants who lived in an apartment behind the office. I had to wake him up. I still remember the look of disgust he gave me. My mother tells me now what I had forgotten—that they refused to call the police and that I had to go back and explain to my mother that I hadn't done the job. I then went back to the office to use a pay phone.

Much of the night, we sat at a steel desk in the back of a small-town police 55 station. Eventually, my grandparents came to get us—my father's parents. My mother was too humiliated to call her own father. My father's parents blamed her for their son's behavior, but she called them anyway.

56 The next morning, my mother and father left us at my grandparents' house. I played basketball a little with my uncle, still a teenager himself, and he told me Jesus is my savior. When I arrived home that afternoon, I saw the knife in the wall.

57 People often ask why women like my mother don't leave. Asking a question like that is accusing a woman, making her responsible for the violence. It's impossible to see the shelter's bruised women too jumpy to look me in the eye and conclude that their injuries are their fault.

58 It's the kind of question that's usually asked after a woman is murdered, like Milwaukeean Virginia Hansen, whose husband killed her last December. She *had* left him. She had a restraining order and was cooperating with prosecutors on a battery charge against him. She had even given neighbors flyers describing him and his car and asking them to call 911 if they saw him. Still, the post-mortem news reports were mostly about what else she should have done.

59 Leaving is often more dangerous than staying. A 1997 State of Florida review of its homicides found that 65 percent of the women killed by husbands or boyfriends were murdered *after* they left the relationship.

60 There are other, less tangible ways that make it difficult to leave. It was embarrassing for my mother to go into those motel offices, her eyes rimmed red from sobbing, to ask for a room, to send us to school in the same clothes we wore the day before, our homework unfinished.

61 Oftentimes, women simply don't have the resources—financial, emotional or social—to leave. The time my mother came closest to leaving, we spent a few days driving around looking at houses in terrible neighborhoods. Every once in awhile, she would weep with frustration.

62 When women do leave, their children ask all kinds of heartbreaking questions. Is my pet okay? Will I get my Rollerblades back? Why can't I be on my soccer team anymore? Does my daddy know I still love him? It can't be easy to have your children feel those anxieties when you can prevent it by just staying.

63 That question—"Why didn't she leave?"—is also hard for me because the honest truth is that I sometimes resent my mother. "Why, why, why didn't you protect us," I ask myself. I heard my father threaten to kill her many times and I saw her knocked to the ground, a fistful of her hair in his hand. I saw, and I understand, but making sense of it is still hard.

64 That's the real effect of witnessing domestic violence—the effect researchers haven't documented. It confuses you. It makes you ambivalent. It makes you angry at the people you love. It makes you identify with victim and abuser, makes you hate in yourself what resembles both of them.

65 But who is to say if staying was the wrong decision? Surviving is the important thing, and we all did that. In my family, some of us are recovering addicts. Some of us are on Zoloft. Some of us have sleep disorders. We rarely speak to each other much about anything of substance. But we're all alive.

66 Something about seeing that steak knife in the wall made me realize that things weren't going to change. In fact, two years after the gun incident, my mother was

still waking us to flee to motel rooms. But that day was the beginning of a long period of giving in, of giving up the hard work of feeling anything in particular.

After these dustups, there would always be a little talk, always with my 67 mother, about how I shouldn't get stressed out about this. I waited this time for her to come.

She would tell me how much my father loved us, how sorry and how sick 68 with alcoholism he was. As I grew into an insolent teen, I grew less interested in these talks. She would say a few words along those lines and then fall silent, frustrated by my unwillingness to join in. She would weep and I would hold as still as I could, facing away from her. She would stare at me awhile, sometimes rubbing my back through my shirt.

Finally, she would say something conclusive like, "Dinner will be ready 69 soon" or "Are you going to watch 'The Cosby Show' tonight?" She would start to slide off of the bed and then pause and say, "I love you, Robert." I would wait a few beats, and when I realized she had paused for a response, I would say, quietly, "I love you, too." The tone in my voice seemed to add, "I guess."

Nothing in this routine ever gave me the idea that what I had seen was 70 wrong, that my outrage at it was justified.

My father left my mother when I was 16. The violence stopped. Shortly before 71 they split up, I lay in my bed one night listening to him beat her up, and I felt so weary. I'm ashamed now of how unsympathetic I felt. The power I had to predict it all was my strength and my emotional defense.

Again my mother appeared at my bedside, whispering to get up and grab 72 my clothes and books. I told her to go, that I would drive myself to school, that I would see her when she got home tomorrow. She was hurt. We argued about it for a minute, and she left with my brother and sister. I lay there trying to go to sleep with my dad prowling around the house. I don't think my mother and I have had a truly intimate conversation since.

So what? 73

You don't know me. You've got troubles of your own. There is already 74 enough heartache in the world. Why should you care?

Author Christina Crawford says domestic violence, child abuse and the in- 75 creasing violence of our culture generally cost all of us: "Family violence has directly or indirectly left its black mark on almost every aspect of our world civilization. . . . Family violence inevitably spills out onto the streets and into the next generation in some form or another. Billions of taxpayer dollars are poured into institutions such as foster care, hospital emergency rooms, prisons, police, social services, courts, etc. to deal with violence after the fact."

Consider the students in your child's classroom who are bullies or are com- 76 pletely withdrawn, who are more preoccupied with the crisis in their lives than with what school is trying to teach them.

Says Mary Lauby of the Wisconsin Coalition Against Domestic Violence: "It's 77 our future. Children who are witnessing violence today are going to school with our children and, though we may not know it, are socializing with our children

and are going to grow up to date and marry our children and have children with our children. They certainly affect our classrooms. Their happiness, their ability to fully participate is marginalized by living in a violent home."

78 Or consider the world all of us will live in a generation from now. Says Nancy Worcester of the Wisconsin Domestic Violence Training Project: "Children who witness violence get more and more tolerant of violence. Every time we let it pass, we let it multiply."

79 Sometimes I worry that I'm like my father, but I understand that in the most important way, I am different. The most significant research statistic on this subject—60 percent of the boys from homes like mine end up being batterers—doesn't apply to me.

80 How do some sons break the pattern? And what will keep my sister from choosing a violent man as her partner, as many from violent homes do? There are no clear answers from professionals, only hunches and vague theories about "psychological hardiness."

81 Most social workers and therapists with whom I have spoken believe a link to the world outside the family is what makes the difference: meaningful hobbies or another adult who cares about the child and helps give a sense of self-worth.

82 My own hunch is that talking is a big part of it—telling family secrets, telling the stories of how we came to be the adults we are, making room for someone to say what is right and wrong. What if somebody had started talking after my father planted that steak knife in the wall? What if I had gotten the idea that somebody else believed that what I was seeing was wrong?

83 My father's younger brother was stabbed to death during a drunken fight with kitchen knives. His killer was a roommate he lived with after his wife left him because he was violent. Another brother chased his ex-wife and their children into hiding last year. What did these three brothers see and not talk about? What if someone had talked?

84 My little brother is getting married next fall and I wonder what kind of family he will create. Is his fiancée about to make the kind of mistake my mother did? Did he escape that cycle? Does he remember that motel? The steel desk in the back of the police station? Was he as scared as I was? I don't know. We never talk.

85 I'm not sure how to end this story—half-empty or half-full.

86 Worcester pleads with me to emphasize that things can turn out okay: "We don't want any young man reading this to think, 'Oh, I've witnessed violence. It's inevitable that I'll be violent.' Anyone who's willing to take responsibility can beat it."

87 As a teenager, I was very active in Boy Scouts. I was on a lot of committees and in charge of some of them. I earned the Eagle award. I worked at the camp swimming pool, teaching younger boys how to swim and save each other from drowning. I even planned a career in scouting.

I had a very close relationship with my scoutmaster. I saw him every Thurs- 88
day night at meetings and on 10 weekend camping trips a year. On those Fri-
day and Saturday nights, we stayed up late gossiping and sipping Pepsi. We sat
around the fire and I slowly learned over the years how to encourage younger
boys instead of belittling them. He told me about his work and asked me about
school.

Sunday afternoons, he would drop off all of the other boys first and take me 89
to a drive-in for a milkshake. He'd let me tune the radio station in his truck to
the Top 40 stations he didn't like. He'd tell me not to play so much with the re-
clining passenger seat. He would explain grown-up concerns to me, how to
keep focused on what's important, how to choose a good pickup truck, which
choices in life will result in pride, which in regret.

He kept me afloat. Just slow, gentle talk, a little bit at a time, listening, gen- 90
tly correcting, taking me seriously. I came out barely all right. I feel like a man
on the lake in a boat with a slow leak and a big pail. I'd rather be on dry land.
I'd rather the boat didn't have a leak. But bailing out is manageable work.

It took a lot of campouts and a few hours every Thursday night for eight 91
years, but I was saved.

I spend a few hours every Thursday night at the shelter that saw 360 chil- 92
dren last year—almost one a day. They're gone in a couple of weeks. I don't re-
member the names of the ones I met last week.

Recently, I helped a talented girl write a story. She looked for ways to make 93
it better, revised it, cut what didn't work. She read it to the other children, and
they laughed spontaneously at her jokes. She showed it to all of her teachers.

When I look at individuals, I see cause for hope. But when I look at an en- 94
tire community, I see a big boat with a very fast leak. And the only thing on board
is a very small pail.

● THINKING CRITICALLY ABOUT "WITNESS TO RAGE"
RESPONDING AS A READER

1. Where were you drawn into this text? Where did you resist it? Focus on
 those specific passages and describe the impact on you of specific words
 and phrasings.
2. In the section that begins "So what?" (paragraph 73), McGuire makes
 clear how he hopes readers will respond to his essay. To what extent was
 he successful in your case? In what ways has your image of domestic
 abuse and its effect on the children who witness it changed? In what
 ways has your understanding of community responses to domestic
 abuse changed?
3. McGuire says that he isn't sure how to end the story—"half-empty or
 half-full." Does the final section satisfy you as a reader? Why or why
 not? In your experience of reading the article, which way does his story
 tip, positively, toward the glass half full, or negatively, half empty?

RESPONDING AS A WRITER

1. McGuire's collage organization here, a technique used by many writers of creative nonfiction, interrupts chronological order by juxtaposing narrative sections from his childhood with interview and analysis sections from the present. For insight into the roles that the different sections play in relation to the essay as a whole, do a descriptive outline with *does* and *says* statements (described in Chapter 3) for the major sections. How does each section contribute to the article's overall effect? How does the mix of personal narrative and journalistic reporting contribute to that effect?

2. Readers have to fill in the gaps created by the collage organization. If McGuire had written this as a closed-form academic essay, he would have needed to write out transitions between the sections. To examine the differences this would make in the essay's effect, choose two or three gaps that interest you and try writing a transition sentence for them. Then compare notes with your classmates to see if you were composing similar or different readings to cover the gaps.

3. McGuire hoped that his article would inspire some readers to act in support of women and children hiding from domestic violence. He received many supportive letters in response to the article, but none mentioned that the writer felt called to take any action. As you understand the article, what actions might be appropriate? Try your hand at a simple, direct, one-paragraph letter to the editor of *Milwaukee Magazine* that seeks to motivate readers to take a specific action. •

BARBARA CROSSETTE

Testing the Limits of Tolerance as Cultures Mix

Barbara Crossette (b. 1939) was United Nations bureau chief for the *New York Times* when this article was published in the Arts and Ideas section of that paper on March 6, 1999. After retiring in 2001, she has become a contributing writer for the *Times* and the *World Policy Journal* and a contributing columnist for UN Wire, an independent news source reporting exclusively on the United Nations. Her more than twenty-five years of work as a foreign correspondent for the *Times* led to extensive travel in India and the Middle East. She has published books on India and on vanishing Buddhist culture in the Himalayas.

• **FOR YOUR READING LOG**

1. When have you encountered a cultural practice that seemed shocking to you?

2. As you read, notice the origins of the questions that Crossette explores and the kinds of evidence she examines in response. •

━━━━ • ━━━━

In Maine, a refugee from Afghanistan was seen kissing the penis of his baby boy, a traditional expression of love by this father. To his neighbors and the police, it was child abuse, and his son was taken away. In Seattle, a hospital tried to invent a harmless female circumcision procedure to satisfy conservative Somali parents wanting to keep an African practice alive in their community. The idea got buried in criticism from an outraged public.

How do democratic, pluralistic societies like the United States, based on religious and cultural tolerance, respond to customs and rituals that may be repellent to the majority? As new groups of immigrants from Asia and Africa are added to the demographic mix in the United States, Canada and Europe, balancing cultural variety with mainstream values is becoming more and more tricky.

Many Americans confront the issue of whether any branch of government should have the power to intervene in the most intimate details of family life.

"I think we are torn," said Richard A. Shweder, an anthropologist at the University of Chicago and a leading advocate of the broadest tolerance for cultural differences. "It's a great dilemma right now that's coming up again about how we're going to deal with diversity in the United States and what it means to be an American."

Anthropologists have waded deeply into this debate, which is increasingly engaging scholars across academia, as well as social workers, lawyers and judges who deal with new cultural dimensions in immigration and asylum. Some, like Mr. Shweder, argue for fundamental changes in American laws, if necessary, to accommodate almost any practice accepted as valid in a radically different society if it can be demonstrated to have some social or cultural good.

For example, although Mr. Shweder and others would strongly oppose importing such practices as India's immolation of widows, they defend other controversial practices, including the common African ritual that opponents call female genital mutilation, which usually involves removing the clitoris at a minimum. They say that it is no more harmful than male circumcision and should be accommodated, not deemed criminal, as it now is in the United States and several European countries. At the Harvard Law School, Martha Minow, a professor who specializes in family and school issues, said that intolerance often arises when the behavior of immigrants seems to be "nonmodern, nonscientific and nonrational." She cites as an example the practice of "coining" among Cambodians, where hot objects may be pressed on a child's forehead or back as cures for various maladies, leaving alarming welts that for teachers and social workers set off warnings of child abuse.

Americans are more than happy to accept new immigrants when their traditions seem to reinforce mainstream ideals. There are few cultural critics of the family values, work ethic or dedication to education found among many East Asians, for example.

8 But going more than halfway to tolerate what look like disturbing cultural practices unsettles some historians, aid experts, economists and others with experience in developing societies. Such relativism, they say, undermines the very notion of progress. What's more, it raises the question of how far acceptance can go before there is no core American culture, no shared values, left.

9 Many years of living in a variety of cultures, said Urban Jonsson, a Swede who directs the United Nations Children's Fund, UNICEF, in sub-Saharan Africa, has led him to conclude that there is "a global moral minimum," which he has heard articulated by Asian Buddhists and African thinkers as well as by Western human rights advocates.

10 "There is a nonethnocentric global morality," he said, and scholars would be better occupied looking for it rather than denying it. "I am upset by the anthropological interest in mystifying what we have already demystified. All cultures have their bad and good things."

11 Murder was a legitimate form of expression in Europe centuries ago when honor was involved, Mr. Jonsson points out. Those days may be gone in most places, but in Afghanistan, a wronged family may demand the death penalty and carry it out themselves with official blessing. Does that restore it to respectability in the 21st century?

12 Scholars like Mr. Shweder are wary of attempts to catalogue "good" and "bad" societies or practices. Working with the Social Science Research Council in New York and supported by the Russell Sage Foundation, he helped form a group of about 15 legal and cultural experts to investigate how American law affects ethnic customs among African, Asian, Caribbean and Latin American immigrants.

13 A statement of purpose written by the working group, headed by Mr. Shweder and Ms. Minow, says that it intends to explore how to react to "official attempts to force compliance with the cultural and legal norms of American middle class life."

14 "Despite our pluralistic ideals, something very much like a cultural un-American activities list seems to have begun circulating among powerful representatives and enforcers of mainstream culture," the group says in its statement. "Among the ethnic minority activities at risk of being dubbed 'un-American' are the use of disciplinary techniques such as shaming and physical punishment, parent/child co-sleeping arrangements, rituals of group identity and ceremonies of initiation involving scarification, piercing and genital alterations, arranged marriage, polygamy, the segregation of gender roles, bilingualism and foreign language use and many more."

15 Some sociologists and anthropologists on this behavioral frontier argue that American laws and welfare services have often left immigrants terrified of the intrusive power of government. The Afghan father in Maine who lost his son to the social services, backed by a lower court, did not prevail until the matter reached the state Supreme Court, which researched the family's cultural heritage and decided in its favor—while making clear that this was an exceptional case, not a precedent.

16 Spanking, puberty rites, animal sacrifices, enforced dress codes, leaving children unattended at home and sometimes the use of narcotics have all been por-

trayed as acceptable cultural practices. But who can claim to be culturally beyond the prevailing laws and why?

Ms. Minow said that issues of cultural practice were appearing in more law 17 school curriculums as Americans experience the largest wave of immigration since the 1880–1920 era. "Immigration is now becoming a mainstream subject," she said. "There is also definitely a revival of interest in law schools in religion," including a study of the relation of beliefs to social practices and legal constraints.

Some of the leading thinkers in this debate will discuss the issue at a con- 18 ference at Harvard in April [1999] on the relationship between culture and progress. "If you believe that there is such a thing as a successful society and an unsuccessful society," said Lawrence Harrison, a conference panelist, "then you have to draw some conclusions about what makes for a better society."

Mr. Harrison, who wrote "Underdevelopment as a State of Mind" (Har- 19 vard) and "Who Prospers?" (Basic Books), said he believed there were universal yearnings for "progress" and that to refrain from judging every practice out there ignored those aspirations.

Paradoxically, while some Americans want judgment-free considerations 20 of immigrants' practices and traditional rituals in the countries they come from, asylum seekers from those same countries are turning up at American airports begging to escape from tribal rites in the name of human rights. Immigration lawyers and judges are thus drawn into a debate that is less and less theoretical.

Mr. Jonsson of UNICEF, whose wife is from Tanzania, says he has had to 21 confront cultural relativism every day for years in the third world. He is outraged by suggestions that the industrial nations should be asked to bend their laws and social norms, especially on the genital cutting of girls, which UNICEF opposes.

He labels those who would condemn many in the third world to practices 22 they may desperately want to avoid as "immoral and unscientific." In their academic towers, Mr. Jonsson said, cultural relativists become "partners of the tormentors."

Jessica Neuwirth, an international lawyer who is director of Equality Now, 23 a New York–based organization aiding women's groups in the developing world and immigrant women in this country, asks why the practices that cultural relativists want to condone so often involve women: how they dress, what they own, where they go, how their bodies can be used.

"Culture is male-patrolled in the way that it is created and transmitted," she 24 said. "People who control culture tend to be the people in power, and who constitutes that group is important. Until we can break through that, we can't take the measure of what is really representative."

Other voices are often not being heard or are silenced. "People forget that in- 25 side every culture, there is a whole spectrum of ideas and values," she said. "There may be women in another culture who defend the practice of female genital mutilation, but in the same culture there will be women who oppose the practice. And men, too."

● THINKING CRITICALLY ABOUT "TESTING THE LIMITS OF TOLERANCE AS CULTURES MIX"

RESPONDING AS A READER

1. Crossette's approach to her subject matter here contrasts with that of the several more personal essays in this section. How personally involved is Crossette with this subject matter? What effect does her approach have on your appreciation of the significance of the questions she explores? Refer to specific passages in the article as evidence that supports your answers.

2. The cultural practices described in this article as "testing the limits of tolerance" can be seen as quite shocking. Where did you find surprises? In what ways did the presentation test your tolerance? How did your views evolve as you read?

3. How do you think Crossette hoped readers would respond to this article? How can you tell? Was she successful in your case? Why or why not?

RESPONDING AS A WRITER

1. Do you feel that the question(s) presented in this piece were adequately explored in it? How do you think more satisfactory answers might be found?

2. Look carefully at the way Crossette identifies her sources and incorporates material from them. If this same discussion were presented as a formal academic paper, how would its format have to be different? What do you think would be the differences in how readers would respond to an academic article about this subject in contrast to Crossette's journalistic approach?

3. What questions does this article raise for you about the role of government in relationship to cultural practice? What questions does it raise about the nature of "tolerance" itself? If you were to undertake your own exploratory essay on one or more of the cultural practices discussed here, what questions would you focus on? ●

GLORIA NAYLOR

"Mommy, What Does 'Nigger' Mean?"

A prominent African American author, Gloria Naylor (b. 1950) was raised in New York City. This article, which has been republished frequently, originally appeared February 20, 1986, as a *New York Times* "Hers" column, a place where noted women published commentaries on their experience. At the time, Naylor was acclaimed for her first novel, *The Women of Brewster Place*, which won the 1983 National Book Award. Since then, she has

published numerous essays, articles, and books, including *Mama Day* and *Bailey's Café*, which were adapted for film and stage.

• FOR YOUR READING LOG

1. "Nigger"—often referred to as "the N word"—is very difficult for most Americans to deal with, regardless of their racial background. Before reading Naylor's description of her discovery of it, and its complex uses, freewrite for several minutes about your own encounters with the word up until now.
2. What (other) derogatory words are used to refer to people of your particular race and ethnicity? Are they always negative in their meaning and use? •

—————— • ——————

Language is the subject. It is the written form with which I've managed to keep 1 the wolf away from the door and, in diaries, to keep my sanity. In spite of this, I consider the written word inferior to the spoken, and much of the frustration experienced by novelists is the awareness that whatever we manage to capture in even the most transcendent passages falls far short of the richness of life. Dialogue achieves its power in the dynamics of a fleeting moment of sight, sound, smell and touch.

I'm not going to enter the debate here about whether it is language that 2 shapes reality or vice versa. That battle is doomed to be waged whenever we seek intermittent reprieve from the chicken and egg dispute. I will simply take the position that the spoken word, like the written word, amounts to a nonsensical arrangement of sounds or letters without a consensus that assigns "meaning." And building from the meanings of what we hear, we order reality. Words themselves are innocuous; it is the consensus that gives them true power.

I remember the first time I heard the word nigger. In my third-grade class, our 3 math tests were being passed down the rows, and as I handed the papers to a little boy in back of me, I remarked that once again he had received a much lower mark than I did. He snatched his test from me and spit out that word. Had he called me a nymphomaniac or a necrophiliac, I couldn't have been more puzzled. I didn't know what a nigger was, but I knew that whatever it meant, it was something he shouldn't have called me. This was verified when I raised my hand, and in a loud voice repeated what he had said and watched the teacher scold him for using a "bad" word. I was later to go home and ask the inevitable question that every black parent must face—"Mommy, what does 'nigger' mean?"

And what exactly did it mean? Thinking back, I realize that this could not 4 have been the first time the word was used in my presence. I was part of a large extended family that had migrated from the rural South after World War II and formed a close-knit network that gravitated around my maternal grandparents. Their ground-floor apartment in one of the buildings they owned in Harlem was

a weekend mecca for my immediate family, along with countless aunts, uncles and cousins who brought along assorted friends. It was a bustling and open house with assorted neighbors and tenants popping in and out to exchange bits of gossip, pick up an old quarrel or referee the ongoing checkers game in which my grandmother cheated shamelessly. They were all there to let down their hair and put up their feet after a week of labor in the factories, laundries and shipyards of New York.

5 Amid the clamor, which could reach deafening proportions—two or three conversations going on simultaneously, punctuated by the sound of a baby's crying somewhere in the back rooms or out on the street—there was still a rigid set of rules about what was said and how. Older children were sent out of the living room when it was time to get into the juicy details about "you-know-who" up on the third floor who had gone and gotten herself "p-r-e-g-n-a-n-t!" But my parents, knowing that I could spell well beyond my years, always demanded that I follow the others out to play. Beyond sexual misconduct and death, everything else was considered harmless for our young ears. And so among the anecdotes of the triumphs and disappointments in the various workings of their lives, the word nigger was used in my presence, but it was set within contexts and inflections that caused it to register in my mind as something else.

6 In the singular, the word was always applied to a man who had distinguished himself in some situation that brought their approval for his strength, intelligence or drive:

7 "Did Johnny really do that?"

8 "I'm telling you, that nigger pulled in $6,000 of overtime last year. Said he got enough for a down payment on a house."

9 When used with a possessive adjective by a woman—"my nigger"—it became a term of endearment for husband or boyfriend. But it could be more than just a term applied to a man. In their mouths it became the pure essence of manhood—a disembodied force that channeled their past history of struggle and present survival against the odds into a victorious statement of being: "Yeah, that old foreman found out quick enough—you don't mess with a nigger."

10 In the plural, it became a description of some group within the community that had overstepped the bounds of decency as my family defined it: Parents who neglected their children, a drunken couple who fought in public, people who simply refused to look for work, those with excessively dirty mouths or unkempt households were all "trifling niggers." This particular circle could forgive hard times, unemployment, the occasional bout of depression—they had gone through all of that themselves—but the unforgivable sin was lack of self-respect.

11 A woman could never be a "nigger" in the singular, with its connotation of confirming worth. The noun "girl" was its closest equivalent in that sense, but only when used in direct address and regardless of the gender doing the addressing. "Girl" was a token of respect for a woman. The one-syllable word was drawn out to sound like three in recognition of the extra ounce of wit, nerve or daring that the woman had shown in the situation under discussion.

12 "G-i-r-l, stop. You mean you said that to his face?"

But if the word was used in a third-person reference or shortened so that it 13
almost snapped out of the mouth, it always involved some element of commu-
nal disapproval. And age became an important factor in these exchanges. It was
only between individuals of the same generation, or from an older person to a
younger (but never the other way around), that "girl" would be considered a
compliment.

I don't agree with the argument that use of the word nigger at this social stra- 14
tum of the black community was an internalization of racism. The dynamics were
the exact opposite: the people in my grandmother's living room took a word that
whites used to signify worthlessness or degradation and rendered it impotent.
Gathering there together, they transformed "nigger" to signify the varied and
complex human beings they knew themselves to be. If the word was to disap-
pear totally from the mouths of even the most liberal of white society, no one in
that room was naïve enough to believe it would disappear from white minds.
Meeting the word head-on, they proved it had absolutely nothing to do with the
way they were determined to live their lives.

So there must have been dozens of times that the word "nigger" was spoken 15
in front of me before I reached the third grade. But I didn't "hear" it until it was
said by a small pair of lips that had already learned it could be a way to humili-
ate me. That was the word I went home and asked my mother about. And since
she knew that I had to grow up in America, she took me in her lap and explained.

● THINKING CRITICALLY ABOUT "MOMMY, WHAT DOES 'NIGGER' MEAN?"

RESPONDING AS A READER

1. "Language is the subject," Naylor begins. How so? Look closely at the
 questions posed and answered by her exploration. To what extent is this
 essay about the ways that language functions interpersonally, and to
 what extent is it about African Americans' experience with the explo-
 sive word "nigger"? Point to specific passages to back up your answers.
2. How would you describe the personality that Naylor portrays for her-
 self in this essay? What specific details contribute to that impression?
 How does this ethos contribute to your appreciation of her experience
 and its significance?
3. The *New York Times* has a multicultural, indeed, multinational audi-
 ence. The vast majority of these readers would never have themselves
 been called a nigger in any sense of the term. What specific strategies
 do you see Naylor using to engage non–African American readers in her
 story?

RESPONDING AS A WRITER

1. To examine the cultural values that inform the uses of "nigger" that
 Naylor discusses, divide a piece of paper into two columns. Put a plus
 sign at the top of the left column and list in it the examples Naylor

gives of positive uses for the word "nigger." Be sure to note what Naylor says about *who* says it and *how* it is said as well as *what* it means in that instance. In the right column, list the examples Naylor gives of negative uses of the word, again noting situational factors. As you look at both lists together, what pattern do you see in the positive and negative uses of the word? When you consider the implied opposite of each use of the word, what do you discover? Summarize your analysis in a paragraph that provides an overview of the values at play in Naylor's essay. (This two-column technique for analyzing ideology is described in Chapter 4.)

2. How does the essay's title, "Mommy, What Does 'Nigger' Mean?" work to draw you into the reading? The title is punctuated as an excerpt from a conversation. What did that fact initially suggest to you about Naylor's approach to the subject matter? Is it an effective title? To explain why or why not, consider what kinds of expectations the title might set up in different readers. Then, imagine how Naylor might respond to an editor's suggestion that this title is too inflammatory. What arguments do you think she would make to keep the title as it is?

3. What do you remember about your own discovery of racism? Did it dawn on you as an abstract idea or through a specific, perhaps ugly, experience? What questions does Naylor's essay suggest to you as a way of exploring your own experience with the constellation of ideas about difference, hostility, threat, (in)equality, and (in)justice that have come to be associated with the term racism. Freewrite for at least ten minutes. ●

Lesley Kuras (Student)

Is Dream Analysis Relevant in Psychotherapy?

Lesley Kuras (b. 1982) wrote this paper during her first year at Marquette University in response to the Exploring a Question assignment at the end of this chapter. She is majoring in Writing-Intensive English as well as psychology and hopes to study psychology in graduate school as preparation for a clinical practice, perhaps with adolescents. Because of the subject matter and her interest in psychology, Kuras used APA style for the citations in the paper, which she wrote for a composition class.

● **FOR YOUR READING LOG**

1. What do you know about dreams and dreaming, from a scientific point of view? What answer do you expect Kuras finds through her exploration?

2. Do you usually remember your dreams? Do you often talk with others about them? Try to remember what you dream tonight, and when you wake up tomorrow, jot down some notes, then reflect on them in writing at some point during the day. What insights does this process bring? How might it be useful over a longer period of time? ●

———— ● ————

They startle us out of our deepest sleep and make us feel overwhelming emotions. Often, they leave us perplexed—what significance do they hold in our lives? The complicated questions of dream analysis are difficult to answer, and often bring about controversy. Since scientific analysis of mental images is difficult from oral description of them, it is also difficult to assess the validity of any form of dream analysis. As a psychology major, I am fascinated by the mystery of the human mind, particularly the study of dreams. My introductory psychology course mentioned two well-known theorists, Carl Jung and Sigmund Freud, and their differing views on the psychological function of dreaming. This brief section of the course made me curious about how a topic so debated by the pioneers of the discipline can be incorporated into a patient's therapy sessions.

When thinking about the analysis and interpretation of dreams, one has to wonder how seriously to take an analyst's interpretation. Can a system of interpretation ever be formulated so that particular types of dreams lead to a certain diagnosis? If not, how important can dreams be in psychoanalysis? Can the interpretation of dreams be classified for clinical use? Not only are these questions of interest to me, but they are important for clinical psychologists to address in their practice. There has to be some agreed upon method or guidelines for interpretation in order to maintain a scientific atmosphere in psychological research and therapy. These questions led me to investigate the question of how relevant and valid dream analysis is in clinical psychology.

Utilizing the ProQuest database, I began my study by searching for articles about dream analysis and psychotherapy. Using a general search as well as Pro-Quest's specific psychology catalog, I found four articles that addressed my question rather thoroughly. As I read through them, some new aspects of the question came to light. One side to dream analysis that I had not thought of was the biological characteristics of the brain while dreaming. An article called "The Cerebral Neurobiology of Anxiety, Anxiety Displacement, and Anxiety Denial" (Gottschalk, Fronczek, Abel, Buchsbaum, & Fallon, 2001) discussed research on brain activity relating to anxiety. The researchers noted that brain activity differs not only between a waking and sleeping state but between waking, REM stage sleep, and non-REM stage sleep. By scanning the brain, the researchers also saw that brain activity during sleep occurs in entirely different portions of the brain than when the brain is in an awake state (Gottschalk, et al., p. 17). This information alerted me to a more solid and scientific way to monitor a patient's dream. After reading this article, I realized that dreams are not only analyzed through patient-to-therapist dream reports, but that they can be studied in a more scientific manner through watching brain activity with advanced

technological methods. I was now aware that using scientific reports of brain activity during dreaming allows for a more concrete clinical interpretation.

4 Another article that broadened my perspective and expanded my question was "The Use of Dreams in Psychotherapy: A Survey of Psychotherapists in Private Practice" (Schredl, Bohusch, Kahl, Mader, & Somesanet, 2000). It described an experiment that was designed to answer five questions that were related to mine: how frequently do privately practicing therapists work with dreams, do psychoanalysts use dreams more than other branches of psychology like humanistic or cognitive, what kind of training do therapists who use dreams have, how does working with dreams benefit the patient, and do therapists who often work with their own dreams work with their patients' dreams more? (Schredl, et al., 2000, pp. 82–83). While I thought the design of the experiment showed new sides of the question for me, the sample that the experimenters surveyed seemed somewhat biased. They sent the surveys to therapists only in Germany, where the famous psychoanalyst Sigmund Freud did his work. As a result of this limited sample, about 50% of the respondents had been trained in a more psychoanalytic approach (Schredl, et al., 2000, p. 83). I found this to be a one-sided experiment because Freud put a great deal of emphasis on dreams, and therefore present-day Freudians also place heavy importance on the use of dreams. Although this flaw in the experiment caused a bias, the researchers were aware of it. At the end of the experiment, they recognized that, given another chance, they would survey different branches of psychology, different countries, and they would also survey patients for their opinions (Schredl, et al., 2000, pp. 84–85). The questions investigated by this survey, as well as the aspects missed by it, provided a more complex expression of my original question. I could now ask, how do different theories of psychology change dream analysis? What effect does the therapist's personal experience with dreams have on his or her use of dreams in therapy sessions? How do patients react to dream analysis?

5 Part of the survey stated that "dream interpretation has lost some of its significance [to] other topics such as transference and counter transference" (Schredl, et al., 2000, p. 81). I found myself unable to understand what that statement meant, so I turned to my psychology textbook for help, Robert Sternberg's *Psychology: In Search of the Human Mind* (2001). According to Sternberg, transference is when a "patient projects his or her feelings and internal conflicts onto the therapist" (p. 550). In contrast, counter transference is when the "therapist projects onto the patient the therapist's own feelings" (p. 550). The fact that this method has replaced dream work in many cases seemed almost redundant to me. The process of reporting and working with dreams forms a therapist-patient relationship in which the thoughts and feelings surrounding the dream are transferred from one person to the other. The definitions of transference and counter transference detracted from the statement that dream work was declining, making them less significant to my exploration. I decided to see what Sternberg said about dreams.

6 Describing many different theories used for dream work, Sternberg's section on dreams proved very helpful. The first theory described was Freud's. Follow-

ing Freud's emphasis on the unconscious, this theory says that "dreams allow us to express unconscious wishes in a disguised way" (Sternberg, 2001, p.178). My reaction to the Freudian theory was that while it seemed intriguing, it also seemed as though it would be very difficult to develop a methodology based on a therapist's assumptions about a patient's unconscious thoughts. It would be far too complicated to create a widely accepted way to interpret dream symbols, and those who have tried do not have a uniform pattern of symbols. Sternberg also saw the Freudian approach as questionable, asserting that very little evidence is available to support it (p. 178). Another well-known psychoanalyst, Carl Jung, held the theory that dreams express everyday concerns in a "language that is peculiar to dreams" (Sternberg, 2001, p.178). A problem I considered with Jung's theory is how to define such a language. I felt that this theory would become cumbersome in clinical practice. While this psychoanalytic approach is most commonly associated with dreams, other theories have emerged about dreams as well. According to Sternberg, some theorists claim that dreams do not have any meaning at all, that they are simply used as a kind of "mental housekeeping" (p. 178).

A final theory outlined by Sternberg was the activation-synthesis hypothesis. 7 I was particularly intrigued to see this theory because it deals with a more neurobiological aspect to dreams, confirming that biopsychology does interpret brain activity during dreams, relating back to the first article. The activation-synthesis hypothesis says that dreams are a way that the brain organizes and interprets neural activation (Sternberg, 2001, p. 179). This view was of interest to me because it showed a more scientific side to dream research. It made me curious as to why it was not a more widely accepted theory, considering that it was based on more empirical evidence. Finally, Sternberg gave his own view on my question, which confirmed my concerns. According to Sternberg, "it is unlikely that scientists will ever devise a definitive model of dream interpretation or for decoding the contents of dreams" (p. 179). This statement re-affirmed my notion that controlling dream analysis is significant and controversial in psychology today.

As I turned to my last article, I was still unsatisfied with the information I had 8 found. This last article was entitled "Dreamspeak," written by Milton Kramer for the popular magazine *Psychology Today* (2000). The title promised to respond to the still unanswered part of my question. Reporting on an experiment conducted by Kramer and his colleagues, the article showed fascinating evidence that dreams have an effect on moods. By monitoring sleeping subjects to see when they were dreaming and promptly waking them up for a quick dream summary, the experimenters discovered a pattern in the theme of each subject's dreams. Most of the dreams dealt with unpleasant emotions that the subject had not been able to resolve throughout the day, and was therefore doing so while sleeping. After the researchers noted the mood of each subject each morning, it was clear that "feeling better upon waking is a result of both getting uninterrupted sleep for an adequate length of time and of experiencing a series of otherwise unremembered dreams that engage disturbing feelings" (Kramer, 2000, p. 56). This evidence can be very useful in psychotherapy because it directly reports the unresolved feelings

of a patient. However, while I was very interested in the findings of Kramer and his colleagues, monitoring each patient's dreams in a clinical setting would be expensive, exhausting, and rather impractical. Perhaps the information most relevant to my question is the most frustrating: a method of scientifically monitoring dreams is simply too difficult to put into clinical practice.

9 At the end of my research, I feel like I have a better understanding of the different approaches to dream work in therapy. The information I found supported my suspicion that psychologists also wonder whether dream analysis is valid for use in therapy. However, I still wonder what kind of consistency should be and is used in psychoanalytic and other dream-related therapy. I also wonder how much weight should be given to dream analysis. To implement a more systematic method of analyzing dreams in therapy, more empirical evidence on the subject must be found.

References

Gottschalk, L. A., Fronczek, J., Abel, L., Buchsbaum, M. S., & Fallon, J. H. (2001). The cerebral neurobiology of anxiety, anxiety displacement, and anxiety denial. *Psychotherapy and Psychosomatics, 70,* 17–24. Retrieved October 4, 2001, from ProQuest.

Kramer, M. (2000, September–October). Dreamspeak. *Psychology Today, 33,* 56–58, 60, 85. Retrieved October 4, 2001, from ProQuest.

Schredl, M., Bohusch, C., Kahl, J., Mader, A., & Somesanet, A. (2000). The use of dreams in psychotherapy: A survey of psychotherapists in private practice. *The Journal of Psychotherapy Practice and Research, 9*(2), 82–86. Retrieved October 4, 2001, from ProQuest.

Sternberg, Robert J. (2001). *Psychology: In search of the human mind* (3rd ed.) Orlando, FL: Harcourt.

• **THINKING CRITICALLY ABOUT "IS DREAM ANALYSIS RELEVANT IN PSYCHOTHERAPY?"**

RESPONDING AS A READER

1. As the essay begins, what reasons does the author give you for reading it? Does she persuade you that the subject and her engagement with it are significant? Why or why not?
2. Kuras wrote this essay in response to the Exploring a Question That Puzzles You assignment at the end of this chapter. A strong narrative thread about her own research process runs through it. What role did that give you to play as a reader? Where did you find yourself most engaged? Least engaged?
3. Are you satisfied with the way the essay develops? With the way it ends? As a reader, would you call it successful?

RESPONDING AS A WRITER

1. Suppose that you were in a peer workshop group with Kuras. What questions would you expect her to ask the group about this draft of the

essay? What feedback would you give her on those points or on other points?

2. An assignment like this one necessitates extensive use of outside sources. Examine the different ways that Kuras summarizes, paraphrases, and quotes, including her use of attributive tags and APA citations. Where is her use of these academic conventions more and less effective? What can you take from this example to apply to your own work?

3. What questions does this essay raise for you? How might you go about exploring possible answers? ●

Writing to Inquire and Explore

The texts in this chapter explore complex questions about how human beings live and work in community, questions that do not have clear-cut answers, problems that do not have ready solutions. The writing assignments below suggest ways in which you can use writing to explore comparable issues that are important to you.

EXPLORING A QUESTION THAT PUZZLES YOU

Choose a question that is difficult for you and others to resolve and explore it with a mix of personal narrative and researched information similar to that in most of the essays in this chapter. To make this a real exploration, not simply a report, work with a question, problem, or issue for which several apparent answers have been posed. Avoid "fake questions" on matters about which you already have a position, such as "Why doesn't this university impose a cap on tuition?" Use chronological organization and the first person as appropriate. Whether you find and express closure on the matter is up to you.

EXAMINING RHETORICAL STRATEGIES

One of the most important aspects of reading rhetorically is considering how a given author has constructed your role and responses within a text and whether this effort has been successful in getting you to change your mind about the subject matter in some way. For this assignment, evaluate the effectiveness of the exploratory rhetorical strategies in one of the texts in this chapter. Use the Questions to Help You Read Explorations Rhetorically on page 218 to guide your analysis. The purpose of your critique is to explain (1) the extent to which the author succeeded in deepening your thinking about the topic and (2) how the exploratory approach contributed to that success or lack of success. Relate the effect of the author's rhetorical strategies to the evident overall purpose of the essay.

Feel free to use the first person in your analysis, but be sure to take into account possible responses and interpretations besides your own. Your points should be supported by evidence from the text and what you can glean about

the context of original publication. As part of your preparation for writing, it may be particularly helpful to take separate looks at content and strategy in the text you have selected by using the descriptive *(does-says)* outline analysis described in Chapter 3.

EXTENDING THE CONVERSATION

There is more to be said about each of the topics explored by the texts in this chapter. Some of that "more" may come from your own questions, even your resistance to the texts; some may come from other published contributions to the ongoing conversation on the topic. For this assignment, we invite you to extend the conversation by (1) formulating your own question in response to one of the texts and (2) writing an exploratory essay about how you have wrestled with the question and how others have answered it. Use points from the author published here as a starting place for your exploration, and then use library sources to update, elaborate, or counter points in the original text. The texts themselves offer clues for where to begin your research: names of experts who may have published on the topic or who may be quoted elsewhere (for example, in the selections by Crossette and McGuire), publications that can be consulted (for example, in McKibben), and, of course, concepts that you can use as search terms. (For additional guidance about finding reliable sources and incorporating them into your own writing, see Chapters 6 and 7.)

CHAPTER 10

Informing
and Explaining

Information and explanation lie at the heart of college study. You read informative materials to gain knowledge; your professors give lectures and lead discussions to explain difficult concepts and provide context for new ideas. You write informative papers and exams to demonstrate the knowledge you have gained, and then go off into the world to inform and explain to others what you have learned. End of story? Not at all. It would be naïve to think that the combination of information and explanation is a simple matter of transmitting facts from one mind to another via a page or screen. To present information and explanation effectively, you need more than clear sentences and well-defined terms. Effectiveness requires considerable rhetorical know-how. Likewise, to read informative and explanatory texts well, you need strong rhetorical skills so that you can determine whether the material you read is significant, reliable, and useful to you.

Texts that inform and explain, also known as *expository* texts, share a rhetorical purpose of expanding their intended audience's understanding, or image, of the subject matter under discussion. The degree of change to be brought about in a given reader's views of the material depends upon the reader's existing understanding and level of engagement with the subject. In its purest or prototypical form, informative writing asserts itself on the assumption that the writer knows something that the reader needs or wants to know and would be pleased to learn. Beyond this simplified prototype, authors of expository texts must find a way to solve these rhetorical problems:

- Readers' interest in a subject will vary.
- Readers may not recognize that they need to know the information being presented.
- Readers won't pause to read just anybody's explanation of something.

Furthermore, if readers sense that the new information will reconstruct their previous thinking rather than just expand it a bit, or if the new material is unwelcome or feels threatening, they are likely to resist or reject what is said. The greater the likelihood of resistance from readers, the greater the writer's need to persuade as well as inform.

Helping Readers Understand Information

What makes an informative or explanatory text good? You can probably list a few qualities by considering what worked in materials that have taught you something, that have successfully expanded your image of their subject matter. Understanding a few of the essential qualities of good expository prose will enable you to assess the methods as well as the content of the texts in this chapter and help you, in turn, apply some of these strategies in your own writing.

An effective expository text gives readers a purpose for reading in the first place. Its author understands readers' need for information and establishes credentials for being taken seriously. Its vocabulary is understandable, and its organization meets readers' expectations. In certain contexts, especially scholarly journals, meeting readers' expectations involves following genre conventions, such as providing an abstract or a distinct section devoted to a literature review (sometimes labeled as such, sometimes not). The scholarly article on sleep research included in this chapter provides an example of both. In other contexts, readers will be engaged best through a personal anecdote, a joke, an analogy, or an attractive page layout. You will find examples of all of these in this chapter's selections.

For some audiences, particularly readers who are browsing through a magazine or on the Web, the best way to pique interest and convey information may be a question-and-answer format or a self-help quiz. Many casual readers find these quizzes irresistible opportunities to measure themselves against a set of norms. For example, the Website of the National Sleep Foundation (http://www. sleepfoundation.org/howsyoursleep.html) offers a "How's Your Sleep?" test that lists typical sleep problems. If you put a check in the box next to any of these problems and click "submit," the site provides detailed information about diagnosing and solving the problem. Quizzes like this appeal to readers by employing a classic expository technique: suggesting tension between what we already know and what we'll know after we finish reading.

Indeed, effective expository texts often originate in such tension by offering something new, something interesting, even surprising, if not in the content then in what the writer has to say about it. These texts engage us by making clear the significance of the content they offer and suggesting what we will gain by continuing to read, why we should remember what we have read, and how we might apply this newly gained understanding to our own professional or personal con-

texts. Of course, many writing assignments in school and on the job may call for what seems to be a fairly dry and straightforward presentation of information—as on an essay exam, for example, or a memo about new office procedures. But even in those cases, whether you are writing about the effectiveness of specific childhood vaccinations or a new method of reporting sales figures, your effectiveness in making your points clearly will be enhanced by your ability to communicate to your readers an understanding of what is significant in the text before them. As you read the various selections in this chapter, note how even the most apparently straightforward texts convey a sense of their subject's significance.

Overcoming Resistance

Effective writers have a fairly accurate sense of the degree of change they want and need to bring about in their readers' understanding of the subject at hand. They also can anticipate the degree of resistance their ideas will meet in those intended readers. The greater the resistance, the more carefully must they pave the way for the changed image. When the intended change in image is negative and the news probably unwelcome—for instance if something thought benign actually has harmful effects—the author's challenge is greater still.

Effective rhetorical readers are able to discern not only a writer's intended message but the strategies invoked for conveying it. (In the article from the *UC Berkeley Wellness Letter*, the purpose is to help readers become more adept at this discernment when they read reports of medical research. Contrast its approach with the call for action in the *New England Journal of Medicine* editorial on the same subject by Marcia Angell and Jerome Kassirer in Chapter 14.) Rhetorical readers can detect assumptions a writer has made about their prior understanding of the subject; they can recognize how the writer has worked to counter their resistance to the message. The sharper the readers' recognition of how the writer is working to change their minds, the greater their freedom in deciding the extent to which they will resist or accept the new information and ideas.

A welcome expansion of a reader's understanding of a phenomenon is rhetorically the simplest expository task, as in the *Wellness Letter*'s advice about reading medical articles. In other situations, the reader's image may need more extensive adjustments, or readers may not even have been thinking about the subject at hand. For example, in "Mickey Mouse Meets Konrad Lorenz," Stephen Jay Gould writes about something that most readers probably have not noticed, so he must pique interest in Mickey's changing appearance over the years. He then provides considerable background and careful explanations so that non-expert readers can understand and care about the ways in which Disney artists' renderings of Mickey fit with biological principles set forth by zoologist Konrad Lorenz. In more personal explanations, Paul Irgang and Nancy Mairs seek to clarify readers' understanding of people like themselves. Mairs's sharp images and challenging descriptions insist that readers reexamine their assumptions about being able to move around in the world. These writers seem intent on changing their readers' thinking in major ways. Nevertheless, we have grouped these pieces in this chapter with other more simply informative texts

because, according to our rhetorical reading, an explanatory focus on subject matter dominates in them. (One of the writing assignments at the end of this chapter invites you to agree or disagree with this assessment.)

In the short story at the end of the chapter, "Consent," C. J. Hribal offers a quite different way of thinking about explanation. The protagonist is confident that he understands a situation better than anyone else, but his view would alter certain people's worldviews so radically that he dare not explain.

The Role of Information Graphics

The time-honored technique of explaining something by providing a picture is becoming more prevalent in published material thanks to advances in computer and printing technology and widespread use of the World Wide Web. As we explained in Chapter 3, contemporary texts employ a wide variety of visual elements to facilitate and influence a reader's experience. In that chapter we distinguished information graphics within a broader category of images that convey ideas, moods, and values. This distinction is based primarily on the fact that information graphics are specifically designed to promote readers' comprehension of discrete points of information. Not surprisingly, the borders between the categories sometimes blur. A typical list of information graphics includes charts, tables, graphs, maps, and diagrams, but a photograph of machinery becomes an information graphic when its various parts are labeled or when, on a computer, it can be animated with the click of a mouse button. Similarly, elements of page design such as checklists, shaded boxes, and bulleted lists can merge into the graphics category when their design is sufficiently complex to dominate a reader's experience of the text.

Understanding the purpose and function of information graphics will help you develop your rhetorical reading skills and prepare you to incorporate graphic elements into your texts in college and on the job. Table 10.1 summarizes

TABLE 10.1 • COMMON TYPES AND USES OF INFORMATION GRAPHICS	
Purpose	**Graphic to Use**
Present detailed or complex data	Table
Bring an object or process to life	Drawing, photograph, flowchart
Show change over time	Line graph
Show relation of parts to the whole	Pie chart
Contrast quantities and phenomena	Table, bar graph
Locate and show distribution of phenomena	Map
Highlight key points	Shaded boxes, bulleted lists

QUESTIONS TO HELP YOU READ INFORMATIVE AND EXPLANATORY TEXTS RHETORICALLY

As you read and work with the expository selections in this chapter, you will encounter differing assumptions about audience expectations and information needs. Use your rhetorical reading skills to assess what you can about each writer's purpose in relation to his or her original intended audience. The questions that follow will help you analyze the writers' aims and techniques for making their subjects intelligible and significant.

1. What techniques does the writer use to pique readers' interest and indicate the significance of the matter at hand? Were the techniques successful in engaging your interest? What role did they give you to play as a reader?
2. What knowledge level does the writer assume readers have? Does the way information is presented match your own information needs? What background information is necessary to understand fully the points being made (for example, concepts, vocabulary, current events)?
3. How does the writer apparently intend to change the reader's view of the subject or phenomenon at hand? Where would you place the selection on a continuum that runs from "adding new information to a reader's image" to "reconstructing a reader's image" of the subject matter?
4. To what extent does the writer apparently expect readers to accept or resist the points being made? How can you tell? Where do you see the writer attempting to smooth away resistance to the ideas presented?
5. Can you pinpoint a thesis statement in the selection? If not, what clues do you find that suggest the writer's purpose and central point?
6. Upon what claim to authority is the writer basing his or her points?
7. How is the selection marked by genre conventions? What do these tell you about the intended audience for the selection?
8. How has your thinking changed as a result of reading the selection? Why or why not? Try to pinpoint the places in the text where you resisted or assented to the writer's designs upon you.

major uses of information graphics; most of these are fairly easy to create with standard desktop software. The advantage of these graphics derives from the ease with which they can present information so that readers can efficiently find, use, and understand it.

You will find examples of effectively used information graphics in three of this chapter's expository texts. In the *Wellness Letter* article, simple devices—headings, bulleted lists, and boxes—help readers locate key bits of information. In the essay on Mickey Mouse, Gould uses a line graph to track changes in three elements of Mickey's features and provides an illustration from Lorenz's research that uses a table (or tabular) format to contrast drawings of adult and

juvenile facial features in a number of species. Most prominent in his article is a composite of Mickey Mouse images that documents Mickey's changing appearance. In "Sleep Schedules and Daytime Functioning in Adolescents," Amy Wolfson and Mary Carskadon use extensive tables to present their data, and three bar graphs provide a visual representation of students' reported sleep patterns. Careful examination of how these selections integrate discussion of the graphics into the text will help you develop your ability to create effective informative and explanatory documents.

UC BERKELEY WELLNESS LETTER

Why Do Those #&?@! "Experts" Keep Changing Their Minds?*

This article on the difficulty of understanding news reports about medical research appeared originally in the *UC Berkeley Wellness Letter*, a consumer publication that bills itself as "The Newsletter of Nutrition, Fitness, and Self-Care." Published since 1984 by the School of Public Health at the University of California, Berkeley, it carries no advertising and takes a skeptical attitude toward trendy remedies and diets. According to the newsletter's Website at www.berkeleywellness.com, its approach to wellness "emphasizes personal responsibility for making the lifestyle choices and self-care decisions that will improve the quality of your life." The *Wellness Letter*'s monthly eight-page issues, which subscribers receive by mail, typically include "how to" articles, question-and-answer columns, buying guides, quizzes, and detailed tables that rate the nutritional value of various prepared foods. This selection appeared in February 1996 as a special report.

● FOR YOUR READING LOG

1. Has someone in your family, or someone else you know, ever taken reports of medical breakthroughs too seriously? What happened? Take a few minutes to freewrite about any instances you know of involving overreaction to press reports about scientific research.

2. News stories about science and health matters are quite common. What news of medical breakthroughs or health warnings have you become aware of in the last few months? What do you recall about your reaction at the time? What did you think about how the new findings might affect you or your loved ones? ●

Let's say that for the last five years you've been paying close attention to health 1
news as reported on TV and in newspapers. Perhaps you learned about anti-
oxidants (notably vitamins E and C and beta carotene), which you can get both
from foods and supplements. These antioxidants may help lower the risk of
heart disease, cancer, cataracts, and other ills. The scientist who had told you
this on the *Today* show was a handsome fellow in a good-looking suit (no rum-
pled Einstein he). He had led the groundbreaking study that had just appeared
in *The Impeccable Journal of Medicine.* Not only was the evidence "very exciting,"
but he was taking hefty amounts of antioxidant supplements himself. So you
started taking the pills. Next thing, you read that a study conducted in Finland
showed that not only was beta carotene *not* protective against lung cancer, it ac-
tually seemed to increase the risk of getting it. Feeling deceived, you stopped
taking your supplements and even gave up your daily carrot. You were tired of
carrots anyway.

You may have seen something similar happen with oat bran (good one 2
week, outmoded the next), margarine (you switched to this supposed health
food a few years ago, and now it's been tagged as an artery-clogger), DDT and
breast cancer (first linked, then not), hot dogs and childhood leukemia (a headline-
maker that soon pooped out, since even the researchers had a hard time ex-
plaining their findings), and household electricity (cancer again—but by then
you had gotten bored). Do these folks just not know what they are talking
about?

In fact, the experts don't change their minds as often as it may seem. This newslet- 3
ter, for example, never told you that margarine was a health food or that oat bran
would solve your cholesterol problems. Both these foods were hyped by the me-
dia and by manufacturers—but most nutritionists never thought or said there
was anything magic about them. A few researchers and journalists eagerly
spread the idea that your power line and your electric toaster and clock could
give you cancer. Most experts thought all along that the evidence was pretty thin.
Headline writers change their minds more often than scientists.

Science is a process, not a product, a work in progress rather than a book of rules. 4
Scientific evidence accumulates bit by bit. This doesn't mean scientists are bum-
blers (though perhaps a few are), but that they are trying to accumulate enough
data to get at the truth, which is always a difficult job. Within the circle of qual-
ified, well-informed scientists, there is bound to be disagreement, too. The same
data look different to different people. A good scientist is often his/her own
severest critic.

The search for truth in a democracy is also complicated by 5

- Intense public interest in health
- Hunger for quick solutions
- Journalists trying to make a routine story sound exciting
- Publishers and TV producers looking for audiences
- Scientists looking for fame and grants

- Medical journals thirsting for prestige
- Entrepreneurs thirsting for profits

6 It pays to keep your wits about you as you listen, watch, and read.

The Search for Evidence

7 In general, there are three ways to look for evidence about health:

- **Basic research** is conducted in a laboratory, involving "test tube" or "in vitro" (within glass) experiments, or experiments with animals such as mice. Such work is vital for many reasons. For one, it can confirm observations or hunches and provide what scientists call plausible mechanisms for a theory. If a link between heart disease and smoking is suspected, laboratory experiments might show how nicotine affects blood vessels.

 The beauty of lab research is that it can be tightly controlled. Its limitation is that what happens in a test tube or a laboratory rat may not happen in a free-living human being.
- **Clinical or interventional trials** are founded on observation and treatment of human beings. As with basic research, the "gold standard" clinical trial can and must be rigorously controlled. There'll be an experimental group or groups (receiving a bona-fide drug or treatment) and a control group (receiving a placebo, or dummy, treatment). A valid experiment must also be "blinded," meaning that no subject knows whether he/she is in the experimental or the control group. In a double-blind trial, the researchers don't know either.

 But clinical trials have their limitations, too. The researchers must not knowingly endanger human life and health—there are ethics committees these days to make sure of this. Also, selection criteria must be set up. If the research is about heart disease, maybe the researchers will include only men, since middle-aged men are more prone to heart disease than women the same age. Or maybe they'll include only nurses, because nurses can be reliably tracked and are also good reporters. But these groups are not representative of the whole population. It may or may not be possible to generalize the findings. The study that determined aspirin's efficacy against heart attacks, for instance, was a well-designed interventional trial. But, for various reasons, nearly all the participants were middle-aged white men. No one is sure that aspirin works the same way for other people.
- **Epidemiologic studies.** These generate the most news because so many of them have potential public appeal. An indispensable arm of research, epidemiology looks at the distribution of disease ("epidemics") and risk factors for disease in a human population in an attempt to find disease determinants. Compared with clinical trials or basic research, epidemiology is beset with pitfalls. That's because it deals with people in the real world and with situations that are hard to control.

The two most common types of epidemiologic research are:

Case control studies. Let's say you're studying lung cancer. You select a group of lung cancer patients and match them (by age, gender, and other criteria) with a group of healthy people. You try to identify which factors distinguish the healthy subjects (the "controls") from those who got sick.

Cohort studies. You select a group and question them about their habits, exposures, nutritional intake, and so forth. Then you see how many of your subjects actually develop lung cancer (or whatever you are studying) over the years, and you try to identify the factors associated with lung cancer.

Pitfalls and Dead Ends

Epidemiologic studies cannot usually prove cause and effect, but can identify associations and risk factors. Furthermore, epidemiology is best at identifying very powerful risk factors—smoking for lung cancer, for example. It is less good at risk assessment when associations are weak—between radon gas in homes and lung cancer, for example. 8

No matter how well done, any epidemiologic study may be open to criticism. Here are just a few of the problems: 9

- People may not reliably report their eating and exercise habits. (How many carrots did you eat each month as an adolescent? How many last month? Few of us could say.) People aware of the benefits of eating vegetables may unconsciously exaggerate their vegetable consumption on a questionnaire. That's known as "recall bias."
- Hidden variables or "confounders" may cloud results. A study might indicate that eating broccoli reduces the risk of heart disease. But broccoli eaters may be health-conscious and get a lot of exercise. Was it the broccoli or the exercise?
- Those included in a study may seem to be a randomly selected, unbiased sample and then turn out not to be. For example, searching for a control group in one study, a researcher picked numbers out of the telephone book at random and called his subjects in the daytime. But people who stay home during the day may not be a representative sample. Those at home in the daytime might tend to be very young or very old, ill, or recovering from illness.
- Health effects, especially where cancer is concerned, may take 20 years or more to show up. It's not always financially or humanly possible to keep a study running that long.

Reading Health News in an Imperfect World

And this is only the half of it. Sometimes the flaws lie in the study, sometimes in the way it has been promoted and reported. Science reporters may be deluged with data. Many are expected to cover all science, from physics and astronomy 10

WORDS FOR THE WISE

✓ **"May":** does *not* mean "will."

✓ **"Contributes to," "is linked to,"** or **"is associated with":** does *not* mean "causes."

✓ **"Proves":** scientific studies gather evidence in a systematic way, but one study, taken alone, seldom proves anything.

✓ **"Breakthrough":** this happens only now and then—for example, the discovery of penicillin or the polio vaccine. But today the word is so overworked as to be meaningless.

✓ **"Doubles the risk"** or **"triples the risk":** may or may not be meaningful. Do you know what the risk was in the first place? If the risk was 1 in a million, and you double it, that's still only 1 in 500,000. If the risk was 1 in 100 and doubles, that's a big increase.

✓ **"Significant":** a result is "statistically significant" when the association between two factors has been found to be greater than might occur at random (this is worked out by a mathematical formula). But people often take "significant" to mean "major" or "important."

to the health effects of hair dyes. Sometimes health reporters may not even have read the studies in question or may not understand the statistics.

11 Many medical organizations issue press releases. Some of these are excellent, and some aren't. Some deliberately try to manipulate the press, overstating the case, failing to provide context, and so forth. Researchers, institutions, and corporations often hire public relations people to promote their work. These people may actually know less than the enterprising reporter who calls to interview them.

12 Finally, people tend to draw their own conclusions, no matter what the article says.

However, the Bottom Line Is Pretty Good . . .

13 None of this means epidemiology doesn't work. *One study may not prove anything, but a body of research, in which evidence accumulates bit by bit, can uncover the truth.* Research into human health has made enormous strides and is still making them. There may be no such thing as a perfect study, but here is only the briefest list of discoveries that came out of epidemiologic research:

- Smoking is the leading cause of premature death in developed countries.
- High blood cholesterol is a major cause of coronary artery disease and heart attack.
- Exercise is important for good health.
- Good nutrition offers protection against cancer; or, conversely, poor nutrition is a factor in the development of cancer.
- Obesity is a risk factor for heart disease, cancer, and diabetes.

SOME COMMONSENSE POINTERS

✓ **Don't jump to conclusions.** A single study is no reason for changing your health habits. Distinguish between an interesting finding and a broad-based public health recommendation.

✓ **Always look for context.** A good reporter—and a responsible scientist—will always place findings in the context of other research. Yet the typical news report seldom alludes to other scientific work.

✓ **If it was an animal study or some other kind of lab study, be cautious about generalizing.** Years ago lab studies suggested that saccharin caused cancer in rats, but epidemiologic studies later showed it didn't cause cancer in humans.

✓ **Beware of press conferences** and other hype. Scientists, not to mention the editors of medical journals, love to make the front page of major newspapers and hear their studies mentioned on the evening news. The fact that the study in question may have been flawed or inconclusive or old news may not seem worth mentioning. This doesn't mean you shouldn't believe anything. Truth, too, may be accompanied by hype.

✓ **Notice the number of study participants and the study's length.** The smaller the number of subjects and the shorter the time, the greater the possibility that the findings are erroneous.

✓ **Perhaps the most blatantly hyped research of late has been genetic.** But the treatment of human illness by altering human genes is still at a very early stage.

The list could go on and on. We suggest that you retain a spirit of inquiry 14 and a healthy skepticism, but not lapse into cynicism. *The "flip-flops" you perceive are often not flip-flops at all, except in the mind of some headline writer.*

There is a great deal of good reporting, and it's an interesting challenge to 15 follow health news. You don't believe everything you read or see on TV about politics, business, or foreign relations, so it's no surprise that you shouldn't believe some health news. Luckily, there are many sources for health news—none infallible, but some a lot better than others.

• THINKING CRITICALLY ABOUT "WHY DO THOSE #&*?@! 'EXPERTS' KEEP CHANGING THEIR MINDS?"

RESPONDING AS A READER

1. What problem does this special report set out to solve, and what reasons does it assert for seeking a solution? What does it *do* (as opposed to *say*) to try to accomplish this?

2. As the reading unfolds, what role does it give readers to play in the solution process? How might readers interact with the text differently if it were entitled, "Read Epidemiological Studies Carefully," and began with paragraph 3?

3. The playful title and introduction give little hint of the information-packed paragraphs and checklists that follow. How would you describe the writer's overall strategy for explaining this fairly complex topic to the newsletter's readers? What assumptions about readers' existing knowledge and information needs are signaled by the use of boxes, bulleted lists, and headings?

RESPONDING AS A WRITER

1. The complications of "the search for truth in a democracy" listed in paragraph 5 suggest the importance of being an alert media consumer no matter what the topic. What examples beyond the health area can you and your classmates think of that illustrate how these factors have interfered with the public's understanding of some process or phenomenon? Consider possible examples from a variety of areas, such as local and national politics, sports, and entertainment.

2. This tightly written article offers information that a college writer might find useful for many different kinds of papers. To practice your summary and paraphrase skills, write a *brief* summary of one of the article's main sections. Build a summary that you might incorporate into a paper after one of the following sentences. Limit your total length to no more than 75 words.

 a. The *UC Berkeley Wellness Letter* explains three different types of studies used for research on health matters.

 b. The *UC Berkeley Wellness Letter* warns that certain types of problems will create flaws in even very well done epidemiologic studies.

 c. Despite the problems inherent to epidemiologic studies, the *UC Berkeley Wellness Letter* says that "the bottom line is pretty good" in certain areas.

3. To test the usefulness of the *Wellness Letter*'s advice about reading scientific studies, apply its suggestions for careful reading to a current news report about a health-related scientific study. Use the Internet or a periodicals database to find an article written for a general audience in a well-known newspaper or magazine on a medical subject that interests you. Note the type of study reported and the language used about findings. Use the *Wellness Letter*'s "Words for the Wise" and "Commonsense Pointers" to analyze the importance of the news being reported. Then, write an informal letter or e-mail to a concerned friend or relative explaining how significant you think the study's findings are and why, given the *Wellness Letter*'s guidelines. •

STEPHEN JAY GOULD

Mickey Mouse Meets Konrad Lorenz

Stephen Jay Gould (1941–2002) was teaching biology, geology, and the history of science at Harvard University when this essay was published in 1979. His official biography lists him as a paleontologist and evolutionary theorist, but to the general public he is best known simply as a brilliant essayist who could make difficult scientific ideas comprehensible to general readers. His popularity as an essayist gave him celebrity status to the extent that in 1997 the renovation of his apartment in SoHo was featured in *Architectural Digest* and he played himself on an episode of *The Simpsons*. Gould's interest in paleontology—the study of prehistoric life forms through fossils—was first sparked by his visit at age five to the Museum of Natural History in New York City, where he grew up. The museum's Tyrannosaurus skeleton, he later recalled, left him both "awed and scared." His connection with the museum proved to be lifelong. The article here was one of 300 he published between 1974 and 2001 in consecutive issues of the museum's magazine, *Natural History*, a general circulation magazine that caters in particular to the museum's members of all ages.

• FOR YOUR READING LOG

1. Imagining that you have run across this article in an issue of *Natural History* rather than in a college textbook, scan the article quickly, taking special note of the visuals that accompany it. On the basis of what you see and what you may have gleaned from the headnote and earlier discussion in this book, write out some predictions about Gould's purpose in the article. What does your scanning tell you are its subject and its point?

2. When you finish reading, compare your original expectations with what you discovered as you read. What details contributed to the accuracy or inaccuracy of your initial perception of the article's purpose? Do you consider the outcome of your predictions to be a function of your scanning ability, of the way the visuals connect with the article's verbal text, or of the way the article itself is written? •

———— • ————

Age often turns fire to placidity. Lytton Strachey in his incisive portrait of Florence Nightingale writes of her declining years:

> Destiny, having waited very patiently, played a queer trick on Miss Nightingale. The benevolence and public spirit of that long life had only been equalled by its acerbity. Her virtue had dwelt in hardness. . . . And now the sarcastic

years brought the proud woman her punishment. She was not to die as she had lived. The sting was to be taken out of her; she was to be made soft; she was to be reduced to compliance and complacency.

2 I was therefore not surprised—although the analogy may strike some people as sacrilegious—to discover that the creature who gave his name as a synonym for insipidity had a gutsier youth. Mickey Mouse turned a respectable fifty last year [1978]. To mark the occasion, many theaters replayed his debut performance in *Steamboat Willie* (1928). The original Mickey was a rambunctious, even slightly sadistic fellow. In a remarkable sequence, exploiting the exciting new development of sound, Mickey and Minnie pummel, squeeze, and twist the animals on board a steamboat to produce a rousing chorus of "Turkey in the Straw." They honk a duck with tight embrace, crank a goat's tail, tweak a pig's nipples, bang a cow's teeth as a stand-in xylophone, and play bagpipe on her udder.

3 Christopher Finch, in his semiofficial pictorial history of Disney's work, comments: "The Mickey Mouse who hit the movie houses in the late twenties was not quite the well-behaved character most of us are familiar with today. He was mischievous, to say the least, and even displayed a streak of cruelty" (*The Art of Walt Disney*, 1975). But Mickey soon cleaned up his act, leaving to gossip and speculation only his unresolved relationship with Minnie and the status of Morty and Ferdie. Finch continues: "Mickey . . . had become virtually a national symbol, and as such he was expected to behave properly at all times. If he occasionally stepped out of line, any number of letters would arrive at the Studio from citizens and organizations who felt that the nation's moral well-being was in their hands. . . . Eventually he would be pressured into the role of straight man."

4 As Mickey's personality softened, his appearance changed in tandem. Many Disney fans are aware of this transformation through time, but few (I suspect) have recognized the coordinating theme behind all the alterations—in fact, I am not sure that the Disney artists themselves explicitly realized what they were doing, since the changes appeared in such a halting and piecemeal fashion. In short, the blander and inoffensive Mickey became progressively more juvenile in appearance. (Since Mickey's chronological age never altered—like most cartoon characters he stands impervious to the ravages of time—this change in appearance at a constant age is a true evolutionary transformation. Progressive juvenilization as an evolutionary phenomenon is called neoteny. More on this later.)

5 The characteristic changes of form during human growth have inspired a substantial biological literature. Since the head-end of an embryo differentiates first and grows more rapidly in utero than the foot-end (an antero-posterior gradient, in technical language), a newborn child possesses a relatively large head attached to a medium-sized body with diminutive legs and feet. This gradient is reversed through growth as legs and feet overtake the front end. Heads continue to grow but so much more slowly than the rest of the body that relative head size decreases.

During human growth, a suite of changes pervades the head itself. The 6 brain grows very slowly after age three, and the bulbous cranium of a young child gives way to the more slanted, lower-browed configuration of adulthood. The eyes scarcely grow at all and relative eye size declines precipitously. But the jaw gets bigger and bigger. Children, compared with adults, have larger heads and eyes, smaller jaws, a more prominent, bulging cranium, and smaller, pudgier legs and feet. Adult heads are altogether more apish, I'm sorry to say.

Mickey, however, has traveled this ontogenetic pathway in reverse during 7 his fifty years among us. He has assumed an ever more childlike appearance as the ratty character of *Steamboat Willie* became the cute and inoffensive host to a magic kingdom. By 1940, the former tweaker of pig's nipples gets a kick in the ass for insubordination (as the *Sorcerer's Apprentice* in *Fantasia*). By 1953, his last cartoon, he has gone fishing and cannot even subdue a squirting clam.

The Disney artists transformed Mickey in clever silence, often using sug- 8 gestive devices that mimic nature's own changes by different routes. To give him the shorter and pudgier legs of youth, they lowered his pants line and covered his spindly legs with a baggy outfit. (His arms and legs also thickened substantially—and acquired joints for a floppier appearance.) His head grew relatively larger and its features more youthful. The length of Mickey's snout has not altered, but decreasing protrusion is more subtly suggested by a pronounced thickening. Mickey's eye has grown in two modes: first, by a major, discontinuous evolutionary shift as the entire eye of ancestral Mickey became the pupil of his descendants, and second, by gradual increase thereafter.

Mickey's improvement in cranial bulging followed an interesting path since 9 his evolution has always been constrained by the unaltered convention of representing his head as a circle with appended ears and an oblong snout. Thus, the circle's form could not be altered to provide a bulging cranium directly. Instead, Mickey's ears moved back, increasing the distance between nose and ears, and giving him a rounded, rather than a sloping, forehead.

To give these observations the cachet of quantitative science, I applied my 10 best pair of dial calipers to three stages of the official phylogeny—the thin-nosed, ears-forward figure of the early 1930s (stage 1), the latter-day Jack of Mickey and the Beanstalk (1947, stage 2), and the modern mouse (stage 3). I measured three signs of Mickey's creeping juvenility: increasing eye size (maximum height) as a percentage of head length (base of the nose to top of rear ear); head length as a percentage of body length; and increasing cranial vault measured by rearward displacement of the front ear (base of the nose to top of front ear as a percentage of base of the nose to top of rear ear).

All three percentages increased steadily—eye size from 27 to 42 percent of 11 head length; head length from 42.7 to 48.1 percent of body length; and nose to front ear from 71.7 to a whopping 95.6 percent of nose to rear ear. For comparison, I measured Mickey's young "nephew" Morty Mouse. In each case, Mickey has clearly been evolving toward youthful stages of his stock, although he still has a way to go for head length.

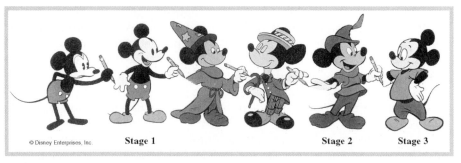

© Disney Enterprises, Inc. **Stage 1** **Stage 2** **Stage 3**

FIGURE 10.1 As Mickey became increasingly well-behaved over the years, his appearance became more youthful. Measurements of three stages in his development (see graph, page 270) revealed a larger relative head size, larger eyes, and an enlarged cranium—all traits of juvenility.

12 You may, indeed, now ask what an at least marginally respectable scientist has been doing with a mouse like that. In part, fiddling around and having fun, of course. (I still prefer Pinocchio to Citizen Kane.) But I do have a serious point—two, in fact—to make. First, why did Disney choose to change his most famous character so gradually and persistently in the same direction? National symbols are not altered capriciously and market researchers (for the doll industry in particular) have spent a good deal of time and practical effort learning what features appeal to people as cute and friendly. Biologists also have spent a great deal of time studying a similar subject in a wide range of animals.

13 In one of his most famous articles, Konrad Lorenz argues that humans use the characteristic differences in form between babies and adults as important behavioral cues. He believes that features of juvenility trigger "innate releasing mechanisms" for affection and nurturance in adult humans. When we see a living creature with babyish features, we feel an automatic surge of disarming tenderness. The adaptive value of this response can scarcely be questioned, for we must nurture our babies. Lorenz, by the way, lists among his releasers the very features of babyhood that Disney affixed progressively to Mickey: "a relatively large head, predominance of the brain capsule, large and low-lying eyes, bulging cheek region, short and thick extremities, a springy elastic consistency, and clumsy movements."

14 I propose to leave aside for this article the contentious issue of whether or not our affectionate response to babyish features is truly innate and inherited directly from ancestral primates—as Lorenz argues—or whether it is simply learned from our immediate experience with babies and grafted upon an evolutionary predisposition for attaching ties of affection to certain learned signals. My argument works equally well in either case for I only claim that babyish features tend to elicit strong feelings of affection in adult humans.

15 Lorenz emphasizes the power that juvenile features hold over us, and the abstract quality of their influence, by pointing out that we judge other animals by the same criteria—although the judgment may be utterly inappropriate in an evolutionary context. We are, in short, fooled by an evolved response to our own babies, and we transfer our reaction to the same set of features in other animals.

Many animals, for reasons having nothing to do with the inspiration of af- 16
fection in humans, possess some features also shared by human babies but not
by human adults—large eyes and a bulging forehead with retreating chin, in
particular. We are drawn to them, we cultivate them as pets, we stop and ad-
mire them in the wild—while we reject their small-eyed, long-snouted relatives
who might make more affectionate companions or objects of admiration. Lorenz
points out that the German names of many animals with features mimicking
human babies end in the diminutive suffix *chen*, even though the animals are
often larger than close relatives without features similar to human babies—
Rotkehlchen ("robin"), *Eichhörnchen* ("squirrel"), and *Kaninchen* ("rabbit"), for
example.

In a fascinating section, Lorenz then enlarges upon our capacity for biolog- 17
ically inappropriate response to other animals, or even to inanimate objects, that
mimic human features. "The most amazing objects can acquire remarkable,
highly specific emotional values by 'experiential attachment' of human proper-
ties. . . . Steeply rising, somewhat overhanging cliff faces or dark storm-clouds
piling up have the same, immediate display value as a human being who is
standing at full height and leaning slightly forwards"—that is, threatening.

We cannot help regarding a camel as aloof and unfriendly because it mim- 18
ics, quite unwittingly and for other reasons, the "gesture of haughty rejection"
common to so many human cultures. In this gesture, we raise our heads, plac-
ing our nose above our eyes. We then half-close our eyes and blow out through
our nose—the "harumph" of the stereotyped upperclass Englishman or his well-
trained servant. "All this," Lorenz argues quite cogently, "symbolizes resistance
against all sensory modalities emanating from the disdained counterpart." But
the poor camel cannot help carrying its nose above its elongate eyes, with mouth
drawn down. As Lorenz reminds us, if you wish to know whether a camel will
eat out of your hand or spit, look at its ears, not the rest of its face.

In his important book *Expression of the Emotions in Man and Animals*, pub- 19
lished in 1872, Charles Darwin traced the evolutionary basis of many common
gestures to originally adaptive actions in animals later internalized as symbols
in humans. Thus, he argued for evolutionary continuity of emotion, not only of
form. We snarl and raise our upper lip in fierce anger—to expose our nonexis-
tent fighting canine tooth. Our gesture of disgust repeats the facial actions asso-
ciated with the highly adaptive act of vomiting in necessary circumstances. Dar-
win concluded, much to the distress of many Victorian contemporaries: "With
mankind some expressions, such as the bristling of the hair under the influence
of extreme terror, or the uncovering of the teeth under that of furious rage, can
hardly be understood, except on the belief that man once existed in a much
lower and animal-like condition."

In any case, the abstract features of human childhood elicit powerful emo- 20
tional responses in us, even when they occur in other animals. I submit that
Mickey Mouse's evolutionary road down the course of his own growth in reverse
reflects the unconscious discovery of this biological principle by Disney and his
artists. In fact, the emotional status of most Disney characters rests on the same
set of distinctions. And to this extent, the magic kingdom trades on a biological

The "Evolution" of Mickey Mouse

cranial vault

90%

70%

50%

head size

eye size

30%

stage 1 stage 2 stage 3 Morty

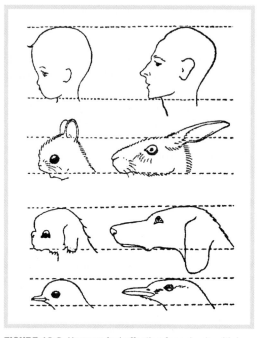

FIGURE 10.2 In an early drawing (see Figure 10.1) Mickey had a smaller head, cranial vault, and eyes. He evolved in stages toward the characteristics of his young nephew Morty (connected to Mickey by a dotted line).

FIGURE 10.3 Humans feel affection for animals with juvenile features: large eyes, bulging craniums, retreating chins (left column). Small-eyed, long-snouted animals (right column) do not elicit the same response.

Figure from "Ganzheit und Teil in der Tierischen und Menschilichen Geminschaft," *Studium Generale*, 3/9, 1950. Copyright 1950 Verlag M. und H. Schaper. Used with permission.

illusion—our ability to abstract and our propensity to transfer inappropriately to other animals the fitting responses we make to changing form in the growth of our own species.

21 Donald Duck also adopts more juvenile features through time. His elongated beak recedes and his eyes enlarge; he converges on Huey, Louie, and Dewey as surely as Mickey approaches Morty. But Donald, having inherited the mantle of Mickey's original misbehavior, remains more adult in form with his projecting beak and more sloping forehead.

22 Mouse villains or sharpies, contrasted with Mickey, are always more adult in appearance, although they often share Mickey's chronological age. In 1936, for example, Disney made a short entitled *Mickey's Rival*. Mortimer, a dandy in a yellow sports car, intrudes upon Mickey and Minnie's quiet country picnic. The thoroughly disreputable Mortimer has a head only 29 percent of body length, to Mickey's 45, and a snout 80 percent of head length, compared with Mickey's 49. (Nonetheless, and was it ever different, Minnie transfers her affection until an obliging bull from a neighboring field dispatches Mickey's rival.) Consider also

the exaggerated adult features of other Disney characters—the swaggering bully Peg-leg Pete or the simple, if lovable, dolt Goofy.

23

As a second, serious biological comment on Mickey's odyssey in form, I note that his path to eternal youth repeats, in epitome, our own evolutionary story. For, as I have argued in several columns, humans are neotenic. We have evolved by retaining to adulthood the originally juvenile features of our ancestors. Our australopithecine forebears, like Mickey in *Steamboat Willie*, had projecting jaws and low vaulted craniums.

24

Our embryonic skulls scarcely differ from those of chimpanzees. And we follow the same path of changing form through growth: relative decrease of the cranial vault since brains grow so much more slowly than bodies after birth, and continuous relative increase of the jaw. But while chimps accentuate these changes, producing an adult strikingly different in form from its baby, we proceed much more slowly down the same path and never get nearly so far. Thus, as adults, we retain juvenile features. To be sure, we change enough to produce a notable difference between baby and adult, but our alteration is far smaller than that experienced by chimps and other primates.

25

A marked slowdown of developmental rates has triggered our neoteny. Primates are slow developers among mammals, but we have accentuated the trend to a degree matched by no other mammal. We have very long periods of gestation, markedly extended childhoods, and the longest life span of any mammal. The morphological features of eternal youth have served us well. Our enlarged brain is, at least in part, a result of extending rapid prenatal growth rates to later ages. (In all mammals, the brain grows rapidly in utero but often very little after birth. We have extended the operation of this fetal rate.)

26

And the changes in timing themselves have been just as important. We are preeminently learning animals, and our extended childhood permits the transference of culture by education. Many animals display flexibility and play in childhood but follow rigidly programmed patterns as adults. Lorenz writes, in the same article cited above: "The characteristic which is so vital for the human peculiarity of the true man—that of always remaining in a state of development—is quite certainly a gift which we owe to the neotenous nature of mankind."

27

In short, we, like Mickey, never grow up although we, alas, do grow old. Best wishes to you, Mickey, for your next half century. May we stay as young as you, but grow a bit wiser.

• ### THINKING CRITICALLY ABOUT "MICKEY MOUSE MEETS KONRAD LORENZ"

RESPONDING AS A READER

1. The "media kit" at *Natural History's* Website (http://www.amnh.org/naturalhistory/) describes the magazine as "the voice of the Museum, conveying a sense of knowledge and adventure, scholarship and science, serious thought and award-winning photographs." That description was no doubt written long after this article was published, but

through the years the magazine has consistently targeted a multi-aged audience of well-educated families. What aspects of Gould's article seem designed to reach particular elements of that audience?

2. Guided by the discussion about Connecting the Visual to the Verbal in Chapter 3, analyze how Figures 10.1 through 10.3 work in relation to Gould's verbal text. In what ways does each figure support, supplement, or extend the explanations in the text? How did each influence your understanding of his points?

3. What assumptions does Gould seem to have made about his reading audience's knowledge and attitude regarding his subject matter? If sections of the text varied in effectiveness for you, analyze why in terms of organization, sentence structure, and word choices.

RESPONDING AS A WRITER

1. How effectively did Gould's introduction engage you on your first reading? After rereading, what do you perceive to be his strategy in the opening paragraph and the long quote included with it? How does it work in terms of the essay's overall structure? Does your evaluation of it change as your understanding of Gould's purpose develops?

2. Analysis of this essay's structure by means of an idea map or a descriptive outline would reveal several different explanations/arguments being presented. Use whichever technique you find more productive to analyze how those explanations and arguments interact with each other. How typical would you say Gould's approach is for expository material? How effective is it in this case? It's likely your answer will involve the phrase "it depends." On what? Use the complexity you discover to articulate some points about how decisions about organizational structure depend upon purpose and audience.

3. Figure 10.3, the table from Konrad Lorenz, does not look like the tables typical of scientific articles; those tables are more likely to present numerical data like the ones in the "Sleep Schedules and Daytime Functioning" article in this chapter. Yet Lorenz's table follows the classic columns and rows structure of a table, a pattern you can set up quickly with any word processing software. Consider why this visual array of data works so well for comparison purposes, then construct a table of your own that compares phenomena about which you know a good deal. Try to come up with visual images that you might use in the table—describe them if you haven't time to create them. For the sake of comparison with the Lorenz table, follow its pattern: columns for categories of comparison and rows for the items being compared. *Note:* There is no rule about what kind of data to put in columns or rows in a table. Case-by-case decisions depend on disciplinary or industry conventions and how the creator of the table expects it to be used. ●

AMY R. WOLFSON AND MARY A. CARSKADON

Sleep Schedules and Daytime Functioning in Adolescents

This research report was the focus of the various article introductions we presented in the rhetorical context exercise in Chapter 2. In this article, which follows the citation conventions of the American Psychological Association (APA), Wolfson and Carskadon document their finding that sleep loss interferes with adolescents' daytime functioning; they link that finding to early school-opening times. *Child Development*, where this article appeared in August 1998, is an interdisciplinary refereed journal that publishes, in addition to empirical research articles, discussions of theory and policy, and literature reviews relevant to all aspects of human development from birth through adolescence. Originally presented at a 1996 conference, the study received widespread press attention and has been influential in policy discussions about moving high school start times to 8 A.M. or later. The authors, both psychologists, are prominent sleep researchers with numerous scholarly publications to their credit. Wolfson (b. 1960) teaches at the College of the Holy Cross in Worcester, Massachusetts, and is the author of *The Woman's Book of Sleep* (2001). Carskadon (b. 1947) is a professor of psychiatry and human behavior in the psychology department at Brown University in Providence, Rhode Island, where she directs the E. P. Bradley Hospital Sleep Research Laboratory. Her most recent publications include *Sleep Medicine* (coeditor, 2002) and *Adolescent Sleep Patterns* (2002).

● **FOR YOUR READING LOG**

1. Reading this study will offer you a good opportunity to explore the structure and content of a typical social science research article that uses APA style. Initially, the many internal citations and references to statistics may seem daunting, and it's true that taking in every detail on a first reading would be extremely difficult. The article's genre may be unfamiliar to you; however, be assured that its main points are not difficult to follow. Its findings are interesting and important; furthermore, the subject matter is something that many college students worry about—sleep.

 As the section in Chapter 2 about matching reading strategy to genre and purpose pointed out, probably very few people, even experts in the field, would read this article front to back, word for word. In fact, the abstract, literature review, and section labels actually help readers *not* read every word of every sentence, at least not initially. Instead, an expert would probably look for the material most relevant to his or her professional and personal interests. What will you do? As you determine your strategy for tackling this text, recall Chapter 2's advice

about preparing to read. Take into account your existing knowledge of the article's significance as well as the context that leads you to read it. That context includes both the way it is presented here and the comments your teacher made when assigning it. Then spend a few minutes writing in your log about your own purpose for reading and the reading strategy you think will work best for you.

2. What specific new knowledge does this article offer you? What will you learn by reading it? These questions are always important to ask before diving into a text, especially one written for an audience of experts that does not include oneself. To answer the question, take time to read the article abstract carefully, then note in your log (a) the major question addressed by the study, (b) how the researchers set about trying to answer it, and (c) the gist of what they found out. Next, spot read through the article to get a sense of its organization and the major topics covered. Then you'll be ready to begin a full reading. ●

━━━ ● ━━━

Sleep and waking behaviors change significantly during the adolescent years. The objective of this study was to describe the relation between adolescents' sleep/wake habits, characteristics of students (age, sex, school), and daytime functioning (mood, school performance, and behavior). A Sleep Habits Survey was administered in homeroom classes to 3,120 high school students at 4 public high schools from 3 Rhode Island school districts. Self-reported total sleep times (school and weekend nights) decreased by 40–50 min across ages 13–19, $ps < .001$. The sleep loss was due to increasingly later bedtimes, whereas rise times were more consistent across ages. Students who described themselves as struggling or failing school (C's, D's/F's) reported that on school nights they obtain about 25 min less sleep and go to bed an average of 40 min later than A and B students, $ps < .001$. In addition, students with worse grades reported greater weekend delays of sleep schedule than did those with better grades. Furthermore, this study examined a priori defined *adequate* sleep habit groups versus *less than adequate* sleep habit groups on their daytime functioning. Students in the short school-night total sleep group (< 6 hr 45 min) and/or large weekend bedtime delay group (> 120 min) reported increased daytime sleepiness, depressive mood, and sleep/wake behavior problems, $ps < .05$, versus those sleeping longer than 8 hr 15 min with less than 60 min weekend delay. Altogether, most of the adolescents surveyed do not get enough sleep, and their sleep loss interferes with daytime functioning.

Introduction

1 Adolescence is a time of important physical, cognitive, emotional, and social change when the behaviors in one developmental stage are constantly challenged by new abilities, insights, and expectations of the next stage. Sleep is a primary aspect of adolescent development. The way adolescents sleep critically influences their ability to think, behave, and feel during daytime hours. Likewise, daytime activities, changes in the environment, and individual factors can have

significant effects on adolescents' sleeping patterns. Over the last 2 decades, researchers, teachers, parents, and adolescents themselves, have consistently reported that they are not getting enough sleep (Carskadon, 1990a; Carskadon, Harvey, Duke, Anders, & Dement, 1980; Price, Coates, Thoresen, & Grinstead, 1978; Strauch & Meier, 1988).

Although laboratory data demonstrate that adolescents probably do not [2] have a decreased need for sleep during puberty (Carskadon, 1990a; Carskadon et al., 1980; Carskadon, Orav, & Dement, 1983), survey and field studies show that teenagers usually obtain much less sleep than school-age children, from 10 hr during middle childhood to less than 7.5–8 hours by age 16 (Allen, 1992; Carskadon, 1982, 1990a; Williams, Karacan, & Hursch, 1974). Although sleeping less than when younger, over 54% of high school students in a Swiss study (Strauch & Meier, 1988) endorsed a *wish for more sleep.*

A consistent finding in studies of adolescent sleep patterns is that they tend [3] to stay up late. Price et al. (1978), for example, found that 60% of the eleventh and twelfth graders whom they surveyed stated that they "enjoyed staying up late." Another large survey study found that 45% of tenth to twelfth graders go to bed after midnight on school nights, and 90% retire later than midnight on weekends (Carskadon & Mancuso, 1988). Another consistent report (Bearpark & Michie, 1987; Petta, Carskadon, & Dement, 1984; Strauch & Meier, 1988) is that weekend total sleep times average 30–60 min more than school-night sleep times in 10- to 13/14-year-olds, and this difference increases to over 2 hr by age 18. Such data are usually interpreted as indicating that teenagers do not get enough sleep on school nights and then extend sleep on weekend nights to pay back a sleep debt. The most obvious explanation for the adolescent sleep debt appears to be a pattern of insufficient school-night sleep resulting from a combination of early school start times, late afternoon/evening jobs and activities, academic and social pressures, and a physiological sleep requirement that does not decrease with puberty (Carskadon, 1990b; Manber et al., 1995; Wolfson et al., 1995).

Many factors contribute to or are affected by increased daytime sleepiness [4] and inconsistent sleep schedules during the junior high and senior high school years. In the sections below, we review several key issues.

PUBERTY: SLEEP NEED, DAYTIME SLEEPINESS, AND CIRCADIAN PHASE DELAY

Several important changes directly affecting sleep patterns occur during the pu- [5] bertal years. One feature that seems not to change or to change in an unexpected direction is sleep need. A 6-year longitudinal summer sleep laboratory study of Carskadon and colleagues (1980) held the opportunity for sleep constant at 10 hr in children, who were 10, 11, or 12 years old at their first 3-night assessment. The research hypothesis was that with age, the youngsters would sleep less, reaching a normal adult sleep length of 7.5 or 8 hr by the late teens. In fact, the sleep quantity remained consistent at approximately 9.2 hours across all pubertal stages. Thus, these data clarified that sleep need is not reduced during adolescence. The longitudinal study of Carskadon and colleagues (1980) simultaneously demonstrated that daytime sleep tendency was increased at midpuberty.

In other words, even though the amount of nocturnal sleep consumed by the adolescents did not decline during puberty, their midday sleepiness increased significantly at midpuberty and remained at that level (Carskadon et al., 1980, 1983). This finding was based on physician assessment of puberty using Tanner staging (Tanner, 1962) and a sensitive laboratory measure of sleepiness, the Multiple Sleep Latency Test (MSLT; Carskadon et al., 1986).

6 A significant change in the timing of behavior across adolescent development is a tendency to stay up later at night and to sleep in later in the morning than preadolescents, that is, to delay the phase of sleep (Carskadon, Vieira, & Acebo, 1993; Dahl & Carskadon, 1995). One manifestation of this process is that adolescents' sleep patterns on weekends show a considerable delay (as well as lengthening) versus weekdays, with sleep onset and offset both occurring significantly later. This sleep phase shift is attributed to psychosocial factors and to biological changes that take place during puberty. For example, in the longitudinal study described above, as children reached puberty, they were less likely to wake up on their own, and laboratory staff needed to wake them up (Carskadon et al., 1980). In fact, they likely would have slept more than 9 hr if undisturbed.

7 Carskadon and her colleagues have shown that this adolescent tendency to phase delay may be augmented by a biological process accompanying puberty. An association between self-reported puberty scores (Carskadon & Acebo, 1993) and phase preference (morningness/eveningness) scores of over 400 pre- and early pubertal sixth graders showed a delay of phase preference correlated with maturation stage (Carskadon et al., 1993). Morningness/eveningness is a construct developed to estimate phase tendencies from self-descriptions. Morning persons tend to arise early in the morning and have difficulty staying up late whereas night persons have difficulty getting up early in the morning and prefer staying up late. Whereas most people are somewhere between these extremes, the cohort value shifts during adolescence (Andrade, Benedito-Silva, & Domenice, 1993; Ishihara, Honma, & Miyake, 1990). A recent study examined the circadian timing system more directly in early adolescents by measuring the timing of melatonin secretion, for the first time demonstrating a biological phase delay in association with puberty and in the absence of psychosocial factors (Carskadon, Acebo, Richardson, Tate, & Seifer, 1997).

Environmental Constraint: School Start Time

8 Many U.S. school districts start school earlier at academic transitions, for example, elementary to junior high school and junior high school to senior high school. Earlier high school start time is a major externally imposed constraint on teenagers' sleep-wake schedules; for most teens waking up to go to school is neither spontaneous nor negotiable. Early morning school demands often significantly constrict the hours available for sleep. For example, Szymczak, Jasinska, Pawlak, and Swierzykowska (1993) followed Polish students aged 10 and 14 years for over a year and found that all slept longer on weekends and during vacations as a result of waking up later. These investigators concluded that the

school duty schedule was the predominant determinant of awakening times for these students. Similarly, several surveys of high school students found that students who start school at 7:30 A.M. or earlier obtain less total sleep on school nights due to earlier rise times (Allen, 1991; Allen & Mirabile, 1989; Carskadon & Mancuso, 1988).

In a preliminary laboratory/field study, we evaluated the impact of a 65 min ⁹ advance in school start time of 15 ninth graders across the transition to tenth grade (Carskadon, Wolfson, Tzischinsky, & Acebo, 1995; Wolfson et al., 1995). The initial findings demonstrated that students slept an average of 40 min less in tenth grade compared with ninth grade due to earlier rise times, and they displayed an increase in MSLT measured daytime sleepiness. In addition, evening type students had more difficulty adjusting to the earlier start time than did morning types, and higher scores on the externalizing behavior problems scale (Youth Self-Report; Achenbach, 1991) were associated with less total sleep and later bedtimes (Brown et al., 1995; Wolfson et al., 1995).

Daytime Behaviors

Very little research has assessed the relation between adolescents' sleep patterns ¹⁰ and their daytime behaviors. Although studies have concluded that associations between sleep/wake patterns and daytime functioning exist, the direction of this relation is not clear. Clinical experience shows that adolescents who have trouble adapting to new school schedules and other changes (e.g., new bedtimes and rise times, increased activities during the day, increased academic demands) may develop problematic sleeping behaviors leading to chronic sleepiness. Several studies indicate an association between sleep and stress. For example, a number of studies have found that sleep-disturbed elementary school-age children experience a greater number of stresses (e.g., maternal absence due to work/school; family illness/accident; maternal depressed mood) than non-sleep-disturbed children (Kataria, Swanson, & Trevathan, 1987). Likewise, sleepy elementary school-age children may have poorer coping behaviors (e.g., more difficulty recognizing, appraising, and adapting to stressful situations) and display more behavior problems at home and in school (Fisher & Rinehart, 1990; Wolfson et al., 1995).

Academic Performance

Sleepy adolescents—that is, those with inadequate sleep—may also encounter ¹¹ more academic difficulties. Several surveys of sample sizes ranging from 50 to 200 high school students reported that more total sleep, earlier bedtimes, and later weekday rise times are associated with better grades in school (Allen, 1992; Link & Ancoli-Israel, 1995; Manber et al., 1995). Epstein, Chillag, and Lavie (1995) surveyed Israeli elementary, junior high, and senior high school students and reported that less total sleep time was associated with daytime fatigue, inability to concentrate in school, and a tendency to doze off in class. Persistent sleep problems have also been associated with learning difficulties throughout the school years (Quine, 1992). Studies of excessive sleepiness in adolescents due

to narcolepsy or sleep apnea have also reported negative effects on learning, school performance, and behavior (Dahl, Holttum, & Trubnick, 1994; Guilleminault, Winkle, & Korobkin, 1982).

SUMMARY OF FACTORS IMPOSING ON ADOLESCENTS' SLEEP/WAKE PATTERNS

12 The interplay among sleep/wake schedules, circadian rhythms, and behavior during adolescence results in an increasing pressure on the nocturnal sleep period, producing insufficient sleep in many teenagers and, ultimately, changes in daytime functioning (Carskadon, 1995). For preadolescents, parents are more likely to set bedtimes, school begins later in the morning, and societal expectations favor long sleep. Prepubescent children are thus more likely to have earlier bedtimes and to wake up before the school day begins (Petta et al., 1984). In contrast, due to behavioral factors (social, academic, work-related), environmental constraints (school schedule), and circadian variables (pubertal phase delay), teenagers have later bedtimes, earlier rise times, and therefore, decreased time available to sleep (Carskadon, 1995). As a result, adolescents get to bed late, have difficulty waking up in the morning, and struggle to stay alert and to function successfully during the daytime.

13 Unfortunately, previous studies of adolescents' lifestyles (e.g., Hendry, Glendinning, Shucksmith, Love, & Scott, 1994) have failed to factor in these important developmental changes in sleep/wake patterns, and unanswered questions remain regarding the developmental changes in adolescent sleep/wake habits, the impact of adolescents' sleep habits on their daytime functioning (e.g., school performance), and the influence of the environment (e.g., school schedules) on teenagers' sleep. The present study examines more closely adolescents' sleep/wake habits and their association with several daytime behaviors using data from a large-scale survey. Such data are useful to assess generalizability of findings; furthermore, a large sample provides an opportunity to accentuate meaningful findings by setting the effect size (Cohen, 1988) and by examining extreme groups from the larger sample (Kagan, Resnick, & Gibbons, 1989).

14 The chief goal of this study is to document the association between adolescents' sleep/wake habits and daytime sleepiness, high school grades, depressed mood, and other daytime behaviors. Our study has three objectives: (1) to describe age, sex, and school differences in sleep/wake patterns; (2) to characterize the relation between self-reported high school grades and sleep/wake schedules; and (3) to compare daytime functioning in students on schedules we define a priori as *adequate* versus those adopting *less than adequate* schedules.

Method

MEASURES

15 In the fall of 1994, an eight page School Sleep Habits Survey was administered in homeroom classes to high school students at four public high schools from three Rhode Island school districts. School start times ranged from 7:10 A.M. to

7:30 A.M. All students who wanted to complete the survey did so unless their parent/guardian refused consent. The survey items queried students about usual sleeping and waking behaviors over the past 2 weeks. Chief variables include school-night and weekend night total sleep time (TST), bedtime, and rise time. To assess *sleep schedule regularity,* two additional sleep variables were derived: *weekend delay* is the difference between weekend bedtime and school-night bedtime, and *weekend oversleep* is the difference between weekend total sleep time and school-night total sleep time.

The survey also covered school performance (self-reported grades in school) [16] and scales assessing daytime sleepiness, sleep/wake behavior problems (Carskadon, Seifer, & Acebo, 1991), and depressive mood (Kandel & Davies, 1982). School performance was assessed by asking students, "Are your grades mostly A's, A's and B's, B's, B's and C's, C's, C's and D's, D's, or D's and F's?" These data were collapsed into four categories (mostly A's or A's/B's; mostly B's or B's/C's; mostly C's or C's/D's; mostly D's/F's).

The sleepiness scale consisted of total responses to items asking whether the [17] respondent had struggled to stay awake (fought sleep) or fallen asleep in 10 different situations in the last 2 weeks, such as in conversation, while studying, in class at school, and so on (Carskadon et al., 1991). The respondent was asked to rate his or her answer on a scale of 1 to 4 (1 = no to 4 = both struggled to stay awake and fallen asleep). Scores on the sleepiness scale range from 10 to 40 and coefficient alpha was .70.

The sleep/wake behavior problems scale included 10 items asking frequency [18] of indicators of erratic sleep/wake behaviors over the course of the last 2 weeks (e.g., arrived late to class because you overslept, stayed up past 3:00 A.M., needed more than one reminder to get up in the A.M., had an extremely hard time falling asleep, and so on; Carskadon et al., 1991). High school students were asked to rate the frequency of the particular behavior on a 5 point scale from everyday/night to never (5 = everyday, 1 = never). Scores range from 10 to 50, and coefficient alpha for the sleep/wake behaviors scale was .75.

The depressive mood scale (Kandel & Davies, 1982) queried the high school [19] students as to how often they were bothered or troubled by certain situations in the last 2 weeks. It consists of six items (e.g., feeling unhappy, sad, or depressed; feeling hopeless about the future), and three response categories were provided, ranging from not at all to somewhat too much (e.g., scored 1 to 3, respectively). The index of depressive mood was based on a total score and has high internal reliability (coefficient alpha was .79 for this sample and .79 in the original study; Kandel & Davies, 1982). The Pearson correlation between the Kandel and Davies six item, depressive mood scale and the SCL-90 scale is .72, and prior studies demonstrated that the scale has high test-retest reliability with adolescent samples ($r = .76$) over 5–6 month intervals (Kandel & Davies, 1982).

PARTICIPANTS

The survey was completed anonymously by 3,120 students, 395 students at [20] School A (rural), 1,077 at School B (urban), 745 at School C (suburban), and 903

at School D (suburban) (48% boys, 52% girls). The sample in Schools B and C comprised grades 10–12, whereas Schools A and D had ninth to twelfth graders. Approximately 8% of the students from schools A, C, and D and 17% from School B were eligible for free or reduced price lunches (State of Rhode Island Department of Education, 1994). Overall, the response rate was 88%. The students' ages ranged from 13 to 19 years (age 13–14, $n = 336$, age 15, $n = 858$, age 16, $n = 919$, age 17–19, $n = 988$). Over 91% of the students from Schools A, C, D reported that they were European American, whereas School B was more diverse (75% European American, 25% multiracial). On average, 81% of the students from all four schools reported that they live with both parents; 46% have older siblings, and 63% have younger siblings living in their homes. Eighty-six percent of their mothers *and* fathers were employed.

STATISTICAL METHODS

21 The findings are presented in three sections: (1) changes in sleep/wake habits according to age, sex, and school; (2) relation between high school grades and sleep/wake habits; and (3) an analysis of the differences in daytime functioning for students in extreme groups on several sleep parameters: short versus long school-night total sleep time, short versus long weekend oversleep, and small versus large weekend delay.

22 In the first two sections, multivariate analyses of variance (MANOVA) were used to examine age, sex, school, and grades in relation to the sleep/wake variables: total sleep time, bedtime, rise time, weekend delay, and weekend oversleep. Three multivariate analyses were computed: (1) school-night sleep variables, (2) weekend sleep variables, and (3) weekend delay and weekend oversleep. When significant multivariate effects were found, univariate effects were then examined using Bonferroni tests to determine significant group mean differences.

23 The large sample size in this study raises the possibility of finding many *statistically* significant results that have very small effect sizes, thus running the risk of overinterpreting inconsequential relations. To address this potential problem, we use an effect size criterion in addition to a statistical significance criterion for discussion and interpretation of those results most likely to prove meaningful in the long run. In the results section that follows, we restrict our discussion to those significant findings that also have effect sizes between what Cohen (1988) characterizes as small and medium. Specifically, a correlation of .20 is the effect size criterion, which is slightly smaller than the midpoint of Cohen's small ($r = .10$) and medium ($r = .30$) effects in terms of variance explained. For analysis of group differences, effects where two groups differ by more than one-third of the sample standard deviation are considered. Again, this is slightly lower than the midpoint between small ($d = .20$) and medium ($d = .50$) effect sizes (Cohen, 1988). (Note that we do not calculate exact effect sizes for our more complex analyses but simply wish to have a reasonable criterion for further consideration of effects most likely to have generalizable implications.) All *statistically*

significant results, regardless of effect size, are noted in the tables that accompany the text.

Results

SLEEP/WAKE PATTERNS CHANGE ACROSS HIGH SCHOOL AGE GROUPS

Our analysis of age-related affects grouped data by four age ranges; Table 1 presents means, standard deviations, and F values for the sleep variables according to age. All school-night sleep variables were affected by age, multivariate $F(9, 6571) = 22.49$, $p < .001$. Specifically, average total sleep time decreased by approximately 40 min across the four age groups, $p < .001$, average school-night bedtimes were about 45 min later, $p < .001$, and average rise times about 10 min later, $p < .001$. Reported weekend sleep habits also showed age-related changes, multivariate $F(9, 6327) = 21.28$, $p < .001$. Average weekend total sleep time declined by about 50 min across the age groups, $p < .001$, as weekend night bedtimes shifted increasingly later, $p < .001$, differing by about 1 hr between the youngest and oldest teenagers. Weekend rise times did not change with age. Overall, weekend delay and weekend oversleep changed between ages 13 and 19, multivariate $F(6, 5060) = 3.93$, $p < .01$. Although this multivariate F is statistically significant, age group differences for weekend delay and weekend oversleep were too small (on the order of .1 SD) to meet our effect size criterion. 24

Although all four high schools had similarly early school start times (between 7:10 A.M. and 7:30 A.M.), students' school-night sleep habits varied among the schools, multivariate $F(9, 6571) = 12.76$, $p < .001$, due to differences in rise times, $p < .001$. In particular, students who attended the school with the earliest school start time (7:10) reported earlier rise times than students at the other schools (School A: $M = 5:53$ versus Schools B, C, D: $Ms = 6:04$–$6:09$, $ps < .01$). Although school differences occurred in reported average total sleep times and bedtimes, these group differences did not meet effect size criterion. Weekend sleep also varied among schools, multivariate $F(9, 6327) = 4.74$, $p < .001$; however, univariate differences for total sleep time, bedtime, and rise time did not meet our effect size criterion. Additionally, small differences among the schools on weekend delay and weekend oversleep were not meaningful based on the effect size criterion. 25

Few sex differences were identified. Female students reported different school-night sleep habits than their male peers, multivariate $F(3, 2700) = 41.36$, $p < .001$, due to female students reporting waking up earlier than males: females, $M = 5:58$ versus males, $M = 6:10$, $F(1, 2702) = 100.81$, $p < .001$. Boys and girls did not differ on reported school-night bedtimes, nor total sleep times. Overall, female students had greater weekend delays and weekend oversleeps than the male students, multivariate $F(2, 2530) = 6.67$, $p < .001$; however, univariate differences did not meet the effect size criterion. Female and male high school students did not report significant differences in weekend total sleep times, bedtimes, or rise times. The overall sample distributions of sleep patterns are displayed in Figure 1. 26

TABLE 1 ● MEANS AND STANDARD DEVIATIONS FOR SCHOOL-NIGHT AND WEEKEND SLEEP VARIABLES BY AGE

Sleep/Wake Variable	13–14 Years (n = 336)	15 Years (n = 858)	16 Years (n = 919)	17–19 Years (n = 988)	F Value	Bonferroni
School-night TST	462 (67)	449 (66)	435 (68)	424 (66)	24.13***	14, 15 > 16 > 17
School-night bedtime	10:05 P.M. (49)	10:20 P.M. (55)	10:37 P.M. (58)	10:51 P.M. (58)	53.54***	14 < 15 < 16 < 17
School-night rise time	5:59 A.M. (24)	6:00 A.M. (25)	6:05 A.M. (29)	6:10 A.M. (31)	19.47***	14, 15 < 16 < 17
Weekend TST	567 (100)	564 (104)	549 (108)	518 (114)	32.53***	14, 15 > 16 > 17
Weekend bedtime	11:54 P.M. (94)	12:06 A.M. (83)	12:30 A.M. (82)	12:49 A.M. (80)	42.33***	14, 15 < 16 < 17
Weekend rise time	9:22 A.M. (85)	9:40 A.M. (104)	9:46 A.M. (107)	9:32 A.M. (107)	ns	...
Weekend oversleep	104 (102)	115 (112)	112 (116)	95 (114)	5.80***+	...
Weekend delay	89 (71)	88 (66)	92 (65)	95 (68)	ns	...

Note: TST refers to total sleep time (minutes). Weekend oversleep is the difference between weekend and school-night total sleep times, and weekend delay is the difference between weekend and school-night bedtimes. Standard deviations, in parentheses, are in minutes; TST, weekend oversleep, and weekend delay are in minutes as well.

** $p < .01$; *** $p < .001$; + does not meet effect size criterion (e.g., effects where two groups differ by more than one third of the sample standard deviation).

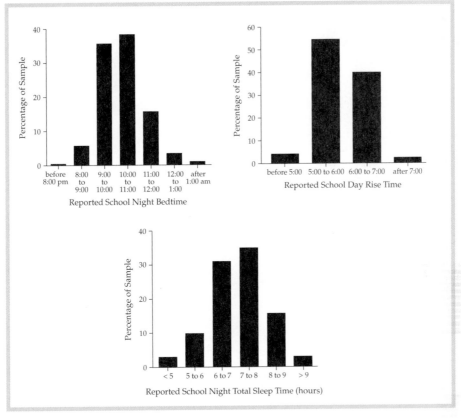

FIGURE 1 Sample Distributions of Sleep Patterns

Academic Performance and Sleep Habits

Table 2 presents the analyses of sleep habits based on self-reported academic per- 27
formance. In general, students with higher grades reported longer and more reg-
ular sleep, multivariate $F(9, 6571) = 8.91, p < .001$. Specifically, they reported more
total sleep, $p < .001$, and earlier bedtimes, $p < .001$, on school nights than did stu-
dents with lower grades. Post hoc analysis showed that these differences dis-
tinguished students reporting C's and worse from those reporting mostly B's or
better. Students' weekend sleep habits also differed according to self-reported
grades, multivariate $F(9, 6327) = 18.79, p < .001$. Specifically, A and B students
reported earlier bedtimes and earlier rise times than did C and D/F students, ps
$< .001$; however, self-reported grades did not distinguish the students on re-
ported weekend total sleep. Finally, students with worse grades reported greater
weekend delays of sleep schedule than did those with better grades, multivari-
ate $F(6, 5060) = 18.22, p < .001$. Thus, C and D/F students reported going to bed
on average about 2.3 hr later on weekends than on school nights versus a dif-
ference of about 1.8 hr for the A and B students, $ps < .001$. Students with D/F's

TABLE 2 • MEANS AND STANDARD DEVIATIONS FOR SCHOOL-NIGHT AND WEEKEND SLEEP VARIABLES BY GRADES

Sleep/Wake Variables	Self-Reported Grades				F Value	Bonferroni
	Mostly A's or A's/B's (n = 1,238)	Mostly B's or B's/C's (n = 1,371)	Mostly C's or C's/D's (n = 390)	Mostly D's/F's (n = 61)		
School-night TST	442	441	424	408	16.66***	A, B > C, D/F
	(62)	(66)	(74)	(94)		
School-night bedtime	10:27 P.M.	10:32 P.M.	10:52 P.M.	11:22 P.M.	24.58***	A, B < C, D/F
	(53)	(56)	(65)	(81)		
School-night rise time	6:02 A.M.	6:05 A.M.	6:10 A.M.	6:09 A.M.	ns	⋯
	(25)	(29)	(34)	(31)		
Weekend TST	547	547	534	549	ns	⋯
	(100)	(109)	(124)	(137)		
Weekend bedtime	12:06 A.M.	12:29 A.M.	1:09 A.M.	1:33 A.M.	51.32***	A < B < C, D/F
	(78)	(82)	(97)	(93)		
Weekend rise time	9:21 A.M.	9:43 a.m.	9:59 A.M.	10:33 A.M.	24.10***	A < B < C, D/F
	(97)	(103)	(113)	(160)		
Weekend oversleep	105	108	109	137	3.32*+	A, B, C < D/F
	(101)	(114)	(130)	(159)		
Weekend delay	99	117	137	133	26.53***	A < B < C, D/F
	(68)	(72)	(77)	(80)		

Note: TST refers to total sleep time (minutes). Weekend oversleep is the difference between weekend and school-night total sleep times, and weekend delay is the difference between weekend and school-night bedtimes. Standard deviations, in parentheses, are in minutes; TST, weekend oversleep, and weekend delay are in minutes as well.

$* p < .05$; $** p < .01$; $*** p < .001$; $+$ does not meet effect size criterion (e.g., effects where two groups differ by more than one third of the sample standard deviation).

reported longer weekend oversleeps than A, B, or C students; however, these differences did not meet the effect size criterion.

DAYTIME FUNCTIONING OF STUDENTS WHO ADOPT
ADEQUATE VERSUS *LESS THAN ADEQUATE* SLEEP HABITS

Data presented in the previous sections demonstrate that older high school stu- 28
dents sleep less and have later bedtimes than younger students, and those who
report a poor academic performance are more likely to sleep less, go to bed later,
and have more irregular sleep/wake habits. These descriptive findings, however,
do not explain whether especially short amounts of sleep and/or irregular
schedules are associated with changes in daytime functioning. To describe more
thoroughly the high school students who are obtaining minimal sleep and/or
who have irregular sleep schedules, we examined a priori defined groups based
on sleep variables that have been cited previously as having an impact on be-
havior, deriving our values from empirical data (Carskadon et al., 1980, 1983;
Carskadon, Keenan, & Dement, 1987). Other potentially important factors (e.g.,
history of sleep disorders) may covary with these, but data from our survey fo-
cused on total sleep and school-night versus weekend schedule changes.

The *extreme* groups of students were defined as follows: long (\geq 8 hr 15 min) 29
versus short (\leq 6 hr 45 min) school-night total sleep time; large (\geq 120 min) ver-
sus small (\leq 60 min) weekend delay; or high ($>$ 120 min) versus low ($<$ 60 min)
weekend oversleep. High school students who had longer total sleep times,
small weekend delays, or low weekend oversleeps were defined as having
adopted *adequate* sleep habits, whereas students with shorter sleep times, large
weekend delays or high weekend oversleeps were defined as having adopted *less
than adequate* sleep habits. We compared these *extreme* groups on daytime and
nighttime functioning. Table 3 displays means, standard deviations, and F val-
ues for depressive mood, sleepiness, and sleep/wake behavior problems for
each of the sleep variable groups. (The demographic breakdown of these groups
reflected the larger sample on age, sex, and school attendance.) Separate analy-
ses of variance were calculated for each dependent variable (depressive mood,
level of sleepiness, and sleep/wake behavior problems), with school-night total
sleep time, weekend delay, weekend oversleep, and sex as independent vari-
ables. Age was analyzed as a covariate in these analyses.

Overall, adolescents who were in the groups defined as *less than adequate* 30
sleep habits reported increased behavioral difficulties in comparison to those we
defined as *adequate sleepers*. Thus, students in the short total sleep group re-
ported more sleep/wake behavior problems, such as arrived late to class because
of oversleeping, tired or dragged out nearly every day, needed more than one
reminder to get up, $ps < .01$, higher levels of depressive mood, $ps < .001$, and
greater sleepiness, $ps < .001$, than those in the long sleep group. Similarly, ado-
lescents in the large weekend delay group described more sleep/wake behav-
ior problems, $ps < .01$, and greater daytime sleepiness, $ps < .05$, but no differ-
ence in depressed mood from those with small weekend delays. One exception
was that the female students with large weekend delays reported increased de-
pressive mood levels, $p < .05$. Adolescents in the high weekend oversleep group

TABLE 3 • MEANS, STANDARD DEVIATIONS, AND ANALYSIS OF VARIANCE FOR DAYTIME BEHAVIOR SCALES FOR ADEQUATE VERSUS LESS THAN ADEQUATE SLEEPERS

| Daytime Functioning Variables | Weekend Delay | | Weekend Oversleep | | School-Night TST | | F Values Sleep Variables | | | | | |
	≤60 (n = 887)	≥120 (n = 928)	<60 (n = 972)	>120 (n = 1,411)	≥495 (n = 959)	≤405 (n = 1,207)	Delay M	Delay F	Oversleep M	Oversleep F	TST M	TST F
Depressive mood	10.13	10.35	9.92	10.42	9.48	10.79	ns	3.89*	ns	ns	10.80***	12.94***
	(2.94)	(2.97)	(2.85)	(2.99)	(2.76)	(3.00)						
Sleepiness	14.63	15.29	14.76	15.23	14.03	15.86	4.37*	6.45**	ns	ns	19.79***	29.77***
	(3.71)	(3.98)	(3.82)	(3.81)	(3.51)	(4.01)						
Sleep/wake behavior problems	19.10	21.80	19.33	21.22	18.48	22.17	13.17***	47.20***	17.83***	7.93**	16.15***	28.70***
	(6.61)	(7.16)	(6.83)	(7.18)	(6.63)	(7.01)						

Note: Weekend delay small = ≤60 min, large = ≥120 min; weekend oversleep short = <60 min, long = >120 min; weekend oversleep short = <60 min, and school-night TST long = ≥8 hr 45 min, short = ≤6 hr 15 min. M = effect for males, F = effect for females.

*$p < .05$; ** $p < .01$; *** $p < .001$.

reported more sleep/wake behavior problems, $p <.001$, but no differences in depressed mood or sleepiness from those in the low oversleep group. No sex differences were found in self-reported sleep/wake behavior problems; however, females reported higher levels of depressed mood: females, $M = 11.04, SD = 2.91$ versus males, $M = 9.20, SD = 2.68, p < .001$, and daytime sleepiness: females, $M = 15.26, SD = 3.59$ versus males, $M = 14.67, SD = 4.16, p < .01$, than did males.

Discussion

The principal aim of this research was to assess the relation between adolescents' sleep/wake habits and their daytime functioning. The relatively high response rate (88%) obtained in this school-based study allows us to consider our findings representative of adolescents enrolled in moderate to large public high schools in this geographical region. The use of a self-report questionnaire enabled us to gather timely information from a large student population. 31

HIGH SCHOOL STUDENTS' SLEEP LOSS AND IRREGULAR
SLEEP/WAKE SCHEDULES

In particular, this sample of over 3,000 high school students reported lower total sleep (school and weekend nights) across ages 13–19. On school nights, the mean total sleep decreased from 7 hr 42 min to 7 hr 4 min. Similarly, average weekend total sleep decreased from 9 hr 20 min to 8 hr 38 min. The sleep loss is due to increasingly later bedtimes in older teens, whereas rise times remain more consistent. The sleep habits of the students attending the four different high schools showed minimal differences, with the exception of school day rise time, which was significantly earlier for students attending the school with the earliest start time. Although the difference between 7:10 and 7:30 may appear slight, the impact on sleep patterns was meaningful. 32

Remarkably few differences were found between male and female high school students' sleep/wake patterns. Female adolescents reported that they woke up 12 min earlier than their male peers on school mornings, a finding consistent with an earlier survey of high school students (Carskadon, 1990b) and a study of junior high school students in Taiwan (Gau & Soong, 1995). In the Gau et al. sample, however, the junior high school girls also reported less total sleep than the boys. We speculate that adolescent girls may be getting up earlier because they require more time to prepare for school and/or for family responsibilities. 33

Taken together, we conclude that most of these adolescents do not get enough sleep. Our laboratory data indicate that optimal sleep length is about 9.2 hr in adolescents (Carskadon et al., 1980). Although individual differences in sleep need are likely, we note that 87% of our sample responded that they need more sleep than they get (median self-reported sleep need = 9 hr). Forty percent of the students reported that they went to bed after 11:00 P.M. on school nights, and 91% went to bed after 11:00 P.M. (67% after midnight) on weekends. Furthermore, 26% reported that they usually sleep 6.5 hr or less, and only 15% reported sleeping 8.5 hr or more on school nights (median = 7.5 hr). Nearly 70% 34

of the students reported weekend delays of 60 min or more; on average, they reported oversleeping on weekends by nearly 1 hr and 50 min. Ninety-one percent of these high school students rise at 6:30 A.M. or earlier on school mornings, and 72% awaken at 9:00 A.M. or later on weekends.

35 These high school students' reported sleep/wake schedules are consistent with the major trends in the field: (1) self-reported nocturnal sleep time declines across the adolescent years; (2) bedtimes during high school become later; and (3) teenagers show large variations between weekend and school-night sleep schedules (e.g., Carskadon, 1990a; Strauch & Meier, 1988; Szymczak et al., 1993). In comparison to data from Rhode Island high school students surveyed 8 years earlier, these students reported on average approximately 15–20 min less sleep per night on school nights, principally reflecting earlier rising times (Carskadon, 1990a). The developmental and secular trends raise concerns about patterns that may have negative effects on teenagers' waking behavior.

36 Not assessed in this survey is the impact of family factors on sleep patterns. In the past, we have shown that parents tend to relinquish control of bedtime while increasing involvement with rising time as youngsters pass into adolescence (Carskadon, 1990a). In this particular sample, only 5.1% of students reported that parents set bedtimes on school nights; thus, the great majority of these youngsters set their own bedtime agenda. Over 80% of youngsters in this survey come from two-parent households in which both parents are employed, and we saw no differences between this cohort and those from single-parent homes on the major sleep variables. We propose that the biological and psychosocial processes favoring sleep delay in teens collide with early rising times mandated by schools and that even in the more well-regulated families the capacity for adequate adjustments may be limited.

Sleep/Wake Habits and School Performance

37 Our data support and extend findings from Kowalski and Allen (1995) and Link and Ancoli-Israel (1995) that students who described themselves as struggling or failing school (i.e., obtaining C's, D's/F's) report that they obtain less sleep, have later bedtimes, and have more irregular sleep/wake schedules than students who report better grades (i.e., A's, B's). In the Link and Ancoli-Israel survey of 150 high school students, students with self-reported higher grade point averages (GPA) slept more at night and reported less daytime sleepiness than students with lower GPAs. One explanation for these results is that students who get more sleep and maintain more consistent school/weekend sleep schedules obtain better grades because of their ability to be more alert and to pay greater attention in class and on homework. In contrast, Gau et al. (1995) found that younger students (junior high school age) on a highly competitive academic track reported shorter school and weekend night total sleep times, later bedtimes, and decreased daytime alertness than students in an alternative, less competitive program. Our data do not show a one-to-one relation between sleep patterns and grades. Certainly some students are able to function in school quite well with short amounts of sleep but may pay a price in other ways. Many students, how-

ever, may be too impaired by insufficient sleep to cope optimally with school demands. A major limitation of all of these studies is that they involve self-report; additional laboratory and field research are needed to clarify the direction of the relations among sleep loss, irregular sleep schedules, and academic performance and to assess other moderating and mediating variables, such as coping strategies, family rules, class schedules, and type of academic work.

ADDITIONAL CONSEQUENCES OF POOR SLEEP/WAKE HABITS

We have attempted to describe more thoroughly certain consequences of insuf- 38 ficient sleep and irregular sleep/wake schedules on adolescents' functioning by comparing extreme groups of students who reported patterns we defined as *adequate* versus *less than adequate* sleep/wake patterns. Students with short school-night sleep reported increased levels of depressed mood, daytime sleepiness, and problematic sleep behaviors in comparison to longer sleepers. Likewise, students with more irregular sleep schedules had more behavior problems. These data suggest that high school students with inadequate total sleep and/or irregular school-night to weekend sleep/wake schedules may struggle with daytime behavior problems. We interpret these findings to indicate that poor sleep habits influence behavior and mood, acknowledging that in certain youngsters the cause-effect arrow may go in the opposite direction.

Researchers are just beginning to compile evidence relating emotional well- 39 being to sleep patterns. Our findings showing that teenagers with very short and irregular sleep/wake patterns have more daytime difficulties support the work of Morrison, McGee, and Stanton (1992), who compared four groups of 13- and 15-year-olds in New Zealand: those with no sleep problems, those indicating they needed more sleep only, those reporting difficulties falling asleep or maintaining sleep, and those with multiple sleep problems. These investigators found that adolescents in the sleep-problem groups were more anxious, had higher levels of depression, and had lower social competence than those in the no-sleep-problem group. Similarly, Carskadon et al. (1991) found that a pattern of short sleep in college-bound high school seniors was associated with reports of sleepiness and sleep problems in males and females, and with anxiety and depression in females. Moreover, in a study calling for ninth to twelfth graders to reduce their habitual sleep by 2 hr over 5 consecutive nights, dysphoric mood changes occurred during the reduced sleep period on both daily and weekly depressive mood scales (Carskadon et al., 1989).

We hypothesize that if adolescents had the opportunity to obtain more sleep 40 each night, they would experience fewer fluctuations in daily mood and fewer behavioral difficulties. In essence, we propose that adolescent moodiness may be in part a repercussion of insufficient sleep. The tendency for some adolescents to have reduced nocturnal sleep times and irregular schedules may have consequences that extend beyond daytime sleepiness to feelings of depression. On the other hand, depressed adolescents may be more inclined toward insufficient sleep and irregular schedules (Dahl et al., 1996). Additional in-depth laboratory and field assessment studies to probe the interplay between context, sleep/wake

patterns, and daytime functioning of adolescents may enable us to tease apart some of these factors.

CAVEATS AND IMPLICATIONS

41 We are very concerned about the important information that we have obtained from this large sample of high school students; however, certain caveats pertain. First, it is difficult to evaluate how representative the sample was, although the congruence between our findings and those from prior research (e.g., Carskadon, 1990a; Strauch & Meier, 1988) strongly suggests that the sample was quite typical. Whether our results hold for adolescents drawn from a wider socioeconomic and cultural background is an important issue for future studies. Second, the results of this study are based entirely on the adolescents' self-reports and suffer limitations because data are retrospective, based only on the last 2 weeks, and subjective. Multiple sources of measurement such as parent and teacher ratings, school record data, standardized test batteries, and sleep laboratory recordings would provide a more comprehensive and possibly more reliable assessment than the current study. Our previous experience in laboratory studies indicates that such self-report data are well correlated with data obtained from daily sleep diaries or continuous activity monitoring, although we have not made a formal comparison. On the other hand, in a study of tenth grade students that included 2 weeks of diaries and activity monitoring followed by a laboratory assessment, we found an average sleep length on school nights of 6 hr, 53 min ($SD = 39$), very similar to self-report (Carskadon, Acebo, Wolfson, Tzischinsky, & Darley, 1997).

42 Third, because the survey was conducted in one geographic area, some caution should be taken in generalizing the findings. Fourth, because the study design was cross-sectional, no conclusions about long-term development and ramifications of inadequate sleep can be drawn. Future investigations should gather several weeks of sleep and behavioral data and consider following high school students over several years. Finally, because the data are cross-sectional it is difficult to demonstrate causal direction. Models that include parameters different than those included in the present study (e.g., home structure, parenting styles, school schedules, and so forth) could also account for variation in grades and/or sleep/wake schedules. Nevertheless, the present study extends the research on adolescent sleep in several ways: (1) to a large population of public high school students; (2) to a broader understanding of the association between sleep/wake habits, emotional well-being, and school performance in high school students from ages 13 to 19; and (3) to a clearer conceptualization of the risks for adolescents who obtain short amounts of sleep and/or experience erratic weekday-weekend sleep schedules on their daytime performance and mood.

43 Although self-report surveys have clear limitations, the implications of these data seem undeniable. First, schools need to take an active role and to examine sleep in the context of academic grades, test scores, truancy, behavioral difficulties, and other aspects of daytime functioning and adolescent development. Second, investigators in other fields who are concerned with adolescent development and well-being need to add the insights regarding adolescents' sleep into

their studies and clinical work. Third, researchers, practitioners, and educators need to take interdisciplinary approaches to understanding and promoting the academic, health, and behavioral well-being of adolescents.

Adolescents confront a multitude of vulnerabilities, uncertainties, and changes. This developmental period is extremely eventful in terms of physiological, cognitive, and psychosocial development. Undoubtedly, most adolescents require more than 7 hr, 20 min (sample mean) of sleep to cope optimally with academic demands, social pressures, driving, and job responsibilities. Although adolescents may be differentially affected by pubertal changes in sleep/wake patterns, school start times, and academic responsibilities, the excessive sleepiness consequent to insufficient, erratic sleep is a potentially serious factor for adolescent development and behavioral well-being. The magnitude of the problem has been unrecognized because adolescent sleepiness is so widespread that it almost seems normal (Carskadon, 1990a). Steinberg and Darling (1994), Petersen, Silbereisen, and Soerensen (1993) and others have emphasized the importance of studying the context of adolescent development. The development of adolescent sleeping patterns cannot be understood without taking into account school schedules and other contexts; likewise, adolescent development (psychosocial, cognitive, emotional) cannot be fully examined without considering sleep/wake factors.

Acknowledgments

This study was supported by funds from the National Institutes of Health, MH 45945. We thank Camille Brown, Catherine Darley, Francois Garand, Liza Kelly, Eric Kravitz, Christopher Monti, Orna Tzischinsky, and Beth Yoder for this assistance in gathering and coding data, and Christine Acebo and Ronald Seifer for their assistance regarding data analysis and interpretation of results. We would also like to thank the participating school districts in Rhode Island.

Addresses and Affiliations

Corresponding author: Amy R. Wolfson, College of the Holy Cross, Department of Psychology, Worcester, MA 01610; e-mail: AWolfson@Holycross.edu. Mary A. Carskadon is at Brown University School of Medicine.

References

Achenbach, T. (1991). *Manual for the youth self-report and 1991 profile*. Burlington: University of Vermont Department of Psychiatry.

Allen, R. (1991). School-week sleep lag: Sleep problems with earlier starting of senior high schools. *Sleep Research, 20*, 198.

Allen, R. (1992). Social factors associated with the amount of school week sleep lag for seniors in an early starting suburban high school. *Sleep Research, 21*, 114.

Allen, R., & Mirabile, J. (1989). Self-reported sleep-wake patterns for students during the school year from two different senior high schools. *Sleep Research, 18*, 132.

Andrade, M. M., Benedito-Silva, E. E., & Domenice, S. (1993). Sleep characteristics of adolescents: A longitudinal study. *Journal of Adolescent Health, 14,* 401–406.

Bearpark, H. M., & Michie, P. T. (1987). Prevalence of sleep/wake disturbances in Sydney adolescents. *Sleep Research, 16,* 304.

Brown, C., Tzischinsky, O., Wolfson, A., Acebo, C., Wicks, J., Darley, C., & Carskadon, M. A. (1995). Circadian phase preference and adjustment to the high school transition. *Sleep Research, 24,* 90.

Carskadon, M. A. (1982). The second decade. In C. Guilleminault (Ed.), *Sleeping and waking disorders: Indications and techniques.* Menlo Park, CA: Addison-Wesley.

Carskadon, M. A. (1990a). Patterns of sleep and sleepiness in adolescents. *Pediatrician, 17,* 5–12.

Carskadon, M. A. (1990b). Adolescent sleepiness: Increased risk in a high-risk population. *Alcohol, Drugs, and Driving, 5/6,* 317–328.

Carskadon, M. A. (1995). Sleep's place in teenagers' lives. *Proceedings of the Biennial Meeting of the Society for Research in Child Development,* p. 32 (abstract).

Carskadon, M. A., & Acebo, C. (1993). A self-administered rating scale for pubertal development. *Journal of Adolescent Health Care, 14,* 190–195.

Carskadon, M. A., Acebo, C., Richardson, G. S., Tate, B. A., & Seifer, R. (1997). Long nights protocol: Access to circadian parameters in adolescents. *Journal of Biological Rhythms, 12,* 278–289.

Carskadon, M. A., Acebo, C., Wolfson, A., Tzischinsky, O., & Darley, C. (1997). REM sleep on MSLTS in high school students is related to circadian phase. *Sleep Research, 26,* 705.

Carskadon, M. A., Dement, W. C., Mitler, M. M., Roth, T., Westbrook, P. R., & Keenan, S. (1986). Guidelines for the Multiple Sleep Latency Test (MSLT): A standard measure of sleepiness. *Sleep, 9,* 519–524.

Carskadon, M. A., Harvey, K., Duke, P., Anders, T. F., & Dement, W. C. (1980). Pubertal changes in daytime sleepiness. *Sleep, 2,* 453–460.

Carskadon, M. A., Keenan, S., & Dement, W. C. (1987). Nighttime sleep and daytime sleep tendency in preadolescents. In C. Guilleminault (Ed.), *Sleep and its disorders in children.* New York: Raven Press.

Carskadon, M. A., & Mancuso, J. (1988). Sleep habits in high school adolescents: Boarding versus day students. *Sleep Research, 17,* 74.

Carskadon, M. A., Orav, E. J., & Dement, W. C. (1983). Evolution of sleep and daytime sleepiness in adolescents. In C. Guilleminault & E. Lugaresi (Eds.), *Sleep/wake disorders: Natural history, epidemiology, and long-term evolution* (pp. 201–216). New York: Raven Press.

Carskadon, M. A., Rosekind, M. R., Galli, J., Sohn, J., Herman, K. B., & Davis, S. S. (1989). Adolescent sleepiness during sleep restriction in the natural environment. *Sleep Research, 18,* 115.

Carskadon, M. A., Seifer, R., & Acebo, C. (1991). Reliability of six scales in a sleep questionnaire for adolescents. *Sleep Research, 20,* 421.

Carskadon, M. A., Vieira, C., & Acebo, C. (1993). Association between puberty and delayed phase preference. *Sleep, 16,* 258–262.

Carskadon, M. A., Wolfson, A., Tzischinsky, O., & Acebo, C. (1995). Early school schedules modify adolescent sleepiness. *Sleep Research, 24,* 92.

Cohen, J. (1988). *Statistical power analysis for the behavioral sciences.* Hillsdale, NJ: Erlbaum.

Dahl, R. E., & Carskadon, M. A. (1995). Sleep and its disorders in adolescence. In R. Ferber & M. Kryger (Eds.), *Principles and practice of sleep medicine in the child.* Philadelphia: WB Saunders.

Dahl, R. E., Holttum, J., & Trubnick, L. (1994). A clinical picture of childhood and adolescent narcolepsy. *Journal of the American Academy of Child and Adolescent Psychiatry, 33,* 834–841.

Dahl, R. E., Ryan, N. D., Matty, M. K., Birmaher, B., Alshabbout, M., Williamson, D. E., & Kupfer, D. J. (1996). Sleep onset abnormalities in depressed adolescents. *Biological Psychiatry, 39,* 400–410.

Epstein, R., Chillag, N., & Lavie, P. (1995). Sleep habits of children and adolescents in Israel: The influence of starting time of school. *Sleep Research, 24a,* 432.

Fisher, B. E., & Rinehart, S. (1990). Stress, arousal, psychopathology and temperament: A multidimensional approach to sleep disturbance in children. *Personality and Individual Differences, 11,* 431–438.

Gau, S-F., & Soong, W-T. (1995). Sleep problems of junior high school students in Taipei. *Sleep, 18,* 667–673.

Guilleminault, C., Winkle, R., & Korobkin, R. (1982). Children and nocturnal snoring: Evaluation of the effects of sleep related respiratory resistive load and daytime functioning. *European Journal of Pediatrics, 139,* 165–171.

Hendry, L. B., Glendinning, A., Shucksmith, J., Love, J., & Scott, J. (1994). The developmental context of adolescent life-styles. In R. K. Silbereisen & T. Eberhard (Eds.), *Adolescence in context: The interplay of family, school, peers, and work in adjustment* (pp. 66–81). New York: Springer-Verlag.

Ishihara, K., Honma, Y., & Miyake, S. (1990). Investigation of the children's version of the morningness-eveningness questionnaire with primary and junior high school pupils in Japan. *Perceptual and Motor Skills, 71,* 1353–1354.

Kagan, J., Resnick, J. S., & Gibbons, J. (1989). Inhibited and uninhibited types of children. *Child Development, 60,* 838–845.

Kandel, D. B., & Davies, M. (1982). Epidemiology of depressive mood in adolescents. *Archives of General Psychiatry, 39,* 1205–1212.

Kataria, S., Swanson, M. S., & Trevathan, G. E. (1987). Persistence of sleep disturbances in preschool children. *Pediatrics, 110,* 642–646.

Kowalski, N., & Allen, R. (1995). School sleep lag is less but persists with a very late starting high school. *Sleep Research, 24,* 124.

Link, S. C., & Ancoli-Israel, S. (1995). Sleep and the teenager. *Sleep Research, 24a,* 184.

Manber, R., Pardee, R. E., Bootzin, R. R., Kuo, T., Rider, A. M., Rider, S. P., & Bergstrom, L. (1995). Changing sleep patterns in adolescence. *Sleep Research, 24,* 106.

Morrison, D. N., McGee, R., & Stanton, W. R. (1992). Sleep problems in adolescence. *Journal of the American Academy of Child and Adolescent Psychiatry, 31,* 94–99.

Peterson, A. C., Silbereisen, R. K., & Soerensen, S. (1993). Adolescent development: A global perspective. In W. Meeus, M. de Goede, W. Kox, & K. Hurrelmann (Eds.), *Adolescence, careers and cultures* (pp. 1–34). New York: De Gruyter.

Petta, D., Carskadon, M. A., & Dement, W. C. (1984). Sleep habits in children aged 7–13 years. *Sleep Research, 13,* 86.

Price, V. A., Coates, T. J., Thoresen, C. E., & Grinstead, O. A. (1978). Prevalence and correlates of poor sleep among adolescents. *American Journal of Diseases of Children, 132,* 583–586.

Quine, L. (1992). Severity of sleep problems in children with severe learning difficulties: Description and correlates. *Journal of Community and Applied Social Psychology, 2,* 247–268.

State of Rhode Island Department of Education. (1994). *Rhode Island Public Schools 1994 District Profiles.* Providence: Rhode Island Department of Elementary and Secondary Education.

Steinberg, L., & Darling, N. (1994). The broader context of social influence in adolescence. In R. K. Silbereisen & T. Eberhard (Eds.), *Adolescence in context: The interplay of family, school, peers, and work in adjustment* (pp. 25–45). New York: Springer-Verlag.

Strauch, I., & Meier, B. (1988). Sleep need in adolescents: A longitudinal approach. *Sleep, 11,* 378–386.

Szymczak, J. T., Jasinska, M., Pawlak, E., & Swierzykowska, M. (1993). Annual and weekly changes in the sleep-wake rhythm of school children. *Sleep, 16,* 433–435.

Tanner, J. M. (1962). *Growth in adolescence.* Oxford: Blackwell.

Williams, R., Karacan, I., & Hursch, C. (1974). *EEG of human sleep.* New York: Wiley & Sons.

Wolfson, A. R., Tzischinsky, O., Brown, C., Darley, C., Acebo, C., & Carskadon, M. (1995). Sleep, behavior, and stress at the transition to senior high school. *Sleep Research, 24,* 115.

● **THINKING CRITICALLY ABOUT "SLEEP SCHEDULES AND DAYTIME FUNCTIONING IN ADOLESCENTS"**
RESPONDING AS A READER

1. It is likely that this text is one of the first scholarly articles you will have worked with closely. What have you discovered about the process of reading difficult material? What have you learned about the way scholars must present evidence to support their research conclusions? Use your reading log to reflect on the experience. Consider which parts of the text—other than the statistical discussions!—were more and less difficult to follow. Why? What made those stretches of text difficult to follow? What aspect of the text was easier to follow than you expected? What will you carry from this reading experience to other challenging assignments?

2. Make as long a list as you can of the ways in which this article follows conventions that are markedly different from articles in a general interest magazine or newspaper. How did these conventions of scholarly writing assist your reading and understanding? Where did they make it difficult to understand the material?

3. Initially, it may seem that the content of this article is so governed by genre conventions specifying how certain sections and headings should look that there is no room for the authors to put a personal mark on it. Yet many people who read the article are struck by the researchers' con-

cern for adolescents who do not get enough sleep. Did this concern come across to you? Where and how amid all the technical details do they bring this issue alive? To put the question another way, what does the text tell us about why anyone should care about this research? Working alone or with your classmates, identify specific passages in the article that (a) connect with readers' everyday lives and (b) assert the significance of the subject matter.

RESPONDING AS A WRITER

1. The fourteen paragraphs in the introduction section of this article constitute what is known as a "review of the literature" (i.e., a review of relevant research). Their purpose is to explain how the study connects with previous research and why it was necessary. Try to explain in your own words, as if you were talking to a friend, why Wolfson and Carskadon undertook the study. What did they want to find out? Jot down your best recollection of their purpose, then go back and examine the main points in the introduction to find material you can use to flesh out your notes to create a 50- to 100-word summary of the literature review. Your purpose in this summary is to explain the researchers' purpose. Your summary, like the literature review itself, should answer two important questions: (a) What had previous research established? (b) What questions did those findings raise for these researchers to explore? As you work, try to pinpoint a place *before* paragraph 14 where the discussion of previous research begins to establish the need for the current study, the place where someone who has read the abstract is likely to think, "Aha, I see where this is going now." Write for nonexpert readers interested in the subject; avoid quotations, and omit the citations of other research. You might open with a phrase such as, "By undertaking the study, Wolfson and Carskadon sought to. . . ."

2. What do your examination of the introduction and your composition of the summary reveal to you about the basic structure of literature reviews? Using paragraphs 1 through 14 as a model, what guidance would you be able to give someone who has assembled all the pertinent articles for a literature review and needs some help getting started with writing it?

3. Perhaps the most daunting aspect of this article is the detailed presentation of statistical findings in Tables 1–3 and the bar graphs in Figure 1. The exercise that follows is designed to help you discover what sense you can make of all this—a difficult task for nonexperts.

 Detailed presentation of statistical findings is essential to the credibility of the study. But is detailed understanding of the statistics essential to your purposes as a reader? As we point out in the opening chapters of this book, dealing with difficult texts is part of effective rhetorical reading. How should you proceed? Avoid the statistics paragraphs? Try to understand every detail? Seek outside guidance (from experts or

reference works)? Or accept the technical details at face value and try to understand the key points based on them? The appropriate decision will vary according to your experience and purpose, of course. For this article, which you are reading in a book for writing students, we recommend the last option: accept the statistical findings as stated and focus on the points derived from them. We feel justified in recommending this because the article has been published in a reputable refereed journal; that means experts have already scrutinized the numbers. Like management executives who let technicians take care of technical matters, we who are not psychologists or statisticians should focus on the points most relevant to us. After all, even scientific researchers often rely on statisticians to help them with data analysis. (Notice that Wolfson and Carskadon acknowledge this kind of assistance at the end of the article.)

Let's turn to the key points that Wolfson and Carskadon derive from their analysis of the statistical data. We list below five generic questions that rhetorical readers can use when reading about data analysis in a field where they are not experts. Working with one or two partners, examine the text to find answers to these questions and write out your answers in everyday language.

a. What questions do the researchers use the data to answer?
b. In their discussion of findings, what answers do they emphasize as important?
c. What aspects of the data are highlighted by the graphical presentations (charts and tables)?
d. What problems, if any, do the authors acknowledge regarding their findings?
e. What are their recommendations for dealing with those problems in future studies?

As you look for answers to these questions, make maximum use of the text's genre conventions. For example, the purpose of a study is frequently articulated most clearly in the final paragraph of its literature review. More specific questions are implied in the headings that mark distinct sections under "Results." Try converting these headings into questions, then look for specific answers. You can check your conclusions by rereading the discussion section. Finally, examine the caveats and implications paragraphs to note the problems Wolfson and Carskadon acknowledge and their recommendations for future research. ●

PAUL IRGANG

When a Wet Vac Counts More Than a Ph.D.

Paul Irgang is a building maintenance technician at the University of Miami. This article appeared in the January 21, 2000, *Chronicle of Higher Education*, a weekly that calls itself "the No. 1 news source for college and university faculty members and administrators," and was reprinted by several building maintenance periodicals and posted on a number of Websites. He began college as a chemistry major, but after time out for work and military service in Vietnam, he ultimately graduated with an English degree. Writing is his hobby. He has published numerous articles in a wide range of periodicals, from *Sea Technology* to the *Miami Herald*. Irgang told Miami's on-line faculty-staff newsletter, "I like to use my writing to make a wrong into a right. I'm like Robin Hood with a pen."

● FOR YOUR READING LOG

1. This article was originally published across four columns, with the opening epigraph in its own column on the left. As an experiment to see how epigraphs can influence a reader's response to a text, try the following procedure. *Put your hand or a piece of paper over the italic section below,* read the essay's first two paragraphs, jot some notes about your response, and then go back to the epigraph and read the article straight through. How did the joke influence your perception of what Irgang has to say?

2. Whom do you know in the physical plant or facilities services department at your college or university? What's your sense of how this person feels about his or her job status in relation to faculty and students? ●

━━ ● ━━

Bringing up the rear of the circus parade were the elephants—eight majestic pachyderms with gleaming ivory tusks, enormous ears, and trunks swaying with each step. Fifty feet behind them was an old man carrying a shovel and pulling a yellow cart.

"Don't you ever get tired of scooping up elephant dung?" he was asked. "Why don't you pursue another line of work?"

He replied: "What, and leave show business?"

—Catskills "Borscht Belt" joke

1 At colleges and universities throughout the United States, physical-plant employees are often unappreciated and undervalued, the campus equivalent of Ralph Ellison's "invisible man."

2 Those of us who work in academe inhabit an unofficial, yet undeniable, caste system. Tenured Ph.D.'s constitute the Brahmin sect, followed by untenured faculty and staff members and research associates, librarians, secretaries, food-service personnel, and, finally, the untouchables: physical-plant employees.

3 If you can use a hammer and have a clean record—that is, no criminal convictions (arrests are OK, but no convictions)—you can get a job here at the University of Miami's department of facilities management (physical plant), where I have been employed as a "building-maintenance worker II" for the past nine years. (Note: If you are unable to use a hammer, you may still be eligible to become an administrator.)

4 Here at U.M., my colleagues and I are most appreciated whenever a hurricane with sustained winds of more than 150 m.p.h. approaches campus. It is usually during this "emergency-preparation phase" that our dean provides us with a free catered lunch and unlimited kudos. When the impending storm is within 100 miles of Biscayne Bay, and the institution is officially closed, we are suddenly given a new moniker—"essential personnel."

5 During these crisis situations the physical-plant team hunkers down, trying to save not only the buildings, but years' and millions of dollars' worth of experiments in progress. Tissue samples must remain chilled by emergency generators. Irreplaceable 10,000-year-old ice-core samples must not be allowed to thaw. Rare specimens of coral must be protected. Computers must be wrapped in plastic, and kept dry and out of harm's way.

6 When the wind speed picks up, proficiency with a power saw becomes a real asset. We board up windows. We man the pumps. We secure all objects that have the potential to become destructive or deadly missiles during the maelstrom.

7 Suddenly, the storm, influenced by a high-pressure system just offshore, takes a sharp turn to the north. The university has dodged the bullet once again; the danger has passed.

8 Within minutes the phone rings at the physical-plant department. It's one of our associate deans: "Listen, I've been trying to get a light bulb replaced for almost a week. How many of you guys does it take to screw in one of those things?"

9 It is my sincere hope that all those involved in higher education begin to understand that the successful operation of a university campus demands a team effort and that there are times when a man with a wet vac is as valuable as any Ph.D. in theoretical physics.

10 Without the assistance of physical-plant employees, for how long would the University of Notre Dame's golden dome remain golden? How long before Stanford's or Cornell's manicured lawns begin to resemble the brush and bramble of some suburban bank in foreclosure? How long before all campuses decline and decay into windblown shells, 20th-century Parthenons that only hint at the glory that once was?

11 So, whether you're a professor or a student, an administrator or a secretary, please treat all physical-plant employees with the dignity and respect they deserve. And remember, we have keys to everything.

• THINKING CRITICALLY ABOUT "WHEN A WET VAC COUNTS MORE THAN A PH.D."

RESPONDING AS A READER

1. Where in Irgang's essay did you find yourself most engaged, and where did you find yourself resisting? Try to account for these responses by pinpointing specific words and phrasings.

2. Irgang's first sentence asserts a point likely to cause discomfort for his audience of *Chronicle* readers—academic administrators and faculty. Yet he needs them to keep reading. How does he balance his intention of bringing negative ideas to readers' attention against his need to stave off any potential resistance to his ideas?

3. On what basis does Irgang assert authority regarding his subject matter? Taking the fact that he works as a "building-maintenance worker II" as just a beginning point, identify the other sources of credibility he establishes. How much of his effectiveness in the essay depends on *what* he says, and how much is a function of *how* he says it? In other words, to what extent can we say that his credibility stems from his rhetorical skill as well as his experience? Refer to specific places in the text to support your answers.

RESPONDING AS A WRITER

1. A common maxim for good writing is "show, don't tell," a phrase that asserts the value of using vivid detail to bring an idea to life. Where, specifically, do you see Irgang following this maxim? How do details help him make his points? Pick one detail that had more impact on you than others and compare responses with your classmates.

2. Details alone cannot make an essay work. The language that a writer chooses to express them is also crucial. On your own or with a partner, go through the essay to highlight word choices that strike you as particularly original or even unexpected. How do they add to Irgang's overall effectiveness? To what extent do you see him choosing language that is likely to appeal to his academic audience?

3. Irgang's essay challenges what he calls the "unofficial, yet undeniable caste system" inhabited by university employees (a group that includes dishwashers as well as deans, remember). What values underlie his effort to change readers' understanding of how these employees do and should interact? According to his implicit assertions here, what makes work valuable? After freewriting for a few minutes in response to these questions, reread the essay to note both implicit and explicit references to values. As you reflect further, through writing or discussion, try to articulate any changes in your thinking that Irgang's essay has brought about. •

NANCY MAIRS

Body in Trouble

Nancy Mairs (b. 1943) is widely acclaimed for her autobiographical essays about her struggles with disabilities, including depression, agoraphobia, and multiple sclerosis, to which she has lost the use of her arms and legs. Her essay entitled, "On Being a Cripple," published in her book *Plaintext* (1986), first brought her to national attention. The essays collected in her five additional books characteristically confront readers with blunt language that asserts feminist values, explores difficult relationships, and depicts the difficulties presented by her disease. She once told a biographer, "In my writing I aim to speak the 'unspeakable.'" This essay comes from *Waisthigh in the World: A Life Among the Nondisabled*, published in 1996. Her most recent book is *A Troubled Guest: Life and Death Stories* (2002).

• FOR YOUR READING LOG

1. This essay is both intensely personal and conceptually abstract. As you read, "listen" to it carefully, highlighting key passages, marking points you don't understand, and jotting down questions as they occur to you. When you have the opportunity to compare the places you and your classmates found difficult, see how you can help each other deepen your understanding and then determine what patterns of difficulty remain.
2. As soon as you finish reading, freewrite in your log about your positive and negative responses to this text. Where does Mairs capture your belief most powerfully? Where do you find yourself resisting or doubting her assertions, perhaps wishing she would state things in a less forceful manner? Freewrite for 3 to 5 minutes from each perspective. •

———— • ————

1 In biblical times, physical and mental disorders were thought to signify possession by demons. In fact, Jesus's proficiency at casting these out accounted for much of his popularity among the common folk (though probably not among swine). People who were stooped or blind or subject to seizures were clearly not okay as they were but required fixing, and divine intervention was the only remedy powerful enough to cleanse them of their baleful residents.

2 Theologically as well as medically, this interpretation of the body in trouble now seems primitive, and yet we perpetuate the association underlying it. A brief examination of "dead" metaphors (those which have been so thoroughly integrated into language that we generally overlook their analogical origins) demonstrates the extent to which physical vigor equates with positive moral qualities. "Keep your chin up," we say (signifying courage), "and your eyes open" (alert-

ness); "stand on your own two feet" (independence) "and tall" (pride); "look straight in the eye" (honesty) or "see eye to eye" (accord); "run rings around" (superiority). By contrast, physical debility connotes vice, as in "sit on your ass" (laziness), "take it lying down" (weakness), "listen with half an ear" (inattention), and get left "without a leg to stand on" (unsound argument). The way in which the body occupies space and the quality of the space it occupies correlate with the condition of the soul: it is better to be admired as "high-minded" than "looked down on" for one's "low morals," to be "in the know" than "out of it," to be "up front" than "back-handed," to be "free as a bird" than "confined to a wheelchair."

Now, the truth is that, unless you are squatting or six years old, I can never 3
look you straight in the eye, and I spend all my time sitting on my ass except when I'm taking it lying down. These are the realities of life in a wheelchair (though in view of the alternatives—bed, chair, or floor—"confinement" is the very opposite of my condition). And the fact that the soundness of the body so often serves as a metaphor for its moral health, its deterioration thus implying moral degeneracy, puts me and my kind in a quandary. How can I possibly be "good"? Let's face it, wicked witches are not just ugly (as sin); they're also bent and misshapen (crooked). I am bent and misshapen, therefore ugly, therefore wicked. And I have no way to atone.

It is a bind many women, not just the ones with disabilities, have historically 4
found themselves in by virtue of their incarnation in a sociolinguistic system over which they have had relatively little power. (Notice how virile the virtues encoded in the examples above.) Female bodies, even handsome and wholesome ones, have tended to give moralists fits of one sort or another (lust, disgust, but seldom trust). As everyone who has read the *Malleus Maleficarum* knows, "All witchcraft comes from carnal Lust which is in Women insatiable." If a good man is hard to find, a good woman is harder, unless she's (1) prepubescent, (2), senile, or (3) dead; and even then, some will have their doubts about her. It is tricky enough, then, trying to be a good woman at all, but a crippled woman experiences a kind of double jeopardy. How can she construct a world that will accommodate her realities, including her experience of her own goodness, while it remains comprehensible to those whose world-views are founded on premises alien or even inimical to her sense of self?

Disability is at once a metaphorical and a material state, evocative of other 5
conditions in time and space—childhood and imprisonment come to mind—yet "like" nothing but itself. I can't live it or write about it except by conflating the figurative and the substantial, the "as if" with the relentlessly "what is." Let me illustrate with an experience from a couple of years ago, when George and I went to a luncheon honoring the Dalai Lama, held at a large resort northwest of Tucson. Although we were not enrolled in the five-day workshop he had come here to lead, we found ourselves in the hallway when the meeting room disgorged the workshop participants—all fourteen hundred of them—into a narrow area further constricted by tables laden with bells, beads, and brochures. And let me tell you, no matter how persuaded they were of the beauty and sacredness of all life, not one of them seemed to think that any life was going on below the level

of her or his own gaze. "Down here!" I kept whimpering at the hips and buttocks and bellies pressing my wheelchair on all sides. "Down here! There's a person down here!" My only recourse was to roll to one side and hug a wall.

6 Postmodern criticism, feminist and otherwise, makes a good deal of the concept of wall-hugging, or marginality, which is meant to suggest that some segment of the population—black, brown, yellow, or red, poor, female, lesbian, what have you—is shouldered to the side, heedlessly or not, by some perhaps more numerous and certainly more powerful segment, most frequently wealthy, well-educated Euro-American males. Regardless of the way marginality is conceived, it is never taken to mean that those on the margin occupy a physical space literally outside the field of vision of those in the center, so that the latter trip unawares and fall into the laps of those they have banished from consciousness unless these scoot safely out of the way. "Marginality" thus means something altogether different to me from what it means to social theorists. It is no metaphor for the power relations between one group of human beings and another but a literal description of where I stand (figuratively speaking): over here, on the edge, out of bounds, beneath your notice. I embody the metaphors. Only whether or not I like doing so is immaterial.

7 It may be this radical materiality of my circumstances, together with the sense I mentioned earlier that defect and deformity bar me from the ranks of "good" women, which have spurred me in the past, as they no doubt will go on doing, to put the body at the center of all my meditations, my "corpus," if you will. Not that I always write *about* the body, though I often do, but that I always write, consciously, *as* a body. (This quality more than any other, I think, exiles my work from conventional academic discourse. The guys may be writing with the pen/penis, but they pretend at all times to keep it in their pants.) And it is this—my—crippled female body that my work struggles to redeem through that most figurative of human tools: language. Because language substitutes a no-thing for a thing, whereas a body is pure thing through and through, this task must fail. But inevitable disappointment does not deprive labor of its authenticity.

8 And so I use inscription to insert my embodied self into a world with which, over time, I have less and less in common. Part of my effort entails reshaping both that self and that world in order to reconcile the two. We bear certain responsibilities toward each other, the world and I, and I must neither remove myself from it nor permit it to exclude me if we are to carry these out. I can't become a "hopeless cripple" without risking moral paralysis; nor can the world, except to its own diminishment, refuse my moral participation.

9 But is a woman for whom any action at all is nearly impossible capable of right action, or am I just being morally cocky here? After all, if I claim to be a good woman, I leave myself open to the question: Good for what? The most straightforward answer is the most tempting: Good for nothing. I mean really. I can stand with assistance but I can't take a step; I can't even spread my own legs for sex anymore. My left arm doesn't work at all, and my right one grows weaker almost by the day. I am having more and more trouble raising a fork or a cup to my lips. (It is possible, I've discovered, though decidedly odd, to drink even coffee and beer through a straw.) I can no longer drive. I lack the stamina to go out

to work. If I live to see them, I will never hold my own grandchildren. These incapacities constitute a stigma that, according to social scientist Erving Goffman, removes me from normal life into a "discredited" position in relation to society.

From the point of view of the Catholic Church, to which I belong, however, mine must be just about the ideal state: too helpless even for the sins other flesh is heir to. After all, parties aren't much fun now that I meet the other revelers eye to navel, and getting drunk is risky since I can hardly see straight cold sober. No matter how insatiable my carnal Lust, nobody's likely to succumb to my charms and sully my reputation. But I am, by sympathy at least, a Catholic *Worker,* part of a community that wastes precious little time fretting about the seven deadlies, assuming instead that the moral core of being in the world lies in the care of others, in *doing* rather than *being* good. How can a woman identify herself as a Catholic Worker if she can't even cut up carrots for the soup or ladle it out for the hungry people queued up outside the kitchen door? Physical incapacity certainly appears to rob such a woman of moral efficacy.

Well, maybe moral demands should no longer be placed on her. Perhaps she ought simply to be "excused" from the moral life on the most generous of grounds: that she suffers enough already, that she has plenty to do just to take care of herself. This dismissive attitude tends to be reinforced when the woman lives at the height of your waist. Because she "stands" no higher than a six-year-old, you may unconsciously ascribe to her the moral development of a child (which, in view of Robert Coles's findings, you will probably underestimate) and demand little of her beyond obedience and enough self-restraint so that she doesn't filch candy bars at the checkout counter while you're busy writing a check. (God, I can't tell you how tempting those brightly wrapped chunks are when they're smack up against your nose.) "Stature" is an intrinsic attribute of moral life, and the woman who lacks the one may be judged incapable of the other.

I am exaggerating here, of course, but only a little. Beyond cheerfulness and patience, people don't generally expect much of a cripple's character. And certainly they presume that care, which I have placed at the heart of moral experience, flows in one direction, "downward": as from adult to child, so from well to ill, from whole to maimed. This condescension contributes to what Goffman calls "spoiled identity," though he does not deal satisfactorily with the damage it inflicts: without reciprocity, the foundation of any mature moral relationship, the person with a defect cannot grow "up" and move "out" into the world but remains constricted in ways that make being "confined to a wheelchair" look trivial. And so I would say that while it is all right to excuse me from making the soup (for the sake of the soup, probably more than "all right"), you must never—even with the best intentions, even with my own complicity—either enable or require me to withdraw from moral life altogether.

So much for carrot-cutting, then, or any other act involving sharp instruments. But wait! One sharp instrument is left me: my tongue. (Here's where metaphor comes in handy.) And my computer keyboard is . . . just waist high. With these I ought to be able to concoct another order of soup altogether (in which I'll no doubt find myself up to my ears). In other words, what I can still *do*—so far—is write books. Catholic Workers being extraordinarily tolerant of

multiplicity, on the theory that it takes all kinds of parts to form a body, this activity will probably be counted good enough.

14 The world to which I am a material witness is a difficult one to love. But I am not alone in it now; and as the population ages, more and more people—a significant majority of them women—may join me in it, learning to negotiate a chill and rubble-strewn landscape with impaired eyesight and hearing and mobility, searching out some kind of home there. Maps render foreign territory, however dark and wide, fathomable. I mean to make a map. My infinitely harder task, then, is to conceptualize not merely a habitable body but a habitable world: a world that wants me in it.

● THINKING CRITICALLY ABOUT "BODY IN TROUBLE"
RESPONDING AS A READER

1. How do you respond to the way Mairs presents herself in this essay? Do you find her self-portrayal credible? More specifically, do you imagine her as friendly or hostile? Does she come across as warm or cold? Strong or pathetic? To what aspects of her personality—as she conveys it here—do you respond most positively? Most negatively? If you were to spend a few hours with her, perhaps over dinner, what do you think would be the easiest and most difficult subjects to talk about?

2. Mairs discusses figurative language and uses it extensively as well. Working with a partner or group, make a list of the five or six nonliteral images here that you consider to be most important to the essay (go beyond those in her list of "dead" metaphors in the second paragraph). What emotional power do these images convey? What values are inherent in her choice of metaphor—for example, "childhood" and "imprisonment" for disability in paragraph 5?

3. What do you understand as Mairs's primary purpose in writing and publishing this essay? What is it that she most wants her readers to understand? To accept? To change?

RESPONDING AS A WRITER

1. The questions above ask you to tap into your responses as a reader. Now, to analyze from a writerly perspective how this essay works to accomplish its purposes, try taking it down to its bones. Use lists, mapping techniques, or whatever works best for you to answer the questions listed below. In the process, try to get outside the linear perspective of your moment-to-moment reading. Instead, zero in on what you take to be Mairs's core points and examine the web of connections she establishes among them and between you and them. Specifically:
 a. What is it that Mairs is seeking to explain?
 b. How is she doing it? (for example, through the use of anecdote, division into parts, analogy, reasoning, narrative, examples, etc.)

c. How do her techniques for conveying her ethos and engaging readers' emotions assist with her explanatory project?

2. As a way of summing up your reading and analysis of this essay, try your hand at a four-sentence rhetorical précis that follows the model presented in Chapter 3. Follow precisely the form described there. The first sentence should state Mairs's primary point, the second should explain how she develops it, the third should indicate her purpose, and the fourth should describe her rhetorical strategies in relation to her readers. Adopt an academic, explanatory tone for an audience of readers who need a quick sense of what the essay is about and how it works.

3. In the end, how has "Body in Trouble" affected your thinking? In your reading log or as your teacher directs, compose a brief response that lays out any insights you've gained, new ways of thinking prompted by the essay, or questions that it has raised. •

THOMAS ROEPSCH (STUDENT)

America's Love Affair with Pizza: A Guilty Pleasure No More

When Thomas Roepsch (b. 1971) wrote this essay for an expository writing class at Marquette University, he was attending school part-time while working as owner/manager of an Italian restaurant. After selling his interest in the restaurant, he completed a B.S. in accounting and enrolled in law school. He wrote this paper in response to an assignment that asked students to use outside research to counter a commonly held view of something that interested them, and specifically, to write a "good news" paper—that is, that he attempt to change readers' views about his topic from negative or skeptical to positive or at least accepting.

• FOR YOUR READING LOG

1. Given Roepsch's writing assignment, what does his title lead you to predict about what his paper will say?

2. This text is similar to papers you might respond to in a peer writing group. Try to engage with it the way you would when you work with your peers, whether your customary practice is to listen to papers read aloud or to examine drafts. Read it once fairly quickly and jot down some first impressions. Then read it a second time very carefully, noting specifically the places that you think work well, places that could be

improved, and places where you have questions. Jot a few notes about these in your reading log, too, so that you can remember your original impressions for class discussion. •

———— • ————

1 The average American eats 46 slices, or 23 pounds, of pizza each year (Marston 28). Despite this popularity, pizza is commonly considered one of the poorest choices you can make when it comes to your health. Every pizza lover knows the guilt associated with devouring a greasy pizza straight out of the box, and health experts have been warning us for years that we would be much better off if we made every effort to avoid foods high in fat and cholesterol like pizza. New information, however, is changing the way nutritionists view pizza. According to a number of popular health magazines, experts have reexamined the pizza and are now finding it to be potentially an excellent way to get a fast, well-balanced meal from a single food item. And even more surprising, pizza is now being credited with the ability to save your life.

2 The most popular pizzas in America are topped with pork sausage, pepperoni, and layers of extra cheese, making them very high in cholesterol and fat. According to an article in *Current Health*, the National Association of Pizza Operators reported that we ate 371 million pounds of pepperoni and 2.2 billion pounds of mozzarella on our pizzas last year (Denny 16). Meat and cheese are the clear favorites when it comes to pizza. The beauty of pizza, however, is that it can be topped with almost anything. Choosing the right toppings is the secret to making pizza "health" food. Limiting the amount of cheese and meat is the key. Top pizzas with more vegetables and go easy on the pepperoni and cheese, and you will have provided yourself with a well-balanced meal.

3 Pizza makes a square meal because, unlike any other single food item, pizza can satisfy all five of the United States Department of Agriculture's food groups (Post 76). The crust is a very good source of complex carbohydrates, and a single slice of cheese pizza can provide a body with one fourth of its daily requirement of calcium (Denny 17). The wide variety of meat, poultry, and seafood toppings available today all provide a good source of protein. Also, if you add on the vegetables, you gain vitamins and minerals. Finally, and perhaps most importantly, don't forget to add extra sauce when ordering a healthy pizza.

4 The tomato sauce used in pizza is now being credited with helping to save lives. Tomatoes contain lycopene (Seppa). This protein, in addition to giving the tomato its color, is an antioxidant that is unlocked when tomatoes are cooked into red sauces. The mutating elements of the cells in our body's tissues depend on oxygen, and antioxidants like beta-carotene and lycopene limit the ability of cells to mutate. Tomato sauces like those in pizza and pasta contain high levels of lycopene and are credited with helping to prevent cells from mutating. In turn, certain types of cancers are prevented. In a clinical study, researchers at Harvard Medical School found significantly lower rates of prostate cancer among men

who ate pizza or other foods with tomato sauce at least twice a week (Seppa). The study said that men who never ate tomato sauce were 21 to 34 percent more at risk to develop prostate cancers.

Women are also able to benefit from the lycopene found in pizza sauce. 5 Wendy Marston, writing for *Health* magazine, reports that another study was able to show a reduced risk of breast cancer in women who were eating foods with tomato sauce on a regular basis (28). Researchers measured the levels of lycopene in the breast tissue of women and found that those who had high concentrations of the compound were less likely to have breast cancer. Another recent *Health* article reports that a research team in Italy found that men and women who ate at least seven servings of tomatoes a week were less likely to have cancers of the stomach, colon, and rectum than individuals who only consumed two servings a week ("How to Slice").

It appears that the benefits of lycopene do not stop at combating cancer. The 6 compound has also been found to help prevent heart disease. A European study of 1,300 men found that men with high concentrations of lycopene in the fat tissue of their bodies were half as likely to have a heart attack as men with low levels of lycopene (Marston 29).

Nutritionists warn, however, that this ability of lycopene is meaningless if 7 you still want to top your pizza with a lot of high-fat toppings. One study by Harvard University suggested, however, that the presence of fat is necessary for the absorption of lycopene by the body. Foods that contain the types of fats found in olive oil and mozzarella actually improve the body's ability to absorb lycopene. They found that the levels of lycopene are two and a half times higher in people who eat pizza rather than salad (Marston 29).

Pizza today is made with a limitless variety of toppings and ingredients. 8 Spinach, artichokes, turkey, seafood, as well as other healthful and exotic choices are growing in popularity as pizza places try to satisfy changing tastes. You can order your pizzas any way you like, but it is important to remember that there are good pizzas and bad pizzas when it comes to your health. More vegetables and sauce but less meat and cheese are the key to a healthy pizza. In our fast-paced society, pizza is an ideal food—a quick, readily available food that you can eat with your fingers. But unlike other foods of this type, pizza can also be a square meal and a healthy choice.

Works Cited

Denny, Sharon. "Heap Health on Pizza." *Current Health 2* Feb. 1999: 16-18. *ProQuest*. Memorial Lib., Marquette U. 23 Feb. 2000 <http://proquest.umi.com>.

"How to Slice Your Cancer Risk." *Health* May 1999: 20.

Marston, Wendy. "Why Pizza's Better Than Ever." *Health* Jan.–Feb. 1998: 28-29.

Post, Robyn. "Pizza Can Save Your Life." *Men's Health* May 1997: 76+. *ProQuest*. Memorial Lib., Marquette U. 23 Feb. 2000 <http://proquest.umi.com>.

Seppa, Nathan. "Tomato Compound Fights Cancer." *Science News* 24 Apr. 1999: 271.

● **THINKING CRITICALLY ABOUT "AMERICA'S LOVE AFFAIR WITH PIZZA"**

RESPONDING AS A READER

1. In the opening paragraph, as Roepsch lays out his subject and the points he will make about it, what role does he assume in relation to his readers and in relation to his subject matter? What role does his approach give you, the reader, to play in relation to the text?

2. What does the text reveal about Roepsch's assumptions concerning his readers' knowledge and values? Is his presentation of the information appropriate for your knowledge level? How, specifically, does he work to accommodate possible differences in readers' information background?

3. What is the source of Roepsch's authority here? Is his use of his sources sufficiently convincing? What else might he have done? If his news were less welcome, or harder to believe—if he were writing, for example, to inform us that chocolate is a health hazard—what would he have to do to make himself believable? (Don't worry, chocolate isn't dangerous as far as we know. Some studies even suggest that it is valuable as an antioxidant.)

RESPONDING AS A WRITER

1. What aspects of this paper do you find particularly effective? How might you apply his approach to your own writing?

2. What questions does the paper raise for you? Are they sufficiently answered? If not, what do you think Roepsch could have done to answer or forestall such questions?

3. The second reading log question asked you to jot down notes about this paper as if you were reading it for a peer review group. As you look over your notes, what points might you raise about his style in the paper? How effective are his word choices? Where might he consider some changes? How about the structure of the sentences themselves? Does the reader move smoothly from one to another? Are there spots where the structure gets tedious or difficult to follow? Again, what advice would you give Roepsch for possible revision? (This is a pretty good paper, but you can undoubtedly find ways that it could be better still. As you consider your response, realize that few writers asking for feedback find it helpful to hear, "Everything's fine.") ●

C. J. HRIBAL

Consent (Fiction)

A Wisconsin native, C. J. Hribal (b. 1956) won the Associated Writing Programs 1999 short fiction award for *The Clouds in Memphis* (2000), in which this story appears. He is a professor at Marquette University in Milwaukee, Wisconsin, and frequently teaches in the graduate writing program at Warren Wilson College in Asheville, North Carolina. Hribal's other books of fiction include the collection *Matty's Heart* (1984) and the novel *American Beauty* (1987). Another novel, *The Company Car*, is scheduled to be published in 2005, and Hribal discusses his writing in the collection *The Story Behind the Story* (2004). "Consent" was first published in 1995 by the literary quarterly *Witness* in a special issue on rural America.

● **FOR YOUR READING LOG**

1. This story presents differing explanations of a painful event. As a way of keeping track of your engagement with the story the narrator presents, stop at several points during your reading to predict what will happen next. We suggest stopping after paragraphs 3, 12, 21, and 40. At each of these points, freewrite for three or four minutes about how the story is unfolding and what you expect next. Note the textual details on which you base your predictions.
2. Immediately after you finish reading the story, write down your responses to it. Freewrite about your emotional reaction and any questions you have about the events and people portrayed. To give yourself a good basis for discussion and further writing, spend at least five minutes writing and reflecting while the story is fresh in your mind. ●

━━━ ● ━━━

Porter Atwood's Chevy Blazer screeches to a halt behind Clayton Jones's police 1 cruiser and a county ambulance. He hears somebody say the county sheriff is on his way. The cars are lined up one two three on Atwood Lane, one of six serpentine roads in Atwood Acres that bear his or his family's name. Porter wipes his face with his handkerchief and makes a mental note to have Leo Puhl at the dealership check his brakes. They might be due. Porter doesn't want to hear any screeches or squeaks when he brakes, just the shower of stones and the slurred crush of gravel. A cloud of gravel dust drifts off behind him, mingling with the white haze of a clean and hot blue day.

He mops his face again, then puts the handkerchief in his pocket. He's here 2 in Atwood Acres because on this very day it has become a real and true subdivision, a place distinct from the fields it used to be. There are enough of these new

people to make it so. They've achieved a kind of critical mass, outnumbering the farmers and the townies, and what they call things is what things will come to be called. And nobody's going to call it Matty Keillor's anymore, or you-know-that-subdivision-Porter-cobbled-together-from-Matty's-eighty-and-the-Brudecki's-and-the-old-Schniederbaum-place. From now on it's going to be called by its proper, true and real name.

3 Atwood Acres has had its first drowning.

4 Porter mops his face again quickly. He's florid. All his weight seems to be going to the balls of his feet and his cheeks. He used to be tight-bodied. The woman he used to sleep with before he was married to his wife, Deniece, used to lick ice cream off his washboard stomach with her tongue. But now Porter is awash in excess flesh, and grease oozes out of him every time the mercury climbs above sixty. The machine of his body labors, tries to keep up with the demands made by the loose folds of flesh on his belly, the dewlaps on his throat, the soft ripplings of fat that dip down his rib cage as though he were melting. He has become the ice-cream cone itself. He thinks of that woman again, the woman who liked him before Deniece. He recalls the bright pink blob of her tongue making its way up and down his belly hair, but for the life of him he can't remember her name.

5 Straightening his string tie as he heads toward the knot of people gathered behind the Surhoff place (dentist from Neenah, upset that the two-and-a-half acre lots on Atwood Cove were already taken), Porter hopes it happened in a pool. Personally he finds pools an abomination. Deniece forced him to install one for their kids, but both the girls go skinny-dipping with their boyfriends in the quarry, same as everybody else. It's the one thing about Augsbury he wouldn't change: the quarry.

6 That pool went in what? three years ago? It's amazing how much he's let himself go since then. He would almost be embarrassed about the weight gain except that it seems like an outward sign of his success. Girth equals greatness. Though not so great that he can throw his weight around in his own home. Deniece makes him swim in the pool, has at first curtailed and then forbidden Porter's quarry visits. She knows, she says, what goes on down there. Porter mops his face again and thinks, Pools. Medallions of stupidity.

7 He goes over to the knot of people around the Surhoff's above ground pool, but it turns out these are the squeamish onlookers, moms with kids who've corralled their youngsters and won't let them get any closer. The more serious gathering of the morbidly curious is by the ravine. Clayton Jones is there, as are the paramedics with their gurney and lockboxes.

8 When this was fields that ravine was a bit of a problem. Cows grazed right to the edge and the spring run-off carved deep crumbling erosion channels in its scoured, plum-colored banks. When he first bought this field he let it sit a few years before he had it lotted. He needed that ravine as a selling point. A creek, good drainage—that field needed time to restore itself. The erosion cuts needed time to heal themselves, the crumbling banks time to acquire some cattails, the scrub trees along the banks time to look less like Halloween scarecrows—that haunted, lonely look people like in landscape paintings but not in their own

backyard. Never mind that their lawnmowers would eat things right down to the nubbins again and the erosion would start all over. What he needed was picturesque weeds.

He got them, and the lots sold nicely. Better than he hoped, really. Feeling 9 pleased, Porter has to remind himself to wipe the smile off his face when he clamps a solicitous hand on Clayton Jones's shoulder and asks, "What's happened here, Clay?"

Jones indicates the gurney. "You got eyes. See for yourself." 10

Porter steals a quick glance. It's not a Surhoff kid. This boy is older. Eight, 11 eleven? As he's gotten older he's lost his ability to distinguish kids by their ages. They all look so big. This kid, though, doesn't. He's thin and his ribs show. He's one of those kids whose limbs look like match sticks; their scapulas stick out like wings when they reach behind themselves to scratch their backs. It would have been years before the flesh on this kid's body caught up with those willowy limbs.

Nobody knows the boy who's drowned. He's a playmate of somebody else's 12 kid, drawn here by the newness of the big houses and his friend telling him that after yesterday's thunderstorm the ravine is running thick and brown, a good day for sending radio controlled boats, plastic boats, construction-paper boats, pieces of bark, anything that floats down the newly revived current. Bikes are clumped or dumped all along the bank. The grass at the top is matted and muddy, trampled under bare and sneakered feet. It was a regular field day. Whole regattas were launched and disappeared.

Porter peers down the bank. The water's running fast, but it's only a foot 13 deep, maybe two or three at the channel's deepest. It's amazing how little water you need to drown in. He's heard of six-month-olds drowning in three inches of water in the bathtub when the parent looks away for just a moment. Ten-month-olds drowning in a toilet. He's even heard of infants drowning without getting wet. Placed on unbaffled water beds, the child sleeps in the warmth of the receiving plastic which eventually conforms to the shape of the baby's mouth. Surrounded by water, dreaming of the womb, the child returns there. It's too tiny to lift its head to save itself.

Usually these ravine and river drownings, though, happen in springtime. 14 The creek's swollen with run off, sometimes four or five or eight feet deep, and the kids, not knowing this, dare each other, or sometimes a single kid, alone, will dare itself to cross the turgid water, will lose its footing, and be swept away. Sometimes the kids will string a rope across a ravine or creek and ford the creek that way. The current is surprisingly strong, however, and young hands weak. They find the body miles away sometimes, usually amid a collection of branches where some municipality has screened its culverts. The child looks like something you find in drain traps. Wet, matted, limp, greasy.

This kid, though, nobody knows what happened to this kid. But edging over 15 the ravine, conscious of where his feet meet the ravine's crumbling muddy edge and conscious, too, of the child's drowned body a few feet behind him, Porter can guess. These kids were playing with their boats. It was a lazy summer day, kids were scattered up and down the ravine, and there was the constant huzzing

of crickets and the voices of children. This kid, or maybe a kid he knew, or maybe a kid he wanted to know, owned one of these radio controlled boats. It got away from him. Maybe the transmitter was weak, maybe the surging of the current was able to overpower the boat's tiny motor, maybe it got tangled in a floating branch and wouldn't heed the call of its owner. Most of these kids wouldn't care that much about losing a boat. They can afford to lose just about anything. Some screeching, a heaved sigh from their parents, a quick trip to Toys R Us, and everything is back to the way it was before, maybe even better if they were able to cajole their parents into something bigger. But this kid couldn't do that. This was it; it was his only boat and if he lost it there wouldn't be another. Or maybe, not having the money for a radio controlled anything, the kid thought that about the boat's owner as well—that if he lost it there would be the inconsolable grief over the loss plus the yelling of the parents. So whether to reclaim what was his, or to impress the boat's owner, maybe get a turn at operating it himself, the kid slogs out the ten or fifteen feet to where the boat is hung up in the branches. The branches themselves are hung up. Maybe they're caught against a rock, or maybe against some other branches growing close to the water's edge and the boat's mired someplace inside them. The boat has a white hull and blue gunwales. Its tiny motor is whirring and can be heard over the intermittent gurgle and rush of the creek. The kid has volunteered to get his friend's boat. At first, the water's only ankle deep. It gets knee deep when he gets to the branches. There's more branch than he thought. He can't simply reach into the tangle and retrieve his friend's boat. A spider walks a tightroped filament of web from one leaf to another, quavering as the leaf does in the light breeze. A mosquito buzzes in the boy's ear. He slaps at it, the buzzing resumes at the base of his neck, by his other ear. His jeans are rolled to his knees but the cuffs are soaking wet. Something drifts past his calf. Instinctively he reaches down to scratch, panicking a little. Recently he's seen for the first time *The African Queen*. His parents rented it. Leech! he thinks, his heart racing, but it's only a leaf. He brushes it aside, knocks the spider off its tightrope just out of spite. The spider spins away on the current, he loses sight of it. Maybe it found a new leaf or twig, maybe not. He forgets about it. The sun's hot on the back of his neck but his legs feel cool. The creek bottom is muddy and rocky both and his shoes are filling with silt. His feet feel squishy. He stands there wriggling his toes inside his canvas sneakers until he's called back to his task by his impatient, lordly friend. The friend with the boat who will be the kid's friend only if he retrieves the boat.

16 But it's not that easy. The boat is trapped in a nest of branches, tucked between them in such a way he can't just reach in and grab it. He has to penetrate the nest. At the same time he has to be careful. If he just pushes himself inside there he could set the whole mess moving and the boat might swamp or get away. So he eases himself between the branches. It's an oak tree these branches came from. They still have last year's leaves on them. They're russet and the twigs break easily. Must have been a lightning kill. He can almost feel the residual electricity. His feet, his fingers are tingling. Perhaps it's because he knows now what he must do. The oak branches, always gnarly, have formed a kind of

dome, and to retrieve his friend's boat he must submerge himself and then resurface inside the dome. There are too many branches to simply throw it aside. How did that thing get in there, anyway?

Perhaps at this point the boy turned to shout something at his better-heeled 17 companion. Perhaps he told him what he was planning on doing—the quick duck, the resurfacing inside the dome of brown leaves. He would be a hero to all of them.

There were other boys in the creek or on the banks, surely, Porter thinks. 18 There was a scattering of bikes there when he came down, and he saw one or two boys with wet jeans and muddy feet and plastered hair. Towels over their heads like monk cowls. Porter recalls seeing these things. He remembers them shivering in the heat.

What next? he wonders. Did he go under, get a belt loop caught on a branch, 19 did he struggle, lose his footing, panic? If he thrashed, would the boy who owned the boat, or any of the other boys notice? And noticing, would they do anything or simply stand there, horrified and fascinated? Maybe where those branches form a dome there's a sinkhole, and stepping into it he lost contact with the surface and face up, sliding, he wound up underneath the dome of branches and was held in place by them. It would be as though he were being pulled by his feet. Pinned, held in place by branches and current, his thrashings lost under the many branches that held him. Even if he screamed it would only hasten his drowning.

Another thought occurs to Porter, and it has to do with Porter's knowledge 20 of the male species in adolescence. Those boys gathered at the top of the ravine or standing on rocks where the current meets the bank—what's to prevent them from doing what they usually do when boys gather?

Pick on the most vulnerable. The new kid from one of those cracker-box 21 ranch houses in the cheesier section of the subdivision. The white trash ghetto, you've heard your parents say.

There are plenty of rocks. Nice hefty granite ones, rocks as big as your fist. 22 You're up high, you've got the numbers, he's down below, disoriented from ducking under those branches and trying to find his way through the fertilizer-laced water. You wait till he surfaces, spluttering, unsure of his footing, and then you start raining rocks down upon him. KaCHUSH! KaCHUSH! The geysers and spray are magnificent. Sometimes the rocks come down next to each other and you can hear the clack of their meeting just a second before the geyser. Hey! he yells. Quit it! Stop it! Stop it, hey, quit it! Ouch!

Somebody catches him on the shoulder. Everybody laughs. Then somebody 23 has the bright idea of going with whole handfuls of rocks—clumps of mud and gravel and pebbles, whatever your fist closes around—and flinging them shotgun style at the now cowering, weeping kid. Then it's a mixture—gravel and clumps of mud from some kids, the bigger rocks from those higher up. The kid is spluttering, confused, crying, bent over, humiliated, ducking beneath the water and resurfacing to fresh fusillades. Sometimes he's bent over with his face in the water, his back taking the blows; other times he's upright, imploring them,

begging them to stop, his arms raised to ward off blows and to surrender. Finally—this is the part that now seems inevitable—one catches him on the crown or by his temple just as he's surfacing. Got 'im! somebody yells. Got 'im a good one! Did you see that?

24 They throw stones for maybe ten or fifteen more seconds. They're waiting, poised, for him to resurface. He's staying under longer this time. Maybe he's hoping to wait them out, the silly dink. Another scattering of plips, plooshes, thlupps and clacks. One kid rolls down the biggest boulder he can move. It tumbles lazily down the embankment, then gathers speed just as it reaches the bottom, and seemingly catapults itself several feet out into the creek a yard away from where that new boy is hiding in his nest of oaks. The KaCHUSH! this time is tremendous. That oughta make him pee his pants!

25 Then nothing for a long time. No movement. Two or three minutes elapse. Some pebbles trickle down the embankment and plop into the water. In the general silence they sound ominous.

26 "Maybe he's hiding," somebody says.

27 "Yeah, maybe he cut one of them reed things. I saw a movie on Nickelodeon where a guy did that. These guys were shooting arrows at him so he ducked into these reeds and breathed through them till the king's horsemen and these arrow guys went away. Arrow Flynn, my mom said it was. The reed guy, I mean."

28 "Maybe he got away," somebody else says. "Maybe he got out from underneath those branches and he swam away."

29 "Dummy! We'd see him if he swam away. He's still there. He's just hiding." And the speaker of this remark throws another handful of gravel at the kid's bower. Some stones hit branches, others plop directly into the water.

30 Everyone becomes immediately aware of how hot the day seems. And how irritating it is to be kept waiting. And how uncomfortable it is to fight off what is suddenly an inchoate but nagging sense of blame, responsibility, and guilt.

31 What happens next Porter's not sure about. Maybe one of the boys screams out, "I see him! I see him!" and they gather around and they do see him, a ghost in the water. Or maybe they look at each other for a few moments of panicked silence and then they scatter, gathering here again only when they hear the sirens.

32 One of them had to have called. He checks this with Clayton. Yes, it was a child's voice, very excited, saying that they could see somebody on the bottom of the creek in Atwood Acres. They didn't stay on the line long enough to identify themselves. They were shouting, nearly hysterical. Then they hung up. No way to trace who it might have been, and upon arriving, Clayton makes one halfhearted attempt to determine who it was—"It would be really helpful if one of you boys, whoever it was called, would step forward"—and gives up on that for now. Porter eyes the kids who stand in clutches near enough the body to be a part of what's going on. A few mothers are with them, their hands protectively on their kid's shoulders.

33 They find the boy up under the branches almost as if he'd been sleeping there. The blue and white boat is still bobbing in the tangle. Now we have something. The boy whose boat it is—he's still clutching the remote as though he could get everything going again if he just keeps turning the dial, pulling the trig-

ger—steps forward under Clayton's prodding. "Just tell me what you saw, son." And the boy says that he saw the kid go under the branches trying to retrieve his boat and they waited and then he didn't come out again. He speaks haltingly, but what he says, to Porter's ear, which is used to hearing lies, sounds rehearsed, insincerely apologetic. "We waited," the boy says. "We waited and waited and waited and we waited but Kenny—" Somebody nudges this kid.

"Danny," the nudger says, "the kid said his name was Danny." 34

"—Danny," the boat boy continues, "Danny didn't show up again." 35

"Who called me?" Clayton asks. "Who called the ambulance?" 36

"I did," the boat boy says. 37

"And why didn't you try getting your friend out right away?" 38

"I was freaking, sir. I was really afraid. I was afraid the same thing was go- 39 ing to happen to me." He shivers involuntarily.

"Please, officer," the boy's mother says. "I'm sure you can see they're scared 40 out of their minds. Can't you leave well enough alone?"

Up until now Porter hasn't been able to—hasn't really wanted to—take a 41 close look at the drowned boy. Just that first cursory glance trying to determine if it was anybody he knew. He looks now. The boy has a spider webbing of hair over his forehead and his lips are blue. His cheeks and eyelids have that bloated quality, and there is the tiniest suggestion of baby fat around his hips, that puff-ing of very pale flesh over his pant loops. His arms are skinny but his belly's full. That could be from the water, though. Or maybe he was recently a chubby kid and was just now hitting puberty, the baby fat stretching itself over willowy bone.

He looks like a child on ice, sleeping. 42

Then he sees what confirms everything he's previously imagined: a bruise 43 the size and color of a pomegranate on his shoulder. An abrasion on his cheek—that could be from the branches—and a bruised spot, quarter-sized, above his right temple. There's the slightest inkling of an indentation where the forehead and the hairline meet.

The kid was wearing jeans and underwear, socks and sneakers. 44

Such a pitifully easy target. 45

For the briefest of moments Porter Atwood wants to see justice done. Check 46 out that bruise, he wants to say to the paramedics, who are already packing up. The one on the shoulder, there, and the one by the temple. Clayton, check these kids for dirt under their fingernails, for gravel dust on their palms. Put the screws to them. Drill them for the truth. A boy died here. The least we can give him is honesty.

The boy's mother doesn't even know he's dead yet. 47

But Porter knows these boys. Knows them in the sense that they look fa- 48 miliar. He sold their parents these houses or the lots they were built on. These kids were the bored ones kicking at the wall boards in the models, leaving scuff marks. These were the boys he had to keep his eyes on. Not that there was any-thing to steal, but if there was, he knew they'd steal it. He has a sense about these things. He knows what happened, he knows what's been done. It would have happened like this, the way he imagined. He has learned to trust his gut feelings on these things, the same as he does when he's calculating to himself how much

a farmer's willing to give up to get off the land that feeds him, and how much a buyer's willing to spend for that same piece of earth. His success depends on appearing absolutely disinterested to both.

49 So Porter satisfies himself by nodding and saying in his mind only, Yes, it would have happened like this. And out loud he says, to the boys and their mothers, to Clayton and the paramedics and all the interested bystanders, to all these people who've bought from him and who want their tranquility restored, who want this unreasonable chaos put into a box, out loud he says, "What a tragedy. What a horrible, horrible tragedy. What a horrible accident. Really, we must take up a collection for the boy's family. I'll personally see that this is taken care of."

50 There, he's done it. He's done what he could. He walks back to his car conscious of his weight, his blubber, really, all that acquired flesh, and puts a new cigar between his teeth. On the way he runs into the mother, a wan woman of thirty, maybe thirty-five, it's hard to tell once these women start having children, especially a woman like this, short and slightly-boned. She comes toward him, but her focus is clearly on what's behind him. She's wringing her hands, clutching her elbows, not willing to believe what she already knows. No, Porter Atwood thinks as she flutters past him, No. She will not get the truth from me. Kenny's or Danny's or whoever that kid's mother is will have to find out her own truth. He's not helping. Porter Atwood has already done what he could.

● **THINKING CRITICALLY ABOUT "CONSENT"**
RESPONDING AS A READER

1. As you and your classmates compare the freewrites in your reading logs, what patterns emerge among various people's predictions, responses, and questions? How accurately did people predict the way the plot would unfold? What details provided either reliable or misleading clues? What did you and the others find most compelling about the story? What was perplexing?

2. Once we become immersed in the world of a story, it's often difficult to recall exactly how we got there. To revisit your introduction to Porter Atwood and Atwood Acres, go back over the story's very first paragraph and try to reconstruct your moment-by-moment reading experience. Consider carefully the effect of the way the paragraph unfolds word by word, sentence by sentence. What is the sequence in which details pile up? What images and expectations does the sequence create? If this were all you knew about Porter Atwood, what would you think of him?

3. The story is told mostly through Porter Atwood's eyes, yet he is not the narrator. How does this separation between the story's main character and its third-person narrator affect your understanding of the unfolding events? How does the separation affect your understanding of Atwood himself, of what motivates him and what he values?

RESPONDING AS A WRITER

1. A good way to develop ideas for a paper on a work of fiction is to locate places in the text where events, motivations, or ideas are unclear or am-

biguous. Look for places where the text doesn't provide clear explanations about why people are the way they are or why events unfold as they do. One way is to review the questions you jotted down immediately after you finished reading "Consent." Separate the *factual questions* for which the text offers clear, definite answers from *problematic questions* for which the text offers more than one explanation. This second set will be more fruitful for starting discussion and developing a paper. (For some questions, the text will offer no clues at all. These unanswerable or *speculative questions* might be interesting to talk about, but since they go beyond the scope of the text that the author created, they should be put aside.)

Within your list of problematic questions, consider which are the most important to a reader's understanding of the story. Some will no doubt involve side details, but others are likely to get at important issues, or *themes*, that shape the story and reveal its significance. On your own or with your classmates, choose two or three questions that you think would be interesting to pose for class discussion. Be prepared to explain why you think these are significant enough to explore in discussion and possibly in a paper.

2. Another productive way to find a focus for a paper about a work of fiction is to identify places where something changes in a major way. Exploration of the change, or *turning point*, and its possible significance can lead you to valuable insights about the themes woven through the story. Apply this idea to "Consent" by noting places where events, characters, or perceptions (even the narrative point of view) change. On your own or with a group of classmates, develop a short list of questions that you think are worth group discussion. Be prepared to explain and advocate for the importance of your questions.

3. We have placed "Consent" at the end of a group of texts that inform and explain. What is the role of explanation in this story? What does and does not get explained? What does the text indicate about why that is the case? Who does and does not understand those explanations? What is left unexplained? From whose perspective? Again, what does the text suggest about why that happens? •

Writing to Inform and Explain

The texts in this section present samples of explanatory writing intended for readers with significantly different interests and backgrounds. The variety demonstrates different kinds of challenges that readers and writers face when they decide to explain a phenomenon. The discussion questions that accompany each text are designed to help you appreciate content and recognize a variety of reader-oriented writing strategies that you can try out in your own written work. The assignment prompts below invite you to apply what you've learned about information and explanation by analyzing writers' methods in depth and trying out similar approaches when you write about subjects that are important to you.

EXPLAINING WHAT YOU KNOW

We invite you to try your hand at the informative and explanatory strategies you have seen at work in this chapter. Write an essay that will enlarge your readers' understanding of a subject you care about by providing new information or a clear explanation. Choose either a subject that you already know well or something that you are interested in learning more about. Your goal is to write an informative or explanatory piece that alters readers' commonly held but incomplete or incorrect view of something. To do this, consider carefully how you can engage your readers with your new view of the subject matter. Also consider what kind of changes you are asking your readers to make in what you take to be their current thinking about the subject matter. To what extent can you expect them to welcome "good news" in your explanation? To what extent can you expect them to resist "bad news" in what you have to say?

Structure your organization and content carefully to maximize your paper's influence on your readers' understanding of your subject matter. Before you write, jot down notes to yourself about how you want to change your readers' thinking about your subject matter. Then, after you have written a draft, test it against your notes to see if it accomplishes the expository task you set for yourself.

EXAMINING RHETORICAL STRATEGIES

When is information really argument, explanation really advocacy? The texts by Irgang and Mairs in this chapter are presented as informative, explanatory articles. However, each has a serious stake in changing our views of something. This assignment invites you to look closely at these texts to compare their strategies for engaging readers in a way that will smooth away resistance to the sometimes uncomfortable ideas they present. Do you consider one to be more effective than the other? If so, how and why? Should either or both be in a different section of this book? Why?

Organize your paper to support a thesis that states how you define the purposes of the two articles, and then devote the bulk of your paper to explaining similarities and differences in the two writers' strategies for gaining readers' confidence and overcoming any readers' resistance. Provide textual evidence to support your points.

EXTENDING THE CONVERSATION

The *UC Berkeley Wellness Letter* article uses conflicting reports about antioxidants as a starting point for its explanation of how to be a discerning reader of headline-grabbing stories of medical research. It was published in the mid-1990s, when these conflicting findings from antioxidant studies were a big news story. What is the current thinking about antioxidants? Find the most recent reports you can on the subject and write an academic, thesis-driven report on the advice that experts currently offer about the role antioxidants should play in our diet.

Analyzing and Interpreting

Much of what we read every day in newspapers and magazines or watch on television involves analysis and interpretation. Political analysts, for example, write about public policy issues in order to educate the public. Sports columnists explain a particular game's outcome by analyzing the performance of the teams and players. Film critics discuss movies in terms of the cinematography, acting, plot, special effects, and so on. In many of these cases, analysis and interpretation are the means to another end. The political analyst may dissect a policy issue in order to persuade readers to share her opinion regarding it, or the film critic may analyze a movie's features to make an evaluative argument. However, unlike texts whose primary aim is to persuade, evaluate, or explain, analytical texts aim first and foremost at understanding a perplexing subject, often by examining how it works, why it is as it is, or what it means.

Analytical texts (and writing assignments for that matter) constitute a common kind of academic prose. In general, analytical texts try to find meaningful patterns in complex data. They try to clarify a puzzling phenomenon by studying its constituent parts and by looking for underlying patterns, cause/effect relationships, and so on. Your psychology textbook, for example, introduces you to Freud's analysis of the psyche in terms of the id, ego, and superego. Your history textbook offers multiple explanations of the causes of the Civil War: economic, geographic, and sociological. Your English instructor asks you to read three different essays about Hawthorne's short story, "Rappaccini's Daughter," each of which uses a different literary critical method to analyze and interpret

the story. What all of these texts have in common is that they "take apart" a particular phenomenon (event, concept, issue, or text) in order to see it differently and understand it more fully, and they "put it back together" in order to offer a "fresh" interpretation or conclusion, a new theory or explanation.

We can better understand how analysis and interpretation work together by taking a closer look at the definitions of these two key words. The word *analysis* comes from a Greek word that means "to dissolve, loosen, or undo." The act of "unraveling" a particular phenomenon or dividing it into its constituent parts allows us to see it from new perspectives. The result disrupts our quick holistic determination of its meaning, enabling us to see connections we have not heretofore seen and encouraging us to think of explanations or interpretations we had not thought of before. *Interpretation* derives from an Old French word that means "to negotiate, translate, or explain," and the branch of study dedicated to the "science" of interpretation is called *hermeneutics* after Hermes, the Greek messenger god. The writer offers an interpretation or translation of a text's or phenomenon's meaning and delivers this "message" to others. Important to note, the first dictionary definition of *to interpret* is "to explain to oneself" the meaning of something. Taken together, these definitions suggest that the act of interpretation is always a matter of negotiation among possible meanings, of deciding upon one translation rather than another, of making sense of things for oneself before passing on that understanding to another.

Although these definitions of *analysis* and *interpretation* imply that analysis precedes and forms the basis for interpretation, analysis itself is inevitably guided by prior assumptions or interpretive frameworks. For example, economists analyze various economic indicators in order to make predictions based on particular economic theories; school officials analyze various student test scores to determine the success of a school's curriculum according to certain definitions of academic achievement. In both cases, the data identified as significant—that is, the economic indicators and student test scores—as well as the theories used to interpret the data reveal the economist's or educator's beliefs or assumptions about how the economy works or what is significant in terms of school achievement. Kenneth Burke, the rhetorical theorist we referred to several times in the early chapters of this book, coined the phrase "terministic screens" to refer to this chicken-and-egg relationship between analysis and interpretation. According to Burke's theory, the "terms" we use to articulate and understand our perceptions "screen" or direct those perceptions: "any nomenclature necessarily directs the attention into some channels rather than others." For example, if we call a person sleeping on a city heating grate a "homeless person," the word "homeless" implicitly directs attention to economic issues and larger social causes. But if we call the person a "wino," alcoholism immediately comes to mind, thus focusing attention on an individual problem rather than on a socioeconomic problem. In Burke's view, the terms we use to take something apart and put it back together to create new meaning are inevitably shaped by our terministic screens, which entail various assumptions, beliefs, and values.

As the examples of the economist and educator suggest, the whole process of analysis and interpretation is central to our efforts to understand complex

QUESTIONS TO HELP YOU READ ANALYSIS AND INTERPRETATION RHETORICALLY

1. What phenomenon is the writer analyzing and interpreting? What is puzzling about this phenomenon to the writer and presumably to readers?
2. What question or purpose seems to guide the writer's analysis and interpretation? Is the writer trying to understand how something works? Why it is as it is? What it means? Why does the writer believe it is important to understand this phenomenon in new ways?
3. How does the writer go about taking this phenomenon apart? What parts of the whole does the writer select for scrutiny? What assumptions does this selection reveal?
4. What, if any, organizational principles direct this writer's analysis? (Examples might be comparison or contrast, identification of causes or effects, classification of parts, or division into preconceived structural categories such as the exposition, rising action, climax, and denouement of a dramatic plot.)
5. What terministic screens seem to guide this writer's analysis and interpretation? What key terms are repeated in the essay? Which terms have a positive meaning, which a negative meaning?
6. If the author cites other writers or texts, what is her or his purpose in doing so? Which are cited to back up this writer's interpretation? Which to show how this writer is modifying or challenging another's interpretations or ideas?
7. What other ways are there of taking apart or analyzing this phenomenon?
8. What other interpretations are possible?
9. What aspects of this writer's analysis and interpretation are convincing? Which unconvincing? Why?

phenomena, generate new knowledge, and make important decisions. Thus, readings that analyze and interpret participate in ongoing conversations within disciplines, professions, and the public sphere. They offer tentative explanations or answers to questions that puzzle us. What does this new migration pattern of birds mean? What accounts for the success of this urban renewal plan over another or this treatment for schizophrenia over another? How are we to understand the concluding scene in Spike Lee's *Do the Right Thing*? What does it mean that some advertisers in the 1990s used models whose look has been described as "heroin chic"?

To summarize: effective analytical and interpretive texts begin by identifying a key question or area of uncertainty. Their method is to examine the parts of the subject systematically in order to see how these parts are related to each other and to the whole. Texts that analyze and interpret pay close attention to detail and often make the implicit features of the subject explicit and therefore available to interpretation. The goal of analytical texts is new understanding. The

opening selection in this chapter, Kirk Savage's "The Past in the Present," for example, analyzes and interprets the significance of public memorials; the short essay by Sarah Boxer interprets a cultural practice. At the center of Toni Cade Bambara's short story "The Lesson" is the issue of interpretation, and this dramatic portrayal of the subjectivity involved in interpretation invites the reader, in turn, to analyze and interpret the meaning of the story.

KIRK SAVAGE

The Past in the Present: The Life of Memorials

Long interested in public monuments, Kirk Savage (b. 1958) is author of *Standing Soldiers, Kneeling Slaves: Race, War, and Monument in Nineteenth-Century America* (1998), which won the John Hope Franklin Prize for the best book in American studies in 1998. Savage teaches the history of art and architecture at the University of Pittsburgh and continues to investigate contemporary representations of slavery and emancipation in American public sculpture. As Savage explains in the introduction to *Standing Soldiers*, public space continues to be a "representational battleground, where many different social groups fight for access and fight for control of the images that define them."

"The Past in the Present: The Life of Memorials" appeared in *Harvard Design Magazine* (HDM) in the fall of 1999. HDM, which is published by Harvard University's Graduate School of Design in cooperation with MIT Press, features "critical explorations of key contemporary issues and practices connected to the built environment." Each issue is organized around a particular theme, such as "What Is Nature Now?" or "Constructions of Memory," which was the theme of the issue in which "The Past in the Present" appeared. Not surprisingly, articles in HDM tend to be scholarly in their treatment of various topics; Savage follows the *Chicago Manual of Style* citation conventions here, using sequential superscript note numbers that refer to *endnotes* at the end of the article.

• FOR YOUR READING LOG

1. The term *memorial* includes monuments, museums, sculptures, and holiday celebrations, any structure or occasion intended as a reminder of a person or event. Examples of memorial structures include the Vietnam War Memorial and Holocaust Museum in Washington as well as the equestrian statue of a local hero in a town square. Think of a memorial that you have visited, either recently or as a child or adolescent. What was your response to this memorial? What, if any, meaning did the experience have for you? Take a few minutes to describe this experience and your memories of the memorial itself in your reading log.

2. In "The Past in the Present," Savage offers various theories about the cultural meaning of memorials, particularly monuments. As you read his essay, mark what you believe to be key passages. After you have completed the essay, go back to the passages you have marked, and try to translate these ideas into your own words in your reading log. If you cannot explain them, then formulate questions about the meaning to raise in class. ●

━━━ ● ━━━

In an office park in suburban Los Angeles, set within a pristine landscape garden designed by Isamu Noguchi, there is a funny monument made of piled stones; the artist dubbed it *The Spirit of the Lima Bean* (1982). Back in the heyday of allegorical sculpture, at the turn of the past century, citizens were likely to encounter the *Spirit of Truth,* or the *Spirit of Fire,* or maybe even the *Spirit of Electricity*—but never the spirit of an ordinary legume. Yet Noguchi's lima-bean monument is more than a joke on an old sculptural genre; it gestures to a lost way of life from the Southern California of his youth. If the lima bean lives in spirit in this garden, the nearby farms that once produced actual lima beans are long gone, victims of a relentless process of displacement in which Noguchi's own work participates.

The Spirit of the Lima Bean could easily stand as an emblem for a whole school of thought that sees modern collective memory as a phenomenon of rupture and loss. According to this school, only when the past has slipped away—becoming a "foreign country" in David Lowenthal's famous phrase—do we begin to mark and commemorate it. Or to paraphrase Pierre Nora, it is when we stop experiencing memory spontaneously from within that we begin to "design" memory, to create its external signs and traces, such as monuments and museums and historic buildings.[1] According to this way of thinking, the intensifying proliferation of the external signs of memory in the contemporary built environment signals the death of a more organic cultural memory that supposedly existed in the hazy premodern past. Thus we can add "the death of memory" to the other assorted deaths—of art, of the author, etc.—that cultural critics have been eager to identify.

But if this sort of lament is increasingly common, we often fail to acknowledge its long genealogy. Long before Robert Musil declared that "there is nothing in this world as invisible as a monument,"[2] many observers were complaining that public monuments were inert, even "dead," worth little by comparison to a memory that "lived" within people's hearts. Ironically, even at ceremonies marking the construction of public monuments, this sort of rhetoric became commonplace. As the orator at the 1867 cornerstone-laying for the first soldiers' monument at the Antietam battlefield affirmed, "Let statues or monuments to the living or the dead tower ever so high, the true honor, after all, is not in the polished tablet or towering column, but in that pure, spontaneous, and unaffected gratitude and devotion of the people that enshrines the memory of the honored one in the heart, and transmits it from age to age long after such costly

things have disappeared."[3] This idea dates back to Pericles's famous funeral oration for the Athenian war dead, in which he argued that the most distinguished monument is the one "planted in the heart rather than graven on stone."[4] The contrast between heart and stone—between spontaneity and fabrication, feeling and obligation—obviously calls into question the authenticity and efficacy of built forms of remembering.

4 Embedded in the very process of memorial building, then, is a longstanding anxiety about monuments. Today, as we are experiencing an explosion of interest in erecting public monuments, it is useful to explore whether this anxiety is still—or was ever—justified. Of particular interest to me are the new monuments to the Civil Rights movement, because they revisit many of the issues—stated and unstated—that we as a nation struggled with at the end of the last century in trying to come to grips with the legacy of the Civil War.

5 Why lavish time and money on monuments, especially if "true" memory indeed resides elsewhere? During the great age of the public monument in the United States, from the mid-19th through the early 20th century, monument proponents were armed with a well-rehearsed response. Monuments did not replace the "true" memory within people's hearts, they claimed; rather, monuments were tangible proof of that inner memory. Thus were monuments construed as the most conspicuous sign that a national people understood and valued its own history.[5] In the United States, the dominant notion of history has been that of a people dedicated to progress. Public monuments helped to celebrate and cement this progressive narrative of national history. To do so, monuments had to instill a sense of historical closure. Memorials to heroes and events were not meant to revive old struggles and debates but to put them to rest—to show how great men and their deeds had made the nation better and stronger. Commemoration was a process of condensing the moral lessons of history and fixing them in place for all time; this required that the object of commemoration be understood as a completed stage of history, safely nestled in a sealed-off past. Until the 18th century, statues were made of living kings, a practice that continued in the early years of the United States when the state of Virginia erected Houdon's statue of George Washington in 1796, three years before his death. By the 19th century, however, it was generally believed that monumental heroes—like Noguchi's lima bean—should be dead and gone, their life histories closed.[6] (At Washington's death, some writers rejoiced that now he could do nothing to tarnish his reputation; it was safe for eternity. They could not foresee that DNA testing might alter a president's reputation two centuries after his death.) Similarly, historical events had to be decisively over: wars won (or lost), acts of statesmanship consummated.

6 This logic of commemoration drastically shriveled history. Women, nonwhites, laborers, and others who did not advance the master narrative of progress defined by a white male elite had little place in the commemorative scheme, except perhaps as the occasional foil by which heroism could be better displayed. This kind of commemoration sought to purify the past of any continuing conflict that might disturb the carefully crafted national narrative. Per-

haps the most dramatic example of this in the United States is the commemoration of emancipation in the aftermath of the Civil War.

The abolition of black slavery in 1865 constituted more of a beginning than 7 an end—the beginning of a long period of intense contestation over the meaning of "freedom" that would, at the end of the 19th century, culminate tragically in a renewed era of the repression of African Americans. Yet as early as 1866, designers of monuments were proposing to "commemorate" emancipation in the form of monuments to Abraham Lincoln. To become an object of commemoration, emancipation needed to be understood as a finished act rather than an unresolved process. Thus the struggle for freedom was condensed into a single human decision—Lincoln's Emancipation Proclamation—even though this action freed only the slaves in Confederate territory, leaving slavery intact in the Union. Similarly, the decisive role played by slaves themselves in their own liberation had to be repressed for two crucial reasons: their actions distracted from the main point of the historical episode, which was the moral glory of the white leader; and their historical struggle against slavery prefigured their continuing struggle for equal rights. A complex and disputed historical process was thus reduced to the stroke of a pen and the waving of a piece of a paper, a work of individual, isolated genius. Most notorious of the memorials that embody this flawed understanding is the so-called Emancipation Monument in Washington (1876), funded but not designed by African Americans; in this monument, a standing Lincoln with one hand on the proclamation appears to be blessing a kneeling slave whose chains have been magically sundered.[7]

By trying to lock up the past in a prefabricated narrative of progress, mon- 8 uments such as these can, as Lowenthal and Nora suggest, work to destroy the sense of a past that still lives within us—a past that helps us define the problems and opportunities we face in the present. Yet the processes of making and experiencing a public memorial always have the potential to undermine the monument's appearance of fixity. The world around a monument is never fixed. The movement of life causes monuments to be created, but then it changes how they are seen and understood. The history of monuments themselves is no more closed than the history they commemorate.

To see this at work, we need only glance at Monument Avenue in Rich- 9 mond, Virginia, which, since the Civil Rights movement, has become a locus of great controversy. This stately boulevard takes its name from the five colossal monuments to Confederate generals and leaders erected along its length between 1890 and 1929, the first and most prominent an equestrian statue of Robert E. Lee. The Lee Monument and its successors worked to strengthen a canonical narrative of the Confederate past—a saga of white valor and statesmanship. The closure of history embodied so effectively in these monuments was part of a larger strategy engineered by the white elite to legitimate its authority in the so-called New South. Sensing that a threat to the avenue's Confederate integrity would be a threat to this version of history, the avenue's defenders long claimed that it was a sacred precinct and therefore exempt from historical processes of change. But like all monumental precincts, Monument Avenue has no choice but to participate in history. The avenue originated in a real estate scheme supported by a

nephew of Robert E. Lee, and from the first it was embroiled in local and state politics.[8] When the black majority finally took control of local government and an African American was elected governor in the late 1980s, the Confederate bastion began to crack. A protracted battle ensued when various proposals were made to place monuments to civil rights heroes on the avenue. Ultimately the battle ended in compromise: the African American chosen for commemoration was black tennis star and native son Arthur Ashe, whose monument was erected in 1996 and located just beyond the five Confederate statues. Although not a political figure, Ashe was an educated and articulate African American who spent his last years campaigning for better AIDS education. The white Richmonders who fought the Ashe Monument worried, rightly, that its presence would profoundly alter Monument Avenue. Now the procession of Confederate heroes, icons of white supremacist rule in Richmond and the New South, culminates ironically in an emblem of exactly the sort of black citizenry the Confederacy feared, outlawed, and fought.

10 But the battles are far from over. Recently, a large portrait of Robert E. Lee was hung on a new riverfront walk in Richmond, only to be removed because of protests from African-American leaders. While the protesters asserted that Lee had fought to keep their ancestors enslaved, the Sons of Confederate Veterans argued that Lee was "a hero of all Virginians" and that removing his picture was a "desecration."[9] This dispute is similar to one that occurred in 1871, when white legislators moved to purchase a portrait of Lee for the Virginia State Capitol, and it recalls scattered protests that took place as the Lee Monument was being constructed.[10] These disputes remind us that there is no single or unified experience of a commemorative image, and conflict often centers on *whose* experience the image tacitly recognizes and legitimates.

11 The essential problem is not that "true" inner memory has disappeared, as Nora would assert. On the contrary, inner memory is alive and kicking: it is the force of living memory that makes the external forms of commemoration meaningful and controversial. The historical memory of the Confederacy is profoundly fractured, and its competing versions continue to be nourished by organizations dedicated to remembering as well as by the oral traditions of families descended from slaves and soldiers alike. Commemorative imagery always has the potential to bring these less visible currents of memory into public contention. For a century, Confederate sympathizers had a near monopoly on public memory in the South; having now lost that monopoly, they are trying to position themselves as "Confederate Americans" with their own right to representation in a multicultural society.[11] Their new ethnic posture is disingenuous, however, given their continuing efforts to claim Lee as a hero for everyone. Lee can be their hero but he is not an African-American hero, nor will he be as long as the memory of slavery remains a vital part of the African-American community.

12 The Civil Rights movement is a more recent, indeed personal memory for its surviving participants; but the commemorative issues it raises resemble those of the Civil War. As an object of commemoration, the Civil Rights movement would appear to offer an ideal opportunity to improve on the dismal precedent

of emancipation. The public realm is far more accessible to African Americans today than during Reconstruction, when they had virtually no opportunity to influence the design of any public monument, even those they funded themselves. Today African-American communities not only are acknowledged as monument consumers, but they also have the political leverage to sponsor and design public monuments. Still, the commemorative enterprise of our own time presents a striking parallel to the dilemma posed by emancipation. The 20th-century movement for civil rights picked up where emancipation left off, and this long continuous history remains unfinished. While the civil rights era has its martyrs, milestones, and tangible accomplishments that provide grist for the commemorative mill, the movement has evolved, fractured, and continued to struggle toward the elusive goal of racial equality. The legacy of the movement's heroic past continues to be disputed in conflicts over affirmative action, school and housing desegregation, and economic opportunity. The key question then becomes: will commemorating this heroic past make it recede further from the present, or can commemoration challenge us to grapple with that past's complicated legacy?

Much of the civil rights memorial activity has been in Alabama, where monuments erected over the past decade run the gamut of commemorative solutions. At one extreme is Maya Lin's memorial at the Southern Poverty Law Center in Montgomery: abstract, contemplative, anchored by its elegant presentation of objective historical fact. Against a backdrop inscribed with Martin Luther King, Jr.'s famous words, "until justice rolls down like waters and righteousness like a mighty stream," a black marble "table" bathed in water displays a circular time line of events from 1954 to 1968, with the names of several dozen martyrs interspersed with a record of judicial decisions and political actions. Like her Vietnam Veterans Memorial in Washington, the Civil Rights Memorial condenses historical process into a sequence of verifiable events and sacrifices with a definite beginning and end; interpretation of this "closed" historical period, however, is left to the individual viewer who is encouraged by the flowing water and the serene surfaces to reflect on history's meaning.[12] At the other extreme is a group of figurative monuments in Kelly Ingram Park in Birmingham, which try to draw the viewer back into the tumult of the past. Several works designed by James Drake along a path named Freedom Walk commemorate the brutal police repression of the famous marches in the spring of 1963. In one work, the walkway passes between two vertical slabs, from which bronze attack dogs emerge on either side and lunge into the pedestrian's space. In another, the walkway leads through an opening in a metal wall faced by two water cannons; just off the walk, by the wall, are two bronze figures of African Americans, a man crumpled to the ground and a woman standing with her back turned against the imagined force of the water. Integrated into the pedestrian experience of the park, these monuments invite everyone—black or white, young or old—to step for a moment into someone else's shoes, those of an innocent victim of state-sponsored terror.

At first glance, Drake's works appear to direct the viewer's experience more imperiously than Lin's does. But Lin's memorial to the Civil Rights movement is far more of a guided experience than her earlier memorial to Vietnam veterans. While the Vietnam Memorial is notable for the absence of any statement

glorifying the cause or linking the war deaths to any lasting achievement, the Civil Rights Memorial obviously valorizes its cause with the quotation from King, and its time line links human sacrifices to tangible accomplishments. At the Vietnam Memorial, the absence of customary explanations of warfare and death forces the visitor to supply her own. In the Montgomery monument, the moral of the story is already part of the package. Yet aspects of the monument work against this neat closure of history. The very circularity of the time line is ambivalent: on the one hand, it suggests completeness; on the other, return and repetition. Unlike a textbook time line, that of the memorial is neither linear nor progressive. And it ends not with an accomplishment but with King's assassination, a tragedy whose implications remain to this day unresolved. Unanswered questions are formulated. Where might we have gone with him? Where have we gone without him?

15 For all their obvious drama, Drake's monuments are unpredictable in their impact. In a sense, they are victim monuments: they do not represent the human victimizer but instead position the viewer as the target of his unseen evil.[13] No single critic can hope to explain or even describe how such a monument affects viewers. As visitors assume the imagined position of the victim, they do not leave their own selves, their inner memories and life experiences, behind. While the monuments are supposed to make history seem less remote, they might have the opposite effect on some visitors, who might see them as emblematic of a barbaric past, long gone. Others might wonder whether the abuses of the past have been rectified; they might connect the repressive tactics of the early '60s with the police brutality that has lately been so much in the headlines. Some might leave Kelly Ingram Park with the message that the fight is behind them; others might feel inspired to continue the struggle in new ways. These simple predictions don't even begin to exhaust the possible divisions—based on race, class, gender, political persuasion, life history, and so on—that can inspire radically different responses to the same work.

16 The design of public monuments is obviously important; but design cannot claim to engineer memory. The inner memories of a culture profoundly shape how its monuments are experienced and lived. The fate of the civil rights memorials will ultimately depend upon how the movement itself is remembered and reinterpreted in the complex reality of the present. In this light, one of the most promising projects is one not yet designed. Last year in Wilmington, North Carolina, a coalition of politicians, business leaders, citizens, and academics sponsored a year-long series of community events and small-group dialogues to commemorate and reexamine one of the most shameful episodes of Southern history: the white supremacist riot of 1898 that destroyed the local black press, attacked black businesses, and forced a legally elected interracial administration to resign from power. The centennial observances in 1998 were partly about history—about setting the historical record right, giving the African-American community the opportunity to voice its own "inner" memory of the past handed down over generations. But even more important, the observances were intended to create a framework for the future based on ongoing dialogue, mutual

understanding, and community action. Dozens of interracial discussion groups, each with a trained facilitator, met for a year; local institutions such as the police, banks, and chamber of commerce reevaluated and revised their practices. A monument has been envisaged as one part of this broader effort.[14] Whatever its design, its success or failure will inevitably be linked to the success of the city's campaign to recast itself. The experience of the monument—the "lesson" of the monument—will be affected by the community's efforts to bridge the racial divide. If this North Carolina city can work toward genuine racial justice, then the monument commemorating this struggle will not become an obsolete marker of a disconnected past but an agent of consciousness in a changing world.

Notes

1. David Lowenthal, *The Past Is a Foreign Country* (Cambridge: Cambridge University Press, 1985); Pierre Nora, "Between Memory and History: Les Lieux de Memoire," *Representations* 26 (Spring 1989), 7–25.

2. Robert Musil, "Monuments," in *Posthumous Papers of a Living Author,* trans. Peter Wortsman (Hygiene, Colorado: Eridanos Press, 1987), 61.

3. *History of Antietam Cemetery* (Baltimore: J. W. Woods, 1869), 4.

4. Thucydides, *History of the Peloponnesian War,* trans. Charles Forster Smith (Cambridge: Harvard University Press, 1928), II: 43.

5. Great men like Washington needed no monuments, many argued, but a nation's people needed to erect monuments to great men to show the nation's gratitude; this was the thrust of Thomas Carlyle's famous argument in "Hudson's Statue," in *Latter-Day Pamphlets* (New York, 1903; orig. 1850).

6. Monuments to living heroes are extremely rare in the 19th century. A Reconstruction-era federally sponsored project for a monument to Abraham Lincoln on the Capitol grounds (never executed) received intense criticism for its inclusion of figures of several contemporaries of Lincoln then living.

7. Kirk Savage, *Standing Soldiers, Kneeling Slaves: Race, War, and Monument in Nineteenth-Century America* (Princeton: Princeton University Press, 1997), 52–128.

8. Ibid., 148–152.

9. Craig Timberg, "Confederate Image Casts Shadow," *Washington Post,* June 4, 1999, B-1.

10. *Richmond Dispatch,* January 18, 1871 and January 20, 1871; Savage, 137–138, 151–154.

11. Craig Timberg, "Richmond Is Seeking a Civil Solution," *Washington Post,* June 17, 1999, B-1. The United Daughters of the Confederacy used the term Confederate Americans in their recent website posting, but the term surfaced during the conflict over the Ashe monument as well.

12. See Daniel Abramson, "Maya Lin and the 1960s: Monuments, Time Lines, and Minimalism," *Critical Inquiry* 22 (Summer 1996), 679–709.

13. Victim monuments of this sort are a recent phenomenon. War memorials in the United States, for example, almost never represented wounded soldiers or men under attack; soldier statues nearly always restored the soldier's body to an intact, vigilant figure—elevated on a pedestal, of course, which deliberately distanced him from the viewer's

space. Also in Kelly Ingram Park is a controversial monument that does depict a white policeman and dog attacking an African-American male.

14. A thorough account of these activities is in the self-published *Centennial Record* (Wilmington, N.C.: 1898 Centennial Foundation, 1998).

● ### THINKING CRITICALLY ABOUT "THE PAST IN THE PRESENT: THE LIFE OF MEMORIALS"

RESPONDING AS A READER

1. In paragraph 5, Savage raises a key question: "Why lavish time and money on monuments, especially if 'true' memory indeed resides elsewhere?" Although he never answers this question directly, he does so indirectly. What, in your own words, is his answer? Does he convince you that this is an important question? What other questions does he implicitly raise regarding monuments?

2. Throughout the essay, Savage discusses specific monuments such as the Emancipation Monument and Drake's monuments in Birmingham to illustrate his ideas. Which of the examples did you find most engaging or most helpful in clarifying a particular idea or debate?

3. Part of Savage's analysis involves presenting and weighing the ideas of others. In particular, he refers several times to the ideas of Pierre Nora. How does Savage position his ideas in relation to Nora's? What does this contribute to his overall analysis?

RESPONDING AS A WRITER

1. Savage organizes his analysis primarily through contrasts. For example, he contrasts memories graven on the heart with those graven on stone, the meaning of the Lee Monument with that of the Ashe Monument on Monument Avenue in Richmond, Virginia, and so on. Make a list of what you consider to be key contrasts in terms, examples, and ideas, and then use these to write a paragraph summarizing Savage's main points about monuments.

2. Return to the memorial you wrote about in your reading log, and reconsider its meaning in light of Savage's ideas. Does this memorial represent the older logic of commemoration that sees history as finished or a new logic that sees history as still unfolding? Write a paragraph recording your insights.

3. In the last paragraph of the essay, Savage refers to a project in Wilmington, North Carolina, where a memorial is being planned to commemorate "one of the most shameful episodes of Southern history: the white supremacist riot of 1898 that destroyed the local black press, attacked black businesses, and forced a legally elected interracial administration to resign from power." This memorial has not yet been designed. Working on your own or with a small group of classmates, propose a design for this memorial, and write a letter to the city council of Wilmington arguing for the appropriateness of your design. ●

Our Celebrities, Ourselves

Neal Gabler (b. 1950) is a cultural historian whose books include *An Empire of Their Own: How the Jews Invented Hollywood* (1988), *Winchell: Gossip, Power, and the Culture of Celebrity* (1994), *Life the Movie: How Entertainment Conquered Reality* (1998), and *Television's Changing Image of American Jews* (with Frank Rich and Joyce Antler [2000]). A specialist in film and American culture, Gabler has taught at the University of Michigan and Pennsylvania State University, and he has been a reviewer on PBS's *Sneak Previews* and ABC's *Good Morning America*. "Our Celebrities, Ourselves" appeared March 14, 2003, in *The Chronicle Review*, a regular section of *The Chronicle of Higher Education*, whose audience is primarily university faculty.

● FOR YOUR READING LOG

1. Before reading this article, write your own definition of the word *celebrity* in your reading log. What does it mean to be a celebrity? What other terms do you associate with this word?

2. Think of a particular celebrity whose life and career interest you. Why do you admire or identify with this celebrity? Do you follow this celebrity's life and career? Write a short paragraph about your interest in this celebrity. ●

———— ● ————

It has been more than 40 years since the historian Daniel Boorstin, in a now famously clever turn of phrase, defined a celebrity as someone who is known for being well known. If he were writing about celebrity today, Boorstin might describe it less flippantly as one of America's most prominent cottage industries and one of television's fastest-growing genres—one in which spent entertainers can find an afterlife by turning their daily existence into real-life situation comedy or tragedy. Anyone caring to stargaze can see *The Osbournes*, *The Anna Nicole Smith Show*, *Star Dates*, *The Surreal Life*, and the network prime-time celebrity interviews conducted by Barbara Walters, Diane Sawyer, Jane Pauley, and others. A reality series for VH1 capturing the life of the former star Liza Minnelli was derailed by a spat between the network and the principals. Meanwhile, cable networks continue to troll for celebrities eager to expose their lives to the public. Programs on the drawing boards include one in which over-the-hill stars spend the weekend with typical families, and another in which stars return to their hometowns and revisit their roots.

When Boorstin was writing in the early '60s, celebrity was one of those absurdities of contemporary culture—a large and ever-growing class of public

figures for which there had been no precedent. Celebrities existed not to entertain, though they usually were entertainers, but rather to be publicized. Their talent, as Boorstin put it, was to grab the spotlight, whether or not they had done anything to deserve it. Now they have not only become an entertainment themselves, a kind of ambulatory show, but are also a cultural force with tremendous appeal, though exactly what that appeal is has been hard to determine. Most conventional analysts, from the popular historian Barbara Goldsmith to the pundit Andrew Sullivan, find celebrity a form of transport—a vicarious fantasy that lifts audiences out of the daily grind. Others, like Joshua Gamson in *Claims to Fame: Celebrity in Contemporary America*, see celebrity-watching as a ritual of empowerment through deconstruction. The audience doesn't seek to be elevated; it seeks to bring the celebrities back to earth. Still others, notably the rulers of the media, attribute the rapid rise of celebrity to mundane financial considerations, like the cheapness of programming real-life celebrities as opposed to fictional stories, and to the power of celebrities to sell magazines and tabloids by appearing on the cover.

3 There is no doubt some truth to each of those explanations—particularly the last one—but none of them fully expresses the range and power of celebrity in contemporary America, or its rampant march through the culture. None really gets to the root of the matter. To do that, one may have to think of celebrity in an entirely new way—not as a status that is conferred by publicity, but as a narrative form, written in the medium of life, that is similar to narratives in movies, novels, and television.

4 The only difference, really, is that since it is written in the medium of life, it requires another medium, be it television or print, to bridge the gap between the narrative lived and the narrative watched. In fact, celebrity narratives are so pervasive, with so many being generated, that they have subordinated other narratives and commandeered other media, until one could argue that life itself has become the dominant medium of the new century, and celebrity its most compelling product. Though purists will blanch at the thought, celebrity may even be the art of the age.

5 When you think of celebrity as a form of narrative art—the romances and divorces, the binges, the dysfunctions, the triumphs, the transgressions—you can immediately appreciate one of its primary appeals, which is the appeal of any good story. Boorstin was wrong: Celebrities aren't known for being well known. They are known for living out real-life melodramas, which is why anyone from Elizabeth Taylor to Joey Buttafuoco can be a celebrity. All one needs is a good story and a medium in which to retail it, and the media, always in desperate need of a story, are only too happy to oblige. And so we get the saga of Ozzy Osbourne, one-time Goth-rock star now stumbling through life as an addled dad to his own teenagers, or Whitney Houston insisting that she isn't addicted to drugs even as she crumbles before our eyes, or Mariah Carey telling us how she has rebounded from a nervous breakdown (she was really just exhausted) and a series of career disasters.

Of course, conventional narratives can provide equally riveting tales, but 6
celebrity has advantages over fiction, not the least of which is novelty. Traditional
narrative forms are so familiar to us now, especially with the proliferation of tele-
vision programs and the staggering number of books published—well over
100,000 each year—that they have become exhausted, attenuated, predictable.
We feel as if we've seen it all before. Celebrity is an antidote to that sense of
exhaustion. Though celebrity narratives themselves have certain conventions—
already, the idea of a famous eccentric displayed into normal life, which *The
Osbournes* introduced a year ago, has been stolen by Anna Nicole Smith—they
also have a *frisson* that so-called imaginative narratives lack.

Part of that *frisson* is the intensification of one of the staples of any form of sto- 7
rytelling: suspense. Readers or viewers always want to know what's going to hap-
pen next, and there are some readers for whom that tension is so excruciating that
they race to the end of the book for the outcome so that they can then read com-
fortably and without anxiety. Celebrity, playing out in real time, obviously has
suspense, since there is no author to imagine the finish, only life itself to devise
the next scene. One never knows what will happen. Who knew that Sharon Os-
bourne would be diagnosed with cancer? Who knew that Michael Jackson would
dangle his infant son from a hotel balcony, or that his nose would erode into a nub
after multiple plastic surgeries? Who knew whether Winona Ryder would be con-
victed or acquitted of her shoplifting charges, or what the sentence would be? Who
knows whether Jennifer Lopez and Ben Affleck will be wed or whether something
will happen to spoil their idyll? No one knows. The scenes just keep unspooling,
and we wait, like Dickens's 19th-century readers eagerly snatching the next in-
stallment of his new novel, or like the moviegoers in the '30s watching the weekly
chapters of a serial—only it is not just the *what* that we anticipate, it is the *when* or
even the *if*. Fictional narratives have closure. They end, and the characters are
frozen in time. Celebrity narratives resist closure. They go on and on and on.

Celebrity has another advantage over conventional narratives. All narratives 8
depend on our emotional connection to the material—not only on our anticipa-
tion of what will happen, but also on our caring about what happens. In the case
of fictional tales, we must, in the timeworn phrase, suspend our disbelief, be-
cause we know that what we are watching or reading is not real, although to be
conscious of the unreality would seriously undermine, if not destroy, our sense
of engagement. We must believe that these are not fictional creations but people,
and that there is something at stake in the outcome of their story. That is one rea-
son Henry James insisted on "felt life" as his aesthetic standard.

Great works still compel us to suspend our disbelief and convince us that we 9
are watching life itself, but that is a harder and harder sell at a time when many
Americans, particularly younger ones, are aware of narrative manipulations
and regard all imaginative fiction as counterfeit. Celebrity, on the other hand,
doesn't require one to suspend disbelief, because it is real, or at least purports to
be. The stakes are real, too. Sharon Osbourne may eventually die of her cancer.
Kelly Clarkson would get a record contract if she won *American Idol*. The vari-
ous celebrities who beam at us from the cover of *People* each week will find

romance or will recover or will succeed—or they won't. Either way, something is at stake. There are consequences that we will be able to see down the road. It matters.

10 Finally, there is the appeal of voyeurism that is heightened precisely because celebrity is unavoidably contrasted with the fictional narratives in which most celebrities find themselves. For many fans today, the roles that celebrities play, both on television and in movies, and the roles they assume as they project themselves in the media, operate as a kind of disguise. They obscure the real person. Celebrity purportedly allows us to peek behind the disguise and see the real person in real joy or torment. This has resulted in an odd reversal that further underscores the power of celebrity. There was a time when celebrities, with a few exceptions, interested us only because of the work they did; their movies, books, albums, TV shows piqued our curiosity. We wanted to know more. But the ratio of interest in the work to interest in the personalities within the work has changed. Now the work they do serves as a curtain that celebrity draws, but since celebrities almost always have a larger appeal than that work—more people certainly know about the Osbournes than buy Ozzy's albums, just as more people are following the exploits of J. Lo and Ben Affleck than watch their movies—the work is almost an excuse for the celebrity. In effect, you need a curtain so that you can reveal what is behind it. Celebrity, then, is the real narrative—the real achievement.

11 After the terrible events of 9/11, some predicted that the days of celebrity obsession were over, and that Americans would prefer the comforts of closure to the roilings of reality. It hasn't turned out that way. If anything, 9/11 itself delivered a narrative of such extraordinary impact that it was impossible for fictional narratives to equal or approximate it, and it may even have created a new aesthetic divide—not between good stories and formulaic ones, but between real stories and imagined ones. In that context, celebrity, for all its seeming triviality and irrelevance, survives and thrives because it still has the mark of authenticity.

12 That element of authenticity is critical in understanding the public's attraction not only to the text of celebrity, but also to its subtext, without which celebrity would just be a bundle of melodramatic, albeit real, stories. The deeper appeal of these narratives is that they address one of the central tensions in contemporary America: the tension between artifice and authenticity, between the image and the reality.

13 The celebrity narrative is especially well suited to reify that issue. One is likely to think of celebrities as creatures of artifice. They wear makeup and costumes (even when they are not before the cameras, the hottest ones are dressed by designers), they rely on public-relations stunts and gossip to promote themselves, and they play roles and affect attitudes. That isn't just the public's view. Celebrities often think of themselves in the same way. Cary Grant was once quoted, perhaps apocryphally, as having said that it wasn't easy being Cary Grant. Presumably he meant that the persona was vastly different from the per-

son who inhabited it, and that the latter was always having to work to become the former.

That idea—of a distance between the celebrity as public figure and the person 14 within the celebrity narrative—is, indeed, the basis for almost every celebrity narrative that features an entertainer, as opposed to narratives, like those of Joey Buttafuoco or John Wayne Bobbit or Kato Kaelin, that create the celebrity in the first place, out of notoriety. As I wrote in *Life the Movie*, virtually every celebrity profile, be it in *People, Vanity Fair, The New Yorker*, or on *Entertainment Tonight* or *Access Hollywood*, focuses on the celebrity's battle to find himself or herself, to achieve some genuineness, to understand what really constitutes happiness instead of settling for the Hollywood conception of happiness.

These stories are all chronicles of self-discovery. Now that she is rid of Tom 15 Cruise, Nicole Kidman can find herself. Having broken up with her boyfriend, Justin Timberlake, Britney Spears is flailing about trying to find herself. Winona Ryder's shoplifting was a cry for help to enable her to find herself. Whitney Houston is now in a state of denial, but she will eventually have to find herself or perish. Lost in romance, drugs, abuse, failure, breakdowns—you name it—celebrities must fight through the layers of image to discover who they really are. Whether that is just more public-relations blather or not, those are the stories we read and see every day.

It is the same process that is charted on the new celebrity television shows. 16 Ozzy Osbourne may be brain-fried and distracted, but his life, for all its oddities and even freakishness, is touchingly ordinary in its emotional groundedness. Ozzy has found himself in his family, which makes the program remarkably old-fashioned and life-affirming. Next to the F-word, the word most often used on the program is "love." Similarly, Anna Nicole Smith, the former *Playboy* centerfold now overweight and bovine and searching for love, may be a moron, but there is something attractive in her almost pathetic ordinariness beneath all her attempts at grandeur. Watching her and Ozzy and the minor stars from old sitcoms now looking for love on *Star Dates*, one is reminded not how different these celebrities are from us but how similar they are once they have recognized the supposed falsity of the celebrity way of life.

All of that may seem a very long way from the lives of those who read and 17 watch the celebrity narrative—us. Not many Americans, after all, have had to struggle with the sorts of things, like romantic whirligigs, drug detoxification, and sudden career spirals, that beset celebrities. And yet in many respects, celebrity is just ordinary American life writ large and more intense. In an image-conscious society, where nearly everyone has access to the tools of self-invention and self-promotion—makeup, designer clothes, status symbols, and quirks of behavior, language, and attitude—people are forced to opt for a persona or else to find out who they really are. That is the modern condition. Each of us, to a greater or lesser degree, is fighting the same battle as the celebrities, which is why celebrity, for all its obvious entertainment value, resonates psychically in a way that few modern fictional narratives do. Celebrity doesn't transport us from the

niggling problems of daily life. It amplifies and refines them in an exciting narrative context.

18 And so we keep watching as we might watch any soap opera, engaged by the melodrama, or any sitcom, amused by the comedy. We watch not because, as Boorstin wrote, we are too benumbed by artifice to recognize the difference between celebrities and people of real accomplishment who are more deserving of our attention. Rather we watch because we understand, intuitively or not, that these celebrities are enacting a kind of modern parable of identity, with all its ridiculousness and all its tragedy. We watch because in their celebrity—Ozzy's and Anna Nicole's and Whitney's and Winona's and J. Lo's and Mariah's and even Jacko's—we somehow manage to find ourselves.

● THINKING CRITICALLY ABOUT "OUR CELEBRITIES, OURSELVES"

RESPONDING AS A READER

1. Gabler makes a number of claims about celebrities in this essay. He argues, for example, that "[c]elebrity is just ordinary American life writ large and more intense" (par. 17). Where in the essay did you find yourself agreeing with his claims? Where disagreeing?

2. Gabler is writing primarily for an audience of college professors, yet his subject is popular culture. How does he go about achieving credibility both as an intellectual and as an expert on popular culture? Find passages in the text that illustrate each kind of credibility. Do you notice any difference in language or voice in these passages?

3. Part of Gabler's purpose is to analyze the reasons for our interest in celebrity lives. Consider the reasons he offers, and recall the celebrity you named in your reading log. Which reasons best explain your interest in this celebrity's life and career? If you think none of his reasons apply, how would you explain the reasons for your interest in this celebrity?

RESPONDING AS A WRITER

1. To understand Gabler's purpose in writing this essay more fully, write a rhetorical précis of it.

2. Imagine that you are the design editor for *The Chronicle Review*, and it is your assignment to choose two images to accompany this article. Describe two images you might choose, and explain why you would choose them. That is, how might they work rhetorically? (See Chapter 4 for a discussion of how images work rhetorically in relation to a text.)

3. When this article was first published in *The Chronicle Review*, it included two pull-quotes to pique reader's interest in the article. Which two quotations would you choose to highlight in this way? Write a paragraph explaining your choices. ●

SARAH BOXER

I Shop, Ergo I Am:
The Mall as Society's Mirror

Sarah Boxer (b. 1959) is a cultural critic who writes regularly for the *New York Times*. Her particular interests are in popular culture, contemporary art, and critical theory. She has also published one book, *In the Floyd Archives: A Psycho-Bestiary* (2001), which is described as "a series of cartoon case histories, an animal tour of all things Freudian." In "I Shop, Ergo I Am: The Mall as Society's Mirror," published March 28, 1998, in the *New York Times*, Boxer offers a brief cultural history of shopping as well as an analysis of the meaning of contemporary trends in shopping. Boxer's title alludes to the famous statement made by French philosopher René Descartes about the relationship between cognition and one's sense of self: "I think; therefore, I am."

● FOR YOUR READING LOG

1. As Boxer reports in this article, the academic field known as cultural studies analyzes ordinary activities such as "eating fast food, buying a house in the suburbs, watching television and taking vacations at Disneyland." A subspeciality in this field is what Boxer calls "shopping studies." Does shopping strike you as a serious subject for academic inquiry? Why might a scholar be interested in studying the history of shopping or current shopping behaviors?
2. Write a short entry in your reading log about your attitudes toward shopping and your shopping habits ●

———— ● ————

In certain academic circles, "shop till you drop" is considered a civic act. If you 1
follow cultural studies—the academic scrutiny of ordinary activities like eating fast food, buying a house in the suburbs, watching television and taking vacations at Disneyland—you will know that shopping is not just a matter of going to a store and paying for your purchase.

How you shop is who you are. Shopping is a statement about your place in 2
society and your part in world cultural history. There is a close relationship, even an equation, between citizenship and consumption. The store is the modern city-state, the place where people act as free citizens, making choices, rendering opinions and socializing with others.

If this sounds like a stretch, you're way behind the times. The field of cul- 3
tural studies, which took off in England in the 1970's, has been popular in this country for more than a decade.

4 The intellectual fascination with stores goes back even further. When the philosopher Walter Benjamin died in 1940, he was working on a long study of the Paris arcades, the covered retail passageways, then almost extinct, which he called the "original temples of commodity capitalism." Six decades later, the study of shopping is well trampled. Some academics have moved on from early classical work on the birth of the department store and the shopping arcade to the shopping malls of the 1950's and even the new wide aisles of today's factory outlets and superstores—places like Best Buy, Toys "R" Us and Ikea.

5 Historically, the age of shopping and browsing begins at the very end of the 18th century. In a paper titled "Counter Publics: Shopping and Women's Sociability," delivered at the Modern Language Association's annual meeting, Deidre Lynch, an associate professor of English at the State University of New York in Buffalo, said the word "shopping" started to appear frequently in print around 1780. That was when stores in London started turning into public attractions.

6 By 1800, Ms. Lynch said, "a policy of obligation-free browsing seems to have been introduced into London emporia." At that point, "the usual morning employment of English ladies," the 18th-century writer Robert Southey said, was to "go a-shopping." Stores became places to socialize, to see and be seen. Browsing was born.

7 The pastime of browsing has been fully documented. Benjamin wrote that the Paris arcades, which went up in the early 1800's, created a new kind of person, a professional loiterer, or flaneur, who could easily turn into a dangerous political gadfly. The philosopher Jurgen Habermas, some of his interpreters say, has equated consumer capitalism with the feminization of culture. And now some feminists, putting a new spin on this idea, are claiming the store as the place where women first became "public women."

8 By imagining that they owned the wares, women were "transported into new identities," Ms. Lynch said. By meeting with their friends, they created what feminist critics like Nancy Fraser and Miriam Hansen call "counter publics," groups of disenfranchised people.

9 Some feminists point out that as shoppers, women had the power to alter other people's lives. Women who spent "a summer's day cheapening a pair of gloves" without buying anything, as Southey put it, were "fortifying the boundaries of social class," Ms. Lynch said. They were "teaching haberdashers and milliners their place," taunting them with the prospect of a purchase and never delivering. It may not have been nice, but it was a sort of political power.

10 Women could also use their power for good. In 1815, Ms. Lynch points out, Mary Lamb wrote an essay called "On Needlework," urging upper-class ladies who liked to do needlework as a hobby to give compensatory pay to women who did it to make a living. Lamb's biographer recently noted that this was how "bourgeois women busily distributed the fruits of their husbands' capitalist gains in the name of female solidarity."

11 The idea that shopping is a form of civil action naturally has its critics. In one of the essays in a book titled "Buy This Book," Don Slater, a sociologist at the University of London, criticized the tendency of many academics to celebrate "the

productivity, creativity, autonomy, rebelliousness and even . . . the 'authority' of the consumer." The trouble with this kind of post-modern populism is that it mirrors "the logic of the consumer society it seeks to analyze," he said. Such theories, without distinguishing between real needs and false ones, he suggested, assume that shoppers are rational and autonomous creatures who acquire what they want and want what they acquire.

Another critic, Meaghan Morris, author of an essay called "Banality in Cultural Studies," has faulted academics for idealizing the pleasure and power of shopping and underestimating the "anger, frustration, sorrow, irritation, hatred, boredom and fatigue" that go with it. 12

The field of shopping studies, whatever you think of it, is now at a pivotal point. In the 19th century, emporiums in London and arcades in Paris turned shopping into social occasions; in the 20th century, academics turned shopping into civic action; and in the 21st century, it seems that megastores will bring us into a new, darker era. 13

Shoppers' freedoms are changing. According to Robert Bocock, writing in "Consumption," the mall walkers of today do not have the rights that the flaneurs of the 19th century had. "In the United States, 'policing' of who is allowed entry to the malls has become stricter in the last two or three decades of the 20th century." 14

In superstores, the role of shoppers has changed even more radically. Superstores are warehouses that stock an astounding number of goods picked out at a national corporate level, said Marianne Conroy, a scholar of comparative literature at the University of Maryland. Shoppers educate themselves about the goods and serve themselves. Thus, the superstore effectively "strips shopping of its aura of sociality," Ms. Conroy said. There is no meaningful interaction between the salespeople and the shoppers or among the shoppers. The shoppers' relationship is not with other people but with boxes and shelves. 15

Does the concept of the shopper as citizen still hold? The real test is to see how the citizen-shopper fares at the superstore. In a paper she delivered to the Modern Language Association, titled "You've Gotta Fight for Your Right to Shop: Superstores, Citizenship and the Restructuring of Consumption," Ms. Conroy analyzed one event in the history of a superstore that tested the equation between shopping and citizenship. 16

In 1996 Ronald Kahlow, a software engineer, decided to do some comparison shopping at a Best Buy outlet store in Reston, Va., by punching the prices and model numbers of some televisions into his laptop computer. When store employees asked him to stop, he refused and was arrested for trespassing. The next day, Mr. Kahlow returned with a pen and paper. Again, he was charged with trespassing and handcuffed. 17

When he stood trial in Fairfax County Court, he was found not guilty. And, as Ms. Conroy observed, the presiding judge in the case, Donald McDonough, grandly equated Mr. Kahlow's comparison shopping to civil disobedience in the 1960's. Mr. Kahlow then recited Robert F. Kennedy's poem "A Ripple of Hope," and the judge said, "Never has the cause of comparison shopping been so eloquently advanced." 18

19 At first, Ms. Conroy suggested they both might have gone overboard in reading "public meaning into private acts," but then she reconsidered. Maybe, she said, it's just time to refine the model.

20 Ms. Conroy suggested that consumerism should be seen no longer as the way citizens exercise their rights and freedoms but rather as "an activity that makes the impact of economic institutions on everyday life critically intelligible." In other words, shoppers in superstores are like canaries in the mines. Their experience inside tells us something about the dangers lurking in society at large.

21 What does one man's shopping experience at Best Buy tell us about the dangers of modern life in America? The fact that Mr. Kahlow was arrested when he tried to comparison shop shows that even the minimal rights of citizen-shoppers are endangered, said Ms. Conroy. Not only have they lost a venue for socializing, but they are also beginning to lose their right to move about freely and make reasoned choices.

22 Without the trappings of sociability, it's easier to see what's what. Stores used to be places that made people want to come out and buy things they didn't know they wanted. And they were so seductive that by the end of the 20th century they became one of the few sites left for public life. But in the superstores, the flaneurs and the consumer-citizens are fish out of water. They have nowhere pleasant to wander, no glittering distractions, no socializing to look forward to and no escape from the watchful eyes of the security guards. If this is citizenship, maybe it's time to move to another country.

• THINKING CRITICALLY ABOUT "I SHOP, ERGO I AM"

RESPONDING AS A READER

1. What kind of a relationship does Boxer try to establish with readers? What roles does she invite readers to play? Point out particular passages that support your answer.

2. What's the effect of the background information Boxer offers about studies of shopping in earlier eras (paragraphs 5–13)? What kind of connection do you see between these studies and more recent studies of superstores (paragraphs 15–22)? How does Boxer help you to understand this relationship?

3. What seems to be Boxer's purpose in writing this essay? What new perspective does this article offer readers?

RESPONDING AS A WRITER

1. Boxer quotes a number of experts in this short article. List three scholars that she quotes, and explain briefly what you believe to be her purpose in citing each. How does she use the ideas supplied by them to develop her points?

2. To what extent does your experience in superstores confirm or counter Boxer's interpretation of them? Write a brief response to her claims based on your own experiences with superstores.

3. Throughout the essay Boxer cites scholars who claim that shopping has always offered people certain kinds of identities—"the public woman," the free citizen who can make choices, and so on. Think of a contemporary shopping practice like shopping by catalogue or online, and offer a brief interpretation of the identity or identities offered by this kind of shopping. •

Toni Cade Bambara

The Lesson (Fiction)

Toni Cade Bambara (1939–1995) was a prominent civil rights activist, author, and educator until her untimely death from cancer in 1995. Through her writing, Bambara portrays the lives of urban African Americans, particularly women, with depth and richness. Bambara also wrote several screenplays, including *Zora*, a film about the life of Zora Neale Hurston, and *The Bombing of Osage*, a film about an incident in Philadelphia in which the African American mayor used lethal force against a group of black militants. Her best-known books of fiction include *Gorilla, My Love* (1972), a collection of short stories that includes "The Lesson," and two novels—*The Salt Eaters* (1980) and *If Blessings Come* (1987).

• FOR YOUR READING LOG

1. Can you remember an experience in which an adult—a parent, teacher, or adult friend—was trying to teach you something you didn't want to learn? Take a few minutes to write in your reading log about your memories of resisting this adult lesson.
2. As you read through this story, mark passages that seem key in the unfolding of the plot. •

════ • ════

Back in the days when everyone was old and stupid or young and foolish and 1
me and Sugar were the only ones just right, this lady moved on our block with nappy hair and proper speech and no makeup. And quite naturally we laughed at her, laughed the way we did at the junk man who went about his business like he was some big-time president and his sorry-ass horse his secretary. And we kinda hated her too, hated the way we did the winos who cluttered up our parks and pissed on our handball walls and stank up our hallways and stairs so you couldn't halfway play hide-and-seek without a goddamn gas mask. Miss Moore was her name. The only woman on the block with no first name. And she was black as hell, cept for her feet, which were fish-white and spooky. And she

was always planning these boring-ass things for us to do, us being my cousin, mostly, who lived on the block cause we all moved North the same time and to the same apartment then spread out gradual to breathe. And our parents would yank our heads into some kinda shape and crisp up our clothes so we'd be presentable for travel with Miss Moore, who always looked like she was going to church, though she never did. Which is just one of the things the grown-ups talked about when they talked behind her back like a dog. But when she came calling with some sachet she'd sewed up or some gingerbread she'd made or some book, why then they'd all be too embarrassed to turn her down and we'd get handed over all spruced up. She'd been to college and said it was only right that she should take responsibility for the young ones' education, and she not even related by marriage or blood. So they'd go for it. Specially Aunt Gretchen. She was the main gofer in the family. You got some ole dumb shit foolishness you want somebody to go for, you send for Aunt Gretchen. She been screwed into the goalong for so long, it's a blood-deep natural thing with her. Which is how she got saddled with me and Sugar and Junior in the first place while our mothers were in a la-de-da apartment up the block having a good ole time.

2 So this one day Miss Moore rounds us all up at the mailbox and it's puredee hot and she's knocking herself out about arithmetic. And school suppose to let up in summer I heard, but she don't never let up. And the starch in my pinafore scratching the shit outta me and I'm really hating this nappy-head bitch and her goddamn college degree. I'd much rather go to the pool or to the show where it's cool. So me and Sugar leaning on the mailbox being surly, which is a Miss Moore word. And Flyboy checking out what everybody brought for lunch. And Fat Butt already wasting his peanut-butter-and-jelly sandwich like the pig he is. And Junebug punchin on Q.T.'s arm for potato chips. And Rosie Giraffe shifting from one hip to the other waiting for somebody to step on her foot or ask her if she from Georgia so she can kick ass, preferably Mercedes's. And Miss Moore asking us do we know what money is, like we a bunch of retards. I mean real money, she say, like it's only poker chips or monopoly papers we lay on the grocer. So right away I'm tired of this and say so. And would much rather snatch Sugar and go to the Sunset and terrorize the West Indian kids and take their hair ribbons and their money too. And Miss Moore files that remark away for next week's lesson on brotherhood, I can tell. And finally I say we oughta get to the subway cause it's cooler and besides we might meet some cute boys. Sugar done swiped her mama's lipstick, so we ready.

3 So we heading down the street and she's boring us silly about what things cost and what our parents make and how much goes for rent and how money ain't divided up right in this country. And then she gets to the part about we all poor and live in the slums, which I don't feature. And I'm ready to speak on that, but she steps out in the street and hails two cabs just like that. Then she hustles half the crew in with her and hands me a five-dollar bill and tells me to calculate 10 percent tip for the driver. And we're off. Me and Sugar and Junebug and Flyboy hanging out the window and hollering to everybody, putting lipstick on each other cause Flyboy a faggot anyway, and making farts with our sweaty

armpits. But I'm mostly trying to figure how to spend this money. But they all fascinated with the meter ticking and Junebug starts laying bets as to how much it'll read when Flyboy can't hold his breath no more. Then Sugar lay bets as to how much it'll be when we get there. So I'm stuck. Don't nobody want to go for my plan, which is to jump out at the next light and run off to the first bar-b-que we can find. Then the driver tells us to get the hell out cause we there already. And the meter reads eight-five cents. And I'm stalling to figure out the tip and Sugar say give him a dime. And I decide he don't need it bad as I do, so later for him. But then he tries to take off with Junebug's foot still in the door so we talk about his mama something ferocious. Then we check out that we on Fifth Avenue and everybody dressed up in stockings. One lady in a fur coat, hot as it is. White folks crazy.

"This is the place," Miss Moore say, presenting it to us in the voice she uses 4 at the museum. "Let's look in the windows before we go in."

"Can we steal?" Sugar asks very serious like she's getting the ground rules 5 squared away before she plays. "I beg your pardon," say Miss Moore, and we fall out. So she leads us around the windows of the toy store and me and Sugar screamin, "This is mine, that's mine, I gotta have that, that was made for me, I was born for that," till Big Butt drowns us out.

"Hey, I'm going to buy that there." 6

"That there? You don't even known what it is, stupid." 7

"I do so," he say punchin on Rosie Giraffe. "It's a microscope." 8

"Whatcha gonna do with a microscope, fool?" 9

"Look at things." 10

"Like what, Ronald?" ask Miss Moore. And Big Butt ain't got the first notion. 11 So here go Miss Moore gabbing about the thousands of bacteria in a drop of water and the somethinorother in a speck of blood and the million and one living things in the air around us is invisible to the naked eye. And what she say that for? Junebug go to town on that "naked" and we rolling. Then Miss Moore ask what it cost. So we all jam into the window smudgin it up and the price tag say three hundred dollars. So then she ask how long'd take for Big Butt and Junebug to save up their allowances. "Too long," I say. "Yeh," adds Sugar, "outgrown it by that time." And Miss Moore say no, you never outgrow learning instruments. "Why, even medical students and interns and," blah, blah, blah. And we ready to choke Big Butt for bringing it up in the first damn place.

"This here costs four hundred eighty dollars," say Rosie Giraffe. So we pile 12 up all over her to see what she pointin out. My eyes tell me it's a chunk of glass cracked with something heavy, and different-color inks dripped into the splits, then the whole thing put into a oven or something. But for $480 it don't make sense.

"That's a paperweight made of semi-precious stones fused together under 13 tremendous pressure," she explains slowly, with her hands doing the mining and all the factory work.

"So what's a paperweight?" asks Rosie Giraffe. 14

"To weigh paper with, dumbbell," say Flyboy, the wise man from the East. 15

16 "Not exactly," say Miss Moore, which is what she say when you warm or way off too. "It's to weigh paper down so it won't scatter and make your desk untidy." So right away me and Sugar curtsy to each other and then to Mercedes who is more the tidy type.

17 "We don't keep paper on top of the desk in my class," say Junebug, figuring Miss Moore crazy or lyin one.

18 "At home, then," she say. "Don't you have a calendar and a pencil case and a blotter and a letter-opener on your desk at home where you do your home-work?" And she know damn well what our homes look like cause she nosys around in them every chance she gets.

19 "I don't even have a desk," say Junebug, "Do we?"

20 "No. And I don't get no homework neither," says Big Butt.

21 "And I don't even have a home," say Flyboy like he do at school to keep the white folks off his back and sorry for him. Send this poor kid to camp posters, is his specialty.

22 "I do," says Mercedes. "I have a box of stationery on my desk and a picture of my cat. My godmother bought the stationery and the desk. There's a big rose on each sheet and the envelopes smell like roses."

23 "Who wants to know about your smelly-ass stationery," say Rosie Giraffe fore I can get my two cents in.

24 "It's important to have a work area all your own so that . . ."

25 "Will you look at this sailboat, please," say Flyboy, cuttin her off and pointin to the thing like it was his. So once again we tumble all over each other to gaze at this magnificent thing in the toy store which is just big enough to maybe sail two kittens across the pond if you strap them to the posts tight. We all start recit-ing the price tag like we in assembly. "Handcrafted sailboat of fiberglass at one thousand one hundred ninety-five dollars."

26 "Unbelievable," I hear myself say and am really stunned. I read it again for myself just in case the group recitation put me in a trance. Same thing. For some reason this pisses me off. We look at Miss Moore and she lookin at us, waiting for I dunno what.

27 "Who'd pay all that when you can buy a sailboat set for a quarter at Pop's, a tube of glue for a dime, and a ball of string for eight cents? It must have a mo-tor and a whole lot else besides," I say. "My sailboat cost me about fifty cents."

28 "But will it take water?" say Mercedes with her smart ass.

29 "Took mine to Alley Pond Park once," say Flyboy. "String broke. Lost it. Pity."

30 "Sailed mine in Central Park and it keeled over and sank. Had to ask my fa-ther for another dollar."

31 "And you got the strap," laugh Big Butt. "The jerk didn't even have a string on it. My old man whaled on his behind."

32 Little Q.T. was staring hard at the sailboat and you could see he wanted it bad. But he too little and somebody'd just take it from him. So what the hell. "This boat for kids, Miss Moore?"

33 "Parents silly to buy something like that just to get all broke up," say Rosie Giraffe.

"That much money it should last forever," I figure. 34

"My father'd buy it for me if I wanted it." 35

"Your father, my ass," say Rosie Giraffe getting a chance to finally push 36
Mercedes.

"Must be rich people shop here," say Q.T. 37

"You are a very bright boy," say Flyboy. "What was your first clue?" And he 38
rap him on the head with the back of his knuckles, since Q.T. the only one he
could get away with. Though Q.T. liable to come up behind you years later and
get his licks in when you half expect it.

"What I want to know is," I says to Miss Moore though I never talk to her, I 39
wouldn't give the bitch that satisfaction, "is how much a real boat costs? I figure
a thousand'd get you a yacht any day."

"Why don't you check that out," she says, "and report back to the group?" 40
Which really pains my ass. If you gonna mess up a perfectly good swim day least
you could do is have some answers. "Let's go in," she say like she got something
up her sleeve. Only she don't lead the way. So me and Sugar turn the corner to
where the entrance is, but when we get there I kinda hang back. Not that I'm
scared, what's there to be afraid of, just a toy store. But I feel funny, shame. But
what I got to be shamed about? Got as much right to go in as anybody. But some-
how I can't seem to get hold of the door, so I step away for Sugar to lead. But she
hangs back too. And I look at her and she looks at me and this is ridiculous. I
mean, damn, I have never ever been shy about doing nothing or going nowhere.
But then Mercedes steps up and then Rosie Giraffe and Big Butt crowd in behind
and shove, and next thing we all stuffed into the doorway with only Mercedes
squeezing past us, smoothing out her jumper and walking right down the aisle.
Then the rest of us tumble in like a glued-together jigsaw done all wrong. And
people lookin at us. And it's like the time me and Sugar crashed into the Catholic
church on a dare. But once we got in there and everything so hushed and holy
and the candles and the bowin and the handkerchiefs on all the drooping heads,
I just couldn't go through with the plan. Which was for me to run up to the al-
tar and do a tap dance while Sugar played the nose flute and messed around in
the holy water. And Sugar kept givin me the elbow. Then later teased me so bad
I tied her up in the shower and turned it on and locked her in. And she'd be there
till this day if Aunt Gretchen hadn't finally figured I was lying about the boarder
takin a shower.

Same thing in the store. We all walkin on tiptoe and hardly touchin the 41
games and puzzles and things. And I watched Miss Moore who is steady watchin
us like she waiting for a sign. Like Mama Drewery watches the sky and sniffs
the air and takes note of just how much slant is in the bird formation. Then me
and Sugar bump smack into each other, so busy gazing at the toys, 'specially the
sailboat. But we don't laugh and go into our fat-lady bump-stomach routine. We
just stare at that price tag. Then Sugar run a finger over the whole boat. And I'm
jealous and want to hit her. Maybe not her, but I sure want to punch somebody
in the mouth.

"Whatcha bring us here for, Miss Moore?" 42

43 "You sound angry, Sylvia. Are you mad about something?" Givin me one of them grins like she tellin a grown-up joke that never turns out to be funny. And she's lookin very closely at me like maybe she planning to do my portrait from memory. I'm mad, but I won't give her that satisfaction. So I slouch around the store bein very bored and say, "Let's go."

44 Me an Sugar at the back of the train watchin the tracks whizzin by large then small then gettin gobbled up in the dark. I'm thinkin about this tricky toy I saw in the store. A clown that somersaults on a bar then does chin-ups just cause you yank lightly at his leg. Cost $35. I could see me askin my mother for a $35 birth-day clown. "You wanna who that costs what?" she'd say, cocking her head to the side to get a better view of the hole in my head. Thirty-five dollars could buy new bunk beds for Junior and Gretchen's boy. Thirty-five dollars and the whole household could go visit Granddaddy Nelson in the country. Thirty-five dollars would pay for the rent and the piano bill too. Who are these people that spend that much for performing clowns and $1,000 for toy sailboats? What kinda work they do and how they live and how come we ain't in on it? Where we are is who we are, Miss Moore always pointin out. But it don't necessarily have to be that way, she always adds then waits for somebody to say that poor people have to wake up and demand their share of the pie and don't none of us know what kind of pie she talkin about in the first damn place. But she ain't so smart cause I still got her four dollars from the taxi and she sure ain't getting it. Messin up my day with this shit. Sugar nudges me in my pocket and winks.

45 Miss Moore lines us up in front of the mailbox where we started from, seem like years ago, and I got a headache for thinkin so hard. And we lean all over each other so we can hold up under the draggy-ass lecture she always finishes us off with at the end before we thank her for borin us to tears. But she just looks at us like she readin tea leaves. Finally she say, "Well, what do you think of F.A.O. Schwarz?"

46 Rosie Giraffe mumbles, "White folks crazy."

47 "I'd like to go there again when I get my birthday money," says Mercedes, and we shove her out the pack so she has to lean on the mailbox by herself.

48 "I'd like a shower. Tiring day," says Flyboy.

49 Then Sugar surprises me by sayin, "You know, Miss Moore, I don't think all of us here put together eat in a year what that sailboat costs." And Miss Moore lights up like somebody goosed her. "And?" she say, urging Sugar on. Only I'm standin on her foot so she don't continue.

50 "Imagine for a minute what kind of society it is in which some people can spend on a toy what it would cost to feed a family of six or seven. What do you think?"

51 "I think," say Sugar pushing me off her feet like she never done before, cause I whip her ass in a minute, "that this is not much of a democracy if you ask me. Equal chance to pursue happiness means an equal crack at the dough, don't it?" Miss Moore is besides herself and I am disgusted with Sugar's treachery. So I stand on her foot one more time to see if she'll shove me. She shuts up, and Miss Moore looks at me, sorrowfully I'm thinkin. And somethin weird is goin on. I can feel it in my chest.

"Anybody else learn anything today?" lookin dead at me. I walk away and 52
Sugar has to run to catch up and don't even seem to notice when I shrug her arm
off my shoulder.

"Well, we got four dollars anyway," she says. 53

"Uh-hunh." 54

"We could go to Hascombs and get half a chocolate layer and then go to the 55
Sunset and still have plenty money for potato chips and ice cream sodas."

"Uh-hunh." 56

"Race you to Hascombs," she say. 57

We start down the block and she gets ahead which is OK by me cause I'm 58
going to the West End and then over to the Drive to think this day through. She
can run if she want to and even run faster. But ain't nobody gonna beat me at
nuthin.

● THINKING CRITICALLY ABOUT "THE LESSON"

RESPONDING AS A READER

1. The story is narrated from the point of view of Sylvia, though she is re-counting this story some time after the event, after the "days when everyone was old and stupid or young and foolish and me and Sugar were the only ones just right." What does this line suggest about how the narrator's perspective has changed over time? What details of the story seem to be from this older, wiser perspective? What details from the narrator's perspective as a young child?

2. What other perspectives, besides the narrator's, are introduced? What do these other perspectives add to the story?

3. Consult your reading log notes, and construct a map or outline of the plot. Since plots usually involve some kind of conflict, how would you define the conflicts that set this story in motion? What is Sylvia's initial attitude toward the outing to F.A.O. Schwartz? What is her attitude toward Miss Moore and her attempts to educate the children and refine their behavior? What is the climactic moment or turning point in the story? How do you interpret the denouement or the outcome of the plot?

RESPONDING AS A WRITER

1. Look carefully at the language of the story, particularly the use of dialect and humor. Find three or four particular passages that you find espe-cially effective, and write about what these uses of language contribute to the story.

2. How do you interpret the meaning of the title? Reread the passages in which the characters discuss the microscope, paperweight, and sail-boat. What lesson or lessons are being taught in these passages? What lesson or lessons are learned by the end of story? By whom? Use evi-dence from the text to back up your answer.

3. When Sylvia enters F.A.O. Schwartz, she feels uncharacteristically shy and ashamed. Why does she have these feelings? How are these feelings connected to the lesson or lessons she learns? •

WILLIAM SALETAN

The Elián Pictures

William Saletan is chief political correspondent for the on-line news magazine *Slate*. Previously the editor of *Hotline*, an electronic political news service, Saletan has also written columns for the *New Republic*, the *Boston Globe*, the *New York Times Magazine*, and the *Wall Street Journal*. Saletan is the author of the recently published *Bearing Right: How Conservatives Won the Abortion War* (August 2003), a book-length analysis of public discourse about abortion over the past thirty years. Published April 24, 2000, "The Elián Pictures" appeared in "Frame Game," a *Slate* column dedicated to explaining "the spin process." In this case, the "spin" involves two photographs of Elián Gonzáles that dominated the news following the forcible removal of Elián from the home of his Miami relatives.

• **FOR YOUR READING LOG**

1. Do you recall this news story? If so, briefly write about your recollections of the case and any opinions you had about it at the time. If you do not recall this news story, formulate a few questions about the case based on the sketchy details provided above.
2. Take a few minutes to glance at the two pictures analyzed in this essay (opposite and on page 352); then write a brief description of what appears to be going on in each picture. •

═══ • ═══

1 We saw the pictures on television and in the papers all weekend. The first shows a federal agent, machine gun at the ready, seizing Elián González from the home of his Miami relatives before dawn Saturday. The second shows Elián smiling with an arm around his father, Juan Miguel, hours later in Maryland. The Miami family and its supporters have used the first picture to foment outrage against the government's raid. Juan Miguel and his supporters have used the second picture to reassure the public that Elián is safe and happy. Don't believe it. Pictures, like words, can project illusions and take events out of context. Look again at each picture. Notice what it disguises and what it omits.

2 Start with the image that dominated the weekend, the picture of the Miami raid.

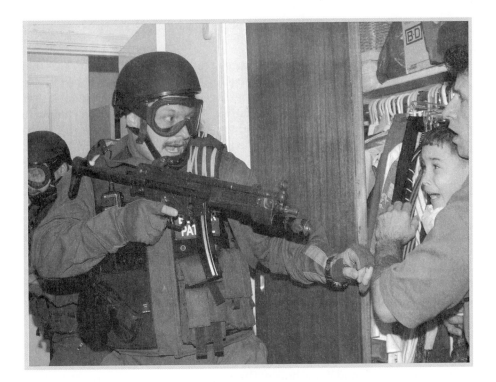

1. **Whose house is it?** "The chilling picture of a little boy being removed from 3
his home at gunpoint defies the values of America," says George W. Bush. But
that's not what the picture shows. Elián isn't being removed from his home.
He's being removed from the house in which his great-uncle and cousins,
against his father's wishes and without legal custody, have kept him. The pic-
ture doesn't convey whose house it is. Instead, by capturing Elián's moment
of terror, it suggests to the eye that the house is Elián's.

2. **Who's holding Elián?** The man holding Elián isn't his father, his cousin, or 4
even a longtime family friend. He's Donato Dalrymple, one of the fishermen
who plucked Elián out of the ocean last November. "They took this kid like
a hostage in the nighttime," Dalrymple protested to reporters after the raid.
But if Elián is the hostage in this scene, who's the kidnapper?

3. **What is Elián doing?** Sunday's *New York Times* said the picture showed Elián 5
"hiding in a closet in the arms of" Dalrymple. But the only person who's
demonstrably hiding is Dalrymple. Since Elián is in Dalrymple's arms, he has
to go wherever Dalrymple takes him. If Dalrymple had carried Elián to the
front door and presented him to the agents, Elián would have gone along. But
that wouldn't have proved that Elián wanted to leave the house, any more
than this picture proves Elián wanted to stay. It turns out, according to

Monday's *Tiimes*, that Dalrymple "grabbed [Elián] and hid in a closet, trying to protect the boy."

6 **4. How did we get here?** A picture captures a moment, omitting the events that led to it. In this case, the missing context includes months of effort by the U.S. Justice Department to get the Miami relatives to relinquish Elián to his father, a government order stripping the relatives of custody, the relatives' failure to turn over the boy, and a final, all-night negotiating session in which the relatives again dragged their feet and tried to set conditions for a father-son visit. According to the *Times*, Attorney General Janet Reno warned the relatives during the night that the time for noncompliance had run out and that if they didn't agree right away to hand over Elián, "We're going to take a law-enforcement action." The raid was the last act of the play. But it's the only act shown in the picture.

7 Even that act has been reduced to its final scene. The agents had arrived with a warrant to search the house for Elián and retrieve him. They had knocked on the door, announcing who they were and why they were there. Only after the relatives failed to respond had the agents broken into the house and entered the room where Dalrymple held Elián. None of these precautions shows up in the picture.

8 **5. What does the agent see?** It seems clear from the picture that Dalrymple is unarmed. But this seems clear only because the raid is now over and no weapons were found in the house. The agent in the picture doesn't know that. He's sizing up the situation in real time. He and his colleagues are heavily armed because Justice Department officials had heard there might be weapons in the house. They were wrong. But they weren't reckless.

9 **6. What's going on outside?** The picture shows only what is going on inside the house. Outside, a crowd of anti-Castro demonstrators that has dwindled from hundreds earlier in the evening is erupting in outrage. Federal officials say they wanted the agents well-armed in case extremists in the crowd made good on threats of lethal violence. That didn't happen, though some of the demonstrators scuffled with the agents and tried to block the door.

10 **7. At whom is the gun aimed?** Sen. Connie Mack, R-Fla., says the agent in the picture is "pointing a gun at the head of a 6-year-old boy." House majority Whip Tom DeLay says the agent is "waving a machine gun" at Elián. But the reason you can see the agent's trigger finger clearly is that it's extended *alongisde* the gun, *not* curled around the trigger. And the impression that the gun is pointed at Elián is an optical illusion caused by compressing a three-dimensional scene into a two-dimensional photograph. In the vertical dimension, Reno says the gun is pointed down, which agents call the "search position." That's not clear, but the more salient point is that in the horizontal dimension, the gun is pointed in the direction of Dalrymple rather than Elián—which is logical, because Dalrymple is holding Elián, and the agents had been warned of violence at the house and were under orders to protect

Elián. If you saw the picture on CNN Saturday morning, you had no idea the gun was pointed at anyone other than Elián, because Dalrymple had been squeezed out of the picture.

8. **Why does the agent look scary?** Many critics have cited the agent's combat [11] gear, helmet, goggles, and heavy weapon as evidence that the government used overkill. The agent's outfit and weapon certainly are intimidating—and that's the point. "A great show of force can often avoid violence," explained former Solicitor General Walter Dellinger on ABC's *This Week*. "It allowed [the agents] to get in and out in three minutes before a crowd could build up through which they might have had to fight their way out. Look again at that iconographic picture and you will see that Mr. Dalrymple . . . is stunned by the officer in his display of a weapon. . . . His jaw goes slack, his arm loses its grip, and that avoided a physical tug-of-war which could have severely injured" Elián. The momentary image is designed to look bad so that the real outcome will be good. But the picture doesn't capture the real outcome. It only captures the momentary image.

9. **Has the gun been fired?** At a press conference Sunday, an attorney for the [12] Miami relatives accused the agents of "going in with guns blazing." The picture lends credence to that charge. In fact, however, no shots were fired. The picture leaves out the key piece of information that would have dispelled this illusion: a soundtrack.

10. **Who took the picture?** Every photograph taken during a complex sequence [13] of events entails two interwoven biases. First, it conveys only the moment and image that the photographer chooses to convey. You're looking at this particular scene from this particular perspective because this is the moment at which the photographer chose to snap a picture, and this is the perspective from which he chose to snap it. Second, having immortalized these two choices, the camera, by its nature, conceals the person who made them. In this case, that person is Alan Diaz, a free-lance photographer. The *Washington Post* says Diaz "had developed a relationship with the González family and was standing nearby when the boy was discovered in the closet." The *Times* says Diaz, "was guided into the bedroom where the boy was being held" before the agent got there. The caption on the photograph, however, tells you none of this. All it says is "Associated Press." (Joshua King of SpeakOut.com has written a brilliant, thorough analysis of how Diaz got the picture and how it was composed and cropped.)

11. **What happened afterward?** According to news accounts, once the agents got [14] Elián out of Dalrymple's arms, they wrapped the boy in a blanket, whisked him outside to a van, assured him that everything would be all right, fed him, gave him toys, and took him by helicopter and plane to his father in Maryland. None of this shows up in the picture. Instead, the still photograph, carried by protesters in the streets of Miami and replayed endlessly on television, immortalizes the episode's worst moment and obscures its actual conclusion.

15 Recognizing the political damage done by this picture of the raid, Juan Miguel's attorney, Greg Craig, released a different picture of Elián, showing the boy smiling after being reunited with his father. But this picture, too, should be scrutinized.

16 **1. What does Elián know?** Craig and his congressional allies say Elián's smile proves that the boy is in good hands. But a smile doesn't prove that the person who's smiling is in good hands. It only proves that he *thinks* he's in good hands. Does Elián understand his situation? The agents who took him from Miami say that he told them he didn't want to go back to Cuba. They assured him he was only going to see his father. Does Elián understand that the U.S. government expects the courts to reject the Miami relatives' appeals to keep Elián in the United States—and that once this happens, Juan Miguel intends to take Elián back to Cuba?

17 **2. Where is Elián's mother?** The impression created by the picture is that this is Elián's nuclear family, and the woman on the left is his mother. On *Meet the Press*, Craig reinforced this impression by discussing decisions about Elián which "Juan Miguel, in consultation with his wife and family, will make." But Juan Miguel's wife, the woman in the picture, is *not* Elián's mother. Elián's mother, who was divorced from Juan Miguel, is missing from the picture because she drowned while bringing Elián to the United States. Had she been alive, she would hardly have cooperated with Craig's reassuring message. Dead men tell no tales, and dead women appear in no pictures.

18 **3. Whose house is it?** The family picture, like the raid picture, generates the impression that Elián is at home. He isn't. In this picture, he's at a house at

Andrews Air Force Base in Maryland. According to the *Post*, "A crib and children's bed had been set up in the living room, with a double bed in the bedroom. U.S. marshals had moved in next door. Several Cuban officials were present, along with a few beefy INS officers." The *Post* says, "Cuban government officials are believed to have access to" the family. The AP says Elián has been "holed up" with the family. The *Orlando Sentinel* reports that Saturday, "Only Craig, [the Rev. Joan Brown] Campbell and a small group of confidants and government officials had access to Elián and his family"; and Sunday, Juan Miguel "refused through a base spokesman to meet with" the Miami relatives. Who controls the premises? Who has access to Elián and Juan Miguel? Who has influence over them? Who gets to interpret their words and deeds? The picture glosses over these questions.

4. **Who took the picture?** In a caption, the *Post* attributes the picture to "González 19 family via AP." but the AP neither took the picture nor received it directly from Juan Miguel—much less from the "González family," a title of authenticity to which Elián's Miami relatives arguably have a better claim than Elián's stepmother does. The picture was provided to the AP by Craig. There's no evidence that Craig is allied with Fidel Castro, as some critics charge. But Craig's role is certainly open to question, since Juan Miguel obviously can't afford to pay Craig's bills. The danger is not, as the Miami relatives foolishly suggest, that the picture has been "doctored." The danger is that just as the photographer in Miami chose to capture Elián at his most terrified, the photographer in Maryland chose to capture Elián at his most relaxed.

The media and the players in the Elián saga are busy congratulating themselves 20 on their use of the pictures to convey what happened this weekend. "One of the beauties of television is that it shows exactly what the facts are," says Reno. "The two pictures . . . captured the story from start to finish," agrees a *New York Times* editor. Nonsense. Reality is one thing. Pictures are another. To confuse the two, you'd have to be blind.

● **THINKING CRITICALLY ABOUT "THE ELIÁN PICTURES"**
RESPONDING AS A READER

1. How would you characterize Saletan's tone in this essay? What features of his language—for example, the use of imperatives—contribute to this tone? What is your response to this tone as a reader?
2. Saletan uses reasoning to question uncritical interpretations of these two photographs. So, for example, in paragraphs 3 and 18, Saletan points out faulty assumptions that the seizure by federal agents removed Elián from his home or returned him to his home. The issue of whose house it is, Saletan suggests, leads to different conclusions about the emotional significance of the event. Choose three of the paragraphs in which Saletan raises questions about the photographs. What accounts for the persuasiveness (or unpersuasiveness) of Saletan's reasoning in these paragraphs?

3. In paragraph 3, Saletan quotes George W. Bush as saying of the first photograph, "The chilling picture of a little boy being removed from his home at gunpoint defies the values of America." What are these values? What American values does the second photograph invoke? What alternative values or concerns does Saletan raise in his analysis of the photographs?

RESPONDING AS A WRITER

1. Return to the initial impressions of these photographs recorded in your reading log. Based on this description, write *says* and *does* statements about each photograph. Now imagine that Saletan were writing *says* and *does* statements for each of these photographs, and write the statements as he might write them. What are the points of similarity or difference between the two sets of statements?
2. *Slate* readers are invited to write responses to the articles it publishes. For example, one reader's response to Saletan's essay began like this: "Your analysis of the raid photo was stronger than that of the family photo." Write a paragraph in which you respond to Saletan's essay, making sure you explain your response.
3. Find a recent newspaper photograph that has accompanied a major story, and pose a series of questions about the photograph using Saletan's questions as a guide. Bring your photograph and questions to class to share with your classmates. •

HEATHER WENDTLAND (STUDENT)

Rebellion Through Music

Heather Wendtland (b. 1978) wrote this essay while majoring in sociology and minoring in psychology at the University of Wisconsin–Milwaukee. After completing her undergraduate degree, she planned to apply to law school. Her assignment in a second-semester composition class was to analyze and interpret a cultural phenomenon.

● **FOR YOUR READING LOG**

1. What kind of music did you listen to in high school? Why was this music appealing to you? Did your friends share your taste in music? What were your parents' or guardians' attitudes toward this music?
2. What do you think of efforts to put restrictions on rock and rap lyrics that promote violence or make derogatory comments about various groups of people? Should such music carry a warning label? Should it

be sold only to people over a certain age? Should it be banned from the radio? Write a short paragraph in which you state your position on this issue. ●

———— ● ————

Oh, the memories of the Vanilla Nation, my group of girl friends from high 1
school! I can still remember riding around and still hear us singing Snoop Doggy
Dog's lyrics about "b*tches gettin it on" and "sippin' on the gin and juice." Un-
fortunately, though, we weren't rollin' in a six-four on Crenshaw in South Cen-
tral Los Angeles. We were cruisin' on College Avenue in Appleton in what we
lovingly referred to as the "Eggplant." It was my '92 purple Ford Taurus, and it
was forever bumpin' to the music we loved. We were what Norman Mailer
would describe as the "White Negroes" of Appleton, and I was the Vanilla
Queen. However, let it be known that none of us were what Master P would call
"Thug Girls," nor were we a gang. We were, though, a group of girls loving rap
music. But the truth of the matter was the things that we sang about in the "Egg-
plant" were never reality for us. We were all virgins, none of us drank really, we
didn't even know where to buy chronic, African Americans were scarce in our
town, and our idea of fun was going to a small truck stop for pancakes every Fri-
day and getting back late for school. The funny thing was, we still had this fas-
cination with rap and hip-hop music. We loved the stuff and ate it up like crazy,
even though we never really had a damn clue what the lyrics of rappers like
Snoop Doggy Dog, Notorious BIG, and Tupac were actually talking about. To us
it was music to dance to and interpret in our own ways.

Why did we love entertainers and songs we knew we should hate? I can 2
think of many reasons, but mainly it just felt good to know that something we
liked was bad. It felt empowering. It allowed us to express aggressive feelings
that are unacceptable for girls, and it annoyed the hell out of adults, which was
very satisfying at the time.

Both Mary Gaitskill in "An Ordinariness of Monstrous Proportions" and 3
Joan Morgan in "The Nigga Ya Hate to Love" articulate similar feelings. Specif-
ically, Gaitskill writes about her love of Axl Rose, and Morgan her love of Ice
Cube. Each explains how she found strength in the rebel's voice, despite her
recognition of all the negatives in this "inspirational" voice.

In her essay, Gaitskill discusses her attraction to two "bad boys," Brad, a kid 4
she knew in junior high school, and rock musician Axl Rose. Both, she says, let
her feel things she knew she should not. She remembers Brad as being "partic-
ularly clever and maddeningly cute" and describes Axl Rose as "obviously sexy"
(272-74). But it was not only their physical attractiveness that appealed to her, it
was their actions as well. She describes how Brad picked on special-ed students.
Even though his actions "made her sick," they gave her an intense rush and put
a certain angry energy into the air (272). Axl Rose did the same thing for her
though he "picked on" minorities and women rather than special-ed kids. Gait-
skill knew Axl's lyrics were politically incorrect, and she did not blame the

groups that he insulted for not liking him, but she could not deny how he made her feel an intense "ferocity." She saw her obsession with both Brad and Axl as "a result of a disavowal of [her own] aggressiveness and meanness" (273). Gaitskill realizes that both Axl and Brad let her express herself in an unconventional way for a woman: "I imagine that girls, even more than boys, could look at Axl Rose and feel intense delight at seeing him embody their unexpressed ferocity and thus experience it temporarily through him" (273).

5 For Joan Morgan, it was Ice Cube's lyrics that offered this sense of empowerment and vicarious expression of aggressive feelings. In "The Nigga Ya Hate to Love," Morgan explains the appeal of Ice Cube by recounting two incidents that occurred during a trip she and her friends took to ultra-white Martha's Vineyard. On the way there, Morgan and two friends were listening to Ice Cube's latest album, *AmeriKKKa's Most Wanted*. After listening to Side A, one of her friends says, "Joan, you know this m*therf*cka must be bad if he can scream b*tch at me ninety-nine times and make me want to sing it" (249). It gave us, we realized, a "sense of pleasure that is almost perverse" (250).

6 On the ferry back from Martha's Vineyard, she witnessed another kind of empowerment offered by Ice Cube's music. The situation involved "a carload of black folks behind [us] playing Ice Cube stupid loud" and "carloads of white folks looking over at the car, extremely uncomfortable" (251). In observing this scene, Morton imagines the empowerment the carload of African Americans must have felt in forcing their music upon the whites who had no choice but to listen. However, Morgan also realizes that this music is not entirely positive for the black community. She knows that calling women b*tches and celebrating the use of drugs has negative effects on the future of African Americans. Morgan sums up both points by stating, "That's the problem with unmitigated black rage. It grabs white people by the jugular with one hand, and strangles black folks with the other" (251).

7 As for my Vanilla Nation, we used the rap group Bone Thugs-N-Harmony as an outlet for our feelings. The Bone lyric used by Vanilla Nation to describe how we felt told listeners to look them in the eye and say what they could see. This idea was important to us because we wanted adults to look deeper than just our surface. At first glance they could only see our youth, color, and gender. It made us angry that those things were all they saw. All that we wanted them to do was to look into our eyes and see the truth: that under the surface we were strong and independent.

8 The Vanilla Nation felt as Morgan and her friends did when listening to Ice Cube. Even though the Bone Thugs-N-Harmony called us "b*tches," we still wanted to sing along. Ironically, perhaps, degrading women was a part of the music we listened to. To us, it was simply the music that made us want to get out there and to shake our booty and want "to get some" (even though we weren't). We knew the songs didn't send positive messages, but we still sang them anyway.

9 Similarly, the Vanilla Nation could identify with the empowerment felt by the "black folks in the carload behind" described by Joan Morgan. We have been in their situation, and it was so invigorating. It was exhilarating to know that you

were making ultra conservative white Americans listen to what they thought was complete rubbish. The best thing was they couldn't turn it off. No words can describe our complete sense of elation when we would go into an Appleton gas station and blast my Lil' Kim. It was especially gratifying when Lil' Kim would shout lyrics about "d*cks and pu**ies." To adults listening, these were especially outrageous coming from a woman. This made it even more offensive, because people have been conditioned to believe such things should never be said by women, even though they have been spoken thousands of times by a man. You could tell by their looks, which were priceless, that they felt it was unacceptable. However, to us, there was nothing that could beat the pleasure we got from putting our music out there and knowing full well that it was offending those in our presence.

It seems the Vanilla Nation, like Gaitskill and Morgan, got something out of 10 music that wasn't exactly politically correct. We loved music that degraded, knowing full well that it did so. These songs and lyrics were outlets for hidden feelings. It allowed us the five minutes of freedom that we so urgently needed. Like the chorus of rapper Mase's song "Bad Boys" says, bad, bad boys made us feel good.

Works Cited

Bone Thugs-N-Harmony. *The Art of War*. Ruthless Records, 1997.

Gaitskill, Mary. "An Ordinariness of Monstrous Proportions." *Rock She Wrote: Women Write About Rock, Pop, and Rap*. Ed. Evelyn McDonnell and Ann Powers. New York: Dell, 1995. 271–75.

Mase. *Harlem World*. MBG/Arista/Bad Boy Entertainment, 1997.

Morgan, Joan. "The Nigga Ya Hate to Love." *Rock She Wrote: Women Write About Rock, Pop, and Rap*. Ed. Evelyn McDonnell and Ann Powers. New York: Dell, 1995. 247–52.

- ## THINKING CRITICALLY ABOUT "REBELLION THROUGH MUSIC"

RESPONDING AS A READER

1. What kind of an image(s) does Wendtland create of herself and her high school group of friends, the Vanilla Nation? What details in the text serve to create this image? How do you think the adults at the gas station in Appleton interpreted the behavior of Wendtland and the Vanilla Nation? What is your response to the image(s) Wendtland creates of herself and the Vanilla Nation?

2. What does Wendtland's citation of the articles by Gaitskill and Morgan contribute to her essay? How does her use of these sources affect her authority as a writer?

3. What appear to be Wendtland's intentions in writing this essay (besides the obvious one of fulfilling her teacher's assignment)? What kind of an effect do you think Wendtland hopes her essay will have on readers?

RESPONDING AS A WRITER

1. What does Wendtland's use of profanity, hip-hop slang, and offensive language contribute to this essay? How necessary was this language or these references to her purpose in the essay? What effect would it have on the essay if she eliminated these aspects of her essay? Briefly explain.

2. Wendtland suggests that it is ironic that she and her friends found it empowering to listen to and sing lyrics that degraded women. In addition to the reasons she suggests for this irony, what other reasons can you think of for these young women's attraction to songs whose lyrics degrade women?

3. If you were a member of a peer response group, what kind of feedback would you give Wendtland to help her revise and strengthen her paper? ●

Writing to Analyze and Interpret

The selections in this chapter analyze and interpret a range of phenomena from monuments to white suburban girls' love of gangsta rap. These readings illustrate a variety of analytical strategies that can be used to shed new light on puzzling subjects: Kirk Savage uses contrasts to illustrate differing interpretations of the meaning of memorials; William Saletan asks a series of questions to suggest alternative ways of reading two photographs; and Heather Wendtland examines the causes for her past behavior. The assignments below offer opportunities to understand analytical writing more deeply by trying your own hand at analyzing and interpreting.

OFFERING AN INTERPRETATION

The essays by Neal Gabler and Sarah Boxer in this chapter aim to complicate readers' understanding of ordinary words and everyday experiences. Write an essay that uses analysis and interpretation to challenge and extend your readers' understanding of a familiar abstract term or cultural phenomenon that they may take for granted or misunderstand. Neal Gabler, for example, analyzes and interprets the meaning of *celebrity* in contemporary culture. Similarly, you might write about the various meanings of *patriotism* since 9/11 or the meaning of the term *reality* as it applies to the reality shows on television. Or you might use Sarah Boxer's discussion of scholarly interpretations of shopping as a social and economic phenomenon as a model for writing about a recent technological development that has implications beyond the obvious and predictable.

EXAMINING RHETORICAL STRATEGIES

Choose one of the essays in this chapter, and note the strategies the author uses to analyze and interpret. How does she or he "take apart" the subject and how

does this taking apart lead to various conclusions regarding it? What assumptions or perspectives inform the author's interpretation? What appears to be the author's purpose in writing this interpretation and to whom is this interpretation directed? How effective is she or he in accomplishing this purpose?

EXTENDING THE CONVERSATION

In "The Past in the Present," Kirk Savage argues that memorials do not function the way many observers (for example, Pierre Nora) think they do. Indeed, multiple perspectives on memorials often result in considerable controversy. Designs for memorials in Oklahoma City and at the World Trade Center have provoked wide discussion, for example. Objections to the starkness of the wall of names at the Vietnam Veterans Memorial in Washington, D.C., led to the addition of a statue of three servicemen and the Vietnam Women's Memorial. Choose one of these or another local or national memorial that has been controversial and research the debates about its design and reception. What issues were or are at stake? Possibilities include the design, location, message, or objects of commemoration. Explain for whom these were important issues—perhaps the families of those memorialized, members of the surrounding community, or the public at large. Connect your interpretation and ideas to those of Savage and/or other cultural critics (his citations might provide a starting point), and write a paper that analyzes and interprets this memorial and the cultural work it performs.

CHAPTER 12

Taking a Stand

The authors you will read in this chapter want to change your mind—unless you already agree with them. They seek to demonstrate the superiority of their views and the flaws in competing views. Their technique is argument, the presentation of claims supported by reasons and evidence. Their arguments move forward on the basis of assumptions that the authors believe they share with their readers. To enhance their readers' identification with these assumptions, the authors choose rhetorical strategies intended to emphasize their own authority and to engage readers' values and emotions. Some of the authors attempt to soothe readers' responses by qualifying their claims. Others try to persuade readers by focusing on what's wrong with the opposition's claims.

These writers want their readers to adopt their viewpoint and reject opposing ideas. Readers must decide whether to agree. From the perspective of rhetorical reading, however, mere agreement is not the only matter at stake. How the argument is constructed—its reasoning, its authority, its appeal to readers—must be examined as part of determining an argument's effectiveness. Rhetorical reading goes beyond the simplified "yes-no" binaries that grab headlines. For college students, and for college graduates in the workplace and public sphere, the intellectual work of reading arguments entails analysis of the rhetorical strategies at work in a given text. As politicians and marketing executives can tell you, there's much to be learned from a well-made argument voiced by the competition.

In your academic work, you will be expected to distinguish good arguments from flawed ones by analyzing not just the arguments' content, but their

methods. In this chapter we present concepts of argumentation that will allow you to perform this kind of analysis, analysis that will make your reading skills more productive as well as give you a persuasive edge in your own writing.

Texts that take a stand attempt to reconstruct a skeptical reader's image of the subject matter. As readers, if we are to make an intelligent decision about whether we will let new ideas replace our previous ideas, we must read carefully and critically. We must analyze the structure of the arguments and recognize the authors' persuasive methods. We must evaluate the authors' claims to authority, examine the reliability and relevance of their supporting evidence, and scrutinize the reasoning that binds an argument together. We must consider both explicit claims and implicit assumptions. We must read with a critical awareness that allows us to pinpoint exactly what is at issue not just from the arguer's perspective, but from the perspective of others who have a stake in the matter, who may disagree.

You might reasonably ask how the selections we label in this chapter as "texts that take a stand" are different from those in the earlier sections of this anthology. After all, you might say, every author, no matter the specific occasion and purpose, seeks to convince readers of the validity of his or her own perspective. You would be making a good point. In the eyes of many experts, all written texts constitute at least an implicit argument. Indeed, in the thesis-driven context of academic writing, the verb "argue" is commonly used to refer to a wide variety of writing, even when the specific aim is primarily explanatory or analytical and nothing particularly controversial is involved.

What we feature in this chapter, however, are texts in which a persuasive aim dominates. The authors here and in the chapters that follow on special types of arguments (evaluations and proposals) address subjects that are recognizably in dispute; they have the direct intention of persuading readers to see the given subject their way. These writers' claims and the reasoning that supports them extend beyond explaining subject matter. They take up questions on which the public or a given segment of it has not been able to agree. The views of their intended audience govern their rhetorical decisions. These authors expect their readers to resist, and so they engage them as people who need to be convinced. They want to change our minds.

For the careful rhetorical reader, the question is, does a given author succeed? Will your mind be changed? What makes a particular argument successful, or not?

Argument and Public Life

Although we have pointed out that writers of arguments anticipate resistance and so work to counter opposing views, we must hasten to point out that the exchange of arguments through reading and writing is ultimately not a matter of winning or losing but a process of seeking truth in situations where reasonable people disagree about what constitutes "truth." In fact, competing arguments provide a means of inquiring into the best way to understand these situations and to choose the best course of action to resolve them. The goal of argument may be best understood not as competition but as cooperation.

We are using the term *argument* to signal concepts more complex than simple "yes-no" disputes. Not every disagreement represents a genuinely arguable issue. People frequently disagree over matters that depend simply upon personal preferences. Coke or Pepsi? Alternative or country? Classical or jazz? You and your friends or family may disagree, perhaps intensely, but your preferences have little impact on others. Agreeing to disagree, you move on. Arguable issues, in contrast, extend beyond the personal. They arise when members of a community must decide how to address a question of common concern but are faced with more than one reasonable response. Rhetoric, the art of persuasion, developed in ancient times precisely because human beings constantly confront situations in which certainty about the best belief or action is not possible but decisions must nevertheless be made about how to proceed. These discussions about finding the best course of action to take, known as *deliberative arguments*, typically depend not on determining empirical truth but on using reasons and persuasion to negotiate differences and contingencies. Finding the best options, in other words, is a rhetorical matter, and often a task for argumentation.

The argument texts in this chapter take a stand by asserting positions on issues that are part of ongoing deliberations about how public life is best understood and managed. If everybody agreed on everything—which accomplishments are most praiseworthy, which policies will foster the greatest good, and how occasional disputes should be adjudicated—civic arguments would be rare. But human beings do not live in circumstances of certainty. As even a quick glance at a newspaper will tell you, perceptions vary, resources are limited, interests compete, values clash. From neighborhoods to international treaty organizations, humans must deliberate over options and make decisions together. Whether the decision concerns funding for a new community library or ethical use of new biological technologies, there's bound to be disagreement.

Indeed, many political theorists have argued that dissent is essential to democracy. The outcome of the resulting deliberative process will depend on who is persuaded by what set of claims and counterclaims. Politicians give speeches, editors write editorials, pundits debate, columnists write op-ed pieces, citizens write letters to the editor. We read, think, discuss, listen, argue back. Advocates take stands and try to convince others to join them. Eventually, elections are held, court cases heard, decisions made. Then another round begins as the effectiveness of those decisions comes under scrutiny.

Why Should You Agree? Claim, Reason, Evidence, and Assumption

The basic frame of any argument is a claim and a reason (sometimes called a *subclaim* or a *premise*). This frame and the way that a given writer elaborates it into a network of reasoning constitute an argument's *logos*, its logical power. What makes the logos of an argument convincing is the way that its elements are connected with each other. To evaluate the effectiveness of an argument and determine whether it earns your assent, you need to analyze how all its components

work together. What follows is a description of the four major components of an argument's *logos* along with a key analytical question that will help you pinpoint each of them within a text.

- **Claim:** The point being argued, the author's answer to the question at issue. *Ask, "What's the main point, the one toward which everything else builds?"*
- **Reason** (sometimes called a *premise*): A subclaim that links the evidence to the main claim, usually with a logical conjunction such as "because." *Ask, "Why is the central point here said to be true/a good idea?"*

 Persuasive arguments are likely to offer several different reasons in support of their claim. Some reasons can be immediately supported with evidence. For example, if we said, "Reject this proposal for expanding the town library because it will be extremely costly," we could immediately provide data about the costs without confusing our audience. Other reasons depend for their support on still other reasons. For example, if we said, "We should legalize drugs because doing so will get the government out of our private lives," we would have to make further arguments about how such legalization would get the government out of private lives and why that would be a good thing.

- **Evidence** (sometimes referred to as *grounds* or *data*): Factual support that provides the particulars, details, and specifics to validate the reason. *Ask, "What empirical information is presented to support this claim and reason?"*

 To evaluate evidence, consider these five criteria: Is it sufficient, typical, accurate, current, and relevant. Regarding the point above about the high cost of the library, we would need to evaluate the data about costs. For the point about legalizing drugs, we would need to evaluate the idea that legalizing drugs would get the government out of our private lives, and, perhaps, examine evidence that the government is, in fact, in our private lives, or that its involvement in our lives is a function of drug laws. Clarification is called for.

Whether the evidence and reason adequately support a claim depends on the reader's acceptance of the next element:

- **Assumption** (sometimes referred to as *warrant*): The stated or unstated values and beliefs that authorize the given reason and demonstrate the connection between the evidence and the claim. Assumptions may be explicitly stated and argued for or left unstated under the presumption that the audience already holds these values or beliefs. *Ask, "What values or beliefs are being asserted here as a bridge between evidence and claim?"*

 The library example above clearly assumes that cost should be the determining factor in a decision about the project. Supporters of the library project may forward counterclaims that other factors are more important than cost, but the assumption that drives the given argument is clear. If the writer suspected that some readers would not put first priority on cost,

then he might devote part of his argument to the importance of cost. The second example assumes that getting the government out of our private lives is desirable and is of paramount consideration regarding the legalization of drugs. For most readers, the logic of this assumption would need to be argued. (Statements that elaborate on or otherwise support an argument's basic assumptions are sometimes called *backing*.)

In your analysis of arguments, you will need to consider several additional factors beyond *logos* that influence the persuasiveness of a claim and its support. You should examine the dynamics of *ethos*, the ways in which the writer seems credible and gains the reader's trust, and *pathos*, the ways in which the writer engages the presumed audience's interests, emotions, and imagination. You should also examine how the writer handles opposing cases, a place where *ethos* and *pathos* may be particularly revealing. Are known and potential objections to the argument summarized and countered fairly? Does the author appropriately qualify or limit the scope of the claims? ("*Unless* other funding sources become available, this library project is too expensive.") Does the author concede that the opposition has raised valuable points? ("*While it is true that* the existing library facility is inadequate, the current plan goes well beyond what is necessary to solve the problem.")

The extent to which a given claim needs evidence to support its reasons, backing to support its basic assumptions, or both, will depend upon the subject matter, the context in which the argument is articulated, and the presumed audience's attitude toward the subject. To illustrate, let's move to a practical situation, family members shopping for a new car. The decision-making process they face provides us with a homespun example of the deliberative arguments so common in public discourse. With one child in college and another graduating from high school next year, everyone agrees that low cost should be the deciding factor, so attention turns to the evidence about cost, which seems to give the nod to Car A. However, the family financial whiz contends that this car, although lower in purchase price, will be more expensive to insure and maintain than Car B. Then circumstances suddenly change. One of the grandparents receives a windfall commission for a special project and offers it for the car purchase. Now the initial cost is no longer a major concern. Cars A and B are no longer at the top of anyone's list, and the basis for the decision is in dispute because the family members no longer share the same assumptions about which criteria should apply. One parent contends that safety is primary; the other argues that comfort on long trips to two different college campuses must be considered. Meanwhile, the college student suggests that commitment to minimizing environmental impact means they should buy one of the new hybrid cars, and the high school student advocates for a sporty-looking car that will be easy to park. These criteria point in very different directions and are not as easily compared or reconciled as cost estimates are. Before they can decide what car to buy, this family must negotiate among the competing beliefs and values so that they can agree upon criteria for selecting the new car.

What's Really at Issue?

For rhetorical readers, a key element of argument analysis is identifying the way advocates phrase not only their claims, but the questions—explicit and implicit—that they intend those claims to answer. It's evident that arguments arise because different parties answer questions differently. What is often less evident is that the parties presenting opposing arguments may have quite different understandings of what is at issue. They are mounting arguments that answer different questions. Yet, as the changing situation of our car-shopping family suggests, the shape of an argument depends in major ways on how an issue is defined. Conflicts that arise because of opposing interests and limited resources are familiar to us all, from childhood squabbles over toys to major labor strikes caused by the difficulty of reconciling workers' desires for higher pay with management's desires to hold costs down. However, even when a goal is agreed on, everything from fundamental values to the details of procedures may eventually be contested. People who share the same values may nevertheless disagree about policies or procedures because they cannot agree on how to translate those values into practical actions or on how to gauge the consequences of a particular course of action. (See, for example, the conflicting views about the effects of a law requiring trigger locks in Kathleen Parker's two op-ed columns in this chapter.) In a still more difficult matter, consider the complexities of trying to establish guidelines for the ethical use of new genetic technologies. What constitutes "ethical" use? Who should establish guidelines? Who should be included in the agreement process? Would the guidelines be legally binding? Who has the authority to make them so? Which technologies would be covered? Would there be an appeals procedure? Each question opens the floor to new claims and counterclaims as conflicts over resources, interests, and values come into focus.

Classical rhetoric offers us a set of conceptual categories for analyzing the ways in which questions are posed and issues defined. These categories, known as the *stases*, are defined by the type of issue that separates disputants in an argument. The word *stasis*, derived from the Greek word *stand*, indicates the point at which agreement comes to a halt. Although originally used as a way to "invent" or find and develop arguments, these categories offer modern readers an equally powerful tool for analyzing the claims in arguments they hear or read and discerning what issues lie at the heart of a given controversy. For example, the family shopping for a car initially faced a question in the *stasis of fact*: Which car would be the most economical? When the family's financial situation changed, the type of claims competing in their deliberations changed as well, from factual claims about economy to claims about comfort, safety, and style that can be categorized in the *stasis of values*. To reach a decision, the family had to decide which of those values claims offered them the greatest good.

In Table 12.1 we present the six stasis categories that we consider to be the most useful for the critical analysis called for in college reading assignments. These categories will serve to guide your analysis of the argument texts in this chapter and in other classes as well. To illustrate the differences among the

TABLE 12.1 • WHAT KIND OF QUESTION IS AT ISSUE? USING STASIS CATEGORIES FOR ARGUMENT ANALYSIS

Sample Argument Issues			
Is Y guilty of Z's murder?	How safe is our municipal water supply?	Should children under 12 be required by law to wear bicycle helmets?	To protect children from Internet pornography, should we place content filters on Internet terminals in public libraries?
Stasis of Fact: Does X exist? Did X occur?			
Did Y kill Z?	What pollutants are present in the drinking water?	What is the evidence that bicycle helmets save lives and prevent injuries?	Do children access pornography via library computer terminals?
Stasis of Definition: What kind of thing is this? What category of things does it fit? What does the category label mean?			
Y did kill Z, but was it murder? Self-defense? An accident?	What kind of pollutants are "safe" or "unsafe"? What do "safe" and "unsafe" mean in this case?	Is the wearing of bicycle helmets a "government matter" or a "private matter"?	Does limiting public access to the Internet through library computer terminals equal "censorship"? Is access to information equal to free speech? Does limiting access to information violate librarians' definition of their responsibilities? What is "pornography"?
Stasis of Cause or Consequence: What caused this thing? What will happen because of it?			
What, specifically, caused Z's death?	What is the source of unsafe pollutants? What effect will they have on human health? In what concentration? How much will it cost to get rid of them?	Would a bicycle helmet law significantly reduce injuries? What would enforcement cost? Will poor children have to stop riding bikes because they can't afford helmets?	How effective are the available filtering technologies? Will they actually block pornography without blocking valuable information? Will limits on one kind of information lead to limits on other types? Do limits on access threaten democracy?

Stasis of Interpretation, Including Similarity and Analogy: What does this mean? What is it like that we already understand?

How do we understand the interactions between Y and Z before the death? Was Z threatening Y?	How reliable is the data interpretation in the tests for these pollutants and their effects?	Is the bicycle helmet safety issue more like automobile seat belts (a public matter already covered by law) or more like nonskid strips in bathtubs (a private matter)?	What makes a given piece of material "pornographic"?

Stasis of Value: Is this thing good or bad?

Was Y's killing of Z justified?	How bad (dangerous) are the pollutants? Can we tolerate a certain level of contaminants in the municipal water supply?	Does the value of reducing children's injuries outweigh the value of keeping government out of people's private lives?	Does free access to information have value equal to free speech? Does that outweigh the value of protecting children from pornographic Internet sites?

Stasis of Policy and Procedures: What should be done? How should it be done? Who has the authority to do it?

Y is a diplomat. Can he be tried in a U.S. court?	The major sources of the pollution in our drinking water are in another state. Who has the authority and the ability to address the problem?	How will a bicycle helmet law be enforced?	How would a filtering law be implemented and enforced? To whom should concerned parents speak about their library's Internet policy?

stasis categories, the table provides generic questions that define each stasis. To illustrate how the stases can generate lines of inquiry useful for both analyzing and developing argument claims, the table lists specific sample questions that apply each stasis category to the four controversies listed at the top. These specific questions demonstrate how the stases can be applied, but by no means cover all possibilities for developing an argument relevant to the issues listed. You will undoubtedly be able to think of additional questions and claims. As you examine the table, consider how certain questions are more likely to be raised by advocates on one side of an issue than on another.

As the sample questions illustrating the stasis categories in Table 12.1 suggest, significant controversies will involve claims and counterclaims in more than one category. In fact, some experts consider the categories to be progressively inclusive because claims in one stasis typically depend on claims in a stasis preceding it. Questions of evaluation and policy, in particular, depend upon prior claims related to definition, consequence, or interpretation, and claims in these categories depend on the ones preceding them. Definitions usually depend on facts, for example; causes and consequences typically determine how the meaning of a phenomenon is interpreted. In turn, agreement and disagreement about definitions, consequences, and interpretations all play a role in questions about the extent to which something should be valued as good or bad. Finally, answers to questions in all of the first five categories play important—and perhaps competing—roles in decisions about how to proceed.

One cause of disagreement among disputants in a controversy is that various voices in the conversation focus on different stases so that all the disputants can't be clearly lined up as "pro" or "con" on an issue. For example, in the sample controversy of whether the state should require that children under twelve wear bicycle helmets, one person, believing strongly in the safety value of helmets, might spend an entire argument providing evidence that wearing helmets would prevent many serious injuries and save lives. Someone else might oppose the law even though she agrees that wearing helmets is important for safety. This person might believe that the government has too many rules and regulations and hence argue that wearing bicycle helmets is purely a private matter between children and their parents. These two arguments don't speak to each other at all. The first disputant is arguing a stasis of fact (wearing helmets can prevent injuries). The second disputant is arguing a stasis of definition. (What constitutes "public matters" in contrast to "private matters"? According to this person's definition of "public concern," the government doesn't have jurisdiction to force kids to wear bicycle helmets any more than it has jurisdiction to make them eat their vegetables.) Still a third person might oppose the proposed law by focusing on a stasis of consequence, that the law is unenforceable. (Passing this law would put police in the impossible situation of having to card kids—"Are you twelve, sonny?"—and then fine their parents.)

When opponents define the issue so differently that they do not even address, perhaps even perceive, each other's concerns, controversies persist and become intractable. You and your classmates can undoubtedly think of a num-

QUESTIONS TO HELP YOU READ
ARGUMENTS RHETORICALLY

The list of questions below summarizes the advice provided in this chapter about analyzing and evaluating argument texts. Choose relevant questions to guide your analysis for both discussion and writing.

1. What question is this argument addressing? What kind of question (stasis) is it?
2. What is the central claim?
3. How is the claim supported with reasons and evidence? What are the basic assumptions about values and beliefs on which this argument depends?
4. Evaluate the evidence. Is it sufficient? Relevant? Reliable? Timely (in relation to the date of original publication)?
5. What point(s) does the author seem to think provide the strongest support for the argument's central claim? Do you agree?
6. How are opposing cases handled? Consider (a) what the author seems to think are the strongest and weakest point(s) for the opposing cases, (b) whether the opposition is treated fairly, and (c) whether appropriate qualifiers and concessions are used (not necessary in every argument).
7. How does the author establish his or her authority on this subject? What specific qualities of arrangement and style create *ethos* here? Which are the most engaging or off-putting? (See Chapter 4 for additional discussion of *ethos* and *pathos*.)
8. What specific qualities of the piece did you find engaging or off-putting? What assumptions does the author seem to be making about the concerns and views of the intended audience for this argument? How would you describe this author's use of *pathos*—the strategies used for appealing to these readers' emotions and imaginations?
9. Overall, how has your mind been changed by this argument? How convincing was it? What are your reservations? Try to pinpoint places in the text where you resist or grant assent to the writer's claims.

ber of policy debates that boil down to stand-offs such as rights versus values, safety versus freedom, or environmental preservation versus economic expansion. Readers trying to understand the complexities of such debates must recognize not just the major claims on each side but what those claims, and the defining questions to which they respond, reveal about what the opposing parties perceive to be at the heart of the issue.

THOMAS L. FRIEDMAN

Eastern Middle School

Thomas L. Friedman (b. 1953), who has worked for the *New York Times* since 1981, is one of the best-known foreign affairs correspondents in the United States. He has won three Pulitzer prizes, two for international reporting (from Beirut, 1983, and from Israel, 1988) and one for commentary (2002). The current selection was published in the *Times* on October 2, 2001, just three weeks after the September 11 attacks, and the next day in newspapers across the country that subscribe to the *Times* syndication service. Friedman's 2002 Pulitzer citation reads, in part, "for his clarity of vision, based on extensive reporting, in commenting on the worldwide impact of the terrorist threat." His most recent book, *Longitudes and Attitudes: Exploring the World After September 11* (2002), collects his twice-weekly columns for the *Times* between December 2000 and July 2002, including this one. Two earlier books have also received major recognition: *The Lexus and the Olive Tree: Understanding Globalization* (2000) and *From Beirut to Jerusalem* (1989), which won the National Book Award. He was living in suburban Washington, D.C., and serving as chief diplomatic correspondent for the *Times* when he wrote this column.

● **FOR YOUR READING LOG**

1. Have you ever attended a parents' night at school, either as a student or as a parent? What was it like? Freewrite for a few minutes about remembered details and feelings. If you've never attended such an event, freewrite instead about what others have told you or you have surmised about these occasions.

2. Where do you get most of your news and understanding about events in the Middle East and about the war on terrorism? Write a paragraph or so about the news sources you do and do not trust and the overall impression they give you of America's role in the Middle East. If you have read more than one or two of Friedman's columns, include some comments about his work. ●

———— ● ————

1 I recently attended meet-the-teacher night at Eastern Middle School, my daughter Natalie's school in Silver Spring, Md. The evening began with the principal noting that Eastern, a public school in suburban Washington, had 40 different nationalities among its students. Before the teachers were introduced, the school's choir and orchestra, a Noah's ark of black, Hispanic, Asian and white kids, led everyone in "God Bless America." There was something about the way those kids sang together, and the earnest, if not always melodious, way the school orchestra pounded out the National Anthem, that was both moving and soothing.

As I took in the scene, it occurred to me how much the Islamic terrorists who just hit America do not understand about America.

Their constant refrain is that America is a country with wealth and power 2 but "no values." The Islamic terrorists think our wealth and power is unrelated to anything in the soul of this country—that we are basically a godless nation, indeed the enemies of God. And if you are an enemy of God you deserve to die. These terrorists believe that wealth and power can be achieved only by giving up your values, because they look at places such as Saudi Arabia and see that many of the wealthy and powerful there lead lives disconnected from their faith.

Of course, what this view of America completely misses is that American 3 power and wealth flow directly from a deep spiritual source—a spirit of respect for the individual, a spirit of tolerance for differences of faith or politics, a respect for freedom of thought as the necessary foundation for all creativity and a spirit of unity that encompasses all kinds of differences. Only a society with a deep spiritual energy, that welcomes immigrants and worships freedom, could constantly renew itself and its sources of power and wealth.

Which is why the terrorists can hijack Boeing planes, but in the spiritless, 4 monolithic societies they want to build, they could never produce them. The terrorists can exploit the U.S.-made Internet, but in their suffocated world of one God, one truth, one way, one leader, they could never invent it.

Lord knows, ours is hardly a perfect country. Many times we have deviated 5 from the American spirit or applied it selfishly. But it is because we come back to this spirit more times than not, in more communities than not, that our country remains both strong and renewable.

Why can't we convey that? In part, we're to blame. President Bush deni- 6 grated Washington during his campaign and repeated the selfish mantra about the surplus that "it's your money—not the government's money." How thankful we are today that we have a Washington, D.C., with its strong institutions—FEMA, the F.A.A., the F.B.I., and armed forces—not to mention a surplus to help manage our way out of this crisis.

In part we don't talk about these issues so we don't embarrass our autocratic 7 allies in the Middle East. But this negative view of America as a nation that achieved wealth and power without any spiritual values is also deliberately nurtured by governments and groups in the Middle East. It is a way of explaining away their own failures to deliver a better life for their own people: The Americans are powerful only because they stole from us or from others—not because of anything intrinsically spiritual or humane in their society.

A society that will dig until it has found every body in the World Trade Cen- 8 ter rubble—because at some level it believes every individual is created in the image of God—a society that raises $600 million for the victims in two weeks, is a godless, spiritless place? Guess again.

These terrorists so misread America. They think our strength lies only in the 9 World Trade Center and the Pentagon—the twin pillars of our wealth and power—and if they can just knock them down we'll start to fold: as if we, like them, have only one truth, one power center.

10 Actually, our strength lies in the slightly dilapidated gym of Eastern Middle School on parent-teacher night, and in thousands of such schools across the land. That is where you'll find the spirit that built the twin towers and can build them over again anytime we please.

11 So in these troubled times, if you want to feel reassured about how strong this country is, or what we're fighting to preserve, just attend a P.T.A. meeting. It's all there, hiding in plain sight.

● **THINKING CRITICALLY ABOUT "EASTERN MIDDLE SCHOOL"**

RESPONDING AS A READER

1. To what question is this argument responding and taking a stand? Is it the same question throughout, or does it evolve? How? What is your response to the stand Friedman takes? How did your response develop?

2. Friedman appeals to *logos*, *ethos*, and *pathos* at different places in the text. Find examples of each and consider how they work. Which is strongest? How do they interact with each other?

3. Friedman's reputation, along with that of the *New York Times*, gives him an enormous audience, from the very local—other parents at Eastern Middle School—to the global—ambassadors and heads of state worldwide. His regular readers include Washington's diplomats and policymakers, and, undoubtedly, terrorists. Examine the text closely to speculate about the readers to whom various paragraphs would speak most directly, paying particular attention to places where he concedes and qualifies points. Note textual evidence to support your hypotheses.

RESPONDING AS A WRITER

1. "Eastern Middle School" is the original headline on this column in the *Times* and in *Longitudes and Attitudes*. As is customary with syndicated columns, the *Milwaukee Journal Sentinel* reprinted it with a new headline: "Great Satan? Terrorists Misread America's Soul." The two newspapers' headlines orient readers to the text in very different ways, establishing expectations that frame the reading experience much as a visual element might. Which do you prefer? Why? Now try your hand at your own headline for the column, endeavoring to capture your experience of it now, some years after September 11.

2. How would you describe Friedman's style in this piece? What kind of persona does he create for himself? How does he assert authority? How does he reach out to readers? Would you "listen" as carefully if you didn't know his reputation? Why or why not?

3. What has Friedman left out? What would you want to add? What kind of rebuttal would you want to make? Your response now might be different than it would have been in early October 2001. If so, how is it different, and how do you explain that? ●

Tom Tomorrow

How Far Is Too Far?

Dan Perkins adopted the pen name Tom Tomorrow when he began publishing his cartoons in the San Francisco alternative zine *Processed World* in 1984. He focused initially on consumerism and the world of work, but "This Modern World"—sometimes referred to as a "seriocomic" cartoon—is now best known for political satire. It appears weekly in approximately 150 newspapers in the United States as well as regularly in the *American Prospect* and *Salon*, and he has published other strips in magazines that range from the *New Yorker* to *Spin*. Perkins/Tomorrow's Website biography (www.thismodernworld. com) lists a number of awards for journalistic excellence, especially in regard to commentary about social justice and freedom of information, including the 1998 Robert F. Kennedy Journalism Award for Cartooning. He has six books of cartoon collections in print, the most recent of which is an oversized career retrospective, *The Great Big Book of Tomorrow* (2003). According to *Editor and Publisher*, Perkins designs his strips with a collage approach, combining his own art work with photocopies of 1940s and 1950s advertisements and contemporary photographs. "How Far Is Too Far?" first appeared on March 11, 2003, as the United States was preparing for war in Iraq.

● **FOR YOUR READING LOG**

1. Before you read the cartoon in detail (see Figure 12.1 on the next page), take a quick glance at its overall visual quality. What mood or flavor does the strip convey? Freewrite for a few minutes about your first impressions of the artwork.
2. If you have encountered Tom Tomorrow previously, freewrite for a few minutes about your attitude toward the strips you've seen. If this work is new to you, freewrite about what you expect of the strip in terms of content and attitude. ●

━━━ ● ━━━

● **THINKING CRITICALLY ABOUT "HOW FAR IS TOO FAR?"**

RESPONDING AS A READER

1. The cartoon's visual layout divides each frame in two and emphasizes the split with the contrast of white-on-black lettering with black-on-white. Within each frame, the verbal content is presented as a conversational exchange. How do these exchanges and frames combine to establish a flow from beginning to end? What role do they provide for you as reader?
2. Trace the way the words and pictures of "How Far Is Too Far?" drew you in, and describe places where you found yourself resisting. At what point did you feel that you "got it"—that is, "got" the cartoonist's point

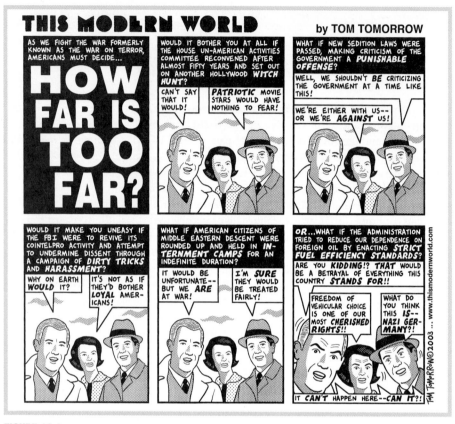

FIGURE 12.1

and purpose? If you hadn't already known to expect satire, at what point in your verbal and nonverbal reading of this strip would you have realized that the words are not meant to be taken literally?

3. Not all humor is laugh-out-loud humor, and satire can make readers uncomfortable; indeed, satire's purpose is to poke fun at foibles and inconsistencies. Did you find "How Far Is Too Far" funny? In what ways? It's likely that there will be disagreement among you and your friends or classmates about how funny this cartoon is. Through discussion, see if you can ascertain what differences in perspective account for differing responses. Try to pinpoint elements of the text to which you and others have strong responses, whether similar or different.

RESPONDING AS A WRITER

1. What is the core argument that Perkins/Tomorrow is making in this cartoon? In what way or ways is he taking a stand? Try making an outline of the cartoon's reasoning, that is, its claims, reasons, and assumptions. What about evidence? What role does the reader play in the making of this argument? Are we merely observers?

2. What openings does Tomorrow/Perkins leave for opposing views? Does he concede any weaknesses in his position? If you wanted to take issue with him, where do you think your best opening would be? How would you take advantage of it to counter his point(s)?

3. "How Far Is Too Far?" is full of implicit and explicit allusions to historical events, cultural concepts, and verbal phrasings that, it seems, readers are expected to recognize. Make as long a list as you can of allusions you find in the cartoon, collaborating with classmates as your teacher directs. Which allusions are obvious and which are subtle? Which allusions are the most and least important to understand in order to appreciate the cartoon? ●

KATHLEEN PARKER

About Face

Kathleen Parker (b. 1951) began her twice-weekly column in 1987 when she was writing for the *Orlando Sentinel*. It has been in syndication with Tribune Media Services since 1995. Her writing focuses on issues related to family, children, and gender, typically from a political perspective that is to the right of center. On her Website (http://www.kparker.com/about/aboutframeset.html), she sums up her goals for writing this way: "My criteria for a column idea is that the subject alter my body temperature. I don't cover beats so much as I try to apply common sense to everyday issues that apply to us all." The two op-ed columns presented here, in which Parker first supports then opposes government-mandated trigger locks, were published three days apart. The first commentary appeared in the *Milwaukee Journal Sentinel* on Sunday, March 5, 2000, less than a week after a six-year-old boy in Michigan killed a first-grade classmate with a handgun he had found in the house where he was living temporarily without his parents. The paper published the second column on March 8.

● **FOR YOUR READING LOG**

1. Before you read either of these columns, spend some time freewriting about your ideas concerning trigger locks. Should their use be required by law? Why or why not? If you don't have a position on the matter, consider and write out the questions you would want answered before you could decide on a position.

2. As indicated in the titles and headnote, the first of Parker's columns advocates government-mandated trigger locks and the second reverses that position. Before you read, try to predict her primary reasoning in each case. Given the context of the shooting death to which she is responding, what reasons and assumptions do you predict Parker uses in the first column to support her advocacy of trigger locks? Given what you know of

other arguments for and against gun control and trigger locks, how do you expect her reasoning to change in the second column? ●

———— ● ————

For Starters, We Can Require Trigger Locks

1 Another shooting, another child dead, another round of debate. This time, the age and innocence of both victim and shooter push the limits of rational thought.

2 Unlike previous school shootings, all too familiar now, there's no easy target for our contempt. No cult to despise, no black trench coat to repel, no pattern of weird behavior to suggest we should have known. Just two little kids, caught in the crosshairs of an accidental moment.

3 One of them, Kayla Rolland, 6, is dead. The other, a 6-year-old boy whose name had not been released at this writing, is in the custody of a relative.

4 Last week's tragedy at Buell Elementary School near Flint, Mich., poses more questions than answers. Foremost, where does one place blame? Can we blame a first-grader who comes to school with a loaded gun he found on the floor of his home? Can we blame a school for not checking the book bags of children just four years out of diapers? Can we blame parents for not being good enough parents?

5 You bet we can blame parents, and we should. We also should blame anyone who opposes the simplest of precautions against such tragedies, such as trigger locks on handguns. Locks aren't a cure, but they're the least we can do to protect children from the adults who pretend to be their parents.

6 I realize the world is full of slobs, and most of them are engaged in procreation. There's not much we can do about that fact, absent a dictatorship and parental licensing, an increasingly attractive option—as long as I get to be dictator.

7 But there is something we can do about parents who refuse to behave responsibly and to take charge of their progeny.

8 Early reports suggested that the shooter was himself a victim, the offspring of a chaotic home and drug culture. He lived in a "flophouse" with his mother, a man known as an uncle and a younger sibling.

9 The gun he brought to school had been reported stolen in December. Investigators also found a stolen 12-gauge shotgun in the boy's home.

10 So these are not the Cleavers or the Huxtables or even the Simpsons. A product of such a home predictably will wind up on a rap sheet one of these days. Better that he steal a car at 16 than kill a classmate at 6.

11 But there you have it. No amount of understanding, compassion or empathy will bring peace to Kayla's parents or to the millions of others who rightfully fear sending their children to school. The time for punitive action against parents is overdue. Someone has to step up to the plate and be held accountable for this child sacrifice.

12 Prosecutors say they'll seek involuntary manslaughter charges against the man they say once had the gun.

Any adult who leaves a weapon around for a young child to take to school is negligent, no yes-buts. Adults may be unable to prevent older children from procuring firearms, either through theft or purchase (Columbine killers Dylan Klebold and Eric Harris come to mind), but a half-witted monkey can keep a pistol from a 6-year-old. If you have guns, lock them up.

When someone dies because you didn't properly tend to home and child, you bear a responsibility.

Regardless of how the judicial system resolves the issue of culpability in this case, we can immediately insist on trigger locks for all firearms, especially handguns. To accept anything less is irresponsible and a crime against common sense, for which we all share blame.

Revisiting the Issue of Trigger Locks

Quick, somebody sell me a bridge over the Sahara before I grow a brain.

I don't know how to explain my recent lapse in common sense. Was my body snatched by an idiot pod?

I'm talking about my last column ("For Starters, We Can Require Trigger Locks," March 5) in which I reacted to the shooting of one first-grader by another first-grader. I urged tough consequences for adults whose carelessness results in a shooting by a child. So far, so good.

Then, I apparently lost consciousness and urged trigger locks for all weapons. Who said that? Surely not I, the daughter of a responsible gun collector who taught me to handle and shoot guns safely as soon as I could hold a rifle. My father must be banging his head against heaven's gate. He taught me better.

Among his more valuable lessons was the lawyerly advice that an unenforceable law is a bad law. A law that makes trigger locks mandatory is about as useful as a law that requires daily showering. You can force gun dealers to sell locks, but you can't force gun owners to use them.

Thanks to readers who managed to remain rational in the wake of the terrible Michigan incident that claimed the life of 6-year-old Kayla Rolland, I've been born again. To the one Colorado reader who agreed with my first knee-jerk response, sorry. The Sahara Bridge Builders Association wants you, too.

The better solution to this and other gun tragedies is to make the consequences for irresponsible gun ownership so severe that such accidents become rarer than sensible government. Responsible gun ownership might include the use of trigger locks—I'd like to think so—but a law mandating them is little more than a political pacifier.

Irresponsible gun owners aren't going to use trigger locks. And responsible gun owners aren't going to leave handguns lying on the floor, as was the case in the Michigan shooting.

The child who killed Kayla, police say, took a stolen .32 semiautomatic to school. The boy was living in a crack house, where trigger locks were about as likely as a well-balanced meal. Or even a real bed.

The boy slept on a couch in the living room of a run-down house inhabited by his 21-year-old uncle and another man, who was 19. The boy's mother left the

child and his 8-year-old brother with the uncle about two weeks ago when she was evicted from her nearby home. The boy's father is in prison.

11 It is ridiculous to suppose that someone who deals in drugs and guns will take the extra step of attaching trigger locks. You can picture the thought process: "Boy, this crack sure smacks good. But, whoa, I forgot to lock the trigger on that piece I stole yesterday. What am I thinking?"

12 "Thinking" is the operative word here, and I've got a turtle's lead on the lowlife who left a child to play with a lethal weapon. There is only one reasonable conclusion: Make adults pay for crimes committed by children.

13 Prosecutors are heading in that direction. In Michigan, police arrested one of the men and charged him with involuntary manslaughter for allegedly allowing the boy access to the gun. The boy's mother has been accused of neglect.

14 Trigger locks are a good idea. They're also readily available and cost as little as $10. I can't imagine why anyone with young children in the house wouldn't use them.

15 But a law insisting on the use of trigger locks would be as effective as laws insisting that people not steal or use drugs, or a law requiring them to be good parents.

• THINKING CRITICALLY ABOUT "FOR STARTERS, WE CAN REQUIRE TRIGGER LOCKS" AND "REVISITING THE ISSUE OF TRIGGER LOCKS"

RESPONDING AS A READER

1. Did your experience of reading Parker's two columns confirm or contradict your predictions? To track her reasoning, work up a basic outline of her primary claims regarding trigger locks in each of the two columns with the reasons, evidence, and assumptions that support them.

2. In the second column, what is Parker's basis for attacking her previous position? What differences are there in the way she counters the opposing positions in each of the columns?

3. How have Parker's two pieces deepened or changed your thinking about the trigger locks issue? About handgun regulation in general? About gun safety in general? What specific aspects of these texts did you find particularly compelling or particularly repellent?

RESPONDING AS A WRITER

1. Parker is known for the informal conversational style of her columns. To examine the details of her style, work with the column of your choice to note which sentences (or parts of sentences) contribute directly to the line of reasoning that supports her primary claim about trigger locks, which ones provide background information, and which ones provide neither. What is the function of this material? How does it contribute to Parker's credibility? To her audience appeal? To her overall effectiveness?

2. Unexpectedly playful word choices and phrasing are characteristic of Parker's style. Working again from the column of your choice, list the words that you consider to be unexpected or unusual in a political commentary. Next to each word, write what would have been a more conventional way to express the idea(s). What does Parker accomplish by making the unexpected choice? Choose three or four of these that you find most interesting and compare them to your classmates' choices.

3. Writing op-ed columns is more difficult than it may appear because content must be condensed to fit strict length limits. (These two have fewer than 600 words.) To understand Parker's approach to this tight structure more fully, try summarizing one of these columns in 100 words. Then condense your summary even further and add commentary about her method by using the model in Chapter 3 to develop a four-sentence rhetorical précis of the column. •

MARTIN LUTHER KING JR.

Statement by Alabama Clergymen and Letter from Birmingham Jail

The Reverend Martin Luther King Jr. (1929–1968) is known worldwide for his leadership of the Civil Rights movement in the United States and for his advocacy of nonviolent protests in pursuit of equality before the law for African Americans. This famous letter was written after he was arrested and put into solitary confinement on Good Friday in 1963 for defying a court order forbidding him and 132 others from participating in demonstrations in Birmingham, Alabama. King, a Baptist minister, is responding to a statement from eight white Alabama clergymen urging that demonstrations cease, which ran as a full-page ad in the *Birmingham News* on the day he was arrested. This well-known explanation of his intent to keep protesting against racial prejudice is said to have begun as notes scribbled in the margins of that newspaper and on scraps of toilet paper. The resulting letter, dated four days after his arrest, was originally published as a pamphlet by the American Friends Service Committee. The version we present here, obtained from the Website of the Martin Luther King Jr. Papers Project at Stanford University, appeared in King's 1964 book, *Why We Can't Wait*. We include as well the text of the statement from the clergymen.

● **FOR YOUR READING LOG**

1. To draw together your expectations about the argument King makes in support of nonviolent protests advocating civil rights, freewrite about what you know about his thinking on this issue. If you have read the letter before, freewrite about what you remember of King's argument.

2. Before you read King's letter, read the statement from the Alabama clergy, then turn to your reading log to record your understanding of its primary point and to predict (perhaps recall) the reasoning King uses to reject it. •

———— • ————

Statement by Alabama Clergymen

12 April 1963

1 We the undersigned clergymen are among those who, in January, issued "An Appeal for Law and Order and Common Sense," in dealing with racial problems in Alabama. We expressed understanding that honest convictions in racial matters could properly be pursued in the courts, but urged that decisions of those courts should in the meantime be peacefully obeyed.

2 Since that time there had been some evidence of increased forbearance and a willingness to face facts. Responsible citizens have undertaken to work on various problems which cause racial friction and unrest. In Birmingham, recent public events have given indication that we will have opportunity for a new constructive and realistic approach to racial problems.

3 However, we are now confronted by a series of demonstrations by some of our Negro citizens, directed and led in part by outsiders. We recognize the natural impatience of people who feel that their hopes are slow in being realized. But we are convinced that these demonstrations are unwise and untimely.

4 We agree rather with certain local Negro leadership which has called for honest and open negotiation of racial issues in our area. And we believe this kind of facing of issues can best be accomplished by citizens of our own metropolitan area, white and Negro, meeting with their knowledge and experience of the local situation. All of us need to face that responsibility and find proper channels for its accomplishment.

5 Just as we formerly pointed out that "hatred and violence have no sanction in our religious and political traditions," we also point out that such actions as incite to hatred and violence, however technically peaceful those actions may be, have not contributed to the resolution of our local problems. We do not believe that these days of new hope are days when extreme measures are justified in Birmingham.

6 We commend the community as a whole, and the local news media and law enforcement officials in particular, on the calm manner in which these demonstrations have been handled. We urge the public to continue to show restraint should the demonstrations continue, and the law enforcement officials to remain calm and continue to protect our city from violence.

7 We further strongly urge our own Negro community to withdraw support from these demonstrations, and to unite locally in working peacefully for a better Birmingham. When rights are consistently denied, a cause should be pressed

in the courts and in negotiations among local leaders, and not in the streets. We appeal to both our white and Negro citizenry to observe the principles of law and order and common sense.

Signed by:

C.C.J. Carpenter, D.D., LL.D., Bishop of Alabama

Joseph A. Durick, D.D., Auxiliary Bishop, Diocese of Mobile-Birmingham

Rabbi Milton L. Grafman, Temple Emanu-El, Birmingham, Alabama

Bishop Paul Hardin, Bishop of the Alabama–West Florida Conference of the Methodist Church

Bishop Nolan B. Harmon, Bishop of the North Alabama Conference of the Methodist Church

George M. Murray, D.D., LL.D., Bishop Coadjutor, Episcopal Diocese of Alabama

Edward V. Ramage, Moderator, Synod of the Alabama Presbyterian Church in the United States

Earl Stallings, Pastor, First Baptist Church, Birmingham, Alabama

Letter from Birmingham Jail

My Dear Fellow Clergymen: [1]
 While confined here in the Birmingham city jail, I came across your recent statement calling my present activities "unwise and untimely." Seldom do I pause to answer criticism of my work and ideas. If I sought to answer all the criticisms that cross my desk, my secretaries would have little time for anything other than such correspondence in the course of the day, and I would have no time for constructive work. But since I feel that you are men of genuine good will and that your criticisms are sincerely set forth, I want to try to answer your statements in what I hope will be patient and reasonable terms. [2]

 I think I should indicate why I am here in Birmingham, since you have been influenced by the view which argues against "outsiders coming in." I have the honor of serving as president of the Southern Christian Leadership Conference, an organization operating in every southern state, with headquarters in Atlanta, Georgia. We have some eighty-five affiliated organizations across the South, and one of them is the Alabama Christian Movement for Human Rights. Frequently we share staff, educational and financial resources with our affiliates. Several months ago the affiliate here in Birmingham asked us to be on call to engage in a nonviolent direct-action program if such were deemed necessary. We readily consented, and when the hour came we lived up to our promise. So I, along with several members of my staff, am here because I was invited here. I am here because I have organizational ties here. [3]

 But more basically, I am in Birmingham because injustice is here. Just as the prophets of the eighth century B.C. left their villages and carried their "thus saith

the Lord" far beyond the boundaries of their home towns, and just as the Apostle Paul left his village of Tarsus and carried the gospel of Jesus Christ to the far corners of the Greco-Roman world, so am I compelled to carry the gospel of freedom beyond my own home town. Like Paul, I must constantly respond to the Macedonian call for aid.

4 Moreover, I am cognizant of the interrelatedness of all communities and states. I cannot sit idly by in Atlanta and not be concerned about what happens in Birmingham. Injustice anywhere is a threat to justice everywhere. We are caught in an inescapable network of mutuality, tied in a single garment of destiny. Whatever affects one directly, affects all indirectly. Never again can we afford to live with the narrow, provincial "outside agitator" idea. Anyone who lives inside the United States can never be considered an outsider anywhere within its bounds.

5 You deplore the demonstrations taking place in Birmingham. But your statement, I am sorry to say, fails to express a similar concern for the conditions that brought about the demonstrations. I am sure that none of you would want to rest content with the superficial kind of social analysis that deals merely with effects and does not grapple with underlying causes. It is unfortunate that demonstrations are taking place in Birmingham, but it is even more unfortunate that the city's white power structure left the Negro community with no alternative.

6 In any nonviolent campaign there are four basic steps: collection of the facts to determine whether injustices exist; negotiation; self-purification; and direct action. We have gone through all these steps in Birmingham. There can be no gainsaying the fact that racial injustice engulfs this community. Birmingham is probably the most thoroughly segregated city in the United States. Its ugly record of brutality is widely known. Negroes have experienced grossly unjust treatment in the courts. There have been more unsolved bombings of Negro homes and churches in Birmingham than in any other city in the nation. These are the hard, brutal facts of the case. On the basis of these conditions, Negro leaders sought to negotiate with the city fathers. But the latter consistently refused to engage in good-faith negotiation.

7 Then, last September, came the opportunity to talk with leaders of Birmingham's economic community. In the course of the negotiations, certain promises were made by the merchants—for example, to remove the stores' humiliating racial signs. On the basis of these promises, the Reverend Fred Shuttlesworth and the leaders of the Alabama Christian Movement for Human Rights agreed to a moratorium on all demonstrations. As the weeks and months went by, we realized that we were the victims of a broken promise. A few signs, briefly removed, returned; the others remained.

8 As in so many past experiences, our hopes had been blasted, and the shadow of deep disappointment settled upon us. We had no alternative except to prepare for direct action, whereby we would present our very bodies as a means of laying our case before the conscience of the local and the national community. Mindful of the difficulties involved, we decided to undertake a process of self-purification. We began a series of workshops on nonviolence, and we repeatedly asked ourselves: "Are you able to accept blows without retaliating?" "Are you

able to endure the ordeal of jail?" We decided to schedule our direct-action program for the Easter season, realizing that except for Christmas, this is the main shopping period of the year. Knowing that a strong economic withdrawal program would be the by-product of direct action, we felt that this would be the best time to bring pressure to bear on the merchants for the needed change.

Then it occurred to us that Birmingham's mayoralty election was coming up 9 in March, and we speedily decided to postpone action until after election day. When we discovered that the Commissioner of Public Safety, Eugene "Bull" Connor, had piled up enough votes to be in the run-off, we decided again to postpone action until the day after the run-off so that the demonstrations could not be used to cloud the issues. Like many others, we waited to see Mr. Connor defeated, and to this end we endured postponement after postponement. Having aided in this community need, we felt that our direct-action program could be delayed no longer.

You may well ask: "Why direct action? Why sit-ins, marches and so forth? 10 Isn't negotiation a better path?" You are quite right in calling for negotiation. Indeed, this is the very purpose of direct action. Nonviolent direct action seeks to create such a crisis and foster such a tension that a community which has constantly refused to negotiate is forced to confront the issue. It seeks so to dramatize the issue that it can no longer be ignored. My citing the creation of tension as part of the work of the nonviolent-resister may sound rather shocking. But I must confess that I am not afraid of the word "tension." I have earnestly opposed violent tension, but there is a type of constructive, nonviolent tension which is necessary for growth. Just as Socrates felt that it was necessary to create a tension in the mind so that individuals could rise from the bondage of myths and half-truths to the unfettered realm of creative analysis and objective appraisal, so must we see the need for nonviolent gadflies to create the kind of tension in society that will help men rise from the dark depths of prejudice and racism to the majestic heights of understanding and brotherhood.

The purpose of our direct-action program is to create a situation so crisis- 11 packed that it will inevitably open the door to negotiation. I therefore concur with you in your call for negotiation. Too long has our beloved Southland been bogged down in a tragic effort to live in monologue rather than dialogue.

One of the basic points in your statement is that the action that I and my as- 12 sociates have taken in Birmingham is untimely. Some have asked: "Why didn't you give the new city administration time to act?" The only answer that I can give to this query is that the new Birmingham administration must be prodded about as much as the outgoing one, before it will act. We are sadly mistaken if we feel that the election of Albert Boutwell as mayor will bring the millennium to Birmingham. While Mr. Boutwell is a much more gentle person than Mr. Connor, they are both segregationists, dedicated to maintenance of the status quo. I have hope that Mr. Boutwell will be reasonable enough to see the futility of massive resistance to desegregation. But he will not see this without pressure from devotees of civil rights. My friends, I must say to you that we have not made a single gain in civil rights without determined legal and nonviolent pressure. Lamentably, it is an historical fact that privileged groups seldom give up their privileges

voluntarily. Individuals may see the moral light and voluntarily give up their unjust posture; but, as Reinhold Niebuhr has reminded us, groups tend to be more immoral than individuals.

13 We know through painful experience that freedom is never voluntarily given by the oppressor; it must be demanded by the oppressed. Frankly, I have yet to engage in a direct-action campaign that was "well timed" in the view of those who have not suffered unduly from the disease of segregation. For years now I have heard the word "Wait!" It rings in the ear of every Negro with piercing familiarity. This "Wait" has almost always meant "Never." We must come to see, with one of our distinguished jurists, that "justice too long delayed is justice denied."

14 We have waited for more than 340 years for our constitutional and God-given rights. The nations of Asia and Africa are moving with jetlike speed toward gaining political independence, but we still creep at horse-and-buggy pace toward gaining a cup of coffee at a lunch counter. Perhaps it is easy for those who have never felt the stinging darts of segregation to say, "Wait." But when you have seen vicious mobs lynch your mothers and fathers at will and drown your sisters and brothers at whim; when you have seen hate-filled policemen curse, kick and even kill your black brothers and sisters; when you see the vast majority of your twenty million Negro brothers smothering in an airtight cage of poverty in the midst of an affluent society; when you suddenly find your tongue twisted and your speech stammering as you seek to explain to your six-year-old daughter why she can't go to the public amusement park that has just been advertised on television, and see tears welling up in her eyes when she is told that Funtown is closed to colored children, and see ominous clouds of inferiority beginning to form in her little mental sky, and see her beginning to distort her personality by developing an unconscious bitterness toward white people; when you have to concoct an answer for a five-year-old son who is asking: "Daddy, why do white people treat colored people so mean?"; when you take a cross-country drive and find it necessary to sleep night after night in the uncomfortable corners of your automobile because no motel will accept you; when you are humiliated day in and day out by nagging signs reading "white" and "colored"; when your first name becomes "nigger," your middle name becomes "boy" (however old you are) and your last name becomes "John," and your wife and mother are never given the respected title "Mrs."; when you are harried by day and haunted by night by the fact that you are a Negro, living constantly at tiptoe stance, never quite knowing what to expect next, and are plagued with inner fears and outer resentments; when you are forever fighting a degenerating sense of "nobodiness"—then you will understand why we find it difficult to wait. There comes a time when the cup of endurance runs over, and men are no longer willing to be plunged into the abyss of despair. I hope, sirs, you can understand our legitimate and unavoidable impatience.

15 You express a great deal of anxiety over our willingness to break laws. This is certainly a legitimate concern. Since we so diligently urge people to obey the Supreme Court's decision of 1954 outlawing segregation in the public schools,

at first glance it may seem rather paradoxical for us consciously to break laws. One may well ask: "How can you advocate breaking some laws and obeying others?" The answer lies in the fact that there are two types of laws: just and unjust. I would be the first to advocate obeying just laws. One has not only a legal but a moral responsibility to obey just laws. Conversely, one has a moral responsibility to disobey unjust laws. I would agree with St. Augustine that "an unjust law is no law at all."

Now, what is the difference between the two? How does one determine 16 whether a law is just or unjust? A just law is a man-made code that squares with the moral law or the law of God. An unjust law is a code that is out of harmony with the moral law. To put it in the terms of St. Thomas Aquinas: An unjust law is a human law that is not rooted in eternal law and natural law. Any law that uplifts human personality is just. Any law that degrades human personality is unjust. All segregation statutes are unjust because segregation distorts the soul and damages the personality. It gives the segregator a false sense of superiority and the segregated a false sense of inferiority. Segregation, to use the terminology of the Jewish philosopher Martin Buber, substitutes an "I-it" relationship for an "I-thou" relationship and ends up relegating persons to the status of things. Hence segregation is not only politically, economically and sociologically unsound, it is morally wrong and sinful. Paul Tillich has said that sin is separation. Is not segregation an existential expression of man's tragic separation, his awful estrangement, his terrible sinfulness? Thus it is that I can urge men to obey the 1954 decision of the Supreme Court, for it is morally right; and I can urge them to disobey segregation ordinances, for they are morally wrong.

Let us consider a more concrete example of just and unjust laws. An unjust 17 law is a code that a numerical or power majority group compels a minority group to obey but does not make binding on itself. This is *difference* made legal. By the same token, a just law is a code that a majority compels a minority to follow and that it is willing to follow itself. This is *sameness* made legal.

Let me give another explanation. A law is unjust if it is inflicted on a minority 18 that, as a result of being denied the right to vote, had no part in enacting or devising the law. Who can say that the legislature of Alabama which set up that state's segregation laws was democratically elected? Throughout Alabama all sorts of devious methods are used to prevent Negroes from becoming registered voters, and there are some counties in which, even though Negroes constitute a majority of the population, not a single Negro is registered. Can any law enacted under such circumstances be considered democratically structured?

Sometimes a law is just on its face and unjust in its application. For instance, 19 I have been arrested on a charge of parading without a permit. Now, there is nothing wrong in having an ordinance which requires a permit for a parade. But such an ordinance becomes unjust when it is used to maintain segregation and to deny citizens the First-Amendment privilege of peaceful assembly and protest.

I hope you are able to see the distinction I am trying to point out. In no sense 20 do I advocate evading or defying the law, as would the rabid segregationist. That would lead to anarchy. One who breaks an unjust law must do so openly,

lovingly, and with a willingness to accept the penalty. I submit that an individual who breaks a law that conscience tells him is unjust, and who willingly accepts the penalty of imprisonment in order to arouse the conscience of the community over its injustice, is in reality expressing the highest respect for law.

21 Of course, there is nothing new about this kind of civil disobedience. It was evidenced sublimely in the refusal of Shadrach, Meshach and Abednego to obey the laws of Nebuchadnezzar, on the ground that a higher moral law was at stake. It was practiced superbly by the early Christians, who were willing to face hungry lions and the excruciating pain of chopping blocks rather than submit to certain unjust laws of the Roman Empire. To a degree, academic freedom is a reality today because Socrates practiced civil disobedience. In our own nation, the Boston Tea Party represented a massive act of civil disobedience.

22 We should never forget that everything Adolf Hitler did in Germany was "legal" and everything the Hungarian freedom fighters did in Hungary was "illegal." It was "illegal" to aid and comfort a Jew in Hitler's Germany. Even so, I am sure that, had I lived in Germany at the time, I would have aided and comforted my Jewish brothers. If today I lived in a Communist country where certain principles dear to the Christian faith are suppressed, I would openly advocate disobeying that country's antireligious laws.

23 I must make two honest confessions to you, my Christian and Jewish brothers. First, I must confess that over the past few years I have been gravely disappointed with the white moderate. I have almost reached the regrettable conclusion that the Negro's great stumbling block in his stride toward freedom is not the White Citizen's Counciler or the Ku Klux Klanner, but the white moderate, who is more devoted to "order" than to justice; who prefers a negative peace which is the absence of tension to a positive peace which is the presence of justice; who constantly says: "I agree with you in the goal you seek, but I cannot agree with your methods of direct action"; who paternalistically believes he can set the timetable for another man's freedom; who lives by a mythical concept of time and who constantly advises the Negro to wait for a "more convenient season." Shallow understanding from people of good will is more frustrating than absolute misunderstanding from people of ill will. Lukewarm acceptance is much more bewildering than outright rejection.

24 I had hoped that the white moderate would understand that law and order exist for the purpose of establishing justice and that when they fail in this purpose they become the dangerously structured dams that block the flow of social progress. I had hoped that the white moderate would understand that the present tension in the South is a necessary phase of the transition from an obnoxious negative peace, in which the Negro passively accepted his unjust plight, to a substantive and positive peace, in which all men will respect the dignity and worth of human personality. Actually, we who engage in nonviolent direct action are not the creators of tension. We merely bring to the surface the hidden tension that is already alive. We bring it out in the open, where it can be seen and dealt with. Like a boil that can never be cured so long as it is covered up but must be opened with all its ugliness to the natural medicines of air and light, injustice

must be exposed, with all the tension its exposure creates, to the light of human conscience and the air of national opinion before it can be cured.

In your statement you assert that our actions, even though peaceful, must 25 be condemned because they precipitate violence. But is this a logical assertion? Isn't this like condemning a robbed man because his possession of money precipitated the evil act of robbery? Isn't this like condemning Socrates because his unswerving commitment to truth and his philosophical inquiries precipitated the act by the misguided populace in which they made him drink hemlock? Isn't this like condemning Jesus because his unique God-consciousness and never-ceasing devotion to God's will precipitated the evil act of crucifixion? We must come to see that, as the federal courts have consistently affirmed, it is wrong to urge an individual to cease his efforts to gain his basic constitutional rights because the quest may precipitate violence. Society must protect the robbed and punish the robber.

I had also hoped that the white moderate would reject the myth concerning 26 time in relation to the struggle for freedom. I have just received a letter from a white brother in Texas. He writes: "All Christians know that the colored people will receive equal rights eventually, but it is possible that you are in too great a religious hurry. It has taken Christianity almost two thousand years to accomplish what it has. The teachings of Christ take time to come to earth." Such an attitude stems from a tragic misconception of time, from the strangely irrational notion that there is something in the very flow of time that will inevitably cure all ills. Actually, time itself is neutral; it can be used either destructively or constructively. More and more I feel that the people of ill will have used time much more effectively than have the people of good will. We will have to repent in this generation not merely for the hateful words and actions of the bad people but for the appalling silence of the good people. Human progress never rolls in on wheels of inevitability; it comes through the tireless efforts of men willing to be co-workers with God, and without this hard work, time itself becomes an ally of the forces of social stagnation. We must use time creatively, in the knowledge that the time is always ripe to do right. Now is the time to make real the promise of democracy and transform our pending national elegy into a creative psalm of brotherhood. Now is the time to lift our national policy from the quicksand of racial injustice to the solid rock of human dignity.

You speak of our activity in Birmingham as extreme. At first I was rather dis- 27 appointed that fellow clergymen would see my nonviolent efforts as those of an extremist. I began thinking about the fact that I stand in the middle of two opposing forces in the Negro community. One is a force of complacency, made up in part of Negroes who, as a result of long years of oppression, are so drained of self-respect and a sense of "somebodiness" that they have adjusted to segregation; and in part of a few middle-class Negroes who, because of a degree of academic and economic security and because in some ways they profit by segregation, have become insensitive to the problems of the masses. The other force is one of bitterness and hatred, and it comes perilously close to advocating violence. It is expressed in the various black nationalist groups that are springing up

across the nation, the largest and best-known being Elijah Muhammad's Muslim movement. Nourished by the Negro's frustration over the continued existence of racial discrimination, this movement is made up of people who have lost faith in America, who have absolutely repudiated Christianity, and who have concluded that the white man is an incorrigible "devil."

28 I have tried to stand between these two forces, saying that we need emulate neither the "do-nothingism" of the complacent nor the hatred and despair of the black nationalist. For there is the more excellent way of love and nonviolent protest. I am grateful to God that, through the influence of the Negro church, the way of nonviolence became an integral part of our struggle.

29 If this philosophy had not emerged, by now many streets of the South would, I am convinced, be flowing with blood. And I am further convinced that if our white brothers dismiss as "rabble-rousers" and "outside agitators" those of us who employ nonviolent direct action, and if they refuse to support our nonviolent efforts, millions of Negroes will, out of frustration and despair, seek solace and security in black-nationalist ideologies—a development that would inevitably lead to a frightening racial nightmare.

30 Oppressed people cannot remain oppressed forever. The yearning for freedom eventually manifests itself, and that is what has happened to the American Negro. Something within has reminded him of his birthright of freedom, and something without has reminded him that it can be gained. Consciously or unconsciously, he has been caught up by the *Zeitgeist*, and with his black brothers of Africa and his brown and yellow brothers of Asia, South America and the Caribbean, the United States Negro is moving with a sense of great urgency toward the promised land of racial justice. If one recognizes this vital urge that has engulfed the Negro community, one should readily understand why public demonstrations are taking place. The Negro has many pent-up resentments and latent frustrations, and he must release them. So let him march; let him make prayer pilgrimages to the city hall; let him go on freedom rides—and try to understand why he must do so. If his repressed emotions are not released in nonviolent ways, they will seek expression through violence; this is not a threat but a fact of history. So I have not said to my people: "Get rid of your discontent." Rather, I have tried to say that this normal and healthy discontent can be channeled into the creative outlet of nonviolent direct action. And now this approach is being termed extremist.

31 But though I was initially disappointed at being categorized as an extremist, as I continued to think about the matter I gradually gained a measure of satisfaction from the label. Was not Jesus an extremist for love: "Love your enemies, bless them that curse you, do good to them that hate you, and pray for them which despitefully use you, and persecute you." Was not Amos an extremist for justice: "Let justice roll down like waters and righteousness like an ever-flowing stream." Was not Paul an extremist for the Christian gospel: "I bear in my body the marks of the Lord Jesus." Was not Martin Luther an extremist: "Here I stand; I cannot do otherwise, so help me God." And John Bunyan: "I will stay in jail to the end of my days before I make a butchery of my conscience." And Abraham

Lincoln: "This nation cannot survive half slave and half free." And Thomas Jefferson: "We hold these truths to be self-evident, that all men are created equal . . ." So the question is not whether we will be extremists, but what kind of extremists we will be. Will we be extremists for hate or for love? Will we be extremists for the preservation of injustice or for the extension of justice? In that dramatic scene on Calvary's hill three men were crucified. We must never forget that all three were crucified for the same crime—the crime of extremism. Two were extremists for immorality, and thus fell below their environment. The other, Jesus Christ, was an extremist for love, truth and goodness, and thereby rose above his environment. Perhaps the South, the nation and the world are in dire need of creative extremists.

I had hoped that the white moderate would see this need. Perhaps I was too 32 optimistic; perhaps I expected too much. I suppose I should have realized that few members of the oppressor race can understand the deep groans and passionate yearnings of the oppressed race, and still fewer have the vision to see that injustice must be rooted out by strong, persistent and determined action. I am thankful, however, that some of our white brothers in the South have grasped the meaning of this social revolution and committed themselves to it. They are still too few in quantity, but they are big in quality. Some—such as Ralph McGill, Lillian Smith, Harry Golden, James McBride Dabbs, Ann Braden and Sarah Patton Boyle—have written about our struggle in eloquent and prophetic terms. Others have marched with us down nameless streets of the South. They have languished in filthy, roach-infested jails, suffering the abuse and brutality of policemen who view them as "dirty nigger-lovers." Unlike so many of their moderate brothers and sisters, they have recognized the urgency of the moment and sensed the need for powerful "action" antidotes to combat the disease of segregation.

Let me take note of my other major disappointment. I have been so greatly 33 disappointed with the white church and its leadership. Of course, there are some notable exceptions. I am not unmindful of the fact that each of you has taken some significant stands on this issue. I commend you, Reverend Stallings, for your Christian stand on this past Sunday, in welcoming Negroes to your worship service on a nonsegregated basis. I commend the Catholic leaders of this state for integrating Spring Hill College several years ago.

But despite these notable exceptions, I must honestly reiterate that I have 34 been disappointed with the church. I do not say this as one of those negative critics who can always find something wrong with the church. I say this as a minister of the gospel, who loves the church; who was nurtured in its bosom; who has been sustained by its spiritual blessings and who will remain true to it as long as the cord of life shall lengthen.

When I was suddenly catapulted into the leadership of the bus protest in 35 Montgomery, Alabama, a few years ago, I felt we would be supported by the white church. I felt that the white ministers, priests and rabbis of the South would be among our strongest allies. Instead, some have been outright opponents, refusing to understand the freedom movement and misrepresenting its

leaders; all too many others have been more cautious than courageous and have remained silent behind the anesthetizing security of stained-glass windows.

36 In spite of my shattered dreams, I came to Birmingham with the hope that the white religious leadership of this community would see the justice of our cause and, with deep moral concern, would serve as the channel through which our just grievances could reach the power structure. I had hoped that each of you would understand. But again I have been disappointed.

37 I have heard numerous southern religious leaders admonish their worshipers to comply with a desegregation decision because it is the law, but I have longed to hear white ministers declare: "Follow this decree because integration is morally right and because the Negro is your brother." In the midst of blatant injustices inflicted upon the Negro, I have watched white churchmen stand on the sideline and mouth pious irrelevancies and sanctimonious trivialities. In the midst of a mighty struggle to rid our nation of racial and economic injustice, I have heard many ministers say: "Those are social issues, with which the gospel has no real concern." And I have watched many churches commit themselves to a completely other-worldly religion which makes a strange, un-Biblical distinction between body and soul, between the sacred and the secular.

38 I have traveled the length and breadth of Alabama, Mississippi and all the other southern states. On sweltering summer days and crisp autumn mornings I have looked at the South's beautiful churches with their lofty spires pointing heavenward. I have beheld the impressive outlines of her massive religious-education buildings. Over and over I have found myself asking: "What kind of people worship here? Who is their God? Where were their voices when the lips of Governor Barnett dripped with words of interposition and nullification? Where were they when Governor Wallace gave a clarion call for defiance and hatred? Where were their voices of support when bruised and weary Negro men and women decided to rise from the dark dungeons of complacency to the bright hills of creative protest?"

39 Yes, these questions are still in my mind. In deep disappointment I have wept over the laxity of the church. But be assured that my tears have been tears of love. There can be no deep disappointment where there is not deep love. Yes, I love the church. How could I do otherwise? I am in the rather unique position of being the son, the grandson and the great-grandson of preachers. Yes, I see the church as the body of Christ. But, oh! How we have blemished and scarred that body through social neglect and through fear of being nonconformists.

40 There was a time when the church was very powerful—in the time when the early Christians rejoiced at being deemed worthy to suffer for what they believed. In those days the church was not merely a thermometer that recorded the ideas and principles of popular opinion; it was a thermostat that transformed the mores of society. Whenever the early Christians entered a town, the people in power became disturbed and immediately sought to convict the Christians for being "disturbers of the peace" and "outside agitators." But the Christians pressed on, in the conviction that they were "a colony of heaven," called to obey God rather than man. Small in number, they were big in commitment. They were

too God-intoxicated to be "astronomically intimidated." By their effort and ex- ample they brought an end to such ancient evils as infanticide and gladiatorial contests.

Things are different now. So often the contemporary church is a weak, inef- 41 fectual voice with an uncertain sound. So often it is an archdefender of the sta- tus quo. Far from being disturbed by the presence of the church, the power structure of the average community is consoled by the church's silent—and of- ten even vocal—sanction of things as they are.

But the judgment of God is upon the church as never before. If today's 42 church does not recapture the sacrificial spirit of the early church, it will lose its authenticity, forfeit the loyalty of millions, and be dismissed as an irrelevant so- cial club with no meaning for the twentieth century. Every day I meet young peo- ple whose disappointment with the church has turned into outright disgust.

Perhaps I have once again been too optimistic. Is organized religion too in- 43 extricably bound to the status quo to save our nation and the world? Perhaps I must turn my faith to the inner spiritual church, the church within the church, as the true *ekklesia* and the hope of the world. But again I am thankful to God that some noble souls from the ranks of organized religion have broken loose from the paralyzing chains of conformity and joined us as active partners in the strug- gle for freedom. They have left their secure congregations and walked the streets of Albany, Georgia, with us. They have gone down the highways of the South on tortuous rides for freedom. Yes, they have gone to jail with us. Some have been dismissed from their churches, have lost the support of their bishops and fellow ministers. But they have acted in the faith that right defeated is stronger than evil triumphant. Their witness has been the spiritual salt that has preserved the true meaning of the gospel in these troubled times. They have carved a tunnel of hope through the dark mountain of disappointment.

I hope the church as a whole will meet the challenge of this decisive hour. 44 But even if the church does not come to the aid of justice, I have no despair about the future. I have no fear about the outcome of our struggle in Birming- ham, even if our motives are at present misunderstood. We will reach the goal of freedom in Birmingham and all over the nation, because the goal of Amer- ica is freedom. Abused and scorned though we may be, our destiny is tied up with America's destiny. Before the pilgrims landed at Plymouth, we were here. Before the pen of Jefferson etched the majestic words of the Declaration of In- dependence across the pages of history, we were here. For more than two cen- turies our forebears labored in this country without wages; they made cotton king; they built the homes of their masters while suffering gross injustice and shameful humiliation—and yet out of a bottomless vitality they continued to thrive and develop. If the inexpressible cruelties of slavery could not stop us, the opposition we now face will surely fail. We will win our freedom because the sacred heritage of our nation and the eternal will of God are embodied in our echoing demands.

Before closing I feel impelled to mention one other point in your statement 45 that has troubled me profoundly. You warmly commended the Birmingham

police force for keeping "order" and "preventing violence." I doubt that you would have so warmly commended the police force if you had seen its dogs sinking their teeth into unarmed, nonviolent Negroes. I doubt that you would so quickly commend the policemen if you were to observe their ugly and inhumane treatment of Negroes here in the city jail; if you were to watch them push and curse old Negro women and young Negro girls; if you were to see them slap and kick old Negro men and young boys; if you were to observe them, as they did on two occasions, refuse to give us food because we wanted to sing our grace together. I cannot join you in your praise of the Birmingham police department.

46 It is true that the police have exercised a degree of discipline in handling the demonstrators. In this sense they have conducted themselves rather "nonviolently" in public. But for what purpose? To preserve the evil system of segregation. Over the past few years I have consistently preached that nonviolence demands that the means we use must be as pure as the ends we seek. I have tried to make clear that it is wrong to use immoral means to attain moral ends. But now I must affirm that it is just as wrong, or perhaps even more so, to use moral means to preserve immoral ends. Perhaps Mr. Connor and his policemen have been rather nonviolent in public, as was Chief Pritchett in Albany, Georgia, but they have used the moral means of nonviolence to maintain the immoral end of racial injustice. As T. S. Eliot has said: "The last temptation is the greatest treason: To do the right deed for the wrong reason."

47 I wish you had commended the Negro sit-inners and demonstrators of Birmingham for their sublime courage, their willingness to suffer and their amazing discipline in the midst of great provocation. One day the South will recognize its real heroes. They will be the James Merediths, with the noble sense of purpose that enables them to face jeering, and hostile mobs, and with the agonizing loneliness that characterizes the life of the pioneer. They will be old, oppressed, battered Negro women, symbolized in a seventy-two-year-old woman in Montgomery, Alabama, who rose up with a sense of dignity and with her people decided not to ride segregated buses, and who responded with ungrammatical profundity to one who inquired about her weariness: "My feets is tired, but my soul is at rest." They will be the young high school and college students, the young ministers of the gospel and a host of their elders, courageously and nonviolently sitting in at lunch counters and willingly going to jail for conscience's sake. One day the South will know that when these disinherited children of God sat down at lunch counters, they were in reality standing up for what is best in the American dream and for the most sacred values in our Judaeo-Christian heritage, thereby bringing our nation back to those great wells of democracy which were dug deep by the founding fathers in their formulation of the Constitution and the Declaration of Independence.

48 Never before have I written so long a letter. I'm afraid it is much too long to take your precious time. I can assure you that it would have been much shorter if I had been writing from a comfortable desk, but what else can one do when he is alone in a narrow jail cell, other than write long letters, think long thoughts and pray long prayers?

If I have said anything in this letter that overstates the truth and indicates 49
an unreasonable impatience, I beg you to forgive me. If I have said anything that
understates the truth and indicates my having a patience that allows me to set-
tle for anything less than brotherhood, I beg God to forgive me.

I hope this letter finds you strong in the faith. I also hope that circumstances 50
will soon make it possible for me to meet each of you, not as an integrationist or
a civil rights leader but as a fellow clergyman and a Christian brother. Let us all
hope that the dark clouds of racial prejudice will soon pass away and the deep
fog of misunderstanding will be lifted from our fear-drenched communities,
and in some not too distant tomorrow the radiant stars of love and brotherhood
will shine over our great nation with all their scintillating beauty.

Yours for the cause of Peace and Brotherhood,
Martin Luther King Jr.

● ## THINKING CRITICALLY ABOUT "LETTER FROM BIRMINGHAM JAIL"

RESPONDING AS A READER

1. King and the people to whom he was responding voice arguments that
 not only are directly opposed but grow out of very different conceptions
 of what questions the citizens of Birmingham, and of the United States,
 should be addressing at that moment. Working with both texts, identify
 the underlying question/issue that each addresses, then identify how
 King transforms the central issue in the Alabama clergy's ad into the is-
 sue he feels must be addressed.
2. Although King is at odds with his fellow clergymen, he devotes much
 of his argument to invoking values he believes his audience shares with
 him. What are these values, and how does he use them in his argument?
3. At the end of the first paragraph, King says he will try to answer the cler-
 gymen's statements in what he hopes will be "patient and reasonable
 terms." Do you think he was successful in achieving that tone? Your con-
 text of reading is, of course, quite different from the context of those Al-
 abama pastors in 1963, but consider carefully King's appeals to *ethos* and
 pathos and try to assess how readers from different political perspectives
 might have responded at the time.

RESPONDING AS A WRITER

1. What aspects of this document spoke most strongly to you? Focusing
 on the *how* more than the *what* of King's writing, examine the paragraph
 or paragraphs that you found most effective and use textual details to
 explain how King's technique worked to engage you.
2. To deepen your understanding of how King's letter is constructed, pre-
 pare a descriptive outline of it as described in Chapter 3 by dividing it
 into chunks and then jotting down what each of these major chunks *does*
 and *says*.

3. Few of us will be called to write a document such as King's, but many of us will be faced with the necessity of refuting ideas we oppose or explaining why we advocate a difficult action opposed by others. The historical importance of King's letter goes well beyond its pragmatic beginnings as a counterargument; nevertheless, it offers considerable food for thought about strategies for composing one. How would you generalize in a few sentences what King has *done* (as opposed to *said*) in this letter overall? What can you learn from it about strategies of argument? •

ANNA WEISS (STUDENT)

Sex and Equality: Christina Aguilera

Anna Weiss (a pseudonym) wrote this argument in response to the Taking a Stand of Your Own assignment at the end of this chapter. The photograph described in the first paragraph of her paper is reproduced in Chapter 4 (p. 78). This student writer graduated recently from Marquette University with a major in English literature, then took a year off from school to volunteer at a Catholic school and see another part of the country. She hopes eventually to earn a master's degree in English.

• FOR YOUR READING LOG

1. What's your opinion of Christina Aguilera? Would you call her a feminist?
2. If you have followed the rivalry between Aguilera and Eminem, what have been your thoughts about it? If this is something to which you have not paid attention, freewrite instead about what you would guess it might be about.
3. If you know nothing about or have no opinions about either recording star, write instead about the kind of music you do enjoy, and why. •

⸻ ● ⸻

1 Every once and a while, singer Christina Aguilera tones down her hypersexuality to make herself clear. A recent photograph in *Us Weekly* presents a message that permeates the singer's music, although few recognize it (Helligar and Majewski). In the photo, Aguilera appears in jeans and a T-shirt that fits conservatively. The T-shirt reads, "A man of quality is not threatened by a woman of equality." Is the artist a feminist? Some might use the phrase "a woman of equality" to describe a feminist, but many people support equal rights without assuming a special title. A feminist believes in equality, but she also advocates for equality, making her position political. Wearing Aguilera's T-shirt, anyone could make a statement. When the singer herself wears it, posing for a national mag-

azine, the message is all the more powerful. The pop star's message deserves as much attention as her midriff.

But when did pop celebrities start having messages worth noticing? Christina, 2 or as it is also spelled, Xtina, is the sort of figure who makes you want to whisper to fifteen-year-old fans, "She's not real, sweetie." By many indications, the singer is a corporate product designed to sell. As a child, she sang with *The New Mickey Mouse Club,* where she shared a stage with two other future teen stars: Britney Spears and Justin Timberlake. In 1998, she took a place in the pop music world by singing the heroine's theme in Disney's animated film, *Mulan.* A year later, Aguilera's first hit single, "Genie in a Bottle," established her stardom, granting the wishes of middle-aged men at RCA. In 2002, Aguilera appealed to even more men. After releasing the album *Stripped,* she appeared on the covers of *Blender, Rolling Stone,* and *Maxim* almost naked. Her video for the album single, "Dirrty," resembled pornography. What about that equality T-shirt?

The T-shirt message is part of her persona, really. Many people can identify 3 Aguilera as the most visible rival to Eminem. The rapper may want his messages taken lightly, but his immensely popular lyrics include the line, "I invented violence, you vile, venomous, vomital bitches." Regardless of whether they calculate their influence, music celebrities do send messages. Aguilera objected to Eminem's lyrics on an MTV video countdown, where she said, among other things, that domestic violence is nothing to joke about. Admittedly provoked by these comments, Eminem used "The Real Slim Shady" to fictionalize Aguilera's sex life. When the anonymous parody, "Will the Real Slim Shady Please Shut Up?" appeared on the radio, listeners incorrectly attributed it to Aguilera. The artist did actually respond to Eminem in "Can't Hold Us Down," a song from *Stripped.* A collaboration with the rapper Lil' Kim, the song encourages women everywhere to have opinions and speak up. It does not directly address the rapper. It does mention a big talker who slanders people to be popular. Ahem, Eminem?

Can Aguilera wear leather and still be a feminist? Feminists themselves 4 might argue that female pop stars sell themselves short by being sex kittens. When Britney Spears sings "I'm a Slave for You," I agree that she may overlook some of her human potential. Aguilera's image is similar to Spears's, but there is a critical difference. In Aguilera's "Dirrty," women are nasty, dirty, filthy, rowdy, unruly, fired up, naughty, jumping, dancing, partying, and sweating. But they are not slaves. In fact, in all of Aguilera's music, the woman's voice enjoys sex (a lot) but never takes a submissive role. In fact, her music challenges traditional or conservative views that femininity is pure, virtuous, mild, and innocent. Many adult women feel restricted by these views, so the feminists might approve of Aguilera's challenge.

But does the artist herself deserve the special title? If a woman uses blatant 5 sex appeal to promote herself, does she really advocate a fair world for women? Before the feminists ask Aguilera to stop singing, it is important to recognize some gray area. First, unlike Spears and several other pop stars, Aguilera does have remarkable vocal strength, a talent. Discussing the video, "Dirrty," Aguilera told *Us Weekly,* "When you can get people [to look], they pay more attention to the

album." She has a point. If she wants to record her voice, sell albums, perform for crowds, and have the opportunity to do it all again, it really helps to shock people with sex appeal. Aguilera wants to be a pop artist, a diva, who sings in full auditoriums and stadiums. No one says that feminists can only sing at coffee shops.

6 Aguilera also makes the point that sex appeal, in and of itself, does not oppress women. In public interviews and lyrics, she hammers her perception of a double standard. In "Can't Hold Us Down," Christina complains that a guy who has multiple girlfriends is called manly, whereas a woman with three boyfriends is called a whore. Aguilera likes being over-the-top sexy; it is part of her bad taste but also part of her style. Aguilera told *Us Weekly* that she took responsibility for artistic decisions in *Stripped*. "I didn't care if I only sold one or two copies of *Stripped*. I wanted to do it my way." Even if Aguilera likes her image, she dislikes apparent disrespect for her art. The realists may shrug, but Aguilera will continue fighting the "double standard" because doing so makes her happy.

7 Why should you care if Aguilera is a feminist? Even if it came across as overly dramatic, Aguilera used *Stripped* and accompanying publicity to heal publicly from domestic abuse, an issue for women everywhere. Also, she publicizes her good relationship with her mom, a once-poor single mom who now has a forum in entertainment media. The first charity listed on Aguilera's Website is a battered women's shelter in Pittsburgh, near where she and her mom once lived.

8 Millions hear, sing, hum, and even memorize Aguilera's songs as pop radio plays them again and again. Her messages would make the world better:

- A tough experience can make you a fighter.
- A romantic relationship can make you happy, make your partner happy.
- You are beautiful in every way.

9 This last message is especially good for the fifteen-year-olds.

Works Cited

Aguilera, Christina. "Can't Hold Us Down." Stripped. RCA, 2002.

Christina Aguilera Stripped. 3 Aug. 2003 <http://www.christinaaguilera.com>.

Eminem. "Kill You." The Marshall Mathers LP. Interscope, 2000.

Helligar, Jeremy, and Lori Majewski. "Christina's World." Us Weekly 3 Feb. 2003: 54–60.

• THINKING CRITICALLY ABOUT "SEX AND EQUALITY"
RESPONDING AS A READER

1. Weiss's argument is based on a question in the stasis of definition: Is Christina Aguilera a feminist? That is, does the evidence about her fit her into the category "feminist"? Weiss argues that there is a fit. Does

her *reasoning* earn your assent? To answer, consider the following. Arguments of the type Weiss makes, termed *categorical arguments*, are vulnerable to two distinct kinds of counterargument. The first is rebuttal of the evidence presented. The second is rebuttal of the way the category is defined. If the category itself is in dispute, the argument becomes more complex because two different concepts must be argued. Weiss uses her opening paragraph to set up her argument by defining the category "feminist" and its relevance to understanding Aguilera. Was treating this as a simple categorical argument the right approach? If you think not, what needs to be added?

2. As you were reading, how did your previous knowledge and opinions about Aguilera and/or the general pop music scene affect your response? How aware does Weiss seem to be of the fact that her readers might be surprised by her argument or might disagree with her? Support your answer by referring to specific passages.

3. How do you read the photograph that sparked Weiss's thinking on this issue? Beyond quoting the T-shirt slogan, Weiss doesn't use visual evidence to bolster her argument. Was this a good decision? What might she have drawn from the photograph to bolster her case?

RESPONDING AS A WRITER

1. Imagine a continuum for describing arguments, with "confrontational" at one end and "cooperative" at the other. According to Weiss, the arguments in Aguilera's lyrics would be located close to the confrontational end. Where would you put Weiss's argument about Aguilera as feminist? Where would you locate the message on Aguilera's T-shirt? (For more information about cooperative arguments that seek common ground, see Chapter 15.)

2. How would you describe the persona that Weiss conveys in the essay? How does she do that?

3. Weiss was concerned that she might not have adequately addressed potential counterarguments. If you were responding to her concern in a peer review workshop, what advice would you give her about what more she could do? (Remember, saying, "It's fine as is," is not particularly helpful.) ●

Writing to Take a Stand

The authors represented in this section use a variety of argument strategies to accomplish their purposes. In the discussion questions that accompany the texts, we have invited you to explore different facets of their claims and strategies, putting special emphasis on how they engage their readers. The writing assignments below are designed to give you a chance to apply your new knowledge about argument strategies by analyzing published work and/or writing an argument that takes a stand.

TAKING A STAND OF YOUR OWN

Write an essay in which you attempt to persuade your readers to accept your stand rather than a competing one on an issue of public concern. Choose an arguable issue and supply your readers with adequate background and a clear explanation of the question(s) at issue. Decide whether you are primarily addressing someone opposed to your position or someone undecided about the issue, then adjust your strategies accordingly. As you work to articulate your claims and reasons, you will need to consider what kinds of evidence will be most persuasive to the audience you are addressing. How informed are your readers about the subject? You will need to decide how much to spell out the assumptions and reasoning that will link your evidence to your claims, so think carefully about the assumptions you share with your target audience. Try to predict where that audience will resist your points. Your paper should anticipate such objections and summarize opposing views fairly.

EXAMINING RHETORICAL STRATEGIES

We invite you to extend your study of argument strategies by writing a rhetorical analysis of two or three short opinion pieces by one writer. A local or nationally syndicated columnist who is published regularly is the perfect subject for this analysis because these writers' success depends not just on their argument skills but also on their ability to convey a personality that brings readers back to them. To begin, find in the newspaper or on the Internet two or three sample arguments by the same political, entertainment, or sports columnist (a person of your choice or as your teacher directs). Whether you choose arguments on similar or unrelated subjects, be sure that they address an arguable issue and take a stand. Expressions of personal taste will not work for this assignment. (It is unlikely that you'll find an "about face" similar to Parker's.) Use the "Questions to Help You Read Arguments Rhetorically" as a basis for careful rhetorical reading of the argument structure, appeals, and stylistic techniques in each piece. Pay careful attention to similarities among them. Then articulate and support a thesis statement that focuses on what the pieces have in common in (1) the way issues are framed, (2) the type of reasoning used, and (3) the style through which the writer engages readers. Since you will be analyzing only two or three writings by this writer, take care not to overgeneralize; instead, use qualifiers to signal that you realize you are working from a limited sample (for example, "If Raspberry's approach here is typical . . ."). Be sure to provide sufficient textual evidence to support your points.

EXTENDING THE CONVERSATION

Op-ed articles and letters to the editor provide an important forum for public opinion in both local and national communities. People write to newspaper and magazine editors (and to radio and TV stations) in hopes that their opinions and arguments will be published or broadcast to the community at large. Sometimes

these letters and columns make specific comments about recently published material, including other readers' comments; sometimes they bring up a new or not recently discussed issue in hopes of getting it in the public eye. Whatever their purpose, writers of such letters and columns face intense competition for a small amount of available space. The pieces must be carefully crafted to gain an editor's approval for publication. Take a look at the letters section of a newspaper in your community. What trends do you see over several issues? Which letters make you want to talk back to them? Why?

Now, go public. Write a brief op-ed column or letter to the editor for your local paper in which you comment on both content and strategy in a recently published piece. Follow the length restrictions of the publication where the argument to which you are responding was published. Remember that you need to reach a multilayered audience: editor, original writer, the reading public. Make your point clearly and succinctly, and include at least one sentence either praising or critiquing one of the rhetorical techniques the other letter writer used. The choice of actually mailing the letter is up to you, but we imagine you will want to see if your letter is chosen for publication.

Note: This assignment focuses on print publications specifically because of the competition for space there. It will be a valuable exercise to work within those constraints rather than with the wide open rhetorical choices on the Internet, where postings in many venues are typically not limited by space.

CHAPTER 13

Evaluating and Judging

E valuating and making judgments is an everyday occurrence in our personal, work, and school lives. Sometimes our daily judgments involve little conscious deliberation—what to wear, what to eat for breakfast, where to park on campus (actually, that may be a highly strategic judgment on some campuses!). At other times, we carefully analyze a situation and weigh our options before making a judgment. Think about what your decision-making process might be if you were choosing an apartment. You would probably read the rental section of your newspaper carefully, noting the apartment's location and square footage, calculating the monthly rent plus utilities, visiting various apartments, comparing their advantages and disadvantages, and talking it over with friends and family. Because a decision such as this is of great consequence to your daily life, not to mention your pocketbook, you would undoubtedly take the time to make a careful judgment. Although we may be more aware of it in consequential decision making, all judgments and evaluations involve *criteria*— that is, standards we use to measure the quality or value of something.

You also encounter other people's evaluations on a daily basis. You read movie reviews and sports writers' ranking of teams; you listen to friends' evaluations of the latest music CDs, or your econ professor's discussion of the pros and cons of raising the interest rate in the current economic climate. Each of these cases involves stated or unstated criteria—the movie's cinematography, the strength of a football team by position, and so on. At the end of the semester, many students are also asked to evaluate their courses and teachers based on a specific set of criteria: organization of course material, use of class time, value of the assignments, and so on.

Not surprisingly, much of the reading and writing that you do in college involves evaluation and judgment. Writing researchers Barbara Walvoord and Lucille McCarthy, for example, found that many college writing assignments take the form of good/better/best questions:

Good: Is X good or bad?

Better: Which is better—X or Y?

Best: Which is the best among available options? What is the best solution to a given problem?

Even writing assignments that do not involve evaluation as their central aim often require you to make evaluative decisions as part of your writing process. All papers that require research, for example, require you to evaluate and select sources based on certain criteria, a topic we discuss in Chapter 6, where we offer guidelines for this kind of evaluation. College reading assignments also frequently involve good/better/best questions. In your history class, for example, you may read contrary opinions about whether it was right or wrong (good or bad), necessary or unnecessary (the best option under the circumstances) to have dropped the bomb on Hiroshima and Nagasaki to end World War II. In your English class, you might read literary criticism arguing that Toni Morrison's *Song of Solomon* is a better novel than *Beloved,* despite the latter's greater popularity.

Readings that evaluate and judge like these argue questions of value. To make claims about value, writers match their subject against criteria (sometimes only implicit) and support their claims with reasons and evidence just as they do in other kinds of arguments. For example, the critic who argues that *Song of Solomon* is a better novel than *Beloved* may cite richness of character development, novelty of plot, and evocativeness of style as her reasons for making the judgment she does. In doing so, she would be using criteria that are commonly accepted standards for judging the merits of literary texts. Others may quarrel with her assessment, but to do so they would have to use the same commonly accepted criteria to demonstrate differing judgments or they would have to argue that other criteria are more relevant.

Since evaluations are by definition judgmental, *ethos* presents a particular challenge for writers of evaluation. To be credible, writers must establish their credentials for making the judgments that they do. At the same time, they must avoid the impression of superiority or condescension toward their subject or audience. Sometimes, to be sure, satire and sarcasm may work as a form of negative evaluation as long as the reader is willing to be positioned as an ally in denigrating the subject at hand. However, a sarcastic tone and style can just as easily backfire if readers do not agree that the subject deserves such treatment. Generally, evaluative writers are most effective when they create a knowledgeable and fair-minded *ethos*.

Although evaluative arguments may appear straightforward—either you like something or you don't, either you think something is harmful or not—this appearance is deceptive. Successful evaluative arguments are challenging both

to write and to read. To make convincing evaluative claims, writers must establish clear and appropriate criteria and then offer evidence that the particular subject meets or fails to meet the stated criteria. If the criteria are inappropriate or if the evidence doesn't match the established criteria, the evaluation will not be persuasive. For example, one would not use criteria appropriate for evaluating indie art films to evaluate a blockbuster Hollywood action film, nor would one cite the charitable giving of a best-selling author as evidence about the quality of his new novel. Before accepting the claims made by an evaluative text, rhetorical readers should consider whether the criteria reflect shared values and common standards for assessing this kind of phenomena and whether the evidence fits the established criteria and sufficiently supports the evaluative claims.

Yet another matter to consider in reading and writing evaluative texts is the role of context and purpose in establishing criteria. If, for example, a supervisor is evaluating the performance of her staff, the criteria she chooses to use in her evaluation (or the criteria that are set for her to use) will be determined by the work involved and individual employee's roles and responsibilities. Similarly, the purpose and use to which performance reviews are put in her company will shape the content and tone of her evaluations. If it is a company that sees performance reviews as formative—that is, as a way of strengthening their employees' abilities—then she might feel quite free to name specific weaknesses and recommend steps the employee might take to address those weaknesses. If, however, performance reviews are seen as summative judgments that are regularly used to fire employees or deny them merit pay, a supervisor might downplay employee weaknesses or refer to them obliquely in order to protect the employees under her charge (unless, of course, she wants to get them fired!). Both the writer and reader of performance reviews need to understand the context and purpose since the judgments made in these reviews have material consequences for those reviewed. As this example suggests, both context and purpose influence the criteria selected as well as the potential consequences of the judgment, and rhetorical readers are well advised to be mindful of both.

A further issue to consider is whether relative or absolute standards are appropriate. Making a judgment based on relative standards assumes that ideal standards cannot be met and that a judgment must therefore be made using relative standards—judging what is good or better, not what is best. The danger in using relative standards is in overpraising the mediocre. However, making a judgment based on absolute or ideal standards can lead to overly negative judgments, for few performances meet ideal standards. If, for example, you were reviewing a high school drama performance, you would probably not apply the ideal standards used to judge professional actors, directors, and so on. Such application would undoubtedly result in a withering and demoralizing review. At the same time, one could argue that applying these ideal standards might motivate the high school thespians to work harder and achieve a higher level of performance. Although most situations call for the application of relative, not ideal, standards, it is important to be alert for situations that may call for the applica-

tion of ideal, or at least, less compromised standards. The issue of relative versus absolute standards is a thorny one, requiring writers to consider the potential effects of their evaluation and readers to consult their own values as they assess the value judgments of others.

Although judgments based on relative criteria are much more common than those based on ideal criteria, occasionally a case is made for something or someone being the "best" in a particular category. For example, some basketball commentators argue that Michael Jordan is the "best" to ever play the game of basketball while others dispute that judgment. In a 1999 special millennium issue, the *New York Times Magazine* featured articles about "the best" of the millennium—best invention, best herb, best pope, best joke, you name it. The articles, one of which is included in this chapter, have two kinds of purposes: to entertain or to offer a serious commentary on our cultural values and beliefs. Some combine these two purposes. The author of the introduction to the issue, Frank Rich, explained that because the authors of the articles found it impossible to make any absolute judgments about their subjects they elected instead to offer their evaluations as a form of cultural commentary: "the Best is most likely to provide a snapshot of our own time, not a definitive guide to that vast expanse of past time we seek to pillage." The larger point is that all judgments and evaluations are shaped by the evaluator's worldview and values and, consequently, reveal as much about the person making the judgment as they do about the thing being judged. To read evaluative texts rhetorically, one must take into account the ideology that informs the judgments being made.

To establish their criteria for judgment, evaluative writers often call on methods that involve other aims, such as to inform and analyze. Articles in *Consumer Reports*, for example, aim to inform as well as to "argue" that a particular product is better than other products in its class. Movie reviews use analysis and interpretation to make their judgments. Though all of the readings in this chapter offer evaluations, some include other purposes as well. Jared Diamond, for example, explains the complicated factors that lead to inventions as part of his re-evaluation of Gutenberg's contribution to the millennium's "best" invention, the printing press. Rhonda Downey's "Through the Looking Glass" interprets as well as evaluates the cultural significance of a television show.

At times, authors of evaluative texts stop short of making a value judgment, allowing readers to draw their own conclusions based on the author's analysis of the positive and negative qualities of the phenomenon being evaluated. For example, Laurence Zuckerman, whose essay "Words Go Right to the Brain, But Can They Stir the Heart?" is included in this chapter, declines to answer directly the question posed in his title. Rather he invites readers to draw their own conclusions about the effects of PowerPoint presentations.

Finally, the readings in this chapter illustrate that what is at stake in a given evaluation varies considerably. In the *Doonesbury* satire of Starbuck's, there is very little of consequence at stake, and the intent seems mainly to poke fun at product labeling. By contrast, a great deal is at stake for Rhonda Downey in her evaluation of the negative stereotypes of African Americans perpetuated by television sitcoms.

QUESTIONS TO HELP YOU READ EVALUATIVE TEXTS RHETORICALLY

Asking the following questions of the texts you read in this chapter offers you practice in the very activity this chapter discusses: evaluating and judging. The questions below imply criteria by which you can evaluate and judge the effectiveness of these texts. Additionally, they offer guidance for writing your own evaluations.

1. What question of value is at issue? Is it a question of whether something is beneficial or harmful? A question of whether something is good, better, or best? Is this question of value stated explicitly or only implied?
2. What criteria are stated or implied? Are the terms clearly defined? Does the writer use relative or ideal criteria? Are the criteria appropriate to the subject being evaluated and to the situation?
3. Does the author offer evidence that the subject being evaluated meets or fails to meet the stated or implied criteria? What kind of evidence is offered—quantitative or qualitative? Does the author offer sufficient evidence to convince you of his or her judgment? Does the author use analogy or comparison as evidence for his or her evaluation? If so, are such analogies or comparisons appropriate and convincing?
4. What's the author's purpose? Is the author merely trying to inform you of his or her judgment, or is she or he trying to persuade you to take some action based on that evaluation? What, if anything, is at stake in this evaluation?
5. What kind of knowledge or authority does the author assert as a qualification for making this judgment?
6. What kind of a persona or personality does the author create in the text? That is, do the author's tone and attitude toward the subject being judged convince you that he or she is fair-minded, someone whose judgment is worthy of respect?

MICHAEL RAMIREZ

Survivors

Michael Ramirez is a Pulitzer Prize–winning editorial cartoonist for the *Los Angeles Times*. Ramirez began cartooning while a premed student at the University of California, Irvine, regarding it at first as merely a hobby. However, his first cartoon published in the student newspaper caused such a stir, he was, in his own words, "hooked." Speaking of the controversies caused by his editorial cartoons over the years, Ramirez says, "If I don't get at least one phone call a day that says I'm a moron, I'm not doing my job." In addition to winning a Pulitzer in 1994, Ramirez won the 1996 Mencken Award for Best Cartoon. "Survivors" was published in the *Los Angeles Times* on July 14, 2003.

• FOR YOUR READING LOG

1. When you first glance at the cartoon below, what words or images are your eyes drawn to?
2. What is your first impression of the cartoon's message?

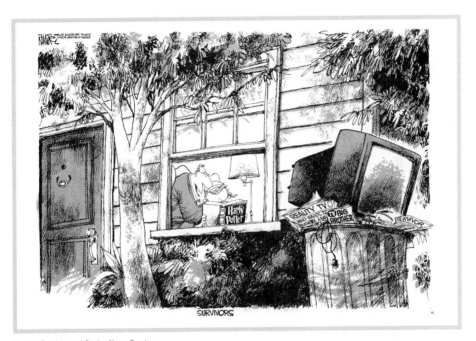

Michael Ramirez and Copley News Service.

• THINKING CRITICALLY ABOUT "SURVIVORS"

RESPONDING AS A READER

1. This cartoon uses only a few words yet creates a strong set of oppositions. How do those words combine with Ramirez's drawing to create sets of opposing values?
2. How do you interpret the cartoon's title, "Survivors"? What is the central claim being made by the cartoon? Try to boil it down to one sentence.
3. What assumptions does Ramirez seem to be making about who will enjoy this cartoon? On what grounds do you think someone might take issue with it?

RESPONDING AS A WRITER

1. What makes for an effective editorial cartoon in your opinion? What are some criteria that one might apply in assessing a cartoon's effectiveness? Using these criteria, write a short evaluation of Ramirez's cartoon.

2. You can view other Ramirez cartoons at http://www.copleynews.com. Examine as many as you can, and then write a brief paragraph describing Ramirez's concerns and typical approach to subject matter. Refer to specific cartoons to back up your analysis.
3. Do you agree with the message in this cartoon? Choose one of Ramirez's cartoons and write a letter to him responding to its method and message. •

JARED DIAMOND

Invention Is the Mother of Necessity

Jared Diamond (b. 1937), a professor of physiology at the UCLA School of Medicine, is the author of several widely acclaimed "trade" books—that is, books written for nonscientists—as well as the author of numerous scholarly articles. His books include *Guns, Germs, and Steel: The Fates of Human Societies* (1997), *Why Is Sex Fun? The Evolution of Human Sexuality* (1997), and *The Birds of Northern Melanesia: Speciation, Dispersal, and Ecology*, with Ernst Mayr (2001). In 1985, Diamond received a MacArthur Foundation "Genius" Award, and in 1998 a Pulitzer Prize for *Guns, Germs, and Steel*. An expert in bird ecology and evolutionary physiology, Diamond is both praised and criticized for his interdisciplinarity as well as for his unconventional theories. For example, in *Guns, Germs, and Steel*, Diamond argues that the peoples of Europe and Asia were successful in conquering others because of an accident of geography that made it possible for them to develop advanced weaponry, immunity to disease, and certain social structures. In this essay on the "best invention" of the past 1,000 years, written for the *New York Times Magazine* April 18, 1999 issue on millennial "bests," Diamond demonstrates both his broad knowledge and his inclination to play the iconoclast.

• FOR YOUR READING LOG

1. This article ran with the following subtitle: "Gutenberg didn't invent the printing press—and other surprises from 1,000 years of ingenuity." What expectations does this subtitle create for you?
2. As mentioned in the headnote above, this article was published with a group of other articles in anticipation of the new millennium. Given the information you have about the rhetorical context—occasion, place of publication, and author—what do you predict about the article's level of difficulty and interest to you? •

My 11-year-old twin sons just told me what they learned today in school. 1
"Daddy, Johannes Gutenberg invented the printing press, and that was one of
the greatest inventions in history." I learned that, too, when I was a child. I sus-
pect that the same view is taught in most other American and European schools.
What we are told about printing is partly true, or at least defensible. Personally,
I would rate it as the best single "invention" of this millennium. Just think of its
enormous consequences for modern societies. Without printing, millions of peo-
ple wouldn't have read quickly, with no transmission errors, Martin Luther's 95
Theses, the Declaration of Independence, the Communist Manifesto or other
world-changing texts. Without printing, we wouldn't have modern science.
Without printing, Europeans might not have spread over the globe since 1492,
because consolidation of initial European conquests required the emigration of
thousands of would-be conquistadors motivated by written accounts of Pizarro's
capture of the Incan emperor Atahualpa.

So I agree with half of what my kids were taught—the part about the im- 2
portance of printing. But things get more complicated when you credit this in-
vention specifically to Gutenberg, or even when you credit him with just the
printing press itself. Gutenberg did much more than invent the printing press—
and much less than invent printing. A more accurate rendering of his achieve-
ments would be something like the following legalistic sentence: "Gutenberg
played a major practical and symbolic role in independently reinventing, in a
greatly improved form and within a more receptive society, a printing technique
previously developed in Minoan Crete around 1700 B.C., if not long before that."

Why did Gutenbergian printing take off while Minoan printing didn't? 3
Therein lies a fascinating story that punctures our usual image of the lonely and
heroic inventor: Gutenberg, James Watt, Thomas Edison. Through his contribu-
tion to the millennium's best invention, Gutenberg gave us the millennium's best
window into how inventions actually unfold. Even American and European
schoolchildren reared on Gutenberg hagiography soon learn that China had
printing long before Gutenberg. Chinese printing is known to go back to around
the second century A.D., when Buddhist texts on marble pillars began to be
transferred to the new Chinese invention of paper via smeared ink. By the year
868, China was printing books. But most Chinese printers carved or otherwise
wrote out a text on a wooden block instead of assembling it letter by letter as
Gutenberg did (and as almost all subsequent printers using alphabetic scripts
have also done). Hence the credit for what Gutenberg invented is also corrected
from "printing" to "printing with movable type": that is, printing with individ-
ual letters that can be composed into texts, printed, disassembled and reused.

Have we now got the story right? No, Gutenberg still doesn't deserve credit 4
even for that. By about 1041, the Chinese alchemist Pi Sheng had devised mov-
able type made of a baked-clay-and-glue amalgam. Among the subsequent in-
ventors who improved on Pi Sheng's idea were Korea's King Htai Tjong (cast-
bronze type, around 1403) and the Dutch printer Laurens Janszoon (wooden type
with hand-carved letters, around 1430). From all those inventors, it's convenient
(and, I think, appropriate) to single out Gutenberg for special credit because of
his advances—the use of a press, a technique for mass-producing durable metal

letters, a new metal alloy for the type and an oil-based printing ink. We also find it convenient to focus on Gutenberg as a symbol because he can be considered to have launched book production in the West with his beautiful Bible of 1455.

5 But a form of printing with movable type was invented far earlier by an unnamed printer of ancient Crete in the Minoan age. The proof of Minoan printing can be found in a single baked-clay disk, six inches in diameter. Found buried deep in the ruins of a 1700 B.C. palace at Phaistos on Crete, the disk is covered on both sides with remarkable spiraling arrays of 241 symbols constituting 45 different "letters" (actually, syllabic signs), which were not deciphered until a couple of years ago. A recent decipherment identifies the signs' language as an ancient form of Greek that predates even Homer.

6 Astonishingly, the symbols of the Phaistos disk weren't scratched into the clay by hand, as was true of most ancient writing on clay, but were instead printed by a set of punches, one for each of the 45 signs. Evidently, some ancient Cretan predecessor of Pi Sheng beat him to the idea by 2,741 years. Why did Minoan printing die out? Why was Renaissance Europe ready to make use of the millennium's best invention while Minoan Crete was not?

7 Technologically, the Minoans' hand-held punches were clumsy. The early Minoan writing system itself, a syllabary rather than an alphabet, was so ambiguous that it could be read by few people and used for only very particular kinds of texts, perhaps only tax lists and royal propaganda. Chinese printing's usefulness was similarly limited by China's own nonalphabetic writing system. To make Minoan printing efficient would have required technological advances that did not occur until much later, like the creation of paper, an alphabet, improved inks, metals and presses.

8 I mentioned that Gutenberg is part not only of the millennium's best invention but also of its best insight into how our usual view of inventions often misses the point. Coming up with an invention itself may be the easy part; the real obstacle to progress may instead be a particular society's capacity to utilize the invention. Other famously premature inventions include wheels in pre-Columbian Mexico (relegated to play toys because Mexican Indians had no draft animals) and Cro-Magnon pottery from 25,000 B.C. (What nomadic hunter-gatherer really wants to carry pots?)

9 The technological breakthroughs leading to great inventions usually come from totally unrelated areas. For instance, if a queen of ancient Crete had launched a Minoan Manhattan Project to achieve mass literacy through improved printing, she would never have thought to emphasize research into cheese, wine and olive presses—but those presses furnished prototypes for Gutenberg's most original contribution to printing technology. Similarly, American military planners trying to build powerful bombs in the 1930's would have laughed at suggestions that they finance research into anything so arcane as transuranic elements.

10 We picture inventors as heroes with the genius to recognize and solve a society's problems. In reality, the greatest inventors have been tinkerers who loved tinkering for its own sake and who then had to figure out what, if anything, their devices might be good for. The prime example is Thomas Edison, whose phono-

graph is widely considered to be his most brilliant invention. When he built his first one, in 1877, it was not in response to a national clamor for hearing Beethoven at home. Having built it, he wasn't sure what to do with it, so he drew up a list of 10 uses, like recording the last words of dying people, announcing the time and teaching spelling. When entrepreneurs used his invention to play music, Edison thought it was a debasement of his idea.

Our widespread misunderstanding of inventors as setting out to solve soci- 11 ety's problems causes us to say that necessity is the mother of invention. Actually, invention is the mother of necessity, by creating needs that we never felt before. (Be honest: did you really feel a need for your Walkman or CD player long before it existed?) Far from welcoming solutions to our supposed needs, society's entrenched interests commonly resist inventions. In Gutenberg's time, no one was pleading for a new way to churn out book copies: there were hordes of copyists whose desire not to be put out of business led to local bans on printing.

The first internal-combustion engine was built in 1867, but no motor ve- 12 hicles came along for decades, because the public was content with horses and railroads. Transistors were invented in the United States, but the country's electronics industry ignored them to protect its investment in vacuum-tube products; it was left to Sony in bombed-out postwar Japan to adapt transistors to consumer-electronics products. Manufacturers of typing keyboards continue to prefer our inefficient qwerty layout to a rationally designed one.

All these misunderstandings about invention pervade our science and tech- 13 nology policies. Every year, officials decry some areas of basic research as a waste of tax dollars and urge that we instead concentrate on "solving problems": that is, applied research. Of course, much applied research is necessary to translate basic discoveries into workable products—a prime example being the Manhattan Project, which spent three years and $2 billion to turn Otto Hahn and Fritz Strassman's discovery of nuclear fission into an atomic bomb. All too often, however, the world fails to realize that neither the solutions to most difficult problems of technology nor the potential uses of most basic research discoveries have been predictable in advance. Instead, penicillin, X-rays and many other modern wonders were discovered accidentally—by tinkerers driven by curiosity.

So forget those stories about genius inventors who perceived a need of so- 14 ciety, solved it single-handedly and transformed the world. There has never been such a genius; there have only been processions of replaceable creative minds who made serendipitous or incremental contributions. If Gutenberg himself hadn't devised the better alloys and inks used in early printing, some other tinkerer with metals and oils would have done so. For the best invention of the millennium, do give Gutenberg some of the credit—but not too much.

THINKING CRITICALLY ABOUT "INVENTION IS THE MOTHER OF NECESSITY"
RESPONDING AS A READER

1. What did you initially expect Diamond to evaluate? At what point did you begin to realize that he was actually going to evaluate something

other than what you initially thought? What effect did this surprising reversal have on you as a reader?

2. While Diamond asserts as early as paragraph 2 that the printing press is the "millennium's best invention," he also makes clear his intention to demonstrate that "things get more complicated when you credit this invention specifically to Gutenberg." How does his discussion of the complications—the role of inventors and the credit they may or may not deserve as individuals—change the way he wants us to understand the term "best invention"?

3. Why does Diamond think it is important to change people's minds about the process of invention? What are possible consequences of this change in perspective?

RESPONDING AS A WRITER

1. Diamond's essay is densely packed with facts, so he tries to lighten his essay with anecdotes, humor, and other strategies meant to engage reader interest. Find examples of these strategies and evaluate their effectiveness in enlivening the essay and engaging your interest.

2. The title inverts the word order of the proverb "Necessity is the mother of invention." First, consider the meaning of this proverb. Does it seem to be true in terms of your knowledge of scientific discoveries and/or your personal experience? Second, consider the meaning of his reversal of the proverb. Does he persuade you of the validity of his claim? Freewrite your responses to these questions.

3. Do you agree with Diamond's claim that inventions "create needs that we never felt before"? He cites the CD player and Walkman. Can you think of other inventions that have occurred during your lifetime that created needs you and others never felt before? Take a few minutes to jot down your ideas. ●

LAURENCE ZUCKERMAN

Words Go Right to the Brain, but Can They Stir the Heart?

Laurence Zuckerman, a staff writer for *Time* magazine and regular contributor to the *New York Times*, writes frequently on technology and culture. This article, published in the *New York Times* in 1999, offers a commentary on the communicative effectiveness of Power-Point, a presentation program created by Microsoft to assist public speakers in organizing and creating visual aids for their talks.

1. How familiar are you with PowerPoint? Have you seen any PowerPoint presentations in class or at work? Have you ever used PowerPoint yourself? If so, what's your assessment of its value to speakers as well as to audiences? If not, do you think such a program might be useful to speakers and audiences? Why?

2. Whether or not you are familiar with the content of King's speech, what does the doctored photograph here suggest to you about the effects of PowerPoint on King's speech? •

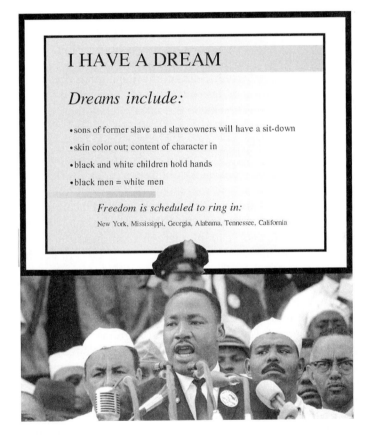

Good Morning.
 The title of today's presentation is: "The Effect of Presentation Software on Rhetorical Thinking," or "Is Microsoft Powerpoint Taking Over Our Minds?"

- *I will begin by making a joke.*
- *Then I will take you through each of my points in a linear fashion.*
- *Then I will sum up again at the end.*

3 *Unfortunately, because of the unique format of this particular presentation, we will not be able to entertain questions.*

4 Were Willy Loman to shuffle through his doorway today instead of in the late 1940's, when Arthur Miller wrote "Death of a Salesman," he might still be carrying his sample case, but he would also be lugging a laptop computer featuring dozens of slides illustrating his strongest pitches complete with bulleted points and richly colored bars and graphs.

5 Progress? Many people believe that the ubiquity of prepackaged computer software that helps users prepare such presentations has not only taken much of the life out of public speaking by homogenizing it at a low level, but has also led to a kind of ersatz thought that is devoid of original ideas.

6 Scott McNealy, the shoot-from-the-lip chairman and chief executive of Sun Microsystems, who regularly works himself into a lather criticizing the Microsoft Corporation, announced two years ago that he was forbidding Sun's 25,000 employees to use Powerpoint, the Microsoft presentation program that leads the market. (The ban was not enforced.) Some computer conferences have expressly barred presenters from using slides as visual aids during their talks, because they think it puts too much emphasis on the sales pitch at the expense of content.

7 Psychologists, computer scientists and software developers are more divided about the effect of Powerpoint and its competitors. Some are sympathetic to the argument that the programs have debased public speaking to the level of an elementary school filmstrip.

8 "The tools we use to shape our thinking with the help of digital computers are not value free," said Steven Johnson, the author of "Interface Culture," a 1997 study of the designs used to enable people to interact with computers.

9 Mr. Johnson uses Powerpoint himself (for example, during a recent talk he gave at Microsoft) but nonetheless said, "There is a certain kind of Powerpoint logic that is brain numbing."

10 Presentation programs are primarily used for corporate and sales pitches. Still, the approach has leaked into the public discourse. Think of Ross Perot's graphs or President Clinton's maps. Critics argue such programs contribute to the debasement of rhetoric. "Try to imagine the 'I have a dream' speech with Powerpoint," said Cliff Nass, an associate professor of communication at Stanford University who specializes in human-computer interaction. Other people, however, have made the opposite argument, saying that Powerpoint has elevated the general level of discourse by forcing otherwise befuddled speakers to organize their thoughts and by giving audiences a visual source of information that is a much more efficient way for humans to learn than by simply listening.

11 "We are visual creatures," said Steven Pinker, a psychology professor at the Massachusetts Institute of Technology and the author of several books about cognition including "The Language Instinct." "Visual things stay put, whereas sounds fade. If you zone out for 30 seconds—and who doesn't?—it is nice to be able to glance up on the screen and see what you missed."

Mr. Pinker argues that human minds have a structure that is not easily re- 12
programmed by media. "If anything, Powerpoint, if used well, would ideally re-
flect the way we think," he said.

But Powerpoint too often is not used well, as even Mr. Pinker admitted. He 13
is on a committee at M.I.T. that is updating the traditional writing requirement
to include both speech and graphic communication. "M.I.T. has a reputation for
turning out Dilberts," he said. "They may be brilliant in what they do, but no one
can understand what they say."

Visual presentations have played an important part in business and acade- 14
mia for decades, if not centuries. One of the most primitive presentation tech-
nologies, the chalkboard, is still widely used. But in recent years the spread
of portable computers has greatly increased the popularity of presentation
programs.

Just as the word processing programs eliminated many of the headaches of 15
writing on a typewriter, presentation software makes it easy for speakers to cre-
ate slides featuring text or graphics to accompany their talks. The programs re-
place the use of overhead projectors and acetate transparencies, which take time
to create and are more difficult to revise. Most lecture halls and conference rooms
now feature screens that connect directly to portable computers, so speakers can
easily project their visual aids.

The secret to Powerpoint's success is that it comes free with Microsoft's 16
best-selling Office software package, which also features a word processing pro-
gram and an electronic spreadsheet. Other presentation programs, like Free-
lance from I.B.M.'s Lotus division and Corel Corporation's Presentations, also
come bundled with other software, but Office is by far the most successful, rack-
ing up $5.6 billion in sales last year.

Because most people do not buy Powerpoint on its own, it is difficult to tell 17
how many actual users there are. Microsoft says that its surveys show that, com-
pared with two years ago, twice as many people who have Office are regular
users of Powerpoint today, and that three times as many Office users have at
least tried the program. Anecdotal evidence indicates an explosion in the use
of Powerpoint.

For instance, the program is used for countless sales pitches every day both 18
inside and outside a wide variety of companies. It is de rigueur for today's
M.B.A. candidates. The Dale Carnegie Institute, which imbues its students with
the philosophy of the man who wrote the seminal work "How to Win Friends
and Influence People," has a partnership with Microsoft and offers a course in
"high-impact presentations" at its 170 training centers in 70 countries. Microsoft
has incorporated into Powerpoint many templates based on the Carnegie pro-
grams and has even incorporated the Carnegie course into the program's help
feature.

Powerpoint is so popular that in many offices it has entered the lexicon as a 19
synonym for a presentation, as in "Did you send me the Powerpoint?"

The backlash against the program is understandable. Even before the advent 20
of the personal computer, there were those who argued that speeches with visual

aids stressed form over content. Executives at International Business Machines Corporation, the model of a successful corporation in the 1950's, 60's and 70's, were famous for their use of "foils," or transparencies.

21 "People learned that the way to get ahead wasn't necessarily to have good ideas," wrote Paul Carroll in "Big Blues," his 1993 study of I.B.M.'s dramatic decline in the era of the personal computer. "That took too long to become apparent. The best way to get ahead was to make good presentations."

22 Critics make many of the same claims about Powerpoint today. "It gives you a persuasive sheen of authenticity that can cover a complete lack of honesty," said John Gage, the chief scientist at Sun Microsystems, who is widely respected in the computer industry as a visionary.

23 Academic critics echo the arguments made by Max Weber and Marshall McLuhan ("The medium is the message") that form has a critical impact on content.

24 "Think of it as trying to be creative on a standardized form," Mr. Nass said. "Any technology that organizes and standardizes tends to homogenize."

25 Powerpoint may homogenize more than most. In the early 1990's Microsoft realized that many of its customers were not using Powerpoint for a very powerful reason: They were afraid. Steven Sinofsky, the Microsoft vice president in charge of the Office suite, said that writer's block was an issue for people using word processors and other programs but the problem was worse with Powerpoint because of the great fear people had of public speaking.

26 "What would happen was that people would start up Powerpoint and just stare at it," he said.

27 Microsoft's answer was the "autocontent wizard," an automated feature that guides users through a prepared presentation format based on what they are trying to communicate. There are templates for "Recommending a Strategy," "Selling a Product," "Reporting Progress" and "Communicating Bad News."

28 Since 1994, when it was first introduced, the autocontent wizard in Powerpoint has become increasingly sophisticated. About 15 percent of users, Mr. Sinofsky said, now start their presentations with one of those templates. The latest version of Powerpoint, which will be released this month, will feature an even more powerful wizard. The new version also includes thousands of pieces of clip art that the program can suggest to illustrate slides. There is even a built-in presentation checker that will tell you whether your slides are too wordy, or that your titles should be capitalized while bullet points should be lowercase.

29 Many see the best antidote to the spread of Powerpoint in a graphic medium that is expanding even faster than the use of presentation software: the Web. Whereas Powerpoint presentations are static and linear, the Web jumps around, linking information in millions of ways. Mr. Gage of Sun tries to use the Web to illustrate his many public speeches, though a live Internet connection is not as readily available at lecterns these days as a cable that can connect a notebook computer to a screen for a Powerpoint presentation.

30 "Powerpoint is just a step along the way because you can't click on a Powerpoint presentation and get the details," said Daniel S. Bricklin, who developed

the first electronic spreadsheet for P.C.'s and more recently a program called Trellix that puts Web-like links into documents.

Mr. Bricklin said the Web, like any new medium, required new forms of com- 31 position just as the headlines and opening paragraphs of newspaper articles helped readers skim for the most information.

But he does not bemoan the popularity of presentation software. "It was a 32 lot worse," he said, "when people got up with their hands in their pockets, twirling their keys, going 'Um um um.'"

● **THINKING CRITICALLY ABOUT "WORDS GO RIGHT TO THE BRAIN, BUT CAN THEY STIR THE HEART?"**

RESPONDING AS A READER

1. What is the effect of Zuckerman's decision to present the introductory paragraph as a PowerPoint presentation? What connections do you see between this opening and the graphic of King's speech? What do these two examples of PowerPoint make you expect in the rest of the essay? Is this expectation fulfilled?
2. Do you find the criteria Zuckerman uses to evaluate the effect of PowerPoint on speakers and audiences to be appropriate and convincing?
3. Who are Zuckerman's intended readers in terms of age, educational background, social class, and profession? Are you part of this intended audience? Explain your answer by citing various allusions, terms, and statements in the text.

RESPONDING AS A WRITER

1. Zuckerman presents both negative and positive evaluations of PowerPoint's effects. Do you find his presentation balanced? Make a list of the advantages and disadvantages he mentions. What do you think his opinion is of PowerPoint—favorable, unfavorable, or mixed? Offer evidence to support your answer. Does Zuckerman ever really answer the question he poses in the title? If so, what is his answer? If not, why not?
2. Zuckerman quotes Steven Johnson as saying, "The tools we use to shape our thinking with the help of digital computers are not value free." What do you think Johnson means? Offer a paraphrase of this statement, and try to think of an example that illustrates Johnson's point.
3. Make a list of situations in which you think a PowerPoint presentation might be appropriate and effective and a list of situations in which it would not be appropriate or effective. What criteria did you use to decide? Choose one of the situations in which you think a PowerPoint presentation would not be appropriate, say, a marriage proposal, and create a mock PowerPoint presentation. ●

DAVID BRODER

August 28, 1963:
A Day Guided by Providence

A winner of the Pulitzer Prize in 1973 and the National Press Foundation's Fourth Estate Award in 1990, David Broder (b. 1929) has been called the "high priest of political journalism." Since 1966, Broder has been a political columnist for the *Washington Post*. His widely syndicated columns appear in over 300 newspapers in the United States and abroad. Broder has also written or co-authored seven books, including *Behind the Front Page: A Candid Look at How the News Is Made* (1987), *The System: The American Way of Politics at the Breaking Point* (with Haynes Johnson [1996]), and *Democracy Derailed: Initiative Campaigns and the Power of Money* (2000). He is a frequent participant on *Meet the Press* and regular commentator on CNN's *Inside Politics*. In 2001, the *Washingtonian* rated Broder among the top four best and most influential journalists in the country. Published originally in the *Washington Post*, this column was reprinted by other newspapers around the country on August 28, 2003.

• FOR YOUR READING LOG

1. On August 28, 1963, Martin Luther King delivered his "I Have a Dream Speech" during the famous March on Washington. Perhaps you have seen a videotape of this event or studied about it in school. Freewrite about your knowledge of this event, or if you have very little knowledge of it, pose some questions.
2. Based on Broder's title, what predictions would you make about the content of his article? •

———— • ————

1 Today is the 40th anniversary of one of the greatest days in American history—the day of the massive March on Washington for Jobs and Freedom, the largest civil rights demonstration of them all. It climaxed with the "I have a dream" speech by the Rev. Martin Luther King Jr.—a speech that ranks as one of the transcendent legacies of American rhetoric.

2 Even after four decades, I can vividly recall the emotions in that crowd of a quarter-million people, which filled the Mall and stretched back toward the Capitol. King stood at the feet of Abraham Lincoln at the memorial to the Great Emancipator and filled the air with his vision of a time when "my four little children will . . . live in a nation where they will not be judged by the color of their skin but by the content of their character."

3 In a brilliant essay in the summer issue of The Public Interest, Adam Wolfson, that journal's editor, elaborates on that famous passage. Although King was speak-

ing extemporaneously at that point, drawing on remembered portions of past addresses, he chose his words carefully. In one earlier speech, he had said America should seek to "substitute an aristocracy of character for an aristocracy of color."

But judging people by character does not mean what so many, including 4 Supreme Court Justice Clarence Thomas, have argued: judging each individual on the basis of talent and ability regardless of race.

"When King spoke of character," Wolfson writes, "he had a different mean- 5 ing in mind. Character is not something we are born with, and it is not measurable in an IQ score or a talent contest. Rather, it is something we develop over a lifetime in the course of our moral education."

King's entire life—like that speech—was an exercise in moral education. 6 Imbued with the spirit of passive resistance, he argued that the means by which civil rights were gained were just as important as the ends. Few of us in the white majority grasped that point before the march demonstrated it.

I had been called back from vacation by my editors at the old Washington 7 Star, because they—along with the entire political and business establishment, including President Kennedy—feared there might be trouble with so many outsiders descending on the city.

As Drew Hansen notes in "The Dream," his newly published book about the 8 march, civil rights legislation was stymied in Congress. Anti-black violence, including the murder of Medgar Evers, meanwhile, had inflamed passions. No one knew what thousands of frustrated protesters might do, and, as Hansen writes, "Washington had barricaded itself against the invaders. The streets downtown were nearly deserted. . . .

"There were so many soldiers on the streets one senator remarked that it 9 looked as though a military coup had happened during the night."

Instead of trouble came inspiration—with the peaceful black marchers 10 (joined by a surprising number of white clergymen and other sympathizers) providing a powerful political impulse that spurred the passage of the great Civil Rights Act of 1964 and the Voting Rights Act a year later.

Last month, John Lewis, the only survivor of the six men who led the March 11 on Washington, organized a commemoration ceremony in the Capitol. At the time of the speech, Lewis was the 23-year-old head of the Student Non-Violent Coordinating Committee. He has been a Democratic representative from Atlanta since 1986, revered in both parties as the moral conscience of Congress.

Lewis' remarks at the ceremony, like Wolfson's essay, made an important 12 point. King's speech moved the country, not because it challenged Americans to accept new ideas, but because it so powerfully invoked the values on which the nation had been founded—the belief in freedom, justice and equality under law.

"Call it the spirit of our founding fathers," Lewis said last month. "Call it the 13 spirit of Abraham Lincoln, Teddy Roosevelt or FDR. Call it the spirit of the March on Washington. Call it the spirit of history."

Senate Majority Leader Bill Frist (R-Tenn.) told the gathering that Aug. 28, 14 1963, was one of those moments in history "when we are reminded that our nation is not simply stumbling along a directionless path, but instead is guided by Providence toward a righteous and noble destiny."

15 He quoted King's own assessment of the March on Washington: "As television beamed the image of this extraordinary gathering across the border oceans, everyone who believed in man's capacity to better himself had a moment of inspiration and confidence in the future of the human race."

16 It was all of that.

● THINKING CRITICALLY ABOUT "AUGUST 28, 1963: A DAY GUIDED BY PROVIDENCE"

RESPONDING AS A READER

1. At what points in Broder's essay were you most engaged? Which of Broder's details or images of the event do you find most striking and why?
2. Broder claims that "King's entire life—like that speech—was an exercise in moral education." What criteria does Broder use in making this judgment? What evidence does he offer in support of this judgment?
3. What purpose or purposes does this reflection about August 28, 1963 serve today? What current issues does this article speak to?

RESPONDING AS A WRITER

1. Broder begins with an evaluation: August 28, 1963 was "one of the greatest days of American history." He develops this claim with a variety of reasons and evidence, some his own, some offered by people he quotes. Examine his reasoning to pinpoint places where it depends on values that are unstated but assumed to be shared by readers.
2. In addition to his firsthand observations of the event in 1963 and reflections on it in 2003, Broder brings together a number of other perspectives and evaluations of the march and King's speech: Wolfson's, Hansen's, Lewis's, Frist's, and King's. What does each add to the overall evaluation of the event and its significance?
3. In Chapter 4 we discuss how a text's ideology is revealed by binary terms and values. Make a two-column list of the binaries that you find in this article. Then write a short analysis of the author's ideology and, more specifically, the concept of patriotism that follows from these ideological values. ●

M. G. LORD

En Garde, Princess!

M(ary) G(race) Lord (b. 1955) is a nationally syndicated editorial cartoonist who works for *Newsday.* Lord's cartoons are known for their bold and biting social commentary; however, her cultural criticism extends beyond cartooning. She is a commentator for National

Public Radio and an investigative journalist. Author of *Forever Barbie: The Unauthorized Biography of a Real Doll* (1995), she is currently working on a cultural history of NASA's Jet Propulsion Lab. "En Garde, Princess!" appeared in the online magazine *Salon* on October 27, 2000, in the regularly featured "Mothers Who Think" department.

● FOR YOUR READING LOG

1. This article was originally accompanied by the subhead "For the first time ever, Barbie may have a challenger who can kick her anorexic butt." What do the title and this subhead suggest about the tone and style of this article? Log on to http://www.salon.com. What commonalities do you discover among the article titles you find? How would you describe the *Salon* style and attitude? Who is the intended audience?

2. Lord's title and first paragraph use military or battle metaphors to discuss the competition between Barbie and the Get Real Girls dolls. As you read this article, mark the examples of military metaphors that occur throughout the article. ●

——— ● ———

If I were Barbie, the 11-and-a-half-inch princess who has dominated the doll 1 world since 1959, I would keep an eye on the newly formed SWAT team of action figures known as Get Real Girls. I wouldn't raise the pink drawbridge or dump the radio-controlled alligators into the moat. Not just yet, anyway. But I would watch my bony little back.

I do not say this lightly. As the author of "Forever Barbie: The Unautho- 2 rized Biography of a Real Doll," I know that the princess has systematically annihilated each and every one of her competitors, beginning in 1963, when Marx Toys introduced a shabby wannabe, Miss Seventeen, with whom Barbie swiftly wiped the nursery floor. There were legal issues involved, but they did not ultimately matter. Miss Seventeen was a wreck—jaundiced skin, shoddily implanted hair, a veritable Miss Teen Runaway—and kids simply didn't want her. Consequently, when I was asked to evaluate these new pretenders to Barbie's throne, I knew I had to move fast. Barbie's challengers do not tend to last long.

When I saw the Get Real Girls, however, I was thrown off guard. These 3 dolls are far from slipshod wannabes. And the time seems right for a toy-world upset. Last year, something happened at Mattel that had once seemed impossible: Jill Barad, the company's Barbie-identified, pink-suit-wearing (a bubble-gum shade) juggernaut of a CEO, resigned—after making such a mess of the company that its stock lost 70 percent of its value. If Barad, who built the Barbie line from about $250 million (when she arrived as a low-level manager in the 1980s) to $1.7 billion last year, could suffer a reversal of fortune, why not Barbie herself? This warranted a closer look: at Barbie and Barad, and the new, punchy young upstarts, the Get Real Girls and their creator, Julz Chavez.

4 The Get Real team has six members: Gabi, a soccer player, Corey, a surfer, Skylar, a snowboarder, Nakia, a basketball player, Claire, a scuba diver, and Nini, a mountaineer. You won't find these girls in toeshoes or figure skates. They are a tough, muscular lot, whose swelling biceps and chiseled abdominals are as much inspired by Brandi Chastain, the U.S. soccer player best known for ripping off her shirt after last year's World Cup victory, as by the original pumped-up action figure, GI Joe. (In fact, if you do rip the shirt off a Get Real Girl, you will find a trim little sports bra covering up a modest package in place of Barbie's bare, bullet-shaped bosoms.)

5 Chavez is not your archetypal doll designer. A cousin to César Chavez, the legendary 1960s labor leader, she worked in toy development for 15 years, several of which were spent behind the fuchsia ramparts of Barbie's own manufacturer, Mattel. Chavez's dolls, however, do not bear a trace of fuschia. Their boxes are blue and orange.

6 "Our stealth name for the project, while we were working on it, was, 'No Pink,'" Chavez told me over coffee recently. But the defiant moniker didn't make it to market. "If you call a concept 'No Pink,' Mattel will come after you big time," she explained.

7 Mattel will usually come after you anyway. In the fall of 1985, for example, the Barbie team learned from undercover sources that Hasbro was planning to release Jem, a new rock star fashion doll, the following February. "Within minutes," a former Mattel executive told me, "we had a war council." Within an hour, they had a plan: Pull together a rock group for Barbie. Although Barbie and the Rockers hurt Jem's sales, the Hasbro doll destructed on her own. At 12 inches tall, she looked like a surly drag queen in Barbie's clothes. "If you're going to go up against General Motors," a dealer in collector merchandise explained, "you'd better be the same size."

8 Similarly, in 1991, Barbie's most recent challenger, Happy to Be Me, fizzled after a promising start. From Allure to People magazine, journalists applauded her alleged "realistic" proportions—closer to the Get Real Girls' 33-24-33 than to Barbie's (roughly) 40-18-22. But the doll did not live up to its press. Created by a Midwestern mom who lacked toy industry experience, Happy was produced cheaply and badly. The doll was repulsive—from its lackluster wardrobe, which seemed to consist solely of frumpy housecoats, to its sparse clumps of hair, scattered so meagerly that the total effect recalled Sen. William Proxmire's hair transplant.

9 It satisfied neither girls' craving for an over-the-top prom queen nor their mothers' desire for a tasteful, realistic role model. Like Barbie, Happy looked like she belonged in a trailer park, but if Barbie was cast in the role of neighborhood slut, Happy was the careworn housewife who had let herself go. She may have been happy to be herself, but it was obvious, even to kids, that she had extremely low standards.

10 The Get Real Girls, by contrast, are beautifully designed miniatures. If nothing else, Chavez's experience at Mattel taught her that details matter. The Get Real Girls are equipped with meticulous replicas of the sporty styles that modern girls covet—exquisite zippered backpacks, painted hiking boots, two-tone beach slippers. Chavez says her girls would "look great in a tight black dress,"

even if they had to steal it from Barbie. And despite their slightly obtrusive ball-like joints, I am inclined to agree (even if their sneaker-ready feet mean that they must pair their cocktail dresses with sensible flats). They also have great, shiny, abundant hair. This is a crucial asset, since "hairplay," as Mattel market research types call it, is a big draw for girls. "Each doll," Chavez reminded me, "comes with a hairbrush."

These dolls express the ethos of their time, which has changed considerably 11 in the 40 years since Barbie first wobbled out in her steep stiletto mules. Today, the adjective "ladylike" has bitten the dust. Parents encourage daughters to sweat and grunt in physical competition, and even supermodels sport muscles obtained by logging hours at the gym. Chastain, immortalized in her sports bra, is a role model for girls, one that meets with the approval of most middle-class parents.

Although Mattel equipped its princess for such country-club sports as ten- 12 nis, at the time of her creation, the idea of a woman participating in a so-called extreme sport was inconceivable. In the 1960s, even swaggering gym teacher types rarely engaged in anything more vigorous than golf or bowling. Barbie, to be sure, has been issued paraphernalia for rougher sports, but with her '60s-era pinup girl figure, she looks ridiculous in a basketball uniform—as if she borrowed it for a photo shoot and cannot wait to give it back.

And the Internet may do for the Get Real Girls what television advertising 13 did for Barbie. In 1955, Mattel became the first toy company to broadcast commercials during children's programs that were aimed directly at underage viewers. Before this time, children were not thought of as significant consumers, and no company had made a large-scale attempt to shape or exploit their buying habits.

Chavez's site speaks directly to girls. It is reminiscent of the early Barbie com- 14 mercials, in which the doll was deliberately portrayed in a subversive way that, during market research sessions, had unnerved parents and delighted kids. Back then, of course, subversive meant unabashedly sexy. The Get Real Girls are subversive in a different way: jocky, and up-to-date on music that may be grating to parental ears. At the Get Real Girl site, users can choose among "dance," "groove," "lounge" and "tune out" sounds. Every single music selection had a thumping beat that irritated me immensely—a sure sign that kids will groove on the music.

It isn't as if Barbie doesn't have her own Web site. She does. It's just shock- 15 ingly uncool and hopelessly out of date. Hit an icon labeled "Storytelling," for example, and you are assaulted by insipid harp music reminiscent of Walt Disney's TV show during the 1950s.

Although GetRealGirl.com is intended to sell dolls, it does not promote spe- 16 cific products by other manufacturers. "I don't want to tell kids that you have to buy brands to be cool," Chavez explained. "We will not post banner ads on our site." (On the other hand, Chavez does encourage kids to obtain certain accessories, even if their makers aren't specified. "I wish I had an MP3 player like Sky does," Corey, for example, laments in the course of her adventure.) The deemphasis on brands, however, places Chavez in sharp contrast to Barad, who

coaxed high-end manufacturers like Ferrari to license Barbie-size versions of their products as a way to teach brand recognition to kids.

17 Born Julia Chavez in 1962, Chavez shortened her name to Julz when, after graduating from the California College of Arts and Crafts, she applied for jobs designing toys not specifically intended for girls. As Julia, she got polite rejections; as Julz, she was invited to show her portfolio. In person her gender was abundantly clear: When I met her, she was chic, thin and stylishly turned out in a turtleneck and leather jacket.

18 Yet her demeanor was a far cry from that of Barad, who made grossly exaggerated femininity her trademark. Barad dressed to intimidate: The suit she wore when I met her while researching my book cost more than my car. During company presentations, she would often dance, cheerleader fashion, to music from product promotions—a practice that appalled Wall Street. "This may be very infectious in a sales presentation at a toy company," an industry analyst told the New York Times, "but you are not accustomed to seeing it at banker presentations."

19 Chavez was never much of a fan of froufrou femininity. Neither Chavez nor her sisters ever owned a Barbie. This did not present a problem until she arrived at Mattel, and was told that all new employees must accept an upscale porcelain version of the doll. "I made it so far without a Barbie," she told them, "I'm not going to start now." When they gave her a hard time, she reluctantly accepted a porcelain Ken.

20 One of 10 children raised by her father, a farmworker, Chavez was born in Yuma, Ariz., and came of age in Southern California. The Arizona years were hard, in no small part because of the discrimination visited on Mexican-Americans. "We were thrown out of restaurants because my father was too dark," she recalled.

21 Chavez based the Get Real Girls on her real-life friends—athletes like Olympic cyclist Stephanie McKnight and former professional surfer Candace Woodward. She claims that out of all her dolls, she feels the strongest affinity for Gabi, the Brazilian-American soccer player, who, like her, is biracial.

22 I asked Chavez for the details on the Get Real Girls' lives: How old are they? Are they still in school? Have they turned pro? Chavez picked up a blue and orange package and read the girls' biographies off the back of the box. Nini plans to steady archaeology. Claire intends to be a vet. "But Nakia," Chavez said slyly, "might turn pro. I'm not sure yet."

23 And where are the tennis players? Aren't Venus and Serena Williams inspiring girls left and right? This question seemed to hit a nerve. The sisters, Chavez said, "made a deal with another company."

24 Inspired by her cousin, Chavez has been vigilant about labor practices involved in the making of her dolls. The Get Real Girls, like Barbie, are made in China. But before Chavez would permit production to begin, she visited the factory to make sure workers had adequate on-site living facilities and received sufficient breaks. (If Barad ever did anything along these lines, she did not tell me or any other journalist.)

25 In the past, Barbie has, of course, navigated shoals that shipwrecked Mattel executives. In 1978, for example, Ruth Handler, the Mattel co-founder who is con-

sidered by many to be the closest thing Barbie has to a mother, pleaded no contest to charges of conspiracy, mail fraud and falsifying Securities and Exchange Commission information. She was sentenced to a 41-year prison sentence and a $57,000 fine, which the judge later suspended. He did, however, require that she devote 500 hours each year for five years to community service and pay $57,000 to fund an occupational "rehab" center for convicted felons. Barbie, however, suffered only a temporary setback. No competitors managed to exploit her weakness. Roughly 15 years later, when Barad arrived, Barbie sales reached their highest point ever.

Mattel's Teflon resiliency over the past 40 years does not signal doom for the 26
Get Real Girls, who, despite their hipster spunk and pumped-up swagger, are still far from perfect. But it does suggest a different way to interpret victory. For the girls to crush Barbie, they don't have to eradicate her. They just have to beat her up a bit, punch a few holes in her sales. Even a tiny dent would be historic, the first such inroad of its kind.

Sparring with the girls might just build Barbie's character—after they break 27
her plastic jaw.

● THINKING CRITICALLY ABOUT "EN GARDE, PRINCESS!"

RESPONDING AS A READER

1. In this article, Lord assesses the Get Real Girls' chances of dethroning Barbie by comparing the dolls according to various criteria. What are those criteria and what judgments do they lead Lord to make?
2. How does Lord use her historical knowledge of Barbie to establish her credibility as a judge?
3. Why does Lord compare Barad, the power behind Barbie's success for many years, and Chavez, the creator of the Get Real Girls, as well as the dolls? What criteria does she use to compare these two women? What does her evaluation of the two doll sponsors/creators contribute to her evaluation of the dolls?

RESPONDING AS A WRITER

1. Review the military metaphors and references you noted in your log. Why are such metaphors appropriate? List all of the ways in which this is a battle. What stakes are involved in winning or losing this battle?
2. Lord claims that "these dolls express the ethos of their time, which has changed considerably in the forty years since Barbie first wobbled out in her steep stiletto mules" (paragraph 11). What images of women are communicated by these two lines of dolls? What messages do these two lines of dolls communicate to young girls about the role and status of women in our society? In your opinion, do the changes suggested in the differences between these two doll lines reflect actual changes in the status of women?

3. Lord briefly compares the Barbie and Get Real Girls Websites. The former, Barbie.com, is still online, but GetRealGirls.com is not. However, Get Real Girls are advertised on Amazon.com. Log on to the Barbie site as well as the ads for Get Real Girls on Amazon, and compare the effectiveness of the respective ads. •

SANDRA CISNEROS

Barbie-Q (Fiction)

Sandra Cisneros (b. 1954) is a poet and fiction writer known for her appeal to children and young adult readers as well as adults. Much of her work draws on her own ethnic and family background as the only daughter among the eight children of her Mexican father and Chicana mother. She was born in Chicago, but the family moved frequently between Mexico and the United States. She is known for her short, lyrical narratives, which are collected in *Woman Hollering Creek* (1991), where "Barbie-Q" was first published, a collection of interior monologues from Mexican Americans. Cisnernos has also published two highly praised novels, *House on Mango Street* (1984) and recently *Caramelo* (2003). Primarily known for her fiction, Cisneros is a poet of some renown. *My Wicked Ways* (1987) is a collection of sixty of her poems. She has been awarded fellowships from the National Endowment for the Arts and the MacArthur Foundation, and has taught as a guest writer at numerous secondary schools, colleges, and universities.

• **FOR YOUR READING LOG**

1. What expectations does the title of this story raise for you? What associations does "Barbie-Q" bring to mind? Freewrite for several minutes, trying to think of as many possibilities as possible.

2. What do you remember about make-believe games from your childhood in which you and your friends were imitating adults you knew or were familiar with from television? •

———— • ————

for Licha

1 Yours is the one with mean eyes and a ponytail. Striped swimsuit, stilettos, sunglasses, and gold hoop earrings. Mine is the one with bubble hair. Red swimsuit, stilettos, pearl earrings, and a wire stand. But that's all we can afford, besides one extra outfit apiece. Yours, "Red Flair," sophisticated A-line coatdress with a Jackie Kennedy pillbox hat, white gloves, handbag, and heels included. Mine,

"Solo in the Spotlight," evening elegance in black glitter strapless gown with a puffy skirt at the bottom like a mermaid tail, formal-length gloves, pink chiffon scarf, and mike included. From so much dressing and undressing, the black glitter wears off where her titties stick out. This and a dress invented from an old sock when we cut holes here and here and here, the cuff rolled over for the glamorous, fancy-free, off-the-shoulder look.

Every time the same story. Your Barbie is roommates with my Barbie, and 2 my Barbie's boyfriend comes over and your Barbie steals him, okay? Kiss kiss kiss. Then the two Barbies fight. You dumbbell! He's mine. Oh no he's not, you stinky! Only Ken's invisible, right? Because we don't have money for a stupid-looking boy doll when we'd both rather ask for a new Barbie outfit next Christmas. We have to make do with your mean-eyed Barbie and my bubblehead Barbie and our one outfit apiece not including the sock dress.

Until next Sunday when we are walking through the flea market on Maxwell 3 Street and *there!* Lying on the street next to some tool bits, and platform shoes with the heels all squashed, and a fluorescent green wicker wastebasket, and aluminum foil, and hubcaps, and a pink shag rug, and windshield wiper blades, and dusty mason jars, and a coffee can full of rusty nails. *There!* Where? Two Mattel boxes. One with the "Career Gal" ensemble, snappy black-and-white business suit, three-quarter-length sleeve jacket with kick-pleat skirt, red sleeveless shell, gloves, pumps, and matching hat included. The other, "Sweet Dreams," dreamy pink-and-white plaid nightgown and matching robe, lace-trimmed slippers, hairbrush and hand mirror included. How much? Please, please, please, please, please, please, please, until they say okay.

On the outside you and me skipping and humming but inside we are do- 4 ing loopity-loops and pirouetting. Until at the next vendor's stand, next to boxed pies, and bright orange toilet brushes, and rubber gloves, and wrench sets, and bouquets of feather flowers, and glass towel racks, and steel wool, and Alvin and the Chipmunks records, *there!* And *there!* And *there!* And *there!* and *there!* and *there!* and *there!* Bendable legs Barbie with her new page-boy hairdo. Midge, Barbie's best friend. Ken, Barbie's boyfriend. Skipper, Barbie's little sister. Tutti and Todd, Barbie and Skipper's tiny twin sister and brother. Skipper's friends, Scooter and Ricky. Alan, Ken's buddy. And Francie, Barbie's MOD'ern cousin.

Everybody today selling toys, all of them damaged with water and smelling 5 of smoke. Because a big toy warehouse on Halsted Street burned down yesterday—see there?—the smoke still rising and drifting across the Dan Ryan expressway. And now there is a big fire sale at Maxwell Street, today only.

So what if we didn't get our new Bendable Legs Barbie and Midge and Ken 6 and Skipper and Tutti and Todd and Scooter and Ricky and Alan and Francie in nice clean boxes and had to buy them on Maxwell Street, all water-soaked and sooty. So what if our Barbies smell like smoke when you hold them up to your nose even after you wash and wash and wash them. And if the prettiest doll, Barbie's MOD'ern cousin Francie with real eyelashes, eyelash brush included, has a left foot that's melted a little—so? If you dress her in her new "Prom Pinks"

outfit, satin splendor with matching coat, gold belt, clutch, and hair bow included, so long as you don't lift her dress, right?—who's to know.

● **THINKING CRITICALLY ABOUT "BARBIE-Q"**
RESPONDING AS A READER

1. How does the title work with the story? Go back to your reading log notes about the expectations it raised and consider how these were expanded. Compare your ideas with those of your classmates.
2. This is a very short story, yet filled with evocative detail. Reread it to consider exactly how these details worked to engage you. Where did you smile? Where did you laugh? Where did you resist what the speaker was telling you? Where were you surprised?
3. Consider the effect of this monologue on you as a reader. Did you find yourself accepting the role of the "you" that Cisneros has her narrator address? When you compare your reading experience and responses to those of your classmates, what similarities and differences are apparent?

RESPONDING AS A WRITER

1. What do the details tell readers about the character of the story's narrator? What can you infer about her age, personality, and values? How does that sense of her change as the story unfolds? Try to pinpoint the places where Cisneros signals the changes through the details as well as through plot development.
2. What is this story about? Is it about toys, or something more? What is it doing in this chapter on texts that evaluate? Who's evaluating what? How? Why?
3. Use the ideology exercise in Chapter 4 to examine the values set forth by the narrator. What does she value? What are the stated or implied opposites of those values? To what extent does your analysis reveal an author behind the narrator? ●

GARRY TRUDEAU

Doonesbury

Garretson Beekman (Garry) Trudeau (b. 1948) is the creator of *Doonesbury*, the well-known cartoon strip that is syndicated in nearly 1,400 daily and Sunday newspapers in the United States and abroad. First published in 1970, *Doonesbury* cartoons have earned Trudeau a Pulitzer Prize (1975), the first ever awarded for editorial cartooning, and an Academy Award nomination and Cannes Film Festival special jury prize for the animated

film *A Doonesbury Special* (1977). *Doonesbury* cartoons have been collected in numerous hardcover, trade paperback, and mass-market editions, which have sold more than seven million copies worldwide. The most recent collections include *The Bundled Doonesbury: A Pre-Millennial Anthology* (1998), *Buck Wild Doonesbury* (1999), *Duke 2000: Whatever It Takes* (2000), and *The Revolt of the English Majors* (2001). Trudeau has also published essays in *Time, Harper's, Rolling Stone*, the *New Republic*, the *New Yorker*, the *Washington Post*, and the *New York Times*. Famous for its biting political satire, *Doonesbury* has frequently been the subject of controversy, and particular strips have sometimes been pulled by local editors. The strip that follows appeared in newspapers across the country on July 20, 2003.

• FOR YOUR READING LOG

1. Whether you are a regular reader or not, you are probably somewhat familiar with *Doonesbury* cartoons. Freewrite about the ideas and opinions you associate with this strip.
2. How do you account for the rapid growth of gourmet coffee shops over the past ten years or so? Do you have a favorite coffee shop that you frequent? Take a few minutes to freewrite about this phenomenon and your assessment of it. •

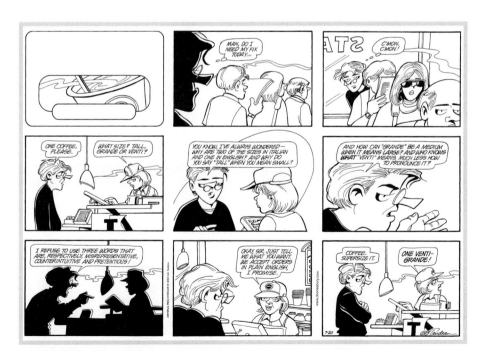

● **THINKING CRITICALLY ABOUT DOONESBURY**

RESPONDING AS A READER

1. How would you characterize the character of Mike Doonesbury, who is featured in this strip as the coffee customer? How does the visual image as well as his thoughts and exchange with the clerk contribute to this characterization? What does his character suggest about the demographics of the intended audience?
2. Each frame in the strip presents part of a brief narrative. Discuss the way in which the visual and verbal elements of each frame work together to create a particular moment in the narrative. Which frame do you find the most humorous and why? How do the frames work as a plot that leads to the final frame?
3. What seems to be Trudeau's purpose here? How serious is he about his critique of product labeling? What features of the strip suggest his purpose and level of seriousness?

RESPONDING AS A WRITER

1. Write a paragraph in which you paraphrase Trudeau's evaluative argument. Do you agree with his critique? Why or why not?
2. Think of other examples of inflated or pretentious product labeling. Make a brief list, and bring it to class. Alternatively, choose a product—say lingerie, facial products for men, or snack food—and create your own product names and ad slogans for this product.
3. In some newspapers *Doonesbury* is placed in the comics section, in others, in the editorial cartoon section. What criteria do you imagine editors use to decide where to place *Doonesbury* cartoons? Visit the Website http://www.doonesbury.com, and read five or six of Trudeau's recent strips. Then write a short explanation of where you would place this strip if you were a newspaper editor. Be sure to refer to the criteria you would use and to specific strips that support your judgment. ●

RHONDA DOWNEY (STUDENT)

Through the Looking Glass

Rhonda Downey (b. 1973) was a community education major at the University of Wisconsin–Milwaukee when she wrote this essay. In addition to being a student, she worked as a research assistant at the Social Development Commission, an agency that awards grants to community groups that offer programs to inner-city residents—job training, day care, after-school tutoring, and so on. The essay responds to a first-year writing assignment to analyze and evaluate a particular cultural image or phenomenon.

• **FOR YOUR READING LOG**

1. Downey analyzes the representations of African Americans in two TV sitcoms of the 1990s. Think of a current sitcom that features an underrepresented group. How is this character (or group of characters) represented? Do they challenge or reinforce stereotypes related to this group?

2. As you read Downey's essay, mark passages where you agree or disagree with her assessment. •

———— • ————

The American media have always played an important part in many Americans' formulations of certain beliefs and ideals. The media have promoted everything from the ideal beauty image (white, tall, blonde, blue-eyed) to patriotism. With worldwide access to American media, many people outside of our culture get their impressions of what Americans look like, behave like, and value from media images. This global sharing of information sounds like a great idea. It should be. However, throughout America's history the media have often misconstrued the cultural images of its minorities, particularly African Americans.

The new wave of African American television shows in the 1990s showed promise. They provided recognition that African Americans do watch television and would like to view themselves portrayed in a positive manner. Shows like *Family Matters* and *Martin* both included committed, loving relationships between the lead male and female characters. They had a caring circle of friends and extended families. Both shows dealt with at least one character doing some kind of community service. These shows were also enormously popular with the black audience (and white) and long running. These shows sound great, don't they? They challenge racial stereotypes and create a positive image of African Americans, don't they? Most people would agree. Unfortunately, after evaluating these cultural images, I have come to disagree.

The first show, *Family Matters*, is about an extended, working- to middle-class African American family. The cast consists of a father, mother, son, daughter, grandmother, aunt, and cousin all residing in the same house. The father is a policeman. The mother works, as I recall, but is seen mostly in the home. The children are obedient, polite, and loving. The matriarch grandmother doles out precious lessons about life, family ties, and cultural pride.

The show seems to want to imitate life for southern Blacks where extended, large families were prevalent. Keeping close family ties and staying strong to survive both as a family and as a people were extremely important. In the past, dark-skinned African Americans were never the main characters in any television show or film. The exclusively dark-skinned family featured in this program seems to try to rectify that. Nevertheless, the antics of the characters do damage to the cultural image of African Americans. The father is an obese, dark man with

protruding eyes and big lips. He reminds me of some sort of old-time caricature. The wife has similar features, however more toned down. The grandmother gives me the impression of some sort of "mammy-figure" used to sell molasses or laundry soap. The actions of the husband are always harebrained, although well intentioned. The wife has to then undo the damage caused by his deeds and schemes gone awry. The entire family can be very loud at times, especially the husband, adding to the myth that African Americans are prone to be loud, boisterous, and unruly. The producer and writers of this show had to have had the best intentions, but the remnants of old-time minstrel shows and black caricatures are still prevalent.

5 The second show, *Martin*, features the leading man in the title role. Martin Lawrence is an African American, male comedian turned actor whose stand-up comedy appeals mostly to the black, urban audience. This show's cast consists of Martin, his long-time love, Gina, his two best friends, and his girlfriend's best friend. All are young, vibrant, and on promising career tracks. The skin tones vary, as they do among African Americans. The show's leading character is known by many in real life to be a highly successful businessman and marketer. In the show, he gives people what they want in terms of humor. I used to find the show funny, too. I used to love watching this program. It was one of my favorites. However, while living in the dorms and watching this program with a mainly white audience, I started to feel different. We were no longer laughing with the show's characters. We were laughing at them. They were not fully developed characters with real substance and meaning, but were flat caricatures that danced, wiggled, and did any dignity-sacrificing thing for a laugh. I looked at how my housemates were viewing the characters. I listened to the kinds of remarks that they made. Somehow, I felt exposed, embarrassed, and betrayed. I wanted to either turn off the TV set or run and hide. It made me think about the way *Martin* was just some sort of updated version of *Good Times*; Martin was just a revamped J.J. A perfect example of a buffoon, scuffling and shuffling for the laughs and the dollars.

6 If I were from another planet and needed to get information on the varieties of earthlings, what would I conclude? What if I were going to be a foreign exchange student and I used American popular television to gather information on my hosts? What would I conclude? While I was living in the dorms, one of these questions was answered. A student from Japan explained to me the reason she did not like to visit my roommate with me present or wait in the room alone with me while my roommate returned. She said the only knowledge she has ever had has come from old black exploitation films like *Shaft, Coffy,* and *Superfly* as well as television programs where the villains were usually black thugs and prostitutes. She felt the African Americans were an undesirable people, the lowest on the totem pole, and she would do best not to interact with them at all. She thought the African Americans would rub off on her.

7 The images that the media project about our various cultures are subtle, but strong. American media, leaders in the promotion of ethnic peace and harmony, should examine more closely the images they project.

● THINKING CRITICALLY ABOUT "THROUGH THE LOOKING GLASS"

RESPONDING AS A READER

1. What criteria does Downey use to evaluate the representation of African Americans on *Family Matters* and *Martin*? Are these criteria a convincing basis for judging the beneficial or detrimental effects of these images of African Americans? Are there additional criteria she might have used to make her judgment?

2. How do you interpret the meaning of Downey's title, "Through the Looking Glass"?

3. Who seems to be the intended audience (or audiences), and what is Downey's purpose in writing this evaluation?

RESPONDING AS A WRITER

1. How does Downey go about establishing her credibility to judge or evaluate representations of African Americans on sitcoms?

2. If you were a member of Downey's peer response group, what advice might you give her for strengthening her paper?

3. Downey writes about 1990s sitcoms featuring African American characters. Have the representations of African Americans changed since then? Explain your answer with examples.

Writing to Evaluate and Judge

MAKING AN EVALUATION

Option A:

Assume that you have been asked to write an essay about "the best" something—you fill in the blank. Choose either a serious or light class of things about which to make a judgment about the best. Some of the topics included in the *New York Times Magazine* issue discussed in this chapter's introduction might suggest possibilities: best toy, best joke, best magic trick, best come-from-behind victory. Even if your evaluation is humorous or meant mainly to entertain, you should make sure you articulate clear criteria and offer evidence that matches these criteria.

Option B:

Write a review of a book, movie, musical performance, or restaurant in which you evaluate your chosen subject according to appropriate criteria. For example, you might evaluate a restaurant in the category of best ethnic restaurant, best Sunday brunch, or best Friday night fish fry. Or evaluate a movie in the category of "action thriller" or "film noir." Use your familiarity with this category of events, places, or performances to establish criteria for judging the success or quality of whatever you are evaluating, and provide ample evidence to support your claims. Your essay should offer a clear purpose for your evaluative claim.

What changed perspective or new insight do you want your readers to have of your subject?

EXAMINING RHETORICAL STRATEGIES

Choose one of the evaluative readings and analyze the text in terms of its purpose and rhetorical strategies. What question of value is at issue for this writer? Are the criteria or basis for the writer's judgment directly stated or implied? Appropriate? Well supported with evidence? What is the writer's purpose in making this evaluation and how successful is she or he in achieving this purpose? Be sure to offer textual evidence to support your analysis and, perhaps, evaluation of this text.

EXTENDING THE CONVERSATION

Choose one of the evaluative arguments in this chapter, and write your own evaluation of the same (or similar) object, performance, or phenomenon but with the goal of offering a different judgment or evaluation. For example, you might evaluate a new technology like PowerPoint and offer your own judgment about its value or effects. Or you might wish to take Rhonda Downey's essay as a starting point and offer your own evaluation of the social impact of reality TV or sitcoms that feature minority characters. Yet another possibility is to evaluate a particular cultural phenomenon like the Harry Potter craze or the proliferation of Starbuck's coffee shops and their imitators, assessing the significance of these phenomena and the values they promote.

CHAPTER 14

Proposing Solutions

Texts that propose solutions ask readers to take an action, which may sometimes be a new way of thinking. For example, a member of the local community writes an editorial in the college newspaper, proposing that university officials take concrete steps to curb late-night, drunken student parties in the neighborhood surrounding campus. The employee of a start-up dot.com company submits a written proposal for delivering products quickly and reliably. A politician outlines her plan for saving Social Security in a policy statement distributed to the press. An op-ed writer argues that Americans must change their attitude toward energy consumption before resources are depleted.

The ability to evaluate the proposals of others and write effective proposals ourselves is essential to responsible citizenship and professional success. As citizens we are constantly inundated with policy proposals to solve everything from deterioration of the local library facilities to global warming. To make informed decisions, we need to be able to analyze the reasoning and evidence offered in such proposals and evaluate their soundness and feasibility. Similarly, the ability to write persuasive proposals is called for in nearly all professions—engineering, architecture, medicine, arts, nonprofit management, to cite just a few examples.

As a form of argument, proposals include all the features of arguments—claims, reasons, evidence, counterarguments, and assumptions. Generally, proposals involve one or more of the following goals: (1) specific, concrete action; (2) acceptance, rejection, or modification of a policy; and/or (3) a change

in outlook or values. The readings in this chapter illustrate all of these goals, usually in combination. For example, in "Literacy and Health: Is There a Connection?" Lynn Bryant calls on health care professionals to change their outlook by recognizing the problem of health illiteracy and to take action by changing the ways in which they communicate with patients. Similarly, Peter Singer in "The Singer Solution to World Poverty" calls for a change in outlook followed by concrete action on the part of the American public at large. Specifically, Singer asks readers to see themselves as responsible for world hunger and, therefore, as responsible for doing something about it by donating substantial proportions of their income to poverty relief efforts. In "The Case for Allowing Kidney Sales," J. Radcliffe-Richards and other experts in medical ethics propose reconsideration and possible rejection of the current policy prohibiting the sale of kidneys by live donors.

The audience for proposals is those who are in a position to act on the proposal either directly or indirectly. To persuade the audience that the proposed action is feasible, beneficial, and better than other proposals, writers need to appeal to their audience's assumptions, values, and interests. Singer addresses Americans generally, arguing that most of us are affluent by world standards and therefore in a position to donate a proportion of our income to alleviate world hunger. "The Case for Allowing Kidney Sales," published in a British medical journal, is directed primarily at medical and health care professionals, the group charged with implementing the current policy and best positioned to lobby successfully for the policy's reversal. The writers assume this audience understands the problems that result from the shortage of kidneys for transplants as well as the ethical arguments that support the prohibition of kidney sales by live donors. Since the ethical arguments are the greatest obstacle to changing current law, they focus mainly on challenging those arguments.

Effective proposals have three components: *description of the problem, proposal of a solution,* and *justification.* How fully each of these components is developed will depend entirely on the nature and goal of the proposal as well as on the rhetorical situation. If the audience is quite familiar with the problem—for example, as would be the case of medical professionals reading "The Case for Allowing Kidney Sales"—then the writers need not spend much time dramatizing the problem's urgency to their readers. If, by contrast, the audience is not familiar with nor concerned about the problem, then the writer's main task is to make the problem present or compelling to the audience. In deciding how to introduce the problem, the proposal writer needs to ask questions such as the following: How familiar are people with this problem? Whom does it affect? Whom am I trying to persuade of my solution—only those directly affected or others who might be indirectly affected? If people aren't concerned about this problem, why aren't they? What would make them concerned?

Likewise, the degree to which the writer needs to spell out in detail the proposed solution depends on the writer's purpose, the nature of the solution, and the audience's background knowledge. Some proposals require detailed explanation if their aim is to convince the audience to take concrete action. Other pro-

posals may require little explanation of the proposed solution because the writer's chief aim is to persuade the audience that there is a problem about which they ought to be concerned. For example, an advertising firm that wishes to persuade a client to accept its proposal for a new ad campaign will need to provide detailed information: test-market data, a detailed cost analysis, a plan for dissemination, a timetable for launching the campaign, and so on. By contrast, writers who propose new approaches to complex social issues may choose, as does Weston in this chapter, to present their recommendations in general terms because they feel they need to change people's thinking about the issue before recommending more specific actions.

Often the most important aspect of the proposal is the justification section, where the writer must persuade the audience that the solution is beneficial, feasible, and better than other possible solutions. To justify their solutions, proposal writers typically argue from principle, consequence, precedent, or analogy. That is, they may appeal to principles, values, or assumptions shared with the audience; to consequences that the audience will agree are good or bad; or to precedents or analogies of similar cases in which their proposed solution was justified and successful. Let's look at each type of argument based on passages drawn from "The Case for Allowing Kidney Sales":

[I]f we are to deny treatment to the suffering and dying we need better reasons than our own feelings of disgust. (**Argument from principle**)

Dialysis is a wretched experience for most patients, and is anyway rationed in most places and simply unavailable to the majority of patients in most developing countries. (**Arguments from consequence**)

Trying to end exploitation [of the poor who sell their kidneys] by prohibition is rather like ending slum dwelling by bulldozing slums: it ends the evil in that form, but only by making things worse for the victims. (**Argument from analogy**)

To summarize: Proposals involve one or more of the following goals: (1) specific, concrete action; (2) acceptance, rejection, or modification of a policy; and (3) a change in outlook or values. In order to achieve these goals, proposal writers must tailor their description of the problem, presentation of the solution, and justification in terms of their audience's values and assumptions and the situation at hand. Some of the proposals in this chapter address issues that are of broad concern to many—environmental policy, world hunger, health care—while others address issues that are of concern to particular communities.

QUESTIONS TO HELP YOU READ PROPOSALS RHETORICALLY

The following questions are designed to guide your analysis of the proposals you read. In addition, these questions offer useful guides for composing and revising your own proposals.

1. How does the writer go about introducing the problem? Does the writer describe the problem in enough detail to give the problem presence and overcome readers' possible inertia? What strategies does the writer use to make the problem seem compelling? If the writer does not describe the problem in detail, can you speculate about why? What is he or she assuming about the audience's background knowledge and concerns? Do these assumptions seem justified?

2. Does the author seem to have the expertise or authority to propose a sound solution? On what do you base your judgment about the author's credibility— the person's public reputation? Or do you base your judgment on the way in which the writer establishes credibility in the text itself by creating a persona that is knowledgeable, concerned, respectful of other opinions, reasonable, and/or practical?

3. What is the solution proposed? How does the author go about presenting it? Does the author provide enough detail to make the solution seem practical and realistic?

4. How does the author go about justifying the solution? To what extent does the writer use arguments from principle, consequence, precedent, and/or analogy? What do these strategies reveal about the author's view of the audience's values, interests, and concerns?

5. Is the author's reasoning sound? Does he or she back up claims with reasons and evidence? Does the author anticipate readers' objections, offer counter-arguments, and/or acknowledge alternative solutions? If not, do you think such anticipation, acknowledgment, and counterargument would have made the author's proposal stronger?

ANTHONY WESTON

The Need for Environmental Ethics

Anthony Weston (b. 1954) teaches philosophy and Interdisciplinary Studies at Elon College in North Carolina. His publications include *Toward Better Problems* (1992), *Back to Earth: Tomorrow's Environmentalism* (1994), and *A Practical Companion to Ethics* (1996). *Toward Better Problems,* the book from which this excerpt is taken, was first introduced in

Chapter 2. As we explained there, *Toward Better Problems* applies pragmatic philosophy to pressing ethical issues of our time: abortion, animal rights, the environment, and justice. However, Weston's aim in this book is not so much to solve these complex ethical problems as it is to transform these problematic situations into more manageable or "better" problems. "The Need for Environmental Ethics" is the opening section of the chapter on the environment. Other sections of this chapter include "Beyond Anthropocentrism," where Weston proposes that we move beyond our purely "human-centered" perspective to consider and respect nature "in its own right," and "Integrative Strategies in Environmental Politics," where Weston proposes seeking common ground in the fight for more enlightened environmental policies.

● FOR YOUR READING LOG

1. Choose a particular environmental issue, and write a short entry in your log about your knowledge and concerns about this issue. If you have little or no knowledge about environmental issues, write about why you think that is so.
2. As you read Weston's text, annotate passages with which you strongly agree or disagree. ●

——— ● ———

We are beginning to struggle with the intimation that something is seriously 1 wrong with our relation to the natural world. It is a little like suspecting cancer but not wanting to know. But the danger signs are all around us. Garbage dumped a hundred miles off the Atlantic coast is now washing up annually on beaches. The federal government is continuing its increasingly desperate search for a way to dispose of the highly toxic radioactive wastes that American nuclear reactors have been generating since they began operating, so far without any permanent disposal plan at all. A state-sized chunk of South American rain forest is slashed, cut, or burned every year, in large part to clear land to graze beef cattle, though the resultant pasture is of marginal quality and will be reduced to desert within ten years. And our society, affluent beyond the wildest dreams of our ancestors and most of the rest of the human race, increasingly fortifies itself inside artificial environments—we see the countryside through the windshield or the airplane window, we "learn about nature" by watching TV specials about endangered African predators—while outside of our little cocoons the winds laugh for no one and increasingly, under pressure of condominiums and shopping malls, the solace of open space is no more.

Short-term solutions of course suggest themselves. If the seas can no longer 2 be treated as infinite garbage pits, we say, let us incinerate the garbage instead. Rain forest cutting could be curtailed by consumer action if North Americans paid a little more for home-grown meat. Sooner or later, we suppose, "science" will figure out something to do with nuclear wastes. And so on. This kind of thinking too is familiar. The problems may seem purely practical, and practical

solutions may be in sight. Environmental ethics, however, begins with the suspicion that something far deeper is wrong, and that more fundamental change is called for.

Beyond Ecological Myopia

3 For one thing, these "solutions" are short term indeed, and ignore or obscure the structural crises that underlie the immediate problems. Incinerating trash just treats the air as a waste dump instead of the sea, with consequences that even proponents of incineration admit are unpredictable. The only workable short-term solution is recycling, and the only workable long-term solution is to stop producing so much garbage in the first place, especially materials that are not biodegradable. But this calls for an entirely different way of thinking: for greater respect for the earth, more awareness of the dynamics and the limits of the wider world, and more insistent reminders that our children's children will inherit the world we are "trashing." And these new ways of thinking in turn call for a different way of living. Sometimes the practical demands are not so very difficult—using paper cups instead of styrofoam is hardly a major lifestyle change—but even this calls for a kind of mindfulness that today we lack. In the background is the suggestion that we need to recognize systematic ecological constraints on economic activity, a kind of constraint that is still unfamiliar and controversial, at least in America.

4 Nuclear wastes are an even clearer case. Even proponents admit that long after the normal operation of nuclear power plants is past, we will be left with enormously toxic waste products from their operation, including the reactors themselves, which after their forty or so years generating electricity may take hundreds of thousands of years to drop back to safe levels of radioactivity. Operating wastes are presently stored at reactor sites and in temporary federal storage areas and tanks, most of them nearly full and some notoriously already leaking. It is not obvious that there is any adequate permanent disposal method. Burying the wastes, even in the most apparently stable site, puts all future life at the mercy of geological changes, which are virtually certain over hundreds of thousands of years. Meanwhile, no state or community will voluntarily accept the proposed storage facilities, let alone have the wastes shipped, as they must be, by truck or rail, across half the nation.

5 Public opposition to nuclear power focuses, for the most part, on the danger of accidents: on the dangers of injury to *us*. But the waste problem mortgages the entire future of the earth. Any significant leakage would be devastating. Even very low-level leakage will cause genetic damage, not just to humans, but to all plants and animals, which over generations can have immense consequences. Again, then, our habitual short-term perspective comes into question; again an ecological point of view suggests radical change.

6 Finally, the devastation of the rain forests too is motivated almost exclusively by short-term and commercial considerations. Since the land can be bought very cheaply (or can simply be expropriated), nothing stands in the way of the most

shortsighted and complete exploitation. The soil, however, is very poor—rain forests are self-sustaining and self-nurturing systems, biotic efflorescences that virtually run of themselves—and so exploitation is complete indeed. In ten years the land will not even support cattle. Like the bare hills of the Mediterranean stripped of their forests by the ancients and since irreparably eroded, the land will become unable to support any life at all. And so for the sake of a few more years of slightly cheaper hamburgers we are turning the most exquisite jungle in the world into desert, and along with it threatening up to 60 percent of the world's plant and animal species, many of them unknown, with unknown medicinal and other benefits, not to mention the completely unpredictable climatic effects of turning enormous areas of the world's wettest ecosystems into the world's driest, the loss of atmospheric recharge, and so on.

Like our willingness to saddle our descendants with radioactive wastes into 7 the unimaginably distant future, our willingness to sacrifice the unknown potentials of rain forest ecosystems to the most trivial and short-term advantage shows an astonishing arrogance toward the human future. And to recognize this disproportion is already to take a major ethical step. Merely to take our own descendants seriously might well require a different way of life. That alone may be enough to require of us a far more respectful and conserving attitude toward the earth, and certainly requires us to avoid making massive, little-understood, and irreversible ecological changes, like destroying the rain forests or leaving genetically lethal wastes to the perpetual guardianship of our children's children's children. *Maybe* the most pressing and vital interests of the race could justify such a thing. Maybe we could justify turning some of the rain forests into deserts if in some unimaginable crisis only ravaging the rain forests could save life on earth. But ten years of slightly cheaper meat does not justify it. Maybe our children could understand reactor waste left littering the landscape of the future if the electricity it made possible saved civilization from some unheard-of threat, or accomplished some great task. But the "need" to run air conditioners is the saddest of excuses. Especially when the alternative is not even so serious as having to sweat in the summer, God forbid, but merely requires designing slightly more energy-efficient appliances and building houses that aren't heat sinks in the sun. Traditional cultures know how to build naturally cool houses. Only we seem to have lost the ability.

"Environmental ethics," then, urges upon us at minimum a much more 8 mindful and longer-term attention to the way we interact with and depend on nature. It urges attention to everything from the medicinal and nutritional uses of rain forest plants to the psychic need for open spaces and various kinds of ecological dependence of which we are not yet even aware. The implications are radical. We need to think of the earth itself in a different way: not as an infinite waste sink, and not as a collection of resources fortuitously provided for our use, but as a complex system with its own integrity and dynamics, far more intricate than we understand or perhaps *can* understand, but still the system within which we live and on which we necessarily and utterly depend. We must learn a new kind of respect.

• THINKING CRITICALLY ABOUT "THE NEED FOR ENVIRONMENTAL ETHICS"

RESPONDING AS A READER

1. In this excerpt, Weston takes on the challenge of trying to make the long-term threats to the environment vividly present for the reader. Which of these threats seems most urgent or compelling to you? Is it Weston's presentation or your prior knowledge that makes this issue "present" for you?
2. Why does he believe short-term practical solutions are inadequate? What reasons and evidence does he offer to support this claim? Are his reasoning and evidence persuasive to you as a reader?
3. Find examples of arguments from principle, consequence, and precedent/analogy. Which of these arguments does he rely on most heavily?

RESPONDING AS A WRITER

1. How feasible or likely are the "fundamental" changes Weston calls for in people's thinking and behavior? What are the barriers to these changes?
2. Weston's task in trying to get readers to share his concerns and outlook is challenging. In his opinion these problems are, in large part, a result of Americans' arrogance, short-sightedness, and greed. How can he challenge Americans to question their behavior and values without alienating them and turning them off? What strategies does he use to criticize without alienating? How does he try to win over readers, establish a bond with them, and appeal to their interests? How successful is he in managing this balance between critique and solidarity?
3. Perhaps one of the most subtle and powerful persuasive techniques that Weston uses is the appeal to readers' emotions. Find some examples and assess their effectiveness. •

PETER SINGER

The Singer Solution to World Poverty

Australian philosopher Peter Singer (b. 1946) has been called the "world's most controversial ethicist." Known for his radical stands on such issues as animal rights and euthanasia, Singer now teaches at Princeton University, where his appointment in 1999 was met by vigorous protests from right-to-life groups. His best-known books include *Animal Liberation: A New Ethics for Our Treatment of Animals* (1975, 2nd edition, 1990), *Practical Ethics* (1993), *Rethinking Life and Death: The Collapse of Our Traditional Ethics* (1995), and *One World: The Ethics of Globalization* (2002). "The Singer Solution to World Poverty," pub-

lished in the *New York Times Magazine* on September 5, 1999, deals with an issue that Singer takes very seriously. In an interview with the *New York Times,* Singer revealed that he gives one-fifth of his income to famine-relief agencies.

• FOR YOUR READING LOG

1. Where does world hunger rank in your list of social and moral concerns? How easy or difficult do you find it to identify with this problem on an international scale? How easy or difficult do you find it to identify with this problem on a local level?
2. What's your response to the title, "The Singer Solution to World Poverty"? What image does this conjure up of the author, who has named a solution to world poverty after himself? •

———— • ————

In the Brazilian film "Central Station," Dora is a retired schoolteacher who makes 1 ends meet by sitting at the station writing letters for illiterate people. Suddenly she has an opportunity to pocket $1,000. All she has to do is persuade a homeless 9-year-old boy to follow her to an address she has been given. (She is told he will be adopted by wealthy foreigners.) She delivers the boy, gets the money, spends some of it on a television set and settles down to enjoy her new acquisition. Her neighbor spoils the fun, however, by telling her that the boy was too old to be adopted—he will be killed and his organs sold for transplantation. Perhaps Dora knew this all along, but after her neighbor's plain speaking, she spends a troubled night. In the morning Dora resolves to take the boy back.

Suppose Dora had told her neighbor that it is a tough world, other people 2 have nice TV's too, and if selling the kid is the only way she can get one, well, he was only a street kid. She would then have become, in the eyes of the audience, a monster. She redeems herself only by being prepared to bear considerable risks to save the boy.

At the end of the movie, in cinemas in the affluent nations of the world, peo- 3 ple who would have been quick to condemn Dora if she had not rescued the boy go home to places far more comfortable than her apartment. In fact, the average family in the United States spends almost one-third of its income on things that are no more necessary to them than Dora's new TV was to her. Going out to nice restaurants, buying new clothes because the old ones are no longer stylish, vacationing at beach resorts—so much of our income is spent on things not essential to the preservation of our lives and health. Donated to one of a number of charitable agencies, that money could mean the difference between life and death for children in need.

All of which raises a question: In the end, what is the ethical distinction be- 4 tween a Brazilian who sells a homeless child to organ peddlers and an American who already has a TV and upgrades to a better one—knowing that the money could be donated to an organization that would use it to save the lives of kids in need?

5 Of course, there are several differences between the two situations that could support different moral judgments about them. For one thing, to be able to consign a child to death when he is standing right in front of you takes a chilling kind of heartlessness; it is much easier to ignore an appeal for money to help children you will never meet. Yet for a utilitarian philosopher like myself—that is, one who judges whether acts are right or wrong by their consequences—if the upshot of the American's failure to donate the money is that one more kid dies on the streets of a Brazilian city, then it is, in some sense, just as bad as selling the kid to the organ peddlers. But one doesn't need to embrace my utilitarian ethic to see that, at the very least, there is a troubling incongruity in being so quick to condemn Dora for taking the child to the organ peddlers while, at the same time, not regarding the American consumer's behavior as raising a serious moral issue.

6 In his 1996 book, "Living High and Letting Die," the New York University philosopher Peter Unger presented an ingenious series of imaginary examples designed to probe our intuitions about whether it is wrong to live well without giving substantial amounts of money to help people who are hungry, malnourished or dying from easily treatable illnesses like diarrhea. Here's my paraphrase of one of these examples:

7 Bob is close to retirement. He has invested most of his savings in a very rare and valuable old car, a Bugatti, which he has not been able to insure. The Bugatti is his pride and joy. In addition to the pleasure he gets from driving and caring for his car, Bob knows that its rising market value means that he will always be able to sell it and live comfortably after retirement. One day when Bob is out for a drive, he parks the Bugatti near the end of a railway siding and goes for a walk up the track. As he does so, he sees that a runaway train, with no one aboard, is running down the railway track. Looking farther down the track, he sees the small figure of a child very likely to be killed by the runaway train. He can't stop the train and the child is too far away to warn of the danger, but he can throw a switch that will divert the train down the siding where his Bugatti is parked. Then nobody will be killed—but the train will destroy his Bugatti. Thinking of his joy in owning the car and the financial security it represents, Bob decides not to throw the switch. The child is killed. For many years to come, Bob enjoys owning his Bugatti and the financial security it represents.

8 Bob's conduct, most of us will immediately respond, was gravely wrong. Unger agrees. But then he reminds us that we, too, have opportunities to save the lives of children. We can give to organizations like Unicef or Oxfam America. How much would we have to give to one of these organizations to have a high probability of saving the life of a child threatened by easily preventable diseases? (I do not believe that children are more worth saving than adults, but since no one can argue that children have brought their poverty on themselves, focusing on them simplifies the issues.) Unger called up some experts and used the information they provided to offer some plausible estimates that include the cost of raising money, administrative expenses and the cost of delivering aid where it is most needed. By his calculation, $200 in donations would help a sickly 2-year-old transform into a healthy 6-year-old—offering safe passage through

childhood's most dangerous years. To show how practical philosophical argument can be, Unger even tells his readers that they can easily donate funds by using their credit card and calling one of these toll-free numbers: (800) 367-5437 for Unicef; (800) 693-2687 for Oxfam America.

Now you, too, have the information you need to save a child's life. How should you judge yourself if you don't do it? Think again about Bob and his Bugatti. Unlike Dora, Bob did not have to look into the eyes of the child he was sacrificing for his own material comfort. The child was a complete stranger to him and too far away to relate to in an intimate, personal way. Unlike Dora, too, he did not mislead the child or initiate the chain of events imperiling him. In all these respects, Bob's situation resembles that of people able but unwilling to donate to overseas aid and differs from Dora's situation.

If you still think that it was very wrong of Bob not to throw the switch that would have diverted the train and saved the child's life, then it is hard to see how you could deny that it is also very wrong not to send money to one of the organizations listed above. Unless, that is, there is some morally important difference between the two situations that I have overlooked.

Is it the practical uncertainties about whether aid will really reach the people who need it? Nobody who knows the world of overseas aid can doubt that such uncertainties exist. But Unger's figure of $200 to save a child's life was reached after he had made conservative assumptions about the proportion of the money donated that will actually reach its target.

One genuine difference between Bob and those who can afford to donate to overseas aid organizations but don't is that only Bob can save the child on the tracks, whereas there are hundreds of millions of people who can give $200 to overseas aid organizations. The problem is that most of them aren't doing it. Does this mean that it is all right for you not to do it?

Suppose that there were more owners of priceless vintage cars—Carol, Dave, Emma, Fred and so on, down to Ziggy—all in exactly the same situation as Bob, with their own siding and their own switch, all sacrificing the child in order to preserve their own cherished car. Would that make it all right for Bob to do the same? To answer this question affirmatively is to endorse follow-the-crowd ethics—the kind of ethics that led many Germans to look away when the Nazi atrocities were being committed. We do not excuse them because others were behaving no better.

We seem to lack a sound basis for drawing a clear moral line between Bob's situation and that of any reader of this article with $200 to spare who does not donate it to an overseas aid agency. These readers seem to be acting at least as badly as Bob was acting when he chose to let the runaway train hurtle toward the unsuspecting child. In the light of this conclusion, I trust that many readers will reach for the phone and donate that $200. Perhaps you should do it before reading further.

Now that you have distinguished yourself morally from people who put their vintage cars ahead of a child's life, how about treating yourself and your partner to dinner at your favorite restaurant? But wait. The money you will spend at the restaurant could also help save the lives of children overseas! True,

you weren't planning to blow $200 tonight, but if you were to give up dining out just for one month, you would easily save that amount. And what is one month's dining out, compared to a child's life? There's the rub. Since there are a lot of desperately needy children in the world, there will always be another child whose life you could save for another $200. Are you therefore obliged to keep giving until you have nothing left? At what point can you stop?

16 Hypothetical examples can easily become farcical. Consider Bob. How far past losing the Bugatti should he go? Imagine that Bob had got his foot stuck in the track of the siding, and if he diverted the train, then before it rammed the car it would also amputate his big toe. Should he still throw the switch? What if it would amputate his foot? His entire leg?

17 As absurd as the Bugatti scenario gets when pushed to extremes, the point it raises is a serious one: only when the sacrifices become very significant indeed would most people be prepared to say that Bob does nothing wrong when he decides not to throw the switch. Of course, most people could be wrong; we can't decide moral issues by taking opinion polls. But consider for yourself the level of sacrifice that you would demand of Bob, and then think about how much money you would have to give away in order to make a sacrifice that is roughly equal to that. It's almost certainly much, much more than $200. For most middle-class Amerians, it could easily be more like $200,000.

18 Isn't it counterproductive to ask people to do so much? Don't we run the risk that many will shrug their shoulders and say that morality, so conceived, is fine for saints but not for them? I accept that we are unlikely to see, in the near or even medium-term future, a world in which it is normal for wealthy Americans to give the bulk of their wealth to strangers. When it comes to praising or blaming people for what they do, we tend to use a standard that is relative to some conception of normal behavior. Comfortably off Americans who give, say, 10 percent of their income to overseas aid organizations are so far ahead of most of their equally comfortable fellow citizens that I wouldn't go out of my way to chastise them for not doing more. Nevertheless, they should be doing much more, and they are in no position to criticize Bob for failing to make the much greater sacrifice of his Bugatti.

19 At this point various objections may crop up. Someone may say: "If every citizen living in the affluent nations contributed his or her share I wouldn't have to make such a drastic sacrifice, because long before such levels were reached, the resources would have been there to save lives of all those children dying from lack of food or medical care. So why should I give more than my fair share?" Another, related, objection is that the Government ought to increase its overseas aid allocations, since that would spread the burden more equitably across all taxpayers.

20 Yet the question of how much we ought to give is a matter to be decided in the real world—and that, sadly, is a world in which we know that most people do not, and in the immediate future will not, give substantial amounts to overseas aid agencies. We know, too, that at least in the next year, the United States Government is not going to meet even the very modest United Nations–recommended target of 0.7 percent of gross national product; at the moment it

lags far below that, at 0.09 percent, not even half of Japan's 0.22 percent or a tenth of Denmark's 0.97 percent. Thus, we know that the money we can give beyond that theoretical "fair share" is still going to save lives that would otherwise be lost. While the idea that no one need do more than his or her fair share is a powerful one, should it prevail if we know that others are not doing their fair share and that children will die preventable deaths unless we do more than our fair share? That would be taking fairness too far.

Thus, this ground for limiting how much we ought to give also fails. In the world as it is now, I can see no escape from the conclusion that each one of us with wealth surplus to his or her essential needs should be giving most of it to help people suffering from poverty so dire as to be life-threatening. That's right: I'm saying that you shouldn't buy that new car, take that cruise, redecorate the house or get that pricey new suit. After all, a $1,000 suit could save five children's lives. 21

So how does my philosophy break down in dollars and cents? An American household with an income of $50,000 spends around $30,000 annually on necessities, according to the Conference Board, a nonprofit economic research organization. Therefore, for a household bringing in $50,000 a year, donations to help the world's poor should be as close as possible to $20,000. The $30,000 required for necessities holds for higher incomes as well. So a household making $100,000 could cut a yearly check for $70,000. Again, the formula is simple: whatever money you're spending on luxuries, not necessities, should be given away. 22

Now, evolutionary psychologists tell us that human nature isn't sufficiently altruistic to make it plausible that many people will sacrifice so much for strangers. On the facts of human nature, they might be right, but they would be wrong to draw a moral conclusion from those facts. If it is the case that we ought to do things that, predictably, most of us won't do, then let's face that fact head-on. Then, if we value the life of a child more than going to fancy restaurants, the next time we dine out we will know that we could have done something better with our money. If that makes living a morally decent life extremely arduous, well, then that is the way things are. If we don't do it, then we should at least know that we are failing to live morally decent life—not because it is good to wallow in guilt but because knowing where we should be going is the first step toward heading in that direction. 23

When Bob first grasped the dilemma that faced him as he stood by that railway switch, he must have thought how extraordinarily unlucky he was to be placed in a situation in which he must choose between the life of an innocent child and the sacrifice of most of his savings. But he was not unlucky at all. We are all in that situation. 24

● THINKING CRITICALLY ABOUT "THE SINGER SOLUTION TO WORLD POVERTY"

RESPONDING AS A READER

1. As you read through this controversial proposal, mark the places in the text where you had the strongest reaction—either positive or negative.

Compare the places you marked with those marked by your classmates. Did you have similar reactions? If not, what accounts for your differing reactions as readers?

2. What kind of a relationship does Singer try to establish with readers? At times, he speaks directly to the reader: for example, "Now you, too, have the information you need to save a child's life" (paragraph 9); "Perhaps you should do it [reach for the phone and donate $200] before reading further" (paragraph 14). Do you think he believes most readers will do what he asks? If not, why does he address the reader in this way?

3. Throughout the article, Singer tries to anticipate and address readers' objections to his proposal in paragraph 22. How successful do you think he is in doing this? Can you think of objections to his proposal that he doesn't address?

RESPONDING AS A WRITER

1. Play the believing and doubting game with Singer's proposal. That is, first write down all of the reasons that you believe Singer's proposal to be a solution to the problem of world poverty. Then write down all of the reasons that you doubt his proposal to be a solution to the problem of world poverty. (For further discussion of this activity, see Chapter 4.)

2. For the most part, Singer chooses to appeal to readers' reason and logic rather than to their emotions. Why do you think Singer chose this approach? Do you think this was a wise decision? What role does emotion play in the way Singer attempts to engage readers? How might he have appealed to readers' emotions differently, and to what effect?

3. Singer uses two analogies to justify his argument about our moral responsibility to donate a significant amount of our income to save the lives of starving children—Dora's moral dilemma in *Central Station* and Bob's moral dilemma in deciding whether to save his Bugatti or the child. In your own words, explain how he uses each analogy to justify his argument. Are you persuaded that these situations are analogous to our situation in choosing whether or not to give money to alleviate world poverty? Singer says, basically, that "any reader of this article with $200 to spare who does not donate it to an overseas aid agency" is behaving as Bob did in not throwing the switch to save the child. Do you agree? Why or why not? ●

AMERICAN LIBRARY ASSOCIATION

Read

Since 1985, the American Library Association (ALA) has sponsored an ad campaign to promote reading in which celebrities of all sorts—movie stars, popular musicians, athletes, business moguls, famous scientists—are pictured holding their favorite books. According to ALA Graphics Director Kathryn Leide, "This simple message continues to be one of the most effective inducements we have found to encourage young people to read for the sheer enjoyment of reading." The nearly one hundred celebrities who have donated their time and copyright to this campaign include Bill Cosby, who was featured on the first poster reading *Treasure Island*; Serena Williams (*A Raisin in the Sun*), L. J. Coolio (*Frankenstein*), Bill Gates (*Old Man and the Sea*), and Mike Mussino (*Casey at the Bat*). Well-known reading advocate Oprah Winfrey is pictured in this poster holding Toni Morrison's Pulitzer Prize–winning novel *Beloved*, Winfrey's first selection for the book club that was a part of her television talk show from 1996 to 2002. In 2003 Winfrey started a new book club, "Traveling with the Classics." It will air three to five times a year and feature literary classics as well as travel to places associated with the author and/or the book.

● **FOR YOUR READING LOG**

1. The ALA campaign promotes reading for pleasure. Why do you think many people value reading for pleasure so highly? Do you? Do your friends and family? Spend a few minutes freewriting about the value and place of reading in your own life.
2. If you were to be featured on a poster in this series, what book would you select to hold and why? Take a few minutes to jot down your response. ●

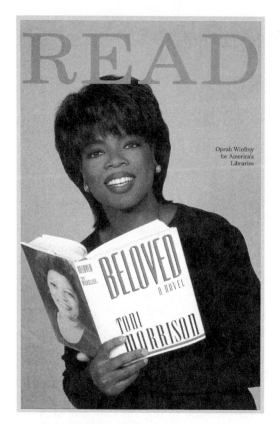

Oprah Winfrey
for America's
Libraries

● **THINKING CRITICALLY ABOUT THE OPRAH WINFREY**
READ POSTER

RESPONDING AS A READER

1. How do Oprah's *ethos* and the *ethos* of her book selection work together to contribute to this poster's proposal argument?

2. For what audience does this image seem primarily intended? What particular features of the poster might appeal to this audience? How does it appeal as well to a more general audience?

3. As a proposal argument, this poster includes only a recommended action. It assumes that viewers already understand the reasons or justification for the proposal. How would you articulate these reasons or justification?

RESPONDING AS A WRITER

1. To get at how this poster works rhetorically, write *says* and *does* statements for the poster.

2. Write a brief analysis of how the visual features of this poster—its layout, Winfrey's expression and pose, the presentation of the book—enhance the poster's message.

3. Go on-line and choose another *Read* poster to analyze in terms of audience appeal, argument, celebrity *ethos*, and visual design. ●

TONY PROSCIO

Jabberwocky Junkies

Consultant to foundations and nonprofit organizations and former associate editor for the *Miami Herald*, Tony Proscio writes frequently about jargon and language misuse. He has published two book-length essays on the subject, *In Other Words: A Plea for Plain Speaking in Foundations* (1999) and *Bad Words for Good* (2001), as well as a book on urban renewal with Paul S. Grogan, *Comeback Cities: A Blueprint for Urban Neighborhood Revival* (2000). In addition to his essays on jargon, Proscio offers "Hints for Avoiding Jargon" on the Edna McConnell Clark Foundation Website (*www.emcf.org*), which is dedicated to fighting the proliferation of jargon in foundation discourse. No less a language expert than William Safire, author of the *New York Times* weekly column "On Language," called Proscio's *Bad Words* a "gem" and recommended it as summer reading in 2002 for writers in general. "Jabberwocky Junkies," published in *The Grantsmanship Center Magazine* in the fall of 2002, was adapted from the two book-length essays mentioned above, *In Other Words* and *Bad Words*.

• **FOR YOUR READING LOG**

1. Look up the term *jargon*, and write the definition in your reading log, along with some examples of jargon you have encountered recently.
2. What is your response to the graphic that accompanies this essay? What expectations does it create in terms of the essay's content and tone? •

———— ● ————

Many smart people in civic and philanthropic organizations of all kinds say, per- 1
suasively, that they find it forbiddingly hard to write more clearly. The problem is not that they don't know any better, but that they find it painful, and sometimes even unwise, to avoid the buzzwords and clichés that make their field seem impenetrable and off-putting to others. It's useful to understand why they feel that way—why so many writers, scholars, and activists bewail jargon in theory but revere it in practice.

Within their field, these writers say, the obscure and stuffy phrases enjoy too 2
much prestige, and encapsulate too many subliminal allusions, to be avoided or omitted entirely. It is simply not the same, they say, to write that some program "helps" parents "deal more effectively" with the school system, when what they want to say—need to say, for subtle reasons of protocol and professional bona fides—is that the program "empowers" parents.

The word EMPOWERS is over-used and vainglorious, they concede. But it also 3
encapsulates a view of the world, shared by like-minded people and institutions, that casts the parents as the heroes of a specific drama, in which the struggle for

power is the chief plot element. It is a drama, moreover, whose cult following includes many of the committed and influential people to whom the writer wishes to appeal.

4 "If you want to preach in this church," said one nonprofit official, "you've got to sing these hymns."

5 When foundation writers and scholars are dealing only with one another, and by extension with their ideological brethren, the hallowed old expressions probably do serve a purpose—especially if the author isn't trying to say anything particularly new. But those expressions, precisely because they are so enthusiastically received among the faithful in the pews, quickly become habit-forming. In time, through overuse, the popular words come not to express serious thinking, but to replace it.

6 So when a foundation officer writes—as one actually did—that "a geographically targeted effort will benefit from synergies," the writer evidently wants the initiated to envision the careful process that adepts understand as targeting, and to expect the calculated chain reactions that social scientists like to call synergy. The implied meaning comes off looking quite grand, really: "We will pick such ingenious locations for our grants that all the healthful vapors will gather like clouds of angels about our cause." Yet what the sentence actually says is so vague as to defy paraphrase. Incredibly, the writer never goes on to describe what synergies might be involved, or how they would bestow their benefits. It's all incantation with no point.

7 The writer no doubt had a point. But because of the soothing, almost narcotic effect of the jargon, she or he was evidently unaware that the point was

never made. Even the old hands who know these words well will gain no insight from reading this sentence (though they may glide right past it, mollified by the murmur of reassuring sounds). Yet in fact, it was written for publication far beyond the philanthropic cloister. Those helpless lay readers who don't spend their days talking about synergies and targets could only be baffled—or, in a worse but likely case, annoyed.

A few lay people, grappling with the sentence about synergies, might silently 8 defer to the author's superior expertise, assuming that the writing expressed something important but beyond their ken. That misimpression might even have been intentional, but probably it wasn't. Most foundations don't set out to intimidate, overwhelm, or befuddle their public. Most, in fact, seem eager to be better understood, and even to endure the self-exposure that clarity and understanding entail. Foundation conferences for some years have been consumed with a search for greater accountability, for a philanthropic bottom line, for metrics of achievement, and so on. Foundation leaders insist they want dialogue and partnership with their grantees, and feedback from their stakeholders. From all this earnestness (however much weighed down with jargon of its own), we can only conclude that foundations are trying to own up to their ambitions, and to be held to account when they fail. Why, then, does their speech so thoroughly belie those good intentions?

The only charitable answer is that they don't realize what they're saying and 9 writing. All that leaden verbiage means something to them, or so they believe, so it comes to them as a bit of a shock when no one else can guess at their meaning. A less charitable corollary, though, may be that the mystifying vocabulary produces pleasant side effects. Warding off criticism is a happy achievement, even if the price is warding off understanding.

What follow are some of the verbal gargoyles lately glowering down at any- 10 one who dares to join the American civic debate. Some of these expressions meet the classic definition of "jargon"—the peculiar vocabulary of a technical field—but others are not really technical; they're just obscure, evasive, or vague. In any case, all of them aspire, in their daily labors, to fit the newer and much harsher definition of jargon that *The American Heritage Dictionary* places first on its list: "nonsensical, incoherent, or meaningless talk."

At-risk

This mystifying expression owes its popularity to one embarrassing fact: The 11 phrase almost always designates a category of people of whom it is awkward to speak honestly. Almost every branch of charity or human service uses AT-RISK to describe the people whom its practitioners are . . . well, worried about. Here is one sample definition, from *Education Week:* "AT-RISK describes a student with socioeconomic challenges, such as poverty or teen pregnancy, which may place them [sic] at a disadvantage in achieving academic, social, or career goals. Such students are deemed 'at risk' of failing, dropping out, or 'falling through the cracks'."

12 Generalize from education to other fields of social concern, and AT-RISK becomes simply the polite euphemism for "headed into trouble." But in today's etiquette of upbeat and respectful neutrality, it would be considered grotesquely prejudicial, not to say hostile, to describe people that way. AT-RISK, however, is regarded as abstract enough to be polite, even in mixed company.

13 Yet if those who use this word are honest, they must admit to being perfectly comfortable classifying people according to a vast realm of unspecified problems that those people do not even have yet. Many people therefore read with scant discomfort that a program "addresses the needs of at-risk youth," never demanding the least description of what the youth are at-risk of. Everyone presumably already knows: The youth are headed into trouble.

14 Now, we are not so coarse as to suggest describing troubled people as "troubled." But surely there are some descriptions slightly more explicit than AT-RISK that do not offend the sensitivity gendarmes. The sibling euphemisms "disadvantaged" and "underserved" are admittedly overused, but unlike AT-RISK, they are at least not transparently unfinished thoughts.

15 Even when a writer decides that no other expression but AT-RISK could possibly do, it may be healthy at least to spend a moment asking, of what? If it is possible to answer that question concisely—as in "of violence," "of pregnancy," or "of dropping out of school"—then it would be a step in the right direction simply to finish the thought that AT-RISK begins. "This program addresses the needs of youth who are at risk of dropping out of school" or "who may be drawn into gangs" or "who risk early pregnancy."

16 In some cases, of course, the writer genuinely may not know what a person's real risk is. That is a sad fact—not about writers, or about jargon, but about life. Often, people really are simply headed into trouble, and we can't say exactly what that trouble might be. Would that it were different. But when it's not, perhaps AT-RISK truly is the best we can do.

-Based

17 On Sunday mornings, fresh from my faith-based institution, I stop at the community-based deli for a caffeine-based beverage. After a thought-based interlude, I select an information-based publication from the rack, and the knowledge-based attendant accepts an income-based emolument in exchange for his customer-based service. I return to my home base wishing I could de-BASE this language for good. But in at least one sense, it is already as debased as it can be.

18 Where did all these -BASES come from? When did things cease to have qualities of their own and start being merely based on other things? In the field of urban development, there was once such a thing as a community development corporation. Now they're all community-based development corporations. Groups of very smart people used to be proud of being learned or expert; now they hide their diplomas behind the lifeless claim of being "knowledge-based." Why are synagogues, churches, and mosques not fighting to regain their sacred charter as religious institutions? Are they content to have it said that they are merely based on faith—perhaps the way Velveeta is based on cheese—and not

AVOIDING JARGON

How does a conscientious writer avoid opaque or muddle-headed writing? Here are a few practical exercises that can help weed out the fuzzy thinking from which the worst jargon springs:

1. **Conjure your audience while you write.** If you are writing for a general audience, meaning well-educated people who don't happen to share your line of expertise, it may be helpful to envision one typical reader—preferably a friend—and write as if you were sending a letter to that person. If your friend wouldn't understand a term or phrase, don't use it. Better still, ask yourself how your nonspecialist friend would describe the same idea, and borrow the language, in a sense, from him or her. Experience suggests that the first few attempts at this method may feel hopelessly limiting (and may be so time-consuming that it jeopardizes deadlines). But regular practice is an effective way of weeding out arcane, obscure, or "inside" expressions.

2. **Make up your own jargon list.** As you sit through meetings—the boring ones are best for this—start a list of the buzz-phrases you hear others overusing. The fact that these phrases annoy you should be reason enough to avoid them yourself. Yet you may be surprised (and humbled) to discover that you do not, in fact, always avoid them. That painful discovery is no fun, but many people find the making and keeping of such a list both helpful and (during the worst meetings) therapeutic.

3. **Outline in plain phrases.** Outlining is one of those tasks from college that you probably left behind with your French irregular verbs. And ordinary outlining can, it's true, be a little burdensome. The key exercise in this context, though, is not really the outline itself; it's the words you use in the outline. The rules are roughly these: (a) use just half a dozen words for the average numbered item, with a maximum of ten; (b) use only words and phrases that would fit naturally in *USA Today*. The point is definitely not that your eventual writing should mirror *USA Today*— only that the topics should each be expressible as a headline suitable for a very general newspaper readership. "Comprehensive initiative impacts system reform" won't do. "Wide-ranging project changes how City Hall serves the neighborhood" is better. Eventually, your full written product may have to contain a few technical phrases, if the subject is at all technical. But in making the outline, you will at least have given every topic an ordinary, clear name. And the process of making up those names usually focuses creative attention on concepts that would otherwise have been expressed in jargon.

4. **Read your finished work out loud.** This may not work for everyone, but when it works, it's powerful. Hearing long, convoluted sentences and dense phrases read aloud can be shocking and revealing. The benefit of hearing text, rather than just reading it, is that it gives the writer an opportunity to ask, "Would anyone really say that?" When the answer is no—and it often is—then the odds are good that a rewrite is in order.

aflame with the genuine article? Why are the clergy not marching on Washington over this? Where is the outrage?

19 The answer is that this dodgy game of base-running is actually useful in the sneaky political realms where such coinages proliferate. The Constitution may look askance at alliances between government and religion, but it might be said to be silent on faith-based activities. Community organizations might be expected to demonstrate actual support from their neighbors—something many of them enjoy, but not all. Yet if they're community-based . . . well, all they really have to do is be based there.

Community

20 In English, COMMUNITY has applied for centuries to practically any association among people, whether profound or superficial. The almost boundless vagueness of this word is therefore not a new invention, an affectation, or a subterfuge. Jargon it's not. But vague it is, and therefore an invitation to mental sloppiness.

21 In some recent expressions like "community development" or "community organizing," the word started off as real jargon—trendy and obscure, with multiple meanings—but it has gained a certain practiced precision, built up over time. COMMUNITY now means, in these contexts, a group of people living near one another who share, by reason of their common residence, some political or economic interests. In this sense, the word can actually be preferable over more precise words like "neighborhood," because some such communities aren't urban enough to be clustered into neighborhoods.

22 But more often, in phrases like "the intelligence community," "the arts community," or "the child-welfare community," the word drops a deliberate scrim in front of a bunch of shadowy people whom no one is expected to identify. Most of the time, those who use such phrases really mean to say "people in these fields whom I consider important, but can't or won't name." Used that way, the word falsely pretends to give information, while actually blotting out important details.

23 Worse, that use of COMMUNITY is sometimes deliberately misleading. It implies a unanimity among members that rarely occurs in reality. These COMMUNITIES that speak so conveniently in unison may suit the polemical purposes of some writers, but not without seeming a little fraudulent. When "the Harlem community" supports or opposes a new shopping center, it is a near certainty that a group of individuals, and not all the residents of Harlem, share one view of the development. Used this way, as with SITE, the word may be just the result of careless diction, but it exposes the writer to suspicions of dishonesty.

24 There is another way this word has muddied philanthropic discourse—in its plainest and most generic sense. For example, "mentally ill people should live in the community," "service should be provided in the community," and "the community must decide how to respond." Should elderly people be helped to remain "in the community" (meaning, we presume, somewhere this side of Antarctica), or would it be more to the point to say "at home"?

25 There may well be a difference between those two ideas, but if there is, the word COMMUNITY does not convey it. When mental health programs are told that

their work should be done "in the community," they are probably being told that their hospitals and clinics are too far away from where their customers live. But the word doesn't say that, unfortunately.

Empowerment

Here is an example of that most pernicious of all forms of jargon: the ideologi- 26 cal shibboleth. To establish one's bona fides as a person concerned about the poor, the disenfranchised, or even ordinary people in general, it is essential in every setting to use EMPOWERMENT—as early (and, in some circles, as often) as possible.

The coiners of EMPOWERMENT invested it with only the broadest meaning, per- 27 haps to make it usable in nearly every context—or anyway, that has been the effect. Foundations now must be careful to empower grantees, communities, individual residents of those communities, voluntary and civic associations, the poor, those who help the poor, and even those who do not help the poor, but would if they were empowered. Scarcely a grant is made anymore without someone or something being solemnly empowered, normally with a timely infusion of money.

The word is a synonym, says *The American Heritage Dictionary*, for "autho- 28 rize," but you wouldn't guess it from the way EMPOWER is used. People are not "authorized" by community development organizations, but they are apparently "empowered" in the hundreds of thousands. No one is "authorized" by public opinion polls, the Internet, charter schools, community policing, a Patient's Bill of Rights, civilian review boards, tax cuts, after-school programs, competition in the telecommunications industry, or community colleges. Yet every one of these things, and many more besides, has been described in recent public-policy or foundation writing as "empowering" people.

This EMPOWER-surge makes at least one thing clear: *The American Heritage Dic-* 29 *tionary* has it wrong. In the ideological camps where EMPOWER is a ritual incantation, the word doesn't mean "authorize," it means "give people some ability to influence something they cannot already influence, or do something they cannot already do." But that definition is so broad that it can apply to almost anything that is not an absolute impediment. (One might argue, just to be churlish, that even an impediment empowers people to impede things.)

Try this exercise, which we might call an EMPOWER-outage: Find five or six 30 instances of EMPOWER among recent memos and papers, and mentally blot them out. Then reread the paper, with the EMPOWER switched off. Most times, the meaning won't have changed a whit. But the paper may grow shorter.

Metrics

Change one or two words, and the following sentence will nestle snugly into the 31 writing of any branch of the human services: "The failure of the mental health industry to devise adequate metrics to capture long-term outcomes has resulted in confusion as to appropriate timing and levels of intervention." The phrase "to

devise adequate metrics" is apparently the universal choice to replace the hopelessly outdated and déclassé verb "to measure." We no longer count anything in the digital age. We now devise metrics.

32 "Without metrics of success," says a recent foundation paper, "it is impossible to say with certainty whether the results of neighborhood redevelopment in the past 20 years justify the level of investment." The sentence is remarkable not so much for its use of METRICS—it would be much more remarkable to find a piece of foundation writing that does not use the term—but for its specific application to the field of neighborhood development. Here, one might have supposed, is a branch of American philanthropy and social policy that is among the most metricked civic activities in history.

33 Neighborhood development groups in the past 20 or 30 years have made an art of counting new houses, refurbished apartments, reclaimed blocks, numbers of investors and lenders, square feet of renovated commercial space, and (with a more fanciful standard of reckoning) the number of jobs added to the neighborhood employment base. Compared with neighborhood development, only professional baseball is more awash in metrics. So what more is the author of the quoted sentence looking for?

34 The key is in the seemingly innocent word "success." In modern philanthropic usage, what distinguishes METRICS from mere measurement is that the fancier word gauges success—or, as the mental health writer would have it, "long-term outcomes." Metrics are contemporary social policy's equivalent of the Philosopher's Stone—an elusive but potent medium that transforms the base metal of mere results into the unalloyed gold of "long-term outcomes." Building houses and treating illnesses are fine, but will they permanently solve the deeper problems? Seek ye the metric that will pierce that mystery. And be prepared for a long search.

Stakeholders

35 In most civic and charitable projects, the people with a "stake" in the results are legion. When people try to improve schools or health care or Social Security, who has a "stake" in the results? Answer: All of us—every last woman, man, and child. Half the time, STAKEHOLDERS is a passable substitute for "all the living, and even a few of the dead." As such, in any practical context it is useless noise.

36 The only explanation for the spectacular success of STAKEHOLDERS in the philanthropic demimonde is that the word sounds tantalizingly like its cousin "stockholders." For those with a painful, gnawing envy of Wall Street and all its blandishments, the desire for stockholders must have the merciless pull of an addiction. (Funny, that: Most actual denizens of Wall Street would be delighted to give their stockholders the heave-ho, as long as they could hold on to the capital.) Among Wall Street wannabes, a word that gives the thrilling feeling of stock without the nuisance of actually paying dividends would naturally be a big hit. For those with a chemical dependence on the gibberish of high finance, STAKEHOLDERS is something like methadone: It eases some of the craving, without inflicting the harmful side effects of the real thing.

Throughput

Born in the corridors of industrial engineering before World War II, THROUGHPUT 37 traveled back and forth a few times between descriptive neologism and itinerant metaphor. After some years of disciplined life describing the pace and scope of work on old-fashioned assembly lines, or the delivery potential of fuel systems, the word made a mid-life career change and became a journeyman metaphor in the infant computer industry. It was such a hit there that it quickly grew to be a precisely defined technical term in its new field, infused with a tight new range of meanings.

That was the word's first definitional leap, but it was a small one. Its origi- 38 nal meaning was in most senses still intact: The processing of information really was a new application of the ideas of productive engineering and fuel delivery; the new meaning was not a metaphor but simply a new use for the original concept. Instead of people assembling machinery or pipes delivering fuel, machines were moving and assembling information. The point, though, remained a combination of transportation, assembly, and production.

But the computer pioneers soon lost control of the word (as of most of their 39 once-specialized vocabulary, starting with THROUGHPUT's parents, INPUT and OUTPUT). THROUGHPUT is now the universal metaphor for any interval between the moment anything is put into anything else and the moment it re-emerges, presumably altered.

● THINKING CRITICALLY ABOUT "JABBERWOCKY JUNKIES"

RESPONDING AS A READER

1. In the first ten paragraphs, Proscio introduces the problem and discusses its causes and effects. He uses both analogy and examples to give the problem presence. How effectively do you think he does this for his primary audience (grant writers for foundations)? For a broader audience of readers like you?

2. How would you characterize Proscio's tone (or differing tones) in this essay? Find examples to support your answer.

3. The box offers guidelines for avoiding jargon. Do you think these guidelines are useful and practical? Can you think of situations in which you might use this advice to avoid jargon in your writing?

RESPONDING AS A WRITER

1. In paragraph 17, Proscio parodies the use of the jargon tag *-based*. Try your own hand at parody by writing a sentence in which you use this or other jargon terms or phrases.

2. In paragraph 10, Proscio discusses two definitions of *jargon*—one a narrow definition ("the peculiar vocabulary of a technical field"), the other a broad definition ("nonsensical, incoherent, or meaningless talk").

Make two lists of words and phrases—one of examples of the first definition, the other of examples of the second definition. Are both types of language use equally problematic in your opinion? Why or why not?

3. On the Website mentioned in the headnote, readers are invited to share their own examples of "foundationspeak" by e-mailing *jargon@emcf.org*. While you may not be familiar with "foundationspeak," you are probably familiar with other types of jargon or buzzwords. Find an example of a jargon term or phrase that you find objectionable or silly, and write a few paragraphs, explaining why. (Use Proscio's analysis of particular buzzwords such as *at risk* as a model.) •

MARCIA ANGELL AND JEROME KASSIRER

Clinical Research—What Should the Public Believe?

Marcia Angell (b. 1939) is a senior lecturer in the Department of Social Medicine at Harvard Medical School and former editor-in-chief of the prestigious *New England Journal of Medicine* (NEJM). A pathologist by training, Angell is the author of *Science on Trial: The Clash of Medical Evidence and the Law in the Breast Implant Case*. Angell is known for her commitment to patients' rights, ethical values in medicine, high standards for clinical research, and cautious dissemination of research results. Her coauthor, Jerome Kassirer (b. 1932), is the former editor-in-chief of NEJM and an internist by training. A medical educator as well as a former editor and practicing physician, Kassirer shares Angell's concern for high ethical standards and rigor in medical research.

In 1994 "Clinical Research—What Should the Public Believe?" appeared in the editorial section of NEJM, a journal for health care professionals. Its articles on medical research are frequently the subject of news reports. Although the essay is an opinion piece, the authors use the same documentation conventions that they would if they were writing a scientific article. NEJM's citation system follows *Index Medicus,* which is similar to that used in many other scientific journals. This system numbers citations consecutively through the text and then lists them in a reference section according to the order they appeared in the text. If a work is cited again later in the text, its initial citation number is repeated. This scholarly care in an editorial suggests that opinions need to be backed up by evidence if they are to be credible to the scientific community.

• **FOR YOUR READING LOG**

1. Are there particular health issues that you follow in news reports or magazines? Perhaps you perk up your ears when you hear a report

about the latest weight-loss drugs or treatments for cancer or mental illness. Why does this particular health topic interest you? How much stock do you put in the reports you hear in the popular media? Write a journal entry in response to these questions.

2. The authors claim that most Americans believe that good health is a matter of living right. Do you believe this to be true? If so, what lifestyle choices have you made to try to ensure good health—exercise, a healthy diet, abstinence from smoking or drinking? If you do not believe this to be true, why not? What is your attitude toward the American preoccupation with healthy living? Make a few notes in response to these questions. ●

———— ● ————

Americans have become increasingly avid for news of clinical research that they feel will improve their health or extend their lives. This is particularly true of research about diet or lifestyle. To many Americans, as Fitzgerald points out elsewhere in this issue of the *Journal,* good health is largely a matter of living right.[1] They believe that they can ward off many if not most diseases and disability simply by knowing what foods to eat, what supplements to consume, and what leisure activities to pursue. This belief is fed by the new emphasis on preventive medicine as a solution to rising costs in health care. Thus, research on how diet and lifestyle affect health is of personal and intense interest to many Americans. Millions now eat low-fat, high-fiber diets, take antioxidant supplements, drink alcohol only in moderation, stay slim, and exercise regularly.

But there are problems. Health-conscious Americans increasingly find themselves beset by contradictory advice. No sooner do they learn the results of one research study than they hear of one with the opposite message. They substitute margarine for butter, only to learn that margarine may be worse for their arteries.[2] They are told to eat oat bran to lower their cholesterol[3,4] but later learn that the bran they dutifully ate may be useless.[5] They substitute low-calorie saccharin for high-calorie sugar, only to hear that some researchers find an association between saccharin and bladder cancer,[6] while other researchers do not.[7] They exercise because they are told that it is good for their hearts, only to learn that exercise may increase the immediate risk of sudden death.[8–10] Most recently, vitamin E and beta carotene, long touted for their ostensible role in preventing cancer, were found in a large study to be no better and possibly worse than placebo.[11] And now, a study reported elsewhere in this issue of the *Journal* concludes that antioxidants are probably not helpful in preventing cancer of the colon,[12] although earlier studies found that they are.[13,14]

Not surprisingly, the existence of all these contradictory reports has not escaped the attention of the media. When the recent study of the effects of vitamin E and beta carotene was published, many of the major newspapers and newsmagazines carried stories complaining about the problem. Ellen Goodman, a popular syndicated columnist, seemed to feel betrayed. She spoke of "planned obsolescence" in research, as though the problem were a conspiracy by scientists

to confuse the public.[15] The recent analysis of the risks of margarine[2] prompted the *New York Times* to editorialize, under the title "Diet Roulette," "No wonder health-conscious Americans often feel they just can't win."[16] Why can't researchers get it straight the first time?

4 In our view the problem is not in the research but in the way it is interpreted for the public. In addition, the public itself must bear some responsibility for its unrealistic expectations. (Why should every scientific study reported in the media be a "win" for them?) We here review some of the features of clinical research that are often misunderstood by both the media and the public.

5 What medical journals publish is not received wisdom but rather working papers. Each of these is meant to communicate to other researchers and to doctors the results of one study. Each study becomes a piece of a puzzle that, when assembled, will help either to confirm or to refute a hypothesis. Although a study may add to the evidence about a connection between diet or exercise and health, rarely can a single study stand alone as definitive proof. In part, this is because there may be unappreciated biases in the works. For example, those who consume high-fiber diets or take antioxidant supplements may be healthier than those who do not, for reasons that have nothing to do with the diet or the supplements. As was discussed in an earlier editorial, we may not always control adequately for these confounding factors.[17] In fact, we may not even know about them. Even when there are no such problems, the results of a study can still be due to chance. Nearly all studies of connections between lifestyle and health deal with probabilities. Chance cannot be ruled out even when it is highly unlikely. Finally, results that are valid in one population may not be in another. The vitamin-E-and-beta-carotene study was performed in male Finnish smokers. There is no reason to believe that their response to antioxidants would be different from the response of women, nonsmokers, or people in different age groups, but it might be. Thus, nearly every clinical research study should be seen as preliminary. No matter how important the conclusions, they should usually be considered tentative until a body of evidence accumulates pointing in the same direction. For example, the now overwhelming evidence that cigarette smoking is extremely dangerous was accumulated bit by bit over many years.

6 Doctors know that clinical research rarely advances in one giant leap; instead, it progresses incrementally. For this reason, the practice of medicine, as well as clinical research, is inherently conservative. Doctors are reluctant to change their practices overnight, for good reason. (Unfortunately, they do not always communicate this reason adequately to their patients.) And researchers often end their reports with the phrase, "More work is required," which is more than a bromide. But because of the public's keen interest in new medical findings, the media may be less conservative. They are serving a public that believes passionately that the more we can learn about what to eat or how to live, the longer we will live. And neither the public nor the media are inclined to wait for confirmatory studies. Often, the media reports are exaggerated or oversimplified. Even when a report itself is circumspect, headline writers may sensationalize the story. For example, the headline over a story reporting that the GUSTO trial[18] found tissue plasminogen activator (t-PA) given after an acute myocardial in-

farction to be only slightly better than streptokinase (mortality, 6.3 percent vs. 7.3 percent) read, "Anti-Clotting Therapy Found to Spare Lives."[19] While technically true, this is nevertheless misleading.

There are many ways the media could improve the way they interpret science to the public. In our view the most important would be to pay closer attention to the following caveats. First, an association between two events is not the same as a cause and effect. For example, prenatal care is associated with better perinatal outcomes, but we do not yet know that it is the reason for the better outcomes. Second, demonstrating one link in a postulated chain of events does not mean that the whole chain is proved. For example, if a screening test for prostate cancer is effective, that does not mean it will save lives.[20] Third, probabilities are not the same as certainties. For example, a study showing that alcohol causes a 30 percent increase in the risk of breast cancer does not mean that a woman who drinks no alcohol will not get breast cancer (nor that she will inevitably get breast cancer if she does drink).[21] And fourth, the way a scientific result is framed can greatly affect its impact. For example, the results of the GUSTO trial could be framed in three ways: t-PA was 14 percent more effective than streptokinase; t-PA lowered the mortality from 7.3 percent to 6.3 percent; or t-PA increased the survival rate from 92.7 percent to 93.7 percent. All three ways are accurate, but they produce very different impressions on readers. The media would do a much better job of reporting medical research if they considered these four caveats explicitly.

Finally, the public at large needs to become much more sophisticated about clinical research, particularly epidemiology. Unfortunately, that is unlikely to happen as long as science education in the United States is so poor. Even with improvements in science education, however, no one could expect people to go to medical journals and evaluate the evidence themselves. But it would be possible for people to learn enough about the scientific method to know that there are very few breakthroughs in clinical research and that claims of a breakthrough should be regarded warily. In particular, they should not rush to change their diets or habits on the basis of reports of one study. Any one study should be regarded as tentative, the more so if the results are spectacular or at odds with the evidence accumulated so far. And the public should remember that the media may sometimes make more of a study than the results warrant.

Although we would all like to believe that changes in diet or lifestyle can greatly improve our health, the likelihood is that, with a few exceptions such as smoking cessation, many if not most such changes will produce only small effects. And the effects may not be consistent. A diet that is harmful to one person may be consumed with impunity by another. Furthermore, any change in diet or lifestyle will almost inevitably involve some sort of trade-off—for example, risking sports injuries in order to enjoy the physiologic advantages of exercise. The subject of trade-offs is considered in more detail by Keeney elsewhere in this issue.[22]

What is called for is more moderation in our response to news of clinical research. Every study reported in the media does not require an all-or-nothing response in our diet or lifestyle. In general, we should not embrace the conclusions of a study until other studies support them. Reserving judgment in this way,

without succumbing to antiscientific nihilism, is the best protection against being whipsawed by media reports of clinical research. People who felt betrayed when they learned of a new study showing that vitamin E and carotene do not protect against cancer should ask themselves why they so readily believed that antioxidants had this effect in the first place and why they now believe that there is no such effect.

References

1. Fitzgerald FT. The tyranny of health. *N Engl J Med* 1994;331:196-8.

2. Willett WC, Ascherio A. Trans fatty acids: are the effects only marginal? *Am J Public Health* 1994;84:722-4.

3. Kirby RW, Anderson JW, Sieling B, et al. Oat-bran intake selectively lowers serum low-density lipoprotein cholesterol concentrations of hypercholesterolemic men. *Am J Clin Nutr* 1981;34:824-9.

4. Anderson JW, Story L, Sieling B, Chen W-JL, Petro MS, Story J. Hypocholesterolemic effects of oat-bran or bean intake for hypercholesterolemic men. *Am J Clin Nutr* 1984;40:1146-55.

5. Swain JF, Rouse IL, Curley CB, Sacks FM. Comparison of the effects of oat bran and low-fiber wheat on serum lipoprotein levels and blood pressure. *N Engl J Med* 1990;322:147-52.

6. Howe GR, Burch JD, Miller AB, et al. Artificial sweeteners and human bladder cancer. *Lancet* 1977;2:578-81.

7. Hoover RN, Strasser PH. Artifical sweeteners and human bladder cancer: preliminary results. *Lancet* 1980;1:837-40.

8. Mittleman MA, Maclure M, Tofler GH, Sherwood JB, Goldberg RJ, Muller JE. Triggering of acute myocardial infarction by heavy physical exertion—protection against triggering by regular exertion. *N Engl J Med* 1993;329:1677–83.

9. Willich SN, Lews M, Lowel H, Arntz H-R, Schubert F, Schroder R. Physical exertion as a trigger of acute myocardial infarction. *N Engl J Med* 1993;329:1684-90.

10. Curfman GD. Is exercise beneficial or hazardous to your heart? *N Engl J Med* 1993;329:1730-1.

11. The Alpha-Tocopherol, Beta Carotene Cancer Prevention Study Group. The effect of vitamin E and beta carotene on the incidence of lung cancer and other cancers in male smokers. *N Engl J Med* 1994;330:1029-35.

12. Greenberg ER, Baron JA, Tosteson TD, et al. A clinical trial of antioxidant vitamins to prevent colorectal adenoma. *N Engl J Med* 1994;331:141-7.

13. Bostick RM, Potter JD, McKenzie DR, et al. Reduced risk of colon cancer with high intake of vitamin E: the Iowa Women's Health Study. *Cancer Res* 1993;53:4230-7.

14. Roncucci L, Di Donato P, Carati L, et al. Antioxidant vitamins or lactulose for the prevention of the recurrence of colorectal adenomas. *Dis Colon Rectum* 1993;36:227-34.

15. Goodman E. To swallow or not to swallow: that is the new vitamin question. *Boston Globe*. April 17, 1994:A27.

16. Diet roulette. *New York Times*. May 20, 1994:A26.

17. Angell M. The interpretation of epidemiologic studies. *N Engl J Med* 1990;323:823-5.

18. The GUSTO Investigators. An international randomized trial comparing four throm-bolytic strategies for acute myocardial infarction. *N Engl J Med* 1993;329:673-82.

19. Lehman BA. Cancer drug is found to have heart benefit. *Boston Globe*. September 2 1993:3.

20. Blood test's value in early prostate cases. *New York Times*. August 25, 1993:C10.

21. Willett WC, Stampfer MJ, Colditz GA, Rosner BA, Hennekens CH, Speizer FE. Moderate alcohol consumption and the risk of breast cancer. *N Engl J Med* 1987; 316:1174-80.

22. Keeney RL. Decisions about life-threatening risks. *N Engl J Med* 1994;331:193-6.

● THINKING CRITICALLY ABOUT "CLINICAL RESEARCH—WHAT SHOULD THE PUBLIC BELIEVE?"

RESPONDING AS A READER

1. What problem does this editorial address? How do Angell and Kassirer go about giving the problem presence for readers? Are they successful in making you feel that this is an important problem with serious neg-ative consequences?

2. To accomplish their persuasive aim, Angell and Kassirer must explain the ways in which the public misunderstands the nature of clinical re-search. How informative was this article to you as a reader? What, if any, of this information was new to you? Do they provide adequate expla-nation and examples to correct the misunderstandings they name?

3. Angell and Kassirer propose practical actions on the part of both the me-dia and the public (paragraphs 7–10). How likely do you think either group is to take the practical actions recommended? Why or why not?

RESPONDING AS A WRITER

1. In paragraph 7, Angell and Kassirer suggest three ways of reporting the results of a study comparing two different treatments (t-PA and strep-tokinase) for heart attack patients. They claim that while all three ways of stating the results are accurate, each produces "very different im-pressions on readers." Take each statement, and explain your interpre-tation of its meaning, paying close attention to the word choice in each statement. What are the differences in the meanings suggested by these three statements?

2. In paragraph 9, Angell and Kassirer say that "many if not most such changes [in diet or lifestyle] will produce only small effects . . . [and] any change in diet or lifestyle will almost inevitably involve some sort of trade-off." What's the function of this paragraph in the context of their overall argument? Imagine that you're talking about the importance of healthy lifestyle choices with a friend who eats a lot of junk food and never exercises. Your friend cites the ideas of these two medical experts to support his claim that changes in diet and lifestyle are pointless. How could you counter your friend's argument? What logical flaws or

errors in reasoning do you find either in their original claims or in your friend's use of them?

3. Find a recent newspaper or magazine article reporting the results of clinical research, and analyze it in light of Angell and Kassirer's article. Does the headline sensationalize the findings? Does the article explain the circumstances and limitations of the study itself or offer qualifications about its results? Are there any particular claims that you suspect are exaggerated, misleading, or oversimplified? Write a paragraph in which you report these clinical findings in terms that Angell and Kassirer would find acceptable. •

Janet Radcliffe-Richards et al.

The Case for Allowing Kidney Sales

British philosopher Janet Radcliffe-Richards, director of the Centre for Bioethics at the University College of London, is lead author of a team of eight—which includes lawyers, doctors, medical sociologists, and philosophers—who wrote "The Case for Allowing Kidney Sales." The article was originally presented at the International Forum for Transplant Ethics and later published on June 27, 1998, in the Department of Ethics section of *The Lancet,* a weekly British medical journal that publishes a wide range of medical articles. For example, the issue in which this article appeared included a story on "UK 'Bristol Case' Doctors Found Guilty of Shaken-Baby Syndrome" in the News section, a scientific report on "Death from Heroin Overdose: Findings from Hair Analysis" in the Early Reports section, and an article entitled "If Children's Lives Are Precious, Which Children?" in the Health and Human Rights section. Lead author Janet Radcliffe-Richards, who is also the author of *The Skeptical Feminist: A Philosophical Enquiry* (1980) and *Human Nature after Darwin* (2002), continues to be an advocate for legalized kidney sales.

The Lancet uses a citation system similar to that used by the *New England Journal of Medicine* and other scientific journals in which citations are numbered consecutively through the text except for repeated citations. In the reference list, the numbered citations appear in the order in which they were first cited in the text.

• **FOR YOUR READING LOG**

1. What effect does this team of authors' diverse professional credentials have on your expectations about the authoritativeness of this article? Read the first paragraph of the article. What relationships do you see between the rhetorical situation they outline in this opening paragraph and their diverse professional backgrounds?

2. Are you familiar with the ethical debates surrounding organ trans-
plants? Make a few notes about your background knowledge, opin-
ions, and questions about this issue. ●

———— ● ————

When the practice of buying kidneys from live vendors first came to light some 1
years ago, it aroused such horror that all professional associations denounced it[1,2]
and nearly all countries have now made it illegal.[3] Such political and professional
unanimity may seem to leave no room for further debate, but we nevertheless
think it important to reopen the discussion.

The well-known shortage of kidneys for transplantation causes much suf- 2
fering and death.[4] Dialysis is a wretched experience for most patients, and is any-
way rationed in most places and simply unavailable to the majority of patients
in most developing countries.[5] Since most potential kidney vendors will never
become unpaid donors, either during life or posthumously, the prohibition of
sales must be presumed to exclude kidneys that would otherwise be available.
It is therefore essential to make sure that there is adequate justification for the
resulting harm.

Most people will recognise in themselves the feelings of outrage and disgust 3
that led to an outright ban on kidney sales, and such feelings typically have a
force that seems to their possessors to need no further justification. Nevertheless,
if we are to deny treatment to the suffering and dying we need better reasons
than our own feelings of disgust.

In this paper we outline our reasons for thinking that the arguments com- 4
monly offered for prohibiting organ sales do not work, and therefore that the de-
bate should be reopened.[6,7] Here we consider only the selling of kidneys by liv-
ing vendors, but our arguments have wider implications.

The commonest objection to kidney selling is expressed on behalf of the ven- 5
dors: the exploited poor, who need to be protected against the greedy rich. How-
ever, the vendors are themselves anxious to sell,[8] and see this practice as the best
option open to them. The worse we think the selling of a kidney, therefore, the
worse should seem the position of the vendors when that option is removed. Un-
less this appearance is illusory, the prohibition of sales does even more harm than
first seemed, in harming vendors as well as recipients. To this argument it is
replied that the vendors' apparent choice is not genuine. It is said that they are
likely to be too uneducated to understand the risks, and that this precludes in-
formed consent. It is also claimed that, since they are coerced by their economic
circumstances, their consent cannot count as genuine.[9]

Although both these arguments appeal to the importance of autonomous 6
choice, they are quite different. The first claim is that the vendors are not com-
petent to make a genuine choice within a given range of options. The second, by
contrast, is that poverty has so restricted the range of options that organ selling
has become the best, and therefore, in effect, that the range is too small. Once this

distinction is drawn, it can be seen that neither argument works as a justification of prohibition.[7]

7 If our ground for concern is that the range of choices is too small, we cannot improve matters by removing the best option that poverty has left, and making the range smaller still. To do so is to make subsequent choices, by this criterion, even less autonomous. The only way to improve matters is to lessen the poverty until organ selling no longer seems the best option; and if that could be achieved, prohibition would be irrelevant because nobody would want to sell.

8 The other line of argument may seem more promising, since ignorance does preclude informed consent. However, the likely ignorance of the subjects is not a reason for banning altogether a procedure for which consent is required. In other contexts, the value we place on autonomy leads us to insist on information and counselling, and that is what it should suggest in the case of organ selling as well. It may be said that this approach is impracticable, because the educational level of potential vendors is too limited to make explanation feasible, or because no system could reliably counteract the misinformation of nefarious middlemen and profiteering clinics. But even if we accepted that no possible vendor could be competent to consent, that would justify only putting the decision in the hands of competent guardians. To justify total prohibition it would also be necessary to show that organ selling must always be against the interests of potential vendors, and it is most unlikely that this would be done.

9 The risk involved in nephrectomy is not in itself high, and most people regard it as acceptable for living related donors.[10] Since the procedure is, in principle, the same for vendors as for unpaid donors, any systematic difference between the worthwhileness of the risk for vendors and donors presumably lies on the other side of the calculation, in the expected benefit. Nevertheless the exchange of money cannot in itself turn an acceptable risk into an unacceptable one from the vendor's point of view. It depends entirely on what the money is wanted for.

10 In general, furthermore, the poorer a potential vendor, the more likely it is that the sale of a kidney will be worth whatever risk there is. If the rich are free to engage in dangerous sports for pleasure, or dangerous jobs for high pay, it is difficult to see why the poor who take the lesser risk of kidney selling for greater rewards—perhaps saving relatives' lives,[11] or extricating themselves from poverty and debt—should be thought so misguided as to need saving from themselves.

11 It will be said that this does not take account of the reality of the vendors' circumstances: that risks are likely to be greater than for unpaid donors because poverty is detrimental to health, and vendors are often not given proper care. They may also be underpaid or cheated, or may waste their money through inexperience. However, once again, these arguments apply far more strongly to many other activities by which the poor try to earn money, and which we do not forbid. The best way to address such problems would be by regulation and perhaps a central purchasing system, to provide screening, counselling, reliable payment, insurance, and financial advice.[12]

To this it will be replied that no system of screening and control could be complete, and that both vendors and recipients would always be at risk of exploitation and poor treatment. But all the evidence we have shows that there is much more scope for exploitation and abuse when a supply of desperately wanted goods is made illegal. It is, furthermore, not clear why it should be thought harder to police a legal trade than the present complete ban.

Furthermore, even if vendors and recipients would always be at risk of exploitation, that does not alter the fact that if they choose this option, all alternatives must seem worse to them. Trying to end exploitation by prohibition is rather like ending slum dwelling by bulldozing slums: it ends the evil in that form, but only by making things worse for the victims. If we want to protect the exploited, we can do it only by removing the poverty that makes them vulnerable, or, failing that, by controlling the trade.

Another familiar objection is that it is unfair for the rich to have privileges not available to the poor. This argument, however, is irrelevant to the issue of organ selling as such. If organ selling is wrong for this reason, so are all benefits available to the rich, including all private medicine, and, for that matter, all public provision of medicine in rich countries (including transplantation of donated organs) that is unavailable in poor ones. Furthermore, all purchasing could be done by a central organisation responsible for fair distribution.[12]

It is frequently asserted that organ donation must be altruistic to be acceptable,[13] and that this rules out payment. However, there are two problems with this claim. First, altruism does not distinguish donors from vendors. If a father who saves his daughter's life by giving her a kidney is altruistic, it is difficult to see why his selling a kidney to pay for some other operation to save her life should be thought less so. Second, nobody believes in general that unless some useful action is altruistic it is better to forbid it altogether.

It is said that the practice would undermine confidence in the medical profession, because of the association of doctors with money-making practices. That, however, would be a reason for objecting to all private practice; and in this case the objection could easily be met by the separation of purchasing and treatment. There could, for instance, be independent trusts[12] to fix charges and handle accounts, as well as to ensure fair play and high standards. It is alleged that allowing the trade would lessen the supply of donated cadaveric kidneys.[14] But although some possible donors might decide to sell instead, their organs would be available, so there would be no loss in the total. And in the meantime, many people will agree to sell who would not otherwise donate.

It is said that in parts of the world where women and children are essentially chattels there would be a danger of their being coerced into becoming vendors. This argument, however, would work as strongly against unpaid living kidney donation, and even more strongly against many far more harmful practices which do not attract calls for their prohibition. Again, regulation would provide the most reliable means of protection.

It is said that selling kidneys would set us on a slippery slope to selling vital organs such as hearts. But that argument would apply equally to the case of the

unpaid kidney donation, and nobody is afraid that will result in the donation of hearts. It is entirely feasible to have laws and professional practices that allow the giving or selling only of non-vital organs. Another objection is that allowing organ sales is impossible because it would outrage public opinion. But this claim is about western public opinion: in many potential vendor communities, organ selling is more acceptable than cadaveric donation, and this argument amounts to a claim that other people should follow western cultural preferences rather than their own. There is, anyway, evidence that the western public is far less opposed to the idea, than are medical and political professionals.[15]

19 It must be stressed that we are not arguing for the positive conclusion that organ sales must always be acceptable, let alone that there should be an unfettered market. Our claim is only that none of the familiar arguments against organ selling works, and this allows for the possibility that better arguments may yet be found.

20 Nevertheless, we claim that the burden of proof remains against the defenders of prohibition, and that until good arguments appear, the presumption must be that the trade should be regulated rather than banned altogether. Furthermore, even when there are good objections at particular times or in particular places, that should be regarded as a reason for trying to remove the objections, rather than as an excuse for permanent prohibition.

21 The weakness of the familiar arguments suggests that they are attempts to justify the deep feelings of repugnance which are the real driving force of prohibition, and feelings of repugnance among the rich and healthy, no matter how strongly felt, cannot justify removing the only hope of the destitute and dying. This is why we conclude that the issue should be considered again, and with scrupulous impartiality.

References

1. British Transplantation Society Working Party. Guidelines on living organ donation. *BMJ* 1986;293:257-58.

2. The Council of the Transplantation Society. Organ sales. *Lancet* 1985;2:715-16.

3. World Health Organization. A report on developments under the auspices of WHO (1987-1991). WHO 1992 Geneva. 12-28.

4. Hauptman PJ, O'Connor KJ. Procurement and allocation of solid organs for transplantation. *N Engl J Med* 1997;336:422-31.

5. Barsoum RS. Ethical problems in dialysis and transplantation: Africa. In: Kjellstrand CM, Dossetor JB, eds. Ethical problems in dialysis and transplantation. Kluwer Academic Publishers, Netherlands. 1992:169-82.

6. Radcliffe-Richards J. Nephrarious goings on: kidney sales and moral arguments. *J Med Philosph*. Netherlands: Kluwer Academic Publishers, 1996;21:375-416.

7. Radcliffe-Richards J. From him that hath not. In: Kjellstrand CM, Dossetor JB, eds. Ethical problems in dialysis and transplantation. Netherlands: Kluwer Academic Publishers, 1992:53-60.

8. Mani MK. The argument against the unrelated live donor, ibid. 164.

9. Sells RA. The case against buying organs and a futures market in transplants. *Trans Proc* 1992;24:2198-202.

10. Daar AD, Land W, Yahya TM, Schneewind K, Gutmann T, Jakobsen A. Living-donor renal transplantation: evidence-based justification for an ethical option. *Trans Reviews* (in press) 1997.

11. Dossetor JB, Manickavel V. Commercialisation: the buying and selling of kidneys. In: Kjellstrand CM, Dossetor JB, eds. Ethical problems in dialysis and transplantation. Netherlands: Kluwer Academic Publishers, 1992:61-71.

12. Sells RA. Some ethical issues in organ retrieval 1982-1992. *Trans Proc* 1992;24:2401-03.

13. Sheil R. Policy statement from the ethics committee of the Transplantation Society. *Trans Soc Bull* 1995; 3:3.

14. Altshuler JS, Evanisko MJ. *JAMA* 1992;267:2037.

15. Guttmann RD, Guttmann A. Organ transplantation: duty reconsidered. *Trans Proc* 1992;24:2179-80.

• THINKING CRITICALLY ABOUT "THE CASE FOR ALLOWING KIDNEY SALES"

RESPONDING AS A READER

1. What is the current policy in regard to allowing the sale of kidneys by live donors? What circumstances led to the current policy? Do the authors present the rationale for the current policy fairly?

2. Why do you think the authors appeal mostly to readers' reason rather than to their emotions? Find examples of their rational treatment of potentially emotional issues (for instance, their use of the term "live vendors" to refer to those who sell their kidneys). What effect did this treatment have on your response?

3. What is their primary purpose in writing this article? Are they proposing a change in policy, a practical action, or a change of perspective on an issue? What is the effect of their decision to wait until the concluding paragraphs to spell out their counterproposal?

RESPONDING AS A WRITER

1. Since the authors are dealing with a controversial subject, they devote most of the article to addressing the objections readers may have to their proposal to reopen and reconsider the sale of kidneys. Indeed, they set up a point-counterpoint structure in this article, responding to opponents' positions point by point. Choose one point that they address (for example, most vendors are the "exploited poor," vendors don't have a free choice, or vendors are too uneducated to make an informed choice), and analyze the reasoning the authors use to counter this objection. What reasons do they offer for reaching a different conclusion? How satisfactorily do they address the concerns of their opponents?

After you have analyzed their reasoning on this point, write a brief response in which you either agree or disagree with their position on this point.

2. The authors use argument from analogy at several points in the article—for example, "if the rich are free to engage in dangerous sports for pleasure . . . it is difficult to see why the poor . . . should be thought so misguided as to need saving from themselves" (paragraph 10) ; there are "many other activities by which the poor try to earn money, and which we do not forbid" (paragraph 11). How persuasive are these arguments by analogy? Briefly explain your answer.

3. Imagine that you are taking a course in medical ethics and have been required to write a rhetorical précis of this article. Use the instructions found in Chapter 3. •

MAUREEN DOWD

Scarred for Life: Courage Begets Courage

Maureen Dowd (b. 1952) has been a columnist for the *New York Times* op-ed page since 1995. After graduating from Catholic University in 1973 with a degree in English literature, Dowd became an editorial assistant for the *Washington Star* and later a sports columnist, metropolitan reporter, and feature writer. After the *Star*'s demise in 1981, Dowd went to work for *Time* magazine, and from there she joined the *New York Times* in 1983, first as metropolitan reporter and subsequently as Washington bureau correspondent. In addition to writing her widely syndicated columns for the *Times*, Dowd writes regularly for the *New Republic*. In 1999 she won a Pulitzer Prize for distinguished commentary. Well known for her witty political satire, Dowd takes up a different sort of topic in "Scarred for Life," which appeared in the *Milwaukee Journal Sentinel* on June 3, 2003: the dire need for organ donors.

• **FOR YOUR READING LOG**

1. Consider the woodcut that accompanies this article. Based on just this image and the title, what predictions might you make about the topic, tone, and purpose of the article?

2. Have you checked the organ donation box on the back of your drivers' license? Why or why not? •

Jennifer showed me her scar last week. 1

It's the most beautiful scar I've ever seen. A huge stapled gash on her stom- 2
ach, shaped like the Mercedes logo. A red badge of courage.

Jennifer is my niece, a 33-year-old lawyer. She had half her liver taken out 3
Wednesday at a Washington hospital to save the life of her uncle (my brother
Michael), who had gotten hepatitis years ago from a tainted blood transfusion.

The complicated and risky operation for the two, side by side, went from 7:30 4
a.m. until after 10 p.m. Then, when a helicopter arrived with a matching liver for
another patient, the same team of doctors had to start on another emergency six-
hour liver transplant.

The night nurse told Jennifer she was an oddity. "We don't see many live 5
donors," she said. "Not many people are that generous."

Or brave. Jennifer's morphine drip wasn't attached properly the first night 6
after the operation, and no one knew it. She felt pain but didn't want to be a
wimp by complaining too loudly. Instead, she was Reaganesque, cracking jokes
and wondering where the cute doctors were.

THE DALLAS MORNING NEWS

7 She survived the first night after this excruciating operation *au naturel*, like Xena the Warrior Princess. If all goes well, her liver will grow whole again in several weeks, as will Michael's half.

8 Unlike her father, who charged people a nickel to see his appendix scar when he was 10, she let me look for free. As we sat in her room, watching Mariah Carey singing with a bare midriff on the "Today" show, I worried a little about how she would take the disfigurement.

9 She's a fitness fanatic who works as a personal trainer in her spare time. She's single, out in the cruel dating world. And we live in an airbrush culture, where women erase all imperfections, removing frown lines with Botox, wrinkles with lasers and fat with liposuction. I told Jen that scars are sexy: Consider that great love scene in "Lethal Weapon 3" when Mel Gibson and Rene Russo, as police officers, compare scars.

10 Jennifer has every quality of heart, spirit, mind and body a woman could want. She's smart, funny, generous, loyal, principled, great looking and, obviously, adventurous.

11 "Write a column about me," she said, smiling, tubes coming out of every part of her body.

12 I knew what she meant. She didn't want me to write about her guts but to encourage others to have the guts to donate organs. When she came to, she asked for the green ribbon pin that encourages organ donation. Her transplant surgeon, Amy Lu, still on the job after 21 hours in the operating room, removed her pin and gave it to Jennifer.

13 As Neal Conan said on National Public Radio Thursday: "More than 80,000 Americans are on waiting lists for organ donations, and most will never get them. Thousands on those lists die every year. One big reason for the shortage is that families are reluctant to give up their relatives' organs. Even when people filled out a donor card or checked the organ donor box on their driver's license, family members often refuse. The need is so acute and so frustrating that more and more doctors are wondering whether financial incentives might persuade some families to change their minds and save lives." (Iran has wiped out its kidney-transplant wait by offering rewards.)

14 As the Web site for the New York Organ Donor Network notes: "One donor can save up to eight lives through organ donation and improve dozens of lives through corneal, bone, skin and other tissue transplants. Across the U.S., 17 men, women and children of all races and ethnic backgrounds die every day for lack of a donated organ."

15 I'm one of the scaredy-cats who never checked the organ donation box or filled out the card to become an organ and tissue donor. Some people don't do it because they have irrational fears that doctors will be so eager to harvest their organs that they'll receive subpar care after an accident. I had nutty fears, too, straight out of a Robin Cook medical thriller, that they might come and pluck out my eyes or grab my kidney before I was through with them.

16 On Friday, Michael's birthday, I got the card online, filled it out and stuck it in my wallet. If Jennifer is brave enough to do it alive, how can I be scared of doing it dead?

• THINKING CRITICALLY ABOUT "SCARRED FOR LIFE: COURAGE BEGETS COURAGE"

RESPONDING AS A READER

1. In paragraph 12, Dowd says, "She didn't want me to write about her guts but to encourage others to have the guts to donate organs." Yet Dowd decides to focus on her niece's courage as a way to accomplish the latter goal. What's the effect of this choice? How does it serve the purpose of encouraging others to donate their organs?

2. How would you characterize the function of paragraphs 13 and 14 in relation to the rest of the essay? How effective is Dowd in giving this problem presence?

3. What's the effect of the last two paragraphs? What persuasive techniques does Dowd use in these paragraphs to encourage readers to fill out a donor card or check the organ donor box on their drivers' license?

RESPONDING AS A WRITER

1. Write a rhetorical précis of Dowd's essay that focuses on her strategy for persuading readers to follow her example. (See Chapter 3 for guidelines.)

2. Imagine that you are a newspaper editor who has been assigned to choose a graphic (other than the woodcut) to accompany this article. Describe the graphic you might choose, and explain your choice.

3. The Greeks called a speech or essay that praises another person's character or actions an *encomium*. What aspects of Dowd's essay make it fit that category? Write a brief *encomium* about a courageous act by someone you know. •

LYNN C. BRYANT (STUDENT)

Literacy and Health Care: Is There a Connection?

Lynn C. Bryant (b. 1950), a second-year nursing major at the University of Wisconsin–Milwaukee, began college in the late 1960s, left to raise a family, and just recently returned after thirty-two years to complete her degree. She plans on becoming an ER nurse. The mother of four grown children, Bryant enjoys running, Harley riding, and her work in historic preservation. Bryant sits on the board of directors for a church on the National Historical Registry in Michigan's Upper Peninsula, where she and her family spend the summer.

● **FOR YOUR READING LOG**

1. How would you define the term *literacy*? Do you think there are wide-spread problems with literacy today? Write a short entry in your reading log in which you answer these questions.
2. What recent interactions have you had with the health care system—either directly or indirectly through relatives or friends? What literacy skills did you need to manage this interaction? ●

═══ ● ═══

1 In recent years there has been growing concern among health care professionals about patients' difficulty in reading and comprehending health care instructions. According to Horner, Surratt, and Juliusson (2000), over half of all patients who enter emergency care facilities read at less than the fifth-grade level, which is the minimal reading level that defines functional literacy. As a future nurse, I find this statistic troubling. In addition, it raises further questions: Does being literate automatically make you literate when it comes to health-related issues? How large a problem is this? What consequences result from patient illiteracy? What is being done to address this problem? In this paper, I investigate these questions in order to understand better the issue of health literacy and ways of addressing it.

2 Although the terms "literacy" and "health literacy" have often been used interchangeably, health care professionals are beginning to consider the latter a special and more demanding kind of literacy. In "Functional Health Literacy in an Urban Primary Care Clinic," Artinian, Lange, Templin, Stallwood, and Hermann (2002) include in their definition of health literacy the ability to read and understand consent forms, directions on a prescription bottle, and even something as basic as a thermometer. Speaking to the scope of the problem, Schwartzberg (2002) reports that the 1992 National Adult Literacy Survey (NALS) found that in addition to the 21% of the U.S. population who are functionally illiterate, another 25% are "marginally" literate, meaning they have trouble with instructions involving words and numbers, an obvious problem when you have a medication with written instructions about how many times per day it is to be taken. While most people associate functional illiteracy with the poor, the 1992 survey indicates that the functionally illiterate come from every socio-economic class. Moreover, Pirisi (2000, November 25) emphasizes that health care professionals need to be aware that the ability to read does not necessarily indicate an understanding of health care information. A researcher told Pirisi that "a third of patients with post-secondary education were unable to understand health information" (p. 1828).

3 Another troubling fact revealed by recent studies is the relationship between age and problems with health literacy. Sibbald (2000, October 17), for example, explains that while as many as 47% of patients have trouble reading, this percentage dramatically increases—up to as much as 80%—for those over 65

(p. 1039). Reinforcing this statistic, Kefalides (1999, February 16) notes that the NALS found that two-thirds of the respondents with the poorest reading and comprehension skills were 65 or older. All agree that illiteracy or low literacy skills put people at risk in the health care system, and since elderly people make up the greatest percentage of those in that system, their difficulties with literacy constitute a significant problem.

A number of consequences result from patients' difficulties with health lit- 4
eracy. Today, as opposed to twenty or more years ago, a patient is likely to remain hospitalized for a much shorter length of time and is often expected to follow to the letter instructions for pre-operative preparations. If these pre-operative instructions are not understood and followed, serious complications can occur during surgery. On the other end of a hospital stay, the patient is often released from the hospital with very explicit instructions on how to care for an incision or take necessary medications. Serious or possibly life-threatening situations can occur if a patient who is marginally or functionally illiterate cannot read or comprehend this information. This problem was directly confirmed for me when I spoke with my son Matthew, who is a Milwaukee Firefighter Paramedic. He said that a large percentage of the calls they receive are from patients recently released from the hospital who do not understand what they need to do. For example, when he asked a diabetic patient who called 911 why he hadn't followed the procedures printed out for him, the patient said simply that he did not understand the directions. Many of these people end up being readmitted to the hospital, driving up health care costs.

Health illiteracy contributes to higher health care costs in other ways. For ex- 5
ample, Artinian et al. discovered that "illiterate patients had more anxiety and three times more hospital visits when compared to patients with higher literacy scores" (2002, Introduction, para. 4). Additionally, because people with literacy problems cannot read the educational material that is available to the public, they often do not recognize the need for preventative care or symptoms that point to the need for medical attention (Horner et al., 2000). When diseases that are preventable go untreated until they reach more advanced stages, this, too, drives up health costs.

Health care profession s have begun to address these problems and propose 6
solutions. Horner et al. (20), for example, suggest that patient educational material needs to be in 12 point or larger font with plenty of white space and perhaps illustrations to make it less intimidating and more understandable. They conclude by noting that improved patient educational material alone will not make a difference, but an improved effort on the part of health care providers to communicate orally at the patients' level of understanding is necessary for improved health outcomes.

Kefalides (1999, February 16) notes that it is not always easy to tell when a 7
patient has low literacy skills. He advises those dealing with patients with low literacy skills to be sensitive to the feelings of shame that people with literacy problems often have. He goes on to suggest ways to spot someone who may be illiterate such as handing someone a pamphlet upside down to see if they turn

it right side up, or noticing when a patient asks others to read for him or her or has trouble keeping appointments or following directions for care.

8 Once a health care giver has identified a problem with literacy, the challenge is how then to communicate effectively with that patient. Kefalides (1999, February 16) describes a method called "cued recall," which uses simple pictures or drawings along with clear, simple oral instructions (p. 335). This method has been shown to raise understanding significantly. He notes that no matter what the patient's level of literacy may be, research shows that "simply worded materials offer the best communication" (p. 335). Pirisi's (2000) report also suggests that health care providers need to be pro-active in communicating effectively with their patients. She describes a method developed by researchers at Emory University called "teach back," in which the health care provider asks the patient to demonstrate his or her comprehension or "teach" the information back to the health care provider (p. 1828).

9 This paper clearly indicates a need on the part of health care professionals at every level to be diligent in seeking avenues to make health care more understandable to all people, but to be especially aware of vulnerable populations whose literacy skills may prevent them from obtaining the quality care they deserve. Further, this paper suggests a need to address issues of health literacy in the curricula of future health care workers. Continued efforts to improve communication will save unnecessary emergency calls, hospital visits, and have a positive effect on health care costs. But more broadly, my investigation demonstrates that health literacy should be a concern for all because everyone sooner or later encounters the health care system, and new treatments, shorter hospital stays, and the proliferation of conflicting medical information require higher and higher levels of health literacy for us all.

References

Artinian, N. T., Lange, M. P., Templin, T. N., Stallwood, L. G., & Hermann, C. E. (2002, June). Functional health literacy in an urban primary care clinic. [Electronic version]. *Internet Journal of Advanced Nursing Practice 5*(2), 24–36.

Horner, S., Surratt, D., & Juliusson, S. (2000). Improving readability of patient education materials. *Journal of Community Health Nursing, 17,* 15–23. Retrieved July 2, 2003, from Academic Search Elite database.

Kefalides, P. (1999, February 16). Illiteracy: The silent barrier to health care. *Annals of Internal Medicine, 130,* 333–336. Retrieved July 2, 2003, from Academic Search Elite database.

Pirisi, A. (2000, November 25). Low health literacy prevents equal access to care. *Lancet, 356,* 1828. Retrieved July 2, 2003, from Academic Search Elite database.

Schwartzberg, J. (2002). Low health literacy: What do your patients really understand? *Nursing Economics 20,* 145–147. Retrieved July 2, 2003, from Academic Search Elite database.

Sibbald, B. (2000, October 17). Can your patients understand you? *Canadian Medical Association Journal, 163,* 1039. Retrieved July 2, 2003, from Academic Search Elite database.

• THINKING CRITICALLY ABOUT "LITERACY AND HEALTH: IS THERE A CONNECTION?"

RESPONDING AS A READER

1. How does Bryant go about trying to give presence to this problem? Does she convince you that this is a serious problem? If so, what makes her argument convincing? If not, what might she have done to give the problem more presence?
2. Bryant argues primarily from consequence. Find passages in her essay where she argues from consequence. Can you think of arguments from principle or analogy that might be included in this argument?
3. Do the solutions seem feasible? Can you think of other solutions?

RESPONDING AS A WRITER

1. Imagine that you are a fellow student in a peer response group. Write a response to this essay in which you mention its strengths and offer advice for revision.
2. Based on your own experiences with the heath care system, write a letter to the editor that recommends ways in which health care professionals might communicate better with patients and their families.
3. In addition to the problem of "health literacy," we hear a lot today about the importance of "technological literacy," "media literacy," "financial literacy," and "visual literacy." Choose one of these types of literacy (or another type that you think is important), and do some brainstorming on paper about this topic. Consider what this literacy might entail, why it is important, and where you might go to find out more about it. •

Writing to Propose a Solution

PROPOSING A SOLUTION

Think of a problem that genuinely concerns you and for which you have a solution to propose. Write an essay that proposes this solution to a particular audience. You may wish to write this essay as an editorial for your school or local paper, or you may wish to make your proposal to a school official, political figure, or work supervisor. In planning and writing your proposal, consider the following questions:

- Do you need to convince this audience that the problem is a problem?
- How will you go about introducing this problem?
- What kind of a solution are you proposing: a specific action, policy, or change of outlook that will lead to policy change and/or action?
- How much detail regarding the solution will you need to provide for your intended audience?
- What kind of evidence will you need to provide to persuade your audience of your proposal's feasibility and benefits?

- What kind of arguments or combination of arguments will you use in your justification section?
- What objections might your audience have and how will you address those objections?
- What alternate proposals exist and how will you support your claim that yours is the better solution?

EXAMINING RHETORICAL STRATEGIES

Choose one of the proposal essays in this chapter (or one that your teacher assigns) and analyze the author's rhetorical strategies. In a sense, your essay will evaluate the proposal using the features of effective proposals mentioned in this chapter as your criteria. Is the description of the problem sufficient and does it persuade you as a reader that the problem is compelling? Is the solution presented in adequate detail for the intended audience? What arguments does the writer use to justify his or her proposal, and are these convincing? Does the author ignore or acknowledge fairly competing solutions and possible consequences? Is the author credible? The effectiveness of your essay will depend upon your use of textual evidence to support your evaluative claims.

EXTENDING THE CONVERSATION

Several of the readings in this chapter propose a change in university curriculum. Bryant suggests that nursing students need to be educated about the problems of health illiteracy. Angell and Kassirer recommend, as one of several proposals, that students be taught enough about the scientific method to be critical consumers of the reported results of clinical research. Other articles indirectly suggest solutions that might be addressed through changes in the college curriculum. For example, Weston, although his article is not directed at educators, suggests that we all need to learn to relate to the natural world in new ways. Similarly, Proscio's recommendations about jargon might inform a course in professional writing.

Think of a curricular change that you believe is needed on your campus. You may use one of the articles in this chapter as a starting point, or you may wish to come up with your own curricular proposal. To write your proposal, you will need to conduct some research. That research may involve examining the undergraduate catalogue for particular kinds of courses, reviewing syllabi online, interviewing faculty, administrators, or fellow students, and tracking down other articles about the issue.

Seeking Common Ground

I t may be that uncertainty, disagreement, and outright conflict are in-
escapable aspects of human life. But must these difficulties lead to incivil-
ity and violence? The authors of the texts presented in this chapter would
say "no."

Most of the essays and articles throughout this book have the explicit pur-
pose of demonstrating that one particular way of looking at things is better
than another. The authors contend—sometimes explicitly, sometimes implic-
itly—that their way of thinking about their subject is better informed, is more
likely to have good results, or is even morally superior to other views of the mat-
ter. Readers expect such clarity and advocacy. The fabric of democratic dis-
course is woven with challenges to and defenses of commonly accepted views
and status quo policies. Through the exchange, people figure out what they
think, why, and what course of action to take. Assertive, even contentious, de-
bate is not only common, but expected. The same is true of academic research
and writing. From applied sciences to the humanities and arts, the work of
scholars is to challenge accepted understandings of phenomena—to build new
knowledge by questioning, enlarging, and reconstructing what's been under-
stood so far.

But can these competing attempts to change listeners' and readers' minds
go too far? Does the noise and rancor of public debate sometimes make it diffi-
cult for productive discussion and decision making to proceed? In recent years,
a growing number of people have answered "yes" to such questions and have

sought ways to "lower the decibel level" of public controversies. Deborah Tannen, author of the first selection in this chapter, urges readers to distinguish between "having an argument" (often an unpleasant experience) and "making an argument" (a potentially productive effort). In tune with her pleas, "civility" and "common ground" have become watchwords in the media; some members of Congress have even attended civility workshops. Schoolchildren learn conflict resolution skills, and people on opposing sides of the abortion rights issue have joined forces to work toward their shared goals of fewer teen pregnancies and more adoptions.

Can such efforts at establishing common ground flourish in a world seemingly filled with racial, ethnic, and religious rivalries, even hatreds? The authors in this chapter explore possibilities for debates that are more civil, relationships that are less rancorous. They consider whether and how even intractable moral issues and ethnic conflicts can be, if not resolved, at least tamed into reasonable conversations. Their levels of optimism vary.

Even though several centuries of rhetoricians and teachers have analyzed the structure and components of arguments, we do not have a specific outline of a "rhetoric of common ground" to draw on as an analytical method. However, a template for rhetorical reading of opposing arguments is suggested by the basic guidelines for conflict resolution that educator Aida Michlowski lays out in her article in this chapter about peaceable classrooms. Analysis that looks for common ground might involve (1) determining the central question at issue, (2) understanding what type of conflict this is (e.g., values, interpretation, or other *stasis* categories) and what is at stake (e.g., money, prestige, freedom, quality of life, or life itself), and (3) detecting possible points of agreement between the competing positions.

In another selection, Sidney Callahan suggests how participants in a controversy might go about creating texts in which a writer extends a hand toward opposing views instead of pounding the table to assert his or her own particular view. Callahan describes four specific tactics for discussing—and arguing about—deeply felt and difficult issues within a family. Her points about civility and respect dovetail with the principles of what has come to be known as "Rogerian argument," which is based on principles of careful listening and empathy that were developed by the psychologist Carl Rogers. The key element of this approach is reducing threat. Instead of focusing on what's wrong with an opposing position (an inherently threatening move), the writer who follows Rogerian principles will emphasize points of agreement between the positions and work to convey understanding and respect for opposing views, even though, in the end, the writer holds a different position. Rogerian arguments feature careful restatement of an opponent's position, suggestion of broad areas of agreement between opposed positions, and delayed statements of the author's own claim or thesis. Advocates of this approach to communication emphasize that an effective restatement of the opposition's claims is meant to convey understanding, not compromise.

Analogies to this written process of exchange are evident in the speaking and listening work that takes place in conflict resolution or mediation groups.

QUESTIONS TO HELP YOU READ RHETORICALLY ABOUT COMMON GROUND

In the selections that follow, pay particular attention to the way writers describe and use techniques for moving readers beyond polarized positions. The questions below will help guide your analysis. Some are similar to those you would use to analyze any text. Others focus on the specifics of moving readers to common ground.

1. What has caused the conflict among the people or groups involved in the issue at hand? For example, do they have different, perhaps competing, goals and incompatible values? Are they competing for the same limited resources?
2. What type(s) of disagreement does the author of the given text identify as the chief impediment to agreement between the parties in the controversy? What kind of question is at issue? (See Table 12.1, pp. 366–367.) What differences are there in the ways the people involved in the dispute define the question that is at issue?
3. What is the writer's central claim or proposal, and how is it developed in terms of evidence, reasoning, and assumptions?
4. What possibility of common ground is evident in the text?
5. What does the writer apparently presume about the intended audience's attitude toward and engagement with the subject?
6. What specific efforts to "lower the decibel level" and "reduce threat" can you identify in the text? If you are working with an explicit argument, examine carefully the treatment of opposing views and try to identify specific places where the writer is using Callahan's "rules" or Rogerian principles of "listening" and reducing threat.
7. How do you imagine various parties involved in the controversy would respond to (a) the way their positions are depicted in the text and (b) the points the author is advocating?
8. If the text has changed your mind, try to identify the specific content point or rhetorical strategy that brought about that change. How extensive has that change been? If your thinking hasn't changed, what else could the writer have done to earn your agreement?

For example, in the model for participation in the Common Ground Network for Life and Choice (whose activities are described in Faye Ginsburg's article in this chapter), individual members take turns explaining their positions and the rationale behind them *without trying to convince anyone else.* Then they listen while someone with an opposing view "says back" what was heard. Only when the first person is satisfied that the restatement accurately reflects his or her views does the group move on to the next person. Crucial to this process is

participants' recognition that listening to and restating unfamiliar (even distasteful) ideas does not obligate one to adopt those ideas.

The selections in this chapter offer new ways of approaching controversies and conflicts. These texts describe, recommend, and demonstrate what it is like to seek common ground. In the end, their primary goal is to reduce tension and create understanding—between opposed political and moral views and between cultural differences. As you read, consider the ways in which deepening someone's understanding of an idea is a form of changing that person's mind.

DEBORAH TANNEN

The Triumph of the Yell

Deborah Tannen (b. 1945), a linguistics professor at Georgetown University, has published many academic articles and books as well as short stories and poems. She became known to the general public with the 1990 publication of the best seller, *You Just Don't Understand: Women and Men in Conversation*, which examines gender differences in conversational style. She has also written dozens of articles for general circulation periodicals. This opinion essay was published in the *New York Times* in January 1994, and its points became the core of her 1998 book, *The Argument Culture*. More recent books include *Talking from 9 to 5: Women and Men at Work* (2001), *I Only Say This Because I Love You* (2002), about family discourse among adults, and the scholarly work, *Handbook of Discourse Analysis* (coeditor, 2001). She once told an interviewer that she sees as one of her missions "the presentation of linguistic research to a general audience—as a means of understanding human communication and improving it."

● **FOR YOUR READING LOG**

1. Where have you observed a public, staged debate—that is, a situation in which two people known to have opposed views were invited to present them? What did you enjoy about it? What did you find uncomfortable?
2. Tannen makes a distinction between "making an argument" and "having an argument." Without having read the article, what's your sense of the difference between these two concepts? ●

═══ ● ═══

1 I put the question to a journalist who had written a vitriolic attack on a leading feminist researcher: "Why do you need to make others wrong for you to be right?" Her response: "It's an argument!"

That's a problem. More and more these days, journalists, politicians and academics treat public discourse as an argument—not in the sense of making an argument, but in the sense of having one, of having a fight.

When people have arguments in private life, they're not trying to understand what the other person is saying. They're listening for weaknesses in logic to leap on, points they can distort to make the other look bad. We all do this when we're angry, but is it the best model for public intellectual interchange? This breakdown of the boundary between public and private is contributing to what I have come to think of as a culture of critique.

Fights have winners and losers. If you're fighting to win, the temptation is great to deny facts that support your opponent's views and present only those facts that support your own.

At worst, there's a temptation to lie. We accept this style of arguing because we believe we can tell when someone is lying. But we can't. Paul Ekman, a psychologist at the University of California at San Francisco, has found that even when people are very sure they can tell whether or not someone is dissembling, their judgements are as likely as not to be wrong.

If public disclosure is a fight, every issue must have two sides—no more, no less. And it's crucial to show "the other side," even if one has to scour the margins of science or the fringes of lunacy to find it.

The culture of critique is based on the belief that opposition leads to truth: when both sides argue, the truth will emerge. And because people are presumed to enjoy watching a fight, the most extreme views are presented, since they make the best show. But it is a myth that opposition leads to truth when truth does not reside on one side or the other but is rather a crystal of many sides. Truth is more likely to be found in the complex middle than in the simplified extremes, but the spectacles that result when extremes clash are thought to get higher ratings or larger readership.

Because the culture of critique encourages people to attack and often misrepresent others, those others must waste their creativity and time correcting the misrepresentations and defending themselves. Serious scholars have had to spend years of their lives writing books proving that the Holocaust happened, because a few fanatics who claim it didn't have been given a public forum. Those who provide the platform know that what these people say is, simply put, not true, but rationalize the dissemination of lies as showing "the other side." The determination to find another side can spread disinformation rather than lead to truth.

The culture of critique has given rise to the journalistic practice of confronting prominent people with criticism couched as others' views. Meanwhile, the interviewer has planted an accusation in readers' or viewers' minds. The theory seems to be that when provoked, people are spurred to eloquence and self-revelation. Perhaps some are. But others are unable to say what they know because they are hurt, and begin to sputter when their sense of fairness is outraged. In those cases, opposition is not the path to truth.

When people in power know that what they say will be scrutinized for weaknesses and probably distorted, they become more guarded. As an

acquaintance recently explained about himself, public figures who once gave long, free-wheeling press conferences now limit themselves to reading brief statements. When less information gets communicated, opposition does not lead to truth.

11 Opposition also limits information when only those who are adept at verbal sparring take part in public discourse, and those who cannot handle it, or do not like it, decline to participate. This winnowing process is evident in graduate schools, where many talented students drop out because what they expected to be a community of intellectual inquiry turned out to be a ritual game of attack and counterattack.

12 One such casualty graduated from a small liberal arts college, where she "luxuriated in the endless discussions." At the urging of her professors, she decided to make academia her profession. But she changed her mind after a year in an art history program at a major university. She felt she had fallen into a "den of wolves." "I wasn't cut out for academia," she concluded. But does academia have to be so combative that it cuts people like her out?

13 In many university classrooms, "critical thinking" means reading someone's life work, then ripping it to shreds. Though critique is surely one form of critical thinking, so are integrating ideas from disparate fields and examining the context out of which they grew. Opposition does not lead to truth when we ask only "What's wrong with this argument?" and never "What can we use from this in building a new theory, and a new understanding?"

14 Several years ago I was on a television talk show with a representative of the men's movement. I didn't foresee any problem, since there is nothing in my work that is anti-male. But in the room where guests gather before the show I found a man wearing a shirt and tie and a floor-length skirt, with waist-length red hair. He politely introduced himself and told me he liked my book. Then he added: "When I get out there, I'm going to attack you. But don't take it personally. That's why they invite me on, so that's what I'm going to do."

15 When the show began, I spoke only a sentence or two before this man nearly jumped out of his chair, threw his arms before him in gestures of anger and began shrieking—first attacking me, but soon moving on to rail against women. The most disturbing thing about his hysterical ranting was what it sparked in the studio audience: they too became vicious, attacking not me (I hadn't had a chance to say anything) and not him (who wants to tangle with someone who will scream at you?) but the other guests: unsuspecting women who had agreed to come on the show to talk about their problems communicating with their spouses.

16 This is the most dangerous aspect of modeling intellectual interchange as a fight: it contributes to an atmosphere of animosity that spreads like a fever. In a society where people express their anger by shooting, the result of demonizing those with whom we disagree can be truly demonic.

17 I am not suggesting that journalists stop asking tough questions necessary to get at the facts, even if those questions may appear challenging. And of course it is the responsibility of the media to represent serious opposition when it ex-

ists, and of intellectuals everywhere to explore potential weaknesses in others' arguments. But when opposition becomes the overwhelming avenue of inquiry, when the lust for opposition exalts extreme views and obscures complexity, when our eagerness to find weaknesses blinds us to strengths, when the atmosphere of animosity precludes respect and poisons our relations with one another, then the culture of critique is stifling us. If we could move beyond it, we would move closer to the truth.

• THINKING CRITICALLY ABOUT "THE TRIUMPH OF THE YELL"

RESPONDING AS A READER

1. How extensive is Tannen's central claim here? When she takes issue with the belief that opposition leads to truth, is she at odds with those who say vigorous dissent is essential for democracy to thrive? What textual evidence supports your view?
2. What type of argument particularly bothers Tannen? Is she more concerned with *how* an argument is conducted or with *what* it is about?
3. How do you respond to Tannen's own argument? What is compelling about it for you? Where do you resist it? Why?

RESPONDING AS A WRITER

1. How would you explain where Tannen draws the line between productive and nonproductive exchanges in a controversy?
2. How does Tannen draw her readers to her point of view? Examine her text closely to trace its development in relationship to the way it engages readers.
3. Consider an instance of the "culture of critique" that you have witnessed recently—in person, through broadcast media, or in print, either on paper or on the Web. If the person you most sympathized with in the dispute requested your advice about achieving a more productive exchange by applying Tannen's ideas, what advice would you give? •

Calvin and Hobbes:
"Conflict Is . . . Marketable"

When Bill Watterson (b. 1958?) retired on January 1, 1996, *Editor & Publisher* reported that the disappearance of the *Calvin and Hobbes* comic strip left a hole in nearly 2,400 newspapers around the world. The strip, which began syndication in November 1985, was much loved by readers of all ages for its commentary on family life and popular culture—and for Calvin's wild space adventures. At the time of Watterson's retirement, his several collections of strips were said to have sold more than 23 million copies. Watterson, reported to be something of a recluse, was much praised for his creative genius and his integrity—he refused all licensing offers, never allowing manufacture of stuffed Hobbes tigers, for instance, or any other potentially lucrative spin-offs. If you are new to the strip, here's some background. Calvin, named after the 16th-century theologian, John Calvin, is a precocious, possibly hyperactive, six-year-old whose main occupation is following his own inclinations; Hobbes, named after the 17th-century philosopher, Thomas Hobbes, is his stuffed tiger, who comes to life only when Calvin is around. This Sunday panel ran on November 26, 1995.

● FOR YOUR READING LOG

1. If you remember reading *Calvin and Hobbes* in newspapers, or if you have read one or more of Watterson's collections, take a few minutes to freewrite what you recall about the strip and how you responded to it.
2. What's your favorite newspaper comic strip these days, the one you check out first? What is it that you like about it? If you indulge in comic strip reading somewhere besides the daily paper, including the Web, talk about your favorite there. If you don't read the comics, jot notes about why you don't. ●

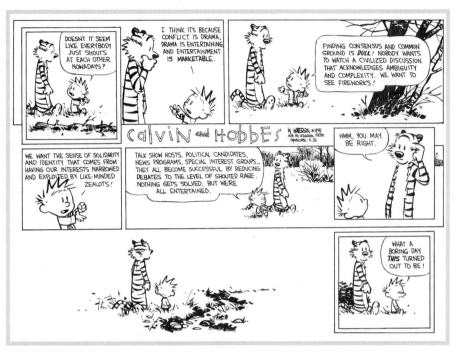

THINKING CRITICALLY ABOUT *CALVIN AND HOBBES*

RESPONDING AS A READER

1. Did you find this strip funny? What made it so for you? It's been said that the heart of comedy is an encounter with the unexpected. How does the idea of encountering something unexpected connect with your experience reading this?

2. What's the basic outline of the argument that Watterson is making here? How is it different from the argument that Calvin is making? How do the last two frames function in relation to the overall point?

3. How do you "read" Hobbes's nonverbal reactions to Calvin's comments? What role do these visual representations play in Calvin/Watterson's argument here?

RESPONDING AS A WRITER

1. Make a brief outline of the chain of reasoning in Calvin's points. If these points were gathered verbatim into a paragraph, perhaps for a letter to the editor, how would it sound? Do you think it would be accepted for publication? What might need to be added? From your thinking about

this, come up with some generalizations about how the verbal element of texts such as this comic strip panel do and do not differ from ordinary linear texts.

2. You probably don't know many six-year-olds who use words such as "ambiguity" and "complexity," much less complain about their absence from public discourse. What's the effect of having these points be made by a young child? If you were going to write a letter to the editor or other opinion piece making similar points—or taking issue with them, for that matter—what persona would you want to establish for yourself? How could you do that in limited space?

3. The issue that concerns Calvin has intensified since this strip was published. Many media critics decry the advertiser-driven competition for "eyeballs" that seems to drive news programs and publications as much as it does entertainment shows and popular magazines. What current examples fit with Watterson/Calvin's point(s)? Where do you see evidence of efforts to change or resist the "norm" that conflict is marketable? ●

SIDNEY CALLAHAN

Fight Fierce but Fair: And Practice at Home

Sidney Callahan (b. 1933), a retired professor of psychology, is a popular lecturer and widely published author, writing frequent commentaries for the *National Catholic Reporter* and *Commonweal*. Her most recent book is *Women Who Hear Voices: The Challenge of Religious Experience* (2003). She and her husband Daniel, both Roman Catholic ethicists, have frequently spoken and written about their opposing views on bioethical issues. They published *Abortion: Understanding Differences* in 1984. The essay we present here explains how they keep peace within the family despite their disagreements. It was published in February 1994 in *Commonweal*, a biweekly edited by Catholic laypeople, which, according to its Website, focuses on "topical issues of the day" and "the links between 'worldly' concerns and religious beliefs."

● **FOR YOUR READING LOG**

1. "Good family fights prepare you for the larger world of democratic conflict," Callahan begins. Do you agree? Before you read the essay, reflect in writing about how your family handles disagreements about public issues. How do you manage to keep peace?

2. Given only the background information above, the essay title, and its first sentence, what do you feel you already know about the personal *ethos* Callahan brings to this text? As you read, pay attention to details that reinforce or alter your initial impressions. •

———— • ————

Good family fights prepare you for the larger world of democratic conflict. If you learn to fight well and fairly at home, you can contribute to the civic struggle necessary to keep a pluralistic society moving. I'm constantly advocating my causes in public debate, but during family holidays I'm kept in fighting trim by late-night arguments with my adult children.

Home debating seems natural to me because I constantly argued with my strong-minded father, who came from a good Southern prejudiced stock (lapsed Calvinist division). He refused to reform his racist, militaristic, atheistic, anti-intellectual views quickly enough for me. But as I married young (forty years this June so I was a bride of nine), my basic combat training and maneuvering skills in argument have come from frequent marital, martial engagements.

It's no secret that my husband Dan and I have had private and public disagreements on religious and ethical issues, as for instance over abortion. Dan takes a moderate prochoice position and I am more militantly prolife. At least we've produced a book and a few articles detailing those internal conflicts.

A magazine reporter once called to ask me how we could continue to stay married since we disagreed so vigorously over abortion. I replied that after so many decades we had so many deep and serious conflicts between us that we hardly noticed the abortion disagreement at all! When the young interviewer (unmarried) didn't laugh, I quickly explained that this was my attempt at a joke, as in irony. You know, like the comment of the obese Herman Kahn, who once said, "Inside this fat man there lives another fat man."

Thankfully, and not hopefully, Dan thinks these kinds of sallies are funny, and makes plenty himself. Obviously this marriage can be saved. A shared sense of humor is the best bonding agent or glue I know of to keep friends, spouses, and adult children sticking around.

Disagreements abound but agreement abounds more. Dan and I, and my children, friends, and relations agree about more things than we disagree. One of the most critical agreements that Dan and I share is our joint commitment to the Callahan guidelines for conducting civilized debate. If we could convince the larger world of these rules (painfully acquired from experience in public debates on abortion), we could make a great contribution to cleaning up our polluted public discourse.

Rule Number 1: Be obsessively civil, courteous, and charitable in your use of language. Words never are "mere words" (as Catharine A. MacKinnon, the prominent feminist theorist, has written). But those who regularly use words (including prominent feminists) should take care to be absolutely accurate in their facts and remain calm enough to argue sans hyperbolic thrusts issued with nasty

sneers of contempt. (A list of all the known offenders against this rule would take up all the space of charity.)

8 Rule Number 2 follows from number one: Always show respect for your opponents and assume their good will and sincerity (even if you might harbor a wee doubt or two in your heart). Address what your opponents say not what you infallibly detect to be their hidden agenda or underlying motives. After all, only the Shadow knows what evil lurks in the heart of men and women, so take the magnanimous high road, even if it doesn't heap coals of fire on your opponent's head, à la Saint Paul.

9 Rule Number 3 may sometimes conflict with the personnel available for debate: Try to argue against the best representative of your opposition, and not against a strawperson, or the other side's most repellent fanatic extremist— that's too easy, and "unsportspersonlike behavior unbefitting a gentleperson."

10 When attacked by an incoherent ranter, veritably foaming at the mouth, or when confronted by a cowed novice too inept to give his or her side's best arguments, present them yourself. If you can't state the opposing side's arguments better than they can, and then show why the position is unsatisfactory, you haven't done your homework. Why should serious differences be decided by which side has the most crazies roaming around its fringes?

11 Rule Number 4 demands the most intellectual integrity and honesty: Admit the price of following your own position. Every side in a serious disagreement has some weaknesses, otherwise all reasonable and intelligent persons of good will would agree already. Unfortunately, it's easy to see the looming drawbacks of your opponents' arguments but difficult to admit that your own solution includes risks and difficulties. A truly unflinching mind can confront a choice between lesser evils and say, "Yes, I am willing to say no to this or that demand, even at the price of legal coercion." Or in another kind of argument, "No, I don't think it wrong to let people abuse their freedom and make mistakes."

12 Americans are all too human. We hate to face dilemmas or scenarios which don't have happy endings. We want everything at the same time, even if the demands are logically contradictory. Perhaps more than anything else, we hate sustained argument and hard-focused thinking.

13 But the right sort of family training can produce people able to persevere in arguments and willing to confront, to persuade, to win through to a higher ground or a better consensus. As the British officer instructed his troops, "One, two, three, and repeat your fire—without rancor."

14 Friendly firefights or the learned ability to listen and "respectfully disagree," take practice. You must fully understand that those who disagree with you and have different positions in politics, sex, religion, or whatever, are not despicable people. (Or if they are despicable, it's not because of their dreadful opinions.)

15 We can resolve to play by the rules of civil and charitable debate. Who knows? By attentive, polite listening to all sides of conflicted encounters in and out of the family, you can learn new things. Your father sometimes did know best, your spouse has had a well-taken point or two, and even your adult children may be onto something you need to know. Let's keep the home fires burning for the greater good of the body politic. Or for the commonweal?

● THINKING CRITICALLY ABOUT "FIGHT FIERCE BUT FAIR"

RESPONDING AS A READER

1. How were your initial impressions of Callahan's *ethos* confirmed or altered as you read? Choose a few specific details that you found particularly effective in the way she conveyed this ethos, then compare your responses to those of your classmates.

2. What underlying question drives this essay? How would you describe the reasoning Callahan uses to respond to it? When you examine her claims, reasons, evidence, and assumptions, what aspects of her argument do you find most and least compelling?

3. In paragraph 12, Callahan suggests that her assertions about the value of debate are countercultural. Do you agree or disagree that "more than anything else, we [Americans] hate sustained argument and hard-focused thinking?" What role does this point play in your response to her larger argument?

RESPONDING AS A WRITER

1. Callahan says here that despite the well-known disagreements she and her husband have about abortion and other ethical issues, "agreement abounds more" in their life together. Her primary elaboration of this is, of course, the four Callahan rules. What explicit values and implicit assumptions do you find in her presentation of these rules? Use the two-column analysis technique presented in Chapter 4 to scrutinize the paragraphs where she explains these rules, then write a short paragraph summarizing what you discover.

2. When you reflect upon intense discussions about public issues that you've had with people close to you (whether literally family members or not), which of Callahan's rules strikes you as the most difficult to apply? Why? Would the same difficulties apply when you write for an audience less familiar to you?

3. Composing a written argument to be read by a teacher, fellow students, and/or strangers in the general public is, of course, quite different from the live give-and-take of a family debate about hot topical issues. How, in your view, do the Callahan guidelines translate effectively as guidelines for writing effective arguments? ●

AIDA A. MICHLOWSKI

From Conflict to Congruence

Aida A. Michlowski (b. 1944) is a professor of education at Marian College in Fond du Lac, Wisconsin, where she teaches courses in education and law. A licensed attorney, she has practiced law as a mediator and a guardian ad litem (child advocate) and has given numerous presentations locally and nationally on conflict resolution, negotiation, mediation, and team building. This overview of techniques for fostering a "peaceable classroom" was the lead article in a special issue on conflict resolution of the *Kappa Delta Pi Record* (Spring 1999). The refereed journal is published by Kappa Delta Pi, an international honor society dedicated to scholarship and excellence in education. The conventions used by the journal for citations follow the *Chicago Manual of Style* author-date system.

● **FOR YOUR READING LOG**

1. This scholarly article uses headings and other typographical conventions to mark sections and highlight terms being defined. Give yourself two minutes to scan the text, taking advantage of these textual clues and spot reading as appropriate, then jot down what you've learned about its purpose and content.
2. Now personalize this preview by reflecting in writing for a few minutes about any experiences you or a member of your family has had with peace education or peer mediation. If you don't have experience related to such programs, write instead about conflicts you or someone close to you has experienced or witnessed in a school setting. Then, given this background, articulate a personal purpose for reading this article. What questions specifically relevant to your experience might it answer? ●

——— ● ———

1 Conflict resolution has found its way from the courtroom to the classroom, from kindergarten to college. Since the founding of the National Association for Mediation in Education in 1984, school-based conflict-resolution programs have increased from fifty to more than 5,000 in the United States (National Institute for Dispute Resolution 1994). As it continues to grow in acceptance, conflict resolution may yet become "the fourth R" in basic education.

2 Conflict is a natural occurrence that can happen when two or more individuals interact. In schools, the interests of students versus students and students versus teachers are at times congruent and at other times in conflict. Congruence means balance, harmony, and conformity. To transform conflict into congruence, teachers and students must understand the nature of conflict, what causes it, and how to manage it creatively and constructively.

Conflict is variously defined as a difference of unwavering opinions, a collision of mutually exclusive interests, a battle of potent wills, and a clashing of incompatible personalities. Maurer (1991, 2) has noted that "conflict is not a state of being, but, rather an active process, which over time takes on various dimensions and dynamics." Whether it becomes destructive or constructive depends on how conflict is managed (Deutsch 1973). Ignored or suppressed, or if confronted with aggression and anger, conflict becomes destructive. Managed positively, conflict becomes a constructive experience resulting in a win-win situation. When schools foster a positive climate, conflicts become opportunities for growth (Johnson and Johnson 1995).

The three major types of conflicts are (1) conflict of goals—when students have incompatible ideas or opinions, but only one can be realized; (2) conflict of needs—when students want different things, but only one can be met; and (3) conflict over resources—when students want the same thing, but only one can have it. These clashes may escalate or de-escalate depending on the classroom climate. A classroom with a highly competitive and intolerant atmosphere and/or an authoritarian teacher tends to foster an "I win; you lose" disposition instead of an "I win; you win" attitude. Implementing conflict-resolution programs, however, enables teachers to change the classroom climate into a culture of caring and congruence.

Methods of Resolution

The peaceful resolution of conflict follows a logical scheme. It begins with disputing individuals attempting to find a solution through negotiation. When negotiation fails, neutral third parties become involved in mediation and, if necessary, arbitration.

Negotiation advocates conflict resolution through partnership that improves and sustains the relationship between two individuals (Weeks 1992). It becomes desirable when there is a balance of power and both parties' needs can be met (Fisher and Ury 1991). Negotiation is a bilateral process with two disputants trying to work out an agreement or a settlement without the intervention of a third party. It begins with negotiators stating their positions and describing their goals, needs, and wants. Negotiators then generate options and search for common ground. If negotiation is successful, it ends with a mutually beneficial solution. If the negotiators fail to resolve their conflict, the next alternative is peer mediation.

Peer mediation adheres to the principles of caring confrontation, using a neutral third party to assist the disputants in reaching a win-win agreement. It focuses on the solution of the immediate problem and the preservation of the relationship (Schmidt 1994). It also directs participants to use prosocial behaviors and positive communication skills.

Peer mediation involves at least three people—the two parties in conflict and a third, neutral person who acts as mediator. It is a voluntary process that follows certain protocols. First, the mediator opens the session with an introductory statement and sets the ground rules: no interruptions, no physical or verbal abuse,

and no lying. Second, the complainant presents his or her case, defines the conflict, states what happened, and expresses his or her feelings in a nonblaming manner. Third, the respondent presents his or her side of the issue, states what happened, and expresses his or her feelings in a nondefensive manner. Fourth, the mediator restates and summarizes the information. He or she may ask questions for clarification. Fifth, the mediator asks the disputants to propose a win-win solution, taking care not to offer advice or criticism. Sixth, if and when an agreement is reached, the mediator writes the agreement in the form of a contract and both disputants sign it. If the disputants cannot agree, then the mediation reaches an impasse, at which point the mediator ends the session and advises the disputants either to try the mediation process again or pursue another form of conflict resolution such as arbitration.

9 *Arbitration* is considered the conflict resolution of last resort, because it is employed only after the disputants have tried negotiation and mediation without success. It involves the intervention of a disinterested third party, such as a teacher, a guidance counselor, or the principal. Voluntary arbitration occurs when students ask an adult to intervene. Compulsory arbitration occurs when students are unable to resolve their conflict through negotiation and mediation. The arbitrator, acting as "judge and jury," hears both sides and makes a final judgment. The disputants must abide by the arbitrator's decision.

Objectives and Outcomes

10 Data on conflict-resolution programs is limited (Lam 1989). The few studies that have been conducted, though, have turned up some interesting revelations. Among the findings:

- Objective: Make students and teachers aware of alternative ways to handle conflict, such as cooperation and affirmation, and improve communication and problem-solving skills. Outcome: Ten out of ten possible teachers developed an understanding of constructive conflict, and forty-five out of fifty students used conflict-resolution strategies (Korn 1994). In addition, third-grade students became aware of their options and learned how to communicate more effectively (Moreau 1994).
- Objective: Teach students to handle interpersonal conflicts in positive, nonviolent ways and replace antisocial behaviors (blaming, bossing, tattling, and pushing) with prosocial behaviors (listening and talking). Outcome: Conflict time declined and prosocial skills usage increased when conflict-resolution strategies were taught to twenty second- and third-grade students (Bastianello 1989).
- Objective: Offer alternative disciplinary measures, increase attendance, improve academic performance, and avoid suspensions and expulsions. Outcome: Discipline referrals for antisocial behaviors decreased and students got along with their peers and felt good about school (Satchel 1992).

- Objective: Encourage students to transfer their knowledge and skills of conflict prevention and resolution to their family and community. Outcome: Kindergartners applied newly acquired problem-solving skills at home (DeMasters and King 1994).

Curriculum Approaches

The two major approaches to establishing conflict-resolution programs in schools 11 are the "cadre approach" and the "total student body approach" (Johnson and Johnson 1995). The cadre approach trains a small group of students and teachers. The total student body approach teaches all students and staff. Conflict-resolution programs often exist as stand-alone modules. Examples include classroom discipline, peace education, multicultural perspective, and just community.

Classroom discipline is the most common form of conflict resolution. As 12 disciplinarians, though, teachers respond to classroom confrontations in different ways. Among the personal styles: "No-nonsense" firmly enforces class rules. "Smoothing" maintains the status quo. "Ignoring" lets the conflict fizzle out. "Problem solving" assumes that conflicts always equal problems that must be solved. "Compromising" encourages listening and settling for smaller victories (Kriedler 1984).

Peace education proposes that conflict resolution is best taught in the context of 13 a caring community. Nonviolent alternatives to dispute resolution and a new generation of peacemakers are at the core of peace education (Crawford and Bodine 1996; Hinitz and Stomfay-Stitz 1996). Two distinct yet similar delivery systems exist: The Peaceable Classroom focuses on social responsibility, a sense of unity, and a spirit of cooperation. The Peaceable School is a comprehensive program extending from personal peace to global peace (Bodine, Crawford, and Schrumpf 1994).

Multicultural perspective seeks to minimize conflict by teaching team build- 14 ing, consensus, self-expression, tolerance, and acceptance. The purpose is not to eliminate cultural differences but to use them in positive and productive ways (Educators for Social Responsibility 1991).

Just community is not usually viewed as part of a conflict-resolution program; 15 however, it can help prevent conflict when implemented in schools. Based on the concept of moral development, just community recommends teaching moral content such as kindness, truthfulness, and fairness (Power, Higgins, and Kohlberg 1989). In addition to teacher-led peer dialogues about hypothetical moral dilemmas, the entire school practices a democratic way of life wherein students have significant input in establishing policies.

Teaching Strategies

Teaching conflict resolution must be developmental and sequential. The type of 16 strategy used will depend on a variety of factors, including grade level, issues causing the conflict, student and teacher training, and available resources (Sprick 1995). Among the techniques that educators have found effective:

- Role playing exploits drama as a teaching tool (Pipkin and DiMenna 1989). First, the teacher describes the conflict scenario and sets the background that simulates real-life situations. Second, the teacher assigns the roles to the participants. Third, the students act out their roles. They are free to improvise as long as they stay in character. The teacher remains in the background, stepping in only to ask leading questions if the players become stuck or get lost in tangents. Finally, at a critical point of conflict, the teacher freezes the role-play and asks the audience for alternative solutions and possible outcomes. A variation of this exercise constitutes additional role players standing next to the main characters and acting as their alter egos. The alter egos then verbalize what they think the main characters really might mean.
- Storytelling enables children to learn creative ways to resolve their conflicts (Shatles 1992). The teacher tells a story about a contrived situation or retells one from a book. When the story reaches its point of conflict, the teacher stops and asks the class to brainstorm solutions. Suggestions are listed on a board, and a consensus must be reached by choosing the best solution. An extension to this exercise includes students writing and/or illustrating their own endings to popular fairy tales.
- Conflict games are effective attention-getters. "Walk in the Shoes of the Other," for example, helps students understand both sides of a conflict. The game begins with two pairs of cutout footprints on the classroom floor. The disputing students face each other, stand on the footprints, and take turns relating differences, similarities, and ways in which they can become friends.
- Humor uses laughter as pacifier. It is difficult to stay angry while laughing. Although conflict is no laughing matter, learning to deal with it in a positive manner need not be all doom and gloom. The Bluegrass Alley Clowns of Kentucky, for example, teach conflict resolution to children through their clown capers. Members of the troupe use funny skits, jokes, stories, and magic tricks to communicate the message of peace.
- Mnemonics and metaphors are creative ways of teaching conflict resolution. They conform to Gardner's (1993) theory of multiple intelligences and brain-based education (Caine and Caine 1991). These teaching tools use meaningful associations by making the strange familiar and the familiar strange. For example, "The Seven C's of Conflict Resolution" (communication, cooperation, caring, compromise, choice, change, and congruence) can be introduced by applying the jigsaw technique. The teacher divides the class into seven groups, with each group assigned a C word. Members of the first grouping serve as experts, so they must understand their C word well enough to teach it to others. After a period of time, the teacher regroups the class for a second grouping comprised of the seven C words. Experts from the first grouping take turns presenting their C word until everyone in the group understands the seven C's of conflict resolution. To apply the lesson, the teacher guides the class in preparing

a recipe and baking a cake or other treat with seven ingredients starting with the letter C.

Changing conflict into congruence is not always an easy task, but it is a worthwhile endeavor. Conflict-resolution programs should aim to do more than resolve present conflicts among students and reduce violence and destructive behavior; they must also help students learn how to solve problems, make wise decisions, take full responsibility for their actions, and face the consequences of their decisions. 17

Hopefully, students will first try to resolve their conflicts through peaceful negotiation. When they cannot reach an agreement, they must know how to get the help of a peer mediator. When peer mediation fails, they should seek the assistance of an adult through arbitration. If students and teachers are successful in making peace within themselves and with each other, a peaceable classroom in a peaceable school will soon evolve. 18

References

Bastianello, S. 1989. Implementation of a program for teaching conflict resolution strategies in a primary classroom. ERIC ED 315 182.

Bodine, R., D. Crawford, and F. Schrumpf. 1994. *Creating the peaceable school: A comprehensive program for teaching conflict resolution.* Champaign, Ill.: Research Press.

Caine, R. N., and G. Caine. 1991. *Making connections: Teaching and the human brain.* Menlo Park, Calif.: Addison-Wesley.

Crawford, D., and R. Bodine. 1996. Conflict resolution education: A guide to implementing programs in schools, youth-serving organizations, and community and juvenile justice settings program report. Washington, D.C.: Office of Juvenile Justice and Delinquency Prevention. ERIC ED 404 426.

DeMasters, R. H., and E. S. King. 1994. Conflict resolution: Teaching social skills in a kindergarten classroom. ERIC ED 373 905.

Deutsch, M. 1973. *The resolution of conflict: Constructive and destructive processes.* New Haven, Conn.: Yale University Press.

Educators for Social Responsibility. 1991. Dealing with differences: Conflict resolution in our schools. ERIC ED 371 983.

Fisher, R., and W. Ury. 1991. *Getting to yes: Negotiating agreement without giving in.* New York: Houghton-Mifflin.

Gardner, H. 1993. *Multiple intelligences: The theory in practice.* New York: Basic Books.

Hinitz, B. F., and A. Stomfay-Stitz. 1996. Dream of peace, to dare to stay the violence, to do the work of the peacemaker. Paper presented at the Annual Conference of the Association for Childhood Education International, 11-13 April, Minneapolis, Minn. ERIC ED 394 733.

Johnson, D. W., and R. T. Johnson. 1995. *Reducing school violence through conflict resolution.* Alexandria, Va.: Association for Supervision and Curriculum Development.

Korn, J. 1994. Increasing teachers' and students' levels of conflict resolution and peer mediation strategies through teachers and student training programs. ERIC ED 375 944.

Kreidler, W. 1984. *Creative conflict resolution: More than 200 activities for keeping peace in the classroom.* Glenview, Ill.: Scott, Foresman & Co.

Lam, J. A. 1989. *The impact of conflict resolution programs on schools: A review and synthesis of the evidence,* 2d ed. Amherst, Mass.: National Association for Mediation in Education.

Maurer, R. E. 1991. *Managing conflict: Tactics for school administrators.* Boston: Allyn and Bacon.

Moreau, A. S. 1994. Improving social skills of third grade students through conflict resolution training. ERIC ED 375 334.

National Institute for Dispute Resolution. 1994. A survey of schools, dispute resolution programs across the country. *NIDR News* 1(7): 6-9.

Pipkin, W., and S. DiMenna. 1989. Using creative dramatics to teach conflict resolution: Exploiting the drama/conflict dialectic. *Journal of Humanistic Education and Development* 28(2):104-12.

Power, F. C., A. Higgins, and L. Kohlberg. 1989. *Lawrence Kohlberg's approach to moral education.* New York: Columbia University Press.

Satchel, B. 1992. Increasing prosocial behavior of elementary students in grades K–6 through a conflict resolution management program. ERIC ED 347 607.

Schmidt, F. 1994. *Mediation: Getting to win-win!* Miami, Fla.: Peace Education Foundation.

Shatles, D. 1992. Conflict resolution through children's literature. New York: The Teachers Network. ERIC ED 344 976.

Sprick, R. S. 1995. *Stop, think, plan: A school-wide conflict resolution strategy training video.* Eugene, Ore.: Teaching Strategies, Inc.

Weeks, D. 1992. *The eight essential steps to conflict resolution: Preserving relationships at work, at home, and in the community.* New York: Tarcher/Putnam.

• THINKING CRITICALLY ABOUT "FROM CONFLICT TO CONGRUENCE"

RESPONDING AS A READER

1. The reading log assignment asked you to articulate a personal purpose for reading this article. Did the article enable you to satisfy your purposes for reading? How accurate was your initial understanding of the article's purpose? Were you able either to find answers to the question(s) you articulated or to find in the text a reference that might be a better source?

2. On what basis is Michlowski's credibility asserted in this text? How would you describe the *ethos* that she establishes for herself as author? What textual evidence supports your answers?

3. What does Michlowski seem to have assumed to be readers' previous attitude(s) toward and knowledge of her subject matter? What is your assessment of how she intended to change attitudes and understanding? In what ways did she succeed or not in relation to your own attitude and understanding?

RESPONDING AS A WRITER

1. Unlike many scholarly articles in education, this one does not begin with an abstract that previews its contents. What essential points would need to be included in such an abstract? Try your hand at writing a brief summary of the article—fewer than 75 words—that could be used in an annotated bibliography or published above the article as a summarizing preview. (See the discussion on composing a summary in Chapter 3.)

2. Consider a conflict—major or minor—that you have recently had with someone. How do Michlowski's categories for types of conflicts help you understand the sources of conflict in a different way than before? What does her description of resolution methods suggest might have been a better way of resolving it than whatever happened? What might still be a good way of working out the conflict?

3. Now consider an unresolved conflict currently in the news, one about which you can readily find opposing statements from at least two perspectives published during the last week or two. (The brevity of letters to newspaper editors makes them particularly good sources of clearly stated opposing views.) Again try out Michlowski's concepts for analyzing and resolving matters. How applicable are those ideas when you look specifically at textual statements of opposing views? •

FAYE GINSBURG

The Anthropology of Abortion Activism

In this opinion article, Faye Ginsburg (b. 1952) discusses what she learned from her anthropological research on grassroots abortion activism and praises the accomplishments of activists who have worked cooperatively in Common Ground groups. The article appeared in the January 26, 1996, issue of the *Chronicle of Higher Education*, a weekly newspaper that is widely read by college and university administrators, staff, and faculty. Ginsburg is a professor of anthropology at New York University and director of the Graduate Program in Culture and Media there. Her book-length report of this research, *Contested Lives: The Abortion Debate in an American Community* (1998), won numerous awards.

• FOR YOUR READING LOG

1. As you will learn from her article, Ginsburg's findings go against some common views of abortion activism. As part of recalling relevant background knowledge, write in your log about your image of people who are involved in abortion activism on either side. Alternatively, if you yourself have been active regarding this issue, consider the stereotypes

you think others may have of people who side with you or stereotypes that you may have once had about either group.

2. As further preparation for reading, try to imagine what goals "pro-life" and "pro-choice" activists might agree on. What beliefs and assumptions do you think they might share either about public policy issues or about productive ways to handle debate and conflict? •

———— • ————

1 Like many people who are drawn to anthropology, I wanted to conduct research that would debunk common stereotypes about "natives." Unlike my colleagues who departed for distant shores to earn their Ph.D.'s in the early 1980s, I was drawn to the abortion issue in the United States. Why does it excite such profound emotions and political virulence in our society? What motivates activists? What kind of political activity occurs beyond the rhetoric and polarizing demonstrations organized by the leaders of both sides? Perhaps most important, I wanted to see whether activists in both camps could find any new, more-creative ways to deal with each other and the controversy surrounding abortion.

2 I felt that the abortion debate needed the kind of research that anthropologists and other qualitative social scientists undertake: studies that try to understand people as part of a community, getting to know them over time and in context, so that we can see the world from their point of view and comprehend why certain issues become more pressing than others in their lives.

3 Unfortunately, except for a few sociological works, such as James Davison Hunter's *The Culture Wars* and Kristen Luker's *The Politics of Motherhood*, as well as the historian Rickie Solinger's *The Abortionist*, most scholarly and popular writing on abortion seems to rely on stereotypes.

4 Journalists generally have focused on the most-violent aspects of the conflict—the headline-grabbing protests at clinics by Operation Rescue and the murders of two doctors and three clinic workers by activists invoking what they considered to be the "Christian" principle of "justifiable homicide." And surveys and statistical research have relied on multiple-choice questions about variables assumed to influence attitudes on abortion, such as religion, income, or education.

5 Much of this research is enormously valuable. For example, the stability of public opinion on the issue for more than two decades—with half to two thirds of the public favoring abortion in some circumstances—is a stunning bit of data that has frustrated many an activist trying to push legislative change.

6 Yet such work does not provide a rounded, complex sense of who the activists are, the diversity of opinion and philosophical divisions within each side of the debate, or where new political possibilities for a solution to the conflict might emerge.

7 Scholarship can help place current "news" in the historical context of the ebb and flow of social movements. For example, the extreme violence that has characterized anti-abortion activism in the 1990s is a relatively new phenomenon.

Through the mid-1980s, most activists on both sides of the issue were moderates—people who felt strongly but were fundamentally committed to public civility, such as nonconfrontational protests and attempts to enact legislation.

Moderates still make up the majority of activists, but their presence is much 8 harder to detect as radicals engage in deliberately provocative acts. Yet, despite all the clamor among activists and the shifting positions of politicians, the legality of abortion, established by the Supreme Court's 1973 decision in *Roe v. Wade*, has remained largely unchanged. And the confrontational and violent tactics of anti-abortion extremists have turned off some potential supporters and aggravated philosophical differences among pro-lifers. Some more-moderate opponents of abortion have begun focusing on activities such as educational programs on fetal development and centers that try to help women with prenatal and obstetric care.

Academic work that looks beyond the front-page stories can help to illumi- 9 nate new political possibilities that offer a brave counterpoint to the atmosphere of increasing violence. In a number of small cities, activists have grown tired of the polarized battles and are trying to find alternative ways to accomplish their agendas at the grassroots level. At a time when our country and the rest of the world seem dominated by the politics of hate, it seems especially important to locate and study how people are finding more-constructive ways to accomplish their political and social ends.

I was fortunate to encounter some of this activity while doing field research 10 on grassroots abortion activists during the 1980s. My work focused on the small, prairie city of Fargo, N.D., where the opening of the Fargo Women's Health Organization in 1981—the first, and still the only, clinic in the state to offer abortion services—has provoked continuing local controversy. In Fargo, I witnessed some remarkable political creativity among activists on both sides, especially those involved in a group called Pro-Dialogue. For a brief time, those activists dared to step out of their stereotyped positions; they tried to imagine a way to work on their different agendas that was driven not by hate and violence, but by a desire to use the political process to improve the conditions faced by pregnant women.

Pro-Dialogue was formed during a meeting of the North Dakota Democra- 11 tic Women's Caucus in March 1984, in preparation for that year's state Democratic convention. A pro-choice plank on abortion was proposed for the state party's platform, and, after much debate, was defeated. A woman who found she had friends arguing on both sides of the issue suggested a compromise position based on areas of agreement. The result read: "The North Dakota Democratic party believes public policy on abortion should provide some positive alternatives which would stress effective sex education, continued research on safer means of contraception, improved adoption services, support for parents of exceptional children, and economic programs which make it possible for parents to both raise children with love and pursue a productive work life."

Pro-Dialogue expired after only a few years, when Fargo—like many small 12 American cities—was subject to prolonged anti-abortion protests by extremists

from outside the community. Compared with the recent years of violence, Pro-Dialogue represented only a fragile moment in the abortion conflict.

13 But fragility is not the same as insignificance. In the past five years, the germ of the idea that emerged in Fargo a decade ago has begun to blossom independently; groups have formed around the country, made up of pro-choice and pro-life activists determined to find alternatives to divisive rhetoric and violence. Like strong families, these groups are finding ways to tolerate differences among their members and work toward common goals, such as helping women with difficult pregnancies. They have created an organization called the Common Ground Network for Life and Choice, whose members are trying to work together on issues such as teen-age pregnancy, ways to provide adequate resources for impoverished mothers and children, and guidelines for protests at abortion clinics.

14 When I first heard about Common Ground, I thought that it must have been founded by people who were interested in the abortion issue but had not put themselves on the front lines. In fact, exactly the opposite was true. Groups have emerged in places where the abortion battle has been the most prolonged and divisive—Buffalo, Milwaukee, Boston, St. Louis, and even Pensacola, Fla., the site of several abortion-clinic bombings in the 1980s and the murders of two doctors and one clinic worker in the 1990s. Indeed, one of the first local Common Ground groups to form was begun by the principal adversaries in the 1989 Supreme Court case, *Webster v. Reproductive Health Services*, a decision that allowed states to impose restrictions on abortion services, such as banning the use of public funds for counseling or for providing abortions.

15 Following that ruling, B. J. Isaacson Jones, the woman who directed the largest abortion clinic in St. Louis, and Andrew Puzder, the leading anti-abortion lawyer in Missouri, decided to find areas in which the two sides could work together. The efforts of the group they founded have resulted in legislation in Missouri providing assistance to drug-addicted pregnant women. Last year, the group issued a position paper on "Adoption as Common Ground."

16 Creative political imagination can flower in many different ways, inspiring people to protest peacefully, to dehumanize their opponents, or to commit murder in God's name. Public and even scholarly understanding of why people are driven to particular forms of activism is as rare as deep knowledge of the "exotic" people whom anthropologists and other social scientists traditionally have studied. Ethnographic research on a divisive issue such as abortion can give much-needed visibility to people who are trying to create new, positive action on social and political issues.

17 Perhaps if more attention had been paid to groups such as Fargo's Pro-Dialogue in the mid-1980s, we might have had a Common Ground network much earlier, which might have helped to prevent the murders of the past few years. Much as Margaret Mead studied other cultures, in part, to help Americans rethink their own cultural habits, contemporary anthropologists and other social scientists can, by the cases they choose to study and write about, help to redefine the way we think about cultural conflict and its resolution.

Social movements are built on trust and dialogue as well as on disagree- 18
ment, but cooperative actions rarely attract as much media coverage as violent
forms of protest do. Yet in an era of profound cynicism, when distrust of any-
one unlike ourselves seems to dominate politics, it is crucial for academics to
focus more research on people whose actions contradict our stereotypes. Such
analyses can help expand and reframe the public discourse on controversial is-
sues and, in the abortion debate, remind us of the key concern that seems to
have been lost: how we can make our society more supportive of women in their
childbearing years, and help people have and raise children under the best
possible circumstances.

● THINKING CRITICALLY ABOUT "THE ANTHROPOLOGY OF ABORTION ACTIVISM"

RESPONDING AS A READER

1. In a nutshell, what are Ginsburg's major points about abortion activism
 and about anthropology? Her article is marked by a theme of unex-
 pected findings and surprising choices. Read through it again to trace
 instances of these surprises and consider how her treatment of them
 contributes to her overall points.
2. What does Ginsburg seem to assume about her intended audience's in-
 terest in her subject and existing attitude about the two major topics she
 addresses? What methods does she use to attempt to change her read-
 ers' minds?
3. What specific possibilities for establishing common ground between
 opposing groups are evident in this text?

RESPONDING AS A WRITER

1. Did you find Ginsburg's presentation of surprising information per-
 suasive? What surprised you in this text? Write a brief paragraph de-
 scribing your response to her text, pinpointing specific places where you
 found her presentation to be effective or flawed.
2. Examine Ginsburg's organizational strategy by preparing a descriptive
 outline as explained in Chapter 3, stating what each paragraph or sec-
 tion *does* as well as *says* to move the reader toward Ginsburg's con-
 cluding points.
3. We include this article in this chapter because it describes common
 ground activities undertaken by activists in perhaps the most intractable
 controversy in recent decades. But is the article itself an example of a text
 that seeks common ground? As you examine its content and technique
 to answer that question, decide whether Ginsburg devotes adequate at-
 tention to the activities and concerns of both sides of the abortion issue.
 Use textual evidence to support your answer when you and your class-
 mates compare responses. To assist your analysis, you may want to use
 the technique described in Chapter 4 for examining binaries. ●

MEL WHITE

Open Letter from Mel White to Jerry Falwell

The letter presented here is the first of a series that gay rights leader Mel White (b. 1940) wrote to fundamentalist Christian preacher Jerry Falwell asking him to accept White's homosexuality, and, on a larger scale, the full humanity of all sexual minorities. An evangelical minister for thirty years, White at one time was a major figure on the religious right. As a ghostwriter for leaders such as Oliver North and Pat Robertson, he was sometimes asked to write antigay materials; he even wrote Falwell's autobiography, as the letter here indicates. White's own autobiography, *Stranger at the Gate: To Be Gay and Christian in America* (1994), relates his story of coming to terms with his sexual orientation. White is now a minister in the fellowship of Metropolitan Community Churches. His letters to Falwell are posted on the Website of Soulforce, an activist organization founded by White and his partner Gary Nixon. Its principles are evident on its home page, which features images of Gandhi and Martin Luther King Jr., and a banner headline that reads, "Join our network of friends learning nonviolence from Gandhi and King, seeking justice for God's Lesbian, Gay, Bisexual and Transgendered Children."

● FOR YOUR READING LOG

1. Based on any background knowledge you have about Mel White and Jerry Falwell and the information about rhetorical context supplied above, what do you surmise lies at the root of the conflict between White and Falwell? What do you predict White will say?
2. When you finish reading White's letter, before turning to the analysis questions that follow the letter, return to your log to record your experience of reading the letter. What surprised you? What moved you emotionally? When you finished, how did you feel about White and his ideas? ●

──── ● ────

June 5, 1999

Dear Jerry,

1 I've been reading your autobiography again. It still moves me. And I'm not just saying that because I wrote it. *Strength for the Journey* inspires and informs readers because you talk about your failures and not just your success.

2 I'm especially moved by those twenty short pages in Chapter Eleven that describe your transformation from 1964, when you were a staunch segregationist,

to 1968, when you baptized the first black member of Thomas Road Baptist Church.

When I asked you what happened in four short years to change your mind 3 about segregation, you told me stories about the African-Americans you had known and loved from childhood.

"It wasn't the Congress, the courts, or the demonstrators," you assured me. 4 "It was Lewis, the shoeshine man, and Lump Jones, the mechanic, and David Brown, the sensitive, loving black man without a wife or family who lived for most of his adult life in the backroom of our large family home in Lynchburg."

It was obvious that you really cared about those black men, especially David 5 Brown. "He was a good man," you told me. "He helped my mother with the cooking and cleaning. He cared for me and my brother Gene when we were children. He bathed and fed us both. He was like a member of our family."

Then, one day, you and Gene found David Brown lying unconscious and un- 6 attended in the lobby of Lynchburg's General Hospital. One portion of his head and face had been crushed from a severe blow with a dull pipe or the barrel of a pistol. He suffered cuts and bruises over his entire body; yet because he was black, he lay dying in that waiting room for forty-eight hours without medical help. You and your brother intervened but your friend was permanently damaged by the racist thugs who left him for dead and by the racist hospital policies that denied him treatment in time.

Do you remember how your eyes filled with tears when you told me, "I am 7 sorry that I did not take a stand on behalf of the civil rights of David Brown and my other black friends and acquaintances during those early years."

I knew from the sound of your voice, Jerry, that you are still sorry that you 8 did not take a stand for equality in those early years of ministry. Nevertheless, after condemning President Johnson's Civil Rights legislation as an act of "Civil wrong" and after preaching fervently against integration, you had the courage to acknowledge your sinfulness and to end your racist ways.

"In all those years," you told me, "it didn't cross my mind that segregation 9 and its consequences for the human family were evil. I was blind to that reality. I didn't realize it then, but if the church had done its job from the beginning of this nation's history, there would have been no need for the civil rights movement."

Well said, friend. But now I have to ask you one more time. Has it ever 10 crossed your mind that you might be just as wrong about homosexuality as you were about segregation? Could it be that you are blind to a tragic new reality, that the consequences of your anti-homosexual rhetoric are as evil for the human family as were your sermons against integration? Have you even thought about the possibility that you are ruining lives, destroying families, and causing endless suffering with your false claims that we are "sick and sinful," that we "abuse and recruit children," that we "undermine family values."

In the 1950s and 60s, you misused the Bible to support segregation. In the 11 1990s you are misusing it again, this time to caricature and condemn God's gay and lesbian children. Once you denied black Christians the rights (and the rites)

of church membership. Now it's gay, lesbian, bisexual, and transgendered Christians you reject.

12 For ten years we've been collecting samples of your dangerous and misleading rhetoric against homosexuals. We have file drawers filled with your antigay mass-mailings to raise funds and mobilize volunteers. We have audio and video collections of your antigay sermons and your antigay radio and television broadcasts. Coupled with your regular appearances on Nightline, Geraldo, and Larry King Live, and your ability to attract media attention (as you did with Tinky Winky) you have become one of the nation's primary sources of misinformation about homosexuality and homosexuals. You are saying things about us that are NOT true, terrible things with tragic consequences in our lives and in the lives of those we love.

13 Please, Jerry, hear your own words about segregation and apply them to my homosexual sisters and brothers. "I can see from the earliest days of my new faith in Christ," you told me, "that God had tried to get me to understand and to acknowledge my own racial sinfulness. In Bible College, the Scriptures had been perfectly clear about the equality of all men and women, about loving all people equally, about fighting injustice, and about obeying God and standing against the immoral and dehumanizing traditions of man."

14 The Scriptures are still clear about the equality of all men and women. The Scriptures are still clear about loving all people equally. The Scriptures are still clear about fighting injustice and standing against the immoral and dehumanizing traditions of man. Why can't you apply THOSE Scriptures to us instead of the six verses you misuse over and over again to clobber and condemn GLBT [gay, lesbian, bisexual, and transgendered] people?

15 For years you supported the "immoral and dehumanizing traditions" used to persecute people of color. Then, finally, the Spirit of Truth set you free. Now, you are a supporter of "immoral and dehumanizing traditions" used to persecute homosexuals. Please, Jerry, let the Spirit of Truth set you free again.

16 Thank you for meeting with me last year to hear the evidence that we are God's children, too, but it was obvious during our meeting (and in your avalanche of antigay rhetoric that followed) that you were not taking that evidence seriously.

17 Today, I begin a series of open letters to you reviewing the evidence one more time. Where I am wrong, correct me and I will confess my error. I hope you will do the same. Let this be a genuine public dialogue. I'm hoping that TOGETHER we can negotiate an end to your tragic misinformation campaign against us. If you refuse to hear the evidence again, if you insist on continuing your false and inflammatory rhetoric, then we will have no other option but to mobilize people of faith across this nation to conduct a serious nonviolent direct action against your Untruths in the spirit of Gandhi and King.

18 In this series of open letters, I'm going to do my best to summarize the psychological, psychiatric, scientific, medical, historical, personal and biblical evidence that demonstrates clearly that homosexuality is neither a sickness nor a sin. I'm putting all this material together one more time in the hopes that God will change your mind and heart about us. In the meantime, you learned that it

wasn't data that changed your mind about segregation. It was knowing its victims and sharing their suffering.

How many lesbian or gay people do you know, Jerry? Have you invited closeted gay or lesbian members of your staff and congregation to tell you what it feels like to be ridiculed and condemned endlessly by their pastor? Have you invited closeted gay or lesbian students at Liberty or Liberty graduates to share the pain your endless attacks have caused them? We know at least one gay student who killed himself after being expelled from your university because of his sexual orientation. Your eyes filled with tears when you thought of a black man lying unattended in a Lynchburg hospital. How will you feel when you finally realize that you have been the source of even worse suffering in the lives of those you love and serve.

Please, Jerry, read Chapter Eleven of your autobiography once again. After years of blindly and enthusiastically supporting segregation, you heard God's voice, admitted your error, and changed your ways. Now, after years of blindly and enthusiastically supporting anti-homosexual ignorance and bigotry, will you stop long enough to hear God's voice again?

Sincerely,

Mel White

• Thinking Critically About "Open Letter from Mel White to Jerry Falwell"

RESPONDING AS A READER

1. Although a reader (especially Falwell) may surmise where the opening paragraphs of the letter are leading, White doesn't directly address his purpose until well into the text. What do you take to be his organizational strategy? What is the common ground that White suggests he and Falwell share?

2. How does White portray the core conflict between Falwell and himself? Would you call th a conflict of goals, needs, or resources? What other description might ɔply instead? Try to articulate the fundamental questions at issue in this conflict. Using the stasis categories in Table 12.1 (pp. 366–367), decide how you would categorize the question(s) you articulated. Given White's portrayal of Falwell's position, does it seem likely that the two sides would agree about what underlying issue it is that separates them?

3. White's argument works with two types of commonalities and similarities: between White and Falwell, and between Falwell's earlier change of heart and the one White is currently asking him to make. To take a second look at these intuitive and ultimately emotional connections, use the argument analysis terminology (claims, reasons, evidence, and assumptions) from Chapter 12 to work out the line of reasoning White is not only using but proposing to Falwell.

RESPONDING AS A WRITER

1. To analyze White's strategy in this letter, review our description of Rogerian argument (p. 480) as a means of reducing threat between antagonistic opponents. How does White's letter match with the features we describe?
2. How would you describe White's use of *pathos* in this letter? He once knew his intended audience very well. What specific word choices and details of evidence can you pinpoint as reflecting values Falwell can be assumed to hold?
3. As a means of solidifying your understanding of the Rogerian "listening" approach to argument that White's letter exemplifies, prepare a brief digest of its contents and methods according to the pattern for a rhetorical précis described in Chapter 3. •

ANDREW SULLIVAN

Let Gays Marry

A high-profile advocate of gay marriage, Andrew Sullivan (b. 1963) is an openly gay conservative journalist who is a practicing Roman Catholic. His Web log, or blog (www. andrewsullivan.com), frequently cited by journalists and pundits, logs hundreds of thousands of visitors per month. He is a senior editor at the *New Republic* and a regular contributor to the *New York Times Magazine*, the *New York Times Book Review*, the *Sunday Times of London*, and the *Advocate*. Sullivan's frequently controversial writing often highlights commonalities between gay and straight people. Born and raised in England, he holds a Ph.D. in political science from Harvard and has authored several books, including *Virtually Normal: An Argument About Homosexuality* (1995) and *Love Undetectable* (1999). He coedited the reader *Same-Sex Marriage: Pro and Con* (1997). Sullivan has published numerous opinion pieces about gay marriage. We chose this one for the current chapter because it is an outstanding example of argument from a common ground perspective. That is, Sullivan respectfully emphasizes commonality with the opposition as well as difference. The article appeared in the June 3, 1996 issue of *Newsweek* as part of the magazine's coverage of the U.S. Supreme Court's overturning of a Colorado constitutional amendment that would have prohibited any antidiscrimination legislation protecting homosexuals. Sullivan's mention of Bill Bennett in the final paragraph refers to the conservative leader's opinion piece opposing gay marriage in the same issue of the magazine.

● **FOR YOUR READING LOG**

1. Before you read this "take a stand" argument, pause to articulate your current thinking about gay marriage. Should it be legal? Why or why not?

2. What are the main opposition arguments that Sullivan needs to address? What do you predict his reasoning will be based upon? ●

———— ● ————

"A state cannot deem a class of persons a stranger to its laws," declared the 1
Supreme Court last week. It was a monumental statement. Gay men and lesbians, the conservative court said, are no longer strangers in America. They are citizens, entitled, like everyone else, to equal protection—no special rights, but simple equality.

For the first time in Supreme Court history, gay men and women were seen 2
not as some powerful lobby trying to subvert America, but as the people we truly are—the sons and daughters of countless mothers and fathers, with all the weaknesses and strengths and hopes of everybody else. And what we seek is not some special place in America but merely to be a full and equal part of America, to give back to our society without being forced to lie or hide or live as second-class citizens.

That is why marriage is so central to our hopes. People ask us why we want 3
the right to marry, but the answer is obvious. It's the same reason anyone wants the right to marry. At some point in our lives, some of us are lucky enough to meet the person we truly love. And we want to commit to that person in front of our family and country for the rest of our lives. It's the most simple, the most natural, the most human instinct in the world. How could anyone seek to oppose that?

Yes, at first blush, it seems like a radical proposal, but, when you think about 4
it some more, it's actually the opposite. Throughout American history, to be sure, marriage has been between a man and a woman, and in many ways our society is built upon that institution. But none of that need change in the slightest. After all, no one is seeking to take away anybody's right to marry, and no one is seeking to force any church to change any doctrine in any way. Particular religious arguments against same-sex marriage are rightly debated within the churches and faiths themselves. That is not the issue here: there is a separation between church and state in this country. We are only asking that when the government gives out civil marriage licenses, those of us who are gay should be treated like anybody else.

Of course, some argue that marriage is by definition between a man and a 5
woman. But for centuries, marriage was by definition a contract in which the wife was her husband's legal property. And we changed that. For centuries, marriage was by definition between two people of the same race. And we changed that. We changed these things because we recognized that human dignity is the same whether you are a man or a woman, black or white. And no one has any more of a choice to be gay than to be black or white or male or female.

Some say that marriage is only about raising children, but we let childless 6
heterosexual couples be married (Bob and Elizabeth Dole, Pat and Shelley Buchanan, for instance). Why should gay couples be treated differently? Others fear that there is no logical difference between allowing same-sex marriage and

sanctioning polygamy and other horrors. But the issue of whether to sanction multiple spouses (gay or straight) is completely separate from whether, in the existing institution between two unrelated adults, the government should discriminate between its citizens.

7 This is, in fact, if only Bill Bennett could see it, a deeply conservative cause. It seeks to change no one else's rights or marriages in any way. It seeks merely to promote monogamy, fidelity and the disciplines of family life among people who have long been cast to the margins of society. And what could be a more conservative project than that? Why indeed would any conservative seek to oppose those very family values for gay people that he or she supports for everybody else? Except, of course, to make gay men and lesbians strangers in their own country, to forbid them ever to come home.

● **THINKING CRITICALLY ABOUT "LET GAYS MARRY"**
RESPONDING AS A READER

1. What point does Sullivan seem to consider to be the strongest support for his argument that gay marriage should be legal? Whether you agree with his ultimate point or not, do you agree that this is his strongest argument? If not, what is? Why?

2. In a relatively short space, Sullivan summarizes and counters several powerful arguments against gay marriage. Tracing his reasons and evidence in each counterargument, what do you discover about the values and assumptions he asserts as shared with his opponents? With his *Newsweek* audience?

3. How has reading Sullivan's argument changed your thinking about gay marriage—even if he hasn't convinced you or you already agreed with him, what aspect of this text showed you a new way of understanding some aspect of this issue?

RESPONDING AS A WRITER

1. What aspects of this opinion column did you find most engaging and/or most off-putting? Why? Analyze specific points in the text that invoked a strong reaction in you. How would you describe his strategy for dealing with potential resistance from readers?

2. Sullivan's core assertion that gay marriage is "a deeply conservative cause" is an unexpected one. What does Sullivan mean by "conservative"? To understand fully the values he asserts here, apply the ideology analysis technique in Chapter 4 to key terms in Sullivan's argument. Using two columns, list on the left the words that signal the values Sullivan is asserting to support his argument and rebut his opponents. In the right column, write the opposing term, using brackets if it is only implied. Summarize your analysis by writing a paragraph no longer than seven sentences that *explains but does not argue for or against*

Sullivan's assertion that support of gay marriage is an issue that should appeal to conservatives.

3. How would you describe the persona that Sullivan presents here? What specific wording, sentence strategies, or organizational decisions contribute to this impression? What does his technique suggest to you as an effective way for writers to assert themselves when writing about highly controversial topics such as this? •

Sarah Glowicki (Student)

Frankencorn or Green Revolution II? How Scary ARE Genetically Modified Crops? A Rhetorical Analysis

Sarah Glowicki (b. 1972) graduated from Marquette University as a Writing-Intensive English major with a minor in chemistry. She wrote this paper in response to the Examining Rhetorical Strategies assignment at the end of this chapter, choosing to focus on genetically modified foods so she could use her scientific background to explain a controversy that seems inaccessible to many readers. She plans to continue her education in English and pursue a career in technical or freelance writing.

● **FOR YOUR READING LOG**

1. What's your gut response to the question in the title? If you don't know how to answer, jot down instead some questions that, when answered, would help you understand how scary genetically modified foods are. Freewrite for several minutes.
2. What kind of common ground can you envision for a controversy that is defined this way? Freewrite again for several minutes. •

"*In an evolutionary blink of an eye, wild populations of agricultural crops could be obliterated by their genetically altered descendants.*" That is not an environmentalist's answer to my question. It is the lead paragraph of a front page article about recent research at the Universities of Wisconsin and Minnesota (Quick and Groshong).

Here's the news: the researchers developed a mathematical model that shows how genetically modified crops *have the potential* to crossbreed with wild plants and thus *could* make them extinct. But phrasing such as "an army of plant barbarians" and verbs such as "invade," "pillage," and "blast" make the article's language so intense that it drowns out all tentative terms such as "could be" and "have the potential." Maybe this language is just the result of a couple of reporters having a good time with words, but it is typical of the rhetoric in the controversy over genetically modified (GM) crops. The ups and downs of scientific research get lost behind attention-getting headlines. That's a problem because we in the public are left bewildered. My goal in this paper is to examine the types of arguments being made in the controversy over genetically modified crops and to point out areas of basic disagreement as well as common concerns within it.

2 The basic issue in the controversy is the question of how the benefits of planting GM crops weigh against the risks. All sides agree on that. But they don't agree on how to weigh those risks and benefits or how to keep the risks in check. High-profile environmental groups such as Greenpeace are skeptical about crop safety and say that GM crops are not worth the risk of unknown and long-term consequences. Greenpeace argues against GM crops with moral indignation. Another "green" group, the Union of Concerned Scientists, advises caution, saying that the world can be fed without biotechnology and that the benefits experienced so far are likely to be short-lived (Frequently Asked Questions). In contrast, major biotech companies and many farmers want to move forward with the new discoveries because planting GM crops results in increased yields on less land with fewer pesticides and fertilizers. To them, these benefits overshadow both the risks and any moral dilemmas about gene-splicing. For scientists in laboratories unaffiliated with the biotech companies, the questions are all about science—that is, testing hypotheses and reporting results, a long process that produces lots of competing claims before definitive answers are found.

3 Toward the end, the news article quoted in the introduction quotes a scientist who criticizes the study's model and a biotech industry spokeswoman who says that the Environmental Protection Agency (EPA) already requires buffer zones around GM crops specifically to prevent or reduce cross-pollination. Anyone who reads to the end of the piece must wonder what the big deal is if it turns out that EPA has already established rules to address such problems. No wonder the public feels bewildered. That's a problem because bewildered citizens cannot participate in policy-making.

4 Analyzing the rhetoric of competing positions about GM crops provides valuable insights into the controversy. The "no problem" position is probably the best place to start. This argument contends that GM crops are just another step forward in the long history of agriculture and that the risks are minimal. People who take this position point out that selecting crop varieties for productivity and durability is nothing new. For example, in response to a news article on Europeans' anxiety about GM foods, Henry Miller, a former director of the Federal Drug Administration's Office of Biotechnology, wrote the *New York Times* last

spring to note that the field of biotechnology began as long ago as 6000 B.C., when humans recognized that cross-breeding could enhance crops. The results are good, he says: "More than 60 percent of processed foods in America contain ingredients derived from gene-spliced organisms. There has not been a single injury to a single person or ecosystem." Miller's view, like the industry's view, celebrates progress.

A similar position is expressed in a recent press release from the Council for Biotechnology Information about the twentieth anniversary of biotech foods. It highlights the advantages of crops that are herbicide tolerant, pest resistant, and virus resistant. The specific focus of the press release and much of the discussion about GM foods is the injection of protein from Bacillus thuringiensis, or Bt, into seeds so that plants develop a natural pesticide against crop-eating insects. As a result, farmers don't need to spray against insects. Furthermore, Monsanto's seed with Bt also produces plants that are resistant to the company's herbicide Roundup. This means farmers can kill weeds with spray without harming crops. When farmers don't have to plow the fields to kill weeds, soil erosion is reduced (Council). This position celebrates increased productivity.

Gregory Conko, Director of Food Safety Policy at the Competitive Enterprise Institute, finds these advantages convincing. Writing in the libertarian Cato Institute magazine called *Regulation*, Conko notes that "Bt sweet corn has reduced pesticide use by between 42 and 94 percent" (22). He goes on to explain that farmers who grow Bt cotton have cut down on industrial waste and saved on raw materials, including the fuel oil used for the manufacture and distribution of insecticide. On the application end, farmers save fuel, water, and many work days. Furthermore, in areas of the world where farmers would have to spray pesticides by hand, pesticide poisonings have declined since the introduction of Bt plants. Conko's careful explanations and detailed statistics do more, however, than lay out a carefully reasoned argument about the benefits of productivity. He extends the argument to the larger environment, arguing that "the sheer reduction in the use of synthetic chemical insecticides in fields planted with Bt varieties tends to reduce the likelihood of [harmful] ancillary environmental effects" (23). Furthermore, he says, increasing productivity is a highly effective way to preserve wildlife biodiversity because this productivity results in "ecological stewardship and habitat conservation" (24).

How could environmental groups object? He's arguing on their ground, saying that the GM seed to which environmentalists object actually helps achieve their goals of habitat preservation and biodiversity.

But environmentalists do object to Bt crops. "Say no to genetic engineering," Greenpeace asserts on the Web ("Campaign Overview"). The wording fits right in with its adamant slogans on other issues, such as "Stop war," "Save the oceans," "Eliminate toxic chemicals." They have always provided an important counterbalance to the sometimes overzealous economic drives of business and industry. Decades ago, activist groups like Greenpeace exposed the hazards of agricultural chemicals used in traditional agriculture. One might imagine that the reduction in pesticide use that Bt crops permit would please these activists.

But their Website presents genetic engineering as "manipulating genes in a way that does not occur naturally," with results that are "unforeseeable" and "uncontrollable" ("Genetic Engineering"). With characteristic insistence, Greenpeace announces that it opposes "release into the environment" of GM "organisms." This wording is much scarier than "planting GM seeds" would be. Greenpeace also advocates labeling of GM products and "segregation" of GM crops from conventional ones. "Segregation" sounds powerful, but would it be different from the EPA "buffer zones" referred to at the end of the recent newspaper article?

9 Intense language marks Greenpeace's presentations about GM crops. When a 1999 Cornell study found that Bt corn pollen had adverse effects on monarch butterfly larvae and caterpillars, Austria banned Bt corn and Greenpeace launched a highly visible campaign calling for similar banning in the United States. The vague language of its press release shows the weakness of an extreme stance. It says, for example, "the banned corn, developed by Monsanto, contains the toxin of the Bacillus thuringiensis (Bt) soil bacterium" without explaining that the Bt corn was modified *precisely for* its pesticide traits ("Greenpeace Calls"). This press release emotionally explains that the "toxin" kills butterfly larvae, and quotes a Greenpeace Genetic Engineering Specialist as saying, "Our environment, our farmers and our families should not be guinea pigs in this corporate experiment on our food."

10 An even more threatening tone is present in a recent Greenpeace Web "News Report" entitled "Italian Seeds Contaminated with GE Maize." The abstract resorts to vague scare strategies by asking, "How are the seeds getting contaminated in the first place? Is it part of a deliberate strategy by companies selling GE seeds?" ("Italian Seeds"). This aggressive, "in your face" rhetoric uses unsubstantiated allegations to set up biotech giant Monsanto as the enemy. Yet the news report reveals the weakness when it says, "Although the exact details of what happened have yet to be made public, local reports and previous experience suggest that GE [Bt] varieties produced by Monsanto may be the source of the contamination" ("Italian Seeds"). While such articles are labeled "Detailed News," readers should be aware that the diction, tone, and lack of evidence reveal heavy bias and unreliability. Loaded language, a field of corn signs labeled with question marks, and photographs of beautiful monarch butterflies may be effective to a casual reader or a hard-core Greenpeace member, but consumers who want a thorough explanation need to look elsewhere.

11 A more balanced presentation of the 1999 findings about monarchs and Bt corn pollen is available at ScientificAmerican.com, which reports the Cornell finding without mentioning "toxin" or "guinea pigs." The article notes problems with the study that have been pointed out by others—phrasing that distances *Scientific American* from the critique. These weaknesses include (1) the large amount of pollen fed to the larvae in the Cornell research is unlikely to be present "more than a few feet from flowering corn," (2) the effects of wind and rain will reduce heavy pollen accumulations quickly, and (3) "butterflies breed all season [but] corn pollinates once" ("Poison Plants?"). The article adds, "others com-

mented that the larvae wouldn't be very healthy either if they were in a corn field sprayed with conventional agricultural chemicals."

For environmentalist perspectives expressed in confidence-inspiring 12 terms, the Union of Concerned Scientists (UCS) is a good source. Like Greenpeace, the group calls for labeling of GM foods, but in more reasonable language. Since one of UCS's major goals is more discussion among citizens, scientists, and regulatory agencies, putting forth a reasonable ethos is very important. A theme of "not enough data yet" and "let's be cautious about unknown effects" runs through their materials. A monarch butterfly is prominent on their logo and their Website, where one can find a detailed, calmly articulated update on the 1999 monarch incident by two Ph.D. scientists (Mellon and Rissler). They call it "a near miss" because in the end, only one strain of Bt corn had pollen that harmed the butterfly larvae, and that strain had not been widely distributed. "It was just a lucky break—not government vigilance—that protected the monarch butterfly," the authors assert, and argue that "The monarch story illustrates serious weaknesses in the U.S. regulatory system." They call for more and better testing before seed is released. This scholarly paper was presented at a scientific meeting in Denmark in June 2003 and contains two pages of footnotes.

What UCS wants is "better opportunities for civil society to debate the ap- 13 propriateness of agricultural biotechnology" through discussion of legislation about regulatory programs and food labeling. Here is where these environmentalists come head to head with Conko of the Competitive Enterprise Institute. Conko's argument was not written for an environmental audience but for *Regulation*'s readership of "policymakers and analysts in Washington and the state capitals" ("About *Regulation*"). His claims about the benefits of productivity are merely stepping stones to his main point: "the biggest threat bioengineered plants face is overly restrictive policies based on the false notion that there is something inherently dangerous about biotechnology" (25). At the opposite pole from Greenpeace and sounding not at all like the UCS, Conko is concerned about too much regulation. They aren't on common ground after all.

Where will the answer be found? Only through intense discussion. Law 14 professor Gregory N. Mandel points to the heart of this issue when he says that "most people lack the ability to assess the quality of competing scientific claims, so they turn to stories about problems with genetic engineering for their views on the topic" ("Genetic Engineering: Lawyer"). According to Mandel, these stories cause people to mistrust the regulatory process more than they fear the GM crops. If he's right, Greenpeace's scare tactics and aggressive rhetoric are not the way to bring people together, and the scary stories serve the interests of the people who oppose regulation. In fact, the public cannot trust the activist groups alone, whether they advocate for more regulation (like Greenpeace) or less (like the Competitive Enterprise Institute). Balancing the needs of various interest groups will not be easy, but *Biotech Week*'s report of Mandel's point makes sense: "An effort to write effective regulations for genetically modified crops will only succeed . . . if a third group—the public—is also represented on the panel by

trustworthy people without interest in either the private industry or activist camps" ("Genetic Engineering: Lawyer").

15 We, the public, need explanations in ordinary language from experts such as those whose work is posted at the UCS site, but from multiple perspectives. We also need restraint from metaphor-happy journalists eager for headlines. Instead of being scared by horror stories of GM crops ransacking the environment or being awed by scientific advancement in and of itself, we need to help the parties to this controversy focus on concerns common to us all: efficient, safe food production. A bewildered public won't have much say in policy-making, but a well-informed public can insist upon and benefit from participation.

Works Cited

"About *Regulation.*" *Cato Institute.* 2003. 30 July 2003 <http://www.cato.org/pubs/regulation/about.html>.

Conko, Gregory. "The Benefits of Biotech." *Regulation.* Spring 2003: 20–25. 16 Jul 2003 <http://www.cato.org/pubs/regulation/regv26n1/v26n1-4.pdf>.

Council for Biotechnology Information. "2003 Marks the Anniversary of Modern Plant Biotechnology." *Ag BioTech InfoNet.* 12 May 2003. 16 July 2003 <http://www.biotech-info.net/20th_anniversary.html>.

"Campaign Overview." *Greenpeace International.* 22 July 2003. 22 July 2003 <http://www.greenpeace.org/international_en/campaigns/>.

"Frequently Asked Questions About Biotechnology." *Union of Concerned Scientists.* 26 Nov. 2002. 31 July 2003 <http://www.ucsusa.org>. Path: Food; Biotechnology; FAQs; Biotechnology.

"Genetic Engineering." *Greenpeace International.* 22 July 2003. 22 July 2003 <http://www.greenpeace.org/international_en/international_en/campaigns/intro?campaign%5fid=3942>.

"Genetic Engineering: Lawyer Says Mistrust of GM Foods Based on Media Stories of Regulatory Error." *Biotech Week.* 23 Apr. 2003: 52+. *ProQuest.* Memorial Lib., Marquette U. 16 July 2003 <http://proquest.umi.com/>.

"Greenpeace Calls for U.S. Action as Monarch-Killing Corn is Banned in Austria." *Greenpeace USA.* 27 May 1999. 17 July 2003 <http://www.greenpeaceusa.org/media/press_releases/99_5_27text.htm>.

"Italian Seeds Contaminated with GE Maize." *Greenpeace.* 10 July 2003. 16 July 2003 <http://www.greenpeace.org/news/details?item_id=292172>.

Mellon, Margaret, and Jane Rissler. "Environmental Effects of Genetically Modified Food Crops: Recent Experiences." *Union of Concerned Scientists.* 31 July 2003. 31 July 2003 <http://www.ucsusa.org>. Path: Food; Biotechnology; Special Features.

Miller, Henry. "And Now, a Rift Over Food, Too?" Letter 1. *New York Times* 16 Feb. 2003, late ed. (east coast): 4.10. *ProQuest.* Memorial Lib., Marquette. U. 16 July 2003 <http://proquest.umi.com/>.

"Poison Plants?" *ScientificAmerican.com* 5 July 1999. 24 July 2003 <http://www.sciam.com/article.cfm?articleID=0009632E-2481-1C75-9B81809EC588EF21>.

Quick, Susanne, and Kimm Groshoung. "Modified Crops Could Erase Wild Counterparts, Study Says." *Milwaukee Journal Sentinel* 25 July 2003, final ed.: A1+.

• THINKING CRITICALLY ABOUT "FRANKENCORN OR GREEN REVOLUTION II"

RESPONDING AS A READER

1. How similar were Glowicki's ideas about common ground in this controversy to the ideas you wrote about in your reading log? Did you find her analysis convincing?

2. What seemed to be Glowicki's assumptions about her audience's attitude toward and engagement with the issues surrounding genetically modified food? How did she make you feel part of her intended audience—or where did you feel excluded?

3. How do you imagine a member of each of the major groups she discusses would respond to her text—a member of Greenpeace, of the Union of Concerned Scientists, a farmer who uses Bt seed, and a scientist who works for Monsanto?

RESPONDING AS A WRITER

1. Where do you see Glowicki making specific moves that seem designed to demonstrate her appreciation of different people's perspectives about this controversy? Do you find this effort credible? Why or why not? What could have been omitted or added to increase the paper's effectiveness?

2. Writing that seeks to analyze conflicting viewpoints can be extremely difficult to organize. Use the descriptive outline technique described in Chapter 3 to pinpoint the function of each paragraph in this text in terms of what it *does* and *says*. Describe the writer's organizational strategy as briefly as you can.

3. How successful has Glowicki been in meeting the goals specified in the Examining Rhetorical Strategies assignment at the end of this chapter? If you were in a peer review group together, what suggestions or advice would you want to give her for revising this draft? •

Writing to Seek Common Ground

This chapter's texts have suggested a number of approaches through which differences can be explored and, although perhaps not resolved, understood more clearly. The assignments here offer you several different ways to try out these ideas in your own writing in relation to difficult issues that hold special significance for you.

MOVING TOWARD COMMON GROUND

Write an argument essay that seeks common ground between you and a resistant audience that opposes your view. Your essay should devote as much of its

space to expressing an understanding of opposition views as it does to explaining and advocating your own position. The following steps will help you develop your essay.

- Choose a controversial issue that is important to you.
- As you explore ideas for your argument, begin by believing and then doubting your own position. Apply Sidney Callahan's Rule Number 4 and "admit the price of following your own position" (p. 490).
- Consider why those who oppose you find your position threatening. How can you alleviate that sense of threat?
- Do research as necessary to understand the central issues for people who hold opposing views on this matter—both their surface claims and their underlying values.
- Lay out as extensively as possible the area of shared goals and values (common ground) between your view and one that opposes it.
- Compose a delayed-thesis argument that clearly presents the commonality between you and the opposing position yet advocates persuasively for your views.

EXAMINING RHETORICAL STRATEGIES

Without taking sides, explain the claims and strategies of two representative opposing arguments in a public controversy of your choice. Your goal is to help readers understand both the underlying issues and the way that advocates for each side make their cases. From a neutral vantage point, use everything you know about rhetorical reading to analyze two representative arguments and explain to your readers answers to the following questions:

1. What is the central question at issue?
2. Is it the same question for both sides?
3. What kinds of evidence, reasoning, and assumptions do the writers use to make their cases?
4. What other qualities of tone, style, audience engagement, and appeals to authority characterize the arguments?
5. What common ground can you find between the two sides?
6. What basic disagreements make this matter so difficult to resolve?

EXTENDING THE CONVERSATION

We invite you to look for and assert common ground. Focus on a difficult issue familiar to you in which you see a greater possibility for agreement, if not complete resolution, than those engaged in argument about the issue apparently do. Examine several different published positions regarding the matter, then enter the conversation with your own point of view. Your goals for this assignment are as follows:

- Present background as necessary to contextualize the issue and various people's positions regarding it.
- Explain to your own readers what you understand to be the difficult issues at the heart of the controversy.
- Use argument analysis and the description of stasis categories in Chapter 12 (p. 366) to describe how the different parties approach the controversy.
- Point to common ground that exists within the conflicting positions.
- Recommend some steps that might bring about a resolution or at least a lessening of intensity or negative feelings.

You may wish to work with one of the difficult issues suggested in this chapter's readings, with a matter raised by other readings in this book, or with readings relevant to an issue currently under discussion in your local community or in the national media. As with any text seeking to draw others to common ground, your main points should assert ideas about how the various sides can recognize and perhaps act upon commonalities in their positions—not the supremacy of one side over the other.

Building a Citation with MLA and APA Formats

Providing accurate, conventionally formatted documentation of your sources will enhance your own authority as well as give your readers essential information for follow-up. This appendix provides model citation formats you can use to prepare lists of research sources in either Modern Language Association (MLA) format—entitled "Works Cited"—or American Psychological Association (APA) format—entitled "References." In both citation systems, the list of sources is regarded as an integral part of the paper. Readers work with both types of lists in the same way. They use the information from the brief parenthetical references in the body of the paper to find full citations on the alphabetized list at the end of the paper. (For guidance about creating in-text citations keyed to these lists, see Chapter 7.)

If you cannot find an appropriate citation model in this appendix or need advice about how to include additional details, consult the current edition of the *MLA Handbook for Writers of Research Papers* (we used the sixth edition, 2003) or of the *Publication Manual of the American Psychological Association* (we used the fifth edition, 2001). Both are almost certainly available in your library's reference section. Your campus writing center will also be a valuable source of information, as are the on-line writing centers at Purdue <http://owl.english.purdue.edu/handouts/research/index.html/> and at the University of Wisconsin <http://www.wisc.edu/writetest/Handbook/Documentation.html>.

The Basics for MLA and APA Citation Lists

The important guidelines in this section will help you format your works cited and references lists accurately and efficiently. The care you take in formatting citations will convey the care with which you have approached your writing project and will thus enhance your credibility. In other words, the quality of your lists reflects the quality of your work.

SETTING UP MLA AND APA LISTS

1. Your list of sources should begin on a separate page at the end of your paper. Center the title "Works Cited" (MLA) or "References" (APA) at the top of the page.

2. Use double spacing throughout.
3. Include in this list only materials that you refer to in the body of your paper.
4. Arrange all citations alphabetically according to the author's last name. If the source lists no author, begin with the title, fitting it into the overall alphabetical order. When alphabetizing, ignore *the*, *a*, and *an* in book and article titles. For sequencing entries for two or more works by the same author, use the guidelines that appear under "Citations for Books" in both the MLA and APA sections that follow.
5. Use the hanging indent format illustrated in the model citations: the first line of each citation starts at the left margin, and subsequent lines are indented a half inch. This format helps readers quickly locate the word(s) provided by in-text citations. If you have trouble setting up the indents, consult your software's help screens.

PROCESS ADVICE ABOUT PREPARING MLA AND APA LISTS

1. To avoid omissions and confusion, add citations to your list while you are composing, as you integrate each source into your paper. An efficient technique for doing this is to keep a separate computer file open so that whenever you use outside material in your paper you can immediately put full information for a citation into the second file. (You can polish the citation format later.) Working this way will help you avoid last-minute scrambles to recover missing bibliographic information.
2. As part of final proofreading, take a few minutes to verify that each of your in-text citations matches a full citation on your works cited or references list. Then check in reverse—use your word processor's search function to move from the list to the in-text citations. The first part of this procedure will reveal any citations missing from your list. The second part will help you notice whether any in-text citations have been accidentally deleted during revision. (Missing in-text citations can prompt questions from your instructor and be embarrassing.) Checking your list against your text will also help you discover any citations listed during early drafting that are no longer relevant. Simply delete them.

Specifics about MLA citation formats follow; the APA section begins on p. 537.

MLA Citation Formats for Books

The basic book citation has three information elements separated by periods.

Author. <u>Title</u>. City, State: Publisher, Date.

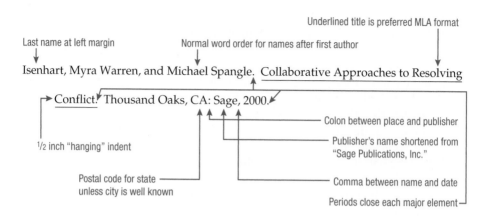

Underlined title is preferred MLA format

Last name at left margin

Normal word order for names after first author

Isenhart, Myra Warren, and Michael Spangle. Collaborative Approaches to Resolving

Conflict. Thousand Oaks, CA: Sage, 2000.

Colon between place and publisher

½ inch "hanging" indent

Publisher's name shortened from "Sage Publications, Inc."

Postal code for state unless city is well known

Comma between name and date

Periods close each major element

MODEL BOOK CITATIONS

Book by One Author

Radway, Janice A. Reading the Romance: Women, Patriarchy, and Popular Literature. Chapel Hill: U of North Carolina P, 1984.

Book with Two or Three Authors

Brooke, Robert, Ruth Mirtz, and Rick Evans. Small Groups in Writing Workshops: Invitations to a Writer's Life. Urbana, IL: NCTE, 1994.

Lutz, Catherine A., and Jane L. Collins. Reading National Geographic. Chicago: U of Chicago P, 1993.

- Note the commas after the first and second authors' names.
- Use regular name order for the second and subsequent authors.
- The names of university presses can be shortened to "U of [school name] P," as in this example, or "[school name] UP."

Using "et al." for More Than Three Authors

In MLA style, when a book or article has more than three authors, you may list all names or you may use "et al." ("and others") after the first name.

Mabey, Nick, Stephen Hall, Clare Smith, and Sujata Gupta. Argument in the Greenhouse: The International Economics of Controlling Global Warming. London: Routledge, 1997.

OR

Mabey, Nick, et al. Argument in the Greenhouse: The International Economics of Controlling Global Warming. London: Routledge, 1997.

Two or More Works by the Same Author

Alphabetize first by the author's name, then by the works' titles. On the second and any subsequent entries, instead of the author's name, type three hyphens, a period, and then the title.

Quindlen, Anna. How Reading Changed My Life. New York: Ballantine, 1998.
---. "It's the Cult of Personality." Newsweek. 14 Aug. 2000: 68.
---. One True Thing. New York: Random, 1994.

Book with Corporate Author

In this sense "corporate" means authored by any group where individual members are not identified.

Hayward Gallery. Rhapsodies in Black: Art of the Harlem Renaissance. Berkeley: U of
 California P, 1997.

Book with No Author or Editor Listed on Title Page

Strong Hearts: Native American Visions and Voices. New York: Aperture, 1995.

Translated Book

Aristotle. On Rhetoric: A Theory of Civic Discourse. Trans. George A. Kennedy. New
 York: Oxford UP, 1991.

If your discussion primarily concerns the translation, begin the citation with the translator's name, followed by "trans." Include the author after the title, preceded by the word "by."

Kennedy, George A., trans. On Rhetoric: A Theory of Civic Discourse. By Aristotle.
 New York: Oxford UP, 1991.

Second or Later Edition of a Book

If a title page doesn't include an edition number, the book is probably a first edition, which is not noted in a citation. If the book's title page does have an edition number, you need to include it in the citation because content and page numbers have probably changed since the first edition. Place edition information as a separate element between the title and publication information.

White, Edward M. Teaching and Assessing Writing. 2nd ed. San Francisco: Jossey-Bass,
 1994.

Book from a Series

If the title page or the page preceding it indicates that the book is part of a series, place the series name as a separate element after the title without underlining or quotation marks, then add the series number, then the publication information.

Folsom, Marcia McClintock, ed. Approaches to Teaching Austen's Pride and Prejudice. Approaches to Teaching World Lit. 45. New York: MLA, 1993.

Special Considerations When Titles Include Titles

To indicate that a book title includes the title of another book, omit the underlining on the included title.

Sten, Christopher. Sounding the Whale: Moby-Dick as Epic Novel. Kent, OH: Kent State UP, 1996.

To indicate that a book title includes a short story or essay title, add quotation marks around the shorter title and retain underlining for the entire book title.

Dock, Julie Bates, ed. Charlotte Perkins Gilman's "The Yellow Wall-Paper" and the History of Its Publication and Reception: A Critical Edition and Documentary Casebook. University Park, PA: Penn State UP, 1998.

Edited Collection

Citations for edited collections follow the book models, with the label "ed." or "eds." inserted after the last editor's name.

Ward, Harold, ed. Acting Locally: Concepts and Models for Service-Learning in Environmental Studies. Washington, DC: American Association for Higher Education, 1999.

Severino, Carol, Juan C. Guerra, and Johnnella E. Butler, eds. Writing in Multicultural Settings. New York: MLA, 1997.

Selection from an Edited Collection

Present inclusive (i.e., first and last) page numbers for the selection as a separate item after the date.

Christian-Smith, Linda K. "Voices of Resistance: Young Women Readers of Romantic Fiction." Beyond Silenced Voices: Class, Race, and Gender in U.S. Schools. Ed. Lois Weis and Michelle Fine. New York: State U of New York P, 1993. 169-89.

"The Dream of the Rood." Longman Anthology of British Literature. Ed. David Damrosch, et al. Vol. 1A. New York: Longman, 1999. 120-24.

Welch, James. "Christmas Comes to Moccasin Flat." A Geography of Poets. Ed. Edward Field. New York: Bantam, 1979. 43.

If the selection is from a book that collects work by one author, use the same format, including an editor only if relevant.

Hribal, C. J. "Consent." The Clouds in Memphis. Amherst, MA: U of Massachusetts P, 2000. 55-67.

Williams, William Carlos. "The Red Wheelbarrow." Selected Poems. New York: New Directions, 1968. 30.

Work Reprinted in an Anthology

When information about the original publication date and venue are important but your page references are from a reprinted version, use the following format to provide publication information for both versions.

Beck, Evelyn Torton. "From 'Kike' to 'JAP': How Misogyny, Anti-Semitism, and Racism Construct the 'Jewish American Princess.'" Sojourner Sept. 1988: 18-26. Rpt. in Race, Class, and Gender. Ed. Margaret L. Andersen and Patricia Hill Collins. 2nd ed. Belmont, CA: Wadsworth, 1995. 87-95.

Selection from a Multivolume Work

Volume information comes between any edition note and the publication information.

"The Dream of the Rood." Longman Anthology of British Literature. Ed. David Damrosch, et al. Vol. 1A. New York: Longman, 1999. 120-24.

Melville, Herman. "Bartleby the Scrivener." Norton Anthology of American Literature. Ed. Nina Baym et al. 5th ed. Vol. 1. New York: Norton, 1999. 2330-55.

List only the material or volumes you use. If you were discussing the entire two-volume collection referred to in the previous example, the citation would begin with the editor.

Baym, Nina, et al., eds. Norton Anthology of American Literature. 5th ed. 2 vols. New York: Norton, 1999.

Introduction, Preface, Foreword, or Afterword of a Book

Hirsch, Edward. Introduction. Transforming Vision: Writers on Art. By Art Institute of Chicago. Boston: Little, 1994. 9-11.

Selection from a Reference Book

Cite material from reference books as you would work in a collection, but omit the editor's name. If the article is signed, begin with the author's name. If contents in the reference book are arranged alphabetically, you may omit volume and page from the works cited list citation, but you should include them in the parenthetical citation in your text. If the reference work is well known and appears in frequent editions, full publication information is not needed. If you are drawing information from an on-line or electronic source, you will find information about formatting details later in this appendix.

MATERIAL FROM FAMILIAR SOURCE ARRANGED ALPHABETICALLY

"Rembrandt." The New Encyclopedia Britannica. 1998.

MATERIAL FROM LESS FAMILIAR SOURCE ARRANGED ALPHABETICALLY

Blasing, Mutlu Konuk. "Poetry: Since 1960." Benet's Reader's Encyclopedia of American Literature. New York: Harper, 1991.

"Hegira." <u>Merriam-Webster's Dictionary of Allusions</u>. Springfield, MA: Merriam-Webster, 1999.

MATERIAL FROM LESS FAMILIAR SOURCE WITH MULTIPLE SECTIONS

"Kentucky Living." <u>Magazines for Libraries</u>. New Providence, NJ: Bowker, 2000. 382.

SPECIFIC DICTIONARY DEFINITION AMONG SEVERAL

"Story." Def. 9. <u>Random House Dictionary of the English Language</u>. 2nd ed. 1987.

Cross References

When you cite several works from the same collection, avoid repetition and save space by using one main entry to which citations for specific works within it can refer. Note the absence of punctuation between the editor's name and the page numbers in this sample list of works from one collection.

Atwan, Robert. Foreword. Gould viii-xii.
Gould, Stephen J., ed. <u>The Best American Essays 2002</u>. Boston: Houghton, 1999.
---. "Introduction: To Open a Millenium." Gould xiii-xvii.
Mayblum, Adam. "The Price We Pay." Gould 213-18.

MLA Citation Formats for Articles in Periodicals

This section presents model citations for articles from print periodicals that you access either from a paper issue or through a database subscription service such as ProQuest or Academic Search Elite. The next section will present models for citing periodical articles that you access through a free, public Website.

The increasing number of full text articles available through libraries' subscription databases gives students the advantage of quick, convenient access to materials they need. However, when it is time to format citations for those materials, determining the best way to show readers how the materials were retrieved can often be a challenge. The models and notes supplied in this section should help you meet this challenge.

INFORMATION TO INCLUDE WHEN CITING PERIODICALS

Citations for periodical articles that originated in paper form should begin with the print information, then provide any details about electronic retrieval. To illustrate, we provide an annotated MLA style citation that provides information as follows:

Information Elements Needed for MLA Citations of Print Periodicals

Author. "Article Title." <u>Periodical Title</u> volume (date): page number(s).

Information Elements Needed for Adding Database Retrieval Details

<u>Database Name</u>. Database Company. Library, Place. Date accessed <URL for database homepage>.

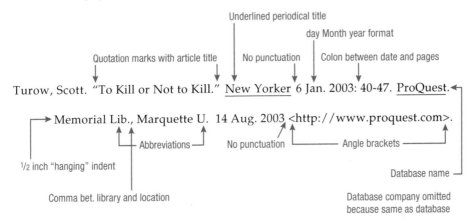

Additional Notes

- Note periods after each major element: author, article title, journal information, database name, location/subscriber for database, and retrieval date plus URL.
- If no author is listed, begin with the title. Do not use the word "anonymous" that appears in some databases unless it appears on the article in the periodical itself.
- MLA format calls for capitalizing all words of a title except *the, a, an,* and short prepositions, even if they are not capitalized in the original or the database.
- MLA format drops an initial *the* from names of periodicals.
- For variations in format for scholarly and general circulation periodicals, see the model citations. The two important distinguishing details to remember are these:
 1. Include volume numbers only for scholarly journals.
 2. Include edition information for newspaper articles when it is available.
- Providing first and last page numbers of an article is preferred unless the article pages are not consecutive.
- If the article's pages are not consecutive, provide the first page number followed by a plus sign.
- If a database service provides only the initial page, put a hyphen after the first page number, then a space, then a period, like this: 40- .
- In general, you may omit information that the electronic database omits.
- You may omit the name of the database company if it is not readily apparent from the search pages or if the name is the same as that of the database, as in the annotated example.

MODEL ARTICLE CITATIONS

Work from Scholarly Journal with Continuous Pagination Through Each Volume

ORIGINAL PAPER VERSION

Krabill, William, et al. "Greenland Ice Sheet: High-Elevation Balance and Peripheral Thinning." Science 289 (2000): 428-30.

ELECTRONIC VERSION RETRIEVED THROUGH LIBRARY DATABASE

Krabill, William, et al. "Greenland Ice Sheet: High-Elevation Balance and Peripheral Thinning." Science 289 (2000): 428-30. Academic Search Elite. EBSCO. Memorial Lib., Marquette U. 15 Sept. 2000 <http://www.epnet.com/>.

Work from Scholarly Journal That Begins with Page One in Each Issue

Pivnick, Janet. "A Piece of Forgotten Song: Recalling Environmental Connections." Holistic Education Review 10.4 (1997): 58-63.

- The numbers between the periodical title and date indicate the volume (10) and issue (4).

Magazine Articles

PUBLISHED WEEKLY (PAPER COPY)

Woodard, Colin. "The Great Melt: Is It Normal, or the Result of Global Warming?" Chronicle of Higher Education 14 July 2000: A20-21.

- The letter "A" is included with the page number because this publication, like many newspapers, has more than one section, each with separate page numbers.

PUBLISHED MONTHLY (FULL TEXT ACCESSED THROUGH LIBRARY DATABASE)

Tyler, Varro E. "Medicinal Teas: What Works, What Doesn't." Prevention Apr. 2000: 127+. ProQuest. Memorial Lib., Marquette U. 10 Sept. 2000 <http://proquest.umi.com/>.

PUBLISHED QUARTERLY (PAPER COPY)

Stephenson, Sam. "Nights of Incandescence." Doubletake Fall 1999: 46-51.

Newspaper Articles

SPECIAL CONSIDERATIONS WHEN CITING NEWSPAPER ARTICLES

- Give the paper's name as it appears in the masthead, but omit introductory *the*.
- If the city is not included in the name, add it in square brackets after the name: e.g., *Times-Picayune* [New Orleans].
- If an edition is listed, include it after the date because different editions of the same issue include different material and pagination.

- If sections of the paper are paginated separately, include identifying letters or labels (e.g., A9 or Sun. Mag. 15).

ARTICLE ACCESSED FROM PAPER COPY OF NEWSPAPER

Claiborne, William. "Iowa Looks Abroad for Workers." Washington Post 16 Sept. 2000, final ed.: A3.

ARTICLE ACCESSED VIA LIBRARY DATABASE

Claiborne, William. "Iowa Looks Abroad for Workers." Washington Post 16 Sept. 2000, final ed.: A3. Lexis-Nexis Academic Universe. Memorial Lib., Marquette U. 13 Oct. 2000 <http://web.lexis-nexis.com/universe>.

Editorial or Opinion Piece

"Soft Money Travesties." Editorial. New York Times 16 Sept. 2000, natl. ed.: A26.

Letter to the Editor

Use the label "letter" after the title, if a title is given. Otherwise, the word "letter" follows the author's name.

Clark, Diana Shaw. "Money and Horses." Letter. New Yorker 18 Sept. 2000: 18.

Review

Include title of the work reviewed (film, book, play, etc.) with the label, "Rev. of," then the author of the reviewed work, as relevant.

Denby, David. "Four Kings." Rev. of The Original Kings of Comedy. New Yorker 4 Sept. 2000: 88-89. [film review]

If the review is untitled, the reviewer's name is followed directly by the "Rev. of" label. Note the comma between the title of the reviewed work and "by."

Grimm, Nancy Maloney. Rev. of Between Talk and Teaching: Reconsidering the Writing Conference, by Laurel Johnson Black. College Composition and Communication 52 (2000): 156-59. [book review]

If the review is untitled and unsigned, begin with "Rev. of" and alphabetize the entry under the work's title. The following citation would be alphabetized under "J."

Rev. of The Jerusalem Syndrome. New Yorker 4 Sept. 2000: 8+. [theater review]

MLA Citation Formats for Internet Sources

As with citations for print sources, citations for material used from Web pages or other areas of the Internet should convey to readers two important matters: the quality of the source (author, sponsor, currency) and information about how to locate the material. For citations of Web sources, the writer's first challenge is

finding the relevant information for a citation; the second is using conventional format consistently. MLA style guidelines recommend that citations of electronic materials closely follow the format conventions for print citations. When formats are familiar, readers can take in their content quickly.

With electronic sources, not every detail will be available or relevant for every citation. Keep in mind your goals for providing readers with meaningful information and context, and include what you can. Err on the side of providing too much information rather than too little. In this section the annotated sample citation is followed by additional notes about what to include in MLA Internet citations, then a list of model citations for a variety of material types. One note of caution: if a Website offers information about how to cite the page, use the information elements provided, but present them in MLA format.

INFORMATION TO INCLUDE WHEN CITING INTERNET SOURCES

The *MLA Handbook* divides Web citations into five basic elements:

Author. "Document Title." Information about print publication. Information about electronic publication. Access information.[1]

Note that each of the five elements is followed by a period. However, within the final element, there is no punctuation between the date of access and the URL. The result links the two, as if to say, "on this date this material was available at this address."

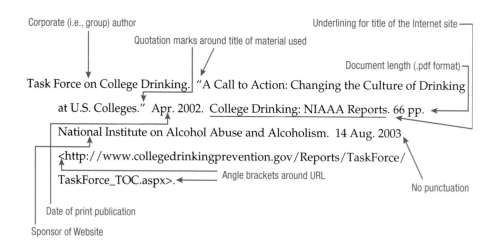

[1]Joseph Gibaldi, *MLA Handbook for Writers of Research Papers*, 6th ed. (New York: MLA, 2003) 208.

Additional Notes

AUTHORS

- You will sometimes need to decide whether to put the name of a corporate author at the left margin or after the document and site titles, in the "sponsor" slot. This decision will depend on what details are available and what you want to emphasize in your text, because the word that begins the works cited entry appears in the parenthetical citation. To see different possibilities, contrast the model citations listed under "Material from an Organization Site" and the examples from Trek Bicycle and Harley-Davidson under "Material from a Commercial Site."
- If the work or the entire site has an editor, translator, or compiler not already cited in the "author" slot, include that name (in regular name order) after the title of the work or site, then add an appropriate abbreviation (e.g., "Ed.") if available.

DOCUMENT TITLE

- In most cases, the Website and document titles will be distinct. The document title comes first; the format is analogous to an article title followed by a book or periodical title. Punctuate titles according to the guidelines for book and article citations.

PRINT PUBLICATION

- If the work has appeared in print but you are retrieving it from a Website, simply follow the guidelines in the previous sections when you format this element of the citation.

ELECTRONIC PUBLICATION

- The site title is one of the most important identifiers in the citation. It should be underlined. If this title is not absolutely clear on the page itself, use the title that appears at the very top of your browser screen. If the site title is already evident from the name of a corporate author such as Trek Bicycle or American Library Association, you can omit it here. When no title is immediately apparent, break down the URL to find the larger site or consider using a label (e.g., "Home page") if it would be helpful.
- Numbers for the date of electronic publication or last update (if available), volume and issue numbers (if relevant), and the electronic document's total number of pages or paragraphs (if numbered) should be placed after the site title.
- The name of the institution or organization sponsoring the site—if not already listed earlier as corporate author or in the site title—concludes the electronic publication portion of the citation. This detail provides important information about context. In cases where it is difficult to discern a

sponsor, it would be wise to spend a few minutes looking for one by breaking down the URL.

ACCESS INFORMATION

- Unlike the format for periodicals accessed through a subscription database, citations for public access Websites must present the specific URL for the material used. For accuracy, copy and paste the URL from your browser window. Remove any hyperlink that transfers with the address.
- MLA style places URLs in angle brackets. Break URLs across lines only at a slash mark.

ALTERNATIVES TO PROVIDING A URL

When the URL of a document you refer to is unique to a particular subscription, not evident, or unmanageably long, you have several options.

- Provide the URL for the subscription service's home page:

 "Suzan-Lori Parks." Contemporary Authors Online. Biography Resource Center. 8 Aug. 2003. 15 Aug. 2003 <http://www.galenet.com>.

- End with the date of access:

 "Suzan-Lori Parks." Contemporary Authors Online. Biography Resource Center. 8 Aug. 2003. 15 Aug. 2003.

- Provide the URL for the sponsoring Website's search page:

 "Manatee Mortality." Save the Manatee Club. 2002. 29 July 2003 <http://www.savethemanatee.org/search_post.cfm>.

- Provide the keyword used by a personal subscription service, labeled as such:

 "AOL Latino Fact Sheet." AOL Keyword: Latino. America Online. 15 Aug. 2003. Keyword: Latino.

- Conclude with the path to follow from an organization's or a personal subscription service's home page:

 Mellon, Margaret, and Jane Rissler. "Environmental Effects of Genetically Modified Food Crops: Recent Experiences." Union of Concerned Scientists. 31 July 2003. 31 July 2003 <http://www.ucsusa.org>. Path: Food; Biotechnology; Special Features.

MODEL INTERNET CITATIONS

An Entire Website

Nonprofit Portal of Greater Milwaukee. Barbara Duffy. 16 July 2003. Center for Initiatives and Research, University of Wisconsin–Milwaukee. 15 Aug. 2003 <http://epic.cuir.uwm.edu/NONPROFIT/>.
Bill of Rights Defense Committee. 15 Aug. 2003. 15 Aug. 2003 <http://bordc.org/>.

A Course or Department Home Page

McManus, Barbara F. Greek Tragedy. Course syllabus. Sept.-Dec. 1999. Classics, College of New Rochelle. 15 Aug. 2003 <http://www.cnr.edu/home/bmcmanus/tragedysyl.html>.

Peace Studies. Program home page. Cornell U. 2003. 15 Aug. 2003 <http://www.einaudi.cornell.edu/PeaceProgram/>.

A Personal Home Page

Tannen, Deborah. Home page. 17 April 2000. 29 July 2003 <http://www.georgetown.edu/faculty/tannend/index.htm>.

Material from an Online Reference Database

"Kempe, Margery." Encyclopaedia Britannica Online. 13 Oct. 2000 <http://www.eb.com:180/bol/topic?eu=46106&sctn=1>.

Material from an Online Scholarly Project

"Yoknapatawpha County." William Faulkner on the Web. John B. Padgett. 31 May 2000. University of Mississippi. 13 Oct. 2000 <http://www.mcsr.olemiss.edu/~egjbp/faulkner/glossaryy.html#Yoknapatawpha>.

E-Book

Bok, Edward William. The Americanization of Edward Bok. New York: Scribner's, 1921. Bartleby.Com. 5 Oct. 2000. 13 Oct. 2000 <http://www.bartleby.com/197/>.

Article from a Scholarly E-Journal

Mazer, Emmanuel, Juan Manuel Ahuactzin, and Pierre Bessière. "The Ariadne's Clew Algorithm." Journal of Artificial Intelligence Research 9 (1998): 295-316. 10 Nov. 1998. 13 Oct. 2000 <http://www.cs.cmu.edu/afs/cs/project/jair/pub/volume9/mazer98a-html/ariane.html>.

Periodical or Newspaper Article Published Online

Appelbaum, Richard, and Peter Dreier. "The Campus Anti-Sweatshop Movement." American Prospect Online 46, Sept.-Oct. 1999. 7 June 2000 <http://www.prospect.org/archives/46/46appelbaum.html>.

Scodel, Harvey. "Illiteracy Test." Email to the Editors. Slate 24 Apr. 1997. Microsoft. 23 May 2000 <http://slate.msn.com/Email/97-04-24/Email.asp>.

Stolba, Christine, and Sally Satel. Rev. of Genes, Women, Equality, by Mary Briody Mahowald. New England Journal of Medicine 8 June 2000. Massachusetts Medical Society. 19 Sept. 2000 <http://www.nejm.org/content/2000/0342/0023/1761.asp>.

Streitfeld, David. "Court Says Napster Must Stop." washingtonpost.com 12 Feb. 2001. 12 Feb. 2001 <http://www.washingtonpost.com/wp-dyn/articles/A59310-2001Feb12.html>.

Article Posted on a Website

Cohn, Ed. "The Civil Society Debate." Electronic Policy Network. 13 Oct. 2000
 <http://tap.epn.org/issues/civilsociety.html>.
Puentes, Robert. "Flexible Funding for Transit: Who Uses It?" Center on Urban and
 Metropolitan Policy. 17 May 2000. 11 pp. Brookings Institution. 13 Oct. 2000
 <http://www.brookings.org/es/urban/flexfunding.pdf>.

Material from an Organization Site

"CIPA Updates." American Library Association. 15 Aug. 2003. 15 Aug. 2003
 <http://www.ala.org/>. Path: Our Association; Offices; Washington Office; Issues;
 Civil Liberties; Intellectual Freedom and Privacy; CIPA.
National Sleep Foundation. "How's Your Sleep?" 12 July 2003 <http://
 www.sleepfoundation.org/howsyoursleep.html>.
Thacker, Shane. "Dos and Don'ts of Grant Proposals for Tech Funding." The
 Grantsmanship Center Magazine. Fall 2000. The Grantsmanship Center. 15 Aug. 2003
 <http://www.tgci.com/magazine/00fall/dosdonts.asp>.

Cartoon or Comic Strip

Horsey, David. "Letter from Home." Cartoon. Seattle Post-Intelligencer: David Horsey.
 17 Aug. 2003. 15 Aug. 2003 <http://seattlepi.nwsource.com/horsey/>.

Posting to a Discussion List, Online Forum, or Weblog

Sullivan, Andrew. "Marriage Again." Online posting. "Daily Dish."
 Andrewsullivan.com. 10 July 2003. 15 Aug. 2003 <http://www.andrewsullivan.com/
 index.php?dish_inc=archives/2003_07_06_dish_archive.html>.

- Whenever possible, provide the URL for the posting's archival version
 so that readers can find it readily.

Material from an Online Information Service

"Guillain-Barré Syndrome." OnHealth.Com. OnHealth Network Company. 15 Feb. 2000
 <http://onhealth.webmd.com/conditions/resource/conditions/item,41282.asp>.

Online Transcript from Television or Radio Program

Havel, Vaclav. "Newsmaker Interview." With Margaret Warner. Online NewsHour.
 PBS. 16 May 1997. Transcript. 21 May 1997 <http://www.pbs.org/newshour/bb/
 europe/jan-june97/havel_5-16.html>.

Television or Radio Broadcast Available Online

Sound Portraits Productions. "Witness to an Execution." All Things Considered. 12 Oct.
 2000. NPR. 12 Oct. 2000 <http://www.npr.org/programs/atc/witness/>.

Material from a Commercial Site

"Harley-Davidson History." Harley-Davidson Motor Company. 17 June 2000 <http://
 www.harley-davidson.com/company/history/history.asp>.

Trek Bicycle Corporation. "Mission Statement." Home page. 18 July 2000. 15 Oct. 2000 <http://www.trekbikes.com/abouttrek/index.html>.

MLA Citation Formats for Other Materials and Media

Government Publications

The information and formats required for citing government documents varies considerably, so it is advisable to consult a specialized handbook such as the *Complete Guide to Citing Government Information Resources*. The following citation, which identifies the government "author" first by country, then by three increasingly smaller bodies, provides a basic model.

United States. Cong. Senate. Committee on Energy and Natural Resources. Global
 Climate Change: Hearing. 104th Cong., 2nd sess. Washington, D.C.: GPO, 1997.

Historical documents and federal laws—the United States Code (USC)—do not need to be listed in the works cited list because they can be cited adequately with an in-text parenthetical citation, for example: "(US Const., art. 3, sec. 1)" or "(17 USC 554, 2000)."

If you want to cite the text of a federal bill or law directly, you can retrieve it from *Thomas*, the Library of Congress's data bank of legislative information. Use the citation model that follows below. The first date is the date of enactment (usually different from the day it was approved by Congress). The last is the date of retrieval; if a date of posting were available, it would be placed between the site title and sponsor (as in other citations for Web material).

Children's Internet Protection Act. Pub. L. 106-554. 21 Dec. 2000. Thomas: Legislative
 Information on the Internet. Lib. of Congress, Washington, DC. 18 Jan. 2001
 <http://thomas.loc.gov/cgi-bin/cpquery/R?cp106:FLD010:@1(hr1033):URL>.

If you are working on something that requires numerous legal citations, refer to the current edition of *The Blue Book: A Uniform System of Citation*, the standard editorial reference for attorneys. Always check with your professor about the citation systems preferred for a given course.

Biblical Citations

Whenever you plan to discuss any sacred texts in a paper, be sure to ask your instructor what kind of citation information you need to provide and what format to use.

Material from the Judeo-Christian Bible as well as from sacred writings in other traditions is typically cited in the text by an abbreviation for the name of the book, then chapter and verse numbers. Page numbers are not used because the citation already permits the reader to find the passage in any version of the Bible. Include the edition of the Bible in your first reference. For example, (New Oxford Annotated Bible, Ps. 19:7) refers to this full citation:

<u>The New Oxford Annotated Bible</u>. New Revised Standard Version. Ed. Bruce M.
 Metzger and Roland E. Murphy. New York: Oxford, 1991.

In MLA format, a particular published edition of the Bible is underlined, but the
version is not. In some classes, especially in religious studies or theology courses,
you may be expected to note only the version, thus eliminating the need for a ci-
tation on your works cited list. You would then use in-text citations such as
these: (New Revised Standard Version Bible, Ps. 19:7) or (New English Bible, Col.
3:12-17). On later references, the version may be omitted or abbreviated, in these
cases to "NRSV" and "NEB."

Lecture, Speech, or Conference Paper

Jamieson, Kathleen Hall. "Deliberation, Democratic Politics, and Journalism." James A.
 Moffett '29 Lecture in Ethics. Princeton University. 17 Feb. 2000.

Material in Varying Media from an Information Service

Follow guidelines for the original media (print publication, lecture, or paper pres-
entation, etc.), adding the information service identification code at the end. The
example is for a document available through ERIC (Educational Resources In-
formation Center) in both paper and microfiche as well as online full text.

CITATION FOR PRINT OR MICROFICHE

Barrow, Lloyd H. "Preservice Methods Students' Response to a Performance Portfolio
 Assignment." Paper presented at the Annual Meeting of the American Educational
 Research Association. New Orleans. April 24-28, 2000. ED 442 826.

CITATION FOR ONLINE TEXT

Follow the model for periodicals accessed through a database. First provide in-
formation for paper copy, then add the database information:

Barrow, Lloyd H. "Preservice Methods Students' Response to a Performance Portfolio
 Assignment." Paper presented at the Annual Meeting of the American Educational
 Research Association. New Orleans. April 24-28, 2000. ED 442 826. <u>ERIC Document
 Reproduction Service</u>. Ovid. Memorial Lib., Marquette U. 10 Sept. 2000
 <http://gateway2.ovid.com/>.

CD-ROM

Follow guidelines for print publications, but specify the publication medium, any
vendor (e.g., SilverPlatter, Microsoft, etc.), and dates for both print and electronic
publication/update, as available.

"Haiti." <u>Concise Columbia Encyclopedia</u>. 1995. CD-ROM. Microsoft Bookshelf, 1995.

Video Recording

Unless your discussion focuses on the contributions of a particular person (per-
former, director, narrator, etc.), begin with the title, underlined, and include the
director, distributor, and year of release. Add other pertinent material between
title and distributor.

Australia's Twilight of the Dreamtime. Writ/Photog. Stanley Breeden. National
 Geographic Society and WQED, Pittsburgh, 1988.

Sound Recording

Your decision about whom to cite first—the performer, composer, or conductor—
depends on the point you are making. The following citation, for example, em-
phasizes the performers and notes the composer.

Ma, Yo-Yo, and Bobby McFerrin. "Grace." By Bobby McFerrin. Hush. Sony, 1992.

 If you cite liner notes or a libretto, provide that genre label before the title.
If the original recording date is important, provide it after the title; then indicate
any medium other than a CD followed by the manufacturer and production
date.

Coltrane, John. Liner notes. A Love Supreme. Rec. 9 Dec. 1964. LP. Impulse, 1964.

TV or Radio Program

"Take This Sabbath Day." The West Wing. Writ. Aaron Sorkin. Dir. Thomas Schlamme.
 NBC. WTMJ, Milwaukee. 9 Feb. 2000.

APA Citation Formats for Books

The most prominent features of APA format are that initials are used for author's
first names and that the date of publication is placed in parentheses immediately
after the author's name. Indeed, scholars accustomed to using APA citations typ-
ically refer to works by author-date shorthand, such as "Wolfson and Carskadon
1991" or "Tannen 1997." (For further discussion about this, see the discussion of
APA parenthetical references in Chapter 7.)

 If you do not find a model citation that fits the type of material you need to
cite either in this appendix or in the APA *Publication Manual*, follow APA's ad-
vice to look over the available models, choose one that most closely matches
your source, and use that format. (We have followed this advice in the sample
citations for entire Websites and for an online transcript.) Finally, as the manual
says, "when in doubt, provide more information rather than less."[2]

INFORMATION TO INCLUDE WHEN CITING BOOKS

The annotated citation for an entire book presents four information elements in
this format:

Author. (Date). *Title*. City, State: Publisher.

 [2]*Publication Manual of the American Psychological Association*, 5th ed. (Washington, D.C.:
APA, 2001), 232.

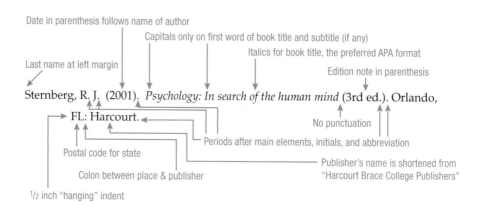

Date in parenthesis follows name of author

Capitals only on first word of book title and subtitle (if any)

Italics for book title, the preferred APA format

Last name at left margin

Edition note in parenthesis

Sternberg, R. J. (2001). *Psychology: In search of the human mind* (3rd ed.). Orlando, FL: Harcourt.

No punctuation

Periods after main elements, initials, and abbreviation

Postal code for state

Publisher's name is shortened from "Harcourt Brace College Publishers"

Colon between place & publisher

½ inch "hanging" indent

MODEL BOOK CITATIONS

Book by One Author

Firstenberg, P. B. (1996). *The 21st century nonprofit: Remaking the organization in the post-government era.* New York: Foundation Center.

Book with Two or More Authors or Editors

Banta, T. W., Lund, J. P., Black, K. E., & Oblander, F. W. (1996). *Assessment in practice: Putting principles to work on college campuses.* San Francisco: Jossey-Bass.

- APA reference entries list all authors by surname plus initials, listing surname first for all. See Chapter 7 for guidance about using "et al." in APA parenthetical citations.
- Ampersand (&) is used instead of "and."

Two or More Works by the Same Author

Alphabetize the references first by author's name, using the full name for each entry, then arrange them by year of publication, earliest first. One-author entries precede and are sequenced separately from multiple-author entries. Multiple-author entries are alphabetized first by the first author's surname, then by the surname of the second author, third author, and so on. When authorship is identical, put earlier articles first. (See Chapter 7 for details about internal citations with multiple authors.)

Carskadon, M. A. (Ed.). (1993). *Encyclopedia of sleep and dreaming.* New York: MacMillan.
Carskadon, M. A. (Ed.). (2002). *Adolescent sleep patterns: Biological, social, and psychological influences.* New York: Cambridge University Press.
Carskadon, M. A., & Mancuso, J. (1988). Sleep habits in high school adolescents: Boarding versus day students. *Sleep Research, 17,* 74.
Carskadon, M. A., & Taylor, J. F. (1997). Public policy and sleep disorders. In M. R. Pressman & W. C. Orr (Eds.), *Understanding sleep: The evaluation and treatment of sleep disorders* (pp. 111–122). Washington, DC: American Psychological Association.

Book or Brochure with Corporate Author

National Sleep Foundation. (2002). *ABC's of ZZZ's: When you can't sleep.* [Brochure].
 Washington, DC: Author.

- When the corporate author and publisher are the same, the word "Author" is placed where the publisher's name usually appears.
- The bracketed label informs readers about what type of document is being cited.

Book with No Author or Editor Listed on Title Page

Publication manual of the American Psychological Association (5th ed.). (2001). Washington,
 DC: American Psychological Association.

Translated Book

Freud, A. (1935). *Psycho-analysis for teachers and parents: Introductory lectures* (B. Low,
 Trans.). New York: Emerson.

- If it is available, include the original publication date in parenthesis at the end of the citation with the following phrase: "(Original work published [insert year])"—omit final punctuation.
- APA uses conventional name order for editors, translators, and so on, when their names are placed after the main title that is cited in the entry.

Subsequent and Revised Editions of a Book

White, E. M. (1994). *Teaching and assessing writing* (2nd ed.). San Francisco: Jossey-Bass.

- The edition note is treated as part of the title but not italicized, and the period ending the title element comes after the closing parenthesis.

Technical and Research Reports

Task Force on College Drinking. (2002). *A call to action: Changing the culture of drinking at
 U.S. colleges.* (National Institutes of Health Pub. No. 02-5010). Washington, DC:
 National Institute on Alcohol Abuse and Alcoholism.

- This citation refers to the paper publication of the report.

Edited Collection

Buley-Meissner, M. L., Thompson, M. M., & Tan, E. B. (Eds.). (2000). *The academy and the
 possibility of belief.* Cresskill, NJ: Hampton.

- Parentheses are used around "Ed." or "Eds." after the name(s).
- The period after "(Eds.)" signals that the editor designation is part of the author element.

Selection from an Edited Collection

Carskadon, M. A. (2002). Risks of driving while sleepy in adolescents and young adults. In M. A. Carskadon (Ed.), *Adolescent sleep patterns: Biological, social, and psychological influences* (pp. 148–158). New York: Cambridge University Press.

- APA style capitalizes only the first word of chapter and article titles and any subtitle.
- The phrase about the larger collection (editor, title, pages) begins with "In" and is treated as a single element.
- Note conventional name order for editor.
- APA uses the abbreviations "p." and "pp." to locate works within a book and does not shorten the second number in inclusive pagination.

Work Reprinted in an Anthology

Use the date of the reprint after the author's name; provide information about the original publication, if available, in parenthesis at the end of the reference without end punctuation.

Villanueva, V., Jr. (1996). *Inglés* in the colleges. In M. Wiley, B. Gleason, L. W. Phelps, *Composition in four keys: Inquiring into the field* (pp. 503-519). Mountain View, CA: Mayfield. (Reprinted from *Bootstraps*, pp. 65–90, by V. Villanueva, Jr., 1993, Urbana, IL: National Council of Teachers of English)

- An in-text, parenthetical reference to this reprint would read: (Villanueva, 1993/1996).

Selection from a Multivolume Work

Melville, H. (1987). Bartleby, the scrivener. In H. Hayford, H. Parker, & G. T. Tanselle (Vol. Eds.), *Piazza tales and other prose pieces: Vol. 9. The writings of Herman Melville* (pp. 13–45). Evanston & Chicago: Northwestern University Press and Newberry Library.

Introduction, Preface, Foreword, or Afterword of a Book

Lacroix, C. (1993). Preface. In J. Peacock, *20th-century fashion: The complete sourcebook* (pp. 6–7). New York: Thames & Hudson.

Selection from a Reference Book

Chambers of rhetoric. (2001). *The new Penguin dictionary of the theater* (p. 113). London: Penguin.

Pincus, A.L., & Ruiz, M.A. (2001). Five-factor model of personality. *The Corsini encyclopedia of psychology and behavioral sciences* (3rd ed., Vol. 2, pp. 582–585). New York: Wiley.

- When the reference article or entry has no byline, begin with the title.

APA Citation Formats for Articles in Periodicals

In this section of the appendix you will find model APA style citations for print periodical articles that are accessed either directly from a paper issue or through a database subscription service such as ProQuest or Academic Search Elite. Models for formatting periodicals materials accessed through free, public Websites are presented in the next section.

INFORMATION TO INCLUDE WHEN CITING PERIODICALS

Acknowledging the widespread use of subscription databases as a tool for retrieving research materials, the latest edition of the *APA Publication Manual* (2001) announced a simplified method for referencing these materials that involves just two parts: (1) information about print publication, and (2) a retrieval statement that indicates the name of the database and the date of access. Here is the format:

Author. (Date). Article title. *Periodical Title, vol #,* page number(s). Retrieved Month Date, Year, from Database Name.

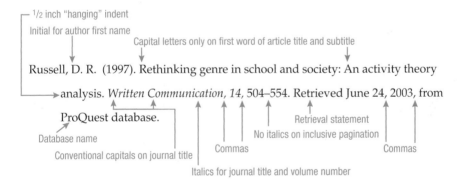

Additional Notes

- APA style does not abbreviate the names of months.
- Periods close each major element: author, date, article title, periodical information (*name, volume,* pages), retrieval statement.
- If no author is listed, begin with the title. Do not use the word "anonymous" that appears in some databases unless it appears on the article in the periodical itself.
- When an article's pages are not consecutive, APA format requires numbers for all pages on which it appears.
- APA format does not drop *the* from names of periodicals.
- For variations in format for scholarly and general circulation periodicals, see the model citations. Two distinguishing details are worth noting:

1. Add publication month and day for weeklies and dailies.
2. Use "p." and "pp." when there is no volume number.

MODEL ARTICLE CITATIONS

Work from Scholarly Journal with Continuous Pagination Through Each Volume

Revonsuo, A. (2000). The reinterpretation of dreams: An evolutionary hypothesis of the function of dreaming. *Behavioral and Brain Sciences, 23,* 877–901.

Work from Scholarly Journal that Begins with Page One in Each Issue

Kessler, R. (1997). Social and emotional learning: An emerging field builds a foundation for peace. *Holistic Education Review, 10*(2), 4–15.

- Note that the italics stop with the volume number; the parenthetical issue number is not italicized even though it follows without a space.

Magazine and Newsletter Articles

PUBLISHED WEEKLY (PAPER COPY)

Hertzberg, H. (2003, June 9). Building nations. *The New Yorker,* pp. 39–40.

PUBLISHED MONTHLY, ARTICLE NOT ON CONTIGUOUS PAGES (PAPER COPY)

Tremain, K. (2003, September–October). Pink slips in the parks: The Bush administration privatizes our public treasures. *Sierra, 88*(5), 26–33, 52.

MONTHLY NEWSLETTER WITH VOLUME AND ISSUE NUMBERS

Spinal stenosis. (2001, June). *Mayo Clinic Health Letter, 19*(6), 1–3.

PUBLISHED MONTHLY (FULL TEXT ACCESSED THROUGH LIBRARY DATABASE)

Lamb, J. (2003, July). How to write a marketing plan, part 1: Product. *Stitches,* p. 8. Retrieved August 24, 2003, from LexisNexis database.

PUBLISHED QUARTERLY, INDIVIDUAL ISSUES NUMBERED (PAPER COPY)

Alter, S. K. (2003, Spring). Business planning for social enterprises. *The Grantsmanship Center Magazine, 46,* 21–22.

Newspaper Articles

ARTICLE ACCESSED FROM PAPER COPY

Coyne, A. (2002, November 3). How to visit your mother in prison. *Milwaukee Journal Sentinel,* p. 1L.

ARTICLE ACCESSED VIA LIBRARY DATABASE

Boxer, S. (2003, May 25). Prospecting for gold among the photo blogs. *The New York Times,* p. 2.1. Retrieved August 24, 2003, from ProQuest New York Times database.

Work Without a Listed Author

Seeing the light. (2003, Summer). *Cathedral Age*, pp. 16–17.

Editorial or Opinion Piece

An empty energy bill [Editorial]. (2003, May 12). *The New York Times*, p. A24.

Ehrenberg, R. G. (2003, August 15). Who pays for the growing cost of science? [Opinion article]. *The Chronicle of Higher Education*, p. B24.

- Identify nonroutine materials with a label in brackets immediately after the work's title, before the period. When there is no title, brackets signal that the words are a label, not a title, as in the Letter to the Editor example below).

Letter to the Editor

Kushner, H. (2003, February 3). [Letter to the editor]. *The New Yorker*, p. 7.

Review

Lahr, J. (2003, February 17 & 24). Rhythm and blues: "Ma Rainey" and August Wilson's mighty music [Review of the play *Ma Rainey's black bottom*]. *The New Yorker*, pp. 190–191.

MacFarquhar, L. (2003, February 3). Bark: Do dogs have history? [Review of the book *The pawprints of history*]. *The New Yorker*, pp. 88–92.

Wilkey, C. (2003). [Review of the book *Community action and organizational change: Image, narrative, identity*]. *College Composition and Communication, 54*, 664–666.

APA Citation Formats for Internet Sources

Use the model citations in this section for materials that you access electronically through the free, public part of the Internet. The APA manual lays out two primary guidelines for citing Internet sources: (1) "Direct readers as closely as possible to the information being cited—whenever possible, reference specific documents rather than home or menu pages"; (2) "Provide addresses that work" (2001, p. 269). APA style does not offer alternatives to providing a URL and does not put a period at the end of a URL. One note of caution: if a Website offers information about how to cite the page, use the information elements provided, but convert them to APA format.

INFORMATION TO INCLUDE
WHEN CITING INTERNET SOURCES

APA format for Internet materials uses a retrieval phrase that includes the date of retrieval and the URL for the source. These phrases read almost like a sentence but do not have end punctuation. Here is the basic model:

Author. (Date). *Title of the work.* Retrieved Month day, year, from http://www.fillin.URL

Month day, year, format for retrieval

Authors — Year first for date of posting Italics for title of material cited

Mellon, M., & Rissler, J. (2003, July 31). *Environmental effects of genetically modified*

food crops: Recent experiences. Retrieved July 31, 2003, from

Union of Concerned Scientists Web site: http://www.ucsusa.org/

food_and_environment/biotechnology/page.cfm?pageID=1219

APA style treats "Web site" as two words

No period after URL means none at end of reference

Retrieval phrase names site sponsor, followed by a colon before URL

Break a URL across lines *only* at a slash

Additional Notes

- When relevant, the name of the Website sponsor should be inserted in the retrieval statement, as in the annotated example.
- Distinguish between article and periodical titles by using italics only on the periodical title.
- Use parentheses to provide relevant information about the role played by individuals listed (e.g., writer, producer) and brackets to provide descriptive labels for media (e.g., broadcast, CD, online posting).

MODEL INTERNET CITATIONS

An Entire Website

APA does not provide a reference model for entire Websites, but following the *Publication Manual's* advice to use a model most like the source, we worked from the format for documents from Websites. In the place of the publication date we used the most recent update, and for natural phrasing, we used "accessed ... at" in the retrieval phrase.

Bill of Rights Defense Committee [Web site]. (2003, August 29). Accessed September 1, 2003, at http://bordc.org/

Site Within a University Program or Department Site

This example is also extrapolated from the models for material available from Websites.

Nonprofit Portal of Greater Milwaukee. (2003, July 16). Accessed August 15, 2003, from University of Wisconsin–Milwaukee, Center for Initiatives and Research Web site: http://epic.cuir.uwm.edu/NONPROFIT/

- Use a colon before the URL when the retrieval statement includes descriptive information after "from."

Material from an Online Reference Database

Calligraphy. (2003). In L. Macy (Ed.), *The Grove dictionary of art online*. Retrieved September 3, 2003, from http://www.groveart.com

Material from an Online Scholarly Project

Johnson, B. R. & Larson, D. B. (2003). *The InnerChange Freedom Initiative: A preliminary evaluation of a faith-based prison program*. Retrieved September 4, 2003, from University of Pennsylvania, Center for Research on Religion and Urban Civil Society Web site: http://www.sas.upenn.edu/crrucs/8_research.html

E-Book

Carpenito, L. J. (1999). *Nursing care plans and documentation*. Retrieved September 4, 2003, from Books@Ovid.com Web site: http://pco.ovid.com/lrppco/index.html

Article from a Scholarly E-Journal

ARTICLE BASED ON A PRINT SOURCE

Henze, G. P. (2001). Building energy management as continuous quality control process [Electronic version]. *Journal of Architectural Engineering, 7*, 97–106.

ARTICLE FROM AN INTERNET-ONLY JOURNAL

Kirsch, I., Moore, T. J., Scoboria, A., & Nicholls, S. S. (2002, July 15). The emperor's new drugs: An analysis of antidepressant medication data submitted to the U.S. Food and Drug Administration. *Prevention & Treatment, 4*, Article 23. Retrieved September 4, 2003, from http://journals.apa.org/prevention/volume5/pre0050023a.html

Periodical or Newspaper Article Published Online

Orenstein, C. (2003, September 5). What Carrie could learn from Mary. *The New York Times*. Retrieved September 5, 2003, from http://www.nytimes.com/2003/09/05/opinion/05OREN.html?th

Article Posted on a Website

Greenberg, D. H. & Pasternak, J. (1998, Spring). Age discrimination in the workplace. *The Successful California Accountant*. Retrieved March 5, 2002, from the Discriminationattorney.com Web site: http://www.discriminationattorney.com/article-age.html

- When available, volume, issue, and page numbers should be provided.

Material from an Organization Site

American Library Association. (2003, September 4). CIPA updates. Retrieved September 5, 2003, from http://www.ala.org/Content/NavigationMenu/Our_Association/Offices/ALA_Washington/Issues2/Civil_Liberties,_Intellectual_Freedom,_Privacy/CIPA1/CIPA.htm

Cartoon or Comic Strip

Trudeau, G. (2003, September 6). Doonesbury [Comic strip]. Retrieved September 6, 2003, from http://www.ucomics.com/doonesbury/

Posting to a Discussion List, Online Forum, or Weblog

Pax, S. (2003, March 25). Where is Raed? [Online posting]. Retrieved September 6, 2003, from http://dear_raed.blogspot.com/2003_03_01_dear_raed_archive.html

- References lists should cite only archived material that readers can retrieve. If you are using personal communication, refer to it only in the text, as in this example: "Scott (personal communication, June 27, 2004) reported . . ."

Material from an Online Information Service

Grayson, C. (2002, January 1). Understanding snoring. Retrieved September 6, 2003, from http://my.webmd.com/content/article/8/1680_54137

Online Transcript from Television or Radio Program

Crystal, L. (Executive Producer). (2000, April 14). Love and knowledge [Transcript of television interview with Margaret Edson]. *Online NewsHour.* Retrieved January 10, 2003, from http://www.pbs.org/newshour/bb/entertainment/jan-june99/edson_4-14.html

- This example adds a bracketed label and a retrieval statement to the APA model for a television broadcast.

Television or Radio Broadcast Available Online

Arnold, E. (Reporter). (2002, April 9). ANWR [Broadcast segment]. *All Things Considered.* Washington, D.C.: National Public Radio. Retrieved August 7, 2003, from http://discover.npr.org/features/feature.jhtml?wfId=1141379

Data File

Department of Health and Human Services. Substance Abuse and Mental Health Services Administration. Office of Applied Studies. (2000). *National Household Survey on Drug Abuse, 2000* (Study #3262) [Data file]. Available from Substance Abuse and Mental Health Data Archive, http://www.icpsr.umich.edu/SAMHDA/

APA Citation Formats for Other Materials and Media

Government Publications

Columbia Accident Investigation Board. (2003). Final report. Washington, DC: U.S. Government Printing Office.

The APA *Publication Manual* has a lengthy appendix regarding citation of legal materials—consult it or the current edition of *The Blue Book: A Uniform System of Citation* if you need to reference court cases, statutes, or legislative proceedings.

Lecture, Speech, or Conference Paper

Suskind, R. (2003, September 4). [Public lecture]. Marquette University, Milwaukee, WI.

Material in Varying Media from an Information Service

CITATION FOR PRINT OR MICROFICHE

Hopkins, S. (2000). *VET and the voluntary sector: Dealing with ambiguities.* (ERIC Document Reproduction Service No. ED470938)

CITATION FOR ONLINE TEXT

Hopkins, S. (2000). *VET and the voluntary sector: Dealing with ambiguities.* (ERIC Document Reproduction Service No. ED470938). Electronic version retrieved September 7, 2003, from Ovid.

Video Recording

Taylor, D. (Translator/Director). (1991). *Antigone* [Video recording]. BBC & Films for the Humanities. (Available from Films for the Humanities, PO Box 2053, Princeton, NJ 08543-2053)

Sound Recording

Fields, D. & McHugh, J. (n.d.). Exactly like you. [Recorded by T. Bennett & K. D. Lang]. On *A wonderful world* [CD]. New York: Sony. (2002)

TV or Radio Program

Cohen, D. (Writer), & Kirkland, M. (Director). (1995). Lisa the vegetarian [Television series episode]. In B. Oakley & J. Weinstein (Producers) *The Simpsons*. Los Angeles, CA: Fox Broadcasting Company.

Credits

Chapter 9

Chapter 10

Chapter 11

322 Kirk Savage, "The Past in the Present: The Life of Memorials," *Harvard Design Magazine* Fall 1999. Reprinted by permission of the author.

331 Neal Gabler, "Our Celebrities, Ourselves," *Chronicle of Higher Education* 14 Mar. 2003. Copyright © 2003 Neal Gabler. Used with permission.

337 Sarah Boxer, "I Shop, Ergo I Am: The Mall as Society's Mirror," *New York Times* 28 Mar. 1998: A13, A15. Copyright © 1998 New York Times, Inc.

341 "The Lesson" from Toni Cade Bambara, *Gorilla, My Love*. Copyright © 1972 by Toni Cade Bambara. Reprinted by permission of Random House, Inc.

348 William Saletan, "The Elian Pictures," *Slate* 24 Apr. 2000. Copyright © Slate/Distributed by United Feature Syndicate, Inc. Used with permission.

354 Heather Wendtland, "Rebellion Through Music." Copyright © Heather Wendtland. Used by permission.

Chapter 12

370 Tom Friedman, "Eastern Middle School," *New York Times* 2 Oct. 2001. Copyright © 2001 New York Times Company, Inc. Used with permission.

372 Headline "Great Satan? Terrorists Misread America's Soul," *Milwaukee Journal Sentinel*. Oct. 2001. Copyright © 2003 Journal Sentinel Inc. Reproduced with permission.

376 Kathleen Parker, "For Starters, We Can Require Trigger Locks," 5 Mar. 2000. Copyright © 2000 Tribune Media Services, Inc. Used with permission.

377 Kathleen Parker, "Revisiting the Issue of Trigger Locks," 8 Mar. 2000. Copyright © 2000 Tribune Media Services, Inc. Used with permission.

380 "Public Statement by Eight Alabama Clergymen," *Birmingham News* 12 Apr. 1963. Copyright © 2003 The Birmingham News. All rights reserved. Reprinted with permission.

381 Martin Luther King, Jr., "Letter from Birmingham Jail." Reprinted by arrangement with the Estate of Martin Luther King, Jr., c/o Writers House, Inc. as agent for the proprietor. Copyright © 1963 Martin Luther King, Jr., renewed 1991 by Coretta Scott King.

394 Anna Weiss, "Sex and Equality: Christina Aguilera." Copyright © Anna Weiss. Used by permission.

458 Marcia Angell and Jerome Kassirer, "Clinical Research: What Should the Public Believe?" *New England Journal of Medicine* 21 July 1994: 189–90. Copyright © 1994 Massachusetts Medical Society. All rights reserved.

464 J. Radcliffe-Richards, et al., "The Case for Allowing Kidney Sales," *The Lancet* 351 (27 June 1998). Copyright by The Lancet Ltd., 1998.

470 Maureen Dowd, "Our Own Warrior Princess," *New York Times* 1 June 2003. Copyright © 2003 New York Times Company, Inc. Used with permission.

470 Headline "Scarred for Life: Courage Begets Courage," *Milwaukee Journal Sentinel*, 3 June 2003. Copyright © 2003 Journal Sentinel Inc. Reproduced with permission.

473 Lynn C. Bryant, "Health and Literacy: Is There a Connection?" Copyright © 2003 Lynn C. Bryant. Used with permission.

Chapter 15

482 Deborah Tannen, "The Triumph of the Yell," *New York Times* 14 Jan. 1994: A29. Copyright © 1994 Deborah Tannen. Used by permission of the author.

488 Sidney Callahan, "Fight Fierce But Fair," *Commonweal* 11 Feb. 1994: 5–6. Copyright © 1994 Commonweal Foundation. Reprinted with permission. For subscriptions go to www.commonweal magazine.org.

492 Aida Michlowski, "From Conflict to Congruence," *Kappa Delta Pi Record* Spring 1999: 108–11. Copyright © 1999. Reprinted by permission of Kappa Delta Pi, International Honor Society in Education.

499 Faye Ginsburg, "The Anthropology of Abortion Activism," *Chronicle of Higher Education* 26 Jan. 1996. Reprinted by permission of the author.

504 Mel White, "Open Letter from Mel White to Jerry Falwell," 5 June 1999. Reprinted by permission of Mel White.

508 Andrew Sullivan, "Let Gays Marry," *Newsweek* 3 June 1996: 26. Copyright © 1996 Newsweek, Inc. All rights reserved. Reprinted by permission.

511 Sarah Glowicki, "Frankencorn or Green Revolution II? How Scary are Genetically Modified Crops?" Copyright © 2003 Sarah Glowicki. Used with permission.

Photo Credits

15 Colin Woodard

41 Frank Renlie/Getty Images

78 Photo of Christina Aguilera by Mark Liddell

186 James Syme

349 AP/Wide World Photos

352 AP/Wide World Photos

374 Tom Tomorrow

411 AP/Wide World Photos

448 American Library Association

450 Frank Renlie/Getty Images

471 Illustration by Randy Mack Bishop/*The Dallas Morning News*

Index